COBRA

Jean-Clarence Lambert

COBRA

Sotheby Publications

Acknowledgements

I would like to thank the following for their co-operation: Pierre Alechinsky, Karel Appel, Constant, Corneille and Édouard Jaguer; they generously opened their archives to me and, above all, were pleased to read my manuscript, which thus benefitted from their invaluable witness of events.

Thanks are equally due to:

Troels Andersen, the Director of the Kunstmuseum in Silkeborg, Enrico Baj (Milan), Mogens and Grete Balle (Asmindrup), Jacques Doucet (Paris), Henri Goetz (Paris), Uffe Harder (Copenhagen), Carl Otto Hultén (Malmö), Josef Istler (Prague), Egill Jacobsen (Copenhagen), Joseph Noiret (Waterloo), Anders Österlin (Malmö), Jean Raine (Rochetaillée), Serge Vandercam (Bierges), Pierre Wermaëre (Versailles) and Guy Dotremont (Limelette), brother of the poet, for their attentive and friendly assistance.

to Mrs. Willemijn Stokvis (Amsterdam) and to Gunnar Jespersen (Copenhagen) for having kindly provided me with the various documents in their possession

to Edilio Rusconi of Milan for having supported this book from the very beginning

Robert Maillard for having ensured its conception and seeing it through to publication

© 1983 Ste Nlle des Editions du Chene, Paris and Fonds Mercator, Anvers

English edition first published in 1983
Published for Sotheby Publications by
Philip Wilson Publishers Ltd,
Russell Chambers, Covent Garden,
London WC2E 8AA

and

Biblio Distribution Centre,
81 Adams Drive, Totowa,
New Jersey 07512, USA

ISBN 0 85667 178 9

Translation: Roberta Bailey
Design: Michel Guillet

Printed in Belgium
Typeset by August Filmsetting, Warrington
And Keyspools Limited, Golborne, Warrington

Cover illustrations:
Asger Jorn, *The moon and the animals*, 1950. Oil on briquette panel (47 × 60.7 cm). Private collection. This painting featured in the Second International Exhibition of Cobra Experimental Art in Liège in 1951. Photo Luc Joubert, Paris.

Gilding iron after a linocut by Corneille made for issue 4 of *Cobra*.

Contents

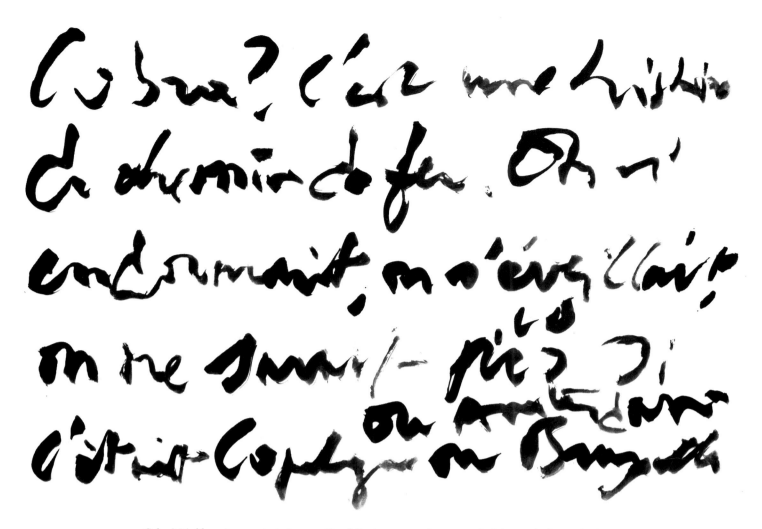

Cobra? It's like going on a train journey. You fall asleep, you wake up, you don't know whether you've just passed Copenhagen, Brussels or Amsterdam. Indian ink on paper (51 × 65 cm). Variation on a text (dated 1962) by Christian Dotremont, written in brush by the author in 1968.

'Like going on a train journey'? Christian Dotremont has described Cobra in numerous other ways. On 8 November 1978, thirty years to the day after the memorable meeting at the Café Notre Dame in Paris, where Cobra was founded, he wrote, in one of the understatements he was so fond of using: 'Cobra was a movement which was sort of organized for three years.' For us, it goes without saying that if, like so many other groups of artists and poets, Cobra effectively ceased to exist when it split up, it would hardly have been mentioned since. All that would remain would be ten issues of a so-called 'avant-garde' review, which never had an easy life, a number of other limited edition publications and the memory of exhibitions organized on each occasion in a rather haphazard way . . . Yet Cobra has become increasingly significant over the years, even if the events which marked its brief existence made little mark on their own time. From the evidence, it seems that Cobra is much more than the 'historical' Cobra, something which cannot be fettered by the narrow constraints of its brief chronology. There was a Cobra spirit, a Cobra art, which will not cease to be productive, even though the movement has broken up. The leading lights in the movement have continued along their own paths and developed their work, straying more or less from the general line they established in the years 1948–51. They have a place among the most important creative talents of the twentieth century and have made the art of Cobra one of the essential components of our sensibility. Nothing has stopped, even if Jorn and Dotremont are dead – their works remain lively and relevant, as much so as the paintings I saw last winter in Alechinsky's studio – hissing fantasmagoria against the background of town plans; or the new celebration of Corneille's lithographs *Women and Birds*; or, again, Appel's anti-robot pictures. Cobra without end. Cobra, a future origin, as Dotremont called it.

As long as he lived, Dotremont remained an active and vigilant witness of the movement. In him, Cobra had a rich resource, a continuous present. It also seems to me that a study of Cobra in all its manifestations can stretch out continuously, as did Dotremont's life. Cobra, existing for three years, lasting for thirty. This book, in whose planning Dotremont was involved, will seek to do that. It is to him, naturally, that it is dedicated.

Paris, January 1982

Willem Sandberg, then director of the Stedelijk Museum in Amsterdam, was one of the first people to sense the importance of Cobra. From November 1949 onwards, he welcomed the group into his museum, continuing to sponsor the development of its protagonists when the group ceased to exist. In 1959 he sat on the organizing committee of the major *Vitalita nell'arte* exhibition at the Palazzo Grassi in Venice, which demonstrated, by way of a comprehensive survey, how the Cobra spirit had become a European movement. In a short prologue, he set it in its historical context.

Sandberg reminds us that Cobra was born of a particular set of historical circumstances – those of the aftermath of the Second World War. This should not be overlooked, since it gives the works their stamp of authority. The three countries involved in Cobra, with its ramifications in France and Germany, belong to the Western Europe which had to reorganize and rebuild during the 'cold war'. In Dotremont, Jorn and Constant in particular, we see a reaction to the political vicissitudes of the time. The life story of Cobra is inscribed in a historical perspective which must be kept in sight in order to understand the evolution of each member and of the whole. In it will be found the principal landmarks of their destined development, in as much as they were members, sympathizers or fellow travellers of the Communist Party during its Stalinist phase. Or, indeed, its opponents.

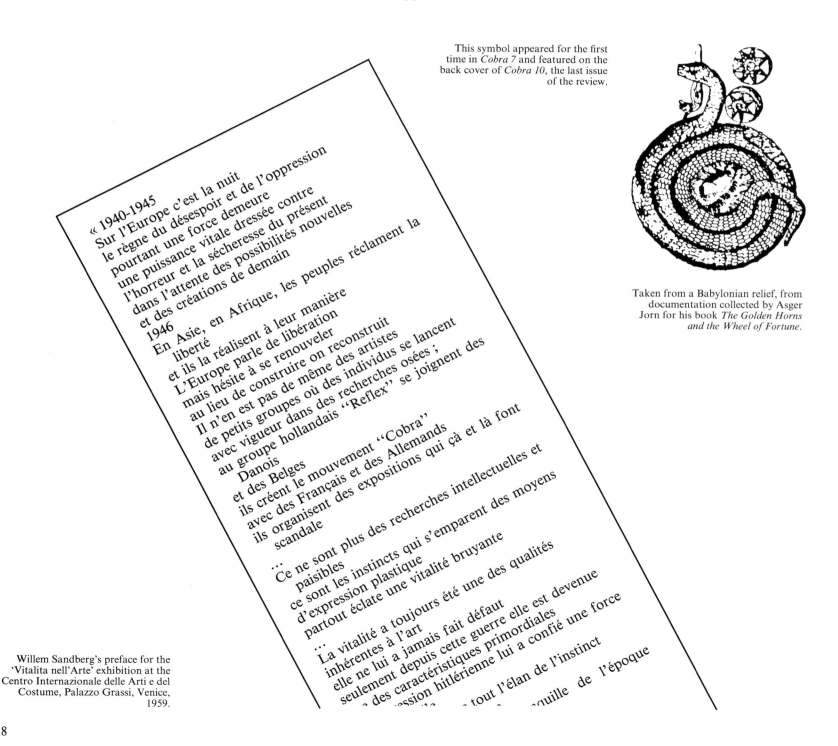

This symbol appeared for the first time in *Cobra 7* and featured on the back cover of *Cobra 10*, the last issue of the review.

Taken from a Babylonian relief, from documentation collected by Asger Jorn for his book *The Golden Horns and the Wheel of Fortune*.

« 1940-1945
Sur l'Europe c'est la nuit
le règne du désespoir et de l'oppression
pourtant une force demeure
une puissance vitale dressée contre
l'horreur et la sécheresse du présent
dans l'attente des possibilités nouvelles
et des créations de demain
1946
En Asie, en Afrique, les peuples réclament la liberté
et ils la réalisent à leur manière
L'Europe parle de libération
mais hésite à se renouveler
au lieu de construire on reconstruit
Il n'en est pas de même des artistes
de petits groupes où des individus se lancent
avec vigueur dans des recherches osées ;
au groupe hollandais "Reflex" se joignent des Danois
et des Belges
ils créent le mouvement "Cobra"
avec des Français et des Allemands
ils organisent des expositions qui çà et là font scandale
...
Ce ne sont plus des recherches intellectuelles et paisibles
ce sont les instincts qui s'emparent des moyens d'expression plastique
partout éclate une vitalité bruyante
...
La vitalité a toujours été une des qualités inhérentes à l'art
elle ne lui a jamais fait défaut
seulement depuis cette guerre elle est devenue
[...] des caractéristiques primordiales
[...]ession hitlérienne lui a confié une force
[...] tout l'élan de l'instinct
[...] de l'époque

Willem Sandberg's preface for the 'Vitalita nell'Arte' exhibition at the Centro Internazionale delle Arti e del Costume, Palazzo Grassi, Venice, 1959.

10 January – First meeting of the United Nations General Assembly in London. Verdict in Nuremberg Trials. Plebiscite in Italy puts an end to the monarchy and installs a Republic. Outbreak of Civil War in Greece. The former Allies are unable to reach an agreement over Germany. USA tests a new atomic bomb at Bikini Atoll.

In France, worsening of the economic situation, food rations remain insufficient. De Gaulle relinquishes power (20 January). Communists in government in France, Belgium and Italy.

Gottwald is President of the Council in Czechoslovakia. He will begin a programme of nationalization.

5 March – in Fulton, Missouri, Churchill speaks of an 'iron curtain' cutting Europe in two. In Brussels, Paul-Henri Spaak delivers a speech on 'the fear which grips the world'.

14 April – War recommences between Mao and Chiang Kai-shek. In Amsterdam, lorry drivers and dockers go on strike to demand the withdrawal of 3,000 Dutch troops from Indonesia.

21 August – Andrei Jdanov speaks in Leningrad: 'The creators have lost their sense of responsibility towards their people, their state, their party. The new social order, which embodies the best of the history of civilization and human culture, is capable of creating the most advanced literature which will leave the finest creations of the ancient world far behind.' Jdanovism, which will weigh heavily on Communist parties everywhere, is launched.

23 November – War breaks out in Indochina with the bombing of Haiphong.

In Paris, Saint-Germain-des-Prés is the 'in' area for both existentialism and jazz (Café de Flore, Hôtel de la Louisiane). In the cinema, it is the era of the rediscovery of Rossellini and Italian neo-realism. New edition of André Breton's *Surrealist Manifestos*. Arthur Koestler's *Darkness at Noon* and Henry Miller's *Tropic of Capricorn* published in French.

'A terrible year' De Gaulle will call it in his *Memoirs*. It marks the beginning of the 'cold war'.

Communist ministers are thrown out of the governments of Italy, France and Belgium, whilst Socialist and Communist parties form alliances in many Eastern European countries.

The 'Truman Doctrine' (Truman will be re-elected President); henceforth the USA will offer aid to countries against 'totalitarianism'. i.e. Communism. At Harvard University on 5 June, General Marshall outlines his plan which complements the Truman Doctrine: aid for Europe in its period of recuperation, to be offered to all governments, including that of the USSR, aimed at 'allowing the emergence of political and social conditions under which free institutions may exist'.

2 July – USSR denounces the Marshall Plan as an 'instrument of American imperialism' and prohibits Eastern European countries from participating in the conference on the reconstruction of Europe, which takes place in July in Paris. In Prague, conflict between Gottwald and Masaryk, who wishes to go to the Paris conference. In October, the Communist Office of Information or Kominform is set up. USSR announces it, too, has the atom bomb. In Moscow, stalemate at the Allied Conference on the problem of Germany.

In France, strikes and riots lead to the end of the CGT and the birth of the Force Ouvrières. In August, the bread ration reaches its lowest level since 1940: 200 grams per person per day.

Gide receives Nobel Prize for literature. Van Gogh exhibition at the Orangerie. International Surrealist exhibition at the Galerie Maeght. Antonin Artaud's *Van Gogh ou le suicidé de la Societé*; Albert Camus' *La Peste*.

The cold war intensifies on all fronts. On 25 February, coup takes place in Prague. The Communists are removed from power; Jan Masaryk 'commits suicide' on 10 March. USSR responds to the reunification of the three occupied allied zones in Germany with declaration on 20 June of the Berlin Blockade which will be enforced by means of an aerial blockade. On 28 June, Tito's Yugoslavia is expelled from Kominform. Civil war in Greece ends with the defeat of the Communists. In Wroclaw in Poland, World Congress of Intellectuals takes place, which will be a prelude to the peace movement. At the tribune of the congress, in which Eluard, Picasso, Fernad Léger, Aime Césaire, Vercors and Richard Hughes participate, the Soviet writer Fadeiev describes Sartre as a 'typewriting hyena; a jackal armed with a pen'. In the USSR, Prokoviev and other composers accused of 'individualism'. The botanist Lyssenko supported by the Central Committee in his denunciation of Mendel's laws on genetics. Jdanov dies on 31 August.

17 March – Britain, France and the Benelux countries conclude a treaty of economic assistance. In April, France finally adopts the Marshall Plan. On 11 June, the Senate in Washington authorizes the government to form alliances outside the continent of America – a prelude to the Atlantic Pact.

Gandhi assassinated on 31 January. State of Israel proclaimed on 17 May, with the sanction of the Western Powers and the USSR. On 5 June, Vietnam is recognized as an independent associated state. UNO in session in September at the Palais de Chaillot; Vychinski, a former Moscow trial lawyer, is the Soviet delegate. Tito declares that the USSR is trying to force him into submission through economic pressure.

In France, a wave of strikes, confrontation in the mines. In December, 20,000 people proclaim Gary Davis a 'citizen of the world' at Vel'd'Hiv . . . André Breton speaks at the tribune. In the theatre, Pichette's *Les Epiphanies* and Sartre's *Les Mains Sales*. Le Corbusier builds the first 'unité d'habitation' in Marseille. Breton publishes *La Lampe dans L'Horloge*; 'This end of the world is not our doing,' he writes, on the atomic threat and the division of the world into two blocs. First exhibition 'Les Mains Éblouies' at the Galerie Maeght in Paris. Founding of the 'Compagnie de l'art brut' by Jean Dubuffet, and André Breton, Jean Paulhan and Michel Tapié. Jorn will join later. Death of Antonin Artaud. Bazaine publishes his *Notes sur la peinture d'aujourd'hui*.

Suicide of the American painter Arshile Gorky. 8 November – founding of the group known as Cobra in Paris.

Cold war continues, fanned by the secession of Tito. In January, Komecon formed as an Eastern European response to the Marshall Plan. Hungary becomes a popular democracy. Cardinal Midszenty condemned to life imprisonment. In April, the Atlantic Pact is signed and NATO created.

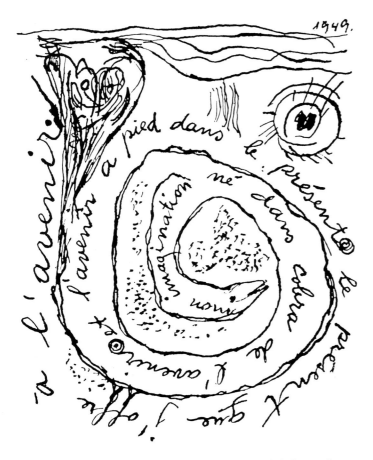

Christian Dotremeont and Asger Jorn, *Word-pictures*, 1949. Extract from *La Chevelure des Choses* (The hairdo of things). Dotremont's text has been transcribed by hand by Jorn: 'My imagination (born) in Cobra of the future and the future is rooted in the present, the present which I offer to the future.'

From January to April, a law suit went on between the communist-dominated journal *Les Lettres Françaises* and Kravchenko, author of *J'ai choisi la liberté*, a book denouncing the concentration-camp regime in the USSR: evidence given by the daughter of philosopher Martin Buber, Margarete Neumann, which Simone de Beauvoir considered had ensured a conviction: 'The existence of work camps in the USSR is a fact. We are beginning to ask ourselves if the USSR and the peoples' democracies really deserve to be called socialist.'

The communist parties in various countries declare their loyalty to the USSR in the event of war. On 5 May, the Federal Republic of Germany is proclaimed with Bonn as its capital. On 12 May, the Berlin Blockade is lifted after 328 days. Arrests of Rajk in Budapest and Kostov in Sofia, both accused of being agents of Tito. They will be condemned to death and executed. 14 July – the USSR carries out its first nuclear test. On 10 October, the People's Republic is proclaimed in China, with Mao as President. Wave of arrests amongst the middle classes in Czechoslovakia. Creation on 7 October of the German Democratic Republic, with Wilhelm Pieck as President. In December, Mao visits Moscow. On 21 December, the Communist world celebrates Stalin's seven-tieth birthday, marking the peak of the 'personality cult'. The Soviet bloc breaks all bonds with Tito's Yugoslavia. On 27 December, the Netherlands recognizes Indonesia's independence.

In France, bread coupons are discontinued and the free currency market is re-established. Camus' *Les Justes* and Ionesco's *La Cantatrice Chauve* are on stage. Faulkner wins Nobel Prize for Literature. Simone de Beauvoir's *Le Deuxième Sexe*. Founding of the review *Art d'aujour'd'hui*, dedicated to 'cold' abstract geometric art. Herbin publishes his manifesto *L'Arr non figuratif non objectif*. Lévi-Strauss' *Les structures élémentaires de la parenté* ('Elementary Structures of Kinship'). First exhibitions for Soulages and Riopelle (Paris) and Francis Bacon (London).

Death of James Ensor.

1950

The year 1950 is dominated by the Korean War; hostilities commence on 25 June with the liberation of the 38th Parallel by the North Korean army. Truman authorizes MacArthur to intervene. In Europe, fear spreads, as much in the West as in the Communist countries; is this the build-up to World War Three, this time an atomic war?

Schuman's plan for a European pool of coal and steel.

In Stockholm, World Peace Congress launches an appeal for the control of atomic weapons. Tito proclaims non-alignment of Yugoslavia. Mao delivers a speech on the possibility of war, which he sees as preventable by the Communist parties. Vietnam war takes a difficult turn for France. In July, Belgium experiences period of uncertainty with the return of Leopold III, who promises to abdicate when his son comes of age the following year. There is talk of the rearmament of Germany. Difficulties with Tunisia and Morocco. Eisenhower is named Commander-in-Chief of NATO forces. At the instigation of Senator McCarthy, a commission of enquiry is set up in the USA into un-American activities (the 'witch hunt').

Jacques Villon wins the Carnegie Prize and Matisse the Grand Prix at the Venice Biennale, where the work of artists of the New York School is on display. Second exhibition of *Les Mains Éblouies* at the Galerie Maeght in Paris. First Mondrian exhibition at the Gemeentemuseum in The Hague. Publication of *L'Almanach surréaliste du demi-siècle*. Charles Estienne's *L'Art abstract est-il un académisme?* ('Is Abstract Art an Academism?'). First 'concrete music' concert (Schaeffer Henry).

1951

Throughout the world, the cold war continues, with confrontation between Eastern and Western blocs. Repression in both East and West. Condemnation of Rosenberg in the USA. Decolonization and emergence of the Third World. An important step towards a united Europe is taken with the signature of agreements on coal and steel by Benelux, France, Germany and Italy.

Albert Camus's *L'Homme Revolté*. Julien Gracq declines the Prix Goncourt. Death of Wols. Creation at Ulm of the Hochschule für Gestaltung under the direction of Max Bill, in the post-Bauhaus spirit. *De Stijl* retrospective in Amsterdam. An international exhibition at the Palais des Beaux-Arts in Liège marks the end of Cobra.

International Exhibition of Cobra Experimental Art at the Stedelijk Museum, Amsterdam, 3–28 November 1949. The entrance hall: in the background, Constant's *The Barricade*, specially made for the exhibition. This painting (355 × 283 cm) is now the property of the Stedelijk Museum, Amsterdam. Photo H.U. Jessenrum d'Oliveira.

'Advertisement' featured on the back of a brochure issued by the Galerie Le Parc in Charleroi, 1950, and dedicated to Pol Bury. Text by Marcel Havrenne.

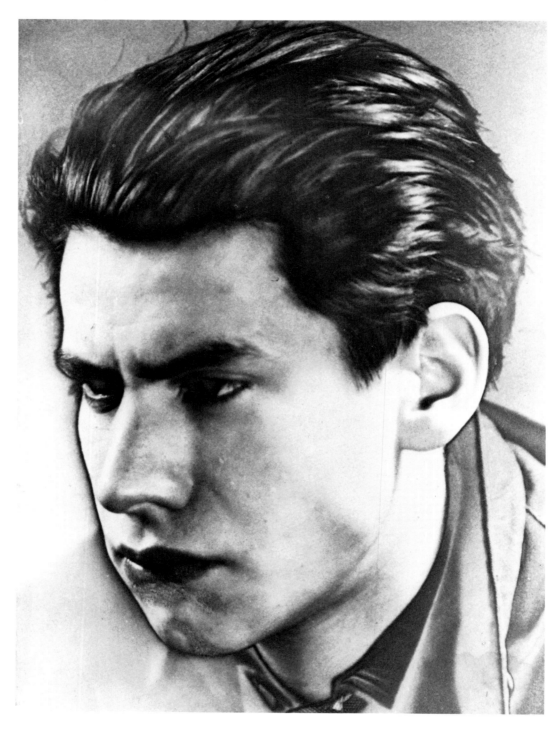

Christian Dotremont. Solarized photograph by Raoul
Ubac, 1940.

1. Cobra before Cobra

An adolescent, expelled from a number of schools (one of which was the Jesuit College in Liège) formed a rapport with the Belgian surrealists, who published the review *L'Invention Collective* ('Collective Invention'). He was eighteen years old, called Christian Dotremont and had just published his first booklet, *Ancienne Eternité*, a long love poem which had already revealed the extent of his talent.

The end of 1939 and the beginning of 1940: 'a phoney war', a period of numb waiting for Hitler's attack. Dotremont drank in the works of Rimbaud, whose ghost he pursued all the way to Charleville. His general rebelliousness ('rather confused' he would later describe his behaviour) was somewhat similar in style to that of Rimbaud; his poetry too – although he had always written poems. It was quite natural for him to align himself with Surrealism; Magritte greeted *Ancienne Eternité* with an enthusiastic letter and Dotremont met him – Ubac and Louis Scutenaire too.

In Belgium, Surrealism was already long established and its protagonists, whom he had been meeting since 1926, gave him a particular direction which did not necessarily coincide with that of André Breton and his friends in Paris. The Belgians were inspired above all by 'a spirit of fury in the face of the given thing' (Christian Bussy). Paul Nougé, to whom can be accredited most of the theoretical texts which defined the aims of the group at its inception, spoke of 'an ethic resting on a psychology coloured with mysticism'. But the mystical colouring was to fade very quickly and Nougé, who was of a scientific persuasion, would tend towards methodical and controlled experimentation; automatism as defined by Breton and André Masson would never hold much appeal for the Belgian Surrealists. 'Let man go where he has never been,' Nougé proposed, 'experience what he has never experienced, think what he has never thought. We must help him, we must provoke this crisis, this transport of the senses; let us create shocking objects.' It is clear how easily a painter like René Magritte could make these words his own, but, in fact, Surrealism in Belgium was above all a gathering of poets, with one painter, Magritte, as an exception and one collage artist, E. L. T. Mesens (Delvaux was not really involved), until Ubac joined the movement when war broke out, followed by Marcel Mariën. And if it is necessary to look for a common denominator, then it would be 'attention, freedom, experimentation, premeditated intervention, invention, deliberate action, anonymity, charm, disposability, adventure in the full sense of the word' (C. Bussy).

In reality, Belgian Surrealism can be divided into two distinct groups. In 1934, a group was formed in Hainaut which called itself 'provincial with an international vocation'; this was the group known as Rupture, whose central personality was the poet Achille Chavée. Closer to Breton and the Parisians than the Brussels group, the Surrealists of Hainaut would experience many internal tensions, due to the taking of successive political stances. In order to distinguish between the friends of Chavée and those of Magritte and Nougé, José Vovelle, who was the first historian of the movement, remarked in *Le Surréalisme en Belgique* (1972), that Hainaut was 'this part of the Walloons' territory with its eyes set upon France, the boredom and sadness of the countryside adding to the difficult life of the working populace' and described the Surrealists there as 'carrying the germ of rebellion and the desire to create works for the Revolution'. Chavée, moreover, would engage in a certain amount of political activity, as would his friend Fernand Dumont, co-founder of Rupture. Chavée joined the International Brigades during the Spanish Civil War, from whence he returned a stalinist. In 1941, following Hitler's invasion of the USSR, he joined the Resistance, along with Dumont; the latter was deported and went missing. After 1945, Chavée regrouped some of his friends to form Haute Nuit. Amongst them were the poet Marcel Havrenne and the painter Pol Bury, who would both later participate in Cobra. Then under Magritte's influence, Pol Bury was painting compositions which 'flouted' the laws of nature; he had still to 'find himself' and the metamorphosis which would lead him to Kinetics was in progress.

In an article on 'Cobra in Belgium', Dotremont would later recall how he visited Raoul Ubac, than a surrealist

One of the ten stanzas of *Ancienne Éternité*, a poem by Christian Dotremont published in Louvain in 1940 under the imprint 'La Poesie est là'.

III

Parlez-moi d'elle. — je la confonds toujours avec elle-même. — dans mes souvenirs, je la fais habiter une petite maison abandonnée — avec des fenêtres sales. — elle était tout en joues et moi j'étais tout en lèvres. — nous étions bien faits pour nous entendre car quatre lèvres soudées ne laissent passer que le monde — (les gestes parlent.) — et c'est déjà bien. — elle a un visage perdu d'avance. — à la place de la bouche, elle a un sourire noir. — noir ? — oui, une joie en peine, je ne sais pas. — son corps n'est pas fait pour exister. — il meurt de vie. — j'avais fabriqué des tas de filles ; — elle fut toutes. — elle fut elle. — elle fut nous. — je ne savais pas où l'embrasser. — je l'ai embrassée partout, jusque dans les villages ; — je mettais des baisers sur le soleil. — elle était tout, — même ce qui est bon. — parlez-moi d'elle.

photographer, in March 1940. 'I had found his address in *L'Invention Collective* – what a good title! I happened on this review partly by chance and it really struck me. I was eighteen and I had just written *L'Ancienne Éternité*. Ubac was younger than the others and consequently our friendship became stronger. He opened many doors for me.'

Until the war, Ubac had connections with the Paris Surrealists and participated in their activities. The review *Minotaure* published his photographs – fine surreal studies – the body of a woman, Dalmation rocks. As he would himself recall (in *Ubac*, published by Maeght Editeur, 1970) – and one can just imagine him telling this to the young Dotremont – 'For the surrealists, art was the way to bring certain revelations out of the darkness into the light of day. All techniques are valid in as much as they serve this purpose. I myself had adopted photographic methods; their impersonal techniques had seduced me much more than drawing or painting, and I used them to achieve that reality whose unusual aspects we shall never cease to reveal.' And Ubac added the following, which surely contradicts the more calculating ethic of the Brussels Surrealists: 'Much more than a means of self-expression, art is a way of life – an attempt at reconciling the dream and love in life.'

Dotremont would remain in contact with Ubac, even when the latter cut his ties with Surrealism, which he did during the war. The cover and heading of issue seven of the review *Cobra* (Autumn 1950) shows one of Ubac's slate engravings and, in 1962, six of Ubac's engravings would illustrate a limited edition of *Ancienne Éternité* published by Adrien Maeght.

L'Invention Collective, a review which included the work of the different Belgian Surrealist groups without distinguishing between them (there were just two issues of this review), published several of Ubac's texts, including 'Les Pièges à Lumière', which revealed an intensity of spirit equal to that of the young Dotremont. It touched on 'the feeble, if not non-existent, *objectivity* of our visual perception' and on still more new technical possibilities which 'register amongst the methods whose aim is to disentangle the poetic from reality itself.' Dotremont suggested that Ubac should work with him on a 'Treatise on Optics', but this remained the mere germ of an idea. However, they did carry out several 'entoptic' experiments together and Dotremont would always maintain an active interest in photography from that time on. The idea, then dear to Ubac, of an interaction (and, if possible, a fusion) between the new photographic techniques and 'that which in painting has gone beyond painting', would also be taken up by Dotremont; it is what he called 'developments of the eye' in his preface to an exhibition of Ubac's photographs, mounted by Roland D'Ursel and Serge Vandercam at the Saint-Laurent Gallery in Brussels in 1950. 'The eye, an organic forest, enters the forest of infinitely small and infinitely large forms, the forest of microbes, those which believe in reality and those which do not, the veins, the blood, the crystals, the thickets of the virgin forest, born of virgin paper.

'Since Corot painted his landscapes, the eye has discovered more Corot landscapes in nature, or, where there are none, it has invented them. Corot, too, has participated in the development of the eye.

'Ever since photography has existed, the eye has always had, unknown to itself, something of the objective. The eye turns away from what the photograph has revealed *too* much. It has taken it and placed it *outside of reality*.'

Amongst Magritte's paintings, Dotremont particularly admired those works which combined one or several words in the picture. There were many of these in the years 1928–30: in *The Betrayal of Images*, for example, a pipe is accompanied by the written phrase 'This is not a pipe'; and in *The Key to Dreams*, the recognizable objects he has painted are deliberately named or renamed because, as Magritte explains in a text in *La Révolution Surréaliste* ('The Surrealist Revolution', issue 12, December 1929), 'an object is not so attached to its name that it couldn't be found another which would suit it better.' There are also his drawings published in *Variétés* (no. 8) – three silhouettes of naked women, each one given a written name: 'tree', 'shadow', 'wall'. The written word intervenes in the plastic image in order to disrupt the relationship between image, object and word; but on each occasion he was playing with the meaning and not the symbols. Magritte exhibited no more interest in the material nature of writing, which is applied and scholarly, than in the material nature of painting. He was as anti the writer as he was anti the painter, contenting himself with uniting two points of reference which were poles apart and very dissimilar from each other. He scorned the dictionary as being constructed on the basis of the more or less fixed connection between words and objects. The 'word-pictures' of Cobra are of a different nature, manifesting a spirit of spontaneity which Magritte did not possess

René Magritte, vignette for Éditions du Serpent de Mer, Brussels, 1944. Indian ink drawing.

and which he derided. Magritte's and Nougé's brand of Surrealism was far too 'cold and calculating' for Dotremont, a fact which would distance him progressively from them, though not before he had again collaborated with Magritte on various occasions – even including an attempt to create some 'cartoons' with him (in 1945–6). But the split had to come; Cobra would reject Magritte's 'illustrative imagination' in favour of a more purely plastic and material imagery. Nevertheless it was Magritte who created the 'little mermaid' logo for

the Éditions du Serpent de Mer which appeared on several of Dotremont's publications in 1943–4 – a little mermaid which was not yet symbolic of Copenhagen, as the snake was not yet of Cobra.

With Paul Nougé, however, there was quite open antipathy. In a letter of 27 November 1949 to Jean Terfve, the first secretary of the Belgian Communist Party, Nougé wrote: 'I have never collaborated with Dotremont, I have no contact with him . . . He has always inspired a rather deep dislike in me.' Dotremont was certainly more at ease – perhaps because they were of the same generation – with Marcel Mariën, the 'egonomist' who received him at Anvers at the start of the Occupation and published his poems *Le Corps Grand Ouvert* in 1941, before a closer collaboration between the two became established. In 1945 he shared with him (and with Paul Colinet) the editorship of the weekly *Le Ciel Bleu* ('Blue Sky'), then participated in Mariën's collection, (1945). Dotremont published some accompanying notes on the 'language of language', which marked his discovery of the 'visibility' of writing and heralded the 'word-pictures' and 'logograms' to come:

'The subject is a word which strikes the eye first of all.

'*It is a pyramid*. Dare one say *it* is the subject? There is a visual grammar.'

Or: '*Machine* shows me a machine, but a Chinese one. And also "complicated".'

With the war, the invasion and the downfall of government, Dotremont, at the same age as Rimbaud, embarked on the vagabond lifestyle which would be his for some considerable time to come and in which experimentation and writing, the real and the imaginary, theoretical reflection and everyday life would be inextricably intermingled. His poetic work consisted principally of sentiments inspired by his romantic liaisons; he would even call the girls he met by the names of poems he wrote about them. Thus *Ancienne Éternité* and *La Reine des Murs* (1960) were 'love letters', according to his classification of them; but for him, love was always held in suspense, as was later his love for Gloria, the Danish girl (*danoiselle*, as he put it) who would occupy a central place in his life and work from 1951 onwards.

'I invent and to invent is to see again in dazzling blindness – the little bit of the invisible which remains – the throat burning on and on.'

By way of an introduction to the poems entitled *Noués comme une cravate* which he published in the form of a brochure in 1941, J.-F. Chabrun wrote these few lines which would hold true for all Dotremont's poetic works: 'With Christian Dotremont, whose whole past is contained in these few sticks of dynamite he is about to throw, to his peril and his glory, one does not pursue in vain the shadow, at once dazzling and transparent, of the vanished Simone, glowing like the lamp of dawn in the clearings of the night.' Dotremont would remain faithful throughout all the vicissitudes of 'real Life' to the mediating woman 'the being who casts the most

shadow and the most light' as the Surrealists conceived her. It becomes clear in reading his 'autobiographical novel' *La Pierre et L'Oreiller* (1955) that his 'real life' never succeeded in eradicating Nadja within him.

La Main à Plume was a collection initiated in Paris in 1941 by Noel Arnaud and Jean-François Chabrun to maintain surrealist activity in Breton's absence. After his encounter with the censorship of the Vichy government, André Breton left Marseilles, where he had taken refuge, for the USA. In 1941 and 1944, *La Main à Plume* would bring out thirty or so publications, with which Dotremont was more or less directly connected during his frequent clandestine trips between Belgium and Paris.

With Breton removed from the field of battle and Surrealism, profoundly affected by the disappearance of Trotsky, becoming more and more mistrustful in the face of immediate political action, *La Main à Plume* became linked, in occupied France, with a network of resistance of various persuasions, one of which was the underground Communist Party. The anonymous and undated foreword to the first loose-leaf collection proclaimed: 'We still refuse to flee reality for poetry. *We will stay*. That is to say we refuse neither to advance in time or bring time forward.'

La Main à Plume was echoed by other publications such as *Quatre-Vingt et Un*, run by André Stil in Quesnoy, who would later receive the Stalin Prize, then become a member of the Académie Goncourt. It was in this review that the first poems by Édouard Jaguer, a future collaborator of Cobra, appeared; Dotremont's 'Les Dangers de la Rue Serpente' were published in the issue dedicated to 'the future of Surrealism', a compilation of 'secret messages from those people (many of whom are dead or missing) who were forced to write *poetry* to say *revolution*.' Announcing 'Les Dangers de la Rue Serpente', Noël Arnaud said of Dotremont: 'In his exile in Louvain, I know that he gladly spilled the ink of the marvellous poem which is his life over the book of the lie which is the life of others.'

In January 1943, Dotremont gave a most daringly provocative lecture at the Catholic University of Louvain: 'The future is a limb of Surrealism'. He would publish extracts from it in the collection *Le Surréalisme encore et toujours* ('Surrealism still and always') in Paris in August of the same year. It merits attention, since it shows at once what Dotremont had positively assimilated from Surrealism and, at the same time, what he would isolate out from it to form the basis of Cobra values.

Dotremont's vigour took him straight into the attack: 'We were speaking here only yesterday about church unity. Now I will tell you about a movement which concerns itself with the struggle for the union of opposites and, in the final analysis, for the union of mankind.' Dotremont placed the accent on the collective activities favoured by the surrealists, rather than individual work created in solitude.

Of those who 'cry "I don't understand" when confronted with a Picasso', Dotremont put the proposition: 'They cannot understand, in fact; they still take the visible for the real, imagination for Utopia, the dream for free, the marvellous for tapestry, the invisible for the subjective and the never-seen-before for the never-existed.'

Dotremont also advocated automatism, but with reservations which would later be echoed by Jorn and Cobra: 'There are degrees of success in automatism' (automatism as a technique giving access to creativity to everyone – a Utopian concept which would be developed by Constant in particular). 'In automatism,' said Dotremont, 'the poet possesses no more talent than other men could easily display.' He would go further than this in talking of 'collective poetry' and 'poetry by every one' 'which should not be the sum total of poems for someone'. He went as far as saying that 'anonymity is the great hygiene', which was surely an early call to folklore, the anonymous art, which would be so much a part of Cobra. At the same time in Copenhagen, Jorn and his collaborators in the review *Helhesten* ('horse of hell') were taking an interest in the art of the banal.

Dotremont also claimed that not finishing a work was the best way to ensure its survival: 'We never permit ourselves to finish a poem (or even to finish off someone condemned to death when the firing squad has failed to kill them), to finish it to begin it, to insert it in space like a cloud.' And this is precisely what Jorn was to say about painting.

Later, Dotremont gave a definition of the image which marked his divergence from Surrealist theorists – no doubt under the influence of Gaston Bachelard, with whom he had made contact: 'The image is not the juxtaposition of two objects, of two ideas [but] the materialization of the connection between them, as the word is the symbolic materialization of the object.' Here, materialization is important. In the 'technical notes' he had previously published in *La Conquête du monde par l'image*, a collection in *La Main à Plume*, Dotremont had already sought to relieve the word 'image' of 'all aesthetic meaning', repeating that 'the imaginary is not the anti-real' and extolling Surrealist images for what they were – 'never clever: they grab, they bite, they strike, they beat a path to the new reality, to reality finally adjusted to the grandeur of King Desire.' Desire would become a key word for Cobra.

In the Paris of the Occupation, to which Dotremont had travelled on foot via Charleville (where, as he confessed to the painter Henri Goetz, he had spent a night on Rimbaud's tomb), he completed what might have been called in the old days his 'apprenticeship', through many contacts made there. He had the good fortune to make the acquaintance of Éluard, who would only go underground after the publication by *La Main à Plume* of his *Poetry and Truth 42*:

La Conquête du monde par l'image. Cover. Inset is Pablo Picasso's *Bull's head*, 1942. Éditions de la Main à Plume, Paris, April 1942.

'All-purpose' enamelled plaque made to order for Christian Dotrement around 1965.

This small murderous world
Confounds the living and the dead
Whitens the mud, reprieves the features
Transforms the word into noise

('The Last Night')

Éluard took Dotremont to meet Picasso in the Rue des Grands-Augustins; Dotremont was particularly fascinated by the sketches with which the painter had illustrated the poet's manuscripts. Éluard and Picasso lived in a closely-knit intellectual community, which bound them when apart and continued until the poet's death. Without doubt, Dotremont found in this relationship a model for that which he sought later to establish with his Cobra companions. Other Parisians

LA CONQUÊTE DU MONDE
PAR L'IMAGE

Noël ARNAUD
ARP
Maurice BLANCHARD
Jacques BUREAU
J.-F. CHABRUN
Paul CHANCEL
Paul DELVAUX
Oscar DOMINGUEZ
Chr. DOTREMONT
Paul ELUARD
Maurice HENRY
Georges HUGNET

Valentine HUGO
René MAGRITTE
Léo MALET
J.-V. MANUEL
Marcel MARIEN
Marc PATIN
Pablo PICASSO
Régine RAUFAST
TITA
Raoul UBAC
G. VULLIAMY
et l'USINE à POÈMES

Objet (1942). Picasso.

Il faut que la force créatrice de l'artiste fasse surgir ces images, ces idoles demeurées dans l'organisme, dans le souvenir, dans l'imagination; qu'elle le fasse librement sans y mettre d'intention ni de vouloir; il faut qu'elles se déploient, croissent, se dilatent et se contractent, afin de devenir non plus des schèmes fugitifs, mais des objets véritables et concrets.
GOETHE

LES ÉDITIONS DE LA MAIN A PLUME
11, Rue Dautancourt — PARIS (XVIIᵉ)

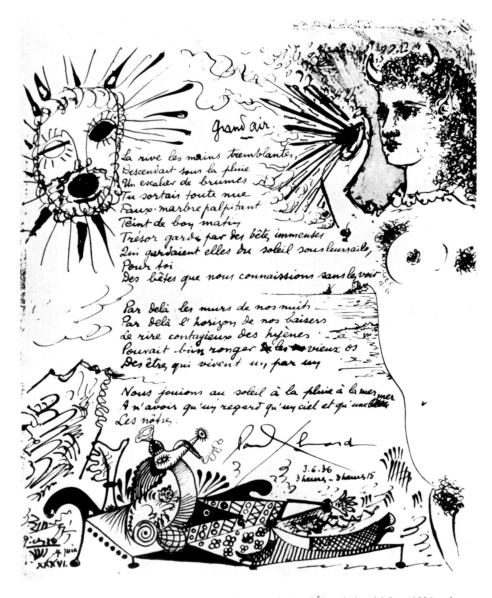

Grand Air, a manuscript poem by Paul Éluard, dated 3 June 1936 and illustrated with sketches by Pablo Picasso. Ink on paper (26 × 22 cm). First published in the collection *Les Yeux fertiles*. G.L.M., Paris, 1936.

who must be mentioned as having left their mark on Dotremont when they met were Oscar Dominguez, who did a sketch for *Noués comme une cravate*, Giacometti, who would later be invited to the Cobra exhibition at Liège, and the painter Christine Boumeester, who, like her husband Henri Goetz, had been attracted for a number of years to non-figuration. 'With non-figurative art,' Goetz would say 'what you lose by the absence of figuration you gain in the freedom you acquire . . . This choice depends entirely on the needs of each artist.' Had Dotremont perceived, as Goetz sought to prove, that Surrealism and abstract art do not necessarily oppose each other unyieldingly, that they could even correspond to and complement each other in a certain way? If the Danes, of whose existence Dotremont was still unaware, had recognized an abstract-surrealist style of painting for a number of years, in Paris their respective

positions were more contrasting and Goetz was a rare pioneer in his attitude. Moreover, Goetz had worked on 'correcting masterpieces', as Breton put it – he painted on top of reproductions of famous works of art, a posthumous collaboration which heralded Jorn's 'modifications' in systematizing Marcel Duchamp's act of derision.

Dotremont printed tracts and posters in collaboration with Goetz, at whose house he was living. These were acts of 'personal resistance' (Goetz had not yet joined any organized network), whose sentiment was that of a general revolt rather than a political one. Making use of the means that chance sent their way, they printed on forms taken from post offices, toilet paper from cafés or leaflets left behind in churches. Perhaps this was where Dotremont developed his taste for the flysheet type of publication which he was to favour all his life. He also took the risk of writing slogans in white paint on the banks of the Seine – 'Down with Germany! Down with France! Down with England!'

He visited Cocteau, whose warm welcome he would never forget; later, he would refuse to take part in the Surrealist condemnation of the author of *Plain-Chant*, which caused him to be briefly 'banned' by the Brussels group in 1945. But most important of all he met, through Ubac, Gaston Bachelard, who was working on his major works on the 'material imagination' at that time.

It was obviously Bachelard's 'materialism' which immediately seduced him, as it had the Surrealists. 'Materialism' meant something quite specific to Bachelard; it stemmed from the four primordial elements or materials – Earth, Water, Air and Fire. 'The primitive philosophers,' Bachelard wrote, 'associated one of the four fundamental elements with their formal principles, which are also marks of temperament in philosophy . . . Wise thought is linked to a primitive material dream, calm and lasting wisdom is rooted in a substantial constancy.' Wise thought? Much more, without doubt, poetic and artistic thought.

Bachelard was hard at work during those years of the German Occupation: his first methodological outline, *Psychanalyse du feu*, was published in 1937; his book *L'Eau et les Rêves* appeared in 1943, *L'Air et les Songes* in 1943. They would be followed in 1948 by the two volumes of *La Terre*, which dealt with the dreams of the will and the dreams of repose. For Bachelard, the imagination was pure demiurge: 'It is the facility of forming images which go beyond reality, which sing reality . . . Imagination invents more than objects and dramas; it invents a new spirit; it opens eyes which have new types of vision.' (*L'Eau et les Rêves*). Using psychoanalysis (sometimes according to Jung) and Phenomenology, Bachelard demonstrated that the perceived image and the created image were, in fact, 'two different psychical cases: a specific word is needed to described the imagined image . . . we always want our imagination to be the faculty of *forming* images. Well, it is rather the faculty of *unforming* images furnished by

perception. It is above all the faculty of liberating ourselves from primeval images, of changing these images. If there is no change of images, no unexpected union of images, there is no imagination, no *imagining action*. The basic term corresponding to the imagination is not image, it is *imaginary*. Thanks to the imaginary, the imagination is essentially *open, evasive*. It is in the human psyche, the very experience of this opening, the *experience of novelty itself*.'

Moreover, Bachelard showed that, if the imaginative function was the animator of matter in his innovative work, it did not allow itself to imagine passively; there was an exchange and a two-way movement, a dynamic interaction between the ego and the world, the will and the matter on which it exerts itself. This interaction determined the images produced and marked them deeply – whether they remained in the mind or the language, or whether they became concrete, plastic, objectivized forms.

Even though Bachelard was interested primarily in poetry and literary work, it is easy to understand precisely what artists could draw from this conception, which overturned classical relationships. Jorn would employ it in his methodology of the arts. In other respects, Bachelard's way of thinking was moving towards a return to the original, which Cobra would also seek in its turn, as much in folk art and folklore as in the childlike or in psycho-pathological expression.

Dotremont would say later: 'Almost unbeknown to himself, the person who understood abstract art most radically, Bachelard, would influence me in the direction of Cobra.' Pol Bury and Jorn would study him in their turn – Jorn above all, who brought a wealth of theoretical extensions to Bachelardism. And one of his few portraits would be that of the philosopher (1960, Kunstmuseum, Silkeborg), whose face became that of a Scandinavian god in the swirling colours, his beard white and green. Moreover, Jorn was passionately interested in depicting the beard, making it a study of it in one of his last works, *Indfald og udfald*, as an especially Nordic iconological theme.

Despite the events of the final two years of the War, they were particularly productive years for the young Dotremont, who had returned to Belgium; he even ended up hiding in the Fagnes region to avoid the *Werkbestelle* (the compulsory work service imposed during the Occupation). It was there that he married Ai-Li Mian, a seventeen-year-old Eurasian girl. He wrote and published several texts of high-flown Surrealism, intended as part of an encyclopaedic project, *L'Homme à Naître: Quand un homme parle des hommes ou les ceintures de la connaissance* and *Note sur les coïncidences, precedée de variations précises sur quelques moyens d'échapper à l'existence*. Particularly in this last text, Dotremont confronted the notions of reality, chance, possibility and negativity, taken in their surrealist sense, with certain data of the exact sciences, with an agility which recalled the best of Aragon. An attempt at

parallelism or at complementation in Bachelard's mobility, as we know, given to philosophy as the task of uniting poetry and science 'like two well-made contraries'. Dotremont claimed: 'Science still can act poetically, when it excavates the recesses of space, our attic, our own cellar, the inhabitants of outboard motorboats. This poetic action seldom goes without poetry: wide open, space insists on it, and the figures straddle so many suns that they take on a Whitmanesque gait, where

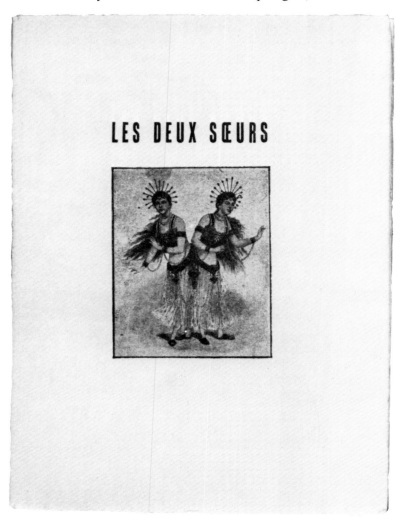

Third and last issue of the review *Les Deux Soeurs*, edited by Dotremont, Brussels, May 1947.

namelessly . . . Before two milliard years have passed, mathematics arrive at the point of finding themselves within reach of the voice of poetry.'

When *La Main à Plume* had to cease its activities (in France), Dotremont drew close to Marcel Mariën, the Surrealist from Anvers, and published with him (and Paul Colinet) the weekly *Le Ciel Bleu*, 'from beyond the looking glass'. It ran only to nine issues (1946). Then came *Le Suractual* (1946), a single issue, printed on bible paper, and the three issues of *Les Deux Sœurs* (1946–7), which were to clear a patch for Revolutionary Surrealism. *Les Deux Sœurs* published not only Breton, René Char, Paul Éluard, Gilbert Lely, Jacques Herold, Yves Tanguy and Victor Brauner, but also some newcomers

to Paris like Yves Bonnefoy and Édouard Jaguer, alongside the Belgians Louis Scutenaire, Achille Chavée and Paul Bourgoignie. The last edition opened with an article by Dotremont which was frankly pro-Stalinist, and which could only precipitate argument and ruptures with Breton and his Parisian group. Moreover, he was preparing himself to proclaim 'the right to heresy which we assert (Bonnefoy for example) in relation to the Communist parties, though it is towards surrealism that we should be directing it.'

André Breton had returned from America in 1946; the Surrealist group had been reconstituted, but it had not taken in any of the leading lights behind *La Main à Plume*, even less the Brussels group. It is easy to understand why: along with Benjamin Péret, who saw it as the 'dishonour of poets', Breton had denounced the political involvement that Satre and the Communists demanded of the intellectual. In addition, Breton had no taste for so-called resistance poetry and suspected the Stalinist ascendancy over people's minds more than ever. The misunderstandings which would generate the conflict were not long in coming. 'It was humanly impossible for us to consider our comrades in the resistance organizations who were members of the Communist Party as enemies,' Noël Arnaud explained. In fact, the Communist Party in the wake of the Liberation did not cease to make allies and had at its disposal a powerful politico-cultural machine. Only the Sartrians of *Les Temps Modernes* really provided a relative counterpoint. Breton's Surrealism and that of his friends counted for little. It was vilified by one side and the other and its end was in sight; it had only a few publications with a limited print run and readership through which to express itself. There were also other points of discord with the then dominant ideologies: Breton, as *Arcane 17* had already shown, was attracted more and more by the occult. The International Surrealist exhibition of July 1947 at the Maeght Gallery accentuated this attraction. In his long preface, 'Devant le rideau' ('Before the curtain'), Breton took the Brussels group to task, which was hardly surprising, since Magritte and his friends had also rallied to the Communist Party and were doing their utmost, as Breton ironically pointed out, to banish from their works all that was 'charm, pleasure, sun, objects of desire', in favour of what could be 'sadness, boredom, menacing objects . . . as if to get into line with the resolutions of the Writers' Committee in Leningrad (1946).' Resolutions which were those of Jdanovism and would – though not until three years later – motivate the split of the Belgian members of Cobra from the Party. Arnaud and Dotremont 'replied' to Breton in a virulent pamphlet which stated all their incompatibilities in highly humorous language: *Le Patalogue*. Apart from parody, the main points to emerge from it were its refusal of all kinds of mysticism, the will to confine itself to materialism as much in the philosophical as in the aesthetic sense.

In July 1947, Breton and his group published *Rupture inaugurale*, which marked the definitive rejection of all forms of collaboration with the Communist Party. It included these telling lines: 'The Communist Party, in adopting the methods and weapons of the bourgeoisie – for the ill-conceived needs of a struggle which is henceforth no longer qualified to lead to a successful conclusion – is committing a fatal and irredeemable error, an error which not only comprises the partial conquests of the working classes more each day and defers indefinitely the hour of their decisive victory, but shows up once again the flagrant complicity of the Communist Party with those it called, yesterday, its class enemies.' This was an uncomfortable stance, and one which met with incomprehension: had not the French President of the Council just dismissed the Communist ministers from government, putting the Communist Party back into opposition, which had provoked strikes and disturbances throughout the country? There had also been the launching of the Marshall Plan, to which the USSR had replied with the creation of Kominform: the split between East and West had been aggravated, the 'cold war' had started. In the minds of the people most of all.

Dotremont decided to create a 'Revolutionary Surrealist' group with his Belgian friends, Paul Bourgoignie and Jean Seeger; this was the culmination of a project formulated over the course of many discussions (Arnaud, Jaguer, Passeron, Battistini, Dotremont etc.), held in Paris since the month of May (photocopies of the minutes of these exist). Revolutionary Surrealism appeared like a last 'theoretical and practical' attempt, according to Dotremont, to 'renew surrealist experimentation, to affirm its independence but also the simultaneous necessity for common action, to which experimentation should submit only in cases where it has a political incidence.' The international conference, called to mark the birth of this new group, and whose title could not hide its modest form of organization, would be the reunion of several friends, coming back to Brussels as best they could; it was held in a room in a cafe called L'Horloge at Porte de Namur on 29, 30 and 31 October 1947.

In his speech, Dotremont made reference to the Marxist philosopher Henri Lefebvre, whose work *Critique de la vie quotidienne* meant enough for him to draw 'experiments on everyday life' from it. Later on, after Cobra, he would arrive, with Constant and the Situationists, at a proposition for a town based on play, in the same spirit. But for the time being, it was a matter of studying 'the collective sensations having relation to the path from desire to pleasure' inside a concrete psychology. Dotremont dreamed of a Marxist aesthetic – which Jorn for his part would call more assuredly materialistic – within which there would be a place for free experimentation, persuaded as he was of his social and historical efficiency. Experimental art was truly an avant-garde movement: 'We defend the necessity for painting, for poetry which transforms *less* men *more*

radically and finishes by transforming them *all* in transforming *those ones* – and in transforming painting itself and poetry itself – and pairing itself with the critical spirit to transform the consciousness.' A programme which was difficult to sustain, as the train of events would show: it was necessary to abandon all hope of political efficiency for experimental art and to replace it with 'Utopian' concepts, distanced from the present moment.

In the formation of a Cobra spirit, the influence of Henri Lefebvre and his book *Critique de la vie quotidienne* was as determinant as that of Bachelard, who, whilst not unaware of the 'social values', did not occupy himself with them. When Lefebvre's book appeared in 1947, Marxist hardliners were reserved, if not hostile, about it: French Marxism was enclosed in the dogmatism and sectarianism of the ideological 'cold war'. In contrast, the Revolutionary Surrealists and a number of others found an indication of new paths of research and action in the book. As we have seen, Dotremont and his friends in Brussels were immediately inspired by it and, in a certain way, it could be said that Cobra's first two exhibitions, *La Fin et les Moyens* and *L'Objet à travers les âges* could not help but invoke Lefebvre's ideas in their titles.

But what did the socio-philosopher, who was more 'marxian' than 'marxist', mean by 'everyday life'? Not so much a concept, difficult strictly to define, as a concrete realm of empirical man, a man of needs and desires, a man of the first degree, of spontaneous speech. And for him, the question became: how to reach that man, when an industrial-bourgeois-capitalist society had alienated and obliterated him? Through a critique of everyday life, Lefebvre replied. A critique which permitted the discernment of what was its substantial wealth and what was currently its poverty. It was a matter of making living and the experienced coincide, of going from the 'absence' of 'real life' (Rimbaud) to an abundant here and now, an abundant present. Utopian optimism? An illusory dream of the aftermath of cataclysm? This would in any case be the moral climate of Cobra, whose works would never claim to be anything other than the realization of essential moments.

The *Critique de la vie quotidienne* outlined a programme which Lefebvre would refine in his later works and with which Jorn and Constant maintained a dialogue in their successive metamorphoses. There are certain points in this programme which, clearly, would seduce Cobra: the methodical confrontation of so-called modern life with the past on one side and the possible on the other; the research of 'exact relationships' between the serious and the frivolous, the banal and the exceptional, the everyday and the feastday, reality and dream, at the same time making a critique of the one in terms of the other. 'Confrontation of effective human reality with its outward expressions: morality, religion, literature, philosophy'; everyday life, according to Lefebvre, was envisaged as a direct critique of philosophy and (why not?) of politics. What was really important in reaching

everyday man were the changes in his everyday life, in relation to which 'the overturning of political superstructures remains superficial.'

There are many themes here which, in addition to Cobra, would touch Situationism and reach out as far as the events of May '68. Lefebvre also underlined the conflictual unity of the natural element (biological, physiological, vital) and of the social element (acquired, conscious, cultural). According to him, it was necessary to dispense with artificial or deviant needs, abstract motivations, the illusions of the consciousness about its needs – in order to encourage and welcome the resurgence of the instinctive as a positive and satisfying force: the critique of everyday life must permit the passage to the qualitative, even if that was a case of humble daily needs. 'Man will be of the everyday or he won't be.' And everyday man, in recognizing himself as such, would be fully human man. Many of the premises of a theory of truly materialist art were here.

Meanwhile, the writings multiplied and collaboration was established between Dotremont and Asger Jorn, who had already met Constant. The Danes, who were distanced from the great ideological debates, thus made their debut on the European scene, thanks to Jorn. The crucial event of the International Conference on Revolutionary Surrealism in terms of the history of Cobra was, obviously, that meeting, which led immediately to friendship and close collaboration. 'Before we knew each other, Jorn and I, we already had many points of agreement, many affinities,' Dotremont said in the *Entretiens de Tervuren* ('Tervuren conversations', 1978).

It was Jorn amongst all the Danish artists who most desired to escape from his Nordic isolation. During an earlier stay in Paris he had met the Dutchman Constant, with whom he would henceforward remain in contact, having realized how much their ideas and personal plans corresponded. In Atlan's studio in the Rue de la Grande-Chaumière, he had got to know Édouard Jaguer and Michel Ragon, arousing their interest in his 'abstract-surrealist' painting, all 'colour-cries'. Then he returned to Scandinavia before going back to Paris once more, on the occasion of the International Surrealist exhibition at the Maeght Gallery. During that visit, he went to see André Breton, who found him 'Swedenborgian' but, according to Jaguer, 'got lost in the labyrinth of theories delivered sometimes rather abruptly in Jorn's gravelly French.' We know what reactions the Maeght exhibition elicited from Noël Arnaud and Dotremont; Jorn would hardly ever be seduced by Surrealism again and talked about Breton and his friends, when reporting on the exhibition in Brussels, as 'reactionaries'. On reflection, the important thing was not this unison of polemics, where political choice played its habitual role, but the presentation – almost the invention – which Jorn made at that time of a 'Danish Experimental Group': a formulation which contained the germ of Cobra.

'I use this designation,' Jorn said in his speech, 'for want of another more precise one; the labels which are

The reproduced newspaper (left portion):

N° 1 DIX FRANCS BELGES — VINGT FRANCS FRANÇAIS JANVIER 1948

BULLETIN INTERNATIONAL DU SURRÉALISME RÉVOLUTIONNAIRE

ORGANE DU BUREAU INTERNATIONAL DU SURREALISME REVOLUTIONNAIRE
CHRISTIAN DOTREMONT, secrétaire général — 32, RUE DES EPERONNIERS, BRUXELLES

NOTRE CONFERENCE

LE PAS GAGNÉ

Prenons garde, écrivait Maurice Nadeau dans *La Revue Internationale*, prenons garde, le surréalisme-révolutionnaire pourrait bien sortir de Belgique, et de France, reprendre en main les positions du surréalisme, devenir *international*. C'est fait.

Les groupes à tous points de vue les plus importants ont trouvé une base commune d'action. Ils seront six ou sept dans quelques mois. Maurice Nadeau devra dorénavant nous traiter de bécasses, qui nous traitait de bécassons.

* * *

Bourgoignie me disait qu'il avait été frappé par l'importance historique de la Conférence. Nous l'avons tous été.

C'est qu'aucun manifeste ne pouvait être aussi concluant que la cohésion non pas outre mais dans les particularités des quatre groupes. Et nous avions beau avoir senti, avoir pesé la nécessité internationale du surréalisme-révolutionnaire, nous avons été frappés de voir cette nécessité aussi concrètement manifestée.

Il ne suffit jamais d'avoir raison, et plus : ce n'est pas avoir raison que d'avoir raison chez soi. Il ne manque pas encore de vieux-surréalistes, mais tous les surréalistes-révolutionnaires manquent pour l'oublier.

* * *

Quand Arnaud et moi avons été à la gare du Nord pour accueillir Lorenc, nous ne savions pas du tout quel était son visage, nous ne savions pas exactement à quelle distance il était de nous. J'avais écrit RA sur un morceau de papier et le portais à la boutonnière. J'avais raison d'adhérer si facilement au groupe RA.

(Suite page 2.)

DECLARATION INTERNATIONALE

Réunis pour la première fois à Bruxelles les 29, 30 et 31 octobre 1947 en Conférence Internationale,
le groupe surréaliste-révolutionnaire en Belgique,
le groupe expérimental du Danemark,
le groupe surréaliste-révolutionnaire en France,
le groupe Ra de Tchécoslovaquie
ont établi leur accord sur les bases suivantes :
1° Sur le plan national, chaque groupe reconnaît le Parti Communiste comme seule instance révolutionnaire ;

Pendant la mise au point de la Déclaration Internationale, de gauche à droite : Max Bucaille, Christian Dotremont, Noël Arnaud, Josef Istler, Asger Jorn.

2° sur le plan international, les quatre groupes sont heureux de constater que les conclusions de la Conférence de Varsovie rencontrent aussi directement leurs préoccupations ;
3° les quatre groupes condamnent le surréalisme, tel qu'il s'est plus ou moins identifié avec Breton, et condamnent en même temps les tendances esthétiques, psychologiques, philosophiques, qui en arrivent aux mêmes échecs, à la même confusion que le surréalisme, notamment l'abstractionnisme, la psychanalyse anti-sociale, l'existentialisme ;
4° ils pensent néanmoins qu'il y a dans le surréalisme, pris dans son ensemble, un point de départ valable, aujourd'hui nié par André Breton : la volonté de mettre en

(Suite page 2.)

AGENDA

28 octobre 1947.
23 h. Arrivée de Suzan Allen, Noël Arnaud, Raymonde Aynard, Paulette Daussy, Jacques Halpern, René Passeron (groupe surréaliste-révolutionnaire en France).
29 octobre.
11 h. Arrivée de Zdenek Lorenc (groupe Ra).
18 h. Arrivée de Asger Jorn (groupe expérimental du Danemark) et Bucaille (groupe surréaliste-révolutionnaire en France).
20 h. 30. En la grande salle de « L'Horloge », porte de Namur. ouverture de la Conférence par Achille Chavée.
Rapport de Christian Dotremont au nom du groupe de Belgique.
Intervention de Bob Claessens, responsable national auprès des intellectuels, au nom du Parti Communiste de Belgique.
Déclaration d'Asger Jorn au nom du groupe au Danemark.
Déclaration de Zdenek Lorenc au nom du groupe Ra de Thécoslovaquie.
Rapport de Noël Arnaud au nom du groupe en France.
30 octobre.
11 h. Rapport d'Asger Jorn. Discussion.
21 h. Création du « Dossier international du surréalisme-révolutionnaire ».
Rapport de Jacques Halpern. Discussion.
31 octobre.
11 h. A « l'Horloge », création du « Bureau international du surréalisme-révolutionnaire ».
Arrivée de Josef Istler (groupe Ra).
Rapport de René Passeron. Discussion.

(Suite page 2.)

SI VOUS NE LISEZ PAS CECI PAR HASARD, ADHEREZ AU SURREALISME REVOLUTIONNAIRE !
BELG.: AU SIEGE DU BUREAU INTERN. — DANEMARK: BILLE, NYHAUN 18, COPENHAGUE — FRANCE: ARNAUD, RUE MESNIL 18, PARIS XVIe — HONGRIE: T. TARDOS, RAKOCZI-UT 61, BUDAPEST 8e — HOLL.: M. JOFFROY, SOPHIAS TRAAT 27, BREDA — TCHEC: Z. LORENC, POUPETOVA 14, PRAGUE VII.

First and only issue of the *Bulletin international du Surréalisme Révolutionnaire*, Brussels, January 1948. In the photograph from left to right: Max Bucaille, Christian Dotremont, Noël Arnaud, Josef Istler and Asger Jorn.

hung on our labours in France and Belgium, *surrealist* and *abstract*, seem inexact to us.' The choice of the word 'labours' instead of 'works' was another herald of Cobra. Jorn traced the history of his evolution and that of his friends since 1935, talking at length about Egill Jacobsen and Carl-Henning Pedersen – the one in favour of 'the explosive contribution of a chromatic system of invention', the other for the introduction of the 'elements of a new symbolism'. He also invoked the War and the Resistance – 'from free art to Nazi obscurantism'. Of course, he was thinking of *Helhesten*, which was like a Danish equivalent of *La Main à Plume*. In the name of the Danes, Jorn relied on an aesthetic and a style which were completely elaborated in works of accomplished originality. He ended his speech with what amounted to a call for common action where political preoccupations were put into second place, and this would be the essential difference between Revolutionary Surrealism and Cobra: 'Help us' Jorn said 'to overturn

the fundamental character of art in the Scandinavian countries . . . we know that you are waiting for us; we are throwing our old inferiority complexes overboard . . .' Thus artistic activity per se was placed in the first rank, in an entirely different spirit from that of Magritte's followers (Magritte attended the opening sessions of the Conference).

Two Czechs also attended the Brussels conference – the poet Zdenek Lorenc and the painter Josef Istler. They both belonged to a regrouping of surrealist inspiration which had been active under the Nazi occupation and which had manifested itself from 1945–8 through exhibitions and collective publications under the Skupina Ra imprint. It was a most remarkable group, mainly owing to the personality of its participants (nine in all, painters, photographers, poets), but also through the theoretical ideas it developed: here was an authentic prefiguration – a model almost – for Cobra. To start with, the name of the group was taken from the first syllable of Rakovnik, the town where the painter Vaclav Zykmund lived at that time. Did Dotremont know that when he invented the name Cobra? The similarity at least bore witness to the same intellectual movement.

'We were and we are even today practicians more than theoreticians,' Lorenc would say in his speech to the Brussels conference. That, of course, was precisely what Cobra sought to be and that was why it would soon be born out of the split from Revolutionary Surrealism – a situation comparable to that of Ra, whose ideas and works no longer fitted into the surrealist framework built by Breton and his friends and which the poet Nezval and the painter and theoretician Karel Teige had reproduced in Prague (the latter having participated in the discussions from which the new group would emerge). Ra's position on artistic matters was analogous to that of Cobra and the Danes in many respects, just as it was to that of Arnaud and Dotremont in political terms. Ra adhered to the Czech Communist Party because, as Lorenc explained, 'as the party of government, it is the bearer of our hopes for political and artistic revolution.' As far as Surrealism was concerned, Ra was mainly critical of its notions, which were, to the Ra mind, insufficient to the 'interior model' and 'automatism'; it intended to overtake Surrealism, heading in the same direction as Cobra.

The few works which Josef Istler brought with him to Brussels, and which he left there on his return to Prague (a number of which were featured in Cobra's 1949 exhibition in Amsterdam) showed that he had progressed towards the symbiosis of surrealism and abstraction since 1945–6 though an operation in which spontaneity and material imagination played their part. In a retrospective article of 1966, Vaclav Zykmund wrote: 'We wanted to achieve a certain equilibrium between plastic values and imaginative values . . . It was a matter of the unit of plastic methods, the bearers of emotive meaning, and others which were determined by original impulses and which, in the course of the process

of creation, were transformed to be finally assimilated into the expressive form of the work.' (*Vytvarne Umeni 4*, 1966). In 1947, Istler and the Ra artists attained a stage 'beyond surrealism', which Jorn and Dotremont were also seeking, and, like Constant and the Dutchmen of *Reflex*, they proclaimed that 'artistic and social progression cannot avoid forming a unity . . . Marxist philosophy is as indispensible to us as artistic experimentation.' But, for them, the subsequent breaking away from the establishment of the Stalinist regime at the end of 1948 would be brutal. The cultural isolation in which Czechoslovakia then suddenly found itself once again prevented the transmission of all the richness it had attained since the works of the Ra group, by preventing the pursuance of cultural exchanges. One year later, talking in *Cobra 1* about the last uncensored issue of the review *Blok*, published in Brno, Dotremont (who had had the chance to collaborate on that review) wrote in a tone which, with hindsight, appears rather ingenuous: 'We understand that our Czech comrades are deprived of bourgeois reviews; we do not understand why they deprive us of *Blok*. It is essential for us to put our thoughts and actions ceaselessly to the test against the thoughts and actions of the avant-garde artists of the new socialist State.' This obviously came to nothing and this collaboration, which Cobra felt to be so important, came to an end.

At the Brussels conference, it was decided to publish a review – *Le Surréalisme Révolutionnaire*. Only one single issue would appear, in Paris, dated March 1948. It was Dotremont who announced it in a tract ('The most living review in the world'), and it was he, too, who wrote the editorial – 'Le Coup du Faux dilemme', a defence and illustration of the experimental spirit in art and an acrobatic attempt to insert it into the politico-cultural sphere of militant Communism. Once again, it was what the majority of the avant-garde artists of the twentieth-century vainly sought: the fusion of two revolutions, the political and the cultural, without the former assuming precedence. Dotremont punctuated his speech with several assumptions: 'Life is revolutionary', 'He who has the experimental spirit must necessarily be a Communist'.

These assumptions were not self-evident. Dotremont engaged in feats of verve and mental agility to prove (or prove to himself) the truth of them. He scarcely succeeded, as certain phrases, which he could not sustain, made clear. 'Our boldness, which is perhaps a kind of simplism (remarkably fertile today), our youth and our ignorance all condemn us to go forward along such a deserted track.'

Here was Dotremont the polemicist, too, in the name of 'the greatest critical vigilance', with the principal cultural, or non-Communist, publications of the moment: *Les Temps Modernes*, *Les Cahiers de la Pléiade*, to which Paulhan welcomed writers who had broken free from political immediacy: and *Critique*, under the direction of Bataille, which was reproached for dealing

Top: Asger Jorn, indian ink drawing, around 1941. Published in the *Bulletin international du Surréalisme Revolutionnaire* (first and only issue), Brussels, January 1948.

Josef Istler, *Cobwebs*, 1944. Oil on canvas. Published in *Le Surréalisme Révolutionnaire*, (first and only issue), Paris, March–April 1948. Painting since destroyed.

too much with books and not with works in general. With a vehemence which to some extent became drunk on itself, Dotremont took up a position against those he called 'our enemies', in a generalization reminiscent of the graffiti of the time of the Occupation: Sartre, Blum, De Gaulle, Breton, Ubac, Malraux. The most interesting thing, however, was not this, but the different definitions of the experimental spirit in art which he gave, and which would remain valid for Cobra.

'More than ever, perhaps, despite the vice and precipitation of the era, the necessity for the spirit of experimentation appears.' To give it legitimacy in art, Dotremont evoked Bachelard and Piaget and referred to scientific experimentation. 'Moreover, a simple glance at science and technology's latest progress is enough to situate the experimental spirit outside of a sort of purely historical *primitive category*, without recurrence.' There was in this an idea which was dear to Jorn, too, and he would later develop it in his methodology. Moreover, Dotremont rejected all categorizing, all the instances which could hinder experiment: Abstraction and Surrealism were excluded as two 'dishonest attitudes'. 'Experiment can and must be conceived as experiment for itself and announce itself as such, because it is effective for it to announce itself, but to see at the same time the dangers of experimentation on the outside, its changing nature.'

Here, Dotremont was touching on the problem of the social significance of the work and, in consequence, its social commitment. He determined two limits: propagandist and laboratory works. 'We think that these two modes of artistic creation must be put and kept in contact, and that they can expect a great deal from their collaboration. What is more, the most serious mistake is to distinguish between these two modes as *genres*, indeed as *subjects*, and not in the public use.' Here was a hint at the discord which would lead to the split with the Communist Party after the 'social realism' affair. Dotremont already sensed it, without daring to admit it too much to himself – 'it is dangerous to ask that a work of art should always be manifestly or literally committed.' It suited him to avoid becoming trapped in that other 'false dilemma'; curiously, he evoked Stalin, who had ordered scientific research and political action to be combined – we have since realized what he meant by that: 'It is said to be difficult. Surely. But since when were the Communists afraid of difficulties?' To escape this difficulty, Dotremont proposed the 'blow of unity', that 'of life and consciousness, of art and knowledge, of knowledge of politics, of sensibility and intelligence.' This unity, he added, and it was his last word on the subject, was 'revolutionary'. Another postulation.

A step towards Cobra, the review *Surréaliste Révolutionnaire* also marked the vigorous arrival of the Danes. Jorn was the director of the committee, the poet J-A. Schade featured in its contents and Richard Mortensen and Robert Jacobsen had some works reproduced, as did Jorn. The Dutch were still not present here.

Nevertheless, the coming together of Dotremont and the Experimental Group (Constant, Corneille, Appel) was imminent; it would take place in Brussels at the time when the internal disagreements within Revolutionary Surrealism were increasing. And it was that which made Dotremont determined to conceive an alternative direction for the action he hoped for. Moreover, Parisian Revolutionary Surrealism, which had come up against Communist hostility in France as much as the surrealism of Breton and his associates had done, dissolved of its own accord. Jorn sided with Dotremont and the Belgians (Chavée and his friends from Hainaut), whilst Mortensen and Jacobsen rallied round the former French group and opted for a more clean or cold abstraction in their works. Finally, the former French group (Noël, Arnaud, René Passeron etc,) proposed a counter-conference, the so-called International Centre for the Documentation of the Art of the Avant-Garde. This took place in Paris at the Maison des Lettres in the Rue Féron from 5 to 7 November 1948. Jorn attended, as did Dotremont, with a young Belgian poet, Joseph Noiret, and the three Dutchmen of the Experimental Group – Appel, Constant and Corneille.

In a conversation with the author in December 1979 in Brussels, Joseph Noiret evoked those decisive moments in Cobra's creation: 'Our sensibility took shape through Surrealism. We had all read Breton and Éluard's texts – texts which knocked each of us out, because one really could be knocked out in those days, whereas it is more and more difficult for that to happen nowadays, I think. It was natural to move towards what seemed to be the capital of Surrealism, towards Paris. But once we arrived there, we realized, by a sort of force of contradiction, that we did not really speak the same language as the people in Paris. The Surrealism we knew was what had been halted by the War and what we thought we could start again in the post-war conditions.

'In Paris, Surrealism was a sort of past which was being kept alive. We realized we wouldn't find what we were looking for in Paris. Too much intellectualism, too much theory, which generated a sort of repulsion, like a movement going backwards.'

Dotremont was living in the Notre-Dame Hôtel on the corner of Quai Saint-Michel and the Rue Saint-Jacques, where he had met Yves Bonnefoy, who was publishing a minor review at that time, *La Révolution et la Nuit*; as a poet, he belonged to the Surrealist movement and was fairly close in that to Benjamin Péret:

For his part, Dotremont described his more than precarious existence at the Notre-Dame Hôtel in his autobiographical novel *La Pierre et L'Oreiller*, which he wrote from 1951–3; he went back there many times and it was when he was there with the 'Danoiselle', Ulla-Gloria, that he spat up blood for the first time . . . *La Pierre et L'Oreiller* also evoked what the simple description of intellectual travels could not fail to hide; the poverty, if not the misery, of his daily existence. And yet

there was the rising of a new sap, an impulse of vitality in this prehistory of Cobra. Dotremont stressed that in one of his numerous cases of 'coming to the point': 'After the war, numerous artists dreamed of an indivisible creative force, neither organized nor disorganized, where form and content would be combined, the end and the means, ugliness and beauty, design and colour, subjective power and the references to external reality – dualities entertained since the Renaissance by aristocratic, then bourgeois, art.' – *L'Oeil* No. 96, December 1962.

All the same, Corneille would say: 'Cobra was born in effervescence, fervour. But the evening Cobra was born does not differentiate itself in my memory from other meetings in the café or elsewhere on the previous days. Only, Christian took a bit of paper and started to write quickly at the corner of the table *La Cause était entendue* ('the cause was understood'), which we had all approved. We were worn out with the discussions we'd been having, which seemed to us to be going nowhere.'

The text, in which the word 'work' but not the word 'art' can be found, would be reproduced in the form of a pamphlet.

Then they split up and each one went back to his own country as best he could. Dotremont wrote to Jorn from Brussels: 'I propose, as the title of an international printed bulletin, *Cobra* (Copenhagen, Brussels, Amsterdam), or *Isabelle* (for a rather more personal reason) or *Manaja* or *Drango* or *Doris* or *Lou*. We must reach an agreement quickly . . . The title we choose must become an obsession, a myth! . . . Paris is no longer the centre of art, it has become the centre of difficulties' (letter of 13.11.1948). Jorn replied that he agreed with *Cobra*; but Dotremont pretended not to be convinced, enjoying spinning the story out: 'I would prefer the name of a woman to *Cobra* and up till now I go for *Lou* (short for Louise). *Cobra* is a bit like Benelux, in its playing with letters, and could be a bit limiting as a result: it would be impossible, for example, to add London!' (letter of 23.11.1948).

In November 1978, in the course of our *Entretiens de Tervuren*, he told me: 'There is certainly much to be thought about in the choice of a name which is not to be an *ism*, but that of an animal. In fact, we were against all *isms*, which implied systematization. And Cobra is, after all, that snake which you often find in Cobra painting.'

The snake did in fact appear – unconsciously – to be Dotremont's own personal totem. In a poem published during the German Occupation by *Quatre-vingt et Un* – a poem inspired by a 'publicly private girl and a private life' – Dotremont wrote:

I met her on Good Friday
In the Rue Serpente

. . .

I envy you tissue paper of sonnets of *You come*
little mainsquare of love
I regret not being the Rue Serpente
for the girl with armpits of laughter
the onomatopoeiac girl of *I love you*.

Symbolic motif found on one of the golden horns discovered at Gallehus in Jutland and chosen by Jorn as a logo for *La Bibliothèque Cobra*.

The bill of foundation of Cobra. Duplicated leaflet. Not published until February 1949 in *Le Petit Cobra No. 1*, Brussels.

The poem was entitled 'Les dangers de la rue Serpente', this being a street in the Latin quarter whose name must have subconsciously attracted Dotremont. Later, in his notes on the 'language of language', he also wrote: 'They cut: seaman means *of the sea*. But there is no sea serpent in *marine serpent*. Moreover there is Valéry.' An interesting anti-literary remark – the more so because Dotremont published his writings under the imprint of *Serpent de Mer* ('Sea serpent').

Many other details should be noted: the sub-title of the review *Cobra*, the 'supple link' between the experimental groups, or, indeed, the note Dotremont wrote on the venom of the Cobra (*Petit Cobra 4*) containing the humorous identification of his bespectacled snake friends: 'The tajiri (Japan), havrenne (Belgium), dotremont (ibid.) snakes. The Dutch snakes do not wear glasses. The alechinsky snake (Belgium) sometimes wears them (in the cinema).'

In the Cobra bestiary, the snake was certainly a favoured figure. As I sought to demonstrate in one particular study (*Central Park*), it dominated all Alechinsky's work as a formal archetype. In *La Terre et les Rêveries du repos* ('The earth and daydreams of rest'), Bachelard dedicated a long chapter to the snake, starting off by noting that it was 'one of the most important archetypes of the human soul . . . In the order of images, the animalized root is the sign of union between the vegetable and animal kingdoms.' All this suited Cobra art rather well, being violently earthy, if not peasantish, above all with the Danes. In anthropological terms, we know that the snake is one of the figures used most in religious symbolism, from India to Mexico, from the Bible to the Scandinavian *Edda*, which Jorn had studied in depth and in which is to be found a leviathan 'more ancient than the gods themselves', Midgarorm, the symbol of primordial indifference. The snake is linked to labyrinths, knots, intertwinings, the wheel, all of which abound in Cobra (Jorn and Alechinsky would dedicate publications to them). It was, in a positive-negative duality (good-bad), a representation of life on the level of the instinctive. Dotremont could not have dreamed of a better symbol for his Internationale of Experimental Artists.

The cause understood, the name chosen, Dotremont did not waste time. He made his first trip to Denmark with Jorn, where he finally met the artists of the Høst cooperative, who had invited the three Dutchmen – Constant, Corneille and Appel – to their annual Salon at the same time. Dotremont also travelled to Malmö to see the Swedish Imaginists. They decided in principle on an international review, the first issue of which was to appear in Copenhagen. On his return to Brussels, Dotremont published a *Petit Cobra* (1949) without

LA CAUSE ETAIT ENTENDUE

Les **représentants** belges, danois et hollandais à la conférence du Centre International de Documentation sur l'Art d'Avant-Garde à Paris **jugent** que celle-ci n'a mené à rien.

La résolution qui a été votée a la séance de clôture ne fait qu'exprimer le manque total d'un accord suffisant pour justifier le fait même de la réunion.

Nous **voyons** comme le seul chemin pour continuer l'activité internationale une collaboration organique expérimentale qui évite toute théorie stérile et dogmatique.

Aussi décidons-nous de ne plus assister aux conférences dont le programme et l'atmosphère ne sont pas favorables à un développement de notre travail.

Nous avons pu constater, nous, que nos façons de vivre, de travailler, de sentir étaient communes ; nous nous entendons sur le plan pratique et nous refusons de nous embrigader dans une unité théorique artificielle. Nous travaillons ensemble, nous travaillerons ensemble.

C'est dans un esprit d'efficacité que nous ajoutons à nos expériences nationales *une expérience dialectique entre nos groupes*. Si actuellement, nous ne **voyons** pas ailleurs qu'entre nous d'activité internationale, *nous* faisons appel cependant aux artistes de n'importe quel pays qui puissent travailler – qui puissent travailler dans notre sens.

CENTRE SURREALISTE-REVOLUTIONNAIRE EN BELGIQUE :
Dotremont, Noiret.
GROUPE EXPERIMENTAL DANOIS :
Jorn.
GROUPE EXPERIMENTAL HOLLANDAIS :
Appel, Constant, Corneille.

Paris, le 8 novembre 48.

Nom et adresse provisoires : COBRA, 32, rue des Eperonniers Bruxelles.

delay, a photocopied sheet which opened, typically, with a text in the form of a manifesto: 'Qu'est-ce que c'est?' (What is it?'), in which Dotremont explained the transition from Revolutionary Surrealism to Cobra.

Putting the specificity of the methods of experimental art first, Dotremont revoked the postulations he had made in the *Coup du faux dilemme* and announced, without any 'inferiority complex', that 'Cobra will seek in action itself to discover how far the stable principles of experimentation can go.' It was indeed towards that 'laboratory art' that Dotremont had pointed not long since as the opposite extreme to 'propagandist art'. 'Cobra is a simplist, experimental movement' and 'simplism is the acute form of experimentation. It is the extremism of experimentation. If the former can be presented as a refusal to take the acquired for the plan of what remains to acquire, simplism is the most obvious aspect of the enterprise. We are ready to pull in the theoretical belt: in order to eat.'

Christian Dotremont 'at the foot of the anti-tubercular cross, Paris, April 1951'. Amateur photograph, later captioned by Dotremont himself.

This last sentence, with its ready irony, came already from that 'humour of power' which Dotremont, like Jorn, loved to practice. One like the other (Jorn with his family responsibilities) had effectively to pull in his belt; they did not always have the wherewithal to satisfy their hunger. They would fall seriously ill with tuberculosis, which would bring about the end of Cobra as an organized movement in 1951. Egill Jacobsen, who also had to enter the sanatorium in his turn in 1954, nicknamed tuberculosis 'the Cobra disease'.

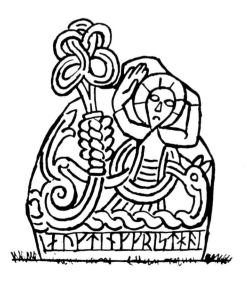

The Jelling Stone, drawn by Henry Heerup around 1935. Indian ink drawing.

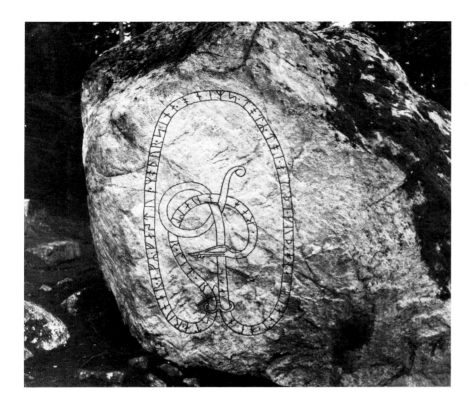

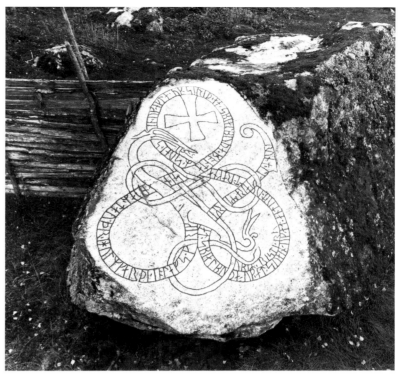

Copenhagen

As in the name itself – *Co* for Copenhagen – the Danish section of Cobra came first. In 1948, the artists whom Jorn had enticed into the communal adventure were in the full flood of their creative talents; their ideas and concepts, to which Cobra would give an international resonance, had already manifested themselves in numerous works which made the Thirties and, to an even greater extent, the Forties an exceptional period of creativity in Danish art, despite the war and the Occupation. It was almost unparalleled in the history of Scandinavia and Jorn, more than any of the others, was aware of it. For him, Cobra was first and foremost a medium for an exchange of ideas, where Scandinavian artists could perhaps for the first time, bring 'a reserve of creative violence' to bear, as Dotremont stressed in welcoming him to the Brussels conference in October 1947. In the speech he gave on behalf of the Danish abstract surrealist group, Jorn explained that 'Scandinavian poets and painters have, in the course of history, taken and learned from the creative talents of other nations, but have never given anything back, much less contributed anything new. We know that you are expecting something from us, so we have cast aside our former inferiority complexes. We have decided to transform the world and to change our life; with you, we cast our eyes into the balance.' These words would mark the end of the isolation of Scandinavian artists, something which was made possible because, as Dotremont later expressed it: 'Scandinavian culture has reached such a pitch that it touches universal culture.' And the Danish experience, which was so decisive for Cobra, would be principally transmitted by Jorn.

Born in 1914 and dying in 1973, Asger Jorn was one of the central figures of the middle years of this century in Europe; more than anything else, he helped to shape events as an artist and theoretician; he was the guiding light of groups he became involved with, a socialist historian and a philosopher, an exceptional personality who can be compared with the great figures of the Renaissance, in that he was as multi-dimensional as they were. And just as Valéry was able to describe a 'Leonardo da Vinci method', so there is an 'Asger Jorn method', which overflows with passion and exceeds all bounds, touching a multiplicity of levels; his universality is undeniable.

But first and foremost Jorn was a Jutlander, born in Vejrum with its many links with Silkeborg, a small town which he 'loved and hated'; he lived there during his early life and then again at the end of Cobra – in its sanatorium. Today the town boasts a museum dedicated to his works and to the collection he had made of the work of his Cobra companions, of the Bauhaus artists and also of surrealists, German expressionists, symbolists, abstract artists, American expressionists, Dubuffet and Michaux – in fact, all that he held to be important in modern art.

Jorn's Jutland is not only that great peninsula where continental Europe terminates in heathlands of purple heather, haunted by sea mists; it is also a land apart from Copenhagen, the capital – the other Denmark, that of crisis of conscience and inner melancholy, of life in the imagination and solitary meditation. Kierkegaard's family came from Jutland and it is there that the philosopher set the Hamletesque fantasy with which he was to remain obsessed: as a young man his father had, in his misery, blasphemed against God. He only confessed it to his estranged son just before his death, and it came as a 'great earthquake' which would turn his vision of the world upside down. Jutland is a land dominated by protestant sects, to one of which Jorn's family belonged. It could well be that Jorn's father may have wavered between the pastorate and the profession of schoolteacher, which he eventually chose – a lay life, as a way of thinking and living. From religious sects to trade unions, from desperate resignation to social and political struggle, that is the history of modern Jutland.

But there is also the lost Jutland, that of Scandinavian antiquity, which Jorn would study with a passion. He published a number of works whose bold theses upset the premises of traditional archaeology. 'Scandinavian culture', he claimed, 'is, above all, a forgotten culture, one without a history, cut off after the Stone Age, older and more set in its ways even than the Chinese culture. What can I say about my ancestors with such a heavy heritage of forgetfulness?' A question which Jorn's whole generation was asking, in turning towards primitive and folk art (or 'natural art' as it is termed in Danish). Not only as a storehouse of forms for a stylistic revival (as was the case for the Cubists with African art), but also, in fact primarily, as a means of rediscovering the spirit and values which transcend history; it was an international movement, a heritage of the Romantic impetus towards a European original, which former generations had, up till then, dreamed of rather than tried to comprehend. The classical models of Graeco-Roman antiquity were cast aside as surely as reborn humanism had imposed them, in the wake of a voyage of self-discovery in the scorned and forgotten territories of Europe. For Jorn and the Danes, it was natural that this should be principally a Scandinavian culture, just as the French surrealists were attracted by the Celtic world. This nostalgia for one's origins is one of the characteristics of twentieth-century modernism; it did not usually develop without some aberrations, but in this respect, the effort of the Danish artists was exemplary. It contributed to the undermining of the racist pan-Germanism which would have liked to take advantage of it. The review *Helhesten* (the horse of hell, a figure in Nordic mythology), which was published by Jorn and his companions during the Occupation, was a centre of active resistance to the aberrant ideology of the Nazis. Its political involvement was inspired in the case of Jorn by Christian Christensen's trade union activities and Jorn dedicated his *Critique of political economy*, which dates from his situationist period (1957–61) to Christensen. 'At the forefront of the struggle of the workers of my

Asger Jorn beside the stone erected in memory of the Trade Unionist Christian Christensen and engraved by Jorn in 1963, at Sejs near Silkeborg. Photo by Børge Venge, 1965.

Jorn's departure for Paris on his BSA motorbike in 1936, by Henry Heerup. Lithograph (40 × 58 cm) dated 1974, one year after the death of the painter.

country, he submitted himself to a long period of imprisonment for their cause. And afterwards, he was forced to spend his life on the sidelines of a movement split by reformist and stalinist bureaucracies. In my youth, I learnt the libertarian content of social revolution at his side. It is impossible to forget it.'

Jorn's portrait of Christian Christensen of 1933 was one of his first pictures to merit collection (Kunstmuseum, Silkeborg). It launched Jorn at the exhibition of Young Free Painters of Jutland, featuring along with a landscape, and was the work of a young man who would hesitate no longer; he would abandon his career as a teacher, despite five years of training for the job, in order to devote himself to painting, which he had discovered through that European expressionism which confronted subjectivity of colour with a dramatic perception of reality.

1933 was a crucial year for Danish art. It was marked by the appearance of abstract art with, on the one hand, the paintings of Wilhelm Bjerke Petersen, who had been a pupil at the Bauhaus in Dessau under the direction of Kandinsky and, on the other, the sculptures of Ejler Bille, small organic forms in wood or stone, freely painted. From Bjerke Petersen's meeting with Bille would be born the review *Linien*. At the same time, Bjerke Petersen published his minor treatise *Symbols in Abstract Art* – he would later say that this was the true point of departure for Cobra art, in that it was a 'new optic on abstract' or 'abstract art which does not believe in abstraction'. Bjerke Petersen 'demonstrates for the first time in an original way the symbolic content of abstract art, thus well and truly compromising the idea of the abstract as a pictorial goal . . . Bjerke Petersen was not even conscious of the revolutionary originality of his works.' In fact, Bjerke Petersen practised the fusion of abstract and surrealist art, which was held at that time, and would be held for some time to come, as scarcely permissible in Paris. 'On the one hand, the idea of a picture composed of structures and forms that are purely abstract, yet universally human; on the other hand, the concept of forms carrying symbolic meaning, like signs of the phenomena of the life of the mind and, through that, like forms in general.' (Troels Andersen, afterword to the French translation, 1980).

'The natural conclusion to be drawn was a new development from the time when Freudian psychology would have been adopted and the results of surrealism in Paris,' Jorn himself would say; he felt an attraction towards abstract art, as his paintings from 1935–6 show. he was influenced by the work of the Copenhagen artists of *Linien*, principally by Bille, who had moved from sculpture to painting, and by Richard Mortensen. In the autumn of 1936, Jorn decided to go to Paris. 'It was really just as easy for me to go to Paris as to Copenhagen,' he would explain. 'Both are, as it were, equidistant from Silkeborg and Paris is, after all, artistically more important than Copenhagen. I would have gone to Kandinsky's school, but unfortunately he had none. I

knew his pictures from reproductions because I had read the Bauhaus books which were coming out at the time. So Fernand Léger was the most modern artist in Paris who had a school. And there I got in.'

Léger was from Normandy, from a family of teachers from the Auge area, which was perhaps one of the reasons he attracted so many young Scandinavian artists. Whatever the reason, Jorn fell completely under his spell: 'I allowed myself to be guided by Léger's academy and the strict discipline we learnt there. I made a deliberate effort to submit as far as I possibly could. But afterwards, it took me ten years to break free from this influence. And even then something always remained – a certain *structure* which in a way I am glad to have. The French are more confident and serious when composing a picture than the people in the Academy in Copenhagen. This is the most important thing I got from going to Léger. Confidence in handling the picture plane is what I owe to him and the French tradition in general. They taught me to work in a much more serious way. Yet at the same time there was freedom and independence. This is something a Dane cannot understand: that it is possible to be disciplined and independent at the same time. Our ideas of freedom are quite different. Ours is a spontaneous freedom, and that is why it is so difficult to switch over from a French to a Danish state of mind, without losing one's own personality.'

This 'submission' to Léger resulted in Jorn painting the fresco *The Transport of Force* (1937) in the Palais de la Découverte for him. He collaborated on this with Pierre Wermaere whom he had met at the Contemporary Academy and who remained his friend and devoted companion throughout his entire life. The fresco, which today is reduced in size, was painted in an aircraft hanger at Belleville. Léger had such confidence in his pupils that he let them work without supervision, contenting himself with signing off the work when it was finished. At the same time, Jorn painted for Le Corbusier an enlargement of a child's drawing on a wall for the Pavillon des Temps Nouveaux at the Universal Exhibition. Through this he acquired a taste for mural painting which he saw as integrating art with the everyday environment and the workplace, and as art in collaboration with architecture. It was 1937, and before returning to Copenhagen, where his first exhibition, shared with Wermaere, would take place (under the name of Jørgensen), he exhibited two abstract compositions at the Salon des Indépendants which gave only the merest hint of his work up to that point. This was already quite prolific in terms of sketches, paintings and even 'flottages' (the application of a sheet of paper onto a surface of oil floating on water), works which bear witness to the ease with which he switched from Léger's rationalism to the dadaist-surrealist automatism in the style of Arp, Miró and Ernst.

In Copenhagen, a situation had evolved at the heart of the *Linien* co-operative as a result of Bjerke Petersen's alignment with orthodox surrealism; he had prepared an exhibition in conjunction with André Breton which was clearly anti-abstract. The review would henceforth be run by Ejler Bille and Richard Mortensen, who attempted to maintain, though not exclusively, the very open programme formulated at the outset in 1934. 'Art is a living thing which, in harmony with its time, changes from day to day ... Middle class art is a funeral procession, but a richer and more genuine new culture is gaining strength, creating a new humanity which must allow each individual the freest possible development with the least restriction.'

In response to the Bjerke Petersen exhibition, *Linien* presented its own collection in 1937 entitled 'Post-Expressionism-Abstract-Neoplasticism-Surrealism'. Invited in company with Mondrian, Van Doesburg, Klee, Miró and Tanguy, Kandinsky was the subject of a special presentation. But the co-operative had also just admitted to its membership Asger Jorn and Egill Jacobsen, as well as Sonja Ferlov, a Danish sculptress who lived in Paris with Giacometti. Strange as it may seem, the exhibition did not arouse great interest among public or critics. For the artists themselves, it was completely the opposite; it was on this occasion that a *Mask* by Egill Jacobsen was shown in a new context, as part of a series of pictures the artist had started the

Ejler Bille's cover for the catalogue of the 'Linien' exhibition at the Student Circle in Copenhagen, 1–15 December, 1939. Ejler Bille, Egill Jacobsen (with *Ophobning*) and Sonja Ferlov took part.

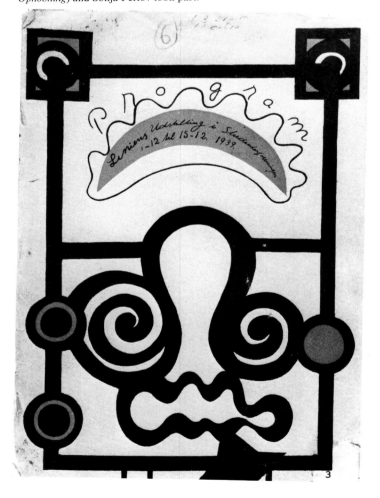

Egill Jacobsen in his studio at the end of the Thirties. On the wall, to the right, *Ophobning* (see page 39).

previous year, which can be said to mark the emergence of a specifically Danish art. Dotremont described it, in 1963, in terms which are applicable to all the Danish abstract surrealists who were involved in Cobra: 'In the final analysis, inventions are often the result of tiredness. Jacobsen ellicits so many influences, responses, questions, starting points, props or sedimentations. All at once, like when one is about to die, all his sources flash through his mind, all the easy ones, all the hard ones. He must invent something fresh and new in all the tension around him. He has painted many self-portraits – what a bore! Should we abandon man's face? A year ago he was letting the colours run over the canvas, just to see what would happen. But should one simply let the colours run like that? He paints a stroke and the mask appears on several canvasses, colour itself, thanks to an inquisitive spontaneity. Basically, it is enough to be oneself without reflecting oneself, in freshness or fire.'

Jorn spoke of being 'knocked out' by Egill Jacobsen's 'spontaneous colourism', which had already manifested itself to full effect in a unique work which was the harbinger of Cobra as it was of the abstract expressionism dubbed 'made in USA'; this was *Ophobning* ('Accumulation'). If the other pictures Jacobsen painted between 1937–8 showed precise forms which allowed the colour to overflow only a little if at all – geometric constructions with marked African rhythms – *Ophob-*

ning (Statens Museum for Kunst, Copenhagen) tended towards informality and gave free rein to the contradictory dynamics of form and colour, as if the painter did not wish to, or could not, control them. From tension to outburst, from implosion to explosion – as Jacobsen confirmed when he recalled that the picture was painted during the anxiety caused by the menace of Hitler, the annexation of Austria and the threat to Czechoslovakia.

Like most artists of his generation, Egill Jacobsen was involved in politics. Social conflicts in Denmark and the growth of National Socialism in Germany, the traditional enemy, had prompted him to join the small Danish Communist Party in 1933. He remained a member throughout the pre-war years and the period of the Resistance, until Jdanovism reared its head. In this respect, his life ran a course parallel to those of Dotremont, Doucet or Atlan, and this was a significant phase which certainly played a role in shaping the group who would become Cobra. It seems that Jorn himself never joined the Communist Party, but he nevertheless remained on the fringes of it (during the Occupation, he printed *Land og Folk* ('Land and People'), the party's underground newspaper). Like Constant, Jorn was a fellow-traveller; orthodoxy was the last thing which appealed to him. But he did try to remain at the centre of Marxist activity, at least in his theoretical reflections. Like Jacobsen and the other members of Cobra, he would play the creative role in every enterprise and would repeat time and again that he was unable to tolerate rules imposed from outside.

Contact with Paris, in the immediate pre-war years, was frequent. Ejler Bille and the architect Robert Dahlmann Olsen, the future editor of *Helshesten* and of *Cobra*, paid a visit to Kandinsky; Jorn returned to spend some time with Wermaere at Versailles, where he was working industriously, as he always did; and another adherent of *Linien*, Carl-Henning Pedersen, himself a newcomer to the group, also visited the French capital.

Jorn returned to Copenhagen in 1939. Denmark was still not taking the outbreak of war seriously, hoping not to become involved and relying on the non-aggression pact it had signed with Hitler, and in spite of the situation, several significant exhibitions were taking place, amongst them the one organized by students for Carl-Henning Pedersen and Else Alfelt, and subsequently one for Henry Heerup. These exhibitions would establish these three future members of Cobra as leading figures on the Danish scene. In December 1939, the last issue of *Linien* appeared, on the occasion of the third and last of the group's exhibitions. Jorn was not represented here, but he did publish a short essay in the review on 'The Process of Creation': 'Creating a work is a continuous process and one whose result is unknown . . . when I see my finished work, I am always filled with the most tremendous astonishment.' Many times, and with the utmost sincerity, Jorn would return to the subject of how his work as an artist was unpro-

grammable or, to use the language of philosophy, his heuristic function. Art reveals; it does not represent, it presents. Thus in the preface to the first volume of the monograph on him by Guy Atkins, he wrote: 'When I first saw the accumulation of photographs of paintings, whose existence I had mostly forgotten, I asked myself what on earth drove me to paint all these pictures? I shall never know the answer to this.' A little later, in a conversation with Jacques Michel (*Le Monde*, 27.1.1971), he would say 'Basically, I know nothing. At least, nothing I can explain. In front of the canvas, I only know what I must do. How I must do it. The why remains beyond the realm of understanding . . . When I paint, I don't know exactly where I'm going . . . If I have an idea, it is always a vague one and I am forced to acknowledge that the result has very little to do with the idea. It is good to have ideas, though, even if you don't follow them. I don't know what purpose that serves. I only know that it does serve a purpose.' And this after he had behind him, apart from the pictures which had assured his fame, several volumes of theoretical reflections, including *Risk and Chance* and *For Form*.

Such confessions are precious, and they contrast in their humility with the self-aggrandizement to which modern artists have accustomed us. The fact that the problem was Jorn's own did not make it any less generally valid for all the art of the mid-century; it is surely a question of the acuteness of the polarity between instinct and the intellect, underlined, if Freud is to be believed, by the malaise of our civilization, of every civilization. It is also a question of the dialectical relationship of the conscious and the sub-conscious, of the spiritual and the sensorial. 'I reject', Jorn would say, 'systems of rationalization and I am fascinated by them at the same time. It reassures me to know that I am capable of rational thought. That I am not falling into a kind of madness.' Madness, the violence of the Nordic 'vandals'; Jorn never fooled himself that this was a path one could tread without losing one's way – 'easily', he would stress. 'Separation from the spiritual and the sensorial leads to schizophrenia, to split personality.'

In fact, since his return to Denmark, in an effort to shake off the influence of Paris, he had become interested in mental illness, which he studied at the psychiatric hospital at Roskilde. Here was another parallel with other future members of Cobra; in Paris, in order to escape the Gestapo, Atlan had had himself admitted to the Sainte-Anne hospital, where he painted among the inmates. This was a most enlightening experiment for Atlan, and one which he would impart to Jorn and the Dutch artists when they gathered together in his studio at the Rue de la Grande-Chaumière in 1946. In their common quest for an uninhibited art form, pictures painted by psychopaths would be much prized.

In the years 1940–1, Jorn's paintings, and also the series of etchings to which he would later give the ironic title *Occupations* – the German occupation of Denmark began in April 1940 – call to mind, in the multiplicity of

Egill Jacobsen, linocut (17.5 × 13 cm) which appeared in *Helhesten*, 1st series, No. 3, Copenhagen, September 1941.

Asger Jorn, illustration for a book of poems by Jørgen Nash entitled *Leve Livet* ('Live Life'), Copenhagen 1948.

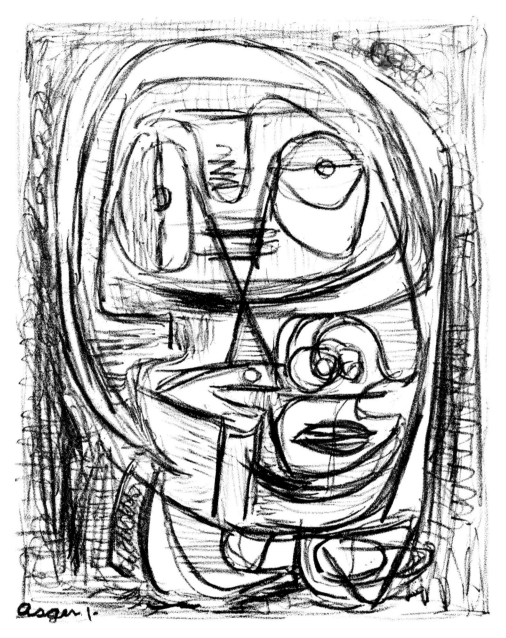

Asger Jorn, lithograph (23.5 × 17.5 cm) which appeared in
Helhesten, 2nd series, No. 1, Copenhagen, October 1942.

Obtrusive Creatures whose 'right to exist is proved by their existence'. This feeling of obtrusiveness would recur many times in his works; perhaps it was a matter of the 'return of the repressed'? *Toutou II* (1940) is not far removed from Egill Jacobsen's *Object-Masks*, just as *Small Things* and *The Blue Picture* (1940) bear witness to his similarity with Ejler Bille and Richard Mortensen in the treatment of the surface of the painting as a concrete surface, free of all intellectual planning – what the American abstract painters would call 'all over'. Jorn conceived *The Blue Picture* in these terms:

'The composition comes of its own accord. I started to paint from one side, adding one form after the other until the picture was full . . . I was extraordinarily surprised that a painting could be made in that way, going from one form to another and carrying on without worrying about the picture as a unified whole. Perhaps it has something rather cubist about it here and there, but it is exactly the opposite of the Cubist method of composition.' Jorn's abundance of forms would accumulate almost to a feeling of asphyxia in *Fantasy Fair* (1941), before reaching the more even rhythm of the great panel *The troll and the birds* (1944, Kunstmuseum, Silkeborg). Egill Jacobsen described the Jorn of the Forties – confusing in many respects – very astutely: 'If Jorn had lived a thousand years ago, he would have been one of those wandering story-tellers, always ready to make a myth out of reality and to discover the inter-relationship of things . . . With Jorn, we can penetrate into the cosmic intensity of the night where small creatures, miniscule creatures jostle for a part in the *grand drama*, the inevitable drama of the *seers* – those who attempt to grab from the enterprise the mortal forces of this world, which is so much more material than spiritual. They try to achieve expression with aggression in painting; thus they manage to touch new cords with infinite possibilities. In his pictures, black often represents a pause, as important as the pause between two musical movements. And what he attains is tragedy, that of the void, of melancholy which has no defence against the world, which pessimism never penetrates. His blacks are always in contact with freely accentuated greys or browns. Red, which is at once the colour of love and of blood, is a transition between the two in his work; that is to say it is the revolution. And drama is to be found in his greens and yellows: gentler colours, marked by the lyricism of nature and the mind. Jorn takes us away from Klee to bring us towards Poe. Let us penetrate the great cosmic night, not to plunge into a deep, dreamless sleep, but to live with small creatures of instinct and desire, which are in this transitional zone between the dream and reality. They move in a rhythm which corresponds to the dreaming state, a rhythm which leads us from the dream towards a richer reality.' This fine text by Egill Jacobsen appeared in the review *Helhesten* which succeeded *Linien*. Twelve issues of *Helhesten* appeared between March 1941 and November 1944, and, if a comparative definition is

directions they took, a remark in Kierkegaards' *Journal*, much read by Danish artists: 'There is a place in the forest of Grib which is called the *Crossroad of the Eight Paths*. I really like this name.' How can one make a choice (if indeed a choice is necessary) if not by trying one by one these paths, which lead who knows where? Towards the work of art, according to Jorn, but one cannot know this at the outset. Thus he painted the gnomes in the *Green Beard* without beards at all (the beard would remain an obsessively iconographical theme with him). Or, indeed, the comical parade of the

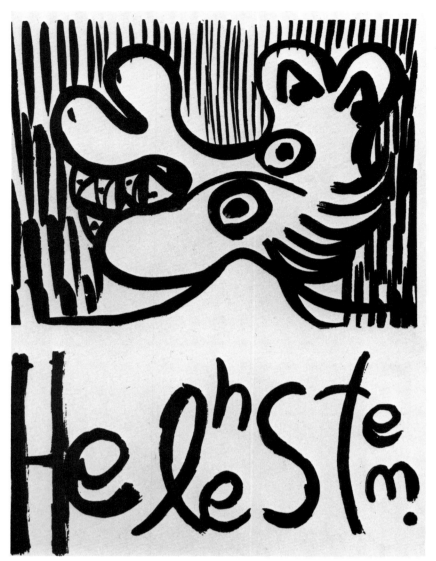

Helhesten . Tidsskrift for Kunst . 1. Aargang . Hefte 1 . Side 1-32 . København i Kommission hos Athenæum . Pris pr. Nr. 1,75 Kr. . i Abonnement 1,50

needed, one could say it was a Danish *Minotaure*, but playing a parallel role to *La Main à Plume* during the German Occupation.

As Dotremont was later for Cobra, it was Jorn who was the initiator and the king-pin of this enterprise, and its cohesion was assured by the architect Robert Dahlmann Olsen, who was already associated with *Linien*. The highly symbolic title had been proposed by Jorn to Ejler Bille and Egill Jacobsen, who immediately took to it as 'a perfect name to flaunt at the Nazis', who, without declaring war, had taken hold of a Denmark which was even less prepared to fight than the Netherlands. Subtle at first, the Nazi takeover became more intense stage by stage; Churchill spoke of Denmark as the 'killer's canary', which is allowed to fly around its cage a few times before being strangled. At first, the Danish government pursued a policy of so-called adaptation, namely of measured concessions: thus the Communist Party was dissolved in June 1941, forcing Egill Jacobsen and Jørgen Nash to take certain precautions, as the members of *La Main à Plume* had had to do in France. *Helhesten*, in its second issue published at that time, nonetheless dedicated part of its contents to Egill

Jacobsen, with a full-page reproduction of *Ophobning* and a commentary by Dahlmann Olsen which could not have been more plain.

From 1942 onwards, the resistance began to be actively organized, although the geography of the country was hardly suited to it. Activity centred above all on clandestine publications and acts of sabotage. In August 1943, violent demonstrations in Copenhagen against the new German demands (martial law, the prohibiting of strikes) caused the occupying forces to seize power and disarm the garrisons: the country overwhelmingly entered open hostilities with methods all its own, ranging from displays of open contempt to the most scabrous derision, in which the famous 'gallows humour' was not lacking. Many of those under threat, such as the surrealist painter Wilhelm Freddie, would finally take refuge in Sweden, a country which played host to a wave of fugitives from August 1943 onwards, swelled by the Jews, whose deportation had been decreed by the Nazis. Like the Netherlands, Denmark went into a nightmare system of underground resistance and reprisals. Danish industry ceased to be operational for the Germans from 1943, as a result of

Asger Jorn, lithograph (25 × 20 cm) created for the cover of the 2nd series of *Helhesten*, cased edition, 1944. Printed on binding paper by J. Christian Sørensen, Copenhagen.

Covers of the review *Helhesten*, Copenhagen. From left to right: Ejler Bille, No. 4, 2nd series, December 1943; Henry Heerup, No. 1, 1st series, March 1941; Carl-Henning Pedersen, Nos. 5–6, 2nd series, November 1944.

sabotage, communications networks were disrupted and the administration collapsed. When the Liberation finally came, Denmark was invited to the Allied Conference in San Francisco, although it had never officially been in a state of war against Germany. Such was the historical background against which *Helhesten* was published.

Dahlmann Olsen later recalled: 'The very idea of getting together for such a bold adventure under the Occupation, with the declared intent of taking a particular interest in *degenerate art*, appeared absurd to most people. But external pressures increased the internal need in the artists concerned to clarify on the one hand the very sources of aesthetic activity and on the other the human values to which their own creations appealed. They also wanted to demonstrate how each of us possesses art inside ourselves and that freeing oneself from artistic prejudice is of primary importance for the whole of society.'

Helhesten, whose cover was designed by a different artist on each occasion (Heerup did the first issue, Ejler Bille No. 4 and Carl-Henning Pedersen Nos. 5–6 of the second and last series), never had more than a modest print-run of around 800 copies. The main articles were written by the artists themselves, and it was no coincidence that the first issue opened with a short presentation by Carl-Henning Pedersen of the writings of Paul Klee. The Danish artists, like those of Cobra, were most willing to write about themselves and their colleagues. Egill Jacobsen published an article in the first issue entitled 'objectivity and mystery', whose conclusion gave us something of a foretaste of Cobra: 'Art renews its forces in the living imagination, on the border between the known and the unknown, of knowledge and mystery . . . Mystery is the unknown. When it becomes known, it is transformed into knowledge and, to increase our knowledge, we must continually seek the unknown.' If art criticism in general was hostile to the artists of *Helhesten*, or ignored them completely, they nevertheless had strong allies amongst the poets. *Helhesten* owed much of its richness to the Danes Jens August Schade, Ole Sarvig, Jørgen Nash, the younger brother of Asger Jorn, and to the Swedes Artur Lundkvist and Gunnar Ekelöf, as well as to the translations of Rimbaud, Kafka or Carl Sandberg which were reproduced in it. Carl-Henning published his own poems

there before making a collection of them, as did Ejler Bille.

Helhesten also took in archaeology, folk art, artistic education, the cinema and photography. The Danes' interest in ethnographic art, apart from a fascination with form (as with Picasso) was guided by a desire to understand the way of thinking and lifestyle of primitive cultures, a process in which researchers and artists were complementary. This was a desire which would remain with Jorn, for his part, all his life and something in which the Cobra group would share. His friend, P. V. Glob, the future director of the National Museum of Antiquities, wrote in a study of 'Rupestral etchings and magic', published in issue 2 of the review: 'Plastic expression no doubt followed the same development as the magical practices of the hunters. The more magic headed towards a conscious abstraction, the more man moved away from naturalist forms to create a particular style which, in the course of time, would liberate itself from naturalist representation.' After having analysed the difficulties the Westerner must overcome in his approach to Asiatic art, Werner Jacobsen concluded, in relation to the 'sino-Siberian bronzes' in the National Museum of Ethnology: 'In the West, the work of art must give the spectator an impulse which is subject to developments. These developments are pre-determined by the cultural environment, but the artist's mark of genius consists in guiding the spectator's thinking in new directions. Western art is complex in its forms of expression, whilst Asiatic art is simple.'

The second issue of *Helhesten* opened on 'Intime Banaliteter', one of Jorn's great theoretical texts (where he was still signing himself as Jørgensen). The illustrations accompanying it, on eight pages, were a revelation of Jorn's graphic style, consisting of ornamented lettering, 'idiotic paintings, lintels and the canvasses of mountebanks', like those which delighted Rimbaud (moreover, reading Rimbaud had made a profound impression on Jorn). There were also designs for tattoos which had come from a small shop in the old port of Copenhagen, at 17 Nyhavn (where Jorn amused himself by painting a sign for a bar called Hyttefadet), photographs taken from American films (one of which was *King Kong*), and, finally, an enlarged sketch of a flea. In the banality he praised, Jorn detected those foundations of art which were the natural, the commonplace or the obvious, access to which had been denied us by various inhibitions of a social or historic origin. 'It is important to stress that the foundation of art rests in common life, the easy and the cheap, which reveals itself to be our most dear and indispensible possession.' These assertions came close to what Paul Éluard would write in the same period under the title *Poésie involontaire et Poésie intentionelle*, a text published by *La Main à Plume* in the collection *La Conquête du monde par l'image*: 'The poet, on the look-out for the obscure bits of news of the world, will return the delights of the purest language to us, that of the man in the street and of the sage, of the woman, the child and the madman. If one wished it, there could

be nothing but wonders.' And Jorn said: 'Children, who like Epinal's pictures and stick them in albums, give more hope to artists than many an art critic or museum director.'

In the second part of his article, Jorn used the pronoun *we* which, assuming he meant the artists of *Helhesten*, also heralded Cobra. Here also, although expressed differently, were to be found some of the fundamental ideas which Constant expressed in his manifesto in *Reflex*:

'If we try to understand the state of art today, we must equally try to understand the conditions which have determined the evolution of our intuition about art and our notion of the relationship between man and society. The artist actively participates in the struggle for that which will deepen his knowledge, which is ours from our very depths and makes artistic creation possible. The artist's zone of interest does not allow itself to be limited, moreover, to a single domain; it must look for the *ultimate consciousness* of the whole and of its details. Nothing is sacred for him, because everything has become important to him.

'It cannot in any way be a matter of choice but, on the contrary, of penetrating, within the entire cosmic system, the laws governing the rhythm, the energy and the substance which makes up the reality of the world and that of the ugliest or the most beautiful, everything which has a character and an expression, be it the most crude and most brutal, or the most fine and most tender, everything that speaks to us because it is life itself.

'We suppress aesthetic principles. We are not disillusioned because we have no illusions. We never had them.

'What we possess, and what gives us our strength, is the fact that life gives us joy and that life in all its moral aspects arouses our interest. And it is this, too, which represents the foundation of the art of today. We do not even know the laws of aesthetics, and the old concept of choice according to a principle of Beautiful or Ugly, and corresponding to what is noble or undeserving on the ethical level is death for us – us for whom the Beautiful is also the Ugly, for whom all that is Ugly also possesses Beauty.

'We know that he who reads the story of criminals also reads something about himself. Neither fine dances nor fine gestures exist, only expression exists, and what is called beautiful is only the expression of *something*. Our music is not unaesthetic, because it has nothing to do with the notion of aesthetics. We do not recognize the existence of architecture. Only houses and sculptures exist. Machines for living and enormous forms. Cologne Cathedral is nothing but an empty magic sculpture, whose aim is purely psychological – just like a glass of beer is architecture.

'Different styles do not exist, they have never existed. Style is the expression of bourgeois content and its various nuances are called taste.

'The absolute distinction between sculpture and painting does not exist. No artistic expression can be

Johannes Holbek, *Death*, 1898. Indian ink drawing (52 × 33 cm), Kunstmuseum, Silkeborg. Illustration chosen by Asger Jorn to accompany his article 'The Prophetic Harps' in *Helhesten*, 2nd series, Nos. 5–6, Copenhagen, November 1944.

isolated by relying on its form, because we are concerned with different methods set in motion towards a common artistic goal. Glass paper and cotton wool are means of expression as noble and useful as oil paints and marble. There, they are of direction signs towards settling a score with the bourgeois concept of art. It is banal to want to end up with idealism as a philosophy, but that also touches on something which is central to art, and that is its vital content itself. The flower is given its structure by its internal tension (it wilts when it loses its sap), and the same applies to art. It is the content which creates the tensions. *Form and content are identical in nature.* Form is the vital phenomenon and content the living picture.

'The picture's content reflects what is inside the painter. It reveals what he senses about himself and his time, what he has been able to apprehend through his mind and heart. It reveals the depth of his experience. We can inherit from the previous generation neither an immoveable and constant concept of life, nor of art. Artistic expression changes with time, exactly as our experiences do, and new experiences create new forms.

'We may well want to learn what previous generations can teach us, but we are ourselves the masters of deciding our needs. No one can make the choice for us. It is not our duty to receive the laws of the previous generation and to fashion them according to their desire. On the contrary, they have a duty to help us where we have need of help.

'The problem touched on here in an exploratory manner is of a nature so intimate that it concerns everyone. No-one can escape. *Today, there are, and can be, no spectators.*'

It is impossible to attach too much importance to this manifesto. Apart from the analogies and the convergences with the thinking of the American artists of Jackson Pollock's generation (about whom the Danes, like the other Europeans, knew nothing as yet), there was in it the reassumption of the radical cause of painting and the outline of a different practice, where the act of painting itself became the principal force behind the work. Moreover, an initial movement was discernable here towards surpassing and generalizing art – the theoretical Utopia which Jorn would develop through Cobra and beyond it.

The last issue of *Helhesten* contained a new article by Jorn entitled 'The Prophetic Harps', which again heralded what would be one of Cobra's richest developments – the similarity of written and plastic forms, their common game, which would give rise to so many specific works, from the first word-pictures with Dotremont in 1948 in Brussels, to the logograms, where the balance of plastic and written imagery found its most perfect expression.

To mark the publication of the second issue of *Helhesten*, a vast collective exhibition was organized in a tent in the Bellevue forest, north of Copenhagen, from 17 May to 8 June 1941. Jorn took part in it with twenty-three miniatures painted on wood, since he could not afford to buy canvasses. It was a definitive stage on the path he was pursuing, with great versatility, from naïve, almost childlike, drawing to abstract form, not without allowing himself the occasional rather more symbolic representation. Henceforward Jorn can be thought of as being possessed by a mania for painting. Atkins' catalogue lists nearly two hundred works between 1940 and 1944, which include an extravagant *Homage to Baudelaire* (1942) alongside a rather Picassian portrait of Balzac (1942), *masks* in the Eskimo style, grimacing troll characters, the fine series of six interior shutters (for the black-out) painted at the house of a Copenhagen patron, or the fourteen doors for Mrs Fonnesbech-Sandberg's country house at Tibirke, where he also

Asger Jorn, *Red Vision*, 1944.
Oil on canvas (70 × 84 cm).
Statens Museum for Kunst, Copenhagen.
Museum photo.

Egill Jacobsen,
Ophobning ('Accumulation'), 1938.
Oil on canvas (80 × 65.5 cm).
Statens Museum for Kunst, Copenhagen.
Museum Photo.

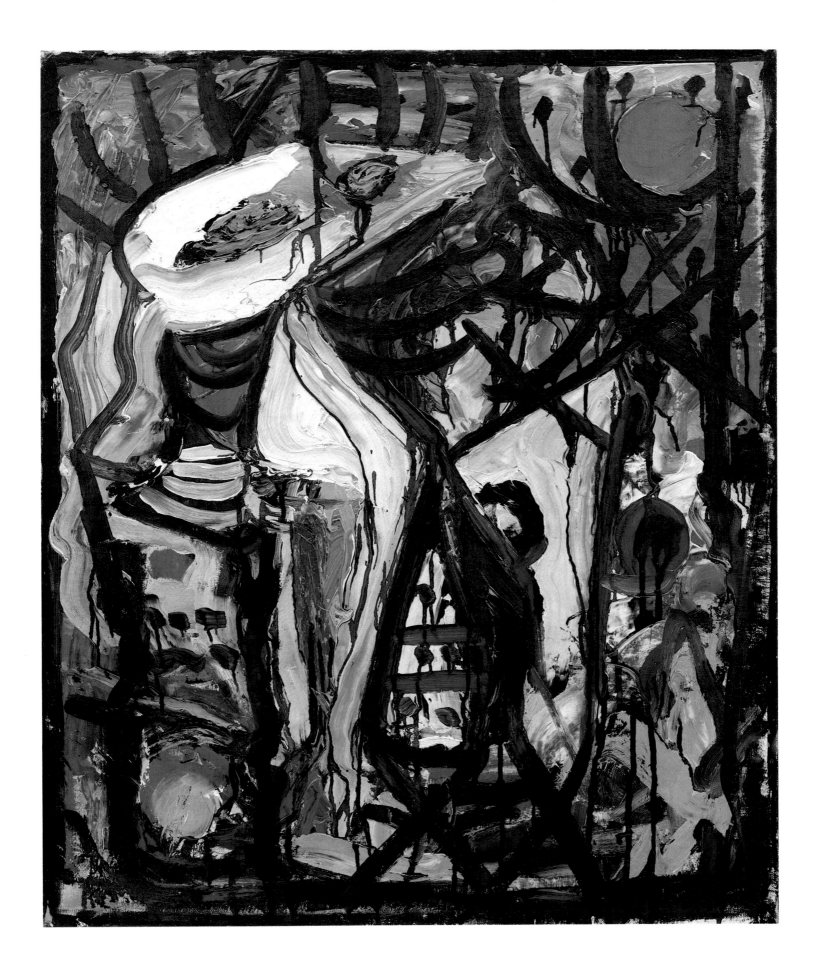

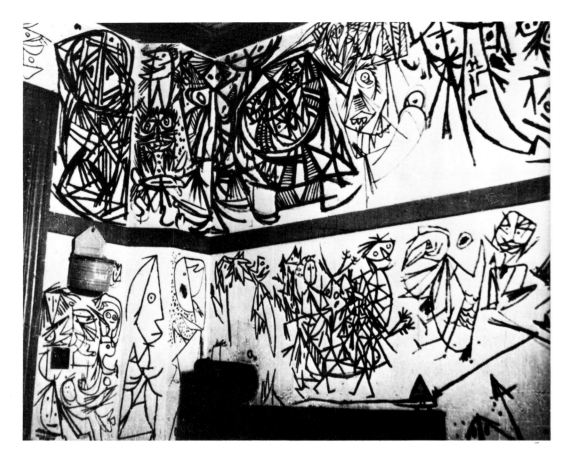

Asger Jorn, decoration in the house of Mrs Elna Fonnesbech-Sandberg in Tibirke, 1944. Black and white mural. Photo Olaf Kjelstrup.

'How many faces are there?' Puzzle picture for children chosen by Asger Jorn to illustrate his article 'The Prophetic Harps', *Helhesten*, 2nd series, Nos. 5–6, Copenhagen, November 1944.

Dobbeltslanger

Panel of illustrations taken from Asger Jorn's book *The Golden Horns and the Wheel of Fortune*, Copenhagen, 1957. Six examples of the double snake: 90 Greek mirror base; 91 Snake staff; 92 Runic stone; 93 The Snake Goddess from Cretan art; 94 Lewdness, fresco in Birkerød Church; 95 Circus snake charmer.

decorated the kitchen with a fresco and the wall of the outer entrance hall with a cement relief.

Jorn was heading towards his *Didaska* series, a title perhaps borrowed from Freud (in *The Meaning of Dreams*), but which could equally well have come from Nordic mythology, in which the ash (*ask*) was a sacred tree, while 'Dida' happened to be the nickname of Elna Fonnesbech-Sandberg, of whom Jorn painted portraits in 1945). It could be said that the same impetus caused the painter to change his surname from Jørgensen to Jorn, to make it sound more as if it had come from the *Edda* – as if to mark a final metamorphosis, this time a definitive one. The *Didaska* series, comprising both watercolours and sketches, like the head entitled *Dida*, whose features had calligraphic texts superimposed on them, was tinted with a new lightness which coincided with the end of the nightmare of war.

At that time in Copenhagen, the Danes had the opportunity to see a collection of two hundred works by Edvard Munch, the master of Scandinavian Expressionism, who had just died at a very advanced age in his native land of Norway, where he had shut himself away for many years. Troels Andersen, a friend of Jorn's who would be charged by him with directing his future 'Museum of a Painter' in Silkeborg, rightly underlined the importance of this exhibition for Jorn and the Spontaneous Abstract painters: 'In the works of Munch, they discovered how personal elements, tensions and inner conflicts could be determinant in the intensity of the motifs, as in their repetition.'

The problematics of drawing preoccupied Jorn for some time, as much in his theoretical reflection as in his work as an artist. It was noticeable in his extremely complex compositions of 1946 – drawings and paintings where, having let a labyrinthine line run its free course, he sought to extract figures from it; to define motifs and pass from a kind of unconscious, quasi-automatic objectivity to an image on which imagination had acted (the act of imagination itself). During the same period, Jorn was trying to transpose this method into a collective experiment, asking different artists in turn to extract figures which appealed to them from the tangled pattern of a sketch. Each time, the drawing would be interpreted differently. Jorn would draw from this the conclusion that the motif was effectively something more than the simple addition of shapes, and that individual shapes could vary considerably without destroying the motif. Slight alterations (like the addition of a few spots) in individual shapes sufficed to induce the 'miracle of the transformation of the motif'. There was in this the key to a great many of Jorn's pictures, and those of Cobra: 'The Danes had understood how an ornamental (non-representational) drawing could be changed into a bird or a chicken, how a flower could become a woman.' Bjerke Petersen had already hinted at it in his minor treatise of 1933: it had taken ten years to progress from the theoretical plan to its execution.

Following on from this, Jorn studied the conditions determining the permanence or migration of certain motifs, an analysis which could apply equally well to the individual work of an artist as to a cultural whole. If the first work which he dedicated to this kind of research, *The golden horns and the wheel of fortune* recalled Scandinavian antiquity more specifically, the collections which followed of knots, labyrinths, representations of the tongue and the beard, were elements of a universal anthropological perspective, limited neither by time nor origins. Jorn acquired from his initial studies a conviction that motifs were transmitted from one culture to another like myths, though not without undergoing transformations, absorbing or being modified by new characteristics. The core, however, remained. As for the tests he made among his friends (he pursued the experiment in Paris with Atlan, Lam, Matta etc.), Jorn inferred from them that if a complex image suggested different forms in each person, its symbolic significance was necessarily plural, that is, open. He would return to this multiplicity throughout his life. Speaking of his own output, he stated in the course of a conversation at Colombes on 23 February 1972: 'The real artistic value of an image stems from the fascination of the onlooker, who does not know where it comes from . . . Only what people see counts, and that independently of intellectual and other pressures which could force them to see this or that.' A multiplicity of meanings and thus a multiplicity of interpretations. Jorn did not exclude any reading – formal, psychological, mythological, social, historical – thus preserving the specificity of the work in his polysemic indetermination. This went far beyond the concept of the motif as Edvard Munch had formulated it, the latter holding to the allegorical and moral significance of images.

From January 1946, Jorn spent hardly any time in Copenhagen, having embarked on the intensely nomadic life he would lead up until his admittance to the Silkeborg sanatorium in May 1951, after Revolutionary Surrealism and Cobra. It was an exceptionally fruitful period, since the artist found time to work on some three hundred paintings, some of which rank among his masterpieces, in addition to his collective activities, publications and exhibitions. There was the major composition entitled *Saxnäs*, after the name of the large village in Swedish Lapland where he spent the summer of 1946. As far as the arrangement of forms was concerned, *Saxnäs* (Statens Museum for Kunst, Copenhagen) owed much to the experiments Jorn had just carried out with the tangled networks of lines; as to its colourism, that, in small, well-defined zones, was in the spirit of the *Didaska* period or of *Noah's Ark*. But *Summer Night*, also painted in Lapland, had none of the confinement of *Saxnäs*; in it, Jorn gave free rein to the spontaneity of coloured drawing, the colour-sketch, which took on a vivacity that was quite animal.

In the autumn of the same year, Jorn was in Paris, having taken some of the smaller Saxnäs paintings with him. It was these, among others, that he showed to Atlan

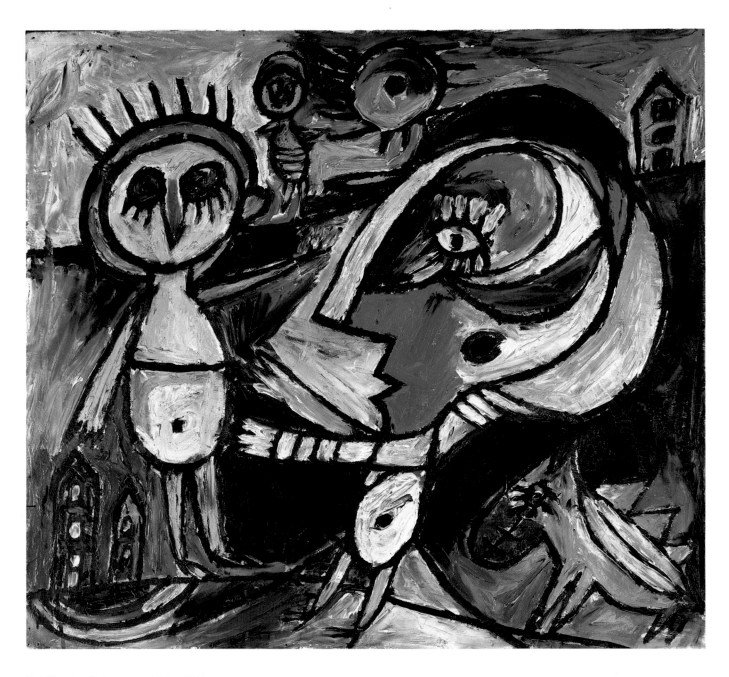

Carl-Henning Pedersen, untitled, *c.*1941.
Oil on canvas (80 × 84.5 cm),
Kunstmuseum, Silkeborg. Museum photo.

Asger Jorn, untitled, 1947.
Oil on sackcloth (101 × 81 cm).
Collection of Édouard Jaguer, Paris.
Photo Luc Joubert, Paris.

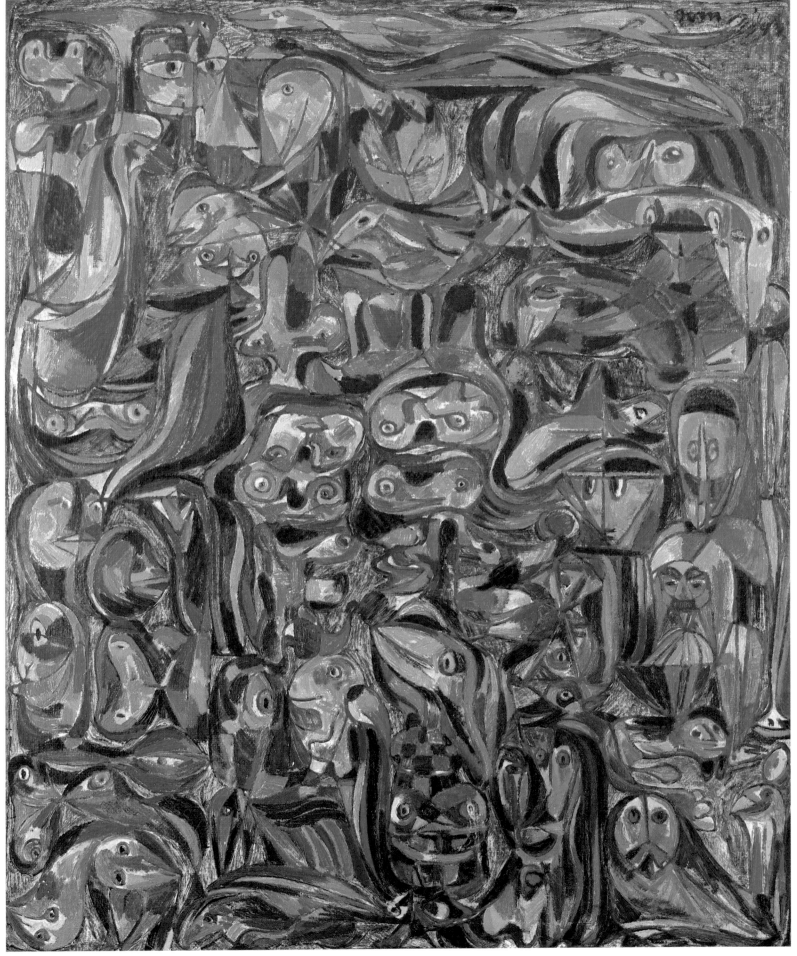

and his friends, and to René Drouin, who ran an important gallery in the Place Vendôme. Jorn travelled down to Nice to meet the critics René Renne and Claude Serbanne, collaborators in the *Cahiers du Sud* who were the first people in France to take an interest in the Danes. Jorn spent the winter of 1947–8 in Djerba, thus getting to Tunisia ahead of Corneille, who arrived there in the spring. This stay, which for Jorn and his family was under precarious material conditions, was nevertheless fertile for him in terms of pictures: he produced around thirty, in which traditional Tunisian motifs were clearly evident. It was merely an exotic interlude though; the dromedary featured in the canvas explicitly entitled *Djerba* (1948) did not migrate into his later works and the *Birds of Paradise* were, when all is said and done, more Nordic than Mediterranean. On canvas, Jorn's 'Tunisian dream' had nothing of the intensity of colour of Klee's – nor of Corneille's, who was able to immerse himself in the reality of Africa. In general, Jorn hardly sought to travel outside Europe; the countries of the sun, the 'tourist countries', would tend to attract his sarcasm: he called a 1961 painting *The sun pisses me off* (Private collection, Paris). He said of the Djerba paintings: 'I was working on the principle that it is the surface of the picture which dictates its proportions and that perspective has nothing to do with the vision of things.'

From Djerba, he returned towards Denmark, towards Cobra: 'Anyway, Jorn is everywhere,' Dotrement wrote. 'In Tunisia and in painting, in Amsterdam and in the comparative history of religions, in Paris and in Symbolistic science. A curious traveller who covers the tracks of his journey or destroys them. If there is no track, he ploughs one.'

If, in the context of Jorn's creative development, one considers his first 'word-pictures' with Christian Dotremont (Brussels, October 1948) as the initiators of the Cobra years, some two hundred and fifty pictures must be considered as belonging to this period, from his confinement in the Silkeborg sanatorium (1951–2) to his departure for Italy and France at the end of 1953. It was a tumultuous and uneven production which was scattered around the world, thanks to his travels, and whose development Jorn himself did not record systematically. Various series can be distinguished which often overlap with each other: *War Visions, Historical paintings* (1949–50), the *Aganaks* (1950–1), the two *Seasons* cycles (1950–3) and *Silent myth* (1952–3). Through the contradictions resulting from fairly numerous failures, but also the most dazzling successes, Jorn reached the peak of his genius. Christian Dotremont summed this up in the preface he wrote to Jorn's first one-man exhibition at the Galerie Taptoe in Brussels in March 1956: 'This painting is whole, one . . . One historian already advances the thesis that Jorn is essentially a draughtsman and the other announces that he is primarily a colourist . . . Well, it is a matter of organic, united work, free from the fashionable spirit of specialization. The fashion is to separate. Jorn adds up. The fashion is to cut the painter

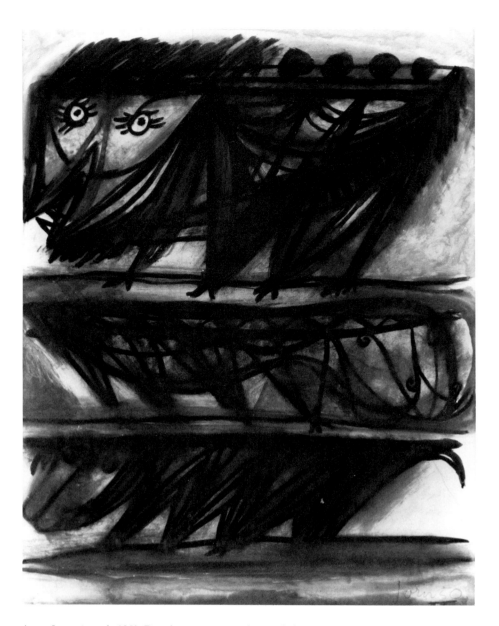

Asger Jorn, *Aganak*, 1950. Drawing on paper, various techniques (63 × 48 cm). Collection of Jean Pollak, Paris. Photo Luc Joubert, Paris.

in two: first as a sensitive person and second as a technical person. Jorn multiplies.

'Some give themselves up to the delights of scrawling, others to the delights of being *neat*. Outside of these alternatives, the spontaneity of the painter of the *Aganaks* is firm – it does not dribble – and his intelligence is supple, it petrifies nothing. Jorn's intelligence is assimilated and becomes emotion. Emotion reflects, but briefly, on the equilibrium in shock, in the light. It happens that the light of this painting verges on the excessive; it is profuse. But . . . it also stems from the immense unease of the Dane, driven back against the mysteries of the depths and in love with the surface: exalted (on a beach under the sun) and timid (when he lights a candle) and criminal (lighter of millstones). In this painting, the most menacing shadows appear amid the light, but all of a sudden, the debate is overturned; the night takes on the tenderness of a pillow, whilst the

sun, the basic master, scarcely visible, becomes demoniacal. This comes from a debate about good and evil, yes and no, to which a solution can only be found in painting. It comes from a doubt powerful enough to encompass nature itself and the prestige of certitude. But how could we tell ourselves where the solutions are, where the problems are? With Jorn, the solution is bristling with problems. That apparently serene, airy canvas – you just have to look at it. The problem, with Jorn, shouts a solution. This hairy, toothed canvas . . . It is because the extreme tension of Jorn's painting is linked to an extreme liberty of sensation. Jorn is a peasant who is dreadfully attached to the land, to matter (and, for example, to the daub of colour from which the picture is composed); and he who is terribly attached to the sky, to the coming and going of the seasons, to the questioning of signs, sees the abyss between the very furrows.'

The paintings of the years 1947–8 were often littered with overlapping forms and figures; an overflowing, a fermentation which could only lead to a bursting of banks, an explosion, liberating those bonds created by the interlacing of lines, which were not those of the thoughtful arabesque, but much more an internal wandering turning back on itself, the result slipping away. It was from this that that most symbolic of all figures, the eagle, appeared, which would haunt Jorn's imagery until 1951, until *The Eagle's Share* (Kunstmuseum, Silkeborg), which was one of the most directly expressionist compositions of his macabre drawings. Did Jorn's eagle belong to Cobra's fantastic bestiary? As a complementary contrast to the snake? Actually, it was only an eagle in the title: the bird of prey contained a big cat, and there was also a tree against which a giant skull was propped up, watched by a cat. The roots of the tree could equally well have been claws. In a letter to Werner Haftmann, who was preparing an exhibition on anguish in modern art (Darmstadt, June–September 1963), Jorn recalled that *The Eagle's Share* was marked by the atmosphere of the cold war, which was then in progress, and by the menace of nuclear disaster. Even more explicit, if that is possible, were the *War Visions*, which were exhibited in June 1950 in Copenhagen, all charged with gloom and pathos: *The Pact of the Predators* (Kunstmuseum, Esbjerg), *The Burning City, The Scavengers, The Bereaved*. They were comparable to canvasses Constant was painting at that time, under the sway of the same sentiments. Jorn was undergoing one of the most disastrous periods of his life, suffering poverty, illness, and emotional tension. The passion for destruction could easily have seized him. In the last analysis, is it not possible to see in *The Eagle's Share* an emblem of hope, of victory over life? This emblem was, in some ways, symmetrical with another, the latter unequivocal in its Kafkaesque bestiality: *The Golden Swine*, an allegory of wealth. Or rather the curse of wealth. It was unquestionably a matter of American wealth: Jorn told Guy Atkins that there was the silhouette of a typical American car of the Fifties beneath the shape of the animal. And the sun is most explicitly marked with a dollar sign. All these symbols were also Jorn's personal response to propagandist art which Jdanovism was seeking to impose, and against which the Cobra artists were making a stand. After that, Jorn would have many opportunities to demonstrate his opposition to the domination of economics and his refusal to assimilate 'utilitarian value' or 'artistic value'. He theorized his position in various publications in Danish and French, thus contributing to the formulation of a libertarian marxism which would bolster that of situationism.

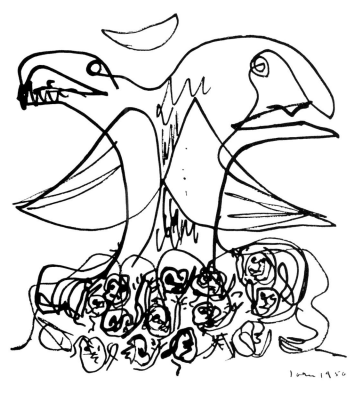

Asger Jorn, *The Eagle's Share*, 1950. Indian ink drawing (24 × 20 cm). Collection of V.O. Permild, Drogør, Denmark.

The Golden Swine (Kunstmuseum, Silkeborg) was the first and most crushing of the *Aganaks*, paintings, gouaches and drawings which Jorn produced in Denmark and Suresnes in 1950–1. It was a made-up name, the Aganak being a metamorphic being, like Kafka's Odradek. The product of a mixed world, it was an amphibian somewhere between a crab and a Hart's-tongue. Sometimes it attempted to fly, but only ever managed to swim in a liquid sky. It could also become like a gnome or a troll from Scandinavian folklore, solemnized by Wagner in the *Nibelungen*, made comical by Walt Disney in *Snow White and the Seven Dwarfs*, redeemed by Tolkien in *The Hobbit*. Jorn developed this alternative zoology as far in the direction of the monster, in canvasses such as *Falbo*, as in the direction of a fairyland, like that of Carl-Henning Pedersen in *The moon and the animals* (private collection).

From the historical to the mythological, Jorn's train

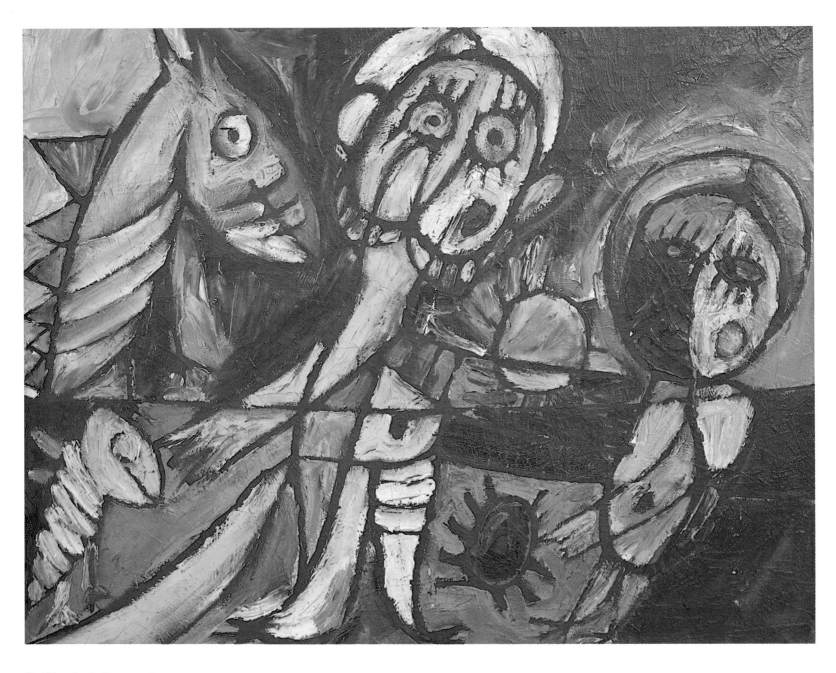

Carl-Henning Pedersen, *Yellow Horse*, 1942.
Oil on canvas (60 × 73 cm).
Nordjyllands Kunstmuseum, Aalborg.
Museum photo.

Carl-Henning Pedersen,
The pink bird. A fantasy 1940.
Oil on canvas (80.5 × 67.5 cm).
Statens Museum for Kunst,
Copenhagen. Museum photo.

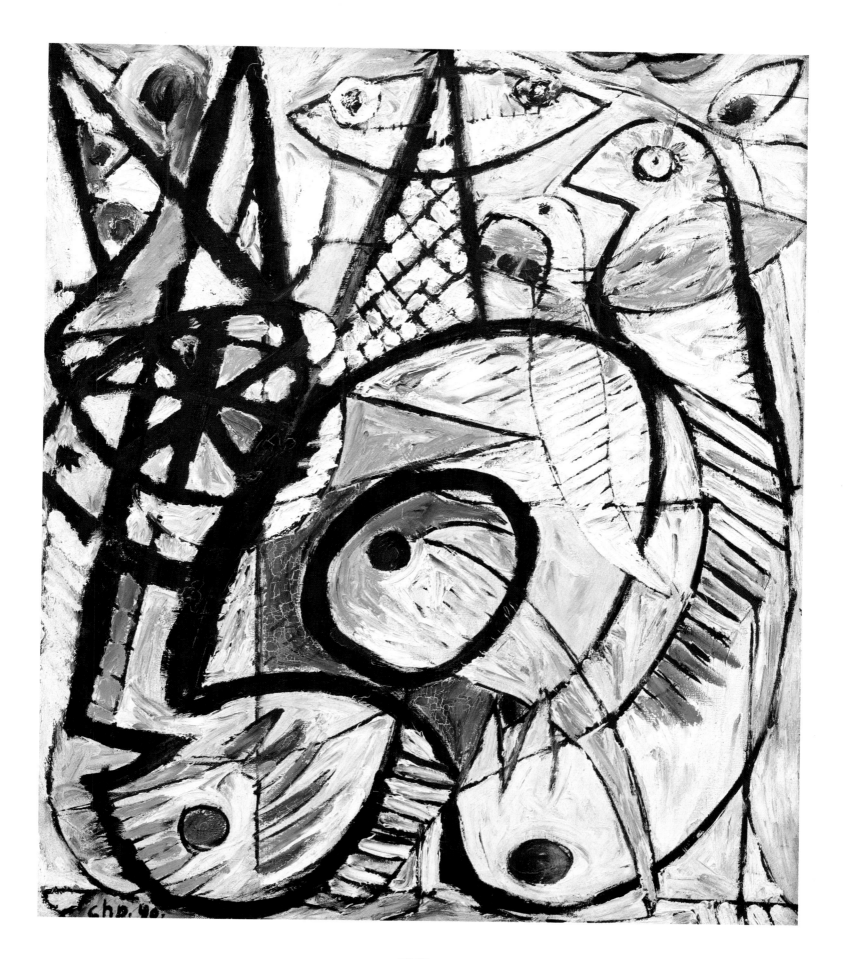

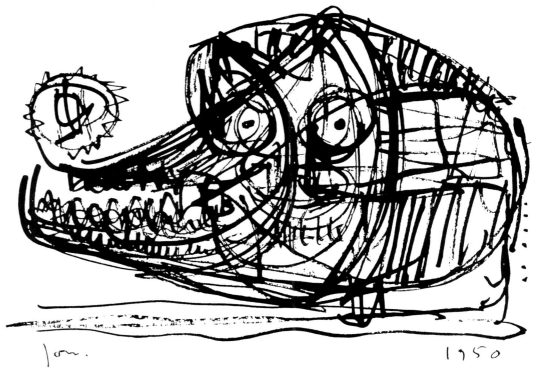

Asger Jorn, sketch for *The Golden Swine*, 1950. Indian ink drawing (18.6 × 24.9 cm). Kunstmuseum, Silkeborg. It has a dollar sign on its snout.

opposite
Asger Jorn, untitled, 1940. Indian ink drawing (27 × 19.5 cm). Private collection.

of thought marked all the difference which separated him from the artists who translated the present – Kokoschka or Picasso. Thus he followed up the six *Historical paintings*, which made reference in their titles to Denmark's precarious fate during the nineteenth century and its recent joining of the Atlantic Pact, with the *Seasons* cycle, which borrowed from popular tradition (*The Feast of Saint John*) and from archaeology (*The Wheel of Fortune*, 1951–2; *The Wheel of Life*, 1952–3, Statens Museum for Kunst, Copenhagen). Then he painted the *Silent Myth*, a generic title for several compositions, two of which were the great paintings *Opus 5* and *Opus 7*, which are to be found in the Kunstmuseum, Silkeborg. Guy Atkins maintains that the *Silent Myth* referred to Jorn's conviction that 'The relationship between mythical tales and the visual arts should be silent, not illustrative.' The 'historical' paintings are a mass of conflicting figures, as historical time can be viewed, made up of episodes, accidents, apparent incoherence, disjointedness. On the other hand, the mythical period had integral value and translated itself into pictorial space through a stream of forms which could be called cosmic, bearing in mind the unity of man and nature which Jorn talked about in his 'Interpretation of Silkeborg', where he discussed the theories of Niels Bohr. In the end, the 'mythical' paintings tend towards an elemental landscape. In some notes of 1958, Dotremont wrote: 'A rustic vision, never entirely removed from his native Jutland, which is the most vast and most obscure area of Denmark. The heaviest and the most lively in nature. In nature and mythology.'

Among the Danes, Carl-Henning Pedersen was the painter who best illustrated spontaneity at its most innocent and natural. He wished to learn about nothing but life; if he finally entered the world of art, it was in following his intimate inclinations, his instincts, his feelings – the constructions of reason never interested him. What he demanded from artistic creation was that it should be a means of opening out the being, a (happy) exercise of his faculties.

Carl-Henning Pedersen did not, however, remain 'unscathed by conscience and disquiet', as Jean Casson described Chagall, with whom Pedersen had often been compared. And in no way did he deny the lesson of established cultures; he only took care to retain his authenticity, which would remain in contact with the memory of the world, and would always give it preference over the historical. His own story had, moreover, something of the legend about it; the son of a working class family in Copenhagen, where he was born in 1913, he had to make his own way from very early on. A militant in the communist youth movements, he worked as a milkman in the early hours of the morning and dreamed of becoming a musician. He also disseminated propagandist literature; he wrote poems and would continue to do so all his life, without worrying whether they were literature or not (they were not). He met Else Alfelt, who was already painting, and in 1933 Carl-Henning joined his own life with that of Else, and with painting. He left his job but not his politics and, unemployed, set himself to the real work: 'I *really* became a painter when I discovered the joy of putting one colour next to another. From then on, I sought the secret of colour and it was like looking for the secret of myself.' He met Egill Jacobsen, Ejler Bille and the other members of *Linien*; his first works were abstract, rather cubist. Kandinsky's pictures, which featured at the Linien exhibition in 1937, in which Pedersen also took part, troubled him profoundly: need we repeat what all his biographies tell us, that he was self-taught? At the

Egill Jacobsen, *Green masks*, 1942.
Oil on canvas (94.5 × 72 cm).
Statens Museum for Kunst, Copenhagen.
Museum photo.

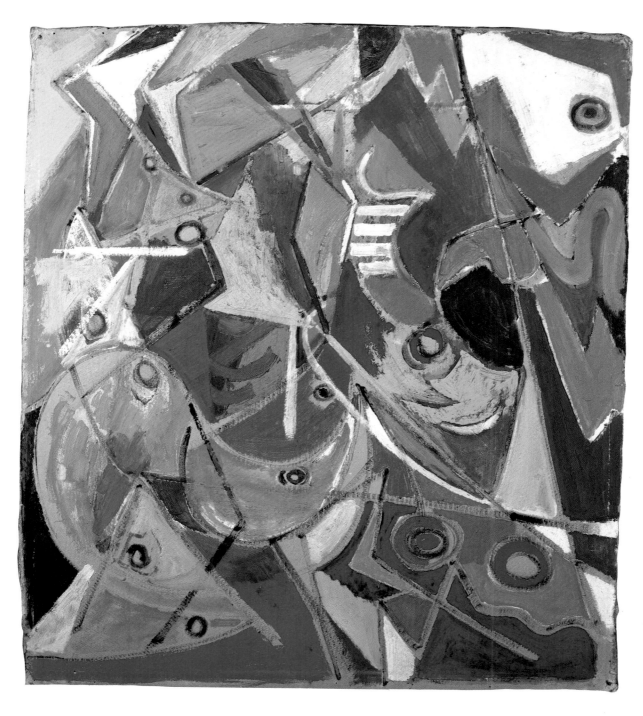

Svavar Gudnason, *Young woman at the ball*, 1940.
Oil on paper (86.5 × 75.5 cm).
Kunstmuseum Silkeborg. Museum photo.

Henry Heerup, *The man with the gramophone*,
carved from a tree-trunk, 1935. Metal and wood (height 178 cm)
Nordjyllands Kunstmuseum, Aalborg. Museum photo.

very least, one could say that he had been sparing in his academic learning and he had been able to choose whoever suited him as a master. In fact, Carl-Henning Pedersen was aspiring towards a sort of virginity in the artistic sense; and he certainly had to decondition himself from Western vision. Whence Egill Jacobsen's timeless *mask* and Carl-Henning's direct pleasure in colour. He felt that this pleasure depended on the 'immediate sensitivity of our eye and, at the same time, of our mind towards colour', as Pierre Francastel noted in respect of his 'Emblems, totems and coats of arms' (a 1964 exhibition at the Musée Guimet, Paris). 'For generations, colour has been linked to still-life. One of the major events of the last half-century will certainly have been the rediscovery by artists, despite the crudeness of its execution, of the specific qualities of a modality of perception as important as that which expresses itself through lines and arabesques . . . the use of colours permits the direct fixation of sensitive values as significant in themselves as that which the lines and the plane support.'

Another important reference for Carl-Henning, as for all of his generation, was Egill Jacobsen's *Ophobning*. Then came the trip to Paris, for which he prepared by familiarizing himself with Surrealism (poetry and paint-

Carl-Henning Pedersen, title page for *Drømmedigte* ('Dream poems'), Helhestens Forlag, 1945.

ing). He returned to Denmark via Frankfurt, where he visited the 'Degenerate Art' exhibition organized by the Nazis: it marked the end of his years of apprenticeship. Later, he would recount: 'I hitch-hiked to Paris and left the same way, travelling via Frankfurt. That was my first encounter with German Expressionism. I was obviously anti-Nazi and felt myself to be in solidarity with those Hitler wanted to *ausradieren*. Think what would have happened if he had won the war! The exhibition was of primary importance to me – the more so because we were about to be separated from each other and for five years! And then walking between the Siegfried and Maginot lines with a rucksack! Amid the great military manoeuvres. There were no cars, so I had to walk. I did seventy kilometres a day, and everywhere there were placards telling you it was forbidden to use this or that road. Although war was still a fantasy, you felt that it was really in preparation there. Undoubtedly that famous exhibition played a deeper role for me than I realized at the time. Up till then, it had been Cubism which attracted me; I painted in a cubist-abstract style. But, having seen the exhibition, Expressionism began to fascinate me. There were greater possibilities in it for sensitivity. And I wonder how I could have continued to paint if I hadn't seen that exhibition. I have never visited any other exhibition which impressed me so much. Some of the pictures there are still living in my memory.'

From that time on, Carl-Henning Pedersen had at his disposal the pictorial means to suit his internal, enchanted world: masks, people, and animals followed each other and, after a brief soft-pink period, grey and white birds appeared in 1939–40, then the yellow horses of 1941. The horses, though, would pass through a range of colours (*Human beings and red horse*, 1943), like the sun (*Pink sun*, 1942) or those intermediary beings which constituted the painter's imaginary family (*Blue Family*, 1943). It was the era of *Helhesten*, and in one of the brief descriptions of his companions Egill Jacobsen wrote for the review, he summed up Carl-Henning Pedersen's work with customary acuteness: 'In painting, fable and myth are not descriptive; they exist as expressions or independent beings. The crucifix represents Jesus, but the negro fetish represents nothing, it is a god which will be rejected when it is no longer useful. The same is true of abstract painting; it is not descriptive, it is life itself, like the fetish for the black man, like poetry, music and the fable for our culture. It is a bridge over prejudice and fear, stupidity and the powers of darkness, thrown from one point to the other by the process of life. And just as, when the picture is finished, the artist has achieved the experience it contains so the picture, if it is successful, becomes an independent world, open and significant. To understand Danish abstract art, we must keep all that in mind. The Danish abstract artists border on fable and legend, against a background of very ancient experiences. Carl-Henning Pedersen has centuries of colour-legends in his head; and when he paints, he uses colour as it is in nature. He follows his impulses with the

125.
Lyset er tændt,
og du gik derude og saa
efter din Skæbnes Hjul
som kører din Vogn.

Carl Henning Pedersen, one of the inside pages of
Drømmedigte, Helhestens Forlag, Copenhagen, 1945.
Printed by J. Christian Sørensen.

greatest attention and that is why he cannot fail to make progress: painting is living. He knows that imitation is a false light which covers the world and that this magnificence is like 'The Emperor's new clothes' – an accident sooner or later reveals the imposture. And these gods too will be rejected. The imagination will rid itself of its fetters. The imaginary will unite with reality, as in the legends, poetry and pictures of Carl-Henning.'

Whilst, from 1942 onwards, the colours became more dramatic in a movement reminiscent of Nolde, and the themes became more sombre as the world became engulfed in war, a new light became detectable in Carl-Henning's canvasses with the rising victory and restored peace: a blond, nordic, cosmic, pagan light, to use the words of Christian Dotremont, who would soon discover it himself: 'If only it was sunny, this night!' And in the pre-Cobra, then the Cobra years, Carl-Henning would paint a whole fantasmagorical sunny nocturne where yellow and blue dominated, from chrome to cobalt: 'For the painter, the colours are the celestial and terrestrial orchestras which he can conduct.' An important stage in Carl-Henning's itinerary was the study of medieval painting, which had escaped the whitewash of the reformation on the walls of a few country churches around Copenhagen and in Jutland. The artist dedicated an article to them published in *Helhesten* in 1944; it was a plea for natural art and an indictment of Christianity, 'which is afraid of it'. Carl-Henning pointed out that the frescoes expressed popular creativity no less for being based on models from Rome and Byzantium, since they were the work of simple men. It was a creativity which brought instinct to bear, as the illustrations to the article showed; for example the painting of a wild man (or demon) in the church at Raaby, whose head and torso are one. This would recur in Pedersen's work.

Without going as far as trying to establish a 'communism of talent' as the Surrealists did, Carl-Henning was no less persuaded that art lived inside every human being: 'We must make artists of all men. Because they are artists.' An optimistic Utopianism which, taking the context into account, had a Kierkegaardian ring to it, since, for the existential philosopher, at the ethical stage which is that of consciousness and responsibility towards oneself, 'the extraordinary man is the truly ordinary man'. In a short manifesto for the catalogue of the Høst exhibition in 1944, Carl-Henning Pedersen also wrote: 'Man is not simply a being who must work in order to live and nothing else. Each man is special, original, he resembles no other; and he only progresses by creating through his own means, having challenged all authority in art.'

These, again, were theses very close to those advanced by Kierkegaard in relation to the individual, in distinguishing the task (working in order to live) and the work (the construction of the being). As for rejecting authority in art, it was an 'anti-culturalism' which sowed the seeds for that of Cobra at the same time as coming close to that of Dubuffet. When Cobra began, Carl-Henning

Pedersen was an artist in full control of his methods and of his convictions. Dotremont said: 'The Danes showed us what was left to do for those who consider art as a weapon of the spirit, as a tool for the construction and the transformation of the world, and the artist as a good worker who subordinates all his activities to the common task and who does not seek to be great but useful . . . A simple art, beautiful like children who are unconscious of beauty.' For Carl-Henning, Cobra would be above all an opportunity to 'finally come out of himself completely.'

It is easy, when talking about Carl-Henning, to evoke a Nordic iconography (or, more precisely, a Viking one, the vestiges of which provide so much food for thought), and also the world of fairy tales which seems to relate naturally to it – a world without a precise location in time or space. His first retrospective, in 1950 – a Cobra year – was entitled *Eventyrets maleri*, making reference to Hans Christian Andersen (the Danish term *Eventyr*, in fact untranslatable, is somewhere between 'fairy story' and 'fable'). It was true that Carl-Henning retained only the bare elements from the external appearance and recognized no immoveable form. Abandoning himself with pleasure each time renewed to the emotive force of the imagination, which was, for him, first and foremost related to colour, he must have encountered figures, signs and even recognizable symbols: it was not necessary to stop there any longer than he stopped. 'I have never painted a specific animal in my life. If I say it is a horse, that is only a postulation. Of course, I like to look at birds very much. But the bird I paint has nothing to do with the bird which flies in the sky . . . It is more of a concept, like the Phoenix. The bird of life. The vital principle in the form of a bird. For, if you think about it, birds which you find in folk art are not birds. They are always the Phoenix in one way or another.'

In their retained spontaneity, Carl-Henning's paintings give us a rare glimpse of an imagination in action – a 'game around the golden tree' (to evoke the title of a 1948 work), without precise limits between day and night, the dream and reality. Between heaven and earth, Carl-Henning was the traveller in the 'cosmic sea', whose shimmering he captured in his glass mosaic for the Orstedt Institute in Copenhagen (1960–5).

Egill Jacobsen played one of the most determinant roles in the 'Abstract-Surrealist' group, both through his painting and his critical reflection. 'He has a hand which thinks and a head which riots,' Christian Dotremont said of him in that instalment of the *Artistes Libres* series (*Cobra Library*) which was dedicated to him. 'His theoretical and critical intelligence, which can be hard, never lead him to paint a demonstrative, cerebral painting; and sensitivity has never made him paint in a void, according only to the rules of inner life.' We have

above
Carl-Henning Pedersen, lithograph (25 × 20 cm) for the cover of the 1st series of *Helhesten*, cased edition, 1942. Printed on binding paper by J. Christian Sørensen, Copenhagen.

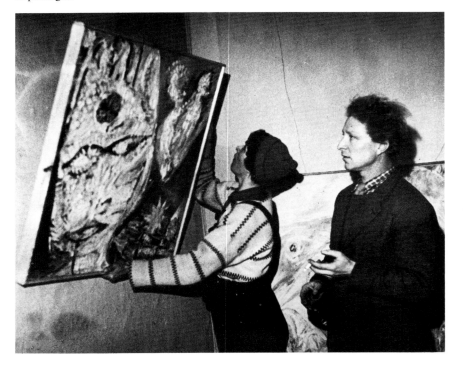

Copenhagen, at one of the annual Høst exhibitions. Hanging of one of Carl-Henning Pedersen's pictures, *Dreams*, by Else Alfelt and the artist.

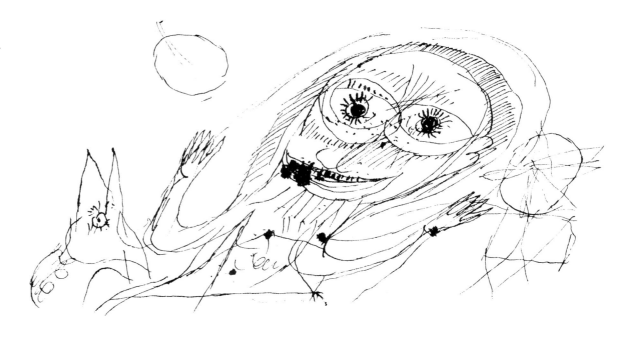

right
Carl-Henning Pedersen, untitled,
1962. Indian ink drawing (12 × 23 cm).
Private collection.

below
Carl-Henning Pedersen, indian ink
drawing (11.5 × 40.5 cm). Statens
Museum for Kunst, Copenhagen.
Museum photo.

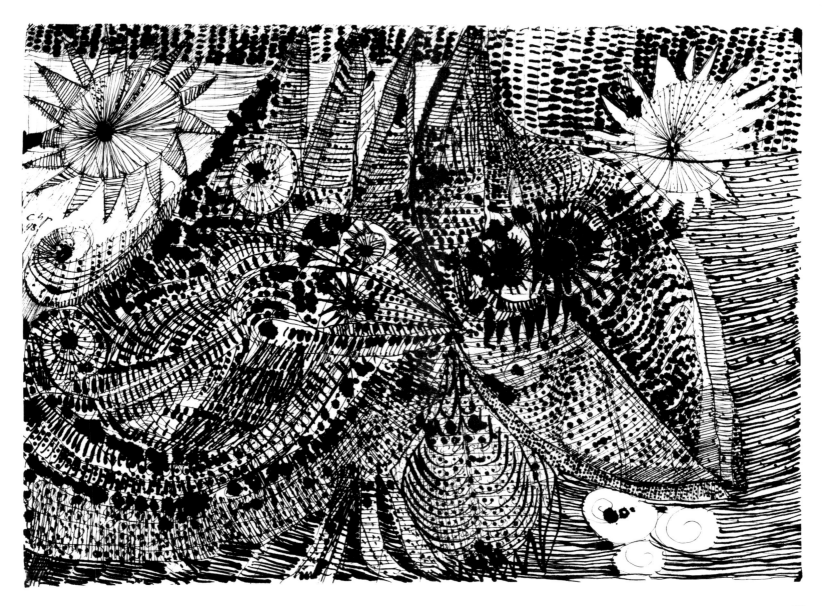

already seen the impact his first paintings in the *Masks* series had on his companions, and likewise the sudden revelation which was *Ophobning* (1938, Statens Museum for Kunst, Copenhagen). Before and after Cobra, which he encountered quite naturally, Jacobsen was better prepared than anyone for international collaboration, beginning from a national specificity which he had attained, and which he would maintain.

It was through a first trip to Paris in 1934 that he familiarized himself with abstract and surrealist painting and that he chose the mask as an image from fable as the fundamental element in his pictorial language. In his monograph on Egill Jacobsen, Per Hovdenak quite rightly dedicated a whole chapter to 'The Mask as language'. 'For Egill Jacobsen,' he wrote, 'the picture is first and foremost the visualization of a process, an action, a period. The representation, that is to say the mask, presents itself as the result of this process, but in such a way that the process remains visible, legible. All the elements of the picture, on their different levels, are gathered in the mask, which is perceived as a signal, a symbol, bearing complex meanings and myths.'

Far from being a simple plastic element – although it also was this – as in Picasso's *Les Demoiselles d'Avignon* the mask was for Egill Jacobsen the key to the imagination at its deepest and most immemorial. In this respect, Egill Jacobsen was a forerunner of Jackson Pollock in the years 1943–5. As Lawrence Alloway explained: 'The correspondences between Danish and American painting bear witness to a common movement towards an art form which is highly autographic in its methods and mythological in its content,' (*Danish Art and Primitivism*, 1963). The Danes took their inspiration principally from Oceanian masks, which were much more varied in their expression than African masks. It was an attraction they shared with the French Surrealists. But, despite their joyous vitality, their brilliant aggressiveness and their festive appetite for life, Jacobsen's masks could also be likened to Viking adornments – dragons' heads and others, like that which decorated the prow of the Oseberg boat. And to children's drawings.

'When I think of the mask,' Jacobsen said, using language which was a little Kierkegaardian in its way, 'it is not to hide or frighten, but to express the inner experience and the external experience, to liberate them and transmit them. The eyes turn in on the interior, trying to recognize something, then look towards the exterior, in the hope of uniting one with the other. A discovery of oneself and a liberation of drama, in the search for poetical synthesis. Why paint masks? Because we painters have need of a point of departure, a skeleton, a structure,' (preface to his exhibition at the Mark Gallery, Copenhagen, 1977).

Inevitably, the mask led Egill Jacobsen to paint festive scenes (*The dance of the grasshopper*, 1941, Nordjyllands Museum, Aalborg), carnivals (1943–4) and tin kettle music (which meant an etymological headache). The colours in them were nothing less than sombre: red and yellow dominated in their vital and solar sense. Dotremont was struck by this and noted, in the preface already mentioned in the *Artistes Libres* volume: 'Egill is a psychologist of colour as Bachelard is a psychologist of form; Egill thinks painting is colour before it becomes lines. He has demonstrated that in its entirety through multiple experiments, the most recent of which are concerned with the possibility of playing with the essence of a single colour without the picture ceasing to be, in whole or in part, sun, rays and shadows. In short, Egill's pictures are a great historical step towards unity: unity of form and content, unity of intelligence and sensitivity, unity of all the methods of painting, unity of the end and the means of the painting.'

Dotremont must have had in mind some of the pictures Egill Jacobsen painted during his stay of almost a year at Cagnes-sur-Mer: animated *Plants*, like those Alice discovered in Wonderland; *Blue lines* which had found their 'dancing floor' as Kierkegaard would have said; a *Lyrical improvisation*, where vegetal green sang in unison with a blue sky supported by yellow – a composition which the presence of a mask lifted to pure abstraction, even though it is almost indiscernible (it is nothing more than a triangle) 'like a wire which prevents a kite being lost in space'. It was on his return to Cagnes that Jacobsen broke away from the Danish Communist

Ejler Bille, lithograph published in *Helhseten*, 2nd series, Nos. 5–6, Copenhagen, November 1944.

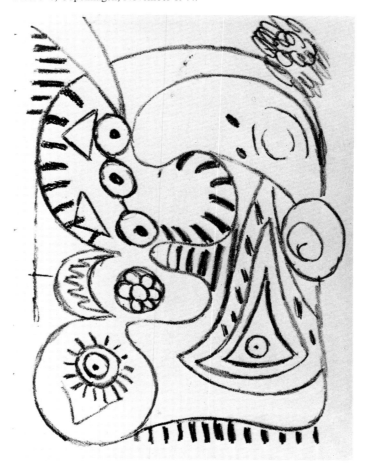

Egill Jacobsen, drawing published in *Helhesten*, 2nd series,
No. 1, Copenhagen, October 1942.

Party for reasons identical to those of Dotremont in
Brussels – the incompatibility of social realism and
experimental art, which became clear to the Danes in a
harsh light on the occasion of the *Vor Tids Kunst*
exhibition, under the aegis of the Communist newspaper
Land og Folk (1948) – an exhibition which would give
rise to debates which were rather too direct. The gravity
of Jacobsen's decision can be gauged when one con-
siders that he had joined the Communist Party fifteen
years previously and had taken an active part in the
organization of the exhibition (in which he featured,
along with several other 'Abstract-Surrealists'). He even
designed the exhibition poster.

Egill Jacobsen expressed his ideas on the relationship
between art and society and on the situation of the
creative individual in the bosom of collective history
many times. In the Linien exhibition catalogue of 1939,
he wrote the following on behalf of his 'Abstract-
Surrealist' companions: 'We do not paint so that the
picture looks like this or that. We paint because our
emotions are saturated with all we see and endure
because we are forced to do . . . The means of painting

are used to attain the richest content, the most complete
from a psychological point of view. The content of
colour has taken shape . . . As artists, we will colla-
borate with those who work to make man happier and
richer, materially and intellectually. We are not spec-
tators, indifferent to invisible tragedies.' In the first issue
of *Helhesten* (1941), Egill Jacobsen explained that, for
him, social realism and constructivism were equally
'intellectual' (in the pejorative sense), in as much as they
underestimated, one as much as the other, the emotive
moment and the psychological content. Social realism
doubtlessly attracted politically-inclined intellectuals,
but it attracted artists very little: 'Its main interest is of a
political order, in that it is a defence of the workers, but
it is of fairly doubtful value in doing so, because it is not
form but content which is dominant.' Yet 'all art, except
that which is superficial, is important for progress –
whether it is figurative or abstract.'

An important (collective) stage in the direction of
Cobra was the 1945 manifesto of *New Realism*, ad-
dressed, at its request, to the Museum of Modern Art in
New York and reprinted in the Høst exhibition cata-
logue in the same year in Copenhagen. Beside Egill
Jacobsen's signature, those of most of the future Danish
members of Cobra were to be found: Carl-Henning
Pedersen, Else Alfelt, Ejler Bille, Henry Heerup, Asger
Jorn, Erik Ortvad and Erik Thommesen. 'Our art is New
Realism, founded not on an intellectual structure like
the Renaissance, but on the natural possibilities for
composition and on a free development of man . . . In
our art, we begin with the phantom which imagination
creates, in preference to the human model or still-life,
which is in opposition to Picasso for example. On this
point, we feel that we are close to Klee and Miró,
although, in a certain way, our way of working is aligned
with Picasso's immediate pictorial spontaneity and his
brushwork. Which has led us to create a whole imagi-

Mother snake, drawing from Jorn's book
*The Golden Horns and the Wheel of
Fortune*, published as a vignette in *Cobra 7*.

nary world, up to a certain degree of advancement,
around the concept of the mask.' 'New realism', as it was
used in this context, remained a vague formulation;
doubtless it was necessary to understand 'new reality' or,
better still, 'new realities' in the plural – those realities
the artist adds to the given world. The reference to the
'interior' model, at least, in the way that André Breton
intended it, remained fundamental. And the conclusion
was also marked by the surrealist spirit: 'The artists
undersigned have the feeling of working in accordance
with the international development of art; they thus

intend to participate in the resolution of new human and artistic problems thrown up by the most recent scientific, psychological and social data.'

A 'conservative revolutionary', as Jorn one day called him, Ejler Bille, who played a leading role in the emergence of Danish Abstract Surrealism, showed his reticence when his dual, or tripartite, work as a sculptor, painter and critic was considered from a Cobra point of view. On the occasion of the Cobra retrospective in 1966 (at the Boymans-van Beuningen Museum in Rotterdam, then at the Louisiana Museum, Humlebaek), Bille made a statement which the historian must take into account: 'To my eyes, Cobra was a mere surface wave. What I lived deeply, for several years, was *Linien* and *Høst*. When we invited Constant, Appel and Corneille on Jorn's initiative, they were young painters whom we

Ejler Bille, untitled, 1940. Indian ink drawing.

found to be gifted, but who had just started out. We were fully developed. Although I took part in various Cobra exhibitions, I always felt that I was far from putting as much emphasis as they did on spontaneous expression, which was and which still appears nowadays to be the dominant factor in this tendency. I prefer organic to spontaneous, if one can, in any case, define the latter term with precision. Or let us say controlled spontaneity, like one finds in Chinese Zen,' (*Louisiana Revy*, August 1966). It was true that Bille had already had an impressive militant career by the time Cobra was formed; more than anything else, he devoted himself to *Linien*, then to *Helhesten*, studied Picasso, surrealism and abstraction in depth in articles which were landmarks in Denmark and were subsequently collected in a major book of 1945, together with translations of Lautréamont, Rimbaud and Éluard.

His artistic work was no less rich; after his debut as a sculptor (in Paris, in contact with Giacometti and Arp), he went on to paint under the influence of his close companion, Egill Jacobsen, whom he too influenced in return. He also crossed paths with Richard Mortensen. Bille's painting tended to create a synthesis, if not the synthesis, between Abstraction and Surrealism. The fruit of earlier reflections, this was a project which gathered an open and seductive lyricism from 1938 onwards, as was evident in *Explosion*, painted in 1938 in Paris, or in the *Bird*, already a more organic synthesis of forms and colours at the limit of figuration. He built up compositions which called on all the resources of colour and material, reinventing a shifting formal organization on each occasion without a really definitive model. In *Helhesten*, Carl-Henning Pedersen described the pictorial imagination in action: 'Brown colours rising from the depths. Singing the songs of the shadows. Finding warmth and well-being. Staying still. And one expects no more than a single note coming from the soul. All is calm in nature. A woman arises. Her voice strains to reach us. Quickly, quickly. The water is going to cover us. Ejler Bille told me in one of his poems: "It is Spring. The sun filters its rays. The palms of my hands are yellow. My hands are pale green. My whole self is irradiated with colours. And my legs go off on an adventure in the blue of space".' (*Helhesten*, 2nd series, Nos. 2–3).

On the theoretical level, Bille beat a path towards Cobra and Dotremont saluted him for doing so. In *Cobra 1*, published in 1949 in Copenhagen, Bille's short article 'Experiment is life' was programmatic for the group. Apart from the title, which could not be more Cobra, the following appeared: 'Practising scales represents a loss for the creator. The painter and the sculptor should express themselves as directly as possible . . . One does not create a style, one expresses content. It is only when works are thrown onto the dung-heap or into the museum that a style can be deduced . . . Static artists exist. They have walled themselves up. They are alchemists who want to make gold, but true alchemists, because of their enthusiasm, allow themselves to try a new alloy from time to time. Walled-up artists never let themselves be distracted from their research and they never find gold.'

Later, in issue 7 of *Cobra*, Dotremont reproduced large extracts of an article by Bille on Danish art under the title of 'The Fraternity of Evolutions': 'Not only does our friend Bille make a remarkable statement here, but he shows in a very general way the current situation of the painting we are defending.' Having globally rejected Constructivism and Surrealism, which he reproached for a common 'sentimental coldness which is the formalists' mark of Cain', Bille wrote: 'In the end, it is the evidence and power of the lived which pass into the brush, into the painter's colours, into the sculptor's medium . . . the basis of living art, of spontaneous art is an intense sensitivity; a lucid intelligence, an intelligence

which represents the lived . . . The artist possesses a sum of sentiments and sensations whose content he will express. And to live a vision and to create it on the canvas are not two separate acts.' Cobra's vitality had no better exponent than Bille in this article, of which Dotremont accentuated the anti-Surrealism in his commentary. Nevertheless, the exchange stopped there: Bille was absent from the contents page of the abortive Danish issue 8-9 and did not participate in the Liège exhibition. Perhaps it was in thinking of Bille that Dotremont wrote: 'Denmark can give nothing that we will take from it.'

Of all the Danes who were so misnamed 'Abstrakte', of whom he was the eldest, Heerup was the most *natural* artist: primitive and modern, rustic and malicious, playing equally easily with memory and imagination. He could not fail to become involved with Cobra and Cobra would have missed his contribution terribly. After visiting Heerup in his garden at Rödo, Dotremont had no hesitation: 'One of the great men of our time.'

Heerup's garden (*Heerups Have*) had about it both something of the earthly paradise and something of the scrap merchant's yard. It was an enchanted place and Heerup was its Prospero; he reigned there over a population of happy stones, preposterous objects set on plinths (very important, the plinths!) all over the place amongst the prairie grass and more or less sensibly arranged in the cabin at the bottom which was his studio – a preserve of painted images – sometimes verging on fantasmagoria.

How could one avoid calling to mind Gustav Munch Petersen's poem 'The Lowest Country'? (Published in *Linien*, it was learned by heart by the artists in the group, so much did it express their sentiments at that time):

Oh great happiness
great happiness which has come to them
those who were born in the lowest country.
You see them everywhere.
they wander
they love
they cry
they go everywhere
and in their hands they take the humble things
of the lowest country

Oh greatest of all the countries
most fabulous
is the lowest country
the land twists upwards
like a spear
and at the bottom
the heavy living blood runs over
and penetrates the lowest country

Little careful feet
and slender limbs
but the air is pure
on the climbing roads
in the closed veins
nostalgia is burning
with those who were born beneath the sky.

Oh you should go to the lowest country!
Oh you should see the people of the lowest country
Where blood flows freely amongst everything
men
women
children
when joy and despair and love
heavy and ripe
throw their multicoloured fires towards the earth
Oh land as secret as a brow
in the lowest country

You can see them everywhere
they wander
they love
they cry
their faces are closed
and in the interior of their soul
there is the earth of the lowest country.

Munch Petersen joined the International Brigades in Spain and died at the front in 1938, in combat against Franco's forces.

Heerup followed the rhythm of the seasons: 'Summer, it seems to me that painting stems from you,' he said, 'painting which happens inside me as much as what I see around me. Winter, with its short, cold days, offers quite different conditions – I work outside all year round. Well, I cut the stone during the daylight hours and, when it gets dark, I go back into the studio and start doing linocuts. Sculpture and engraving complement each other marvellously well. Stone comes forth from joy in form. The durability of the material brings about the satisfaction which exists in conquering resistance.'

Egill Jacobsen said of Heerup that he occupied a place among the Linien and Høst artists which was analogous to that of Chagall (or Rousseau) amongst the Cubists. Not in the least concerned with style or doctrine, Heerup was neither abstract nor surrealist – he was unclassifiable. He retained his allergies more than anything else from his spell at the Académie des Beaux-Arts

(1927–32). In studying the history of art under the guidance of good teachers, he miraculously returned to primitivism: 'I am going to shake the tree of art,' he proclaimed at that time. The elemental, matter, raw material would henceforward be his principal sources of inspiration. Thus began his triple work as a painter, sculptor and – for want of a better word – an *assemblagist*.

'When Heerup is in front of his canvas,' his friend Preben Wilmann said, 'he follows the method of free inspiration. Without stopping, he covers the surface with broadly stylized coloured figures which adapt rhythmically to each other in a powerful unity of movement. Human beings, animals, plants are composed with all the possible elements of the world of technology, houses, cars, bicycles, war chariots and aeroplanes, and are gathered together in intelligible designs. He adds ancient symbols to these re-invented everyday symbols – the heart, the cross, the wheel, the belfry, the bell, sexualized forms, the horn of plenty and the imp, that symbol of himself. Energetic, palpable, impassioned, the colour is inseparable from the image. Heerup uses what Chagall called the original palette.' In his paintings, which do not shy from being decorative, Heerup featured human emotions (*Child at the breast*, 1935; *Loving couple*, 1940), just as he did fantasies of the sub-conscious (*The rabbit and the aviator, The soul of a bird crushed by a car*, 1933). He was able to make very special use of a freedom of the imagination which he

Henry Heerup, *On the road of life*, 1960. Linocut.

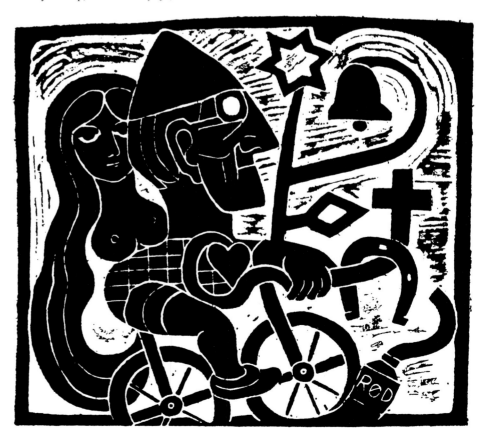

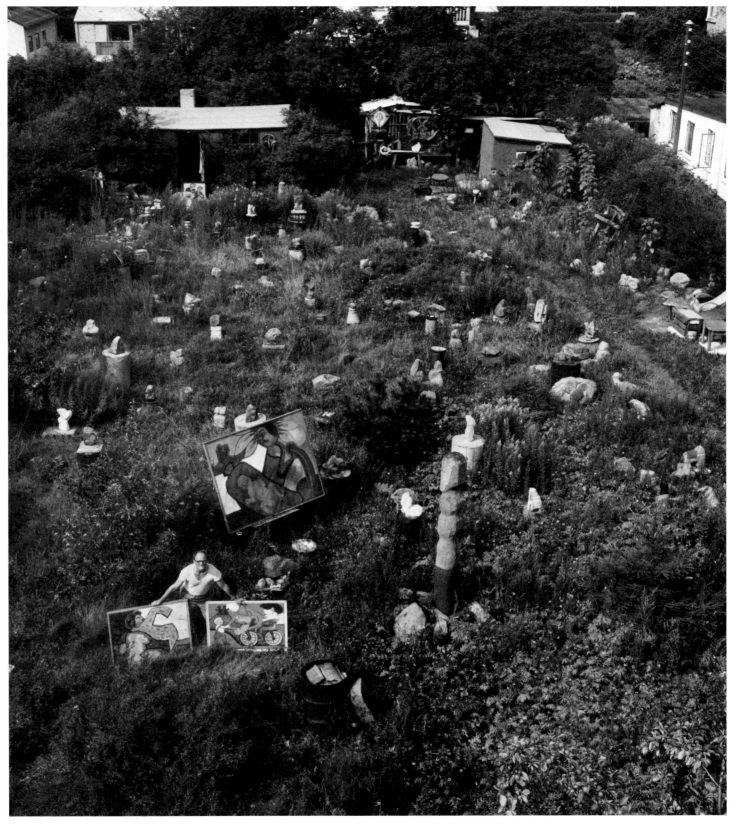

Henry Heerup's garden at Rodøvre in 1960. Photo Tage Nielsen.

'Heerup is walking in his sculpture garden. Green moss fills the cracks in the stones. He walks slowly, going from one to the other, his finger pointing, but painfully, very pink, covered with a plaster. Enter the visitor.
– Are you hurt?
– No, I put a dressing on to remind myself. They have invited me. I have to send all my sculptures to Venice.
The following year. Heerup in his garden. It is winter. Minus ten. A woollen cap, round glasses, a large unbuttoned coat, oilskin trousers, shiny boots with wooden soles. He taps on a stone. Enter the visitor.
– Well, you must be pleased with that exhibition. I heard it was successful for you. Well done again.
– No, it was terrible. They took all my sculptures. I'll never see them again. Before, when I sold one in Copenhagen or roundabout, I would go and see it now and again on my bicycle. It was near. Now, they're gone. Far away. I'll never see them again. It's terrible.'
(Pierre Alechinsky: *Titres et Pains perdus* ('Lost titles and loaves'), Paris, 1965).

seemed to owe to Surrealism. In this respect, he was as unclassifiable as Chagall. But his mythological references were not biblical; no-one could have been more Nordic or Scandinavian than Heerup, none more Danish. Like Carl-Henning Pedersen, he made frequent reference to Hans Christian Andersen, whose stories he had occasionally illustrated (*She was good for nothing*, 1963). Heerup was Cobra's closest link with folk traditions: 'His painting is essentially of the fairground,' Dotremont would say, 'but it is the fairground of the great circus of life.'

In sculpture, no-one provided a clearer illustration of Bachelard's aphorism, which was quoted in the last issue of *Cobra*: 'Art is grafted nature.' Heerup worked principally in granite, erratic blocks which he chanced upon on his walks, and which he transported to his famous garden – he was a real rock-thief, a stone-kleptomaniac ... He jokingly called each block of granite a 'hard-boiled egg of nature' – to him each of them was a treasure of life, treasure contained in the material itself as much as in the artist's imagination. It was the sculptor's task to discover it (in the true sense of the word) by playing with the forms, and sometimes with the colours, it provided. This was a game which had to respect the very nature of the material. In one of his rare texts (for *Helhesten*, II, 4), Heerup forcefully explained his conception, which corresponded perfectly with what Bachelard called 'material imagination': 'A block of Stone is a Piece of Nature. That is Why it is More than You, Sculptors who Have Worked along with Artists who are Not Interested in Cutting Stone for Dozens of Years. The Eternal Academy. Classic Meat. Renaissance. Ability. Resemblance and Bluff. (A Stone must Be a Stone, it Doesn't Matter if it is Sculpted. Stone is neither Flesh nor Blood.) Is it a Block of Stone if One cannot Give it its own Body, its Functional Anatomy? A Torso is a Classic Block. Can't one Imagine a Stone? Of Course one Can. Can't one Make a Leda out of Scree? Scree has its Laws, Material its own Form. Power and Right of Precedence of Material in All Art. That is What Creates. The Central Idea of the Brain, without forgetting the 'Carrots', the Avant-Garde of the Nervous System. Of course, We Are Sensitive, but we Do Not Sense the Dancer in Rough Stone, rather in a Log. And We Do Not Paint the Grey Stone Grey and the Moss Green Stone Green. On the Contrary, we use Complementary Colours. We Seek the Effect. Things Must See and Be Seen. They Must Live.'

One of Heerup's first granites was *The Scavenger*. It dates from 1933, which was also the period of his first 'Skraldemodeller', assemblages of rubbish and junk of all kinds which Heerup searched for in rubbish dumps rather, this time, than in nature. Just as the granite work was a dream of happy fusion, so the assemblages were heterogeneous: this fundamental category of 'primitive thought' was, as Lévi-Strauss had shown, *bric-à-brac*. Schwitters and the Dadaists had explored certain resources in a very intellectual way; Heerup was primarily

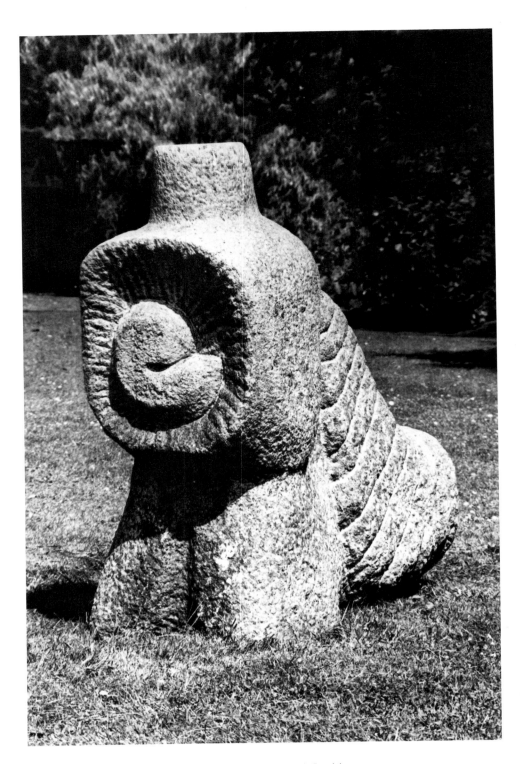

Henry Heerup, *Horn of Plenty*, 1935. Granite (height 100 cm). Louisiana Museum, Humlebaek. Museum photo.

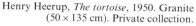

Henry Heerup, *The tortoise*, 1950. Granite (50 × 135 cm). Private collection.

Henry Heerup, *Death, the Reaper*, 1943. Assemblage of wood and metal. Height 75 cm. Louisiana Museum, Humlebaek. Museum photo.

attracted by the way in which junk could arouse immediate emotions and moving images in us; he could never resist pushing it towards allegorical representation (*Death the Reaper*, 1943, Louisiana Museum, Humlebaek), anthropomorphic imagery (*The man with the gramophone*, 1935, Nordjyllands Museum, Aalborg) or towards the toy (*The wooden horse*, 1950); this was 'New realism', long before its systemization by Duchamp's followers.

Heerup also heralded Appel's very first 'poor' sculptures in Amsterdam of 1946–7. There was in him, too, the anti-specialism which Cobra favoured. 'Children have Always Made Sculptures from Rubbish,' he wrote. 'But they never Bother to Keep them. Much Less to Call them Art. Not really. Rubbish Sculpture is close to Nature Since the Material does not Strive to be. It Is. Wood is Wood, Iron is Iron above all. It only Lacks a Name. Naturalist, if the Resemblance Comes from Itself. No need for Noble Material. But if We have Something Noble about Us. We Take it Equally Well. No snobbishness in one sense or the Other. Everyone

63

Can Make Sculpture from Rubbish. Get on With It! Take any Old Things. A Work of Art is no Better for Being More Durable.'

With uninhibited self-confidence and manners which were crude and sensitive at the same time, Heerup was one of the active forces behind Danish art. 'He taught us', Egill Jacobsen once said of him, 'that the distance between past and present is a small one,' (Gunnar Jespersen, *De Abstrakte*). It was true that nothing could have been closer to 'runic stones' than some of Heerup's granites; issue 10 of *Cobra* carried a picture of the great Jelling Stone from Jutland on its cover, something he especially admired and which he had been studying since his youth. And the almost abstract terra-cotta figures he modelled in 1935–7 (for example *Female temple* in the 'feminine forms' series) seemed to emanate from a fertility cult which could only be that of Frey (Frøj), which was prevalent in pre-Christian Scandinavia. It was therefore quite natural that Heerup should be approached to design the cover for the first issue of *Helhesten* – the mythological horse of hell, which he depicted quite maliciously. Heerup also brought his own interpretation to the mask image: a great sculpted and painted head, *Prince Carnival*, whose lopsided mouth hailed the charivaresque figures which Egill Jacobsen was painting in those same years.

Among the Danish group, there were two artists who had participated in the collective Cobra exhibitions who were in a similar position to Ubac and Bazaine as far as the École de Paris was concerned (Ubac had become a painter and sculptor after breaking away from Surrealism); these were Else Alfelt, Carl-Henning Pedersen's companion, who had introduced him to painting, and the Icelander Svavar Gudnason.

Else Alfelt ('whose secret', according to Dotremont, after he had met her at Bregneröd, 'is to have seen what

Henry Heerup, *Self-Portrait*, 1957. Woodcut.

she has dreamed'), had already advanced some way along her own personal trajectory of painting when she met Carl-Henning Pedersen, whom she married in 1934 and from whom nothing would ever separate her, even his accidental death in 1974; their works maintained a kind of dialogue in the museum dedicated to the two of them at Herning in Jutland. It was Else, moreover, who had won Carl-Henning over to painting; in 1933, as we know, the young man was wavering between music and sculpture, until the day he tried out Else's paint and brushes, taking advantage of her temporary absence; by the time she came home, he had painted his first canvas.

Following the various stages of her apprenticeship and a flirtation with Social realism, encouraged by her meeting with Bertold Brecht who was then in exile in Denmark, (in 1933, she painted a portrait of Carl-Henning which she called *The young communist*), Else directed herself towards a form of abstraction which was close to Kandinsky. Her inspiration owed much to music (*Rhapsody in Blue, Tiger Rag, The Rite of Spring*); she became what would come to be called an 'abstract landscape painter', chronologically one of the first. Since 1939, she had been well aware of what fascinated her most – the spectacle of nature, above all of mountains, which she discovered on a trip to Lapland, her 'land of the heart's desire'. Subsequently she travelled around the Mediterranean and later as far afield as Japan.

'She expresses her lyrical and dramatic experiences whilst remaining in harmony with life,' Egill Jacobsen wrote of her in *Helhesten*. 'There is something delicate and enchanting in the rhythmic play of her colours and lines and a gentle modulation in her material.' Else Alfelt proceeded via large thematic series with inexhaustible variations, which owed their sustained richness to colour – as did her sharp-edged constructions, all peaks of glaciers or rigs of forests. 'Green, blue and yellow can be a summer's dream' – Egill Jacobsen again, always the best interpreter of his *Helhesten* companions, thanks to his obvious empathy with them. The sparkling yellow of infinite fields and, above all, the green (one of Else's great pictures was entitled *The universal green, or mountain landscape*, 1943). 'Light grey, dark grey, gentle like a mist or hard like a stone, that is everywhere the life of the town. These paintings are no fanfare carrying us along; instead, we are asked to plunge into a world of sensitive and richly graduated colours.'

In the Cobra perspective, Else Alfelt's painting did not escape without a certain degree of criticism, particularly from the Dutch, who found her too abstract; through its participation in the life of nature, it brought that feeling which is best described as panic. 'I am a part of space. My paintings are a lyrical perception of the world,' she declared. 'They are outside of reality. They are reality within which the unexpected can take place.' There were many interior landscapes with undefined limits between the dream and the imaginary. To use a word I am very fond of, this was *dépaysage* 'in all directions, even taking on quasi-fantasmagorical forms'

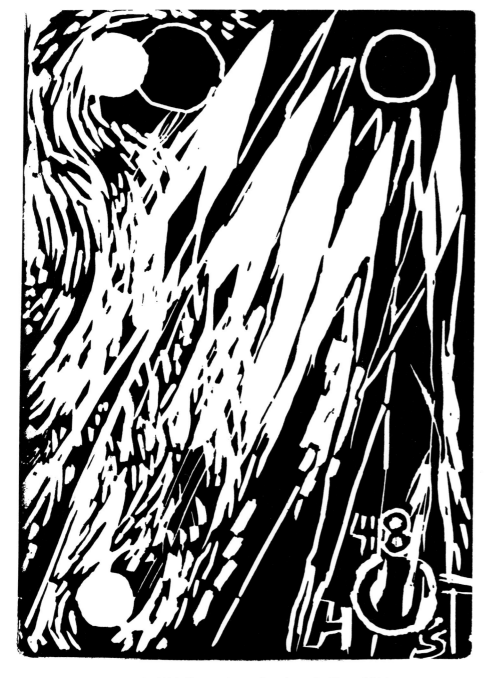

Else Alfelt, linocut. Cover of catalogue for Høst exhibition,
Copenhagen, November–December 1948, to which the
artists of the Dutch Experimental Group were invited.

(Egill Jacobsen). In 1960, she called her major retrospective in Copenhagen 'Poem to the full moon'. The moon, Diana's star, had become a dominant motif in her work, where forms were swept away in a vast spiral movement – that cosmic spiral which was one of the imaginary archetypes, capable of being carried away by the profound dynamism of the dream.

Arriving in 1935 from Iceland, which at that time was linked politically with Denmark, Svavar Gudnason brought a particular light to his colours, which he owed to his island of birth and whose music he well knew how to spread in his painting. Music is no arbitrary metaphor in this connection; one of his most important canvasses,

painted at the end of the war and which made him one of the masters of Abstract Expressionism, was justly entitled *Icelandic Melody* (National Gallery of Iceland, Reykjavik). Moreover, music was always present in the Danish artists' way of life; we have seen that Carl-Henning Pedersen thought about becoming a musician in his youth and that Else Alfelt was inspired by jazz and Stravinsky; Heerup was also inseparable from his recorder and Jorn from his violin.

In 1938, Svavar Gudnason was living in rather precarious conditions in Paris with his wife, almost in a state of destitution. He only stayed one week at Fernand Léger's academy, where he came across Jorn. But his stay in Paris influenced him, as it did Ejler Bille, whom he saw often, and the sculptress Sonja Ferlov, who had been living in the French capital for two years. Gudnason devoted himself to free abstraction, which set him on the path towards spontaneity when he returned to Denmark. His friendship with Else Alfelt and Carl-Henning Pedersen also had much to do with that; they exhibited together (with Jorn too) in 1939 at the 'Scandinaverne' exhibition. 'We were spontaneity,' said the Icelander in 1962, in the course of a conversation published in the journal *Les Beaux Arts* (No. 971) in Brussels. 'Spontaneity without symbolism, without specialization, thanks to the nerves we have in our mind and body. I have a primitive spirit.'

Gudnason, the most Nordic of the Cobra group, did not have recourse to the formal vocabulary of the mythical world – strange for one whose land, more than any other in Europe, was a land of myths. His forms were large and imprecise; like Else Alfelt, it was 'the experience of nature' which was his source of inspiration. Ejler Bille, who dedicated an article in *Helhesten* to him, wrote: 'He does not bring us the image of a strange world but talks to us directly by means of artistic reality itself.' Artistic reality nourished by the bright light of Iceland; 'something', Bille went on, 'more lively, more dazzling in its atmosphere, something intransigent and fragmented in the form which is at the base of dreams, dreams which come from farthest away, where his pictures have come from.' A 'man of the dawn before the flood', Svavar gave Dotremont plenty to dream about, from the 'Scattered Dictionary of the Bregnerød meetings' onwards (*Le Petit Cobra No. 2*). The fact that he was Icelandic excited an entirely lyrical pan-Nordism: 'The colours, the slides, the lakes and fjords of colour which *feature* in Svavar's convasses come from without and within and are like the images of a skating camera . . . Svavar's pictures make me think of a mirror which has both memory and imagination.'

Even though Svavar never once exhibited with Cobra, he nevertheless figures in a monograph published in the *Artistes Libres* series, written by Édouard Jaguer. In contrast, Erik Ortvad, whose canvasses appeared at the Cobra exhibitions at Amsterdam and Liège, only had his monograph published in 1979, thanks to the Kunstmuseum in Silkeborg, who ran an exhibition of his

works in that year. Dotremont's accompanying text dated from 1949 but lack of funds had prevented the printing of the series being carried through to its conclusion. The way in which his work appeared, disappeared and reappeared was rather appropriate to his own journey through life, and to his painting, which was frankly abstract before *Helhesten* and *Høst*. Then his canvasses gave birth to a mythology which was related to that of Carl-Henning Pedersen and perhaps also to that of André Masson, before becoming obliterated by a form of imaginative landscape painting where carnivorous flowers grew in the bosom of a vegetation which owed much of its luxuriance to the gestural spontaneity of the painter. Nothing brutal, at least, with Ortvad; having 'painted with the sun' as Dotremont put it, he let himself be won over by subtle colours and mezzotint. After Cobra, he even stopped painting, filled with a sense of anguish which was exorcised through each one of his drawings. Eventually he took himself off to live in a forest in Sweden.

Sonja Ferlov had been associated with *Linien* from the start, along with Ejler Bille, Richard Mortensen, Bjerke Petersen and Gustav Munch Petersen, who had met each other in her studio in Copenhagen. She was a dedicated painter until 1935, when the discovery of some pieces of wood she collected on the island of Bornholm gave her a taste for 'spaces which inhabit space'. Thus her first 'sculptures' were born; assemblages entitled *Living branches*, 1935, closely followed by her work in plaster with the organic forms, *Living beings*. Apparently unthought of by nature, they were frontiersmen on the border between the animal and vegetable kingdoms, less abstract than Arp and more surreal than Laurens. Sonja Ferlov realized (in the true sense of the word) that synthesis to which the Danes aspired; that of abstraction and surrealism. She moved to Paris, renting a studio in the same courtyard as Giacometti in the Rue Hippolyte-Maindron: for her, as for all the *Linien* artists, Giacometti was a precious example. Sonja Ferlov worked in Paris up until the War, but she destroyed or lost most of her works from that period; amongst the few which survived were *Birds*, whose subjects were coupled in a single, strange being, and some *Masks*, whose inspiration was purely African – Sonja had met the Zulu artist Ernest Mancoba and married him in 1942. The masks could have been complete beings, like the great *Torso* (1939, which was destroyed, then recreated in a less African, more Pascuan form in 1977); it was natural that they should join the amazing cohort which we know, led by Egill Jacobsen and to which most of the Danes of *Linien* contributed. But Sonja also painted very free compositions, using a simplified semantic vocabulary – lines, crosses, knots thrown onto the canvas, seemingly by the brush itself. During the war, which was a particularly difficult period for her and Ernest Mancoba who, as a British citizen, was interned by the Nazis, Sonja Ferlov worked on a single sculpture which passed through numerous stages before being cast in bronze in

1946. It was an abstract form which had 'dramatic elasticity behind its free, precise and final appearance', according to Dotremont, in a small Cobra monograph dedicated to her. *Sculpture* (1940–6, Kunstmuseum Silkeborg) was a totally exceptional, meteoric work, disturbing in its simplicity and of which one is tempted to say, with Lovecraft in mind, that it had 'fallen from the sky' or come from another world – not to worry us, however, but to make us dream.

Whilst living in Denmark between 1947 and 1949, Sonja Ferlov exhibited with *Høst* and joined the Cobra movement at Jorn's instigation. In fact, she had very little taste for collective activity, preferring to work alone. Her works from the Fifties have a disturbing subjectivity – 'something double, as if Sonja was afraid to leave a form or a work on its own' (Dotremont). In the way they played with the concave and convex, her

Sonja Ferlov, Sculpture, 1949. Bronze (height 28 cm). Louisiana Museum, Humlebaek. Museum photo.

sculptures took up corporial attitudes, but nourished on tenderness, and, as such, addressed themselves to feelings in their least sophisticated elements. No, or few, living edges, stretched lines, cold surfaces but sensitive forms, 'gently geometrical'. Sonja Ferlov scarcely cared about exhibitions; once finished, her sculptures became alienated from her. She preferred to think of her sculptures in parks and public places, taking root in the abundant and silent depths of the earth rather than seeing them in galleries or, even worse, in salons. For her, sculpture was also 'listening out for silence' (title of a 1969 bronze).

Erik Thommesen valued his (historical) association with Cobra even less than Ejler Bille. He had, however, taken part in the Amsterdam and Liège exhibitions, as well as the debatable retrospective (which *was* debated by Dotremont) at the Boymans-van Beuningen Museum

Erik Thommesen, *Woman*, 1950. Background: *Woman's Head*, 1949. Both wood (oak).

in Rotterdam in 1966 (and afterwards at the Louisiana Museum in Humlebaek). As far as he was concerned, Cobra had been a simple prolongation of Høst, in which he had participated from 1945 to 1948; it was compatible with the prevailing experimental spirit, which Cobra developed. All the same, Thommesen had been one of those who had decorated the classroom of a primary school in Copenhagen along with Jorn and the other members of *Helhesten*; a collective work which foreshadowed the Cobra period. But he soon withdrew to pursue his own works of sculpture which he had begun in 1937–8; at that time, he had started to work with wood (a favourite material of his, along with granite), imparting to it rhythms reminiscent of African sculpture. Thommesen progressively reduced his references to reality: 'When I look at a head,' he said, 'it is a formal experience first of all, a lived experience.' Even when he gave titles to his sculptures, such as *Women, Woman's head, The girl with plaits*, they retained only very distant memories of faces or elongated silhouettes, as with Telem. Thommesen was not truly abstract, but, in the hope of dispensing with 'artistic prejudices' and seeking to overcome certain particularities through a more universal plastique, he attained a form of abstraction which represented for him the attainment of something more profound. Rhythm, his major preoccupation, was no surface phenomenon: 'A blind man must sense it just by touching sculptures,' he said. Rhythm was what linked forms together, making the forces they concealed visible, similar to natural tropisms. One could say that Erik Thommesen's sculptures were at once 'the root and the plant'.

The last issue of the review *Cobra* opened with a text by Thommesen, 'Content and Form', which clearly formulated certain fundamental data on Cobra art in its energetic conciseness: 'lived experience and the act of expressing oneself are one. I am inclined to believe that the content cannot adorn itself in an indifferent form . . . Only the sincerity of the experience can give the creation meaning and value. When all is said and done, the divorce between content and form and the incapacity to grasp its profound unity are doubtlessly only the symptom of conflicts which ages like ours suffer under. There are two forces confronting and fighting each other; life such as it is and life as we would like it, as we create it in art. This last refuge of existence which used to be a natural one, now seems to be prohibited to us. There seems to be a morbid cult of the individual, cut off from the world – a cult hostile to life; the coquetry of language seems to flourish wondrously. Nevertheless, I believe that a new path is being forged out of the conflict. The vital force of art traces it and prolongs it even further.'

A retrospective look at the exceptional generation of 'Danish Abstracts', 'Abstract Surrealists' or 'Abstract spontaneous painters', who have all achieved a well-deserved national and, in some cases, international fame should take into account that the group were very much on the fringe and working in conditions of extreme

poverty in the years 1930–40. Dedicating themselves exclusively to art, they only survived because of state benefits which kept them from starving to death; when the Cobra period arrived, their market was still practically non-existent, apart from a few collectors like Elise Johansen and Elna Fonnesbech-Sandberg, who were their indispensible allies. The fact that the Statens Museum for Kunst in Copenhagen can now offer a significant collection of paintings and sculptures of that period is due to a donation it received from Mrs Johansen of part of her collection. When this was exhibited at the museum at the end of 1954, it was the Parisian Édouard Jaguer rather than a Danish critic who ensured its presentation. Another factor which cannot be over-emphasized was the role played by the artists' co-operatives, of Danish origin, which made up for the lack of galleries. Directed by the artists themselves (from which conflicts in tendencies inevitably arose), thse co-operatives organized annual exhibitions and sales. They were called 'Høst', 'Corner', 'Groningen', 'Monde', 'Spiralen', 'Den Frie' etc. As far as relations with Cobra were concerned, it was the Høst co-operative (meaning 'autumn' or 'harvest') which played a decisive role, at the time when the influence of the *Helhesten* artists was dominant, in that they invited the three young Dutchmen Jorn had just met in 1948 – Corneille, Constant and Appel. As we will see, contact with the Danes greatly reassured Constant on his own ideas; he talked about it in his article in *Cobra 1*. Corneille was no less affected: in his account of the trip, published in *Reflex 2*, he wrote: 'The Danes know – and that is their strength – that art is not a luxury, but the logical and natural expression of the mind and that each artist only constitutes an element of the society that they serve in expressing sincerely that which lives within them, as in all men, and which they wish to make visible.' And Corneille concluded, in Danish: 'Thank you for your pictures, comrades.'

From the time when the three Dutch painters and Dotremont went to Copenhagen, the game of inter-influences carried on freely, but, given that the Danes were older, they gave more than they were able to take. This was moreover what Jorn had said in his speech to the International Conference on Revolutionary Surrealism. In a more generally European perspective, Cobra helped put an end to the introspection and isolation of the Danes for some time to come, even if, after Cobra, Jorn would be the only one of them to remain faithful to internationalism. Whilst the Dutch and Belgian Cobra artists had the whole of the Western world as their field of activity, the Danes stayed at home amongst themselves. Dotremont reproached them for this 'danishism'; indeed it would be one of his great arguments after Cobra and something in which he agreed entirely with Jorn, who never tired of reproaching his compatriots for being 'always ready to dissolve in the petit-bourgeois washing . . . to turn to the comfort of adaptation.'

Dotremont would return many times to the specific subject of Danish art, at least to that of the 'Abstract Surrealists'. Presenting an exhibition of one of them in 1965 (Mogens Balle, whose works did not reach full maturity until after 1951), he wrote: 'In general, the Danish art of our era harks back to far-off times. It proposes a sort of *artist's stone* as an alternative to the various barbarisms of our age – notably to the religion of instantaneousness, which characterizes it in a thousand ways; an artist's stone relative to the philosopher's stone, a thinking vivacity, a spontaneity which complies with time, with our origins, with the "confused sensation we get in being born" . . . And perhaps, after all, it is art itself which Danish art offers to our era, but art most intensely and profoundly practised.'

Henry Heerup, emblem designed for the Høst artists' co-operative, 1947.

Ejler Bille,
Composition in green, Cagnes, 1947.
Oil on canvas (102 × 91 cm).
Statens Museum for Kunst, Copenhagen. Museum photo.

Amsterdam

Constant (Nieuwenhuys) was two months away from being twenty when the destruction of Rotterdam by Hitler's Stukkas put an end to the secular neutrality of the Netherlands, a tragedy which threw the calm and prosperous country into the general turbulence that was European history. Constant had grown up in a society of 'modest happiness' which had avoided the torment of the First World War; in that respect, the Netherlands resembled Jorn's Denmark but differed from Dotremont's Belgium. The specific situations of each nation prior to the general apocalypse provoked by Nazism should be borne in mind.

More important than his simply being Dutch, Constant was a citizen of Amsterdam, where he was born and where he remained all his life. Amsterdam is the 'republican' and bourgeois (in the medieval sense) capital of the Netherlands. Corneille, born in Liège, discovered it as such at the end of his adolescence, but never really became a part of it; Appel, a native of Amsterdam like Constant, would abandon it like the prodigal son as soon as he was able.

Up to the war, Amsterdam had remained on the sidelines of the great European debates. If politically, socialism had succeeded in gaining strength and asserting itself against a particularly conservative right, the moral climate remained unshakeably Calvinist. In the artistic sphere, it was the modernist movement *De Stijl* which reigned supreme, thanks to Van Doesburg and the architects. But Mondrian, who was its inspiration, was living in Montparnasse – the traditional place of exile for those Dutch artists who could not stand the narrowness of mind and intolerance of their compatriots: with Mondrian, the explosive Van Dongen, the monastic Bram van Velde; and, before them, Van Gogh and many others.

De Stijl was a review which appeared from 1917–28 and was, according to Van Doesburg's definition, most spiritual or, perhaps, most non-materialist: '*De Stijl* is to contemplate the truth in peace.' Almost Spinoza. An international movement, *De Stijl* quickly created its stereotypes: a cold abstraction, which undoubtedly owed certain of its characteristics to the Calvinism so deeply rooted in the Dutch soul. A kind of simplism too, but attained at the end of a long process of reflection. Cobra too would be simplist, but from the outset. *De Stijl* corresponded almost perfectly with the illusory tranquillity of Dutch society between the wars – *De Stijl* but not Mondrian, who went beyond it; his last works in New York are jazzy, 'boogie-woogie' pieces. For the purposes of polemics, Constant proposed a temporary amalgamation with Cobra: 'Let us fill Mondrian's virgin canvas, even if it is only with our misfortunes!' Mondrian's first major exhibition in Amsterdam took place in 1946. Constant and Jorn went to see it together; they felt both attraction and repulsion, but repulsion came out on top. Together with Magritte, Mondrian

was Cobra's negative pole. 'We are all sick of him', Dotremont wrote to Constant in a letter dated 7.10.48, and he had himself photographed by Karl Otto Götz at the house of the architect Aldo van Eyck 'taking the measurements' of a Mondrian with a tailor's tape measure.

Dadaism had scarcely provoked any reaction in the Netherlands. As for Surrealism, that was the preserve of a number of isolated artists in the provinces such as H.-J. Moesman; writers despised it, even those connected with the review *Forum*, which took more notice of what was happening in Paris. 'A product of the war and of Freud.

Christian Dotremont (photographed by Karl Otto Götz) taking the measurements of one of Mondrian's pictures, at the home of the architect Aldo van Eyck, Amsterdam 1949.

The literary heritage of Lautréamont and Jarry', as it was disdainfully characterized by Eddy du Perron, André Malraux's intimate friend, to whom he had dedicated *Le Condition Humaine*.

Lautréamont, in any case, merits special mention. He had been remarkably well translated in 1917 by a Freudian psychiatrist, G. Stärke, and published with a preface by the writer Willem Kloos. Constant, like Appel, had read and re-read *Maldoror* in Dutch; both of them had, like the majority of members of Cobra, created a veritable fantastic bestiary; perhaps its impulse can be found in Lautréamont. With this difference: whilst the animal visions of *Maldoror* were obsessively dominated by aggression – beasts with claws and suckers, birds of prey, sharks and crabs, spiders, octopuses and vampires ('you should know', says Maldoror, 'that each vile animal that raises its bloody claw in my nightmare is actually my desire') – the animals created by the Dutch members of Cobra were, as well as being

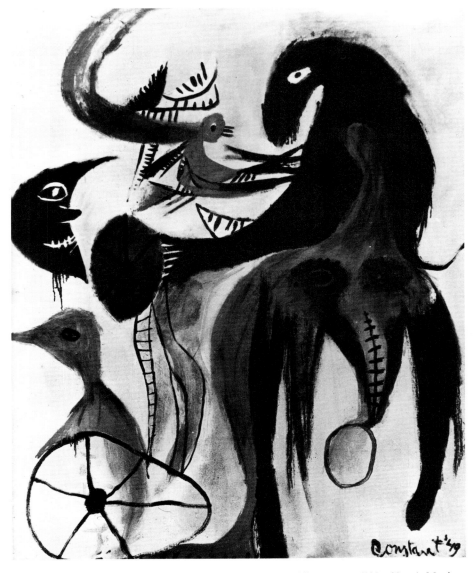

Constant, *The animal sorcerer*, 1949. Oil on canvas (120 × 90 cm). Musée National de l'Art Moderne, Centre National d'Art et de Culture Georges-Pompidou, Paris.

menacing, figures of instinctive vitality, tenderness and pity. Constant, who had lived for many years just a stone's throw from Artis, the famous Amsterdam zoo, had always had animals around him – dogs, cats and birds, of course, but also a baboon, the fierce Jocko, and an iguana, which he had been forced to give away when it became too big for his home vivarium (he made a gift of it to Artis, as he had already done with Jocko). The Cobra group, like the primitive people of Lascaux, were attracted by the magic of the animal world: *The animal sorcerer*, (1949, National Museum of Modern Art, Georges Pompidou Centre, Paris) is the significant title of a shaman-like composition by Constant.

When war broke out, Constant was in Bergen, a small suburb north of Amsterdam discovered by artists and writers. He had studied at the École des Beaux-Arts in Amsterdam, which had given him a good trade, on which he would come to depend more and more during the years of Occupation. And what an Occupation it was to be! The Nazis decided to annexe the Netherlands and named a certain Seyss Inquart as its Gauleiter.

After a 'liberal' period of seduction, and, disappointed by their lack of results (not even a collaborationist government), the Nazis resorted to terror; proportionally, the Netherlands would be the country where the Nazis claimed the most victims. In the forefront of this was, of course, the Jewish community, eighty per cent of which was exterminated. In February 1941, the dockers of Amsterdam went on strike, inspired by the underground Communist Party, to protest against the widespread arrests of Jews and the destruction of their quarter, Nieuw Markt, where Rembrandt had lived. From 1942 onwards, the Nazis embarked on a real manhunt, whilst the Dutch resistance networks were being set up. Young people who wanted to avoid deportation or forced labour had to go underground; all the future members of Cobra found themselves in this position. The Nazi presence was resented by the Dutch as a violation of the values which had formed the basis of their society – before the military operations of the Liberation, one of the last in Western Europe, brought ruin to the provinces of Sud, Zeelande, North Brabant and Limbourg. The winter of 1944 was frightful; to the cold was added famine, deliberately provoked by the Nazis, who, by way of reprisal against the Amsterdam strikes, were stopping all transport of foodstuffs towards the capital. People even ate tulip bulbs.

Constant remained for ever marked by that period and war would return to haunt his works – the Korean war, then Vietnam. His revolt was nourished by the criticism of a society, bourgeois capitalist in nature, which had been unable to prevent (or which had actually caused) such an apocalypse; henceforth, whatever the cost, he would be one of those who sought to organize revolt with the aim of putting an end to Revolution. For some, the Second World War resulted in the Absurd (Beckett and Ionesco), or in pessimism, nausea and existentialism, like Sartre. Then there was the future for the stalinian communists, who toed the party line; Constant undoubtedly shared their optimism, but did not want any of the takings. He put his confidence once again in life – in the 'natural coincidence of living and creating', as his friend the poet Gerrit Kouwenaar put it.

Thus, as soon as he was able to start painting again, Constant ran the gamut of modernism from Cézanne to Braque and Picasso with great intensity; he captured their style with an ease which is all the more astounding since he knew them mainly through poor reproductions. He painted *Still Lifes* and *Portraits* of his wife Matie and his son Victor (1946). These canvasses can be compared with those painted by Pignon at the same time, having a similarity of pictorial and intellectual ambition – a quest for reality, lived in and through painting. But for Constant, these were not more than necessary stages in the progress towards liberty, that is to say experimentalism: 'First and foremost, a negation of style.' In 1946, he made his first trip to Paris, and this also marked his first association with Jorn.

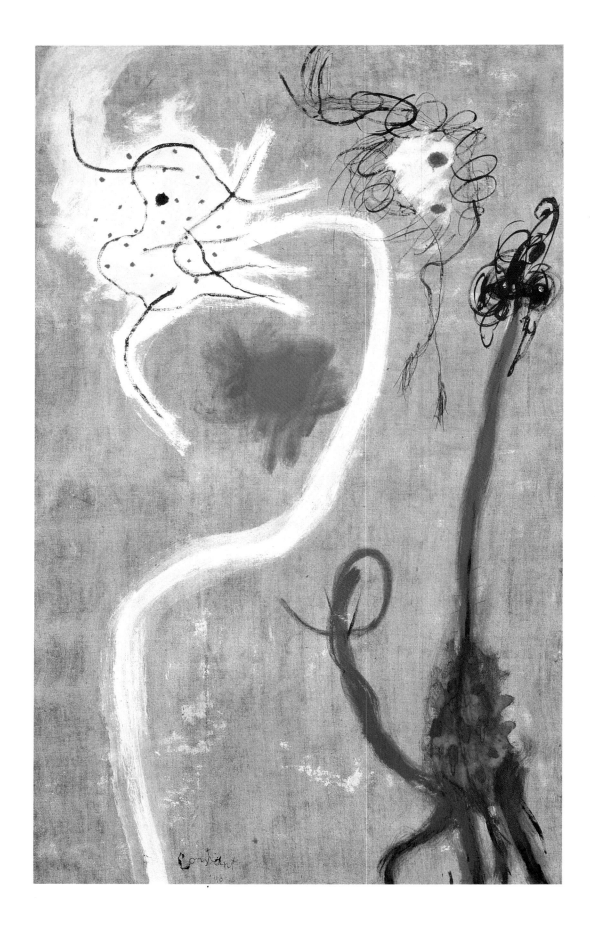

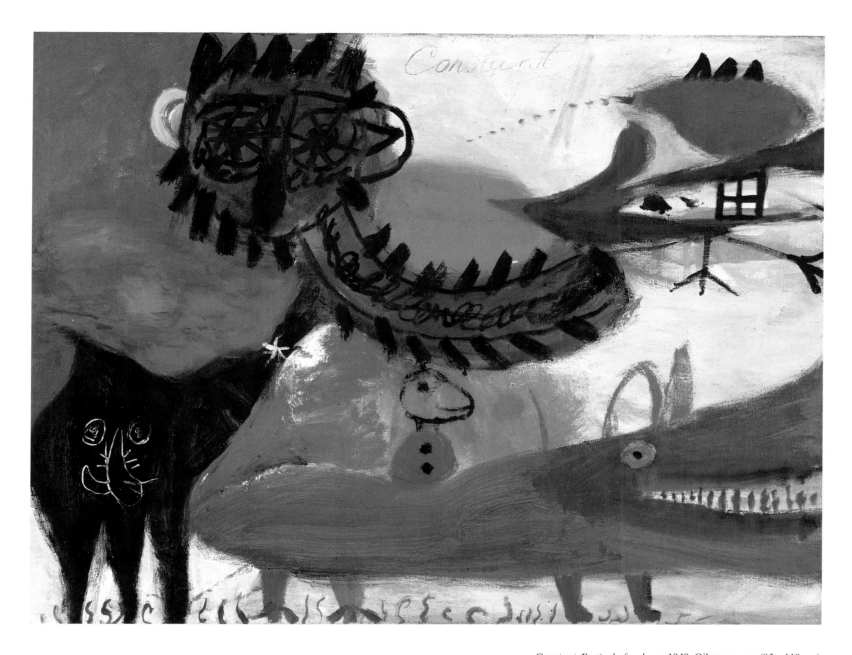

Constant *Festival of sadness*, 1949. Oil on canvas (85 × 110 cm).
Boymans-van Beuningen Museum, Rotterdam. Photo Victor E. Nieuwenhuys-
A. van den Born, Amsterdam.

Constant, *The White Bird*, 1948.
Oil on canvas (140 × 65 cm).
De Jong collection, Ascona, Switzerland.
Photo Victor E. Nieuwenhuys-
A. van den Born, Amsterdam.

This took place in the Rue des Beaux-Arts at the Galerie Pierre, which was showing a Miró exhibition. One is tempted to marvel at the way fate arranges things, for it is clear that Constant needed Miró to complete the metamorphosis he was undergoing, just as Jorn needed contact with Constant in order to realize his grand scheme, which would in the end become Cobra. The Catalan Miró was an anarchist painter, perfectly destructured, whose forms, abstract or otherwise, only knew the non-prescribed order of desire and pleasure. Certainly the Surrealists recognized themselves in him – André Breton had just written a collection of poems on Miró's *Constellations*. But he can also be called abstract and, in fact, occupies a place outside all historical or cultural continuity. Moreover, he had made it known that painting, for him, had been nothing but a long slide into decadence since Altamira. His works of the immediate post-war period play with pure symbols, coloured forms and elementary figuration: *Woman and Bird in the Night*, *The Morning Star*. Their space is not representational – everything happens between the four corners of the picture and nowhere else. Miró had packed intellect off on holiday. 'First morning, last morning. The world begins', Éluard said of him. An innocent world – but how could that be possible after the horrors of war?

Constant told me the story of that fateful meeting with Jorn at the Miró exhibition. 'It was really quite by chance . . . But, the same evening, we met up again at the Café de Flore. We sparked off a discussion which would last for years. Jorn talked to me about his project for an international movement, mainly Nordic, to counter the École de Paris, which was, as far as he was concerned, nothing more than an extension of what was going on before the war, with which I agreed. Jorn didn't know my painting. He took me to his hotel in the Rue des Ciseaux to show me his pictures. A few weeks later, he visited me in Amsterdam, where I had returned in the meantime. It was then that we really discussed things. Our ideas coincided – we were certainly both Marxists. We visited the Mondrian retrospective together. And we were persuaded – and this is the important thing – that purely abstract art is an illusion, because all forms conceal a content which excites our imagination and provokes the formation of images which have meaning.'

When Jorn left, Constant felt less alone, even though there were still no groups of artists in Amsterdam like there were in Copenhagen. He painted a nocturnal *View of the Magere Bridge*, (Stedelijk Museum, Amsterdam), thinking more and more of the resources that the spontaneous expression of children could offer him. Even if its craft, like the choice of subject (Van Gogh's Amsterdam canal bridges), was still expressionist, the different elements of the picture were released from the bounds of probability: houses are pointed like windmills, or imps preparing for the dance, windows fly away into space and the bridge is more like the trace of a bounce than a stable structure resting on the two banks

of a canal. With his next canvas significantly entitled *Declaration of Love* (1946, Rijksmuseum Twente, Enschede), he completed his sloughing of old skin: Constant had jumped the barrier and found the 'green paradise' of children. This was to be one of the common denominators of the Dutch group of Cobra – their constant reference to childhood. The poet Bert Schierbeek, who was associated with the Experimental Group and subsequently with Cobra, prior to developing a very personal experimentalism in his literary work, summed up what the spirit of childhood could bring to artistic creation: 'Recent studies of the working of the brain have proved that the child's brain reacts more spontaneously to its surroundings. In fact, I would say *the most*

Constant, *Copulation*, 1946. Indian ink on a page of an exercise book (21 × 16 cm). Private collection.

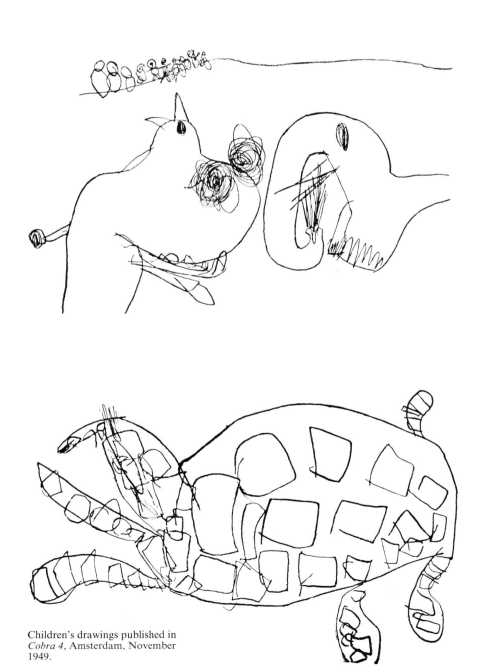

Children's drawings published in *Cobra 4*, Amsterdam, November 1949.

74

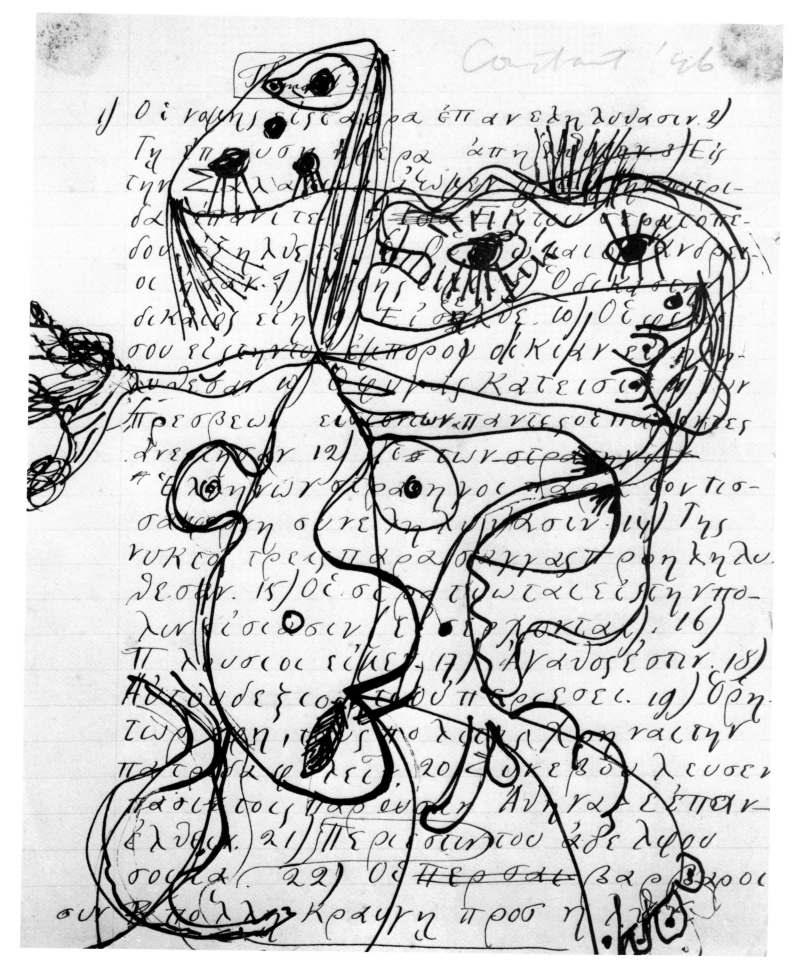

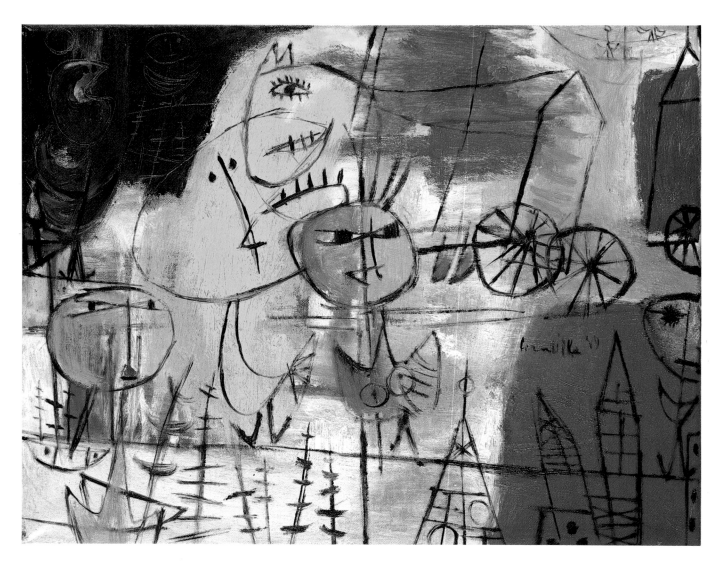

Corneille, *The Street*, 1949.
Oil on canvas (40.5 × 51 cm).
Private collection, Paris.
Photo Luc Joubert, Paris.

Corneille, *Harbour and fishing*, 1949.
Oil on canvas (70.5 × 61 cm). Private collection, Paris.
Photo Luc Joubert, Paris.

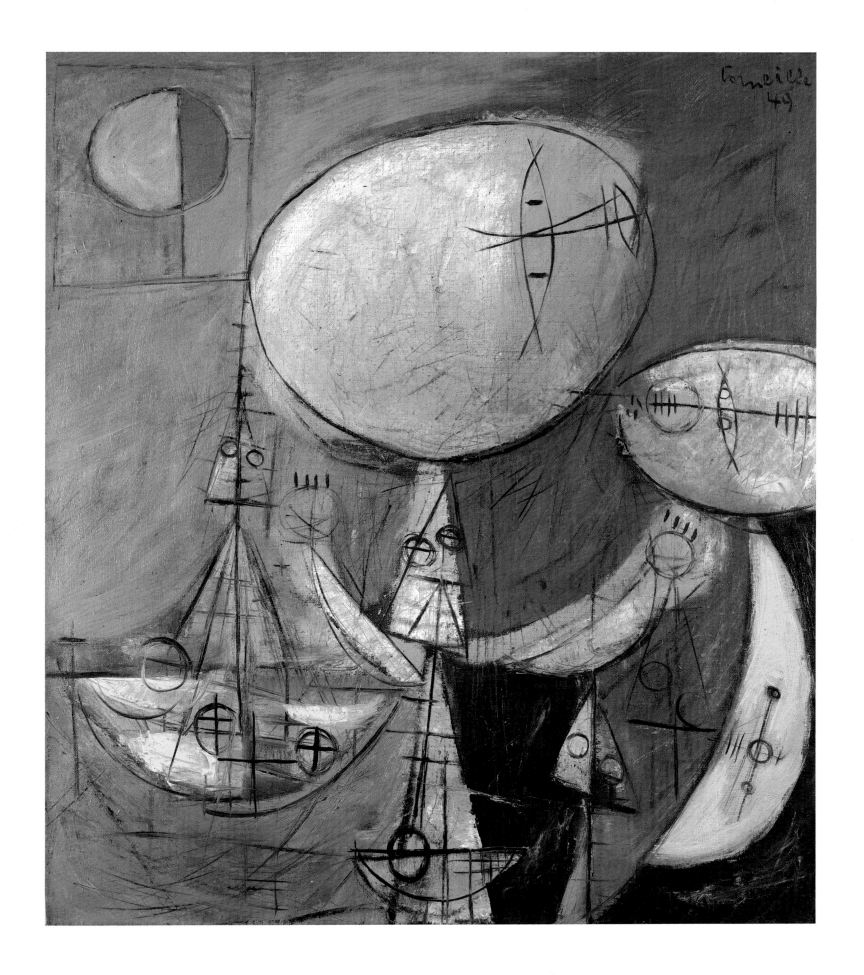

spontaneously, the most completely. Their whole brain vibrates constantly. Their reflexes are not yet conditioned to the point where they cannot assimilate and reflect without a preconditioned plan. Their circumvolutions are not fixed. Children retain the possibility of becoming complete men. Obviously they differ from each other in their nature and aptitude, yet they are the most free people in the world. They also possess creative intelligence which functions unfettered. They have not yet been classified or demarcated, they have the space to play in . . . Alas, the majority of people are constrained to act and to think like a doormat, trampled by thousands of feet. The only thing which finally escapes is dust.'

The preservation or rediscovery of childlike sensibility: this has been the almost obsessional nostalgia of our civilization since the Romantics and Rousseau. It has doubtless contributed to the current which has depreciated the wisdom of the Past, of the old man; it has been encouraged, as one can imagine, by the universal population explosion which has come to compensate for the massacres of the two world wars. Europe at the end of the Forties had become old and childhood was the living possibility, the eternal starting point. Where better than in childhood to find the forces vital for a change in art and life, of art in life?

The infancy that Constant, Corneille and Appel were trying to grasp was not boyhood, but the infancy of art. In issue 4 of the review *Cobra*, they had no qualms about reproducing alongside their own pictures some drawings and paintings by children themselves, which had been the subject of an exhibition at the Stedelijk Museum in Amsterdam; there was a relationship between them but, when all is said and done, very little resemblance. It was Karel Appel who went furthest in identifying with children; the child was one of the iconographic themes to which he would return throughout the entire course of his work, after the famous fresco, *Questioning Children*, which he painted for the dining-room in Amsterdam Town Hall. 'Very often, people exclaim when they see my work "Look at that! My three-year-old daughter could have done it!" To which I reply: "Yes, that's true, but the difference is I did it while she didn't".'

The infancy of art also meant pleasure in painting, pleasure in the materials, pleasure in form, pleasure in colour; pleasure, finally, in the picture itself, where the conscious and the subconscious could interplay unrestrictedly. Play. This was a fundamental theme which would be developed by Constant in his thinking as well as his painting; to be part of Cobra was to recognize oneself as *Homo ludens*, a designation which the Dutch historian Johan Huizinga proposed substituting for the inadequate *Homo sapiens* or *Homo faber*. It is also the title of his book, published in 1939, which is a key work of modern anthropology: 'Play as a fundamental factor in everything in the world which reproduces itself'. Huizinga relied on the work of other Dutch scholars, F. J. J. Buytendyk and H. Zondervan, who studied play in

animals, children and adults as 'manifestations of the vital drives' (*levensdriften*).

Although animals were the chosen theme of Constant's paintings of the years 1946–7, it would certainly be impossible to say what species they were: as a prelude to *The Animal Sorcerer*, his *Fantastic Animals*: 1947, Nordjyllands Kunstmuseum, Aalborg) should be studied, or *Two Animals* (1946, Frans Hals Museum, Haarlem), as muddled in their appearance as the drawing technique which fashioned them. The imaginary, here, verged on the mythological. Constant was aware that Carl-Henning Pedersen, Jorn, Egill Jacobsen and the other Danes of *Helhesten* had drawn on ancient Scandinavian art. But there was no such far-off mythology for a Dutchman to draw on and his dreams would always be less dramatic than Hamlet. Or perhaps it was that the dream and the imaginary would lead him infallibly towards the reality of the senses. Constant's bestiary, rich as it was in surprises, jokes and threats, drew on familiar animals – birds, cats, dogs, even a cow. He would respond to that of Picasso with a *Wounded Dove* (Boymans-van Beuningen Museum, Rotterdam) as a herald of peace.

At the same time, he was allowing his creativity more room for manoeuvre and painting pictures which were clearly instinctive – *The Satyr*, also known as *Mask* (1948, Kunstmuseum, Silkeborg), *The Blue Eye* (1948, ibid.), *The Bird Woman* (1949). In continuing his contact with Jorn, Constant elaborated on his theory of a new art in a new society.

Nevertheless, he remained isolated in the years 1945–7. He was not invited by W. Sandberg to join in the exhibition at the Stedelijk Museum in Amsterdam, *Jonge Schilders* ('Young Painters'), which took place in 1946. On the other hand, several people who would become associated with Cobra did take part – Appel and Corneille (who knew each other from the École des Beaux-Arts), Eugène Brands and Theo Wolvecamp. It was not until the end of 1947, or the first few days of 1948, that Corneille came with Appel to visit Constant in his studio (Corneille had just returned from a trip to Budapest, where he had met the Frenchman Jacques Doucet). Another natural encounter, Dotremont would have called it. Despite each having very different temperaments, the three Dutchmen experienced no difficulty in finding common ground in art, as in the realm of ideas. They would exhibit together twice in Amsterdam in the course of 1948 – while Constant worked on the *Manifesto* which would become, in July, that of the Experimental Group and would, in September-October, form the bulk of the first issue of *Reflex*.

Amongst Constant's correspondence with Jorn, which was written in often rather clumsy French, and of which only a few letters remain, there is one letter which seems probably to have been written in the spring of 1948 (it is undated) and provides particularly valuable information about their state of mind at that time. 'The artist nowadays is a *parasite*, an outlaw, a luxury for

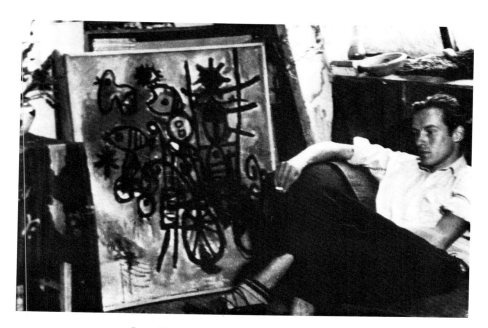

Corneille in his studio on the Prinsengracht, photographed by Henny Riemens, Amsterdam, 1949.

society,' Jorn wrote. 'We are the remnants of an old system . . . we are excluded, but this is not an external rule. Evolution does not proceed in a straight line but in a spiral: here is the discovery of dialectical materialism, something which can be seen in the universe, the stars, the nebulae, just as much as in shells and plants.' Jorn had just published an article in the Dutch review *Forum*, where he demonstrated that the ancient law of periodical alternation (academic classicism – romantic reaction – romantic formalism – classicist reaction) was coming to an end. 'Until Cubism, each period spanned the whole life of an artist, but starting with Picasso, this is no longer the case. The process can be compared with a deep wave of higher and higher frequency and to a long wave becoming progressively shorter.' A stage had now been reached where 'time and motion are no longer separable' and where 'spontaneity and maturity' dominated and confounded each other.

It was indeed a spiral development – one of the grand generalizations which Jorn was so fond of making in situating artistic activity within total cosmic activity. Furthermore, he proposed a new role for the artist and, in the immediate, a precise moral duty and orientation.

'Marx said that the capitalist regime is a mortal enemy of art and poetry. In another society, the opposite would be true and (the fact) that one is heading more and more towards folk art does not mean that the artist who feels obliged to sacrifice all to art will not be held in esteem. On the contrary. We are going through a hard time in history, we must come to terms with it!

'You write that artistic creation has now been reduced to its core, (that it is the purest act of our life. That's exactly it. Art has been reduced to pure poetry, but that is not the core of art, (it is) its essence. All the rest is a lie.'

What Jorn sought was – to recall the famous formula of Ortega y Gasset – a re-humanization of art, after all the intellectual and theoretical adventuring of the cen-

tury. 'How does the natural transmission of art occur? It is a transmission of vitality and inspiration, (given) by the artist in his work and received by the spectator who wants to *identify* with our work, that is to say with us.' Here, Jorn echoed Éluard's definition of the poet: 'he who inspires, rather than he who is inspired'. 'The current process of art,' Jorn wrote, '(is not) a search for acclaim, admiration, being marvelled at like an elephant at the zoo, but (being) a tool capable of acting on the spectator. That is why art is action and not description. Where does the artist find the vitality he expresses? In nourishing himself on the life of nature and the human environment, sociability in the broadest (international) and the deepest (Local) sense.'

From this it is plain just how much separated Jorn and Constant from pure abstract art on the one hand and circumstantial commitment, as demanded by the Stalinians and the Sartrian Marxists, on the other. What is more, Jorn was under no illusions as to the 'non-conformity' of his position – which, in art, removed him just as far from the École de Paris as from Social Realism or Surrealist Oneirism. 'We don't have a public. It is therefore necessary for us artists to communicate amongst ourselves, organize ourselves and evaluate our artistic capabilities.' And he concluded: 'We expect you to do your artistic duty, to furnish the results of your most detailed research . . . We need you and you need us. That is the special agreement, the natural interdependence.'

The manifesto published in *Reflex*, the organ of the Experimental Group, would be Constant's reply to that call, which Dotremont, for his part, had already acknowledged. A first rate-dialectician, Constant here further radicalized his position; but, as he would vehemently repeat, it was not a 'revolution', but a 'Liberation' to which he intended to contribute. Between revolt and revolution, Cobra would be a libertarian movement.

Constant announced, or confirmed, that individualist culture, linked to bourgeois society, was dead, and proposed instead 'the necessity of discovering new laws for a new aesthetic which will be that of *folk art*.' As we have seen, this was also the formula employed by Jorn; Constant defined it in these terms: 'Folk art is the direct expression of life, of a natural and thus universally shared need; art which does not seek to resolve the problems posed by objective aesthetics and accepts no norm other than that of expressivity: it spontaneously creates what intuition inspires in it . . . The masses, trapped by their respect for aesthetic concepts imposed from outside, do not know that they too are capable of creation. This will be awakened by an art which makes suggestions but does not spell anything out, an art which awakens and foresees the association of images.' And how was this possible if not through recourse to material imagination, just as Bachelard analysed it in another connection? Through matter itself, which suggests shapes, images and ideas; through imagination which

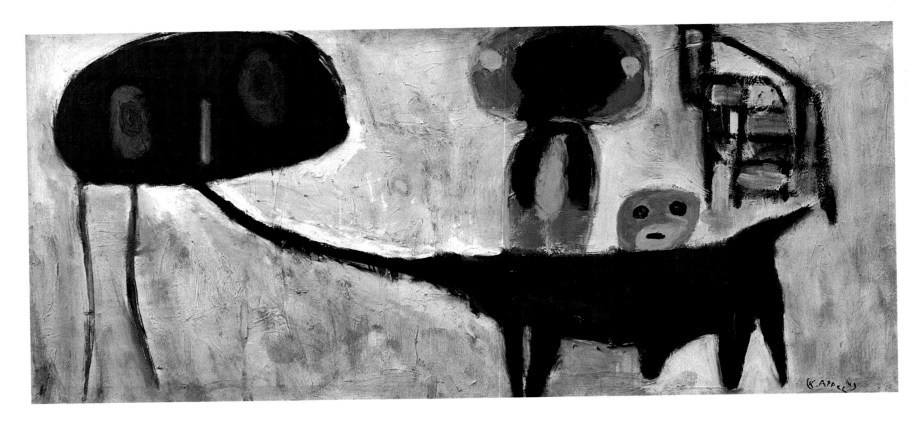

Karel Appel, *The little donkey*, 1949. Oil on canvas (70 × 155 cm).
Private collection. This painting was shown at the First International
Exhibition of Cobra Experimental Art, Stedelijk Museum, Amsterdam, 3–28 November 1949.

Karel Appel, *Questioning Children*, 1948. Collage
and oil on wooden panel (85 × 57 cm). Private
collection, USA.

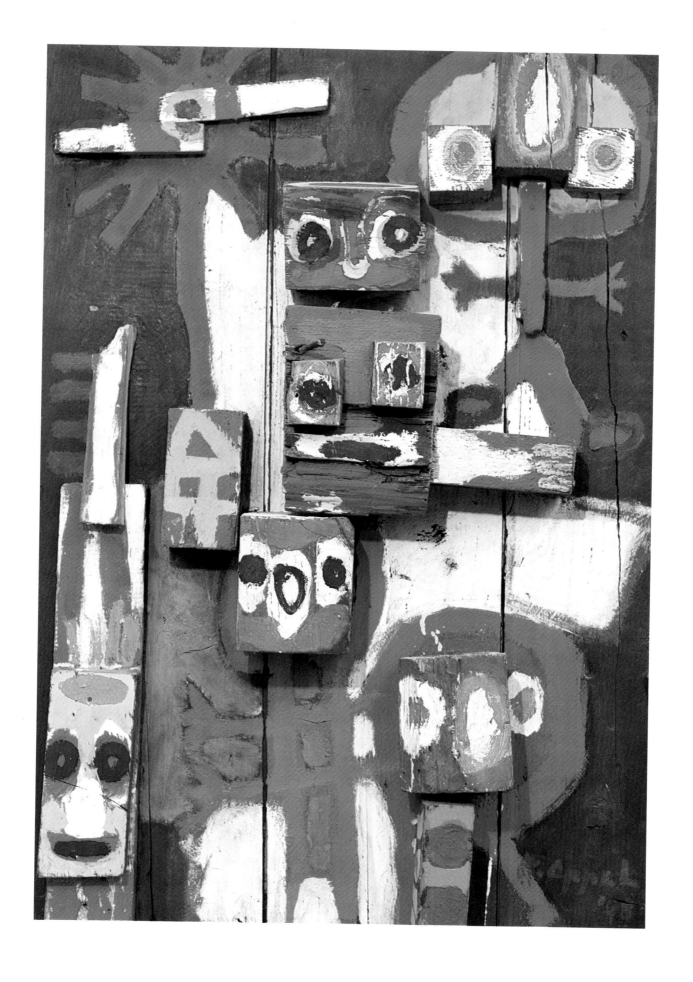

tries to recognize itself in forms, thus establishing a new
relationship with reality, as much for the artist as for the
active spectator. 'This power of suggestion is unlimited
and that is why we can say that, after the age when
painting represented nothing, we will enter into one
when it will represent everything . . . And, since we
consider the stimulation of the creative impulse as art's
main task, we will try henceforth to arrive at an effect
which is as material and suggestive as possible. In this
respect, the creative act is much more important than the
object created.'

This last formula would find itself going beyond
Constant and Cobra, to be used again in the most
diverse contexts. It has relevance to all the art of the
second half of the twentieth century.

Standing against 'asphyxiating culture' and linked,
according to Constant (who differed in this from
Dubuffet), to the organization of society, is childhood
'which knows no other law than that which sponta-
neously imparts to it its sense of life . . . truly living art
makes no distinction between the beautiful and the
ugly.' One should therefore take into consideration all
the manifestations of the need to express oneself –
graffiti, for example, which Jorn would later systemati-
cally study in Norman churches.

'We have on the walls and pavements proof that man
is born as a being who desires to demonstrate his
existence . . . A painting is not a construction of colours
and lines, but an animal, a night, a cry, a man, or all of
them at once.' In conclusion, Constant claimed that the
problematic phase of modern art was over and that an
experimental phase was beginning. 'The laws of the new
creativity must stem from the enjoyment of unfettered
liberty. In that way, a new consciousness will be born

dialectically from more or less unconscious creations.'

These are the ideas which Constant would put up
against those of Revolutionary Surrealism – ideas
burning to be put into practice without further ado; this
would be Cobra.

Of Dutch parentage, Corneille (Guillaume van
Beverloo) was born in 1922 in Liège, which made him
not only completely bi-lingual but also both anti-Dutch
and anti-French – a precious advantage for Cobra
internationalism. Somewhere in Corneille's childhood,
there was a garden: he would remain nostalgic for it
throughout his entire life and never stopped dreaming of
once again finding himself a child in a garden, of seeing
and painting the world and nature as a garden seen
through the eyes of the child within him, which he so
dearly wished to preserve. 'As a child, I loved to lie for
hours on end in the grass of our tiny garden . . . A great
estate stretched out behind our house – a real delight of
vegetation which never ceased to thrill me. The garden
of my childhood, the begetter of dreams . . . Lost, I
listened to the grass disturbing the silence. With my eyes,
I followed the multiple flights going on above the grass
. . . On the ground, I would often seen a golden beetle
walk amongst the busy ants. In the garden of my
childhood, summer never came to an end.' In this prose
poem, accompanying his 1962 lithographs *For a spec-
tacle of nature*, are to be found all the thematic and
ontological keys to Corneille's work, exceptionally
faithful to first principles. In Corneille, Bachelard would
have found the ideal illustrator for *La Terre et les
Rêveries du repos*.

But this garden was destroyed by the war; even today,
Corneille has anxious memories of those black years. He
was living in Haarlem with his family and taking a
course at the École des Beaux-Arts in Amsterdam,
sometimes having to walk there, which took him a good
two hours. It was at the École that he got to know Appel,

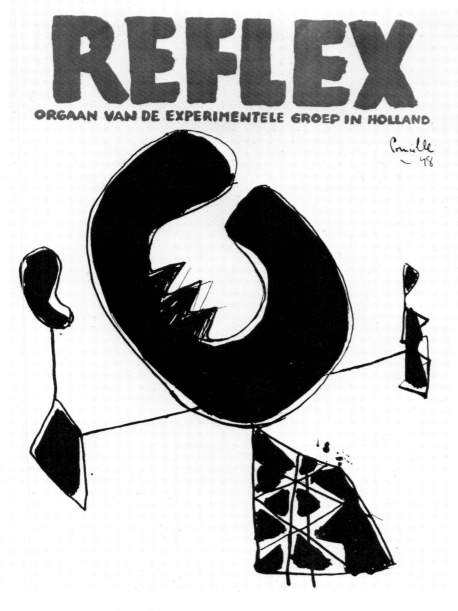

REFLEX
ORGAAN VAN DE EXPERIMENTELE GROEP IN HOLLAND.

Cover of the review *Reflex* No. 1, designed by Corneille, Amsterdam, September/October 1948.

a significant meeting for Cobra art. Both of them rapidly absorbed the highly academic teaching that was dispensed to them: 'Van Gogh was taboo,' Corneille recalls, 'Matisse considered a house painter. It was as if painting had stopped with the Hague school.' Corneille very soon felt the need to work on his own, away from all the imposed models. But first, it was necessary to escape from the Nazis. He lived from one hiding place to another and only avoided the call-up by a miracle. When the Liberation came he would destroy what he had painted in those anguished, famine-ridden conditions – pictures dominated by sombre, funereal colours, whose destruction was his own personal 'liberation', his participation in the joy (a word he liked to use very much), the euphoria of restored freedom. He needed to go and search for the wonderful garden which had been lost, in more senses than one, now that Corneille himself had joined the world of adults killing each other amongst the ruins . . .

The artistic climate in Amsterdam after the war was 'really not very encouraging'. Filled with an immense need to renew himself, which he kindled through what little he knew of Matisse, Dufy and Modigliani, Corneille exhibited for the first time in Groningen; he was then invited by W. Sandberg as a 'young painter' to the group exhibition at the Stedelijk Museum, where Constant was not represented. In January 1947, he was sharing the attics of the Gildenhuys in the old centre of Amsterdam with Appel. But he was still waiting for something, as his *Self-Portrait*, (collection of the artist) of that period shows; a strange portrait, his sallow face resting on a rather greenish hand, his lips of a red almost as intense as that of his sweater. An interior, if not enclosed, scene: nature here was reduced to familiar objects, to decorative motifs – very large fruits in a bowl, the silhouettes of trees on a panel and a strange plant which rears up like a modern-style snake.

The miracle was so very near. But perhaps this is not the right word to use: it was simply one of those happy occurences which would mark Corneille's destiny and lead him, or lead him back, each time towards the garden. Leaving the Gildenhuys pushing a cart full of canvasses, which he had just taken off the walls, he caught the eye of a young Hungarian lady . . . and found himself a little later in Budapest for a quite unexpected stay of four months. Everything he had lacked in Amsterdam was there; in the library of Imre Pan, brother of the surrealist Arpad Mezei, he read the French poets from Rimbaud to the Surrealists. It is surely unnecessary to stress again that the poets were for Corneille, as for all the Cobra group, the closest of half-brothers, or, indeed, that poems emerged naturally from his pen when he wrote. In this too, he was like Miró, whose work he discovered whilst in Budapest, as he did that of Klee.

Klee – still so little known at that time, when Corneille saw a few of his works in the Hungarian capital. Klee was the painter who advocated the analysis of the base of 'plastic methods' in order to master them better (such was his teaching at the Bauhaus), an attempt to reconcile the original of the being and the emergence of that being in a work of art: 'Our heart, in beating, constantly drives us forward towards our origins,' he would say. And where best to attain these origins if not in childhood? Klee reached out towards it in the name of 'the liberty which proclaims only its right to be as mobile as great nature itself.' He therefore added childlike sketches to the deliberate or conscious forms in his pictures, for which he would be gravely reproached, but of whose irreplaceable value he was fully aware. He explained himself in the address he delivered at the Museum of Iena in 1924 – an important date for modernism – giving an impassioned call for 'making life a little more vast than it generally seems to be' by means of an art closer to life itself.

None, perhaps, was better prepared than Corneille to receive this message; it came through to him forcibly and he could readily identify with it. And he wished to re-

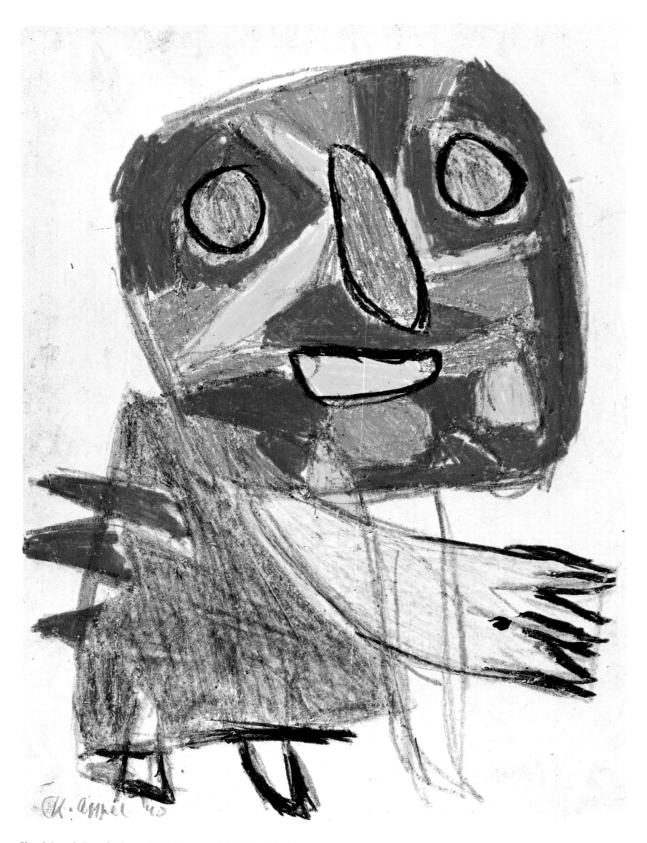

Karel Appel *Cry of Liberty*, 1948. Greasepaint (38.4 × 28 cm).
Collection of the artist. Photo Henk van der Vet, The Hague.

enact the journey to Tunisia, which had been so decisive in Klee's destiny; he went there the following year, at the same time as Jorn, whom he got to know through Constant. A remarkable repetition of events – Klee and Macke in 1914; Corneille and Jorn in 1948.

In his diary which finishes there, being a diary of his years of apprenticeship which came to an end precisely at the time of the Tunisian journey, Klee noted after a visit to the white city of Kairouan in the desert: 'A happy moment . . . The atmosphere penetrates me so gently that it creates within me more and more self-confidence, without making me any more zealous. The colour takes possession of me, there is no need at all to try to grab it. It possesses me, I know it. That is the feeling of the happy moment: the colour and me, being one. I am a painter.' And the following day: 'Once again, spent the morning painting out in front of the town, right next to the city wall, on a sand dune. Afterwards, walked alone, because I was so full of joy, went through a gate . . . I had to be alone, so powerful was the experience I had just lived through. And I also had to go away, to get a grip on myself! A return upstream, towards the source of emotions, towards a total existence like that of childhood.' One cannot help comparing these lines with those Corneille would write from Tunis to his friend, Louis Tiessen: 'I have so much to take in here. Every evening I retire exhausted, and every morning I wake up early. It is another world here; everything around me was unknown to me before now . . . To one side, there is the horizon of purplish mountains. A violent storm breaks, the air becomes black as ink, but the sea remains translucent. I huddle in a cranny on a hillside. I throw a stone at a camel's head to make him show his teeth – I have just discovered the complete skeleton of a camel. Big drops of rain make holes in the sand; there is the smell of jasmine and of seashells. I was so happy at that moment!'

But before reaching this living garden, which would remain with him always, Corneille had experienced the devastated garden of the Royal Palace in Budapest, destroyed by war, as his own youth had been. In Budapest, nature had regained possession of the ruins, the tumbled stones, statues and balustrades. There, Corneille had passed days as rich as in the original garden: 'Here, nature is deploying its great vitality; man is no longer watching and it can have free rein. A magnificent rhythm, powerful as the sea, that makes us tremble, fills us with a strange feeling of exaltation . . . Ruins create an effect of lines, taut and stretched, vertical, horizontal, diagonal; vegetation gives quite another effect, one of supple rounded lines, of swirling and curved surfaces.' Although he obviously did not know it (Klee's diary would not be published until 1956), Corneille used the same fervent intonations as Klee: 'New joys await me. I shall pursue my research most patiently; I have confidence in a new style of painting – free, poetic and healthy.'

On his return to Amsterdam, things moved very

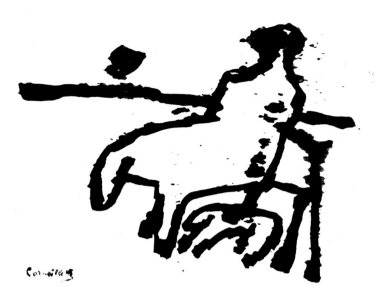

Corneille, untitled, 1949. Indian ink on paper.

quickly, and a certain impatience was discernible in Corneille at finding himself back on the stagnant Dutch scene. It was this which caused him to leave for Brussels, then Paris, together with Appel. What the two young artists discovered there – much more important for them than their contacts with Bazaine, Pignon, Estève and others of the École de Paris – was the resounding proof that challenging all aesthetic codes, all 'isms', could inspire the most original creation. It was the era when Dubuffet was exhibiting, at the Galerie Drouin, his 'portraits of extracted likeness, of likeness cooked and preserved in the memory, of likeness exploded in the memory'. This was non-cultural art, art which elevated matter itself to a level of equality (or superiority) with the forms it registered. Dubuffet was still of interest, then, only to a small group of intellectuals surrounding Paulhan. But Corneille immediately saw in him the confirmation of his own tendencies. In the event, there would always be a great gap between Dubuffet's finely calculated anti-intellectualism and Corneille's happy-go-lucky (uneasy, but always happy) impulsiveness. But it did not matter. It was after the various stays in Paris that the metamorphosis was accomplished: the birds hatched in all their colours; bearing the secrets of life, they began their lasting confidence in the Queen of the garden: *The Woman* (his 1948 gouaches). The walls, so close to oppressiveness in the self-portrait, had flown away; *My room is full of joy* is the title Corneille gave to a painting of particularly destructured graphics, reproduced in the first issue of the review *Reflex*.

So the Experimental Group was formed. In Budapest, Corneille had met the young French painter Jacques Doucet, who also found himself there thanks to the good offices of that same providential Hungarian lady. This meeting was doubly fateful for Corneille; personally, and because of the exchanges which would culminate in *Reflex* and *Cobra*. Doucet was searching for a different kind of art, a return to his origins. At the start of the Occupation, he had visited Max Jacob at the monastery

of Saint-Benoît-sur-Loire, where the poet was pursuing his literary and artistic work in a climate of Christian meditation. Max Jacob, who had given him a most warm reception, had realized that Doucet must be encouraged to carry on in the naturally humouristic vein which he had made his own, drawing on 'Klee, for drawing and Miró, for the feeling of space.' But Doucet had been more occupied with the secret activities of the communist party, of which he was a permanent member, than with painting, until his arrest by the Gestapo. Happily, the Liberation came just in time for him; he was in a cell at the prison of La Santé, about to be tried. Even after regaining his freedom, the young painter would remain marked by what Jean Laude called 'the sordid magic written on prison walls, the graffiti charged with the energy of liberation.' Such had been his formative period as an artist; a complete stranger to art schools and museums, but having lived in truly exceptional circumstances. The difference it made was that Doucet's 'green paradise' had given way to more volcanic colours; he had acquired a taste for matter in its own right which would never leave him. It might be called the art of poverty, of the everyday, of the 'small time'. At Imre Pan's European School, Doucet exhibited compositions which were more or less figurative, 'with memories', as Klee would say – such as the couple of *Cyclists* who appeared on the cover of the catalogue. Very correct gentlemen, in homage to Jarry; yet the bicycle wheels had a tendency to be autonomous, freeing themselves from the anecdotal image to become independent symbols, organizing themselves into another, more active construction, one which was more directly expressive of the *ego*. In his turn, Doucet understood Klee perfectly when he responded to the reproach of 'childishness' by explaining that he was attempting to combine figurative 'representation' with pure 'presentation' of linear elements. And it is clear how much Corneille could be seduced by this. Through Corneille, Doucet joined with the Dutch contributors to *Reflex*, then 'Cobra; through Doucet, Cobra came to the attention in Paris of Colette Allendy, that 'grande dame' who gave them their first Paris exhibitions in her private mansion at Auteuil. Doucet had participated in the brief adventure of Revolutionary Surrealism before quietly breaking away from the Communist Party at the first signs of Jdanovism. Fiercely individualist as an artist and a self-contained character, he would hardly ever again be tempted to take part in collective activities. In the *Cobra Library* handbook, which is dedicated to him, Jean Laude wrote: 'The work of an anguished individual is not heartbreaking, it is an outlet, a flaw in the system surrounding it. If it is not happy, it tends towards happiness.' Doucet, the Parisian Cobra.

'Born a Taurean' in the port area of Amsterdam, in 1921: sometimes Appel would have liked to limit his biographical details to that. For him, the only important thing was what he painted or sculpted, what he thought, what he dreamed. But at other times, he liked to talk

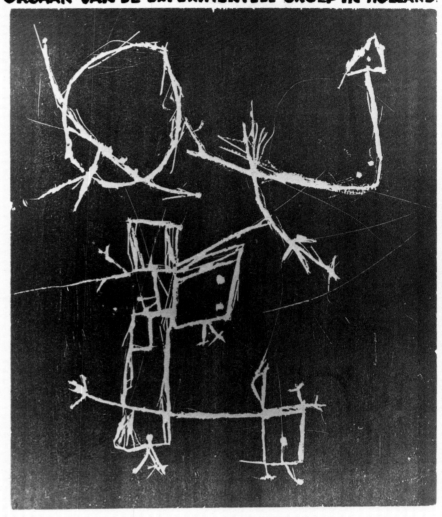

Cover of the review *Reflex* No. 2, with a woodcut by Jacques Doucet. Amsterdam, February 1949.

emotionally about his town and his family; the French Huguenot lineage of his mother, a most cultured person; the strict protestant education he underwent, followed by two year's apprenticeship in his father's hairdressing salon. In making him make copies of the Impressionists, his uncle, an amateur painter, had made him convinced of his vocation ('I have always known I would be a painter.'). He was steeped in the Amsterdam bourgeoisie – and all 'Amstellodamois', from proletarian to *jonkheer* are irredeemably bourgeois! 'On Sunday afternoon, a neighbour would come and fetch us in his car and take us

Appel, Corneille and Constant in Appel's studio in Amsterdam, Oudezijds Voorburgwal, 1948. In the foreground, a painted wooden sculpture by Karel Appel.

stormed over the Netherlands, the destruction and upheaval were irreparable. Appel would always feel nostalgia for the town of his quiet and, all in all, happy childhood: small happiness, which he would often evoke in his memory; his sentimental roots were there and they had been irredeemably torn up. Until the Nazi deportations, Amsterdam was strongly impregnated with Jewish culture: Appel liked to stress that he owed his warm and irreverent sense of humour to this. It was an attempt to disarm fate by playing the clown. 'Clown, I want to be like you,' he would one day say. 'The anti-robot!'

The École des Beaux-Arts functioned intermittently during the war years; the teaching there left much to be desired. Appel just had time to learn what he would soon have to unlearn – the worn-out rules of the whole substance of fixed academism. Moreover, a great deal of his time was spent in looking for something to eat, round the town or in the country on his tyreless bicycle. In the bars and cafés he would exchange one of his paintings for cigarettes, or sing for them. Like the whole Cobra group, Appel had an ear for music; folk, gypsy music and jazz. He painted portraits of the great soloists in New York and recorded a disc of himself playing percussion entirely by ear. He liked to have jazz as background music when he was painting.

Appel rented an attic in the port area and used it as a studio (all the Cobra artists were studio painters). The works from his first period show how perfectly he had mastered traditional techniques; he was an excellent draughtsman and painter, full of confidence in himself, as he reveals in his self-portraits. Here he is, well groomed, a white shirt and bow-tie, with a certain air of defiance which was nothing less than defiance of life. He visited museums to admire (and question) Breitner, the Vuillard of Amsterdam, Van Gogh and Van Dongen, those explosive Dutchmen whose tradition he followed. The German Expressionists too, the paintings of *die Brücke* and, above all, Nolde, whose violent colourism resounded most strongly in him. Later it would be Matisse and Picasso. One day, a young lad from Haarlem appeared at the École, by the name of Corneille. It was one of those occurrences whose overpowering significance makes one use the word 'destiny'.

Like Corneille, Appel was treading the path to self-discovery, motivated by the same youthful fervour, doubly troubled by lack of food and lack of working materials. The Liberation was on its way, but the worst moments of the war were yet to come. Despite these abominable conditions, Appel worked prodigiously, already experiencing those intoxicating moments, 'drunken bouts of work', as Delacroix, of whom he is reminiscent in so many ways, expressed the sensation. One hand was not enough for him – he was naturally right-handed, but started working with his left hand too and felt that it behaved in a totally different way from the other, which had been well-trained at school and was

for a slow drive around the neighbourhood. My father would greet people, a bowler hat on his head and smoking a cigar. "Not so fast!" he would say over and over again to our driver, who would ultimately deposit us, the tour over, at our point of departure in front of the house.'

When he was eighteen, Appel left this untroubled family, because 'real life' always seemd to be 'somewhere else', and presented himself for the entrance examination at the École des Beaux-Arts, where he was accepted. It was really the end of an era; when the Nazis

polished and obedient. This was a significant discovery for his future work; the left hand, controlled by the right-hand side of the brain, was the spontaneous, instinctive one – destructive if necessary, full of immediacy and direct energy. Consequently, Appel entrusted it principally with the colour work, the paint and materials. In doing so, it set the 'good example' of clumsiness to the other one; the left hand 'liberated' the right and, for Appel as for Constant and Corneille, there was a certain coincidence of time between the liberation of their country and that of their creativity. The end of stress and repression; liberty rediscovered, and discovered anew. The works of the years 1944–7 are very varied: paintings, gouaches, sculptures. Appel could and did try everything; he pitted himself against all the European art of the period, about which more specific information was now filtering through: the École de Paris, but also the dadaism of Schwitters; the sculpture of Laurens and Picasso; Klee's magical pictures and negro art, whose primitive strength touched him deeply. In a letter of 2.12.1947 to Corneille, he explained that what he wanted, and what he would achieve would be a synthesis of all the elements through colour: 'I am writing to you in haste. I am working day and night. I really have started now. All of a sudden, tonight, I've got it! From now on, my work will be powerful, primitive, stronger than negro art and Picasso. How is this? Because I am carrying on the twentieth century and I have emerged from Picasso, the herald. I am violating colour. I have beaten my way through the wall of abstraction and surrealism. You will find all that in my work.'

He travelled to Brussels, where he was attracted by the ephemeral group 'Young Belgian Painting', founded as a counterpart to 'Young French Painting' by several future adherents of Cobra, such as Louis van Lint, whose canvasses of the period border on non-figuration, with their warmly coloured shapes. Appel and Corneille spent several weeks with him; they also worked at the Place du Grand-Sablon, in the studio of Marc Mendelson, who was more Picassian in his imagery, which was both everyday and a little surreal at the same time. In Ghent, Appel paid a visit to the old Constant Permeke, the greatest Flemish expressionist, who was dramatic and profound, charged with all the weight of the world, a painter close to the soil who shared the fears of the workers, and also their fruitfulness. Appel could not help but sense it – and disregard it.

After Belgium, it was Paris. Appel joined Corneille there and, together, they discovered Dubuffet and met Atlan. On his return to Amsterdam, Appel threw himself into his work with 'abandon and confidence', as Hugo Claus put it. In his paintings, sketches and plaster sculptures, he was constructing and dismantling figures and forms with a vigour which would henceforth be untameable, 'action, nothing more than the cry of the essential forces' (H. Claus). From this period on, Appel's art would be the art of permissiveness – not yet a fashionable code; he allowed those age-old images from

Karel Appel in his studio, Oudezijds Voorburgwal, Amsterdam, 1947. Photo Willemijn Stokvis Archives.

deep inside himself, or from here and there outside, into the workspace. From then on, his task was to find the least inadequate methods of calling them into being. *Together in the Night*, a 1948 gouache and crayon, is the allegory of his increasingly comic theatre. The horrors of war were fading, becoming more remote; born of the dark base of the composition, the two puppets, a boy and a girl, prepare themselves for the dance. Appel makes the child within us, who may have left us but is still our accomplice, play; he lets it play and catches it in the act of playing. Such, prior to Cobra, is his progression towards Cobra: the exploration of the adult world of art and his progressive abandoning of it, which is marked in his work by the progressive abandonment of adult representation. The latter benefits the conscious at the expense of the unconscious, the rules at the expense of spontaneity. It is the non-primitive; also the thing that provokes and causes wars – Appel banishes it, repudiates it, the more willingly because, since finding himself in the adult world, he had known violence and misery more than anything else.

His revolt would blend naturally with that of the other future members of Cobra, and had as its symbol a subject which would lead him from a 1947 sketch to the decoration for the dining-room in Amsterdam Town Hall, which was to cause a scandal – *Questioning Children*.

Karel Appel, lithograph published in *Reflex* No. 1, Amsterdam, September–October 1948.

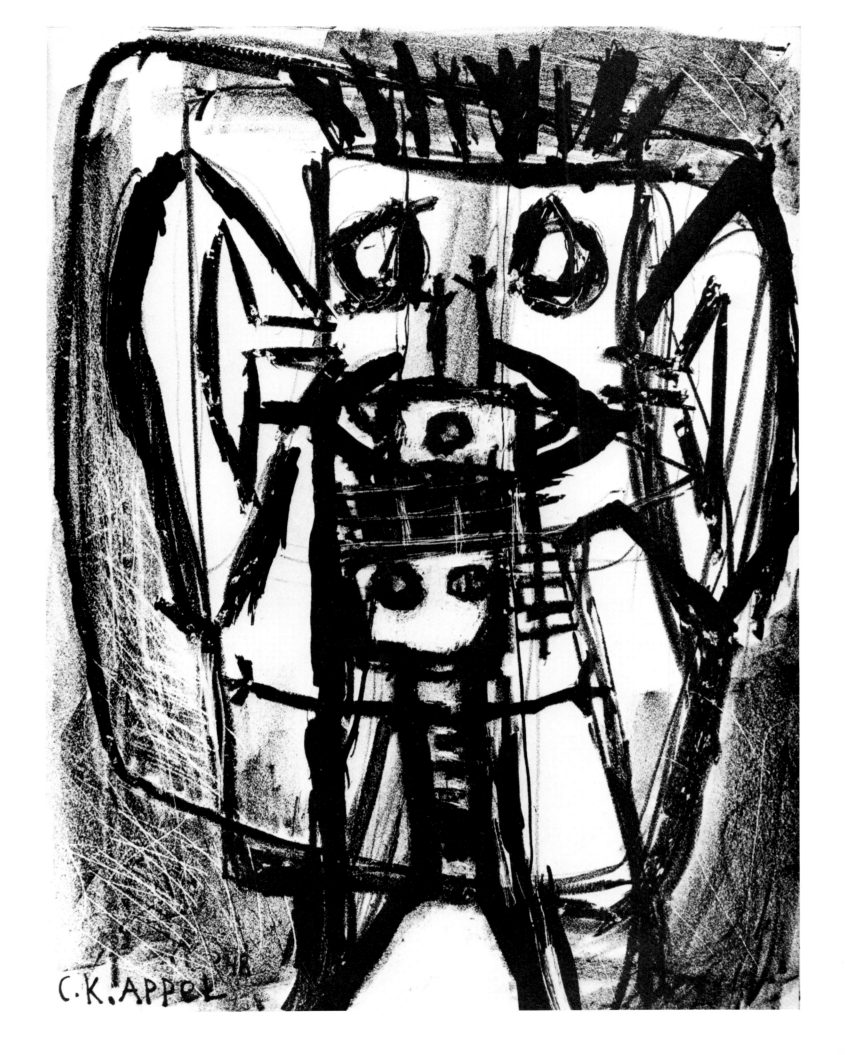

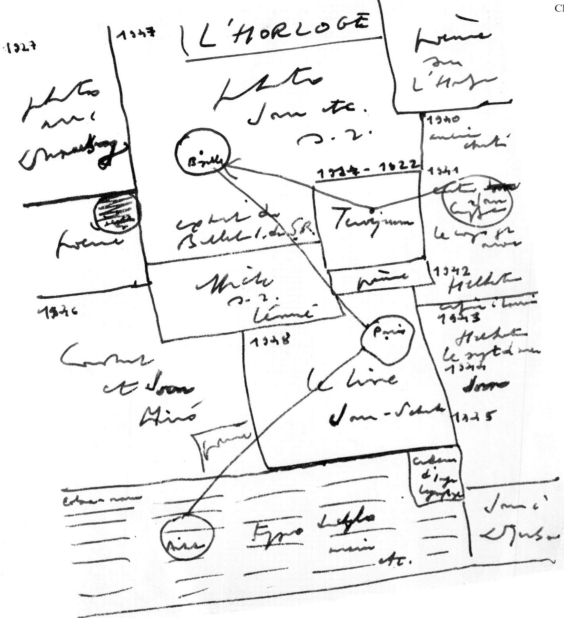

Amongst the numerous notes relating to the *Cobra*-forêt ('Cobra forest') project were six sheets like this one, which give an idea of the total scheme for the mural which the poet was planning.

First sheet

1927 Photo with Daneborg: A souvenir of Dotremont's childhood, photographed at the age of five with his brother Guy and the Daneborg, the Danish national flag.

1914–22 Tervejrum: writing Asger Jorn's date of birth (1914) side by side with his own, Dotremont invented the name of a town, mixing Tervuren, where he was born, and Vejrum, Jorn's birthplace.

1940 Ancienne Éternité: Dotremont's first major poem.

1942 Helhesten: the Danish review whose principal collaborators were Asger Jorn, C.-H. Pedersen, H. Heerup.

Conference in Louvain 1943: conference on Surrealism held by Christian Dotremont and Marcel Mariën at the Literary Circle of the Catholic University of Louvain, 21 January 1943.

Helhesten (again), which continued to survive under the German Occupation.

Le Serpent de Mer 1944: project for a publishing house, which never saw the light of day but for which René Magritte designed a vignette.

1946 Constant and Jorn–Miró: allusion to the first meeting with Constant and Jorn at the Miró exhibition at the Galerie Pierre, Rue des Beaux-Arts, Paris.

1947 L'Horloge: a Brussels' cafe (since demolished) at the Porte de Namur, where the International Conference of Revolutionary Surrealism was held.
A Photo of Jorn in company with Dotremont, Noël Arnaud, Max Bucaille and Josef Istler (see page 21 of this book).

An extract from the *Bulletin international du Surrealisme Revolutionnaire* should have featured in the same 'box'.

The circled word *Brussels* is joined, after a detour via 'Tervejrum' with *Copenhagen* (where one reads: 'return Copenhagen Jorn') and with *Amsterdam*, via *Paris*.

At the centre: *Lenin poster.* A poster published in 1949 by Dotremont, reproducing a quote wrongly attributed to Lenin.

1948 The Jorn-Schade book: Jorn's conversations with the poet Jens August Scahde, published in *Le Livre* No. 3, Paris, July–August 1948.

Jorn in Djerba: Jorn's stay in Tunisia during the winter of 1947–8.

Cobra-roman-Typo-Dactylo-Main etc.: here, Dotremont planned to include a number of texts in the most varied forms, notably 'La Cobraïde' (published in *Le Grand Hôtel des Valises*), 'Cobractes', 'Cobratlas', 'Cobravo', 'Cobraland'.

The word *poem* appears three times (apart from the reference to the *Poème sur l'Horloge*).

The other five pages set out similarly the principal events which charted the life of the movement, a special place being set aside for the word-pictures, and for the ten issues of the review *Cobra*.

90

Christian Dotremont: Cobra-Forêt

With the support of Paolo Marinotti, organizer of the exhibitions 'Vitalita nell'arte' (1959) and 'Visione Colore' (1963) at the Palazzo Grassi, Venice, Dotremont worked from February 1965 to September 1968 on a project he called *Cobra-forêt*, which would celebrate the life of the Cobra movement in the form of a mural collection. This collection was to be made up of all kinds of documents, objects, poems, paintings, drawings, photographs, diagrams etc. 'Here, I am digging up a few roots, cutting a few swathes, in the forest that we were, are and will be, without the least ambition of being comprehensive; it is a broad panorama with grand schemes, and it is through this living movement, through this inveterate irregularity, that I am most faithful to Cobra, which was exploration and not exploitation, in the speed in which names are mixed up, in the slowness where things form sediments, spontaneity jumping and weaving in turns, in the texture and the torn, the snaking pain, the bursting laughter, in the manner of the forest we will be, are and were.'

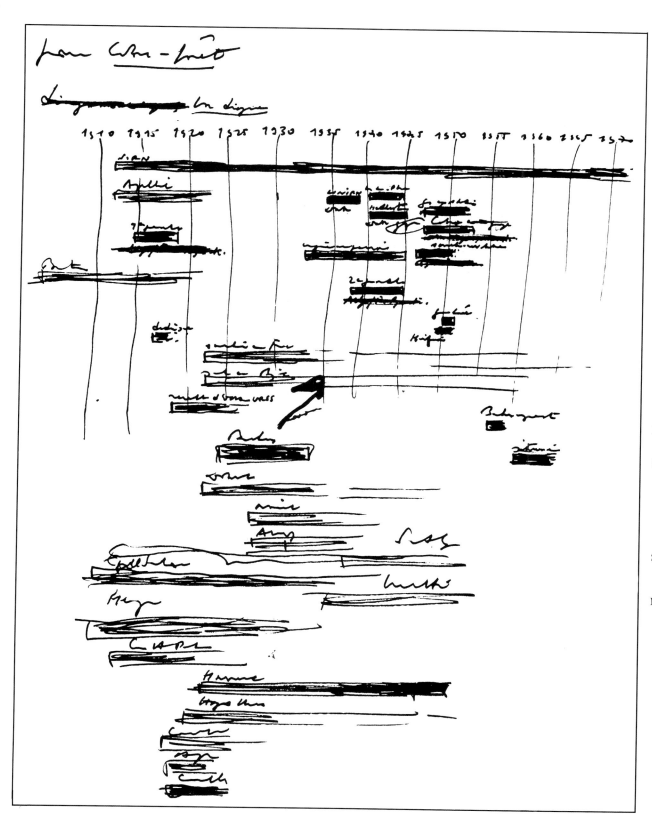

Jorn (*1914*)

(*illegible*)

Breton

Dadaism

Surrealism in France

Surrealism in Belgium

October Revolution in
 USSR

Bauhaus

Dotremont (1922)

Noiret (1927)

Alechinsky (1927)

Egill Jacobsen (1910)

Heerup (1905)

C.-H. Pedersen (1912)

Havrenne (1912)

Hugo Claus (1929)

Constant (1920)

Appel (1921)

Corneille (1922)

In the diagram

Linien, Denmark
La Main à Plume
Helhesten, Denmark
Dutch Experimental Group

Cobra group

Revolutionary Surrealism
Nazi Occupation

Second World War

Korean War

Kominform

Imaginist Bauhaus

Situationism

Sandberg

Marinotti

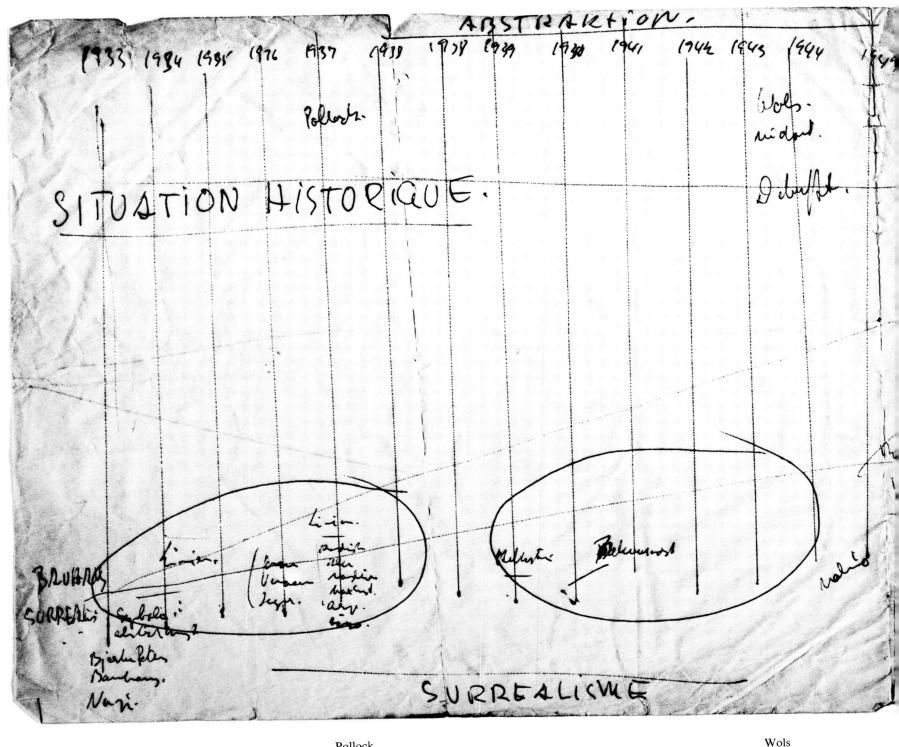

Pollock

HISTORICAL SITUATION

Linien

Linien

Kandinsky
Klee

Wols
Michaux

Dubuffet

Belgium
(illegible)

BAUHAUS

SURREALISM

Jorn
Wemaere
Leger

Klee
Mondrian
Max Ernst
Arp
Miro

Helhesten

(illegible)

Malmo

Symbolism
Abstraction
Bjerke Petersen
Bauhaus
Nazi(sm)

SURREALISM

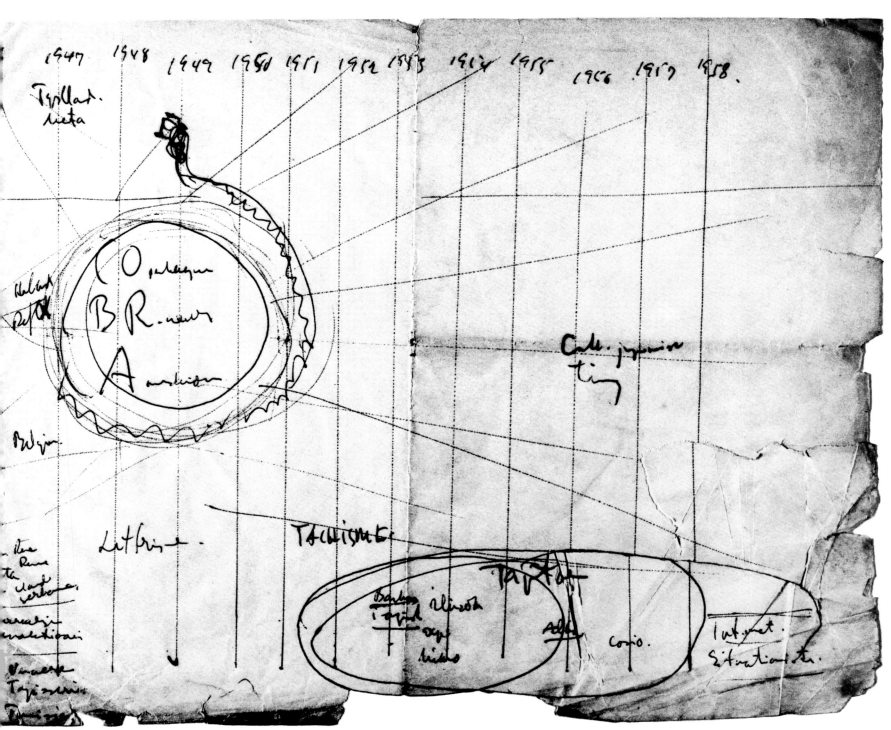

Tyskland (Germany)
Meta

Holland
Reflex

COpenhagen
BRussels
Amsterdam

Belgium

Japanese calligraphy
Ting

Lam Rene Renne
Matta Claude Lettrism
Jorn Serbanne

TACHISM

Taptoe

Revolutionary
Surrealism

Imaginist Albisola
Bauhaus Alba

Internationale
Situationiste

Expo
Milan

Cosio
*(town in Italy where the
Internationale Situationiste
was created)*

Wemaere
Tapestries
Tunisia

Historical situation of Cobra, as seen by Asger Jorn, 1958. Handwritten sheets.

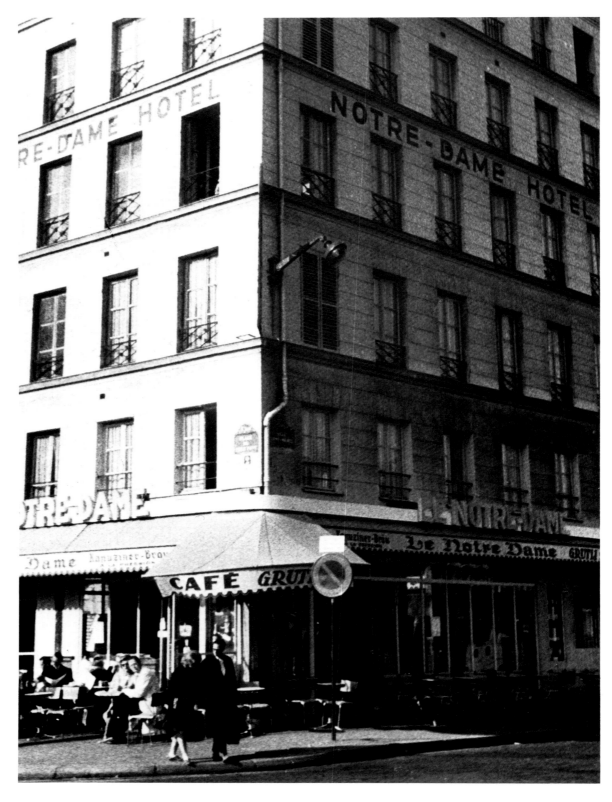

The Cafe Notre-Dame, Quai Saint-Michel in Paris, where Cobra was founded. Photo Suzy Embo.

2. The Collective Adventure

La Cause était entendue ('The Cause was understood') –
this was the title of the text which Dotremont and five of
his dissident friends (Joseph Noiret, Jorn, Appel, Const-
ant and Corneille) drafted on 8 November 1948, gath-
ered round a table in the Café Notre-Dame in Paris. It
contained the various basic data, clearly formulated,
which would be the groundrules of Cobra: 'An organic,
experimental collaboration which will avoid all sterile
and dogmatic theory . . . We have established that we
have a common way of life, of working and of feeling; we
understand each other on practical matters and we
refuse to enrol in an artificial theoretical union. We do
and we will continue to work together.' In fact, the same
principles guided all the avant-garde, who sought to
have a particular mode of action within a general
cultural movement which they denounced as a separate
sphere, if not an institution; a mode of action in an
everyday life open to exchanges of ideas. It was not a
question of creating a group or an exclusive élite with a
precise programme, but of inviting artists to a collective
adventure and making up that adventure as it went
along. It was a project which would only have the chance
to develop as long as each of its participants – and such
was the case with the future Cobra group – carried
within himself, even if in a fairly confused way, his
'working force', as Jorn called it. In a 1956 conversation,
Jorn said that Cobra's novelty had still not then been
clearly perceived – not even in the articles of the review
of the same name. 'If Christian Dotremont gave us a
great shock, it was without us painters being aware of
what was going on. Dotremont stimulated us constantly
in every way in an *experiment* which was always young
and alive . . . Through him, Cobra held itself in total
opposition to all possible aesthetism and formalism
(classical formalism as much as warm or cold abstrac-
tion). In this way we unconsciously added the climate of
continuous research to the unity of form and
expression.'

Even before the momentous meeting at the Café
Notre-Dame, Jorn and Dotremont had abandoned
themselves to the pleasure of creating their 'word-
pictures', less than half a dozen small canvasses, both at
Massy-Verrières and in the Rue des Éperonniers in
Brussels. The novelty of the experience consisted in the
simultaneous emergence of writing and painting, of
forms and graphics inter-relating to bring about birth of
the work. In a letter addressed to Constant in Amster-
dam, Dotremont recounted how it all came about: 'Jorn
and I had done a great deal of work over three days. We
used small canvasses. Sometimes, I began to write
words, then Jorn painted (all done automatically);
sometimes it was the other way round. We wanted
(automatically) to mix words and images organically –
and Jorn could see in that a following of rural tra-
ditions.' Dotremont did not elaborate further on this
last reference, but Jorn was no doubt alluding to the

dalmålningar which had captured his attention and on
which he had written an article for the Czechoslovakian
review *Blok* (a resumé of which is to be found in *Cobra
I*). Painted in the fourteenth century in the province of
Dalecarlia, the *dalmålningar* are scenes from the Bible
given a contemporary Swedish setting and accompanied
by biblical quotations.

Whatever else they are, the phrases in Jorn and
Dotremont's word-pictures are certainly biblical: 'There
are more things on the Earth of painting than in the
Heaven of aesthetic theory' one of them reads. Or again:
'Poems never read anything, oh gentle coat with pockets
of flesh, lace of lightning.' In another, the bust of a
woman was accompanied by a proverb in surrealist
taste: 'A face suffices to deny the mirror.' Or, again, a

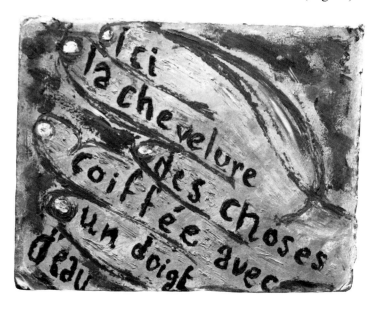

Christian Dotremont and Asger Jorn, *The Hairdo of
Things*, word-picture, 1948. Oil on cardboard (17.5 × 21.5
cm). Private collection. Photo André Morain.

swollen hand with the following formula, which will
furnish the title of a collection of word-pictures yet to
come (after Silkeborg): 'Here the hair of things is coiffed
with a finger of water.' In another of these pictures an
almost plant-like hand has the legend 'I rise, you rise, we
dream', a text which heralds the *Jorn lève* ('Jorn rises') of
the jubilee poem written by Dotremont for Jorn's fiftieth
birthday in 1964. In 1948, however, at the date of the text
for the picture, Dotremont is still unaware that *Jorn lève*
will be called *Long Live Jorn*! in Danish, a meaning
which he will play upon at a later date.

During the Cobra period and after, Dotremont would
increase these collaborations, which demanded like-
mindedness above all else. He would work with
Corneille, Appel, Alechinsky, with Balle, Atlan – I was
about to say: with himself (in terms of the 'Logograms'
from 1960–1 onwards). In the facsimile edition of the
Transforms (published in 1950 in Brussels), which were
Dotremont and Atlan's word-pictures, Pierre Alech-
insky recalled the way things were done at that time: 'In

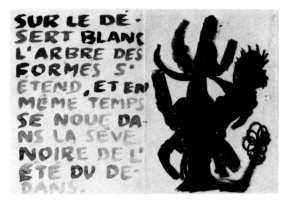

Christian Dotremont and Jean-Michel Atlan, *The Transforms*. Original roughs from the Marais studios, Brussels, April 1950. A notebook of six double pages (page format: 25 × 35 cm), gouache on grey tinted paper.

my studio, Dotremont and Atlan would ask for a piece of paper – I had some grey stuff; with their colours, consisting of a schoolboy's box of gouaches, cracked saucers, a brush for each of them, some water, a rag, a lithographic pencil, they would sit down at the kitchen table. Without thinking, Atlan would trace out rough words in red, blue and black: "If I get lost in the woods, it is only to find the forest." Clever he who knows at the first reading if the phrase came before the image or vice versa. This interplay between writer and painter, these mixtures, are characteristic of Cobra.'

The *Transforms* (1950) act as a kind of codex, African rather than Mexican, because of the magic of Atlan's symbols which dance, with their horns, teeth and claws on display, 'in the black sap of the summer within'.

If Cobra's stamping grounds in Brussels were Dotremont's address, 10 Rue de la Paille and also the Ateliers du Marais rented by Alechinsky and his friends, in Amsterdam it was Constant's studio at 25 Henri Polaklaan, a stone's throw from the Artis Zoo, which served as the rallying point for the Experimental Group. There, the first two issues of *Reflex* were put together. Thanks to the encounters made possible by the two exhibitions at the Stedelijk Museum in Amsterdam (the 'Young Painters', then the Klee retrospective in April 1948), the team of Constant, Corneille and Appel was reinforced by new painters like Anton Rooskens, Theo Wolvecamp, Eugène Brands, Jan Nieuwenhuys (Constant's brother), and by the young poets Lucebert, Jan G. Elburg, Gerrit Kouwenaar and Bert Schierbeek. 'We realized that we were cut free from the past and were enjoying unfettered liberty,' Rooskens wrote. 'Only primitive beings, children and psychopaths could count on our sympathy. There was a period of weekly meetings and marvellous mutual co-operation . . . It was the custom then to bring your latest work along to the meetings for discussion. This would contribute enormously to the foundation of the style that was so characteristic of the group. And the poets used to come along, too, to read out their poems.'

Jorn had the group invited by the Høst co-operative to its annual exhibition, which opened in Copenhagen on 19 November 1948, just eleven days after the declaration at the Café Notre-Dame. This exhibition is considered, and rightly so, as the first manifestation of Cobra. The seven painters of the Dutch Experimental Group were represented there, with a number of works. Only Appel, Constant and Corneille actually made the trip to the exhibition – the first of a series of journeys which would characterize the moving web of the Cobra years. They were joined by Dotremont, who took advantage of his stay in Copenhagen to prepare the first issue of the review with Jorn.

Of the Dutch experimentalists, Anton Rooskens was the oldest member, being forty-three when the group was formed. He was self-taught in painting; having picked up what suited him from Van Gogh or Permeke, then the first École de Paris (Picasso, Matisse), he was suddenly confronted by some works from New Guinea,

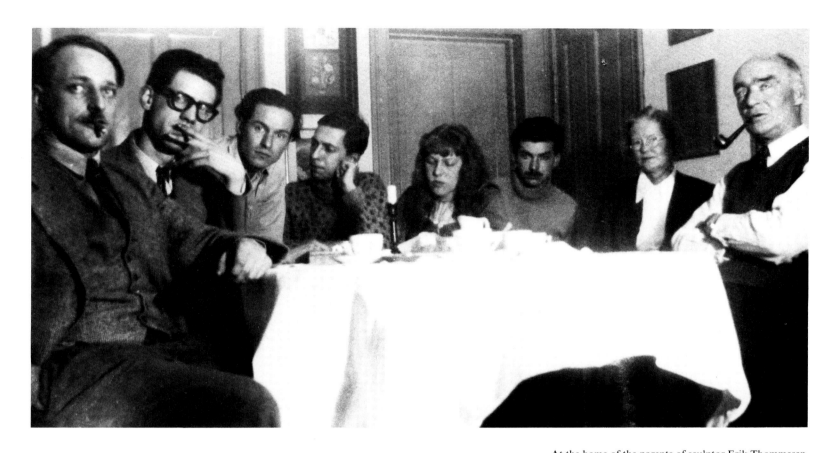

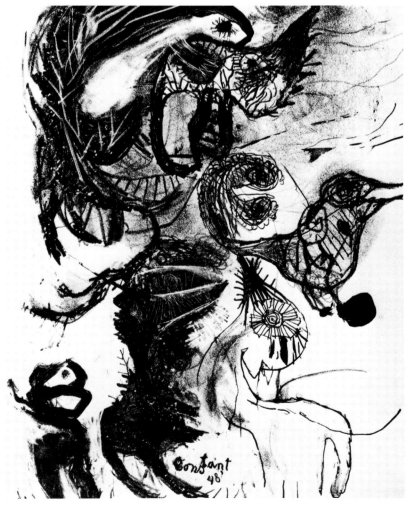

at a 1945 Amsterdam exhibition called *Kunst in Vrijheid* ('Art in Freedom'). It was the revelation, or rather the confirmation, he was waiting for, that these forms coming from the deepest past, bringing the primitive so close, would enable him to give a new depth of expression to the anguish and violence which filled him at the end of the war. There is a coincidence here which must be stressed; ten years before, and in a completely different context, it had been the discovery of an Oceanian mask which had bowled over Egill Jacobsen and his Danish friends. For Rooskens, the experience was of the same order; it was not a question of exoticism, and the works he painted under its impact, from *The Sun People* (1945) onwards bore perfect witness to that. If there were *Demons* (a 1948 gouache reproduced in *Reflex 1*), it was first and foremost because they had come from the 'distant interior', the limbo of the painter's imagination. Moreover Rooskens is an example of the great migration of forms which characterizes the twentieth century, the first century in Western history to have opened, that is to say universalized, its formal vocabulary, just as it has opened (universalized) its conception of the *ego*. The unknown world of the psyche, the lost continent of the sub-conscious, rediscovered through psychoanalysis, is also, in the atlas of culture and civilizations, that of so-called primitive art.

Constant, lithograph published in *Reflex 1*, Amsterdam, September–October 1948.

Rooskens, in his Oceanian, then his African period, was following the same descent towards man's origins as Jorn through mythology, Constant through the childlike, Heerup through folklore, Doucet through graffiti and Pedersen through magic. It is the same rejection of the historical, this 'sixth sense' of the conquering Westerner. In the way they trace the great life-force, Rooskens' paintings are like the steps of a dance, and they would be marked more and more strongly by African rhythms. (After Cobra, Rooskens would travel throughout North Africa.) He would remain faithful to 'improvisation', a term which suited him better than 'spontaneity', like a jazz musician. Improvisation in an area situated between light and dark, the pure sensation of colour and plastic thought, where intermediary beings appear: 'I only paint what interests me – animals, fish, birds. You could say: Oh look, a bird! But it is not, it is the form of a bird. In primitive communities, this creates magical images. Priests disguising themselves as birds – isn't that magic?' Thus Rooskens gave us a *Battle of Birds* (gouache, reproduced in *Reflex 2*) or a *Dance of Death*, which has something of the *shaman*'s trance about it.

Rooskens did not cement his relationship with Cobra; he ceased to participate in it after the Amsterdam exhibition, being motivated above all by his own work as a painter. Later, he would say: 'Cobra was a refreshing adventure for me, with some very happy moments. There were rivalries, but also a great emphasis on youth and promise.'

The first issue of *Reflex*, of which 1,000 copies were printed in 1948, and which opens, as we know, with Constant's manifesto, ends with a text by a newcomer, Eugène Brands, whom the experimentalists had noticed at the *Jonge Schilders* ('Young Painters') exhibition at the Stedelijk Museum. Also self-taught, Brands devoted himself to dadaist collages and assemblages with a great spirit of invention; and he had already, in 1945, given the name *Cobra* to one of his drawings. He was also an avid music fan and the 'sounds of far-off lands' (the title of an oil on canvas of 1950) would often inspire him in his painting. He would have liked his text 'To the Point', which appeared in *Reflex 1*, to be accompanied by a jungle drum; a sort of hymn to the vital impulse: 'We are mainly optimists. And that does not cost us the effort that you might imagine. We have formed this new group and we have much less money and support for our painting than we would ideally like. And that establishes a valuable equilibrium. In fact, we have realized that, when one piece of gold is reflected in the monotony of another, the concept of 'Ideal' put into words is nothing but a hollow sound; we have realized that, if modern life was withdrawn into minimal reserves, it would still be possible to open skylights giving onto unknown or unsuspected constellations. That is why it is easy for us to be optimistic and we declare ourselves in favour of joy – in the most elementary sense of the word.' Corneille, too, was motivated by the same sentiment. 'Museum-

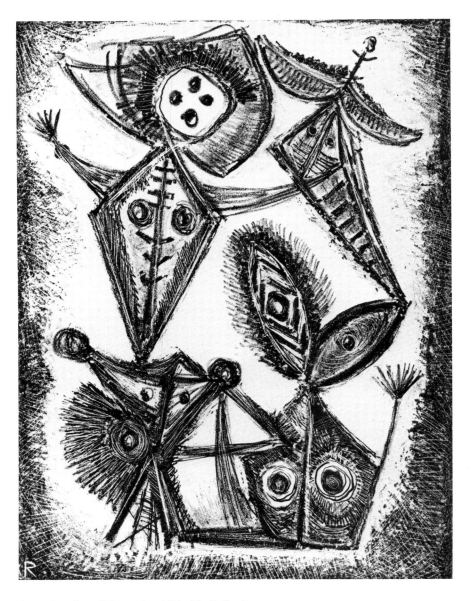

Anton Rooskens, lithograph published in *Reflex 2*, Amsterdam, February 1949.

The Dutch Experimental Group in Appel's studio, Amsterdam 1948. From left to right: *front row* Theo Wolvecamp, Corneille, Constant, Jan Nieuwenhuys, Eugene Brands and Anton Rooskens; *second row* Karel Appel, Jan G. Elburg and Gerrit Kouwenaar. Photo Gemeentemusea, Amsterdam.

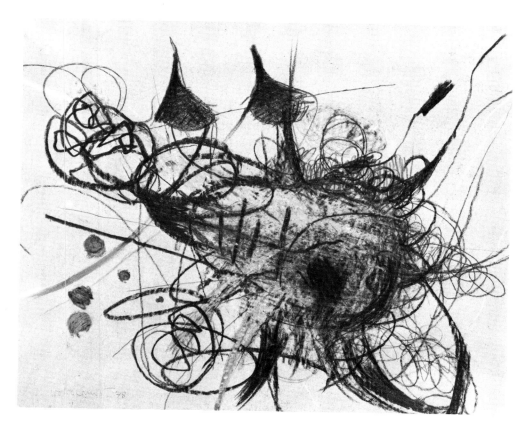

Theo Wolvecamp. Charcoal and greasepaint, 1948. De Jong collection, Ascona, Switzerland.

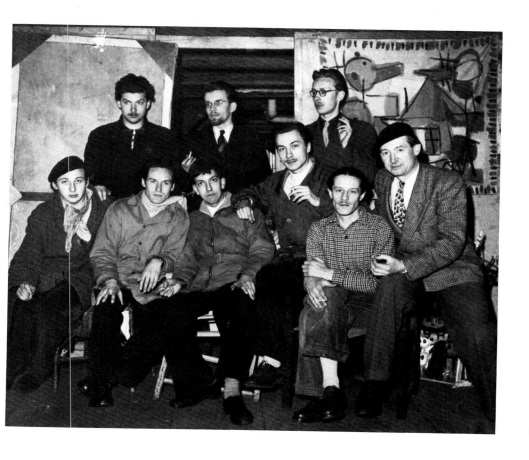

frog, gun-cardboard, tongue-petrol, belly of water, break my morning joy of piano-fish', he sang in a poem written at about the same time in Paris.

In *Reflex 2*, Brands suggested that the Experimental Group, which had just taken in a number of poets, should also become involved in authentic popular music. The idea was to find much support, corresponding as it did with the basic tendencies of the Dutch artists, as well as the Cobra group. His declared attraction towards the primitive arts put Brands in harmony with Rooskens, and, like the latter, he would leave Cobra after the 1949 exhibition at the Stedelijk Museum. All the same, it was thanks to him that it was able to take place: W. Sandberg had reserved some rooms for him for a one-man exhibition; Brands offered them to the newly formed group. The photograph of his studio which appeared in *Cobra 4* shows us a large canvas (no longer in existence) with rather African forms. Brands would evolve from there towards a lyrical abstraction, which was no surprise.

'A man of the pools, the woods, the marshes, of frosty, fantasmagorical mornings'. Thus Bert Schierbeek described Theo Wolvecamp. 'He *sees* a landscape when the translucent vapour of a morning dew envelopes all the lines and shapes in a mysterious mist, leaving them only to be sensed. He compounds these feelings in his work in a violent movement of colours and lines.' Wolvecamp was the most earthy of the Experimental Group, which he joined in the summer of 1948, having met its three founders – a lucky encounter for him, since it enabled him to shake off the last traces of Cubism which were encumbering his paintings. Wolvecamp's territory was the province of Gueldre, the 'high country' on the edge of the Germanic forest; he was born there, and would return there to work in peace, after the Cobra years, with two breaks in France, at Pont-Aven and Paris. For him, the Cobra years were those of more or less systematic experimentalism, when he forced himself, in his own way, to 'dismantle' the opposition of abstraction and figuration which had no more value in his eyes than that of the beautiful and the ugly. Like Rooskens, he was above all a painter's painter, which explains the small part he played in the collective activities and his relative lack of involvement. Dotremont compared Wolvecamp with Jorn, and not without reason – the one like the other having willing recourse to automatism. After all, Jorn greatly appreciated Wolvecamp's work and if the small monographs of the Cobra Library had got beyond the letter P, one would surely have been dedicated to him. What Wolvecamp said about his own method of painting also applied rather well to Jorn: 'I start with a spot of colour, with the materials, I do not know where I am going. I improvise and, in the almost automatic act of painting, I feel that I am liberating myself. When I paint, I do not judge what I've done – that comes later. What suggests forms and ideas to me is the contact with the materials . . . It is a matter of universalizing everyday reality.' Wolvecamp became the foremost

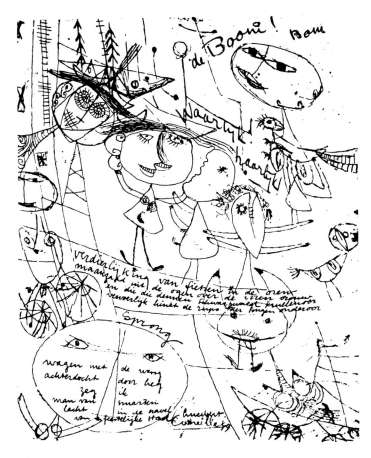

Corneille and Lucebert, *Word picture*. Handwritten text by
Lucebert on a sample of Corneille's lithography
(29.9 × 23.2 cm) published in *Reflex 2*, February 1949. C.A.
Groenendijk collection, Amsterdam.

'landscape painter' among the Dutch members of Cobra
– but his landscapes hardly reproduce the marshes of
Gueldre any more than Pollock's 'drippings' represent
the vast prairies of Wyoming: here too, the feeling of
nature is interiorized.

The *Experimentele Groep* also counted amongst its
members Constant's younger brother, Jan Nieuwen-
huys, who was then seeking to animate a small fan-
tasmagorical theatre, in a rather uninhibited way,
ranging from the *Robot* to the *Sleepwalking Cockerel*.
For the first issue of *Reflex*, he produced a lithograph
depicting a group of wealthy people watching the dance
of a cockerel which is changing into a flowering plant.

Just as the poets Schade, Nash and Sarvig had come
to take a more active role in the *Helhesten* group, so the
Reflex painters attracted young poets to their ranks,
whose pre-occupation was the revival of Dutch poetry
(and language) and who would come to be known, or
recognized, under the name of *Vijftigers* or Experimen-
talists – Lucebert, Kouwenaar, Elburg, Schierbeek.
They all featured in the second (and last) issue of *Reflex*,
as well as in *Cobra 4* the following year, which was
published on the occasion of the exhibition at the
Stedelijk Museum in Amsterdam. If Dotremont was a
product of Surrealism, and if the Belgian poets he drew
into the Cobra adventure had links with it too, this was

far from being the case with the young Dutch poets;
what they had behind them, in a literary sense, was
narrow provincialism, an academic formalism which
corresponded almost exactly with what the painters had
had to slough off before entering their 'experimental'
period. Kouwenaar, Lucebert, Elburg and Schierbeek –
none of them theoreticians – could not help but
recognize themselves in Constant's 'Manifesto' pub-
lished in *Reflex 1*. And they did recognize themselves in
it; for them, it meant going on to a new form of poetry,
albeit anti-poetry, politically militant. Jan Elburg de-
clared: 'With poetry, I try to establish lines of commun-
ication from person to person. To renew both myself
and others; to learn to see more, to feel more; to
advertise, to give an example.' The *Vijftigers* countered
intellectualism with 'psychic poetry'. Reflecting on this
brief period in 1953 (the Dutch poets broke away from
Cobra after the Amsterdam exhibition), Kouwenaar
explained: 'In the body, in sensorial experience and what
is connected to it by, let us say, social, biological and
above all psychological elasticity, you have our means of
penetrating existence, more than any proposition of
humanitarian idealism. We want to strip the word of its
imaginary layer of frost and give it its tangible function.
Through our everyday experience (feeling, seeing, read-
ing the newspaper, hearing, saying *oh!*, drinking, slipp-
ing, riding a bicycle, kissing, being afraid) we try to
(re)discover something of the Being in its primal naked-
ness (to avoid the word 'purity' which has been con-
taminated by religion); to begin again from this point.
Our poems are simultaneously *songs of innocence and
experience*. From here on, our aesthetic criterion is not
the cultural *beautiful* or *ugly*, but the empirical *real* or
unreal.' The parallels with the *Reflex* manifesto are clear.
Kouwenaar's very first publication would be a booklet
produced jointly with Constant under the *Experimentele
Groep* imprint in Amsterdam in 1949, *Goede morgen
Haan* ('Good morning cockerel'); the handwritten text
and the drawings overlap closely in the Cobra style;
moreover each page is coloured by hand by Constant.
Goede morgen Haan, which is now a collectors' item,
since only thirty copies were printed, was a veritable
feast for the eye. The 'quantity of life which spreads into
all the corners', as Tristan Tzara said, seems completely
inextinguishable here. And if joy is the real theme of the
poem – a carnivorous joy – Constant's translation of it
into pictures follows close behind, with his clawed and
toothed creatures dancing around the words and trans-
forming themselves before our very eyes.

Kouwenaar, for whom Cobra was a mere episode,
would deepen and develop in his work the exploration
through poetry of the relationship between language
and the world of objects, words and things: 'The
question for me', he said, 'is to discover to what extent
they can be reconciled, even though they remain sep-
arated by the space of the paper.' He wanted his poems
to be 'things' inserted amongst the other elements of
reality.

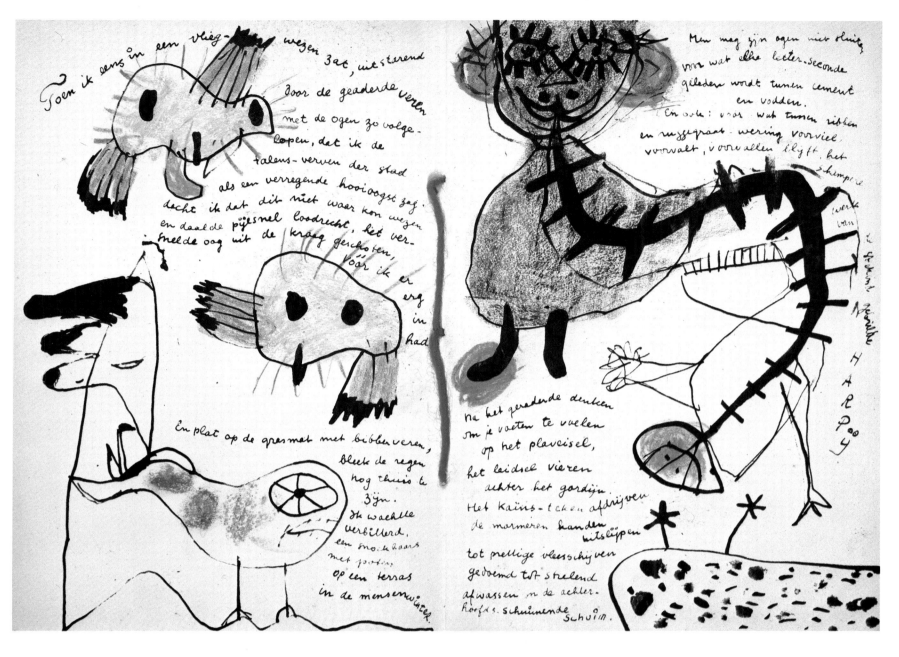

Title page and double-page spread from *Goede morgen Haan* ('Good morning cockerel'), text by Gerrit Kouwenaar with drawings by Constant. Format: 17.5 × 25.5 cm. Each copy was touched in with coloured pencils. Published by the Experimentele Groep in Holland, Amsterdam, 1949. Print run: 30 copies.

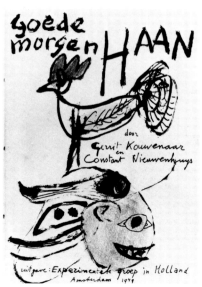

Title of the first issue of *Cobra* (Copenhagen, March 1949), indian ink drawing by Carl-Henning Pedersen.

Issue 2 of *Reflex* published a long and impassioned 'love letter to Indonesia, our martyred bride'; issue 4 of *Cobra* a 'speech in the defence of the *Vijftigers*': these two poems mark the debut of one of the protagonists of the renewal of Dutch sensibility, the poet, painter and illustrator Lucebert (the pseudonym of Lubertus J. Swaanswijk, born in Amsterdam in 1924). To be honest, Lucebert's participation in Cobra was rather a casual affair; in the years 1948–9, the young rebels had few places to meet in Amsterdam and even less possibilities for publishing their work: *Reflex* and *Cobra* offered an unexpected chance to do so. But Lucebert would say that, on the one hand, he was too 'egocentric' for communal activities and, on the other, he was not as 'spontaneous' as people believed.

Although he had received some training in the plastic arts (six months at the School of Decorative Arts in 1938), drawing and painting as much as he could (drawing mostly, since painting was 'too expensive'), he was, in 1949, a poet first and foremost – a poet who rejected established values in favour of a global radicalism, seeking to replace the 'traditional certainties' with 'generalized uncertainty'. The 'love letter' in *Reflex 2* denounced quite virulently the last – bloody – bounds of colonialism; the 'speech in the defence' in *Cobra 4* is no less aggressive:

You who, in your masters' houses,
Deepen your actions
I call them Acts of pleasure and privation
When you read blake, rimbaud or baudelaire
Listen! a sacred spirit breathes in our poems
Kiss the bare backside of art beneath your
sonnets and ballads

And, even though he does not abuse it like Rimbaud, he declares that he can have no confidence in *beauty*:

What was always called
Beauty beauty has burnt its own face
It no longer consoles men
It consoles larvae, reptiles, rats
But it frightens man
And forces him to realize
That he is a crumb of bread on the napkin
of the universe

In accordance with their temperament and in the specific context of the post-war Netherlands, Lucebert and the

Vijftigers took from the techniques of surrealist writing what could best liberate the violence which drove them on – violence which could be turned around and made into non-violence, as later with the Provos of the Sixties (Lucebert would later argue in their favour, seeing himself reflected in them). But there was to be no labelling; that was what horrified Lucebert most. Poet and/or painter (never more than in his case do the two conjunctions have the same value), he was the astonished demiurge of a complete tireless and rich genetic code, of an excessive carnival of infernal and celestial beings 'who come to me from their transcendental world like familiar guests . . . For me, all notions have value. I do not wish to give any of them preference and I am the last person in the world to arrive at syntheses. I think that contradictions continue, quite simply, to contradict each other. Instead of trying to resist their shock, I give free rein to them and I enjoy that liberty that they alone can give me. My pictures, my poems are playgrounds filled with pleasure where the Sahara and the oceans meet in sandcastles.'

There is nothing in this which contradicts Cobra – particularly as Lucebert went on to say: 'Concrete, abstract, for me it is all one, I can hardly see the difference; I only know that they are concepts of an ideology to which I am, and wish to remain, a stranger. A xenophobic stranger.' And he added this, which was so much in unison with Jorn: 'A good picture, a good poem, is always incomplete, always unfinished; both remain open, disordered. They reject the calm of suffering or of the smile, they love the manipulation of time and of eccentrics. Words seldom die heroes, and the same is true of pictures. And if a poem or a picture is successful, well, their fate is worse than that of the most miserable of mortals.' (Warning at the Lucebert exhibition at the Van Abbemuseum, Eindhoven, in 1961: 'Beware, children, it could fall and it is heavy'.)

Lucebert's situation in relation to Cobra is comparable with that of Michaux in relation to Surrealism. And,

Publisher's logo designed by Karel Appel for *De blijde en onvoorziene week* ('The happy and unforeseen week') by Hugo Claus. Éditions Cobra, Paris, December 1950.

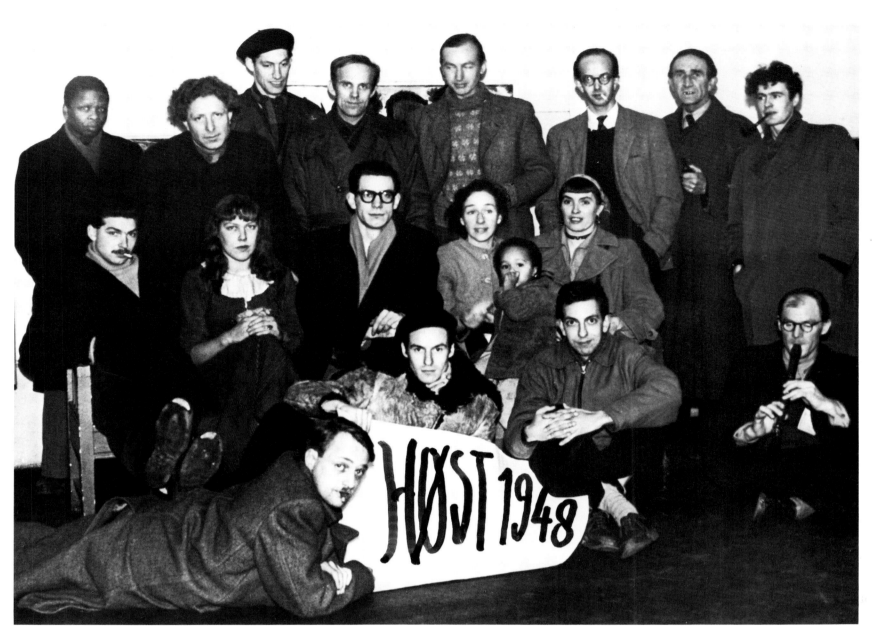

In one of the rooms at the Høst exhibition in Copenhagen, November–December 1948. *Standing, from left to right:* Ernest Mancoba, Carl-Henning Pedersen, Erik Ortvad, Ejler Bille, Knud Nielsen, Tage Mellerup, Aage Vogel-Jørgensen and Erik Thommesen. *Middle row:* Karel Appel, Christian Dotremont, Sonja Ferlov and Else Alfelt. *Front row:* Asger Jorn, Corneille, Constant, Henry Heerup and his recorder.

as Michaux, Lucebert did not really give precedence to either of his forms of expression, even though he found painting 'easier'. He practised alternation of the two: 'one cannot write poetry at just any old time, whilst one can start to paint at any hour of the day or night. And I would also become immensely bored if I limited myself to poetry.' Neither the collectivism or the internationalism of Cobra interested Lucebert and the Dutch poets; their principal work in those years centred on the Dutch language, which they brought back to life. The artists were able to jump the language barrier with more or less agility (as the correspondence in French between Jorn and Constant shows); not so the poets – with the

exception of Dotremont, who had a go at Danish and later at English, though scarcely at Dutch.

Eleven days after the meeting at the Café Notre-Dame, Appel, Corneille and Constant went to Copenhagen for the Høst exhibition, where they took along their own works and some by Brands, Rooskens, Wolvecamp and Jan Nieuwenhuys. Jorn and Dotremont had also gathered at the Danish capital and the Høst exhibition became the first manifestation of the Cobra movement. Yet of the Danes who were featured at the Høst exhibition, and appeared in the famous and much reproduced 'family photograph', almost half would not become involved in the international collaboration proposed by Jorn and Dotremont. It was a meeting of two generations, with the older Danes, who had for the most part attained maturity, welcoming the dynamism of the young Dutchmen, and it created a novel situation, which the preface to the Høst catalogue attempted to define. An extract of this was reproduced in *Cobra 1*:

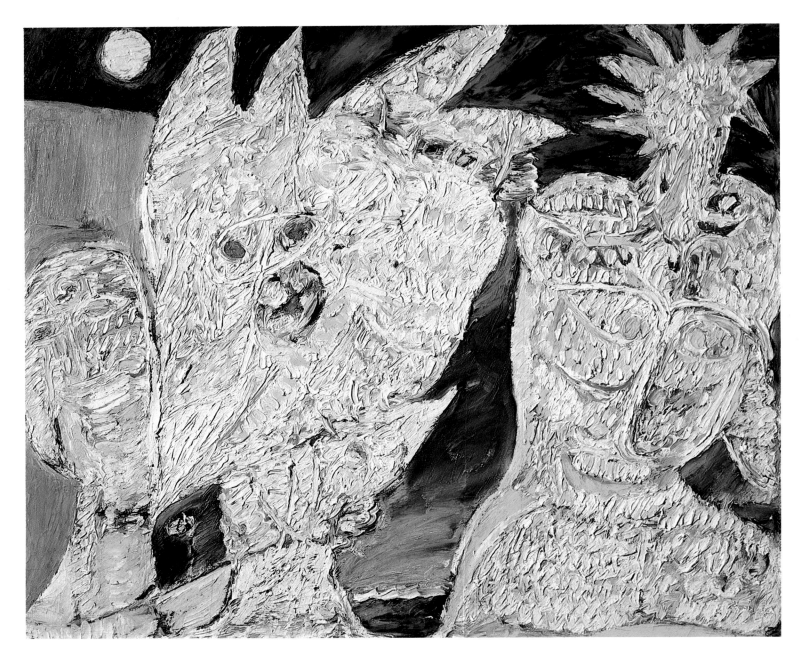

Carl-Henning Pedersen, *Starred heads*, 1949. Oil on canvas
(102 × 121 cm). Louisiana Museum, Humlebaek. Museum
photo.

Christian Dotremont and Asger Jorn,
I rise, you rise, we dream, 1948.
Oil on canvas (38 × 33 cm).
Private collection.
Photo André Morain, Paris.

une main
qui n'
existe pas
rencontre
(la nuit)
une main
qui va bientôt
apparaître

JE LÈVE
TU LÈVES
nous rêvons

105

'We do not have to go to France to find Danish art; and we are not so francophile as to give the French an opportunity to see themselves in a mirror – which would in any case probably not amuse them. In short, we are not serving French cuisine here. In the last few years, interest in the École de Paris (a justified interest) has reached such a pitch that some go as far as to seek out the *Parisian* tendency before artistic content.'

The first issue of *Cobra*, which Jorn and Dotremont put in hand without further ado, was, quite logically, dedicated to the defence and illustration of Danish art. In it, Dotremont and Constant gave free rein to their enthusiasm (Corneille would reserve his for an article in *Reflex 2*). After describing their welcome at Copenhagen railway station by Ejler Bille, whose name sounds rather comical in Dutch (*Bille* meaning 'buttock' in that language), Constant continued: 'There were so many surprises . . . The discovery of our Danish comrades' pictures, the interviews, sales, dinners, speeches, festivals, discussions, *Smørrebrød*, Danish girls, neon lights . . .' a whole vitality contrasting, by implication, with the hostility or mere indifference they had encountered elsewhere, notably in Holland itself. 'But I have nearly forgotten the most important thing, the *Høstudstilling* ('Høst exhibition'), that manifestation of free, happy and active life. I have never seen anything like it in other countries. Our Danish comrades showed us, us and our Belgian comrades, what there still remains to do for all those who consider art as a weapon of the spirit, as a tool for the construction, the transformation of the world, and the artist as a worker who subordinates all his possibilities, all his activities to the common task, and who does not seek to be great but useful . . . We shall return to Holland with a sensation of power.'

This was echoed by Corneille in *Reflex 2*: 'Our Danish friends' pictures were exhibited in a spacious pavilion, situated opposite the Osterport station. In life, there are some emotions which will never leave one; such are those which those pictures gave us. With some rare exceptions, they bear witness to the greatest vitality; new perspectives open up, and this is what is so valuable about them. We are submerged in a great sense of joy because we have found artists in Denmark who have fought all kinds of formalism indefatigably. What happiness! What they have to offer us goes way beyond what we had hoped.'

The Høst exhibition lasted from 19 November to 2 December. When it closed, Dotremont stayed on in Copenhagen to complete the first issue of *Cobra*, which would be printed there in French. He explained in a letter to Constant: 'I am dog tired. I have to copy all the texts LIKE THAT (in capitals) for the printer.' (15.12.1948). For his part, Dotremont's account of Denmark, of which he had dreamed so often, is that of a traveller who arrives in the promised land, in the land which keeps its promises. From that time on, Dotremont would maintain a very special relationship with Denmark and the Danes; from exaltation to disappoint-ment, they would make him happy or unhappy. He would return there throughout his entire life, faithful in his friendships and also because the woman who would become the central female figure in his work lived there. She appears under different names: Ulla (in *La Pierre et l'Oreiller*), Boule D'Or, Gloria (in the poems and logograms), a 'Danoiselle', Bente W*** in real life, his intermittent companion, his far-off lover. 'The Danes have opened the door,' he wrote in *Cobra 1*. 'They go as far as the dancer of Allais; they tear off those over-short trousers which are the skin. They believe that painting as conceived by Labisse cannot expose everything; it is still necessary to enter the interior to see the rest. But one does not enter, one is flat-footed, one does not trifle with objects, one cannot skate on their optic lakes . . . Denmark – our Denmark – sets an example in a notable way . . . for the liberty for which it paints, and I am talking about the liberty the painter has in front of a wall as much as in front of other painters and the stranger . . . An unprecedented experience begins . . . Copenhagen sets out to find the world – to *discover* it. Cobra is the first leaf of a huge forest full of trees which are ours – because they grow.'

All this signifies that a great departure had taken place. And the first issue of *Cobra*, which would not be published until March 1949, announced itself as a 'Bulletin for the co-ordination of artistic investigation' and a 'flexible bond between the experimental groups of Denmark (Høst), Belgium (the Revolutionary Surrealists) and Holland (Reflex).' And it was indeed from the fusion of these three groups that Cobra was born in the sense that Dotremont intended. Meanwhile, the first issue, whose title page was drawn by Carl-Henning Pedersen, would remain the only one of the whole series which published a collective work – the blue-green and orange lithograph which adorned the cover and which had been drawn jointly by Jorn, Egill Jacobsen and Carl-Henning Pederson. The absence of collective works, so characteristic of the Cobra spirit, in other issues of the review, was much regretted by Dotremont. He wrote to me much later: 'The image which we ourselves gave Cobra was limited, almost falsified, by our economic and practical problems . . . We were moreover not very conscious, we made Cobra almost without thinking, rather than thinking about it,' (letter dated 13.1.1975).

Cobra 1 was close in spirit to *Helhesten*, but the Danish texts were translated into French. It featured a poem by Jørgen Nash, 'Corn', whose imagery recalled that of Carl-Henning Pedersen ('By the light of the rainbow, a girl I had seen before opened my ear and then my pulp. But when I raised my eyes to see her better, she had disappeared with the rainbow'); a poem by Carl-Henning Pedersen, 'The Strange Night'; the brief declaration by Ejler Bille, 'Experiment is in Life', which opens on a true Cobra catch-phrase 'The painter and the sculptor must express themselves as directly as possible'; an archaeological study by P. V. Glob on the 'Scandinavian *Guldgubber*', amulets linked to Viking fertility

Cover of *Cobra 1*, Copenhagen, March 1949 (24.5 × 31 cm). Lithograph designed jointly by Asger Jorn, Egill Jacobsen and Carl-Henning Pedersen. Numerous copies have been retouched by hand.

rites; lastly, notes on the peasant art of Czechoslovakia and Sweden, which were a resumé of articles which had appeared in *Blok*, the Brno review, with which direct exchanges had been established (soon to be interrupted by political events). This resumé too was indirectly programmatic for Cobra. Vladimir Boucek wrote: 'The art of Czechoslovakian, Moravian and Slovakian peasants and shepherds . . . springs from life itself, following all its vibrations and oscillations . . . Its forms, through their function, their materials and their technique, correspond to actual tendencies. In total, folk art is the expression of a monumental optimism, of subconscious contentment which is to be found in repose and pleasure.' As for Jorn, he developed a thesis concerning the paintings from Dalecarlia which would remain essential Cobra, as for his own future critical and iconographic work: 'Folk art is considered generally from a point of view which is too nationalistic and even chauvinistic. And yet it is possible to find astonishing points of similarity in folk art from the most widely separated countries. There is no difference between East and West. Folk art is the only one which is truly international.' In a certain way, this is in accordance with the concept of culture which was being organized in the Soviet bloc countries. But Jorn immediately understood that it was necessary to offer universal folklore, of the kind that psychoanalysis and anthropology were revealing, as an alternative to the chauvinism of the 'return to the land'.

Also in *Cobra 1*, Jorn's *Conversation with the Penguins* resumed his arguments with surrealism; Dotremont would call it 'one of the most important Cobra texts'. Firstly, Jorn tackled the 'pure psychic automatism' introduced by Breton in his definition of surrealism (*First Manifesto*, 1924): 'The three words *pure psychic automatism* express a concept whose internal contradiction in terms is insoluble. One cannot express oneself in a purely psychic way; the act of self-expression is a physical act which embodies thought. So psychic automatism is linked organically to physical automatism. Even the psychic automatism which can be imagined in man's inner being is not *purely psychic* . . . what is the reality which *forms* thought? It is man's body, or, to put it another way, his "soul".' Here, Jorn uses the word *anima*, for which Dotremont recalls that he was unable to find a suitable French translation. Jorn said: 'Here, the *soul* is *the quality which reunites the different chemical elements which constitute the human body*.'

Here, the critique of Breton was made from a strictly materialist point of view, emphasizing 'needs' and 'desires' – man's vital interests. 'Our experimentation strives to let thought express itself spontaneously, beyond all the controls exerted by reason. By means of this irrational spontaneity, we attain the vital source of the being. Our goal is to escape the rule of reason which has never been and will never be anything but the idealized rule of the bourgeoisie – and to result in the rule of life.' A certain degree of Kierkegaardism was discernible in this suggestion of Jorn's, particularly when he spoke of the internal dialectics of natural aesthetics and morals. But he reversed these terms, having obviously suppressed all reference to a religious stage, the supreme stage for Kierkegaard, who sets the aesthetic before the moral.

'For the bourgeoisie, aesthetics and morality are not only distinct, but in a dramatic juxtaposition. For the materialist, they are linked in a dialectical situation . . . the goal of art is first of all moral, and then aesthetic.' The law of aesthetics should pass from the general to the individual, 'from need to desire . . . for us, at its limits, need can be satisfied without desire, but never desire without need.'

In *Cobra 4*, Constant was to give the exact complement to these ideas in a text entitled 'It is our desire which creates Revolution', but as early as *Petit Cobra 1*, published in Brussels in February 1949, Dotremont was announcing that Cobra would not be as 'ism' but a 'delirium of action'. Dotremont wanted the experiment-

108

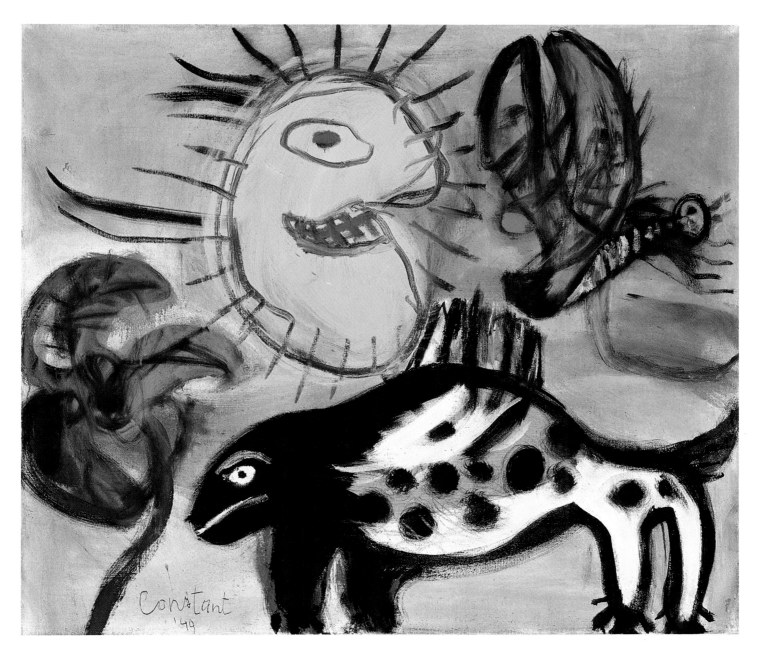

Constant, *Faun*, 1949. Oil on canvas (70 × 85 cm). De Jong collection, Ascona, Switzerland. Photo Victor E. Nieuwenhuys-A. van den Born, Amsterdam.

Constant, *Woman with dog*, 1949.
Oil on canvas (100 × 70 cm).
Collection of Mrs E. Kuijper-Sluyters.
Photo Victor E. Nieuwenhuys-
A. van den Born, Amsterdam.

ation put forward by Jorn, as a general concept, as the means of encouraging spontaneity and, through that, of encouraging the vital source of being, to be extremist, even simplistic. 'Cobra is an experimental-simplistic movement . . . simplism is the acute form of experimentation . . . Cobra will seek to find out in its very actions how far the stable principles of experimentation can go.' It was a matter of watching out so that 'the notion of experiment which generates art . . . and the experiment itself (does not) allow itself to get on its feet by virtue of whatever modesty, whatever opportunism.'

Whether they are Jorn's, Dotremont's or Constant's, the stances taken have common ground; more than a particular art form, they are concerned with creative activity for its own sake, the conditions under which it emerges, its ontological statute, its place in society and real life, with all the contradictions and paradoxes which that entails. Cobra's pre-occupations were, in fact, global ones: painting, sculpture, poetry, architecture, cinema, ethnography. It practised interspecialization, a kind of modern version of reborn humanism, and would create that Utopia of fully-realized, multi-dimensional man, of whom the interspecialist artist is the herald. For this reason, architecture was featured from the first issue of *Cobra* onwards. In this, an article by Michel Colle, denouncing functionalism and the return to rationalism via Perret and Le Corbusier, gave a plea for the liberation of the façade and preached symbolic architecture, which took the part of poetry and the dream, and responded to 'all the aspirations of the human being'. And it was Michel Colle who reminded us that curves are 'infinitely more generous and natural than straight lines' and that they 'can be disciplined with equal ease'. Cobra would, in fact, manifest a real phobia for the straight line and the form of abstract art which favoured it (Mondrian). In a series of articles for the Swedish review *Byggmästaren* (Stockholm 1946–7), in which he dissociated himself from Le Corbusier (in whose office he had worked) and from the rational and Apollinian concept of art, Jorn had opted for the dionysiac spontaneity of the 'barbarian'. To counter the classical distinction between the background and the form as construction and ideology, Jorn proposed substituting 'spontaneous simulaneity', construction and arabesque developing freely and without compromise, as in Celtic or Viking art, in Islam or in Mexico.

After Copenhagen, and in accordance with the logic of the name, Brussels was the location for the second Cobra exhibition, *La Fin et Les Moyens*, ('The end and the means') which Dotremont organized at the same time as editing the second issue of the review. As Noiret recalled, it developed 'amongst discussions and regular meetings held several times a week. At Dotremont's place, in the Rue des Éperonniers at first, then Rue de la Paille, with Marcel Havrenne, Paul Bourgoignie, Jacques Calonne, the musician of the group . . . Belgian Cobra was dominated at that time by poets, in contrast to the Danish and Dutch groups.'

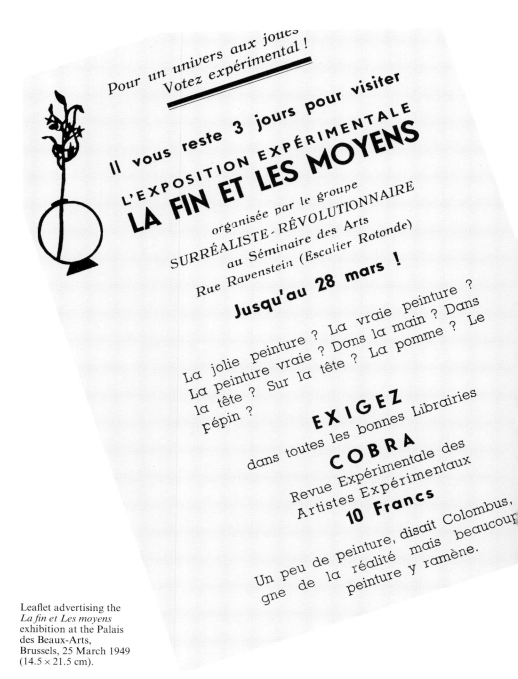

Leaflet advertising the *La fin et Les moyens* exhibition at the Palais des Beaux-Arts, Brussels, 25 March 1949 (14.5 × 21.5 cm).

Into this situation, peculiarly that of Brussels, Dotremont immediately started to introduce an international dimension through his incessant letters to Copenhagen and Amsterdam. Dotremont would remain a most active letter writer throughout the whole of his life; his correspondence is an integral part of his work and irreplaceable documentation for Cobra. Among those letters which have survived are two addressed to Constant around that time which throw light on Dotremont's concept of the co-existence of the painter and the non-painter (the poet, for example) and the dialectic of their exchange of ideas. Dotremont's worry was that Cobra was becoming too much involved with painting and was therefore falling into a limited specialization. 'You do not take into account the immense difference which exists between the painter and the non-painter. In order to go forward, a painter needs a set

purpose and even a "prejudice" but when the non-painter looks at a picture, he sees it from the outside and either likes or dislikes it. The painter is right to evaluate pictures from a concept of art, but the non-painter would be wrong to give up any of his freedom in front of the picture or substitute a concept of painting for his own taste . . . It would be equally absurd to create pictures which are full of fantasy and which prevent the spectator using his imagination. The spectator is not a soldier who steps in front of the picture and obeys an order to salute it. He is a man without a uniform, who lives in a society which is full of contradictions and which holds personal stories for him. When you put butter on a fire, the butter melts, but when you put a spectator in front of a picture, it is not quite the same equation,' (letter of 8.3.1949). And on the very day of the opening of 'The End and the Means', Dotremont wrote again: 'Emotion and understanding are inseparable, but they are not one and the same thing; they are two inseparable things. There is something worse than dualism and that is confusion. And there are cases where emotion runs contrary to comprehension and vice versa.'

It is easy to realize the effort Dotremont must have employed in bringing together so many very different individuals into a collective project, and organizing 'freedom for all'. 'Mixing administration, experimentation and travel', his action on the practical level seemed to enjoy all the obstacles it came up against. On the train journey from Copenhagen to Brussels, with the financing of his double project of an exhibition and *Cobra 2* in mind, he had no hesitation in selling his jacket. Throughout its entire existence, Cobra knew only need: 'We united because we were hungry,' Dotremont said later. The realization of *Cobra 2* was especially problematical. Despite the help of an Indonesian artist, Harry Wiggers, who featured in 'The End and The Means' and who had gathered some funds, Dotremont could only afford to have forty copies of the review released from the printer, which also had to serve as exhibition catalogues. The remaining copies (numbering 400) were held until a collector bought them in 1961.

The exhibition itself was a most modest affair; a floor of the Palais des Beaux-Arts was hired for nine days from 19–28 March 1949 and Dotremont had assembled forty-three small 'pictures, drawings and objects'. It was nevertheless quite a coup to gather Danish, Dutch and Belgians together, with a few 'outsiders' – twenty artists in all. The Danes involved were Jorn, Bille, Egill Jacobsen, Carl-Henning Pedersen and Elsa Alfelt (whose participation created some difficulties, since she was regarded as not sufficiently 'spontaneous'); the Dutch were Appel, Constant and Corneille. In the exhibition title, Dotremont was accenting what would be a constant feature of Cobra: the complementation and interaction of the painter's 'means', in terms of what materials were available, and his 'ends' (the finished picture). 'The means', he wrote in *Cobra 3*, 'cannot,

without metaphysics, be indifferent to the end, and their interest in the end is far from being fatally gluttonous.' For his part, Joseph Noiret said of his first contact: 'We are finally discovering a kind of painting where the means of expression themselves take part in the experiment, where the means are no longer the servants of the mind . . . for our part, we will undoubtedly get the Dutch and Danish artists to despise roundly what we call *pictorialism*; art must be changed from within, but a profound change is needed, a more general one, to relate one art form to another and art to everyday life.' The Belgian contribution was, in fact, principally a literary one, with Joseph Noiret, Paul Bougoignie and Dotremont, who exhibited, amongst other things, one of the word-pictures resulting from his recent collaboration with Jorn: 'There are more things in the Earth of a picture than in the Heaven of aesthetic theory.'

In addition to the participation of certain individuals (Walter Hoeber, Selim Sasson, Robert Willems), which was without consequence for Cobra, Dotremont brought along Pol Bury, who played an important role at that time in *Cobra 2*, Jacques Doucet and the Englishman Stephen Gilbert, whom Jorn had noticed at the Salon des Surindépendants in Paris in 1948 and whom he drew *nolens volens* into the Cobra adventure.

The pictures exhibited by Stephen Gilbert – small format for the most part – had been painted in perfect isolation in Ireland during the war (Ireland remained neutral). In them could be recognized insects, vegetation and fantastic creatures, which could be said, at least where they are not too much marked by the stamp of anguish, to have come from beyond Carroll's looking glass. They were, what is more, curiously related to the imaginary beings which sported in the pictures of several of the Danish artists; contact with Celtic art (subconscious in Gilbert's case) doubtlessly explains this remarkable coincidence. But whilst it would be one of Cobra's most profound impulses to develop mythical representation, this period had already come to an end for Gilbert. Having returned to Paris, where he settled permanently, it was non-representation which attracted him; when the monograph which Édouard Jaguer

Karel Appel, drawing, 1948. Indian ink (13 × 23 cm).

111

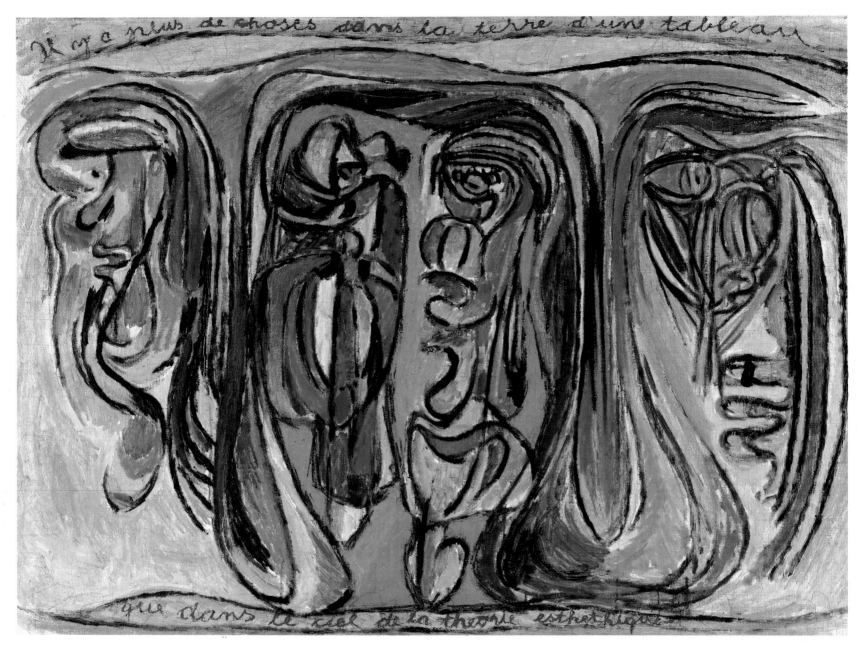

dedicated to him appeared in the *Cobra Library*, Gilbert was already a different painter. His works had become directed towards a sensitive neo-constructivism and he would finally abandon painting in favour of three-dimensional reliefs and sculptures, which accorded with the theoretical experiments which marked his dialogue with Constant, whose evolution after Cobra would proceed parallel to his own.

Dotremont wrote to Jorn from Brussels: 'So the exhibition opened on 19 March and the work was collective – perhaps for the first time in Brussels . . . there is something very pleasing about the fact that ten *writers* should organize and mount an exhibition of *painting*.' (25.3.1949). And to Constant: 'For ten days, I had to watch over the room every afternoon, talk to people and sell Cobra. But I was rewarded for my

Christian Dotremont and Asger Jorn, *There are more things on the earth of a picture than in the heaven of aesthetic theory*, 1949. Oil on canvas (100 × 129.5 cm). Private collection, Liège. This painting was featured at the Second International Exhibition of Cobra Experimental Art at the Palais des Beaux-Arts, Liège, 6 October–6 November 1951. Photo Speltdoorn, Brussels.

Christian Dotremont and Corneille, *Fourteen improvisations*, Brussels, April 1949. Each gouache measures approx. 16 × 13 cm. Private collection, Paris. 'Daubs of paint put down on the paper were inspired by Dotremont's manuscripts' (Letter from Corneille to Constant). Photo Luc Joubert, Paris.

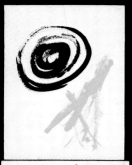

DE GROS ÉPIS JAU-
NES VONT EMPÊ-
CHER LE NOIR DE
SE PÉTRIR LUI-
MÊME CAR LE
PAIN NOIR A LUI
AUSSI BESOIN DE
JAUNE.

DANS LE JARDIN
DE LA PALETTE
UNE FLEUR QUI
A PLUSIEURS COU-
LEURS SOUS LA
MAIN APPARAÎT
MAIS RESTE BLAN-
CHE.

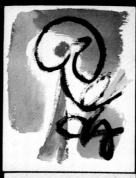

LE MONSIEUR A
GROSSE TÊTE
INQUIÈTE A
FAIT DES NŒUDS
POUR SE SOUVE-
NIR QU'IL DEVAIT
PRENDRE SES
JAMBES A SON COU
MAIS IL N'AVAIT
PAS DE MOUCHOIR
ET IL A NOUÉ SES
JAMBES MÊMES.

LE ROUGE SAUTE
A LA CORDE ET
LA CORDE C'EST
LE ROUGE. IL
NE SE PEND JA-
MAIS ET IL NE
SAUTE JAMAIS
PAR DESSUS LUI-
MÊME.

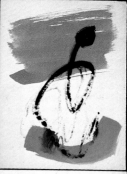

ENTRE CIEL ET
TERRE LE MA-
LINGRE PERSON-
NAGE NOIR COM-
MENCE A AVOIR
LES JAMBES COU-
PÉES.

LE JEUNE HOMME
COIFFÉ A LA RAIE
FAIT UN CLIN
D'ŒIL SI FER-
VENT QUE SON
ŒIL EST DER-
RIÈRE LE CIEL
ET QUE SON CŒUR
ÉCLATE EN ROUGE
ET EN VERT.

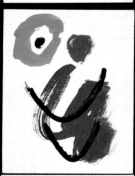

SURVEILLÉ PAR
LE MONSTRE QUI
DORT D'UN ŒIL,
LE NOIR DANSE
AVEC LA NOIRE
SUR LE PARQUET
OÙ LE MONSTRE
A GLISSÉ.

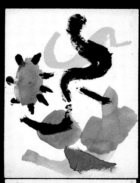

SOUS LA MER
BLANCHE, L'
ESCARGOT, L'
OURSIN, LA SI-
RÈNE, LE MAN-
DIBULAIRE ET
LA TACHE S'
INSTALLENT
POUR REGARDER
PASSER LEURS
COULEURS.

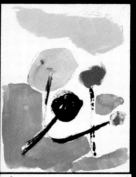

IL FAIT ÉTOUFFANT
ET DE GROSSES
TOUFFES DE COU-
LEUR A TÊTE
DE LAINE S'
ÉVADENT DE LA
TERRE.

DANS LA CENDRE
DE LA RAISON
LA PENSÉE SE
PENSE, TRICOTE
SES TRAITS D'
ESPRIT ET LES
COUPE EN QUATRE
A L'ABRI DU
SOLEIL.

MUET, IL FAIT
SIGNE DE SA BOU-
CHE, DE SES YEUX,
DE SON NEZ, DE
SES CHEVEUX
ET NE VOIT RIEN.

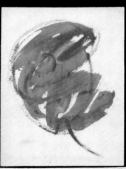

LE ROUGE, PARTI
VERS LE COQUE-
LICOT, LA CRÊTE
DU COQ OU LE
CARACO, GARDE
PARFOIS LE SOU-
VENIR DU TUBE
TANT IL EST
RÉALISTE !

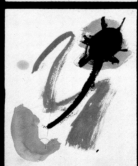

DANS LA RUE
SANGLANTE LE
RÉVERBÈRE EST
FERMÉ. C'EST L'
ALLUMEUR DE
RÉVERBÈRES
QUI A ÉTÉ AS-
SASSINÉ. IL GIT
DANS UN SAC
BRUN.

SUR LA MÉDITER-
RANNÉE LA
GONDOLE EST
BRUSQUEMENT
BRISÉE PAR
UNE BÊTE NOIRE
A UNE PATTE.

efforts. There were 1,200 visitors, which is not bad for a first attempt in Belgium. There were some important people, communists and others. Three buyers came along, but they bought nothing.' (6.4.1949). Most important of all, a twenty-one year old painter came to visit the exhibition, for whom the encounter with Dotremont and the discovery of spontaneous painting were crucial – Pierre Alechinsky. 'Went along to the seminar at the Arts out of curiosity and found a succession of discrete rooms laid out in the labyrinth of the Palais des Beaux-Arts. I met a tall, stooping enigmatic person with a dull complexion and hair smoothed down with its morning brilliantine,' Alechinsky recalled. 'The frame of his spectacles had just been repaired with sticking plaster. He was standing absolutely alone amongst the pictures hanging there. Christian Dotremont seemed to be on sentry duty, although he never let go of his heavy coat with big pockets stuffed with papers, his "document case". Under his arm he carried a Newspaper with a heading in green letters, *Les Lettres Françaises* and there were other publications sticking out of his shirt, copies of a review called *Cobra 2* with worm-like black and white drawings on the cover – "Lino-cut by Pol Bury" he confirmed. At least I knew a bit about *him*; we had exhibited together at the Belgian Young Painters in 1947 . . . I was struck by the Jorns, Constants and Corneilles on the wall – what a way to shake up the formalist teaching pumped down us at the École. From then on, Cobra was my school.'

Issue 2 of *Cobra* was the shortest of the series, having only eight pages within that cover by Pol Bury, who also published a long article in it 'De la pièce montée à la pierre', which was remarkable in that it concerned Cobra far more than it did his personal work, which was in the process of a complete change at that time. Bury would later say: 'The Cobra adventure as I experienced it was not a participation in a pictorial movement. It was more through texts than pictures that I collaborated in it.' But the meeting with Dotremont had had its effect: like him, he was a product of surrealism, from which he was dissociating himself, 'abandoning the image, the imagined fantasy in the manner of Magritte and Tanguy', in order to return to the 'material imagination'; this was moreover the theme of his article in *Cobra 2*. 'Here we are, having entered into the realm of the material; for the good of painting, we should stay there, we must take great care not to stray from it.' Constant would echo these words in the name of the Dutch Experimental Group: 'As for us, we only find the real source of art in the material. We are painters and materialism is for us, first and foremost, a sensation – sensation of the world and sensation of colour.' In his notes on 'Forms conceived as language' (in the same issue), Jorn, in his turn, defined what he understood by materialist art. Bury, Constant, Jorn – the convergences are clearly defined, and this short issue of *Cobra 2* showed the common denominators most clearly of all. Dotremont saw his role as listening to the artists before

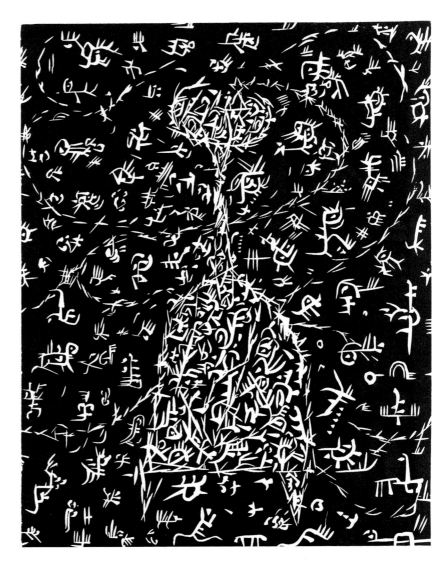

Cover of *Cobra 2*, Brussels, March 1949 (23 × 30.5 cm). Linocut by Pol Bury.

amplifying their ideas and demonstrating how they were put into practice: such was the theme of his speech in November at the Stedelijk Museum in Amsterdam, *Le Grand Rendez-vous naturel* ('The Great Natural Encounter'). For the moment, though, this idea only came across in issue 2 through the first episode of a humourous story, *Columbus*, in which he let his taste for drifting – dreamed language and life – have free rein.

Like Jorn and Dotremont, Pol Bury made reference to Gaston Bachelard and, more precisely, to his book *La Terre et les Rêveries de la Volonté*, which he read through a painter's eyes. 'There, we were able to find the foundations of material painting, where the active imagination insinuates itself between the coloured surface, using its wits to rediscover in the arabesque and the tracing of various movements which the mind passed through at the time of creation or in dreaming about it over again, what the mind of the painter did not suspect.' Active imagination is bound to the sensorial reactions aroused directly by colours and shapes; and that must be why Jorn demanded, for his part, that we should 'put art back on the basis of the *senses*. We have

to say "put back", because we think that the origins of art are instinctive, therefore materialist.' But again, it was necessary to be rid of the double illusion of realism (naturalism) and surrealism. Asger Jorn: 'The true realism, material realism, consists in searching for and expressing forms faithful to their content.' Pol Bury: 'From Dali's lazy frequentation of conical anamorphs to the mythical creatures of Delvaux, never will the mind be caught more *in flagrante delicto* playing truant. He sits on a stone and looks at the *countryside*, but he forgets that that stone, which he has made into a seat, contains more truth than all these mounted pieces.' Constant: 'We condemn all art which calls itself surrealist and which depends on the old naturalist methods . . . abstract art stems equally from naturalism and equally we condemn it . . . Both the one and the other refuse to consider and make use of *organic* methods of painting. The one and the other are to be found . . . in the same state of indifference to sensitivity *for sensitivity's sake* (and not as the object, as the subject).'

Jorn and Constant must be viewed in a marxist-revolutionary perspective: 'material realism' as they understood it 'seeks forms of reality *common to the senses of all men*' (Jorn) 'to arrive at a *common* art, art which responds to the transformation of society,' (Constant). When Jdanovism became established, this became like spreading a heresy: Cobra would be that heresy; yet surely heresy is the divine right of the creative artist. Having asserted it in *Les deux Soeurs* ('The Two Sisters' no. 3) against Breton's surrealism, Dotremont would soon come to depend on it in the name of Cobra against the Communist Party. *Cobra 2* also brought Pol Bury into contact with the poet Marcel Havrenne; together, they would publish *La Main Heureuse*, one of the finest books of the Cobra period. Havrenne, who 'weighed his words' like Bury 'weighed his colours' saw the latter animated 'in all conscience . . . by that secret gravity which is always to be found in the very expression of the most liberated fantasy.' A fruitful collaboration between the poet and the painter had become established. But Bury was already moving away from Cobra; chance, spontaneity and material did not attract him and he would abandon surface for volume, the fixed form for movement in action. 'I have made nothing but clumsy inroads into this kind of painting

. . . where the gesture is supposed to say everything, where the brush must toy with the skill of a cat toying with its shadow,' he explained later. 'I have never been able to throw the brush across the canvas.' He would, however, provide a plate for the sixth issue of *Cobra*, a swirling sketch, all claws and tendrils, and, for issue 7, the 'First plate of the Atlas of Universal Psychology', a project of emotional geography which aimed to provide a substitute for the cadastral surveys of 'the administrative organization.' This first plate is a map of the 'Centre', which is none other than Hainaut, the province where Bury was born and, as we know, one of the centres of Belgian Surrealism. Bury was then living in Louvière and running a bookshop.

There is one last point to note in relation to *Cobra 2*: the juxtaposition on the title page of two images widely separated in origin (a broken window pane and an aerial view of a settlement) with the caption: *For natural art, like the breaking of a window or the growth of a town.* It is a direct appeal to the image-making imagination; or, as Havrenne put it (whose two photographs accompanied this proposal): 'Here as elsewhere, new sensorial habits will create new images and new mythologies.' Alechinsky's meeting with Dotremont at the 'End and the Means' exhibition was another 'skingraft' for Cobra. If Jorn and the 'Abstract Surrealists' represented the generation of 1914, and Constant and *Reflex* (along with Dotremont) that of the Twenties, then Alechinsky and his friends in Brussels (Jean Raine, Luc de Heusch, Reinhoud etc.) represent the direct line of departure from that point: born around 1927, with the Second World War as the background to their adolescence, everything really started for them with the Liberation. And, after the Liberation, there was Cobra. Alechinsky was fascinated immediately: it was as well that some points on his personal itinerary had prepared him for this conjunction. He had been in contact as much with Surrealism (Magritte, André Souris, Marcel Lecomte, whose *Le Sens des Tarots* he illustrated) as with the abstract art of Van Lint and that of the 'Young French Painters' (which would have as its counterpoint the ephemeral 'Young Belgian Painters' of which he was a member). A painter by vocation, he also had a graphic training at the École de la Cambre (in advertising and magazines), thus avoiding specializing as a painter.

Juxtaposition of images published on the first page of *Cobra 2* with the comment: 'For natural art, like the breaking of a window pane or the growth of a town.'

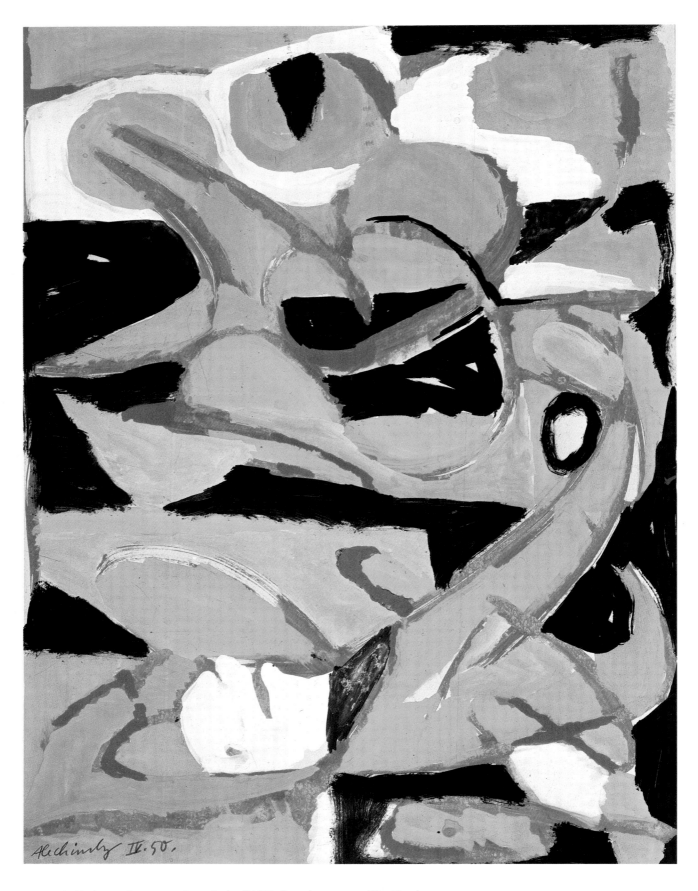

Pierre Alechinsky, *Night Exercise*, Brussels, April 1950. Gouache on paper (58 × 51 cm).
Collection of Stephane Janssen, Beverley Hills, California, USA.

The Ateliers du Marais, the 'International Cobra Research Centre', Brussels (Rue du Marais), now demolished. At the windows, from left to right: Michel Olyff, Olivier and Gina Strebelle, Micky and Pierre Alechinsky, Serge Vandercam, Reinhoud (D. Haese). Photo Serge Vandercam.

Moreover, having read the Surrealists in his adolescence, thanks to his friends Luc de Heusch and Jean Raine, he knew that poetry and painting were inter-communicating vessels for the Surrealists; the writings of Max Ernst or André Masson were in no way secondary to their paintings. Alechinsky was able to grasp the interplay of words and shapes and use it to his advantage, which is very much in the Cobra style. Bachelard's books, of which Jean Raine was the assiduous disciple in Paris, were even more significant in his intellectual formation, giving him the taste for 'material dreams': one could hardly wish for more points of similarity. Then there was that trick of nature which allowed Alechinsky, a thwarted left-hander, to have retained that instinctive skill inside himself. 'Society put a pen in my right hand, I put a pencil in my left. I draw and paint with my left hand.' Surely Cobra art, too, is the revolt of the left hand against the constraints it has been taught. Constraint for constraint, Alechinsky, the left-handed minority, would cultivate two ways of writing; one, his usual one, learnt by a naturally 'clumsy'

hand, the other, illegible without a mirror, practised by his natural left hand. This faculty was to determine his interest in calligraphy and his predilection for the printing process in which inverted words and images are put back into the right-reading sense.

What else? A taste for communal life: just before his meeting with Dotremont, Alechinsky and his young wife organized the Ateliers du Marais in the centre of Brussels, together with the ceramist Olivier Strebelle; here, artists could 'work, eat and sleep' in a community. And it was thus that the Ateliers du Marais became Cobra's 'International Research Centre', where Alechinsky's friends – Jean Raine, Luc de Heusch, the coppersmith and sculptor Reinhoud and the graphic engraver Michel Olyff – would meet those of Dotremont. During the Cobra years, it was certainly in his lithographic works, executed at the Ateliers du Marais and collected together subsequently under the title *Experiments without Experience*, that Alechinsky most obviously found himself and Cobra. Before Cobra, he had had two one-man exhibitions – the first of his portraits of 'monstrified' girls (in 1947), then, the following year of drawings, engravings and gouaches entitled *Sports and Spoilsports*, which showed something of Dubuffet's influence. Alechinsky would return time

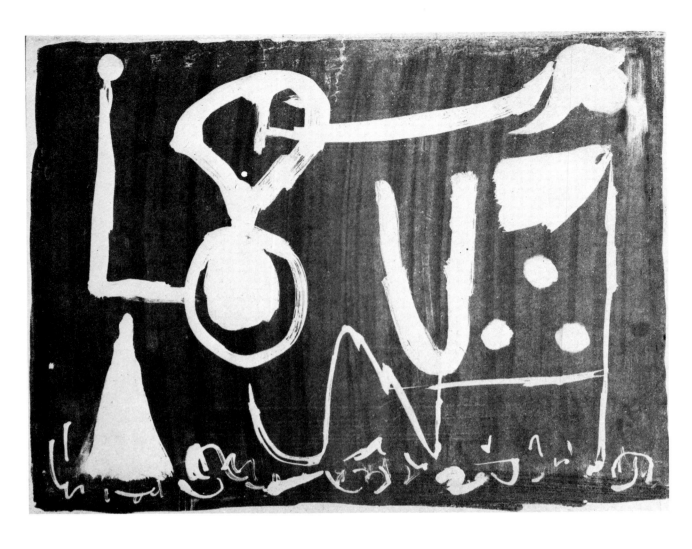

Pierre Alechinsky, *Colour wash*, 1950. Lithograph (22 × 29 cm). Only copy (made at the Marais studios). Musée Royale d'Art Moderne, Brussels.

A new edition of 100 copies of this lithograph was produced in 1979 for the 'Expériences sans l'expérience' collection.

Christian Dotremont, Micky Alechinsky and Luc de Heusch (Luc Zangrie) at the Ateliers du Marais in 1950.

On the typewriter cover, a wooden African object from the Congo.

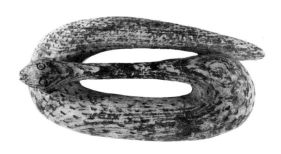

Pierre Alechinsky, *Sun at Mourlot's*, 1950.
Lithograph (15 × 32 cm).

Pierre Alechinsky, painted cupboard at the Ateliers du Marais, Brussels
1949 (since destroyed). Photo Roland d'Ursel, Brussels.

Headed paper used by the
Brussels Cobra group, with
the draft of a poem by
Christian Dotremont.

and time again to the theme of the fair and, indeed, this theme, with its links with popular culture, ran throughout the whole of Cobra (another point of affinity). In presenting the exhibition, Luc de Heusch (Luc Zangrie) wrote: 'Do not take him for a shipwrecked soul, because he bites. He knows how to paint any kind of cube and behind him, the birds eat them one by one; it is thus that Tom Thumb gets lost in the forest of symbols. He waits there for hungry children.' This exhibition took place at the Galerie Apollo, whose director Robert Delevoy had become interested in Cobra straight away; it really was a 'natural encounter'.

Christian Dotremont's new abode at 10 Rue de la Paille became at the same time a *Cobra place*, destined to become legendary. In a 1968 poem, Dotremont evoked it good-humouredly (and with a certain degree of nostalgia):

The table the tableu
of contents

the physical potato
the psychological feast

the fable of contents
versus the sand of manners

the earth the apple of bread
the forest of ruined houses

the straw of poverty
the corn of beauty

Cobra values
the café

the pâté on the new exercise
book of the old street

the cake the only thing
with the bean for the republic

the painting which falls
on the wall which rises

the fresh reviews of
improvisation and printing

painting in oil
cooking with margarine

Alone
amongst the Cobra group

Jorn peels the potatoes
before painting the eyes

Atlan opens the wine
Noiret the discussion

Alechinsky paints the cupboard
Calonne sets the monocle

Österlin starts the bread
Havrenne the poem

Appel's painting
in singing cries

Sandberg's hand grips
the door handle

Corneille's painting
in crying songs

Constant's block
of electrified wood

the cut light
the branched sun

the typewriter
at the pawn-brokers

to pay for the red and
black letter paper

poetry letters
the initiative taken

to paint poetry
without model or fashion

but modern in the deepest ages
right to the end of the nails

to eat like three
plus four

the folly of greatness
the happiness of roundness
the suitcase which goes to the Palais
des Beaux-Arts without going there

the train which goes to Copenhagen
to the Tycho Brahé tower

the tram which goes to Colinet
the shoe which goes to Amsterdam

the proprietary town of Brussels
in Cobra-on-Universe

the life and soul
until the end

neither florins nor crowns
nor francs but like bread

the first the last square
of the anti-squares

where I write the speech on the encounter
of the natural and the scandal

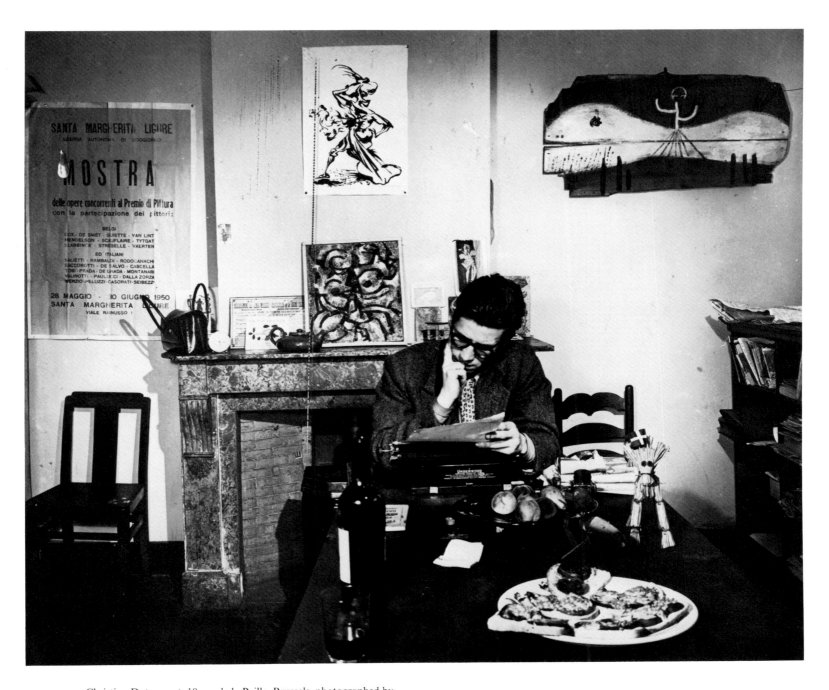

Christian Dotremont, 10 rue de la Paille, Brussels, photographed by
Serge Vandercam on 24 August 1950. On the mantelpiece, a gouache by
Pol Bury; above it, an indian ink drawing by Kurt Seligmann; on the
right, a painted object by Constant. On the table, a *jule buk*, a Danish
folk object made of straw, and associated with Christmas.

The arrangements at Rue de la Paille were, to say the
least, rudimentary. In a letter to Jorn (30.6.1949),
Dotremont recounted how 'my wife and I have been
living without gas or electricity for a month . . . and we
sleep on the floor so that we won't have to buy a bed.'
There was a small shed in the courtyard which served as
a temporary shelter and workshop for Cobra members
passing through. Their collaboration with Dotremont
was an active one and Corneille was able to tell Constant
(in a letter of 19.4.1949): 'Excellent work in Brussels with

Dotremont. Blobs of colour I threw onto the paper
sparked off a handwritten text from him (we each
worked on separate sheets). Four series of gouaches,
there are seven of them in all – the magic number. One
has already been framed.' From the documents of the
time and the 'collaborative works' (Dotremont with
Corneille, but also with Appel, Atlan, Alechinsky and
Dominguez) it is clear what unique hours were passed at
10 Rue de la Paille, as at the Ateliers du Marais, where
Utopia was made reality: 'poetry made by all', in

accordance with Lautréamont's wishes; in total, the 'communism of talent' that the Surrealists had attempted to initiate. In a 1962 article Dotremont said: 'The real foundations of our 'collective farms' are not only fraternity, poverty, exuberance, not only the need to establish stages in order to go beyond them, or to form groups to escape formalism in the act of creation; the essential thing was the conspiracy of subjectivities.'

It is certain that Dotremont's role was the dominant one every time; and it was he, of course, who would write the presentation for the first Paris exhibition of the three Dutch members of the Experimental Group, two of whom, Corneille and Appel, travelled together to the home of Colette Allendy, that great lady who was the widow of the Surrealists' psychoanalyst friend. Colette Allendy kept a floor of her house in Passy for exhibitions, all of which were landmarks. The Experimental Group's exhibition took place from 3 May to 2 June. Its brief catalogue, published under the imprint 'Éditions Cobra, Amsterdam' included Dotremont's text *Par la grande porte* where he treated a fundamental Cobra theme which he would later tirelessly develop: art and life going hand in hand. It was in this way that the first news reached Paris, a few months afterwards, of the dissidents of *La cause était entendue*.

'Far from being the withdrawal that some call it, experimentation in art is a permanent war. Doubtlessly there are painters who set off one fine day towards the goal they have dreamed of, full of enthusiasm and with their hands empty, advance and then settle down in a trench where nothing further reaches them. There are others, however, who go straight to their objective and ask those who are leaving to attach themselves like goats to this winning post and graze the remains, or at least to take them on their shoulders: in the name of their 'experiment', they ask those leaving not to take the experimental road. But experiment, in art as elsewhere, is neither dogmatic iconoclasm nor a relay race. This is what the painters of the Dutch Experimental Group have understood instinctively. They have accepted experimentation with all its difficulties, all its risks. They have refused to paint in a void, as if Surrealism had never existed and as if Holland was the spirit's whole horizon, and they have refused to copy what other experimentalists painted before them.

'Simple minds will be tempted to say that they are threading their way between surrealism and abstract art, taking this from the one, that from the other, like a housewife at the grocers taking three leeks, four turnips, one onion and three sticks of celery. They have entered painting through the front door – that of life – and they have rejected the thing that surrealism (in painting) and abstract art have in common: they put painting in a hall of mirrors.

'They are against pre-fabricated painting (or I could equally well say fabricated), which transforms the painter's hand into a pistol. They have simply noticed that they are not one-armed and have given their hand to

the picture, which has evidently accepted it.

'They are against platonic painting, which turns the painter's sex into a question mark. Against cultivated painting which makes the painter a toucher-up of the coats of arms of the bourgeoisie. Against scientific painting, which seeks to present the skeleton before the body is born, or has grown up and reddened its cheeks in the picture.

'They are against ironic painting, which may well express the organic joy of the universe and the historic joy of the world in 1949, but which is ashamed and which cuts the aesthetic impulse (if aesthetic is taken to mean sensorial, sensual and sensitive pleasure) with an elegant little intellectual penknife. They believe that the pleasure of life is not unworthy of painting and that the pleasure of painting is not unworthy of our life. And they have thus left the front door open.' This same preface of Dotremont's would be used for one of the later exhibitions of the three Dutch artists, this time taken to the Birch Gallery in Copenhagen by Constant.

The titles of the works speak for themselves, if one dares say it. Appel: *Innocence Accuses* (a relief of little wooden dolls painted like Russian *katchinas*); Constant: *Disobey* (a canvas which wavers between aggressiveness and levity); or, again, a drawing with the ironic title *School for Villains*. Amongst other things, Corneille

Pierre Alechinsky, poster for the First International Festival of Experimental Film, Knokke-le-Zoute, 25 June–8 July 1949.

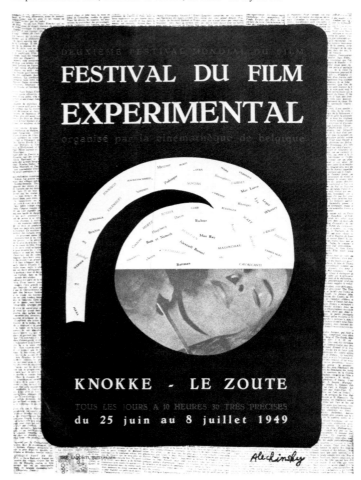

exhibited *Port Ahoy*, a gouache with collage which demonstrates his travel-pangs: the following month, he would once again be in North Africa. After all, the themes which dominated him in the years 1949–50 were principally linked with the sea – from the fish to the fisherman, from the sail to the sailor.

Cobra 3 was published in Brussels in liaison with, and on the occasion of, the International Festival of Experimental and Poetic Film, which had been organized by the Belgian Cinemathèque from 25 June to 8 July 1949 at Knokke-le-Zoute. Alechinsky, who had 'thrown himself into the Cobra fire' and was helping Dotremont, designed the cover. A reproduction of a black and white lithograph, it illustrated various new, cinematographic, trades, augmenting the series he had engraved the year before (*The Fisherman, The Musician, The Seamstress, The Unknown Soldier* etc.). *Cobra 3* was more 'revolutionary surrealist' than Cobra proper, to the extent that the Dutch and Danes were absent from it; furthermore it concerned only the cinema and experimentalism in the cinema, as Dotremont conceived it and wished to develop it. In *Petit Cobra 1* he had already enthusiastically presented Jørgen Roos's report on the 'Danish experimental cinema' and announced a revolutionary surrealist film for July 1949 – a project which finally finished in 1951 with Luc de Heusch's *Perséphone*, the only Cobra film.

In relation to the cinema, Dotremont once again took up most of the ideas which were dear to him ('the means cannot, without metaphysics, remain indifferent to the end and their interest in the end is far from being fatally gluttonous'). He insisted that men of art and men of science should collaborate and mutually complement each other: 'At the deepest source of what animates the wise man and the poet, the scientific film-maker and the poetic film-maker, is the same indestructible mixture of desire and curiosity, of need and taste.' To illustrate this most Bachelardian position, Dotremont and Alechinsky reproduced on the same page both the head of a waterflea, taken from a film shot through a microscope by Jean Painlevé, and the head of an Indonesian leather shadow puppet: the analogy of form is striking, as is that, several pages further on, of the disturbing grimaces of Dr Caligari, Dr Mabuse and Adolf Hitler. Dotremont further emphasized what experimental cinema could bring to the realm of the sensible consciousness and to

Comparisons published in *Cobra 3*:

above:
The head of a waterflea, taken from a film by Jean Painlevé; head of an Indonesian shadow puppet.

right:
Caligari (1920), Doctor Mabuse (1922), Hitler (1933). Illustration to the text of the 'Cinemasurrealifesto'.

poetic investigation. In this, he found himself in harmony with many Paris Surrealists. The 'Cinemasurrealifesto' in *Cobra 3* could have been signed by them too: 'The war between reality and the camera is a dream . . . The images have no sense except in every sense. Cinema has no meaning if the camera is a dormitory, if the camera obscura is a black cabinet, if the darkened hall is a hall of mirrors. Reality has no sense if it is insensitive. We are not amongst those who are frightened that the door will open of its own accord. We are amongst those who will not let it shut.' The way in which Dotremont used and re-used his image-concepts and articulated his thoughts are clearly illustrated here; 'the door which opens of its own accord' went back to the preface for the Dutch exhibition, *Par la grande porte*, just as 'the means which cannot remain indifferent to the end' recalled the March exhibition 'The End and the Means'.

Cobra 3 marked, along with Alechinsky's arrival, that of Jean Raine and Luc de Heusch. Jean Raine, born Jean-Philippe Robert Geenen in Brussels in 1927, had interrupted his extensive higher education to meet André Breton in Paris and to work with Gaston Bachelard, Pierre Mabille (who was to take part in the so-called 'Village' psycho-sociological test) and Henri Langlois, director of the French Cinemathèque. As a poet, it was first and foremost the cinema that inspired him in those days – an open cinema, free of images; he collaborated in the making of *Perséphone* and organized a Festival of Experimental and Abstract Film during the last Cobra exhibition, in Liège. Yet it took ten adventurous years before he set himself to 'paint Cobra, spontaneous Cobra, the Cobra cry'.

His companion in secondary and university studies, Luc de Heusch, who appeared in *Cobra 3* with a humorous note on a precursor of the Lumière brothers, Dr E. G. Robertson, opened the Cobra field of activity in just as important a way. An ethnologist, he paved the way for a new approach to far-off societies and to their systems of thinking and living; through him, Cobra would cease to be exclusively European. It was of Luc de Heusch (who used the pseudonym Luc Zangrie during the Cobra years), as of Jean Raine and a few others who became involved at that time, that Dotremont was thinking when he wrote to Jorn: 'The true members of Cobra are the working ones . . . Constant believes that Cobra is entirely composed of founders. That is a static conception of the experimental movement. For myself, I accept everyone who wishes to work in the same direction.' (26.5.1950).

As a 'revolutionary surrealist group, a member of the international front of Cobra experimental artists', the Belgian poets organized an exhibition entitled *L'Objet à travers les âges* ('The Object Through the Ages') in August 1949, once again at the Palais des Beaux-Arts in Brussels; this exhibition can be regarded as a development of the 'experiments on everyday life' inspired by Henri Lefebvre.

'Towards a purely poetic goal

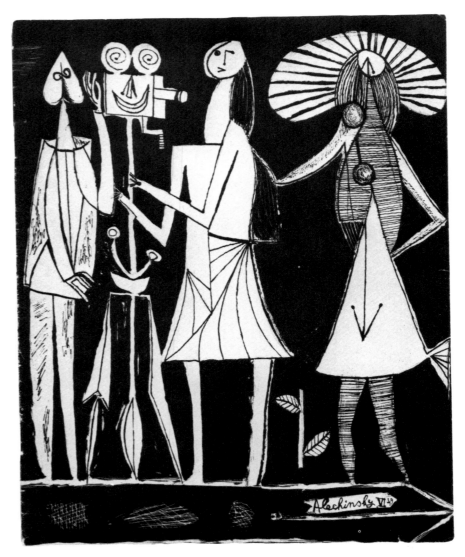

Cover of *Cobra 3*, Brussels, June 1949 (22 × 27.5 cm). Lithograph by Pierre Alechinsky printed on yellow paper.

whatever the knowledge of it might be
desire and curiosity being
originally identical . . .
Towards a purely experimental goal
Whatever the pleasure of it might be.'

Thus reads the yellow sheet printed *recto verso* which served as a prospectus. One cannot help but compare these intentions with what one reads in the *Critique de la vie quotidienne*: 'man's relationship to the object', Lefebvre wrote, 'is different, according to Marxism, from his relationship to possession. It is incomparably greater; what is important is not that I have possession of the object (as a capitalist or egalitarian), but that I have enjoyment in the human and complete sense of the word; it is that I have the most complex relationship, the richest in joy and happiness, with the *object* – which can be a thing or a living being. It is again through this object, in it and for it, that I enter into a complex network of human relationships.' This short exhibition, which lasted only from 6 to 13 August 1949, displayed

only simple, anti-aesthetic objects and in that respect it differed from the surrealist exhibitions and heralded *arte povera*, the neo-dadaism of the Sixties, anti-art: 'Bourgoignie, Calconne, Havrenne, Noiret and I', Dotremont recalled in *Quelques Observations . . .* ('Some Observations . . .', 1966) 'exhibited a compass drawing, a telephone, a huge mural poem, *Isabelle*, a bottle containing some words, a suitcase, the wax head of a shop window dummy (*Authentic head of authentic realism*), some coins arranged on the shelves of a velvet jewel case, potatoes etc. Three elements at least should be given

special consideration: a basket containing various objects put at the public's disposal (entitled *Les Réserves de la Sensibilité*), a brochure on musical perspectives, to which a call button had been fixed – an object which announced visitors – and the potatoes (we were eagerly awaiting the end of the exhibition so we could eat them).'

In a commentary of 1970, with Pop Art and the influence of Marcel Duchamp at their height, Dotremont added: 'Whereas Duchamp's coaster, ready-made and interchangeable as it is, remains just as exhibitable as when it was exhibited for the first time, potatoes are

L'objet
à travers les âges

Dans un but purement poétique
quoique la connaissance y soit pour quelque chose
le désir et la curiosité
étant originellement identiques
le groupe surréaliste-révolutionnaire
que l'on trouve trop surréaliste
et qu'ils trouvent trop révolutionnaire
parce qu'il est l'un et l'autre
pour que soit comble la mesure
et que la fête batte leur plein
pour que je retrouve Isabelle
pour que tu te trouves
et parce que nous n'aimons pas
les fougères réalistes

Prospectus for and invitation to 'The Object through the ages' exhibition, Palais des Beaux-Arts, Brussels, 6–13 August 1949.

Reconstruction of two 'objects' which were featured in the exhibition, made for the Cobra Retrospective at the Town Hall in Brussels in 1974:

left: The reserves of sensibility by Paul Bougoignie, Jacques Calonne, Christian Dotrement, Marcel Havrenne and Joseph Noiret.

below: Potatoes by Christian Dotremont. Photos Suzy Embo.

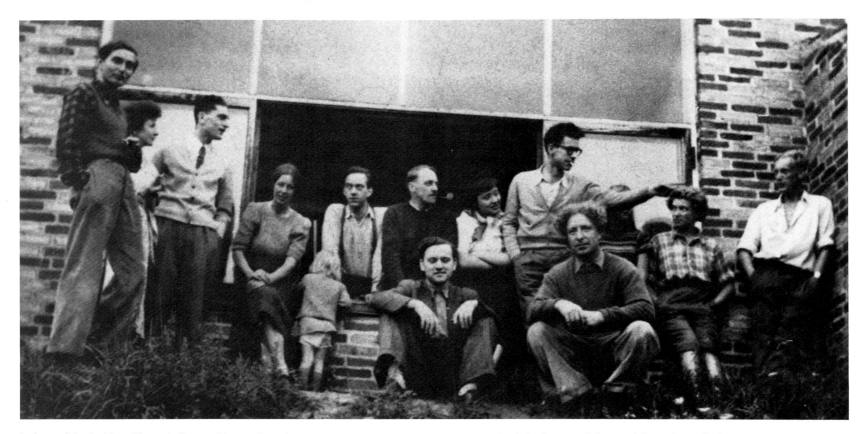

In front of the Architects' house in Bregneröd, near Copenhagen (August–September 1949): Stephen Gilbert, Simone and Édouard Jaguer, Mrs Gilbert, Anders Österlin, Asger Jorn, Ai-Li and Christian Dotremont, two architects; *front row*, Robert Dahlmann-Olsen and Carl-Henning Pedersen.

perishable and need replacing and anyone has the right to replace me as *author* in order to exhibit *them* today. Let us also note that the potatoes were raw, as if full of all their possibilities, capable of being mashed, made into chips or even plugs, whereas Pop Art, more often than not, celebrates the cooked, non-transferable *finished products*, the inedible and the pre-eaten.' This last distinction is clearly reminiscent of Lévi-Strauss – but in the half-paradoxical, half-serious sense in which Jorn and Noël Arnaud excelled (for example in their 1968 volume *La langue verte et la cuite*).

'One of our most total experiments': it was in these terms that Dotremont described the Bregneröd Meetings, which were organized on Jorn's initiative in the Summer of 1949. *Petit Cobra 2* was dedicated to them. Principally edited by Dotremont, it provides the best witness of events, not least of all because the absence of the Dutch artists is totally glossed over. This omission is understandable; it is easy to imagine how emotional relationships came into play in the life of a group as open as Cobra. A short time before the Bregneröd Meetings, Mathie van Domselaar, who was married to Constant, had decided to leave him and live with Asger Jorn, whose own marriage was in the process of breaking up. Dotremont expressed his feelings about it in a letter to Jorn: 'You may well think that I cannot take a stance over the Mathie affair. However, there is a surrealist

moral, the moral of desire, and from this point of view you are defensible to the extent that your desire and Mathie's were burning, exceptional, invincible.' For a while Jorn and Constant avoided each other, but eventually they resumed a collaboration which would last for many years to come, nourishing by exchanges of ideas, reciprocated influences and intellectual fascination. But in that August of 1949, Constant refused to participate in the Bregneröd congress and, to show solidarity with him, Corneille and Appel, who were expected there, did not go either. According to Dotremont, these meetings were 'exemplary' because 'they were not organized but, as the Danes say, *organic*. Exemplary because they integrated work *and* holidays, art *and* life. At Bregneröd it was impossible to see any contradiction at all: experimentation was in full flood . . . Bregneröd was the centre of the spiral. We were staying in a huge villa erected by young Danish architects as a homage to freedom.'

Sharing this Nordic Indian summer with Dotremont were two Swedish painters of the Imaginist group of Malmö, Carl Otto Hultén and Anders Österlin, who also became followers of Cobra; the Parisian Édouard Jaguer and his wife Simone; the English painter Stephen Gilbert with his wife and children; and, on the Danish side, Asger Jorn, Carl-Henning Pedersen, the architect

The Architects' house in Bregneröd. The ceiling with its painted panels. From left to right: *first row* Anders Österlin, *second row* 1. Carl-Otto Hultén; 2. Musen Pedersen, Carl-Henning's daughter; 3. Alfred H. Lilliendahll; 4. Erling Jørgensen; 5. Alfred H. Lilliendahl; 6. Carl Otto Hulten, *third row* 1. Asger Jorn; 2. Carl-Henning Pedersen; 3. and 4. Anders Österlin (fragments); 5. Erlin Jørgensen; 6. Mogens Balle. Photo K. Høver-Nordisk Presse Foto, Copenhagen.

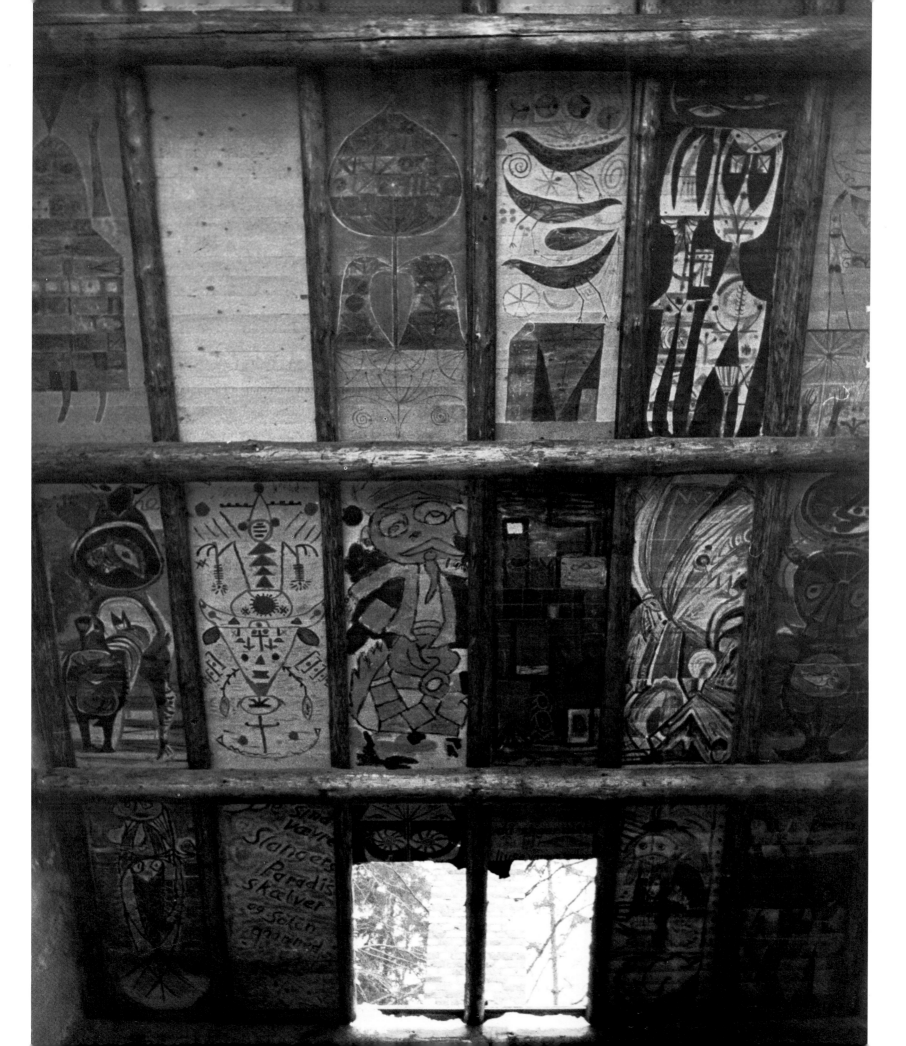

Robert Dahlmann-Olsen, the former editor of *Helhesten* and Danish editor of *Cobra*, as well as three members of the Spiralen co-operative which Jorn had just joined on resigning from Høst: Erling Jörgensen, Alfred H. Lilliendahl and the young painter Mogens Balle.

In 'Great Things' (*Petit Cobra 2*), Dotremont gave a substantial account of what happened at Bregneröd. The meetings were experimental in the very way they unfolded, as one can easily imagine, and which clearly distinguished them from the 'internationaleries' which had become fashionable, marking the rise of cultural institutions: 'no green baize or red carpets there, we played practical jokes, great practical jokes, made puns, terrific puns, we sang, we recited . . . The mark of valour, of justice, of the health of experimental art was in that humour, that carelessness, that youth; experimental art does not need to take things seriously to be taken seriously, to wear a wig, to always strike the right note. I prefer to treat words as others treat their friends.' History, in the narrative sense, cannot avoid making the facts become fixed as it tells them, ignoring as it does the dimension of sensitivity – perhaps because this has in fact evaporated. History classifies, creates a classification or a classic from what was formerly alive. It is a falsification. In the case of Cobra particularly, it can only lead us in the wrong direction, because Cobra 2 was a movement *in* movement, which sought to escape static forms. Listening to Dotremont makes this clear. 'In Bregneröd, the non-painters painted, the non-sculptors sculpted, the easel specialists got on their high horse, the non-poets wrote, the Danes spoke French, the francophones spoke a pidgin language where the nouns were essentially Danish, the adjectives English and the verbs German.' For Dotremont this 'confusion of languages' was welcome and fertile and, indeed, he tried to develop it in the 'Cobra Babel' experiment, a parallel effort to that of the painters: the fixed structures of communication, like those of representation, were jumbled up in order to make a contribution to 'the general kitting out of the aesthetic pleasure of the age'.

Jorn had authorization to use the Architects' house in Bregneröd for one month 'in return for the promise to decorate it, and that promise was kept.' What is more, Jorn had obtained 'a gift of 200 Krone worth of paints and brushes from the famous Stelling House in Copenhagen. Jorn made a huge and extremely colourful fresco which I find perfect in that it is spontaneous and deliberate like Asger himself . . . Also, Carl-Henning Pedersen filled a huge wall in the very obviously spontaneous and extremely refined way he has of saying everything in a few hours, but as if he was creating a giant picture . . . Stephen Gilbert occupied himself with the wall at the base of what Jorn called the "deliberation room" where we did spend an hour or two deliberating . . . Two of the dining room doors were decorated, one by Klaus Jorn who is seven, with automatic transfers in a kind of Japanese style, the other, by Gilbert again, using a number of phrases I had written in 1948:

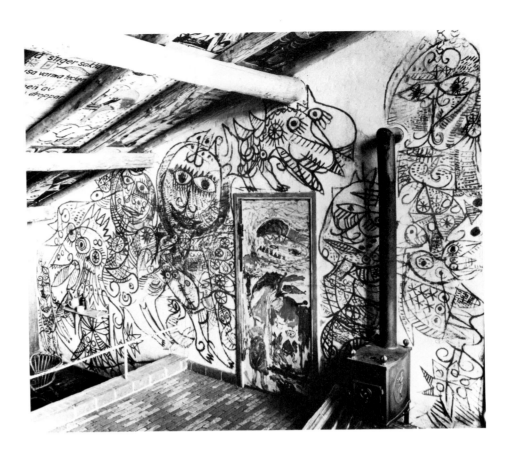

Architects' house at Bregneröd, Carl-Henning Pedersen's mural. The door was decorated by Jorn's son Klaus, aged seven. Painting subsequently removed.

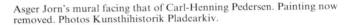

Asger Jorn's mural facing that of Carl-Henning Pedersen. Painting now removed. Photos Kunsthihistorik Pladearkiv.

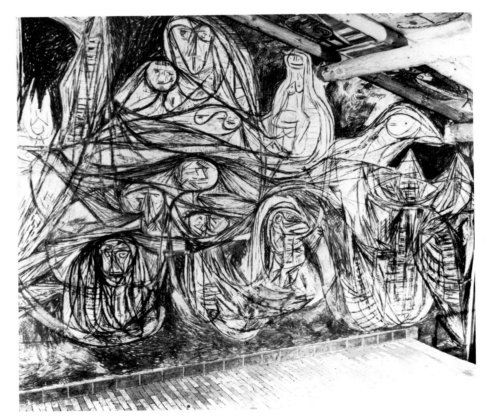

Do not crush your dream on entering
Put it like a rucksack on your shoulders
To share with us.

The ceilings running from the "dining room" to the "deliberation room" . . . appeared from within like a queens move on thirty or so squares . . . After the specialist Carlo had painted the base sections, three painters and ten or so non-painters set to work.'

Today, there is almost nothing left of so much festive imagination: a short time after the Cobra congress, the house played host to a youth organization and they were employed to clean the walls. Certain sections of the ceiling escaped their cleansing zeal, however, and were much later restored and transported to Sophienholm (Ljungby). Should we be scandalized beyond measure by this, when Cobra asserted the right to 'be an iconoclast'? Dotremont had clearly proclaimed: 'We are iconoclasts when necessary, painters when it suits us.' Many other Cobra works, collective or individual, met a similar fate (starting with Appel's mural *Questioning Children* in the dining room in Amsterdam Town Hall).

At the end of his account, Dotremont found a formula which might serve as a metaphorical definition of Cobra: 'Singing *Auprès de ma blonde* to the tune of the *Internationale*.' It echoes the foreword of the same *Petit Cobra 2*: 'A rapid explanation of the two words *national* and *international*'. This was taken up by Jorn: 'Art must have national roots and an international life . . . The Nation, for us in Cobra, is not an affair of government, police, army and customs. The Nation is an affair of the population, of these people. The artist's surest way is to support what he has of his own in these qualities.' Such ideas certainly suited the Danes: 'We are searching for our original mixture, our future origins, buried beneath the culture of the dominant classes', they said. The Belgians too could turn to a living folklore, as Alechinsky did not fail to do. But the Dutch of Amsterdam had no such thing at their disposal; that is why the original – for 'national' is synonymous with roots, origins – was for them the art of the child and the childhood of art, until they made contact (Corneille above all) with the folk art of North Africa, or, for Rooskens, with that of Black Africa.

Under the pens of Dotremont and Édouard Jaguer, *Petit Cobra 2* celebrated the rallying to Cobra of Carl Otto Hultén and Anders Österlin, two Swedes from Malmö in Scania, beyond the Sund; for them Copenhagen, much more than Stockholm, was a pole of attraction. Carl Otto Hultén, the elder of the two (born in 1916) had already run a course determined by the knowledge (scanty until the end of the war) he had been able to glean of Surrealism, when he came across Cobra. Like most of the Nordic painters, he had been particularly sensitive to Miró, Max Ernst, André Masson, even Dali (who was very influential in Sweden), and also to the poets, translated by Lundkvist and Ekelöf in parallel with their own poetry. C.-O. Hultén had been a member of Minotaur, a group founded in 1942, with his friend Max Walter Svanberg. A climate of oneiric eroticism, nourished by the study of Freud, was common to both of them, as was the spirit of metamorphosis which Hultén would never give up. He for his part increased his technical experimentation, thus making further adventures in the exploration of the imaginary. In 1944, at the advertising agency where he worked, he met Anders Österlin, a young painter ten years his junior, who was a fan of Klee, although he did not know a great deal about him. Hultén and Österlin would make their first trip to Copenhagen together and immerse themselves in the exceptional micro-climate created by *Helhesten* and the Høst and Spiralen co-operatives. They met Carl-Henning Pedersen and Jorn, who would then pay them a visit in Malmö on his way to Lapland (Saxnäs). Jorn was not one to pass by without leaving a trace: spontaneity filtered through to Hultén's canvasses and from then on he gave richer expression to colour.

Carl-Otto Hultén, heading for the *Imaginisterna* ('Imaginists') portfolio, published by Image, Malmö, 1948.

Then, according to the almost obligatory scenario for future Cobra members, came the trip to Paris; Hultén and Österlin saw the International Surrealist exhibition at the Galerie Maeght and made contacts with Victor Brauner, Jacques Herold and Riopelle. They travelled all the way to Berne to study Klee and, on their return to Malmö, the gathering of the *Imaginisterna* ('Imaginists') took place with publications under the imprint of 'Image Editions'. Amongst other things, a collection of Hultén's *'frottages'* appeared, entitled *Drömmar ur bladens hand*, which marked a new conquest for the process which had been rather put aside by its inventor, Max Ernst. Just as C.-O. Hultén's imagination was fed by a fertile sap, a desire which made colours and forms blossom and even explodes that of Anders Österlin was meditative, oriented towards the depths, slow breathing. Österlin demanded that a number of schematized, almost archetypal forms – the eye, the hand, the spiral, the wheel (here he is so close to Cobra) – should animate transparent spaces which play on one another in a light which seems to come from beyond the horizon. His primary interest was in metamorphoses – woman to flower, woman to bird, winged trees – which he executed with a taste for precision of construction which would become his dominant characteristic and would later alienate him from Cobra's primitiveness. In 1949,

Österlin and C.-O. Hultén were invited to the annual Spiralen exhibition, which was very much under Jorn's influence. After that, there would be Bregneröd, where Österlin would paint seven ceiling sections which fortunately, owing to their position, escaped the Boy Scouts' cleaning spree.

After Bregneröd, Dotremont and Jaguer visited the *Imaginisterna* in Malmö; from that point, the Cobra spiral developed a Swedish, or perhaps a Scanian, whirl. 'The Österlins' sister showed me into Anders' room', Dotremont tells us. 'I must say simply what emotion I experienced on walking in there. The feeling of being at home in a strange place.' Österlin would participate fairly actively in Cobra, but it was Hultén who would remain closest to Dotremont. In 1962, they executed a dozen word pictures together during a stay in Malmö by Dotremont, including *A flash of ink, We must jump the barriers of writing,* and *Du Fria* ('You who are free', which are words of the Swedish national anthem). To mark the occasion of one of Hultén's exhibitions in Stockholm, in 1963 at the Pierre Gallery, Dotremont wrote a preface which is doubly interesting in that it situated the painter's work in the Cobra perspective and related it at the same time to the experiments which he, Dotremont, had just carried out in Lapland, which he had just visited for the first time. 'The art of C.-O. Hultén does not only express the North, it does more; it intermingles deeply with the North. By saying that I have almost said it all. From time to time he travels away from the North, to see the French chateau of the instrument-maker Cheval, to find an African fetish or a Serbian peasant. But mainly he travels North of the North. He is part of the Nordic Cobra movement which, instead of uniting the vegetables, unites the roots. Cobra was a promise: Hultén kept it. In the Cobra days our friend Carl Otto played with techniques, invented the notable one of *imprimage* – he crossed his ground before diving in. Other Cobra painters had a similar evolution; Appel and Alechinsky for example.

'He discovered that the North is not purely fable nor purely reality, but both fable and reality, and that the methods of art are not simply methods but that they, too, constitute a universe. Are not canvas and paper already heavens? Is not a tube of colour an earth? Is ink not a river – or a night? The problem is therefore to make the materials of universal art coincide with Nordic fable – Nordic reality. How could Hultén succeed? Through a rare spontaneity which searches, which advances at a thousand and one different speeds and which resembles the way in which the Nordics think *towards* language, whereas the Southerner's thought stems *from* language. The spontaneity we are interested in is not the flair which glides along but the force which, having swallowed up the techniques, bites! The fundamental fable/reality in Hultén, it seems to me, is the night – that night which is the foremost Scandinavian speciality, furniture-making aside, the night from which the light needs must be torn by a permanent lover's struggle. The North itself is a

15ème *fascicule de la série des arts plastiques (monographies). Encyclopédie permanente de l'art expérimental. Direction: Internationale des artistes expérimentaux. Sec. gen.: Christian Dotremont. Bruxelles.*

The French edition of the collection 'Artistes Libres' in the Cobra Library. Heading of the fifteenth and final volume, dedicated to Carl-Henning Pedersen. Éditions Ejnar Munksgaard, Copenhagen, 1950.

huge drawing, or rather a huge engraving, which tells of the birth, life and death of the night, from a frosty beach to a primeval forest, from a hamlet of small dots to a town of wide lines, from a river full of stars to a sky full of lakes, from the mid-day mists to the midnight sun.'

Soon after the gathering at Bregneröd, Jorn set to work at the publishers, Munksgaard, on the small *Cobra Library* project. The fifteen monographs in the first and only series, which would appear the following year, were preceded by a general programme where Jorn and Dotremont explained what they meant by 'Free artists': 'This collection of monographs is designed to illustrate a new artistic tendency in making known some of the most typical people who represent it and in showing the principal characteristics of each artist through a series of modest brochures. We have tried to create contact between artists and public and to establish analogous exchanges with those who have been using the power of science for some time and who have pushed forward to international collaboration in that domain. We hope that artists representing other tendencies will take up this idea and that they too will help to break down the artificial framework within which the . . . *ism* schools confine contemporary art.

'Breaking down artificial barriers is the first principle of the movement which is represented here. We do not seek to combat the particular tendencies of today by creating a mixture of ancient traditions where the salt makes the food dull. On the contrary, it is our desire to seek the *synthesis* of the living in the abstract as much as in its real content, to approach social unity in which the personality can freely express itself, to create a liberated society and attain the surrealist dream just as much as the concrete facts and to found all these in romantic realism.

'We believe that these tendencies, if they are also taken up by other groups, will lead us to a change of style and a new artistic quality, to a metamorphosis, to that direct and true form of art of which we all dream – universal art, liberated from classical dogmas and formalist taboos: a human art.'

Leaving Denmark, where he had lived in a true community of ideas and emotions, as he wrote in *Petit Cobra 2*, Christian Dotremont found Brussels a troubled place by comparison – due, amongst other things, to the ravages that the dogma of 'social realism' had started to create. He travelled to Paris with Joseph Noiret to take part in the Congress of the Peace Fighters at the Salle

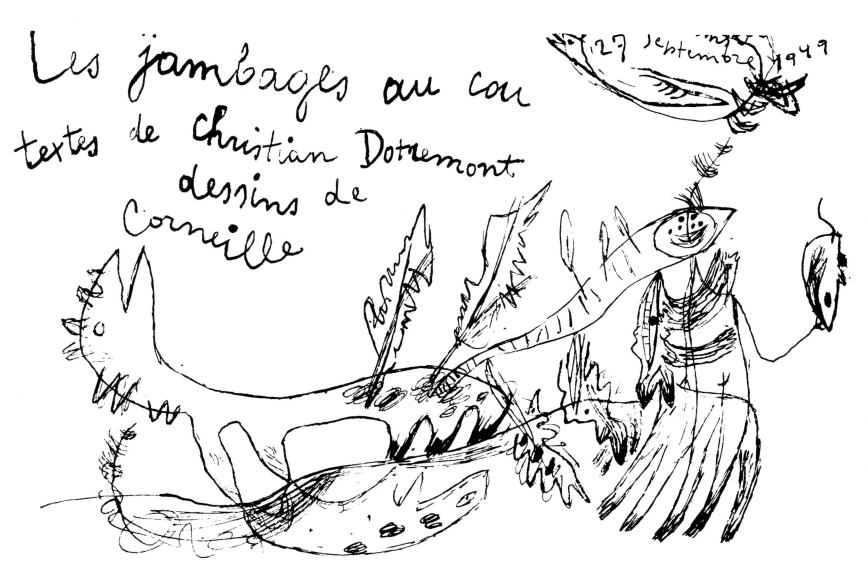

Legs around the neck, texts by Christian Dotremont, drawings by Corneille. Title page (18 × 25 cm), Cobra Uitgaven, Amsterdam, 1949.

Pleyel; this Congress would ratify the banning of Tito – a political turn of events which was followed in the People's Democracies by a wave of arrests, accusations and iniquitous trials which would cause many fellow travellers and sympathizers of the Communist Party to have serious doubts (Jean Cassou, Vercors, J.-M. Domenach, Clara Malraux etc.). Those people would become alienated, as was demonstrated in their polemics in articles which marked the birth of 'Titoism'. For their part, Noiret and Dotremont arrived at the Pleyel with a tract by the title of *La Colombe de Picasso*; in fact it consisted of three poems, one from each of our young Belgians, Éluardian in tone, the third of which, by Marcel Mariën writing under the pseudonym of Rene Caluwaert, was in Flemish. Dotremont's poem contained certain verses which could be read as a critique in anticipation of the stance the Congress would take. Moreover Noiret and Dotremont would publicly demonstrate their approval of the Yugoslav delegate's theses, when he presented them at the tribune to general hostility.

It is not enough to talk upside down
to be a crayfish with a long tongue
so that we dream
It is not enough to speak of fine weather
Whilst opening an umbrella
Nor to open an umbrella
Whilst we are preparing for spring
A lie awakes us
we only dream truth
The tip of our ear
makes a noise to wake
the dead we have in our memory
and our dream does not sleep
we are up in our lessons
and up in our dream
You would have to cut our heads off
to make us wear your helmets your mistakes
You would have to tear out our hearts

Since July, the Communist weekly *Les Lettres Françaises* had been publishing an edition in Brussels with two local pages added to the Paris edition; the man responsible for this was a certain Fernand Lefebvre (not to be confused with the philosopher of that name). As a

131

Revolutionary Surrealist, that is to say a Surrealist allied to the Communists, Dotremont was pleased to collaborate in these Belgian pages. It was to be his last attempt at 'walking a tightrope'; in fact, on the one side, Jorn pressed him more and more to break away from Surrealism and, on the other side, the party Communists, applying Jdanov's directives, were objecting to everything that did not conform to their norms, as much in the realm of the imaginary as the experimental. Dotremont and his Belgian friends could not even let their growing disenchantment be known publicly. By the end of the year, they had broken off with *Les Lettres Françaises* and all Communist and sympathetic organizations.

This split was a difficult one for Dotremont, causing him many problems, on which he expounded in numerous letters to Jorn and Constant who, less involved than he with any local communist party, did not feel that he himself faced any such dilemma. This battle would 'waste a lot of time' for Dotremont, as he admitted in his pamphlet ' "Social Realism" against the Revolution', in which he definitively formulated the position he was taking in the name of Cobra. Something had already crept into the poems he wrote in September, relating to some of Corneille's drawings and published in the booklet *Les jambages au cou*, of which twelve copies were printed in Amsterdam.

> Wherever I am
> I say what I see
> With closed eyes
>
> I see what I say
> Wake up and arise
> To make it change
> Even if someone tries to stop me

Corneille spent the summer in Algeria and Tunisia – in the burning lands bathed in southern light which would henceforward be his favourite countries; there, the stone and the ground had captured his attention and imagination and he had already started to cover and to describe these in his capacity of a 'winged geologist', as Dotremont called him. He had returned to Amsterdam to prepare the Cobra exhibition at the Stedelijk Museum and issue 4 of the review; concurrently with the drawings in *Les jambages au cou* (which date from 27 September 1949) he was scratching out (how nervously sharp are his pen lines on the paper) the sixteen pages of *Wandeling in het land der appelen* ('A Walk in the land of apples') this time unaccompanied by text. A commentary (on the title more than the drawings) appeared in *Cobra 4*: 'Amsterdam has become an immense garden with apple trees as far as the eye can see and, beside each tree, there are women, men, girls holding apples in their hands, dogs and cats clasping apples between their paws, birds playing billiards with apples.' 'The land of apples' is also one of the names for paradise in Celtic mythology – which Corneille knew more or less instinctively, even though the apples in question call to mind Cézanne (who

painted their 'memory, (their) past . . . and forgot every time to eat one') and the Surrealists who 'shot them at point blank range with their great photographic eye'.

It was thanks to Willem Sandberg, who was entirely responsible for the direction of the Stedelijk Museum at that time, that the Cobra exhibition was able to take place. It was a remarkable decision on his part from a number of points of view; Sandberg was sensitive to the fire and vitality of the young experimental artists, within the general perspective of European reconstruction; he explained himself over and over again in the prefaces he was glad to write for their last exhibitions – as in 1963, for Appel:

> After the war
> I asked myself
> What art's reply would be
> To all this violence
> To all these huge changes
> In human relationships
> The famous artists hardly responded
> I was about to turn away
> When I noticed a group of young people
> Who had something to say
> And who said it on a new note
> Violently
> In a primitive way perhaps
> They were seeking a new language
> With much warmth
> And resolution.

Given the political stance of Cobra, which was in direct opposition to that of the municipality of Amsterdam, Sandberg's decision was not taken without personal risk. And even if he did not follow the preparations for the exhibition that closely, he did allow the Cobra members the utmost freedom – which they used to full advantage, and out of this came the 'Amsterdam Scandal'. Sandberg himself was attacked violently and, in defending himself, he was forced to take on the defence of Cobra, which involved him far more than he had perhaps envisaged.

Sandberg thus cleared the way for a more dynamic conception of the role of the director of a museum of modern art. At that period, such museums hardly existed – there was one in New York and another in Paris and that was all. In fact, the museum in Amsterdam itself was not a modern art museum as such, but a municipal (*stedelijk*) one. Sandberg hosting Cobra represented the museum tackling current events face on, overturning the traditional conception; from then on, the museum would not be simply an instrument for registering, filtering and classifying. The past would cease to rule there exclusively, with the opening up of the institution to the present and even to the future. From that moment on, museums would exercise a constantly crucial influence on artistic life, adding to that of the commercial gallery in enhancing the reputation of artists and influencing the market place. This was to prove a new sociological factor.

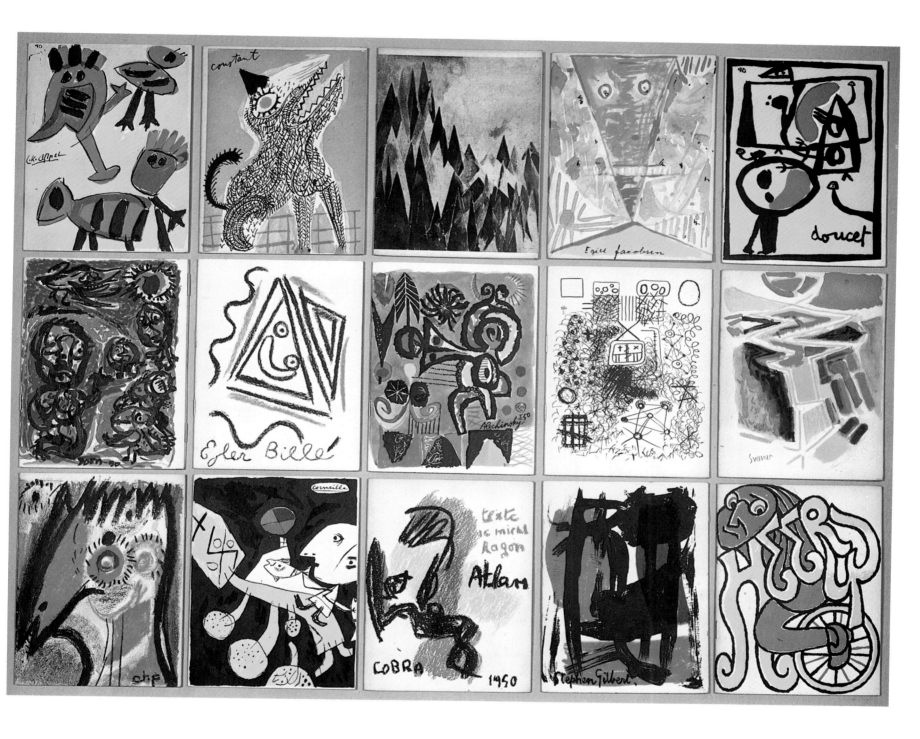

'Les Artistes Libres', first (and only) series of the Cobra Library. Covers of 15 volumes (13 × 17 cm), published by Ejnar Munksgaard, Copenhagen 1950. Photo Luc Joubert, Paris.

The whole collection was presented in a cardboard slipcase, lithographed by Asger Jorn.

Also planned were volumes on *Erik Ortvad* with text by Christian Dotremont (published in 1979 by the Kunstmuseum, Silkeborg) and on *Erik Thommesen* with a preface by Dotremont, which still exists in proof form.

From left to right.
First row: Christian Dotremont, *Karel Appel* (vol. 3); Christian Dotremont, *Constant* (vol. 6), Édouard Jaguer, *Else Alfelt* (vol. 2); Christian Dotremont, Egill Jacobsen (vol. 13); Jean Laude, *Jacques Doucet* (vol. 8);
Second row: Christian Dotremont, *Asger Jorn* (vol. 14); Michel Ragon, *Ejler Bille* (vol. 5); Luc Zangrie-de Heusch, *Pierre Alechinsky* (vol. 1); Christian Dotremont; *Sonja Ferlov* (vol. 9); Édouard Jaguer, *Svavar Gudnason* (vol. 11);
Third row: Christian Dotremont, *Carl-Henning Pedersen* (vol. 15); Christian Dotremont, *Corneille* (vol. 7); Michel Ragon, *Jean-Michel Atlan* (vol. 4); Édouard Jaguer, *Stephen Gilbert* (vol. 10); Christian Dotremont, *Henry Heerup* (vol. 12).

OBRA COBRA COBRA COBRA COBRA COBRA COBRA COBRA COBRA COBRA C
A COBRA COBRA COBRA COBRA COBRA COBRA COBRA COBRA COBRA COBR
OBRA COBRA COBRA COBRA COBRA COBRA COBRA COBRA COBRA C
A COBRA COBRA COBRA COBRA COBRA COBRA COBRA COBRA COBRA COBR
OBRA COBRA COBRA COBRA COBRA COBRA COBRA COBRA COBRA C
A COBRA COBRA COBRA COBRA COBRA COBRA COBRA COBRA COBRA COBR
OBRA COBRA COBRA COBRA COBRA COBRA COBRA COBRA COBRA C
A COBRA COBRA COBRA COBRA COBRA COBRA COBRA COBRA COBRA COBR
OBRA COBRA COBRA COBRA COBRA COBRA COBRA COBRA COBRA C
A COBRA COBRA COBRA COBRA COBRA COBRA COBRA COBRA COBRA COBR.

OBRA COBRA COBRA COBRA COBRA COBRA COBRA COBRA COBRA COBRA
A COBRA COBRA COBRA COBRA COBRA COBRA COBRA COBRA COBRA COB
OBRA COBRA COBRA COBRA COBRA COBRA COBRA COBRA COBRA COBRA
A COBRA COBRA COBRA COBRA COBRA COBRA COBRA COBRA COBRA COB
OBRA COBRA COBRA COBRA COBRA COBRA COBRA COBRA COBRA COBRA
A COBRA COBRA COBRA COBRA COBRA COBRA COBRA COBRA COBRA COB
OBRA COBRA COBRA COBRA COBRA COBRA COBRA COBRA COBRA COBRA
A COBRA COBRA COBRA COBRA COBRA COBRA COBRA COBRA COBRA COB
OBRA COBRA COBRA COBRA COBRA COBRA COBRA COBRA COBRA COBRA
A COBRA COBRA COBRA COBRA COBRA COBRA COBRA COBRA COBRA COB

A COBRA COBRA COBRA COBRA COBRA COBRA COBRA COBRA COBRA COBR
OBRA COBRA COBRA COBRA COBRA COBRA COBRA COBRA COBRA C
A COBRA COBRA COBRA COBRA COBRA COBRA COBRA COBRA COBR
OBRA COBRA COBRA COBRA COBRA COBRA COBRA COBRA COBRA C
A COBRA COBRA COBRA COBRA NUMÉRO HOLLANDAIS COBRA COBRA COBR
OBRA COBRA COBRA COBRA COB COBRA AMSTERDAM RA COBRA COBRA C

Endpapers of *Cobra 4*, Amsterdam, November 1949 (24 × 30.6 cm). Stills from an experimental Danish film by the film-maker Jørgen Roos and the painter Willem Freddie.

The preparation and realization of *Cobra 4* and the exhibition at the Stedelijk Museum were due in great part to Corneille's initiative – he had taken over from Constant as secretary to the Experimental Group. Dotremont supplied some texts by himself and his friends for the review, also the cover illustration – a photomontage of the Danish filmscript-writer Jørgen Ross and the Danish painter Wilhelm Freddie, which was the first manifestation of Cobra's obsession with representing the tongue. However, Dotremont was not in control of the final contents, nor did he correct the proofs of the French section, which contained numerous errors and literals (Pierre Alechinsky becoming Paul Aleschinsky etc.). Whilst Corneille and Constant were busy in Amsterdam collecting works for the exhibition (some hundred to be shown, according to the agreement with Sandberg, in the seven ground-floor rooms), Dotremont put out an invitation, or appeal perhaps, to an international congress of experimental artists, which would run concurrently with the exhibition and take place in the very same rooms of the museum, from 4 to 5 November 1949, exactly one year after the 'founding' of Cobra.

Dotremont desired to reinforce the experimental current which he felt to be 'more than ever under attack because it is more and more necessary in a society paralysed by *formalism*.' Under the heading of formalism, Dotremont included (in a letter to Jorn, January 1950) the 'three dangers to Cobra: Surrealism, Abstract Art, Social Realism' as being each of them 'against spontaneity, and dualistic: they separate the end and the means, the content and the form.' The accent in his invitation was very much on the notion of union: 'Cobra is a dialectical union of the dream and action, form and content . . . it is for a wider and wider union of experimental artists.' On the page of commentaries opening issue 4 of the review, other formulations underlined this point: 'For the first time in the history of experimental art, and contrary to the *stories* of experimental art, it seems that natural unity and efficient activity are carrying the day.' 'Experimental artists of the world unite!' was the call Dotremont sent out. Indeed, the true Marxist tone can be found in Constant's manifesto, 'It is our desire which creates the Revolution', which aligned itself directly with Marx's 1844 manuscript in advocating an 'appropriation of human reality'. Constant situated artistic activity in a generality which went beyond the simple production of pictures; it was creativity which was of primary interest to him and the psycho-socio-economic conditions under which it could most completely flourish. Constant's latterday evolution, his progressive abandonment of painting in favour of the Utopian concept of 'New Babylon', a place for collective creativity translated into action, was already germinating at that time. The only artist to whom Constant made reference was Mondrian, and that in order to take up the opposite point of view to his; he wished himself to be thought of as being as perfectly materialist as Mondrian was idealist (even spiritual). But, as we know, unlike poles attract: Mondrian, too, wanted to pass beyond art by means of a perfect

communication and reciprocity between art and life. In his article for the first issue of the review *De Stijl*, Mondrian wrote: 'The whole of modern life, growing deeper, can be purely reflected in the picture.' Constant wished for nothing different:

'To talk of desire to us men of the twentieth century is to talk of the unknown, because all that we know of the realm of our desires is that they lead to an immense desire for freedom. Freedom in our social life, which we consider to be something quite elementary, opens for us the door giving onto the new world, a world where all cultural aspects, all the internal relations of our united lives, will have another value.

'It is impossible to know a desire other than in satisfying it, and the satisfaction of our elementary desire is *the Revolution*. Creative activity is thus situated in revolution, the cultural activity of the twentieth century, that is, and only revolution can make us know our desires, even in 1949. No definition can substitute for revolution! Dialectical materialism has taught us that consciousness is dependent on social circumstances. And when these prevent us from satisfying ourselves, it is our needs which drive us to recognize our desires, whence comes experimentation, that is the widening of knowledge. Experiment is not only an instrument of knowledge, it is the very condition of knowledge in an age when our needs no longer correspond with the cultural conditions which must channel them.

'But on what should experimentation be based from now on? Since our desires are unknown to us for the most part, experimentation should always take as its point of departure the actual state of our knowledge. What we already know is material from which we derive possibilities it did not acknowledge. And, having once found the new functions of this acquisition, an even wider field spreads out before our eyes, a field which can lead to discoveries which are as yet unimaginable to us.

'It is thus that artists are put to the discovery of creation, which has been stifled since the current culture became established, then of liberation, then of revolution. Present day individualist culture has replaced creation with *artistic production*, which has produced nothing but the symbols of a tragic impotence, nothing but the cries of despair of the individual chained by aesthetic prohibitions: Thou shalt not . . .

'To create is always to do what is not yet known, and the unknown frightens those who believe they have something to lose. But we who have nothing to lose but our chains can easily try adventure; in this adventure, we only risk our rather sterile virginity, that of the abstract painter. Let us fill Mondrian's virgin canvas, even if it is only with our misfortunes. Is not misfortune preferable to death for strong men who know how to fight? It is the enemy himself who has made us partisans, to form the resistance, and, if discipline is his strength, courage is ours – and it is courage, not discipline, which will win the war.

'Such is our response to the abstracts, whether or not they praise themselves for their spontaneity. Their *spontaneity* is that of the rebellious child, who does not know what he wants; he wants to be free without being able to do without his parents' protection. But being free is like being strong; liberty only manifests itself in creation or struggle, which have the same goal at base – the carrying out of our lives.

'*It is life which demands creation, and beauty is life!*

'If, then, society turns against us, against our works, reproaching us for being rather *incomprehensible*, we reply:

1. That, in 1949, humanity is incapable of understanding anything but the struggle necessary for liberation.

2. That we, too, do not want to be *understood*, but to be liberated and that *we are condemned to experimentation by the same causes which drive the world into the struggle*.

3. That we would not be able to be creators in a passive world and that *it is the current struggle which nourishes our invention*.

4. Lastly, that humanity, having become creative, cannot say goodbye to the aesthetic and ethical concepts which have never had any goal save putting a brake on creation and which are now responsible for people's lack of understanding of our experimentation.

'So understanding is nothing more than recreating what is born of the same desire. Humanity, including ourselves, is on the point of discovering its desires and, in satisfying them, we will make them known.'

Constant's manifesto in *Cobra 4* was illustrated, if that is the right word, with reproductions of children's pictures (and Sunday painters), mixed up unconventionally with reproductions of pictures by artists participating in the exhibition. They were commented on purely and simply by Corneille's slogans which appeared throughout the whole issue: 'The best picture is the one which reason can admit.' Cobra was, of course, a growth of irrationality, or (particularly in Constant's case) of 'reasoned irregularity' in art. Even if the term was rarely employed by them, the Cobra artists were seeking ways towards the sub-conscious (the non-conscious, the pre-conscious). Some of these ways were indicated to them by children's drawing and painting. It was not a question of 'acting like a child' but of finding the eternal child in man, 'the abandoned, the forsaken and, at the same time, the divinely powerful', to recall Jung's terms (*The Essence of Mythology*) which are most appropriate here. Children's drawings (which also fascinated Bachelard – see his preface to J. Boutonnier's *The Drawings of Children*, 1953) possess many elements – some of them the most difficult to isolate – which can effectively pass into 'adult' work when, as in Cobra, it depreciates the conventional system of representation and conceptualization and no longer lets it dominate, without taking a share itself in the running of things. In psychological terms, it is a question of emotional expressivity, automatism of representation, schematization of appearances with a certain playful interference.

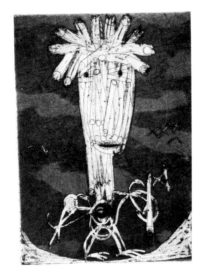

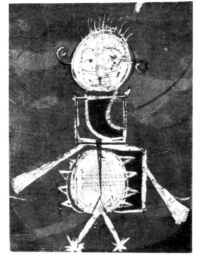

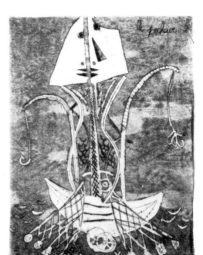

Pierre Alechinsky, *The Trades*, suite of nine etchings, Brussels 1948, accompanied by texts by Luc de Heusch (Zangrie). Each etching is approx. 13.5 × 10cm.

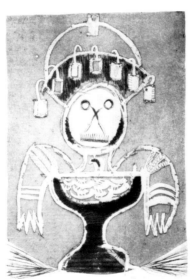

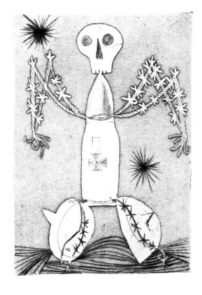

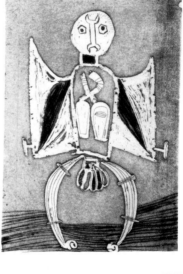

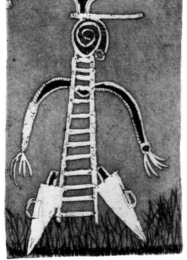

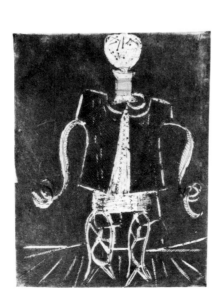

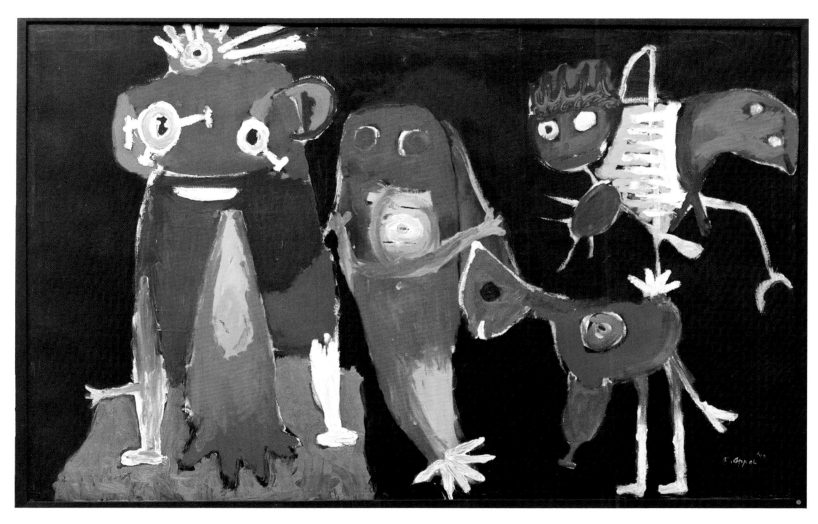

Karel Appel, *Hip, hip, hip, hourra!*, 1949.
Oil on canvas (82 × 129 cm). Private collection.

opposite, top to bottom
First row: *The Butcher, The Hairdresser, The Seamstress*
Second row: *The Musician, The Unknown Soldier, The Fireman*
Third row: *The Fisherman, The Mechanic, The Priest*

This last point, play, is naturally linked to pleasure: 'No good picture without great pleasure' read one of Corneille's slogans. In this respect, Cobra was in accord with Dubuffet, or with André Masson who had just published a valued collection of texts entitled *Le plaisir de peindre*. For Corneille above all, it must also be recognized as fundamental optimism, in contrast to the despair of Sisyphus, or of Sartre: 'Who denies happiness on Earth denies art!' A particularly forceful formula which echoed revolutionary Utopianism. Corneille said again: 'Experimentation is the search for well-being'. This hedonism in the relationship of the artist to his work sent Mondrian's puritanism and the pathos of expressionism right back to the underworld.

Cobra 4 attacked Realism as well: 'Realism is the negation of reality' (Corneille). And Dotremont (in *Le Grand Rendez-vous Naturel*) added: 'All the same, it is impossible for reality to limit itself to the melancholy of

the blind alley, to the metallurgist's overalls, to the woman who combs her hair in front of her psyche, to the minotaur, to celery, to a herring, the guitar, the flower pot, a church, a monument on the corner.' Corneille again: 'The imagination is the means of knowing reality.' And Dotremont: 'Formalism completes the circuit, they have sacrificed all to it, what they were able to see and what they were going to be able to see, what they could become and what they could touch and what they could do.' In the end, Dotremont would call formalism an 'illness' against which he put up the 'health' of the Cobra painters. An unconsciously revealing metaphor and a touch of rather black humour, when we consider that Cobra would later come to an end because both Jorn and Dotremont fell gravely ill. 'Between you and me, the dab of colour appears to me to be the dab of health. The splash of colour makes a hole on a white wall, a star in an empty sky, and it is impossible to play with it: it falls on the senses like a meteorite, though coming from very near, it gives the eye the power of the hand and never lies, because it is not a sign made into an object.' This was all long before Paris discovered 'tachism' – in which Dotremont, making fun of himself, as was his habit, would not fail to play his part, comparing the marks of paint with those of tuberculosis: 'There are various sorts of spots. Catastrophe can replace the aesthetic,' he would finally write, with a touch of particularly black humour, in *La Pierre et L'Oreiller*.

Issue 4 also contained a short article by Marcel Havrenne, 'Pour une physique de l'écriture', which marked an important theoretical stage between Jorn's reflections and Dotremont's future logograms. There were also poems by Edouard Jaguer and Hubert Juin as well as the *Vijftigers* – Elburg, Kouwenaar, Lucebert and Schierbeek. Jan Elburg also published a photomontage in which Titian's *Venus and Urbino* took on the features of a bitter old man in the Truman mould, watched by a number of strikers. Because of the 'obscenity' of this image, the local magistrate with responsibility for the arts in the municipality of Amsterdam demanded that this issue should be banned from sale at the museum.

From good photographic archives, we are able to reconstruct the exhibition rooms as arranged by the young architect Aldo van Eyck, a new ally of Cobra. Van Eyck took up the theme of discontinuity and irregularity with a boldness and sureness of eye which provoked both wonder and outrage. Apart from an oblong canvas by Eugène Brands (*Neergeschrevendrift*), two very large pictures by Appel (*Animals* and *Men and Beasts*), painted specially for the exhibition, and *Barricade*, a monumental picture painted *in situ* by Constant, most of the works were of small and medium size, due to the poverty of the artists and transport difficulties. Van Eyck had no hesitation in hanging them on the walls from the lowest point (on the skirting board or on the floor itself) to the highest (three metres), arrang-

Christian Dotremont, manuscript page of *Le Grand Rendez-vous Natural* ('The Great Natural Encounter'). Written at a stretch in Corneille's studio in Amsterdam, this discourse would be read in public by the author on 3 November 1949 at the opening of the International Exhibition of Cobra Experimental Art at the Stedelijk Museum, Amsterdam.

Cover of the first edition of Christian Dotremont's autobiographical novel (Gallimard, Paris 1955) with the band which advertised its launching.

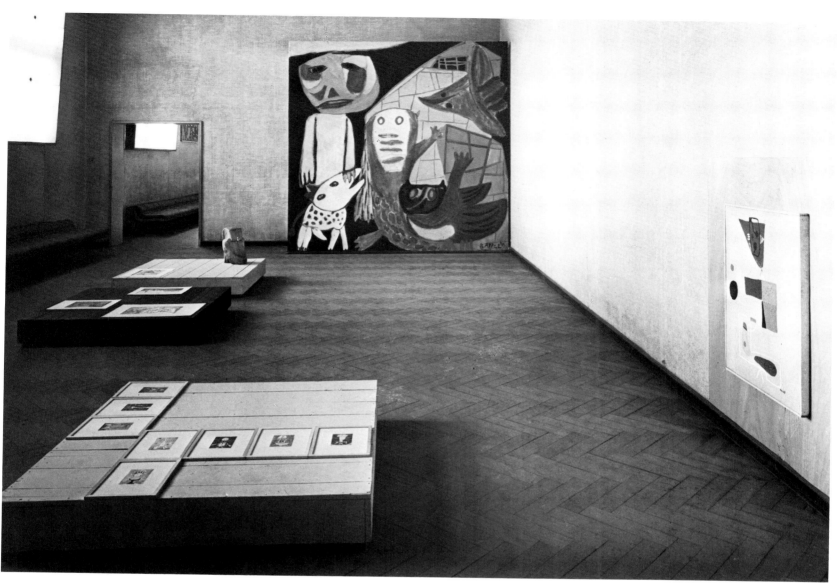

The International Exhibition of Cobra Experimental Art, 3–28 November 1949. At the back, Karel Appel's *Men and Animals* (350 × 360 cm), which was specially painted for the exhibition and today belongs to the Stedelijk Museum, Amsterdam; in the foreground, eight etchings from Pierre Alechinsky's *Trades* series; further back, a wooden sculpture by Erik Thommesen. Exhibition layout by Aldo van Eyck. Photo H.U. Jessenrum d'Oliveira.

ing the free space in a constantly striking way. According to Rooskens' account, this new type of 'spacial configuration' was not accepted without a certain amount of reluctance on the part of the artists. 'In the last few days before varnishing day, there was much jealousy and animosity. When opening day arrived, certain artists were still trying to change the position of their respective pictures.'

To display the graphic works and sculptures, Van Eyck had had platforms built to the height of a long step, rather like stage sets in a theatre. The exhibition was entered by a long corridor, one wall of which bore the letters COBRA along the whole of its length; at the end of the corridor was Constant's great *Barricade*, its brutal jeering figure shaking its fist. The next room, whose dim

lighting and black cage-like racking gave it a funereal atmosphere, was the poetry room: there, the *Vijftigers* had gathered together some of their works, word-pictures and others, together with some battered copies of what was being published at the time by way of traditional literature. An inscription explained: 'Here is the poetry we wish to abolish.' Kouwenaar had added an *Object*, which could equally well have been featured at the Brussels exhibition – a bottle filled with the pages of a novel by Gide, deliberately torn up into little pieces. Some slogans by Dotremont, Marcel Havrenne and Lenin had also been pinned to the wall: 'We must dream, but on condition that we seriously believe in our dreams, we must carefully examine real life in order to confront our observation with our dream, properly to realize our fantasy.' (In fact, these precepts, taken up again by Lenin and quoted after Romain Rolland, are from Pissarev. Joseph Noiret was to use them as the afterword to his brochure *L'Aventure dévorante* to be published by Éditions Cobra).

The works exhibited in the suite of rooms were not necessarily those listed in *Cobra 4*. Carl-Henning

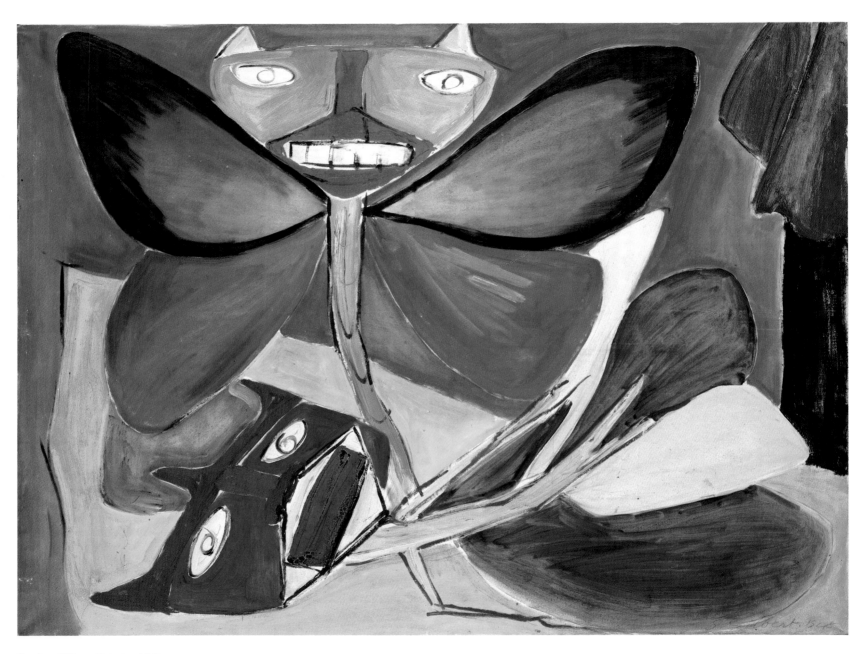

Stephen Gilbert, *Painting*, 1948.
Oil on canvas (75 × 100cm).
Collection of the artist.

Karel Appel, *Cat in the night*, 1950.
Oil on canvas (100 × 100 cm).
Collection of the artist.

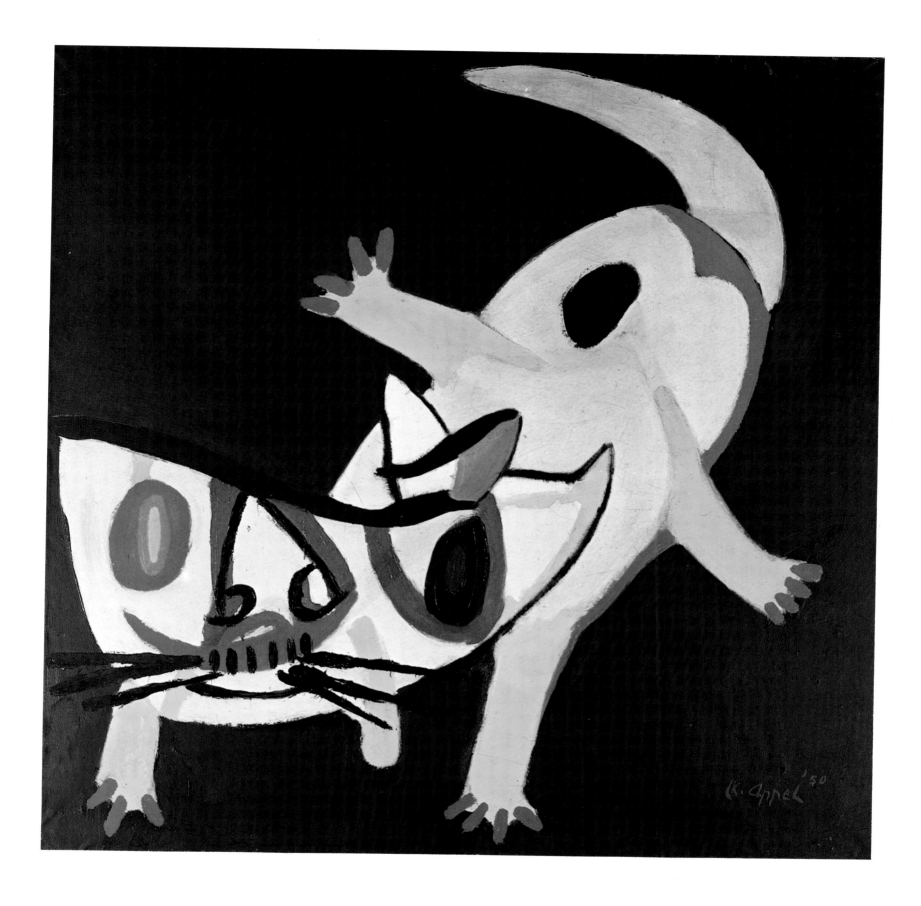

141

Pedersen's contribution dominated the Danish entry with four remarkable canvasses; there were only two pictures from Jorn, small but intense, three by Else Alfelt, three by Bille and Ortvad, as well as four stone sculptures by Heerup and four in wood by Thommesen. Egill Jacobsen, Svavar Gudnason and Sonja Ferlov, all of whom were invited, failed to deliver their works within the given time. On the Dutch side, Appel presented a sculpted and painted *Totem*, in addition to his two large canvasses already mentioned; apart from *Barricade* Constant exhibited seven canvasses, one of which was *Animal sorcerer*; Corneille contributed a painted *Cube*, displayed at floor level, and five pictures; Rooskens and Brands had four pictures each and Wolvecamp a selection of paintings and drawings. Belgium was solely represented by Alechinsky's suite of nine engravings, *The Trades*. From Paris, there were three pictures sent by Atlan and four from Doucet (who came to Amsterdam for the exhibition); there were also two pictures by the English artists Stephen Gilbert and William Gear. Only Österlin was featured from the Imaginist group in Malmö, Carl Otto Hultén having been told about it too late. Joseph Istler represented Czechoslovakia and the Ra group, with works he had left behind in Brussels the previous year – it was no longer possible for Czechs to send their works beyond the Iron Curtain.

Thanks to Corneille's Parisian contacts and to his ever watchful curiosity and enthusiasm, the Stedelijk exhibition was able to include a collection of gouaches, monotypes, woodcuts and photograms by German artists linked to the minor review *Meta*, whose leading light was Karl Otto Götz. For the Dutch to invite Germans along in this way, having suffered so much under the Nazis, set a moral example; it is true, of course, that Karl Otto Götz was the very illustration of art not submitting in the face of the horrors of recent history. Born in 1914 at Aix-La-Chapelle, at the top of the Rhine delta which irrigates Belgium and Holland, Götz was of that generation of artists who had to develop under the worst conditions; after the closing of the Bauhaus and the exiling of the foremost German artists, all creative activity had to take refuge 'in the catacombs' during the Hitler period. As he made clear in *Cobra 6*, Götz, as an innovator of graphic and technical research, had been inspired by the Bauhaus, whilst not however ignoring the little of Surrealism which had filtered through to his awareness. In one sense, he was not far removed from Bjerke Petersen and the Danes of *Linien*.

Unfortunately, Götz was drafted into the army in 1936 and was not out of uniform until the defeat of 1945 having spent part of the war in Norway, posted at a radar station. Since various of his homes were successively bombed, few of his works of that period remain. In spite of everything, he had succeeded during that time in painting and drawing some small pictures, making some woodcuts and also experimenting with still and movie cameras, discovering that black and white

suited him perfectly: many of his future works would retain that same achromatic ascetism. Before the end of the Nazi horror in 1944, Götz and some of his friends secretly printed a book of surrealist poems by Éluard, Breton and Péret, illustrated with abstract works (one cannot help calling to mind *La Main à Plume*). Götz had got together with Willi Baumeister who, having been denounced as a 'degenerate' (his work appeared in Goebbels' infamous exhibition), chose the internal exile of an imaginary 'Mesopotamia', beyond and before history, which inspired mysterious material compositions in him. In 1948, Götz started a review, *Metamorphose*, which was shortened to *Meta* from the second issue onwards. This was no chance title; metamorphosis is the visible manifestation of the vital impulse, of becoming, of forces reborn from nothingness and ruins. Götz was dominated by the spirit of metamorphosis: his work of that period consisted of series of variations (up to twenty-four) on one or several themes, as if to create a spectacle of visual music or fixed filmography. Moreover Götz was familiar with the abstract films of Viking Eggeling, Hans Richter and Fischinger (who would feature in the Cobra festival in Liège). In parallel with these deliberately abstract compositions, Götz practised automatism and was not unaware of the fascinations of the sub-conscious. Painting canvasses in this way related him to the 'visceral surrealism' of Masson and Ernst, where a whole submarine (and polar) fauna and flora proliferated, until – after Cobra – he simplified his style, adopting a more flowing one. According to Édouard Jaguer's definition, he would become the hurricane painter, invoking and evoking a hyper-dynamic space through the gesture he used. Götz claimed that the traces of this gesture 'are no

Photographed by Karl Otto Götz during the hanging: Corneille with Aldo van Eyck; in the foreground, Micky and Pierre Alechinsky and Dotremont's hand holding a cigarette.

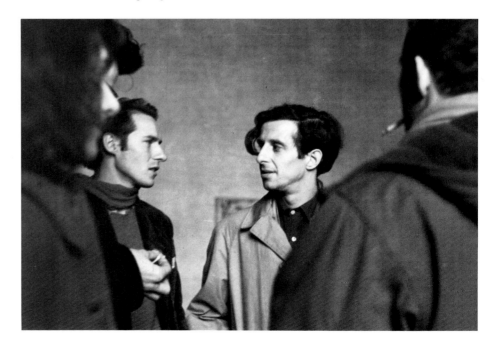

more or less important than the moraines which deposit the glacier along the course of their cold wanderings.'

The Germans who exhibited with Götz at the Stedelijk Museum were his wife, Anneliese Hager, Heinz Trökes, Wolfgang Frankenstein, Karl Hartung and Otto Hofmann. Karl Otto Götz, who was able to attend the exhibition, proposed that an issue of *Meta* should be dedicated to his new friends: this would be *Cobra 5*.

In addition to Madeleine Szemere and her husband Zoltan Kemeny, who both practised a wild, materialist art close to Dubuffet which was in no way indicative of their future metal reliefs ('revised radiators' as Dotremont would call them, and which would bring notoriety to Kemeny), Corneille had invited to Amsterdam an unknown sculptor whom he had noticed at the Salon des Indépendants in Paris in 1949: Shinkichi Tajiri. Here, too, Corneille's instinct did not falter, and Tajiri's joining Cobra represented a new influx of lively forces; usually a calm and even sedate art, sculpture suddenly discovered, with Tajiri, the virtues of aggressiveness. Corneille was particularly fascinated by the 'one-day Sculptures' made from scrap materials – 'junk sculptures', as they would come to be called – on which Tajiri worked on the banks of the Seine at the Quai de Javel, from 1950–1. Only photographs remain of these, taken by Sabine Weiss.

International Exhibition of Cobra Experimental Art, Stedelijk Museum, Amsterdam, 3–28 November 1949. In the foreground, sculptures by Erik Thommesen; left, two paintings by Theo Wolvecamp; in the angle of the room, four paintings by Carl-Henning Pedersen. The platforms grouping various works (sculptures, watercolours, gouaches or drawings) were made to the specification of Aldo van Eyck. Photo H.U. Jessenrum d'Oliveira.

A Japanese born in Los Angeles in 1923, Shinkichi Tajiri came to Paris in 1948 and never left Europe again. His formative experience and progressive attainment of what Dotremont called 'the refinement of ignorance' had been gained at Zadkine's studio, then with Fernand Léger and finally at the Grande-Chaumière. In addition to four gouaches, one of which was *Mechanical Bird*, which held a special place in the Cobra bestiary, Tajiri sent a 135cm high *Warrior* to the Amsterdam exhibition, a piece which had something of both the insect and the Samurai about it. Tajiri had been deeply affected by the war; as a Japanese, he had been imprisoned after Pearl Harbour. He had enrolled in the U.S. Army in order to get out (a 'sick joke', as he called it) and had gone on the Italian campaign, taking part in the liberation of Rome. Wounded there, he spent six months in hospital. 'Tajiri's aggression', wrote Dotremont in *L'Arbre et l'Arme* (1953), 'is at once the expression of our age – which stems directly from that era of which Hiroshima was one of the major events – and, at the same time, a response to

143

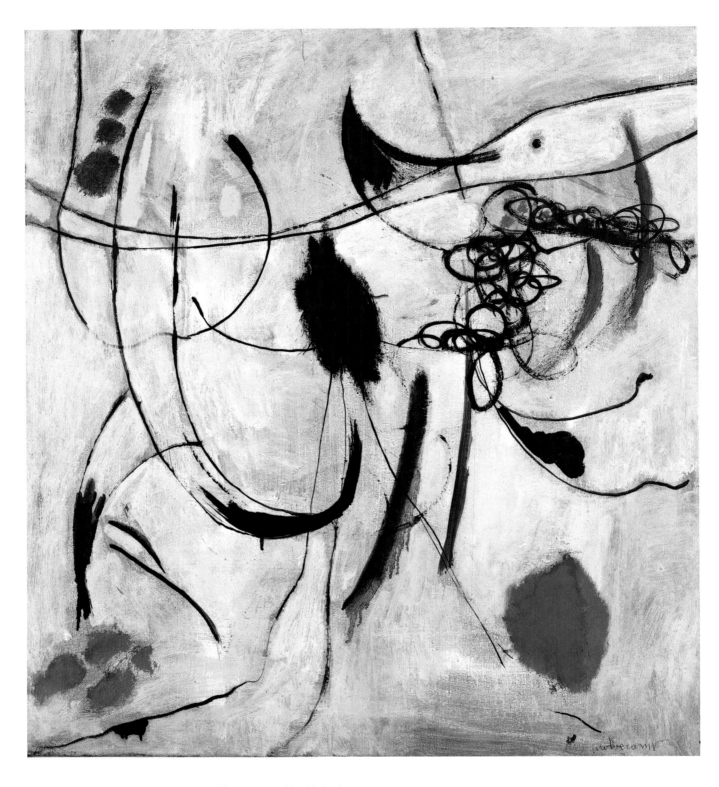

Theo Wolvecamp, *Composition B3*. 1949. Oil on canvas (90 × 80.5 cm).
Stedelijk Museum, Amsterdam. Museum photo.

Shinkichi Tajiri, *One-day sculptures* on the banks of the Seine, Paris 1951.
Photographed by Sabine Weiss.

that age . . . That this little man can, all alone, wrench these huge and terrible sculptures from material is a victory over that age, over the aggression of the age. For this age is fond only of the aggression it can master for its own purposes; all aggression which comes out of art is a double check for it: firstly because it reveals its own aggressiveness and secondly because it arms the Resistance.'

From Rooskens' memory of it, varnishing day at the exhibition was particularly lively. After the brief customary speech by Constant, 'people hurled themselves

Shinkichi Tajiri, *One-day sculpture* on the banks of the Seine, Paris, 1951. Photographed by Sabine Weiss.

into the rooms to the beat of a great jungle drum. A great deal of fun was had and I got the impression that most people thought it was all a huge joke.' In a long letter to Édouard Jaguer dated 18 November, Dotremont gave a circumstantial account of events, centering on two *soirées* which constituted what the hostile press called the 'Amsterdam Scandal'. 'On Saturday evening, a session of experimental poetry. Appel, Corneille, Doucet, Alechinsky and I had organized it. I took fifteen minutes for a critical text on experimental art, in French of course. Doucet and I chose the poems. Appel had found the films. On the other hand, Lucebert and the other spontaneous poets had organized something for the same evening! When I arrived at the museum with Doucet, Lucebert was holding forth in Dutch. That was the first surprise. He slipped me one of your poems to

read. When he got down from the podium, I got up to read my text. Towards the middle, an individual shouted "I don't understand". I carried on. Lucebert came up to the podium and asked me in Dutch to read your poem and my own. But I went on with my text, finally translating it into a thunderous Dutch. There was an indescribable uproar, anti-Soviet jeers and anti-French insults flying. Doucet bawled, of course.'

The text Dotremont read was a fragment from *Le Grand Rendez-vous Naturel*. On the manuscript, which Corneille found, Dotremont had underlined the phrase which had unleashed the scandal: 'Thus the art arrived at by the people through being exploited is the brother of experimental art. If the difficulties of the one and the other are not always the same, they are more or less equivalent.' According to Rooskens, the Cobra members set about throwing out the trouble-makers, chairs and all if necessary, whilst Dotremont went on with his lecture, quite unperturbed. 'When the words *Soviet* and *Russian* were mentioned, that brought the house down. There were violent scuffles in several places. Lucebert tried to calm the crowd, but he did not even succeed in making himself heard. As the situation got worse, certain people got up to leave singing the *Marseillaise*. The battle continued outside in the night.' Dotremont finished his lecture by pouring the traditional orator's glass of water over his head. He went on to say, in his letter to Jaguer: 'With the room empty, I declaimed the poem I had written half an hour before in the corridor, which ended with the truly prophetic line: *And I only go into the museums in order to remove the muzzles*.' Dotremont used this phrase again as the title of a lampoon in which he replied to the Press of all shades of opinion, from the Trotskyists to the Right, who treated him as a *provocateur*. 'Provo' was a word which had not yet come into common usage.

The next day, Sunday, the Congress proper took place. 'Not without chaos. There were three Danes, a Belgian, (Alechinsky and Bury had just left), loads of Dutchmen as you would expect, a Swede, a German, a Frenchmen, Tajiri had left, an Englishman. The basis was established for the Internationale of Experimental Artists (this name had been chosen at my suggestion). There was a brief discussion in Hollando-Danish on the principle of international experimental exhibitions: should national canvasses be chosen on a national basis? Final text written on the knees at midnight by *the writer*. Afterwards, a burial of unknown pictures: we shouted the *Dies irae Dies illa* in the streets of Amsterdam, carrying the pictures like coffins and I cried, in shades of Nietzsche: *Painting is dead*, also, remembering Dotremont's reputation for puns: *No florins, no crowns*.'

In the wake of this scandal, the Dutch Experimental Group broke up; only Constant, Corneille, Appel and Wolvecamp remained faithful to Cobra, the latter very soon drifting away from it too. As might be expected, the Press raised a hue and cry over the exhibition and the review: 'On Sunday, we sold eight copies of *Cobra*; on

« ... ET JE NE VAIS DANS LES MU_SEES QUE POUR ENLEVER LES MU_SELIERES. »

AU moment de quitter le sol hospitalier de la Hollande, nous « Tito belge » (¹) et secrétaire de l'Internationale des Artistes Expérimentaux, « danger pour l'Etat hollandais » (²) et rédacteur en chef de « Cobra », « nudiste » (³) et « poète français » (⁴), « secrétaire de la fédération bruxelloise du parti communiste » (⁵) et « expérimentateur — pour — l'expérimentation » (⁶), tenons à remercier la presse hollandaise pour avoir dévoilé avec une beauté généreuse son haut souci de ne pas exactement informer ses lecteurs. Nous buvons au Stedelijk Museum d'Amsterdam un demi-verre d'eau, et la ~ hollandais~ imprime que nous en avons bu ~

de l'historien soviétique C

exempl~ '

core ~

d'êr

WIJ, « Belgische Tito » (¹) en secretaris van de Internationale van experimentele kunstenaars, «staatsgevaarlijk » (²) en hoofdredacteur van « Cobra », « nudist » (³) en « frans dichter » (⁴), « secretaris van de brusselse federatie van de communistische partij » (⁵) en « experimenteel terwille van het experiment » (⁶), op het ogenblik dat wij de gastvrije hollandse bodem ~~~ verl~ staan Wij erop de hollandse pers te bedanken vo' heid, waarmede zij haar zorg heeft betoond,

Wij drinken openlijk een h~

Christian Dotremont's reply to the Dutch press in the form of a bilingual tract, printed in Brussels at the end of November 1949. The notes in the text refer to the following magazines:
(1) *Het Parool*, 7.11.1949; (2) *De Volkskraant*, 8.11.1949;
(3) *Algemeen Handelsblad*, 7.11.1949; (4) *De Tijd*, 7.11.1949;
(5) *De Vlam*, Trotskyist Journal, 12.11.1949; (6) *De Waarheid*, the organ of the Dutch Communist Party, 8.11.1949.

left: one of the most important fragments of *Le Grand Rendez-Vous Naturel* by Christian Dotremont. His public reading of it at the Stedelijk Museum in Amsterdam unleashed a scandal.

below: Caricature which appeared in *De Volkskrant* on 11.11.1949.

Mais tout se passe, en vérité, comme si le peintre, comme si l'homme, aujourd'hui, était définitivement et absolument pourri ; comme s'il fallait capituler devant le formalisme, et composer avec lui, et signer avec lui un pacte germano-soviétique ; comme si à s'exprimer spontanément, d'un jet, à la manière de l'arbre, il risquait de dire de bien gros mots, de peindre de bien vilaines choses ! Et si c'était vrai ! Ne faudrait-il donc pas qu'il évacue ses horreurs, ses ordures ? Ne faudrait-il point que l'art se charge d'enlever ce que la raison de peur de se salir les doigts n'ose toucher ?

S'il faut à l'homme être hypocrite pour être propre, mécanique pour être « convenable », quelle jolie raison vous lui avez donc faite, ô traîne-cervelle, ô tape-majuscules ! Elle serait propre comme le Roi : de ne pas sortir, de ne pas se frotter aux manants ! Elle serait propre de ne pas se mouiller.

Or, c'est le seond terme du dilemme qu'il faut considérer : à coups de trique formaliste, à coups de pied dans le cœur, la raison que nous connaissons a versé aux oubliettes ce qui devait non pas jurer nécessairement, mais nécessairement jurer avec elle. Parce qu'elle, elle est dégoûtante, elle encrasse tout ce qu'elle touche, et rien de l'homme ne paraît propre qui sort de ses bureaux d'administrations, demander tant de visas à tant de *casquettes de plomb*, remplir tant de formulaires, débattre tant de problèmes dans tant de parlements, passer par les douanes de tant d'intérêts qui ne nous intéressent pas, que parti nu, nous arrivons masqué. En fait, nous n'arrivons pas. Ce qui sort de l'affreuse machine à salir n'est pas ce qui était entré. Il s'agissait de faire de bon pain pour notre bon appétit, il s'agit de faire de bon argent. Il s'agissait de t'aimer, Isabelle, il s'agit de te rouler. Il s'agissait de dire oui, il s'agit de dire non ou de ne rien dire ou de dire oui parce qu'il va croire que je pense non. Il s'agissait de créer, il s'agit de se vendre à un sujet.

La merde, la merde, toujours recommencée.

L'orthocatalographe

jamais je ne me rappelle j'appelle
par son nom ce que j'interpelle

jamais je ne me contiens je me contente
de ce qui constamment me tente

jamais je ne m'écorne ni l'œil ni l'oreille
je vote contre les corbeaux pour les corneilles

jamais je ne vais à la guerre
j'orne mon cœur de ma colère

jamais je ne donne de hennin à ma femme
j'aime sa chevelure comme une flamme

jamais je ne machine ni ne m'exquise
je ne m'allèche que si me grise

jamais je ne suis petit poucet
dans la douce forêt du passé

jamais je ne jette par la fenêtre
le tas gitbant de rires qui est maître

jamais je ne m'égosille
tombe du la gueule du loup
je ne tombe jamais dans la gueule

et je ne vais dans les musées que pour enlever
les muselières
du goût

5 XI 1949

Appel

Constant

Corneille

Jorn

Alechinsky

Doucet

Tajiri

I only go
into museums
to remove
the muzzles

148

Monday, when the papers came out, we sold eighty. Sandberg pronounced that the outcry we had created guaranteed our youth, our strength and our seriousness. Basically, he is with us.'

In issue 6 of *Cobra*, which published the second part of his *Le Grand Rendez-vous Naturel*, Dotremont analysed the underlying causes of the scandal, with much covering of tracks: 'The general slackening of the critical faculty is such that one can easily pass for reactionary, dilettante, Titoist, Trotskyist or Stalinian when one if defending a position which does not directly inspire the *if you aren't for us, you're against us* type of politics, but which is anxious, on the contrary, not to cut off the culture, art and painting which are dear to us from our social life, in an artificial way. This is itself an experimental position, a position which refuses to be taken, but which takes itself, and which we prefer to define through our *consciousness* rather than through the stupid, complacent formulae of a guide to moral, ideological and aesthetic conformity. The difficulty of taking this position seems more bearable to us, allows us to breathe more easily, than the facility of the *pedestrian crossing*.'

Constant did not accept this diagnostic of Dotremont's, although written in the first person plural, without a certain degree of reticence. Nor did Jorn, observing the matter from Denmark where he was experiencing the worst material difficulties, made worse by the ostracism of his friends – he was accused of 'betraying' Constant, their guest and their host. This feeling of rejection was only too familiar to the three

Dutchmen: the hostility of both press and public, the internal rift in the group, the alienation of the *Vijftigers* – could all this be compensated for by the knowledge that they were in full command of their creative forces? The exhibition at the Stedelijk Museum should have been comforting in that respect: they believed that they would henceforth attract a more international audience. But this could not be achieved in Brussels, even though Dotremont was there, active and committed. From then on, all the remaining issues of *Cobra* would be published there, with the exception of *Cobra 5*, published in Germany by *Meta*. It did not happen either in the Denmark Jorn was trying to leave, finally doing so when the small *Cobra Library* was finished. There remained Paris, which did not really belong to the 'snake' of the Internationale of Experimental Artists, despite the presence of Jacques Doucet, Atlan, Édouard Jaguer and Michel Ragon. And yet, if the first active phase of Cobra was predominantly Danish and the second Dutch, the third epoque would be most specifically centred on Brussels and Belgium, with a slight sideways movement towards Paris.

Immediately after the Amsterdam scandal, Corneille, Appel and Constant went to Copenhagen once again to take part in the annual Høst exhibition (to which Stephen Gilbert and William Gear were also invited). Then Jorn, who had left Høst for Spiralen, where he exhibited with Hultén and Österlin, took the Dutchmen to his home town of Silkeborg, with which he had a love-hate relationship. In Silkeborg, the three young painters were taken in by a ceramist friend of Jorn, Erik Nyholm, at his farm in Funder. The atmosphere was warm, the more so since the Cobra painters had just sold a few canvasses to a Silkeborg collector, Einar Madsen. When Nyholm showed them his own collection, a small painting by Richard Mortensen attracted their attention

Christian Dotremont, *L'Orthocatalographe*, a poem improvised on the occasion of the Cobra Exhibition at the Stedelijk Museum, Amsterdam, on 5 November 1949. Tha names of several of the artists in the group appear disguised in the poem. Dotremont used the last line again in his tract in response to the Dutch press (see p. 147).

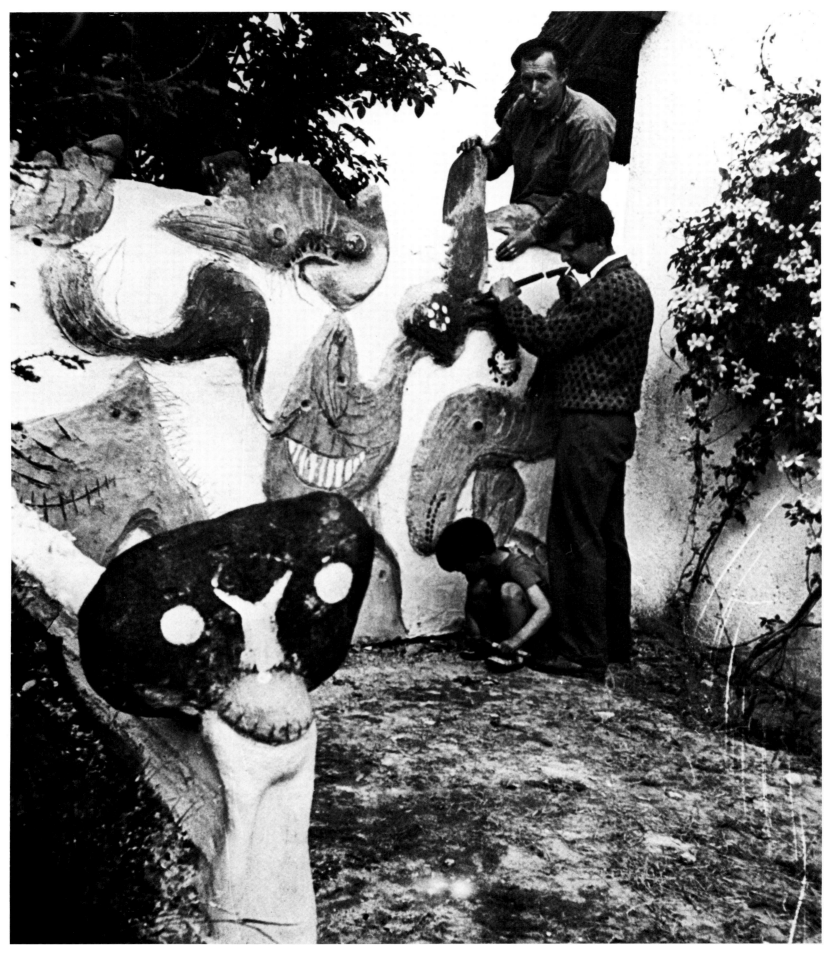

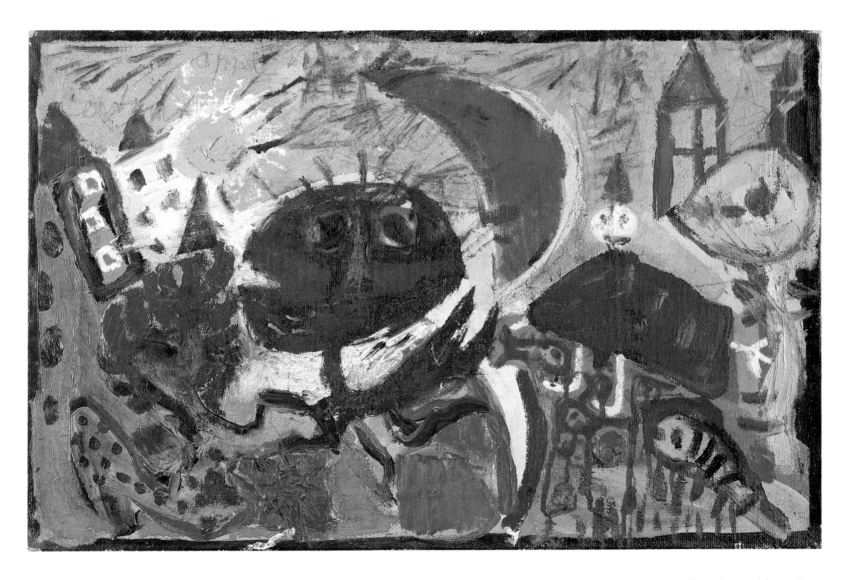

Asger Jorn-Constant-Karel Appel-Corneille, *Cobra-Modification* (on a painting by Richard Mortensen), 1949. Oil on canvas (46 × 62 cm). Kunstmuseum, Silkeborg. Photo Lars Bay.

Constant working on the decoration (a relief in cement) for the home of the poet Jørgen Nash in Tibirke, Denmark, summer 1949.

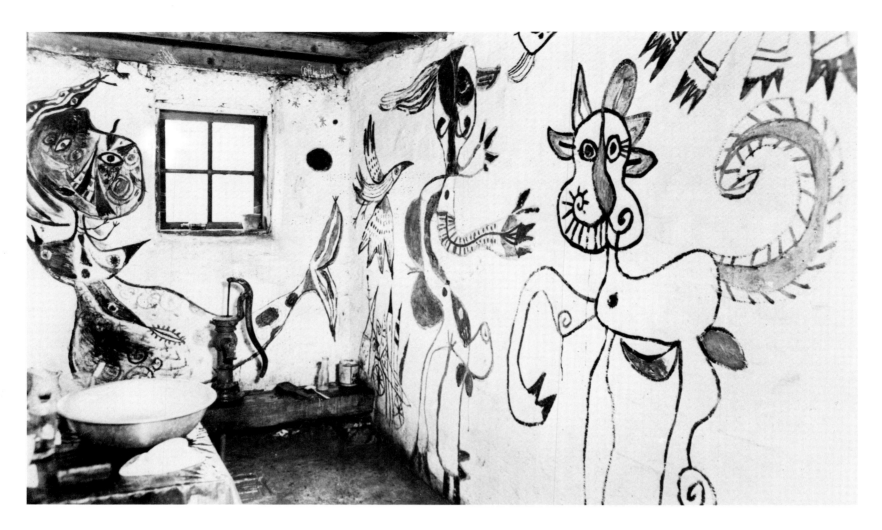

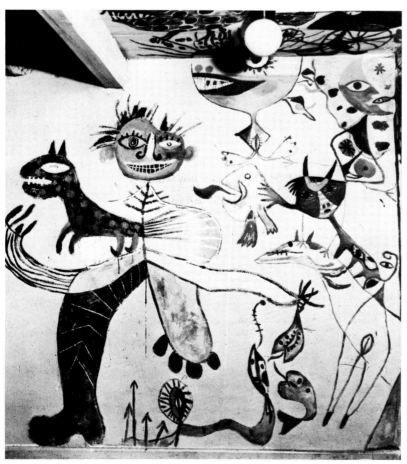

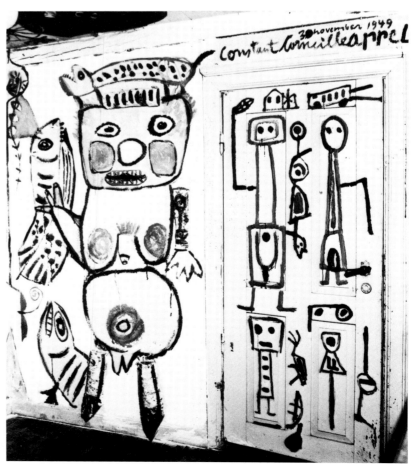

most of all, mainly, no doubt, because Jorn had started to paint on top of it to signify his disapproval of the evolution of the painter, who had gone over to cold abstraction as one would go over to the enemy. Thus a fairly characteristic Cobra process unrolled; Appel could not resist the temptation to add a sun bursting with colours to Jorn additions; then Constant and Corneille both took their turn, so that Mortensen's picture was transformed into a *Cobra-modification*. In the excitement of the moment, the three Dutchmen suggested that they should decorate their host's entire house, which they did – in a single evening, walls, floors, doors, furniture, mirrors and even household objects. It was 30 November 1949 when the three friends put their signature to one of the doorframes. And so that everyone would notice, they added an inscription in French 'Entre ici, c'est vivre!' ('To enter here is to live!'). They had brilliantly animated a most joyous procession, from Corneille's little mermaid to Constant's centaur-like creature, passing by Appel's fishwife. Some time after that, when Jorn visited the house, he too took his turn, with Nyholm's help, at painting a section of the kitchen wall which had escaped the Dutchmen's painting zeal: four labyrinthine heads, surmounted by a bold Dotremontesque device: 'Plentiful are the fish in the ocean, plentiful are the women one can love.' Jorn also had the bright idea of photographing everything, which was destined to disappear in due course; only Mortensen's former painting is still in existence, presented to the Kunstmuseum in Silkeborg by Erik Nyholm. It illustrated the 'defigurations' and 'modifications' to which Jorn had devoted himself after 1959, an idea which had been germinating for some time. He had already written to Constant on the subject of the Mortensen experiment: 'I am in the process of creating a new area of operation for us which I call the *Phase of improving old canvasses*. We shall propose, in the name of Cobra, to improve old canvasses, collections or entire museums. I have already started with some Raphaëls, Manets, Braques and Dalis [he was talking, of course, about reproductions]. These last two are the best. I suggest that you do the same, above all with Mondrian and the most esteemed Classical works of the Renaissance; and in such a way that the original can be seen through your *tamperings*. A Dutch Cobra Titian would be negative, because it would be a moral satire. What I suggest is that we paint over images in our own way to maintain their topicality and help them not to be forgotten. I hope you understand the task we have to accomplish. Have a go and send them to Dotremont.' Jorn's suggestion was not followed. It took his meeting with the Italian Enrico Baj in 1953 to make it a reality, using second-hand (and rather bad) pictures they bought in flea markets.

opposite
Murals (since removed) in Erik Nyholm's house in Silkeborg. *Above: Siren* by Corneille and *Centaur* by Constant; *below left:* paintings by Constant; *below right:* by Karel Appel. Above the door, the signature of the three Dutchmen, dated 30 November 1949. Photos Johs. Jensen.

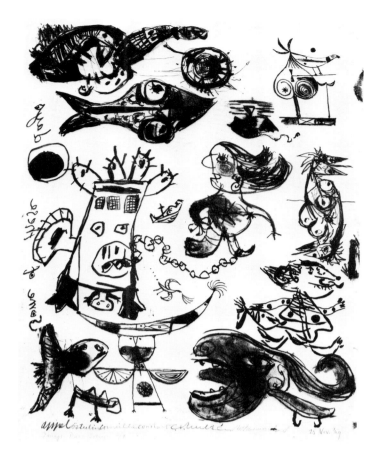

Karel Appel, Constant, Corneille, Carl-Otto Hultén, Anders Österlin, Max Walter Svanberg, *Some of these days*. Collective lithograph, Malmö, dated 25 November 1949 and printed in an edition of nine copies.

'We did a good job . . . in a lost house in Jutland', Corneille would resume in a letter to Pierre Alechinsky dated 11.12.1949, in which he told him about the 'fifty hours' spent in Malmö with the Imaginists: 'We did a lithograph together, which didn't turn out too badly; only we had to do it in a bit too much of a hurry and this shows in the work. A real Indian ritual around a stone.' Carl Otto Hultén, Anders Österlin and Max Walter Svanberg were also involved with the three Dutchmen on this small lithograph (in sepia), nine copies of which were printed; it would be Svanberg's only collaboration with Cobra. The work is dated 25 November 1949.

When they returned to Amsterdam in December, full of their Scandinavian adventures, the three Dutchmen found that the hostility, far from having died down, had been fed by a new 'scandal', that of Appel's painting for the Town Hall dining-room. On 12 January 1950, in what would be its last collective act, the Experimental Group published, with Aldo van Eyck, a tract entitled *Een appel aan de verbeelding* ('A call to the imagination' – in Dutch, of course, it allows a pun on the painter's name). In *Petit Cobra 3*, Dotremont analysed the affair and linked it, not without cause, to his polemics in Belgium against Social Realism. In general terms, it was the control of art and of the artist's freedom by a social group or by whatever authority it might be which Cobra sought to prevent. By the Amsterdam bourgeoisie or by

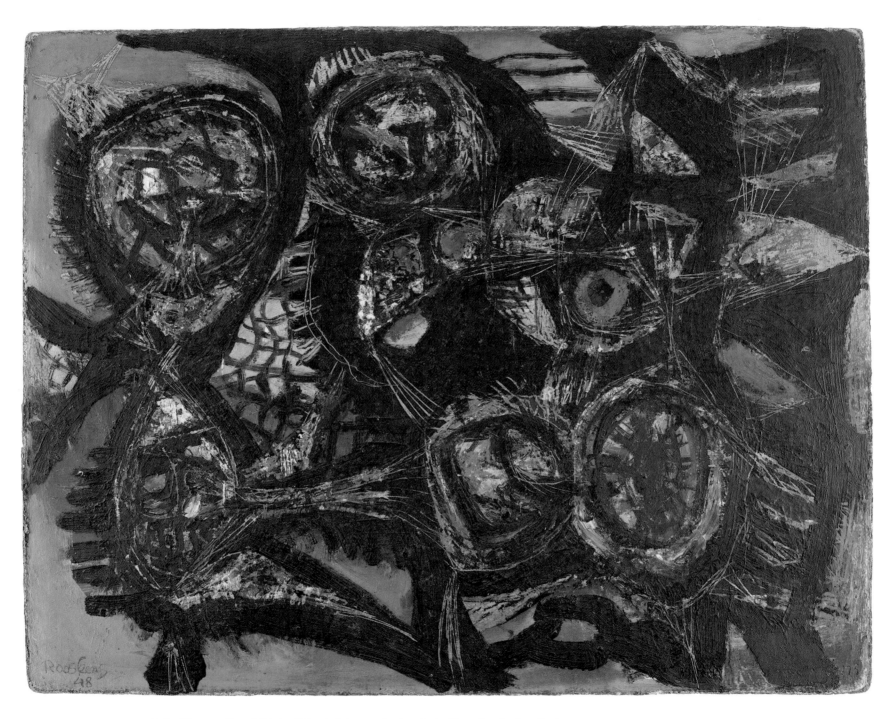

Anton Rooskens, *Painting*, 1948. Oil on cardboard (49.5 × 60.3 cm). Private collection, Paris. Photo Luc Joubert, Paris.

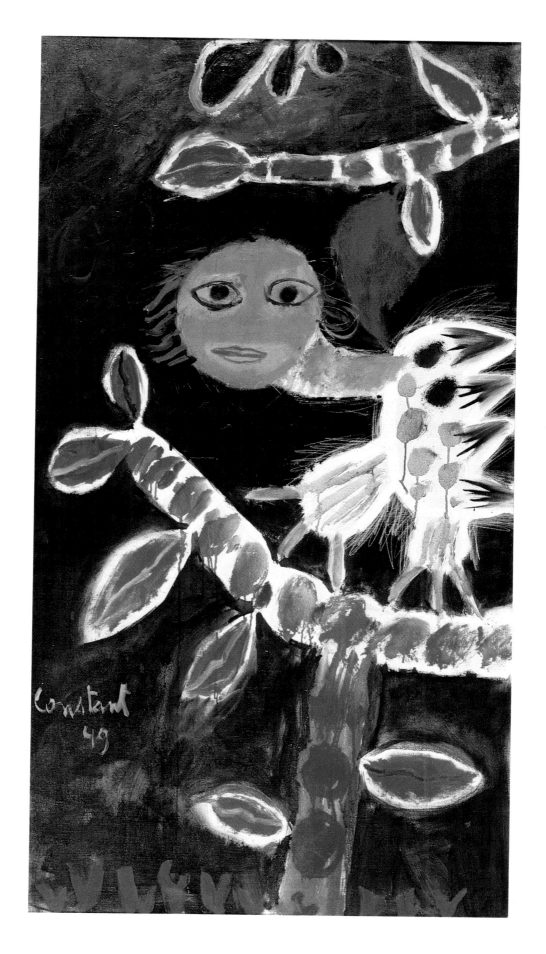

Constant, *Bird-woman*, 1949.
Oil on canvas (120 × 65 cm).
Private collection.
Photo Victor E. Nieuwenhuys-
A. van den Born, Amsterdam.

international Stalinism, experimental art was cast into the outer darkness. By the end of 1950, Corneille, Appel and Constant would have left Amsterdam and the Belgian members of Cobra had left the Communist Party. 'With the consent of the relevant authority, our friend Karel Appel of the Dutch Experimental Group had decorated one of the walls of the dining-room in the Town Hall in Amsterdam,' wrote Dotremont. 'It is pointless to say his *decoration* was not *decorative*; as I said, he is a member of the Dutch Experimental Group. The authorities might have expected that – Appel created something violent, but its violence was justified, of the people: Appel is a man of the people, he does not have the sense of the old Surrealist scandal. But the top officials who dined in the restaurant lost their appetite when faced with Appel's *Vragende Kinderen* ['Questioning Children'] and asked the council of which they were members to intervene.

'The council did not dare have the fresco wiped off, but they covered it with wood. They gagged the *Vragende Kinderen*. The architect Aldo van Eyck, who was both a member of the relevant authority and of the Experimental Group, did not see it that way and took a stance over the revolutionary fresco, sticking out his tongue, as did the other Dutch members of Cobra, at the high-class diners, notably a municipal magistrate, who was red (with anger). Then he published a long tract of a preciseness not often seen: *Een Appel aan de Verbeelding.*

'As for us, we advised the Amsterdam Council to approach (with Baelux's help) that group of *social realist* Belgian fresco painters who go around everywhere saying that experimental art is an ideological manoeuvre of the reactionary bourgeoisie. Nothing to fear from a fresco by the social realists, councillors, the *Vragende Kinderen* may perhaps have a book by Laurent Casanova concealed in their rags, but they will not have that terrible force of misery in their eyes, the terrible desperate hope which made you lose your appetites. With a fresco by the social realists, the *Vragende Kinderen* will not beg for food, they will ask themselves what is the role of the subject of the painting.'

Cobra 5 would be published by *Meta*, that is by Karl Otto Götz, who had suggested this collaboration at the Amsterdam congress. Dotremont had approved it enthusiastically, seeing in it 'new victory, new progress' for the Internationale of Experimental Artists: 'The friends of Cobra are multiplying . . . the cultural situation demands that the power and justice of experimental art are recognized everywhere.' Jorn was less convinced.

Cobra-Meta was 'authentically international'. It had the added benefit that it appeared to be one of the issues best balanced between Danish, Dutch and Belgian artists. And Dotremont was quite right, too, to stress that this publication was an event for Germany, 'that country where the experimental artists have had to stifle their sensitivity and their conscience for twelve years . . . and, when peace returned, might have sunk into a terrible feeling of inferiority.' The issue was printed in

Un appel à l'imagination

Ils ont eu ce qu'ils voulaient, Karel, les trompeurs et les trompés, ceux qui ont réussi par ruse à te faire parler pendant que tu travaillais ! Mais ils n'en ont pas publié un seul mot authentique dans leurs gazettes, et ils ont écrit au crayon rouge sur tes *Enfants interrogateurs,* ils ont jeté contre le mur la collecte pour les enfants, c'est comme s'ils les avaient mitraillés jusqu'à un mètre au-dessus du sol. Et ils rient jaune parce que, dans tes formes et tes couleurs devenues symboles, il n'y a ni anecdote ni ressemblance !

Ils ont eu ce qu'ils voulaient. Tes *Enfants interrogateurs* vont être détruits. On va leur donner du pinceau blanc parce qu'ils sont vrais, parce qu'ils interrogent vraiment, parce que ce sont vraiment des enfants qui interrogent — sur des ruines ou sous des arbres. Félicitations, messieurs... Karel, félicitations.

Qu'ils n'aient pas pu (ou voulu) prendre une autre décision ne nous étonne pas. Ils sont aussi sensibles que le gravat à ce que tu as imaginé globalement. Ils ont perdu un sens, ils ont une hormone en moins. Mais promène-toi dans notre beau monde urbain et tu verras que c'est partout pareil, et que ces

gens-là, pour le malheur de tous, trouvent tout particulièrement refuge dans la politique, cette marmite universelle des personnes sans imagination. Partout, parce qu'il n'y a pas un village en Afrique où ils ne sont venus avec leur Bible, leur genièvre, leurs napperons à fleurs, en échange de tout ce qu'ils ont rapiné et vendu de l'autre côté. C'est vraiment trop abominable pour durer encore longtemps.

Ils reprochent à l'enfant son enfance et à l'homme sa passion. Le cycle naturel les étrangle tellement qu'ils fabriquent un cycle à eux, un contre-cycle : le cercle vicieux. Par peur de la liberté, ils cherchent à détruire le peuple et sa force novatrice parce qu'ils savent qu'on ne peut les séparer.

Oui, Karel, ce sont les héros d'un monde à l'envers qui détruisent ton œuvre !

Ils disent que nous sommes des *barbares,* des *timbrés,* et que notre travail est parfaitement inintéressant.

Mais qui le dit et à qui ?

Ils disent que nous sommes *dangereux pour l'État.* D'accord, ils ont raison.

Celui qui préfère le miracle de la réalité à la banalité de l'illusion, le naturel au succédané, la vita-

lité saine à l'impuissance hésitante, la prise de possession passionnée au tic réprimé, le caprice de ce qui croît à l'immobilité de ce qui est révolu, l'élémentaire à la perfection ; celui qui se sert de son imagination pour son propre rajeunissement et celui de la communauté ; bref, celui qui a le courage et le pouvoir d'être libre est dangereux pour l'État.

Oui, qu'ils n'aient pas voulu (ou pu) prendre une autre décision ne nous étonne pas.

En faisant des tours de passe-passe avec leurs idées flétries, ils s'activent pour parachever leur vicieuse monstruosité. Ils ne savent pas que les fondations vacillent, parce qu'ils prennent appui sur le néant, parce que la tyrannie de l'intellect a atteint sa dernière phase.

Et nous... Nous, on continue notre petite magie à base de couleurs, de lignes, d'espaces, de mots, parce que nous savons que ce ne sont jamais les prestidigitateurs qui accomplissent les métamorphoses, même si nombreux sont ceux qui éclatent de rire et les trouvent très raffinés. Nous ne sommes pas satisfaits pour si peu. Ils veulent rire parce qu'ils doivent rire. Ils veulent être libres — c'est le droit du poisson et de l'oiseau, de la pierre et de l'étoile, un droit qu'ils prennent eux-mêmes.

Karel, de tous ces gens-là, tes *Enfants interrogateurs* n'ont rien à attendre.

Aldo van Eyck pour le Groupe expérimental Hollande Cobra

Text of Aldo van Eyck's tract, *Een appel aan de verbeelding* ('A call to the imagination').

Advertisement for *Cobra 5*, which appeared in Karl Otto Götz's review *Meta* (No. 3, January 1951), Frankfurt.

COBRA
Internal. Zeitschrift für experimentelle Kunst. Organ der „Internationale des artistes experimentaux" (I.A.E.) Brüssel. Erscheint abwechselnd in jeweils einem anderen Land.
COBRA Nr. 5 ist eine deutsche Nummer und durch den META-Verlag zu beziehen.

French and German and contained poems and theoretical texts with, as in the Dutch issues, aphorisms running from one page to another. Novalis was doubtful: 'The galleries are bedrooms for the world to come'. Miró was beyond doubt: 'I make no distinction between painting and poetry'; and Ejler Bille's theoretical maxims: 'Good taste always expresses stagnation. It is seeking to console oneself for one's poverty in singularity. Instead of being simple, it runs after originality', or 'Bourgeois aesthetics determine the Beautiful (and the Ugly). From a moral point of view, that is determining Good and Bad. But art is a recognition of life, independent of all moral codes'. From Constant: 'A picture is not a construction made up of colours and lines but an animal, a night, a cry, a human being, or all that combined'; from Alechinsky: 'Antimony does not make bronze. Good taste does not make happiness. Let us beat the canvas in as much as it is false. Here, one goes around looking through one's teeth'; from Jean Raine: 'Good canvas, good back'; and from Dotremont (who else!): 'Exploitation of the thought by the thought must stop! Objects unite!'

There was a tangible difference in tone between the Belgians on the one side and the Dutch and Danish artists on the other. The former followed the Surrealist tendency of playing with the disorder of language and of thought; the latter were preoccupied with the formulation of an aesthetic corresponding to their works. In this respect, Jorn's contribution (an article previously published in the Spiralen catalogue) was one of the most important. Together with *Speech to the Penguins* and *The Forms considered as language* it constituted the essence of his contribution to Cobra during the Cobra era. It treated three themes, as indicated by the title, which is worthy of a La Fontaine fable – *Harengs socialistes, Peinture à l'huile réaliste et Art populaire* ('Socialist herrings, Realist Oil Painting and Popular Art'). Jorn's fundamental pre-occupations, and the directions in which he wanted to take Cobra, were expressed there: exultation of art as a spontaneous manifestation of the living; showing that experimental and popular art could unite as the expression of spontaneity; and that true realism was the expression of that spontaneity, which belonged first of all to the working classes – contrary to the Jdanovist doctrine's claim which maintained the conventions of nineteenth-century bourgeois art under the false appellation of 'social realism'. 'Art exists in the art of happy men,' Jorn affirmed. 'Art is the joy of living. It is the automatic reflex of our concept of life.' The condition of happiness is freedom. 'The more freedom people have, the more art penetrates into their spirit and their habits. A people's freedom is the basis of its joy in living and, thus, of its artistic creativity.' If Jorn did not speak of social classes, it was because he did not allow himself to limit in any way this artistic creativity which he generously accredited to human beings in general. The important thing was to give all men the means of creating art by abolishing the artist's specialization.

Cover of *Cobra*, Brussels, April 1950 (24.5 × 32 cm). Lithograph by Leo van Roy printed on pink paper.

'Folk art does not want to *force* the people to sing, but it encourages them to sing. Not to create art which pleases the people but to do what makes the artistic creation coming from the people blossom. To make people pass from the role of spectator to that of creator. In fact the contrary has happened. The social reality of art is its real existence in social life and the influence it exerts upon it. The content of art is man and his desires. At once the beautiful and the ugly. And that is neither beautiful nor ugly: forms and objects do not have beauty *within themselves*. It is through their relationship with us that they acquire it. Beauty is subject to continuous change, just as our needs change. What is beautiful always corresponds to a given historical situation. It is foolish to believe that one can achieve artistic development living under censorship, or exclusive forms of criticism or selection.

'If one wishes to impose a certain art form instead of expressing a new quality by quantitative experimentation, if one speaks in France or Denmark of socialist art, but that that art has nothing to do with concrete social realities, it is a deception, like making people believe you can harvest fruits before planting the tree. It is also a sinister joke which diverts people's attention from art's elementary and vital problems, in order to use them as cheap propaganda.

'There is only one single concrete artistic reality and that is the real, objective action a work of art produces in

157

Pierre and Micky Alechinsky at the lithographic press in the Ateliers du Marais, Brussels, 1950.

Jan Cox, sketch for a lithograph ('Don't play the villain. It suits you too well') which appeared in *Cobra 6*. Distemper and indian ink (30 × 23 cm). Brussels, April 1950.

Design for a Cobra flag drawn by Christian Dotremont on the page of a diary, 1950.

« Le peintre a tout dit quand il peint. Le reste doit se comprendre sans explication. L'art n'est qu'à ce prix; autrement la littérature vaut mieux. Un sujet qui a besoin d'un interprète n'est pas dans les conditions de l'art, c'est une vignette à placer au milieu d'un texte. »

(De Laborde, cité par L. Moussinac)

Le tout petit COBRA

Le Tout Petit Cobra, No. 1. Printed by Joseph Noiret on the press of the Koekelberg Atheneum, Brussels, 1950 (10.5 × 14 cm).

Pierre Alechinsky, *The Tall Grass*, 1951. Oil on canvas (130 × 162 cm). Private collection.

man. What is represented in the work, what one believes it represents, what the artist wanted to achieve, what one believes or feels, all is finally unimportant in relation to this single point.'

Here, Jorn was praising the power which resulted, for him, from the right to dare to do anything. In a letter to Constant of the same period (but undated), he assured him: 'The only rule of art which can exist is that of effectiveness . . . the style which is free to use whatever means of expression it chooses, that is our style. And the most effective means is fantastic realism. In drawing, one should deform objects and people, so that they take on a real significance.'

Cobra 6, on which Dotremont and Alechinsky were working in Brussels concurrently with the preparation of *Cobra-Meta* in Hanover, was thoroughly impregnated with Jorn's ideas. For his part, Dotremont had ardently developed them in the conclusion of his discourse in Amsterdam, *Le Grand Rendez-vous Naturel*; he also gave them a clearly Marxist accent. It was in this that Cobra differed from *l'art brut*, as conceived by Dubuffet, which was above all preoccupied with belittling intellectualism in art. Organized into a 'company' since June 1948, *l'art brut* is set against a perspective of the cultural dualism which has been present in the West throughout the centuries: on one side, the art of the museums, galleries and salons, the art of cultivated people and, on the other, that of the common people, the peasants with their secular traditions, self-taught men and all kinds of fringe groups, such as the mentally ill. Dubuffet (whose charming letter to the Brussels art dealer and publican, Geert van Bruaene, Cobra would publish) was not at all concerned about the socio-historical context of the wild productions he collected and which inspired him. He was apparently unaware that Europe was living through the end of this cultural dualism, with the recommencing of industrialization favoured by the Marshall Plan of 1947: all art, even the most savage, wild and brutal, the most marginal, would soon be found in museums, alongside the primitive art of long ago. Dubuffet's own works would be the perfect illustration of this evolution; his tremendous success and international fame marked the triumphal entry into the field of 'great art' of non- or anti-professional works. Jorn and Cobra had foreseen it, or rather hoped for it, and had helped clear the way for a merger of specialist art, that of the artists, with the art of the people.

'When capitalist industrialism wins the day and when popular art only has urinals in which to express itself freely, it goes elsewhere,' said Jorn. This 'elsewhere' was perhaps – had to be, according to Cobra – 'experimental art' because it offered a field endlessly renewed by that spontaneity it shared with popular art. In this spirit, *Cobra 6* was, in its entirety, a confrontation between 'the art of the town and the art of the country', to paraphrase the title of an article by Jaguer. This was illustrated by the cement *Gorilla* by Jules Hubinont, an old artist from the Walloons-speaking part of Brabant discovered by Alechinsky, Giacometti's *Woman*, a composition by Oskar Schlemmer and a rustic object from the Harz mountains. *Cobra 6* also assembled texts drawn from 'natural poetry', which was, according to the definition given by Camille Bryen and Alain Gheerbrant in their *Anthologie de la Poésie naturelle* (Paris, 1949), 'the expression of an immediate consciousness which has no other criterion of its own existence', and from 'literary' poetry – Jean Raine, Joseph Noiret, Dotremont and Armand Permantier, a former train driver. In the course of the review, mention was made of 'the role of the *reserve* which popular art provides for the styles of all ages' (H. Rasmussen, on the Danish *Manglebraedder*, wooden instruments for beating laundry, given as wedding gifts); of the 'experimental sense' which calls art into question again and leads to the rediscovery of 'the original sources of artistic creation' (Karl Otto Götz under the pseudonym of André Tamm on *Popular German art in its relation to experimental art*). And Götz believed that he could prove that abstract-surrealist art 'whose *metaphors* are dependent on *metamorphosis* . . . does not need to descend towards the people because it has popular roots.' He gave a most lucid comparison of Nazi propagandist art and social realism – 'we bitterly regret that it appears to follow the same anti-popular (and thus anti-experimental) tendency where it can', he said. This was echoed by the Italian Augusto Moretti (*Towards a popular Italian art*) in his analysis of 'the failure of Guttuso and his friends . . . who attempt to paint, with a *technique* which is not that of folk art, *subjects* which are theoretically those of folk art.' Thus it was in 'rediscovering the virtues of the rudimentary', bringing into play the 'natural dialectic of the *personal* which merges with the *communal*' that experimental art could become stronger and richer through contact with folk art 'until it finally becomes confused with it'.

In fact, *folk art* is a rather inadequate term; it limits the terms of reference to traditional European folklore – while the Cobra artists were much more eager to find 'symbols common to all', as Jorn put it, the 'original cells of life itself' (letter to Constant in 1950). Cobra was set in a more generally anthropological perspective, where pre-historic art had a place alongside the art of the Celts or Vikings, highly professional and elaborate art, or, indeed, non-European art. Even if this last had scarcely any impact on the work of Cobra (apart from Corneille and Rooskens, the most African-oriented member of the group), Cobra could not ignore it; the presence of Luc de Heusch, who was to become one of the great ethnologists of the structuralist school, was proof of that. In *Cobra 6*, Luc de Heusch published his notes on the art of the Basumba (a people from the former Belgian Congo), amongst whom he had just made a film. Speaking of the dynasties of professional sculptors, he stressed that 'there is no folk art with the Basumba, they seem never to have had one.' A man at the crossroads – art, political science, poetry, ethnology, cinema – de Heusch could not fail to be attracted by the Cobra spirit.

In Jean-Michel Atlan's studio in the rue de la Grande-Chaumière, Paris 1949. From left to right: Jacques Doucet, Constant, Christian Dotremont, Denise Atlan, Jean-Michel Atlan, Corneille, Karel Appel.

Despite the variety of its contents, issue 6 of the review did have a focus (rather hidden, of course, as suited a movement with a spiral development), and this was Atlan's short article 'Abstraction and adventure in contemporary art'. In the course of his *Tervuren Conversations* (1978), Dotremont described this worthy title as a first attempt at defining Cobra, a first attempt at synthesis. Atlan began by describing 'the two conformisms to which we are absolutely opposed: a) banal realism, the vulgar imitation of reality; b) orthodox abstract art, the new academism.' And he put forward as an alternative arguments in favour of concrete action and immediate practice: 'The forms which appear the most valuable for us today, as much through their plastic organization as through their intensity of expression, cannot properly be called either abstract or figurative. They participate in these cosmic powers of metamorphosis where true adventure can be found (whence emerge forms which are themselves and other than themselves, birds and cacti, abstraction and new figuration). The creation of a work of art cannot be reduced to a few formulae nor to some more or less decorative ordering of forms, but it supposes a 'presence', it is an adventure a man tackles with the help of the fundamental forces of nature. Certain amongst us put ourselves at risk today – in the cause of living to the end, turning our backs on vain doctrinal disputes, resolutely setting off along paths which fashion and the public have still hardly trod.'

No-one could have put it better than Atlan at that time. It was true of himself, having found himself rejected after his brilliant debut at the Galerie Maeght, as the Dutch artists did after the exhibition at the Stedelijk Museum and as Jorn did in Denmark. For them, this approach to the original, to fundamental forms, also meant a descent into the incomprehension of artistic circles, and a descent towards poverty, from which they would not emerge until several years later. It would not, however, diminish or affect the force of their creative impulse in any way in the years after Cobra.

Atlan's role in Cobra, direct or indirect, cannot be underestimated. He had appeared in *Cobra 1* then, at the other extreme of the scale, in *Cobra 10* and was one of the chief participants in the final exhibition at Liège, where he went to give a speech. And instalment 4 of the little *Cobra Library*, on whose cover he drew the word 'Cobra' by hand, is dedicated to him (text by Michel Ragon). These, of course, are two names impossible to separate. 'When we met', wrote Ragon in a public letter, 'you were already a well-known personality . . . you had just had an exhibition at the Galerie Maeght and your Saturday meetings at your studio at the Rue de la Grande-Chaumière were famous. The following year, that is in the winter of 1948–9, we took a train together to Copenhagen, where I had organized an exhibition of yourself and Pignon at the Museum of Charlottenborg

Corneille, *Native village*, 1951.
Oil on canvas (65.5 × 91 cm).
Private collection, Paris.
Photo Luc Joubert, Paris.

Constant, *The little ladder*, 1949.
Oil on canvas (90 × 75 cm), Gemeentemuseum, The Hague.
Photo Victor E. Nieuwenhuys-A. van den Born,
Amsterdam.

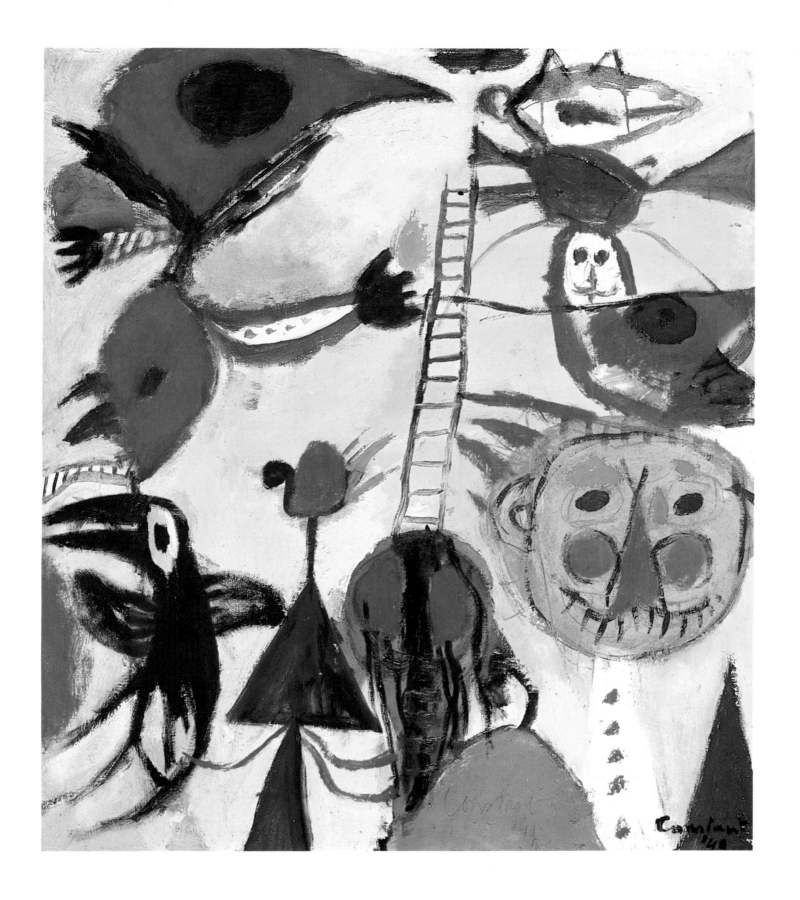

. . . Denmark, accustomed to the intertwinings of baroque and Viking art, to the diabolical frescoes of its ancient churches, acclaimed you, despite the current vogue for geometric art. Then there was that night, that great night of commercial crisis which would last for almost seven years. Without a single gallery or salon in Paris willing to exhibit you, you went for the gamble of placing your trust in your originality alone . . . you painted with rich materials, spontaneously.' It is certain that Atlan the Mediterranean, the 'Jewish-Berber', was the artist best equipped in Paris to respond to Cobra – to respond to it and, at the same time, to give it direction, as much in the treatment of forms and colours and in the materials themselves, as with ideas. Well before the birth of Cobra, as we have seen, Jorn, who was much of an age with him (Atlan was born in 1913), then Constant, Dotremont and the others had often called at the studio in the Rue de la Grande-Chaumière. During the Cobra period, they held working meetings there. Alechinsky wrote in a note: 'Atlan lit up the stove, connecting the gas pipe amongst all that clinker. The heat rose with the stench of cats, filling the whole studio and strengthening our simplistic impression of Africa . . . in the yellow light of a 60-watt bulb, we made out a single picture on an easel, living, earthy, the darkness of bones against the powdery chalk . . . imagine a cave, Atlan would say to us. Painting is like going into the depths of a cave where a very beautiful naked girl is standing. A picture is that girl. And we would catch our breath.'

Atlan, who had actively participated in the Resistance in Paris before being arrested, had only found salvation in simulating madness, thus entering the Prison de la Santé at the psychiatric hospital of Sainte-Anne. After the Liberation, he played an active part in the politics at the heart of Communism; at that time, he was one of those who refused to adhere blindly to Stalinism, knowing that he shared his views with Dotremont, whom he had met frequently at the beginning of 1950 and with whom he painted the *Transforms*. In a letter to Jorn (17.3.1950), Dotremont wrote: 'Atlan has arrived at the same conclusion as I have on the subject of the Communist position in artistic matters. Like me, he has made sincere efforts through practical work and he has the same history. One day, he took part in a debate with Duclos, Fougeron etc. He showed through an historical parallel that Daumier had been very revolutionary in his own age, but that Van Gogh was today more revolutionary than Daumier. The next day, *L'Humanité* wrote that comrade Atlan had shown that Daumier was more revolutionary than Van Gogh. In short, the opposite of what he actually said . . . the result was that Atlan left the Communist Party.'

It was now 1950: all this was against the background of the cold war and, from 25 June onwards, the Korean war. How could vertigo, if not despair, be avoided? 'When humanity desires peace,' Dotremont wrote, 'when men give up combat for everyday reality, resisting it, transforming it, it is inadmissible to let war happen, to

Jean-Michel Atlan, Painting, 1951. Published in *Cobra 10*, Liège, October 1951.

vaunt, in all senses, the ignoble idea of war!' In Denmark, Jorn painted feverish, tormented *War Visions*, which he would show in June of the same year in Copenhagen at the *Ung Dansk Kunste* ('Young Danish Art') exhibition. 'We should not describe the human animal, but describe *ourselves* as human animals,' he explained to Constant. Black, nightmarish and violently Expressionist in their composition, these canvasses seem to draw the relationship between the artist's own subconscious and – if it exists – the collective sub-conscious behind the disastrous scene of then current events. These were also 'exorcisms' in as much as it is true that the faculty of symbolizing is the best defence against fate, the best response. In Amsterdam, Constant was no less haunted by the events which he translated into works of brutal immediacy; going beyond the great *Barricade* of the exhibition at the Stedelijk Museum, it was the universe of aggression and destruction which was bearing down upon him: a *Slaughtered Horse* or a *Fallen Cyclist* (1950, Groningen Museum), a *House on Fire* or a *Devastated Land* – to which would be added the

numerous versions of *War* painted later in Paris in the conviction that he was creating the 'real socialism' through these works where the plastic imagination was paramount. 'I do not accept', Jorn wrote at the beginning of 1950, 'that Cobra, under Dotremont's direction, is struggling against Social Realism, with which we have much in common. Personally, I am fully in agreement with the theory, . . . but I believe that artists such as Fougeron or Taslitzky have miscarried . . . bourgeois realism has been adapted, for want of something else. It is for us, who know that form and content are inseparable, to create the style of Social Realism. This can only be arrived at through painting: it is also this painting which interests me for the moment!'

Most happily, Constant did paint, without worrying further about polemics or theory. Then, the following year, he participated in the Cobra exhibition at Liège with his *War* paintings, which were not out of place there, even though they could have been included in an official exhibition of Social Realism. Although he would have liked to do so, at no time did Constant handle space according to the conventions of Italian perspective,

Le Tout Petit Cobra No. 4. Linocut by Pierre Alechinsky (9.5 × 13 cm), Brussels, 1950.

based on Realism. At no time did he give his figures any resemblance to everyday life; at no time did he use graphics and colours as the simple means in the service of an imposed subject. The scenes of war are more 'Korean' than Picasso's *Massacres*, exhibited in May 1951. They belong to a universe of symbols, as Jorn wished it, more than to an immediate historical experience, as Constant imagined. His work would, moreover, evolve rapidly towards an ever more stark symbolism: *War Visions* would be followed by some 'grand schemes' of a simple detail blazing with colours: a hand, a fist, a flame, standing as a symbol of revolt, more and more removed from a representation of the external spectacle.

The question of Social Realism, which covered that of the relationship between experimental art and Revolutionary Surrealism with Marxism as practised by the Communist Party, was treated one last time, and definitively as far as he was concerned, by Dotremont in his pamphlet '"Social Realism" against the Revolution'. Published under the Cobra imprint towards the middle of 1950, it was the conclusion, by the declaration of incompatibility, of this grand debate, which had been going on since before *Les Deux Soeurs*. Dotremont's pamphlet was the direct result of an attack on the Revolutionary Surrealist positions by Fernand Lefebvre, who was responsible for the Belgian contribution to the Communist journal *Les Lettres Françaises* – a satirical attack, followed by a refusal to publish Dotremont's response. The sixteen pages of '"Social Realism" against the Revolution' was that response, argued point by point. Together with a defence of Surrealism, it contained an analysis of the inconsistencies of the communist tactic in cultural matters and announced that all sides were preparing a split. This break would entail the definitive end of Revolutionary Surrealism and of all collaboration by Dotremont with Communist organizations, or those sympathizing with Communism. Pierre Alechinsky, who had been person-

Title page of Christian Dotremont's pamphlet (format: 14 × 22 cm). Éditions Cobra, Brussels, 1950.

ally attacked in *Les Lettres Françaises*, had, for his part, written to Fernand Lefebvre: 'You are a typewriter, don't count on us to serve as carbon paper', and, to summarize: 'Many things to Arno Brecker' (22.10.1949).

The title chosen by Dotremont for his pamphlet referred to one of Roger Vailland's lampoons which made fun of the 'pure and strong' Bolshevik, ready to stoop to anything to serve 'the cause' – 'Surrealism against the Revolution'. In the course of his arguments, many of Dotremont's formulae hit their mark: Social Realism, he said, was 'the suicide of *revolutionary content* by means of bourgeois naturalism . . . let us understand each other, you old fools who copy the sad face of bourgeois society in the name of *happy tomorrows*, and you young arseholes who live in 1850 because we were born in 1924, and you *ideologists* who put the taste that the bourgeoisie has infiltrated *at the people's service*, you surrevolutionary realists and you theoreticians of painting, let us understand each other; we are not in the least opposed to propagandist art, provided that it does not play the enemy's game through its methods and provided that it does not play the enemy's game by pretending to resolve all problems, to contain all the promise of revolutionary art.' Dotremont put forward an authentically revolutionary culture as an alternative to Jdanovism, that paradoxical prorogation of bourgeois culture; an authentically popular culture, of which Cobra was the manifestation and the illustration. Dotremont could not resist a passing evocation of Chico Marx – not without a paradoxically serious intent which heralded in a way the joyous leftism of May 1968. Like Alechinsky, Dotremont would remain a fervent admirer of the Marx brothers and liked to be photographed in situations and poses which recalled their films. 'You have made us waste time': this short sentence at the end of his pamphlet demonstrated well enough that Dotremont had abandoned all hope of meaningful co-operation with the Communist Party. He would become 'more and more anti politics', as he wrote in a letter to Alechinsky (17.8.1950). 'Although I am obviously still as worried about politics as ever.'

In the tract 'Cobra for Contact', published to accompany various 'decentralizing and unifying' manifestations in May–June 1950, Dotremont took the Internationale of Experimental Artists definitively out of politics. This could not but upset Jorn and Constant, who told him: 'Politics are (not without our complicity) put between us and the Universe like barbed wire: before being a cigarette, this cigarette is *American*; before being a turnip, this is a *Soviet* turnip; before being the greatest poet of all time, Mitchourine is a *Russian*. Which teaches us that friends regard each other as china dogs and that these dogs all piss on the same *ideological* lamp-posts . . . Painting practically no longer exists; it disappears behind its classifications. This so-called left-wing painting is *abstract* and therefore *bourgeois*; *realist* and therefore *progressive*; *surrealist* and therefore *reaction-*

ary. In the eyes of the Left, if I can put it that way, it is enough to paint like in the nineteenth century to belong to the *avant-garde*; and it is enough to seek twentieth-century painting to be called an *agent of Wall Street*. Experimentation, in these conditions, has an historical role to play; to thwart prejudice, to unclog the senses, to unbutton the *uniforms of fear* . . . it is a matter of finding the resources of freshness which are still intact under the tactical layer of mud.'

The first 'decentralizing' manifestation, announced by Dotremont, would be 'Cobra Reality', an ephemeral gathering operating in Liège under the leadership of the painter Georges Collignon. Closer to the abstract landscape painters of the École de Paris than to Cobra and its 'exchange of monsters', Collignon nevertheless found himself at the last meeting of the group, which took place in Liège in October 1951. Meanwhile, jointly with Alechinsky, he had won the Belgian Young Painters' Prize. The second 'decentralizing' exhibition, planned at Louvière, was banned on the eve of varnishing day, fixed for 26 May. Dotremont's tract had been considered scandalously subversive by an official of that town – the town which had hosted, albeit in 1935, the first International Surrealist exhibition in Belgium.

Pierre Alechinsky, drawing, Brussels, 1951. Indian ink (16.5 × 8 cm).

According to Dotremont, Brussels in 1950 was the 'proprietary capital of Cobra-on-Universe'. A great deal was happening in terms of exhibitions, projects and publications between 10 Rue de la Paille and the Ateliers du Marais. On the occasion of the publication of *Cobra 6*, the Galerie Apollo presented, from 8–15 April (a short enough time!) an 'international relay exhibition' which marked the arrival of a new participant who was destined to become one of the great disturbing influences of his age: Hugo Claus. A Flemish experimental poet, attracted by the plastic arts, it was almost inevitable that he would become involved with Cobra in Brussels. In the Flanders of the post-war years, no-one could have been more isolated than he was, even though his precociousness and exceptional gifts had brought him a certain local fame. Many affinities led him to collaborate with Dotremont's friends. Their agreement was an immediate one: poet and painter, painter or poet, Hugo Claus would exhibit his works with the Cobra group, exchang-

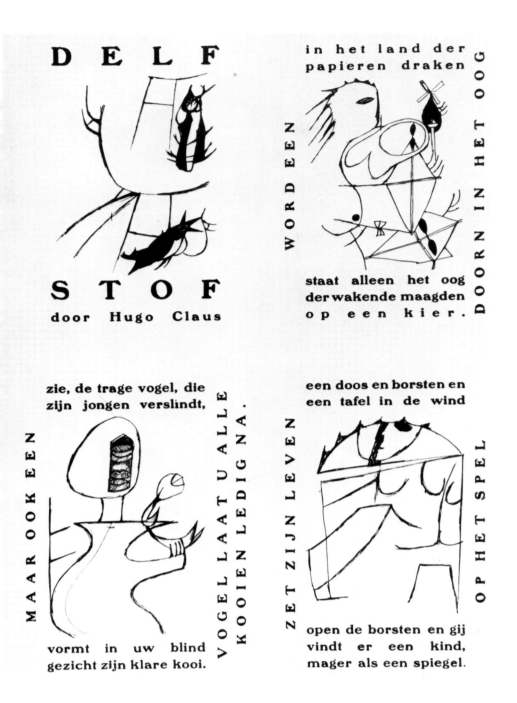

DELF
STOF
door Hugo Claus

in het land der
papieren draken

WORDEEN DOORN IN HET OOG

staat alleen het oog
der wakende maagden
op een kier.

zie, de trage vogel, die
zijn jongen verslindt,

MAAR OOK EEN VOGEL LAAT U ALLE KOOIEN LEDIG NA.

vormt in uw blind
gezicht zijn klare kooi.

een doos en borsten en
een tafel in de wind

ZET ZIJN LEVEN OP HET SPEL

open de borsten en gij
vindt er een kind,
mager als een spiegel.

Delfstof ('Ore'), poem written and illustrated by Hugo
Claus, published in *Cobra 6*, Brussels, April 1950.

ing texts and illustrations with Alechinsky (in a leaflet printed in June entitled 'Zonder Vorm van Proces'), then with Corneille and Appel, after they had emigrated to Paris, in a warehouse in the leather market in the Rue Santeuil. From the Santeuil era dates (December 1950) the first and only 'handwritten' book, containing seven poems by Hugo Claus and seven of Appel's drawings: *De Blijde en onvoorziene week* ('The happy and unforeseen week'), which inaugurated a new series of Cobra publications, *De handreeks in de Cobra Biblioteek*. 'Our intention', Hugo Claus said, 'was to produce such a book in a single afternoon. With the minimum of encouragement, we could have done fifty a year.' The second book got no further than the planning stage. This

was *April in Paris* (1951), containing eight poems and eight gouaches by Corneille and was intended as a celebration of the jazz musician Charlie Parker. Jazz, a music with popular origins, but which each great interpreter stylized and lifted to the status of a work of art, was an invigorating source for many artists and poets at that time. 'In jazz, creation and interpretation are reconciled,' Dotremont noted. 'In poetry, editing and writing should be unified.' A third project of Claus and Corneille, *Het Wandelende Vuur* ('The Walking Fire'), would remain the unique and original example of this.

In *Cobra 6*, Hugo Claus published four drawings framed by inscriptions: 'A thorn in the eye', *Ore* and, in *Cobra 7*, a 'Conversation about a young dead artist', which he illustrated himself with a brisk drawing. In February 1951 he took part in the Cobra exhibition at Librairie 73 in the Boulevard Saint-Michel; but he would never delve deeper, unlike Lucebert; painting was his 'hobby'. 'We do not think it is necessary to be dull to be contemporary,' Dotremont said with him in mind. 'Behind this dreadful weather we've had to put up with the pleasant weather is waiting and it is already ours.' Hugo Claus never gave up painting, however, and the Cobra spirit resurfaced on many occasions in his work. In 1963 he dedicated a dazzling book to *Karel Appel the Painter* at the same time as he wrote a *Love Song* to him, with which Appel would construct 'the biggest book in the world' – two metres high, one metre wide, each of the sheets of plastic of which the work was made up being fifteen centimetres thick. In 1978 in Ghent, Hugo Claus worked again with Alechinsky and Appel. Inspired by the great *Ink drawings with two brushes*, which Appel and Alechinsky had drawn 'inter-individually' over a period of two years, through amicable cross-fertilization and a grafting of their 'personal diversity', he illustrated twenty-five poems and eighteen comptines with them, entitled *We groan in unison*.

One of Claus's poems, written for Corneille, gives a remarkably precise insight into the relationship of the poet to visual expression (or how for him the 'given to see' is always the 'given to say'). It dates from 1954:

the inhabitant, exclaimed:
'Your heart (his spider's web) is a heart
You salute your bird-catcher, oh you parrots'.

When the birds and the spirals
When the articulations were revolted
They left their prairies, their virgin rocks
for the warm leather warehouse
and Corneille, he-who-whirls,

Sauteuil and flea market approved
Nerves and filaments denounced their dryads.
That all this has really arrived
is subject for discussion
with the travellers of the sands, the tempters of the night,
With the tears of the beheaded, with astonishment,
with gentle rains.

Subscription bulletin for *De blijde en onvoorziene week* ('The happy and unforeseen week'), poems by Hugo Claus, illustrated with hand-coloured drawings by Karel Appel (22.5 × 27.4 cm). Éditions Cobra, Paris, December 1950. Print run: 200 copies.

'Karel Appel and Hugo Claus spent a week in Paris, writing and drawing together. The result is *De blijde en onvoorziene week*. This booklet contains eight poems by Hugo Claus and eight drawings by Karel Appel, handwritten text and drawings being reproduced by photocopying. Cost: 50 Belgian Francs, 3 Dutch Guilders or 300 French Francs.'

opposite
The Brake, photograph by Serge Vandercam, 1950. This work featured at the 'Developments of the Eye' photography exhibition at the Galerie Saint-Laurent, Brussels, 30 September–15 October 1950.

De BLÿDe en ONVOOR ziene week.

Karel Appel en Hugo Claus brachten enkele weken in Parijs door en natuurlijk tekende Karel Appel en maakte Hugo Claus gedichten

Zo ontstond De Blijde en Onvoorziene Week. Dit bockje dat acht gedichten van Hugo Claus en acht tekeningen van Karel Appel bevat en volgens een Foto-copy-systeem gedrukt is naar de met de hand geschreven tekst en de tekeningen, kost 50 belgische frs of drie gulden of 300 franse francs.

'Go beyond pictorialism', Dotremont repeated, with the aim in sight of 'an immediately collective art where the specific can disappear without ceasing to be active.' Cobra in Brussels was certainly quite as poetic as it was pictorial, as photographic as cinematographic. Thus Pierre Alechinsky's little book *Les Poupées de Dixmude* ('The Dolls of Dixmude', 1950) corresponded with and responded to a 'complementary note' by Luc Zangrie (Luc de Heusch), illustrated with photographs taken in a deserted castle on the outskirts of Brussels by Roland D'Ursel, and the 'Developments of the Eye' exhibition (Galerie Saint-Laurent, September–October 1950) where Dotremont presented photographs by the same Roland D'Ursel alongside those of Ubac and a newcomer to Cobra, Serge Vandercam.

A literary work by a painter who saw himself as a 'writer', like most of the Cobra group, *Les Poupées de Dixmude* was an oneiristic text which mixed the fantasies evoked by Bellmer's 'Jeu de la poupée' with memories of childhood and the story of the discovery by Alechinsky, his wife and Christian Dotremont of a deserted, crumbling castle whose rooms were 'filled with family papers, postcards from 1900, love letters, letters of commiseration, old sepia photographs . . . Our attention was attracted now and then [wrote Alechinsky] by a large yellow velvet couch or a torn net curtain or a great mirror with a gilt frame which the thieves had not even bothered to take. We were walking on letters like you walk on dead leaves in autumn . . . A garden of rough grass spread out around this silent cataclysm with a tumbledown construction at the bottom, licked by a drain.' Here, a tendency can be sensed which characterized André Breton and the Surrealists in the Paris of the Twenties, who solicited the 'objective chance' to put the real and the imaginary in communication. Dotremont remarked that Roland d'Ursel's photographs 'seem to have been taken by Alechinsky whilst dreaming, and yet they have documentary precision.' Those featuring on the cover – a scree of bricks pouring through a door frame, are reminiscent of *Cobra 4*'s 'tongues sticking out'. In the afterword, Luc de Heusch coupled Alechinsky's story with the ancient mythologies of the Middle East: Ishtar, Aphrodite, Persephone – the 'Earth Mother'. And this was also to be the theme of the film he made in the castle. 'One of the most harrowing revelations of the East: maternal love rules over death as over life, the Mother holds all the keys, her hands indifferently weave the white veil or the black veil of Isolde.'

This figure of the 'Earth Mother' dominated the whole of the following issue of *Cobra* (No. 7, autumn 1950). Jean Raine dedicated an article to her which was Freudian in its references; Asger Jorn, on the subject of the Scandinavian fertility goddess Frey (Frö) suggested that 'the earth mother exerts a rule, in fact, in the Scandinavian and Germanic countries, whose memory art and ritual have preserved'; in a poem, Luc de Heusch associated her with the cruel sea, and a photograph of a beach was repeated obsessively on one page after

Les Poupées de Dixmude ('The dolls of Dixmude'), with a complementary note by Luc Zangrie. Pages 1 and 4 of the cover, photographs by Roland d'Ursel (13 × 16 cm). Éditions Cobra, Brussels, 1950.

another. Finally, Alechinsky presented a folk sculpture from the Ardennes, a curiously erotic scene representing original sin. 'The artist, who lays the blame on Woman, has taken his revenge by sculpting a death's head on the sex of Eve the Terrible, by way of a warning.' As for the film *Perséphone*, which got off the ground thanks to Henri Langlois, a founder and guiding light of French cinema, that would be ready only the following year for the Liège exhibition, all kinds of difficulties having delayed its completion.

Perséphone, 'which has neither Cobra's spontaneity nor its imagination, bears witness to a project realized with more friendly collaboration than financial support', according to Dotremont. At its presentation in Liège, Jean Raine stressed that the film, which saw itself as a cinematographic poem, accepted that 'art is a lie and the lie is the only truth.' Most of the Belgian members of Cobra played as extras alongside the principal actors and actresses (Nadine Bellaigue, Catherine Romanette, who would become the Comédie Française's excellent Catherine Samie, and Jean Soubeyran). 'I acted in it like the others,' said Jacques Calonne, a young friend of Dotremont who was destined to become one of the most remarkable composers of post-dodecaphonic music. 'We had gas masks and there were phony policemen – Havrenne was extraordinary – he ticked off some young

rascals who took him for a real one . . . The scenario changed considerably in the course of making the film. Dotremont's idea was a telephone: when someone spoke through it, the person listening heard Persian – hence Perséphone.' The dodecaphonic music composed by André Souris was played by the 'Toujours Pressés' brass band. Kuc de Heusch would make several documentaries concurrently with his ethnographic work in Africa and in Belgium itself; amongst other things, he made his 'cinematographic portraits' of *Alechinsky-d'après-nature* (1970) and *Dotremont-les-logogrammes* (1972).

This constant motif of the Earth Mother never lost its significance. Certainly most of the artists which Cobra brought together had read Freud; but one is inevitably struck by the fact that Cobra values, as formulated by Jorn, Constant and Dotremont, belonged purely and simply to the *imago maternelle*, to use the language of psychoanalysis. When Jorn spoke of 'putting art back onto a basis of the senses', when Constant praised desire, need and the childlike, when Dotremont described Cobra as a 'natural' encounter, propositions were present on each occasion which hark back to the 'mother figure'. And if the path of civilization was conceived, through Freud, as an historical succession of 'matriarchal society' and 'patriarchal society', in the course of a process marking 'the relegation of direct sensorial perceptions to a secondary level to make way for reflection and intellectually superior processes' (*Moses and Monotheiism*), Cobra's anti-cultural revolt could be taken for a regression towards the mother figure. Even

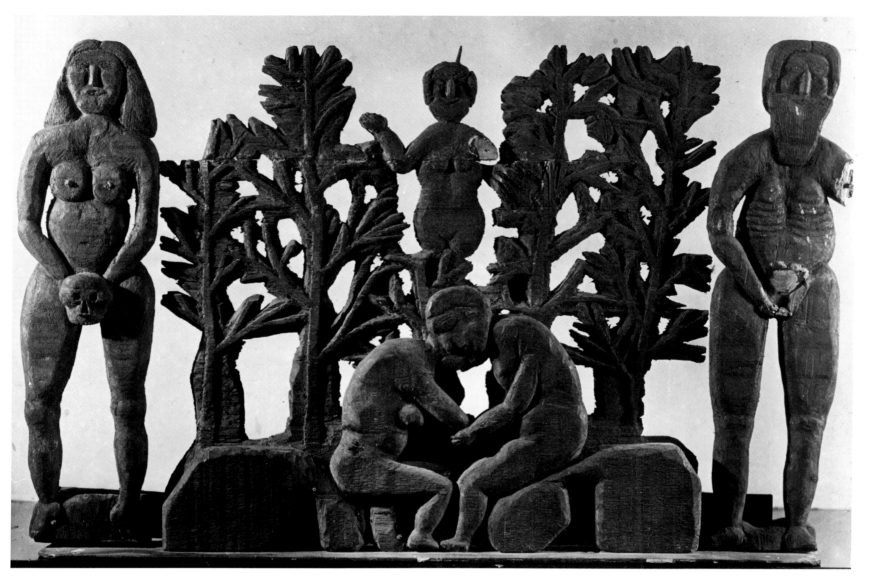

Folk sculpture from the Ardennes, published in *Cobra 7* under the title *Eve the Terrible*. Boxwood with walnut stain (39 × 52 cm). Photo Serge Vandercam.

avoiding over-simplification, as one must, Cobra's desire not to separate form and content could be regarded as research into 'the pleasure of fusion'; its abandonment of material to the imagination could be seen as a return to 'magical thought' in conjunction with Mother Nature. Yet is not every artist, as far as his sources of inspiration are concerned, a 'son of the Mother'? Does not the descent towards myth, towards archetypal forms, correspond to a voyage beyond the 'Father's world'? If the image of the Earth Mother imposes itself, is it not as a 'return of the outcast', of the guilt felt towards Mother Nature because she has been the victim of history's aggression? Cobra illustrates most clearly one of the ceaseless, fundamental conflicts common to the individual and to the collective psyche: the opposition of the patriarchal technical universe and the matriarchal world of the senses. That it is possible to overcome this opposition in certain cases where artistic

activity is dominant is precisely what Dotremont implied in the preface he wrote for the photographic exhibition at the Galerie Saint-Laurent, 'The Developments of the Eye': 'Man's eye, the eye which is a mirror to a thousand strokes of the cane (as the blind man said to Diderot), is developing with photography. The eye, an organic forest, enters into the forest of forms, into the forest of the infinitely small and the infinitely large . . . since photography has existed, it has always had something of the objective, unbeknown to itself . . . tomorrow, after the objective, the eye will discover the physical geography of things; it will see that neither their contours nor their uses suffice to define them; that they have spots, skin, pores. It is the development of the eye which is in progress.' Ubac was a particularly good example of how the opposition between the technical and natural worlds could be surmounted; in fact, it was photography which led him at once towards a kind of painting nourished by material in its most earthly form and towards engraving on slate, whose dullness, blue-grey colour and flaky surface he liked. On one of these, he wrote the name Cobra, with the snake symbol. The

third photographer exhibited at the exhibition was Serge Vandercam, one of Dotremont's new recruits. Vandercam, born in 1924, departed from the 'games of shadows, games of black, games of lines, things reminiscent of staircases, boar-spears, griffures and graffiti' and directed them towards almost non-figurative compositions. Later to become a film-maker, painter, sculptor and ceramist, he would be one of those called upon to develop Cobra after Cobra.

The two issues of the review *Cobra* published in Brussels in 1950 (Nos. 6 and 7), carried numerous poems, as did issue 8–9, dated 1951 and put together in Copenhagen with the help of the young poet Uffe Harder. That issue, however, would get no further than proof stage; it was not possible to refer to it until the 1980 reprint. Pol Bury insisted, not without reason, but with a certain degree of exaggeration too, that Belgian Cobra was dominated by literature: 'I always feel a kind of despair when I see that Cobra today is regarded as nothing other than a pictorial movement. For me, this aspect was secondary . . . And I must say that I do not recognize the Cobra I knew in what is now called Cobra painting – expressionism which is sometimes refined, sometimes intellectualized – a superficial way of giving an account of a movement which was not essentially pictorial. The quality of that painting is not in doubt, but to pay attention only to the money-making aspects of it is to limit the group's adventures. Let people who are interested seek there what was Cobra, but don't let the pictures take up all their attention!' (Conversation with André Baltazar, 1973.) What Bury was actually reminding us of here is that Cobra wished to be and was an anti- and inter-specialist movement. And that Dotremont, no less than Jorn and the Danes or the Dutch from the era of *Reflex* onwards, could not imagine being able to express themselves if they were confined to a single sphere of activity.

Dotremont apart (and his Surrealist friends like Louis Scutenaire or Paul Colinet, who remained close to Magritte), the most significant Cobra poets, alongside Paul Bourgoignie and Armand Permantier, were Marcel Havrenne, Joseph Noiret and Jean Raine. As we have seen, Hugo Claus represented the emergence of the new Flemish poetry single-handed, having more links with the *Vijftigers* of Amsterdam than the French-speaking surrealists of Brussels. In a general way, Belgian Cobra poetry went back to that great lyrical/anti-lyrical current which stemmed from the intellectual movement described by Breton in his famous *Anthologie de l'humour noir*. All the Belgian Cobra poets were to some extent 'black humourists', which excuses us from bracketing them otherwise within a definition which would not have failed to embarass them in the extreme. 'Black humourists', but always with a lyrical dimension, like Christian Dotremont, whose poetic work remains scattered amongst reviews, underground brochures and manuscripts: with the exception of *La Pierre et L'Oreiller* (1955) and the *Logbook* (1975), there are only two

Pol Bury, pen sketch for *L'Aventure dévorante* ('The consuming adventure') by Joseph Noiret. Format of the book: 12.5 × 17.8 cm. Éditions Cobra, Brussels, 1950.

posthumous collections of his work in existence – *Traces* (1980) and *Grand Hôtel des Valises* (1981), which are nevertheless enough to place him in the front rank of French poetry of the middle of the century. Another 'black humourist' was Marcel Havrenne (1912–57), older than Dotremont and his friend from their Revolutionary Surrealist days; his participation in Cobra 'through writing' (although he had also invented one of the 'objects through the ages') made an irreplaceable contribution. 'That gentle man,' wrote Dotremont in *Phantômas*, the Brussels review, run by Havrenne, Joseph Noiret and Theodore Koenig, which partially took over from *Cobra*, 'that gentle man who was worn down by a ridiculous task never raised his voice and never had any need of modernist showiness for his texts to be dazzling. He seemed to take his revenge on the calm appearance of monstrous reality by making his protests in the most violent style of maxim. None of us possessed as much force combined with as much discretion, nor so grave a form of humour. He laughed with

us, but amused himself too, at an admirable moral distance, over our lightweight enthusiasms. Was he a sceptic? I came to believe he was; but did the help he gave our efforts in 1947, then to Cobra (his text 'On vous montre des tableaux' is crucial), then to this review itself stem from scepticism? Was it as a joke that he dialled a friend's telephone number when he was a prisoner in Austria? Was it through indifference that he sent me things to read when I was in hospital?'

Marcel Havrenne's essential works – aphorisms – are collected in a slim volume which appeared during the year of his death: *Du pain noir et des roses* (1957). Jean Paulhan noted in his short foreword that the way he strung words together caused ideas to evaporate – to give way to what? Borgès, Havrenne's great admirer, replied: 'to images'. In fact, like Swift or Lichtenberg, in whose direct line of descent he can be placed, Havrenne proceeded by the concept-image or image-concept, half-reality, half-dream, half-experienced, half-thought up, in that singular zone (touched upon by H. Lefevbre, cf. *La Somme et le Reste*) 'where ambiguity rules but where ambiguity dissolves', a zone of 'dissonances and of the resolutions they have attempted'; the black humourist

Raoul Ubac, slate engraving (30.5 × 20.5 cm), Paris, 1950. Reproduced on the cover of *Cobra 7*, Brussels, Autumn 1950.

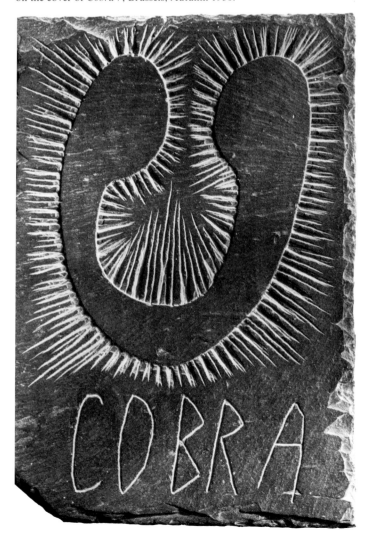

finds himself there as if in forced labour, with silence as his only alternative. Havrenne defied common sense as he did cosmic fact: 'One does not bathe twice in the same apricot.' Lichtenberg's remark defined him better than anyone else (and at least as well as Valery's 'Le Monsieur Teste'): 'This man had so much intelligence that he was good for almost nothing in the world.'

During the Cobra period, Havrenne published *La Main Heureuse* illustrated by Pol Bury. 'I no longer know', said the latter, 'which parts of the text or drawings existed first. Havrenne did not write in terms of my drawings and I began this series because that was the way I was handling the brush at that time. Neither of us looked over the other one's shoulder.' Bury also illustrated Joseph Noiret's *L'Aventure dévorante*; he too was a 'black humourist', close, one might say, to Benjamin Peret (to pursue the reference to Breton's *Anthologie de l'humour noir*). With Noiret, it was also that 'words and what they mean, having escaped domestication once and for all, . . . vie with disposibility.'

Listen in the silk
To the frogs
Croaking the witticisms
The ceremonial ties of the involuntary virgins
The appearances worthy of a banker
Boredom the enemy the priests
Rhyme, crime Love
Frogs
Frogs
Frogs

Head of a cobra from Ceylon.

In 1965, Noiret went on to cross a sparrow owl with a prawn and observed the result in a suite of poems illustrated by the Dane Mogens Balle: these poems, published in a book, were one of the sudden and frequent resurgences of the Cobra spirit.

Cobra 7 published two important steps towards that development of Cobra art which would be Dotremont's 'logograms': *L'Écriture Rêvée* by Marcel Havrenne and Dotremont's *Signification et Sinification* (his neologism for *putting into Chinese*). Since *Cobra 4*, Havrenne had

been talking about a 'physique of writing' and pondering on a kind of pan-scripturalism; according to him, alphabetic writing, like Chinese ideographs, could refer not only to the dictionary but to Nature, to the world in its very material substance: 'It is not impossible to rediscover in nature or in human constructions the form of letters or even of entire words.' And its corollary: 'Considered carefully, the profile of a mountain chain can perhaps form a rich sentence of unforeseen parts of speech.' Here again, one of the obsessions of modern poetry can be found, of all poetry, no doubt, when it attempts to struggle against what Saussure called the 'arbitrariness of the linguistic symbol'. To ink words in also means to anchor them to the substance of the world. Havrenne suggested distinguising between words which 'always stay on the surface of the object they define' and those which 'astonish and deceive at first sight because they seem curiously estranged from or even contradictory to their object – at once different and indifferent: one must stop there, because they are often the richest in meaning and depth. Through their form, their texture and their sound, they reproduce the secret dimensions of the object they name and contain the image which our imperfect senses had been unable to discover in the outside world; they thus reinstate for us what our narrow vision, further impoverished by habit, would let us lose: these substantial words are naturally written on the heart of things; they shine even in that place where the universe which is present in every object turns its darkest face towards us.' In saying this, Havrenne had gathered together several notions which have reference as much to Mallarmé as to the mystic visionaries like Swedenborg, Boehm or Novalis: it was a matter of situating writing within a conception of a coherent universe, interwoven with 'correspondances'.

In the article following Havrenne's, Dotremont, too, pondered on words grasped in their appearance, their graphic aspects, the visible, plastic part of the writing of them, which was of the same nature as painting, according to what Jorn had said in *Helhesten*. Looking at one of his original manuscripts in a mirror and held vertically, in 1950, Dotremont decided that his writing, 'my most ordinary writing' showed traits of oriental influence: 'The sentence then appeared to me like the ciphers on the cover of an undecipherable poem . . . but how *incomprehensible* is the *comprehensible*? Why does my glance sometimes come freely to rest on Egyptian or Chinese texts which I just do not *understand*? I do understand them in fact; when I *read* a page of Chinese writing, I am in the streets of Peking.' Considered from this angle, the field of calligraphy becomes unlimited: the writing does not refer uniquely to the writer enclosed within himself; it is also the manifestation of an imagination which, like all imaginary things, 'tends to become real'. Scriptorial imagination is a special case of the plastic imagination. The 'logograms' were to be repeated examples of this; yet, since they were also poetic texts, they would not break the 'verbal-graphic unity':

Pierre Faucheux, 'Dotremontage', repeating the experiment described by Dotremont whereby he turned his manuscript *recto verso*, then from left to right, before looking at it in a mirror (montage for 'Le Grand Hotel des Valises – Locataire: Dotremont', Galilée Éditeur, Paris).

Le Train Mongol ('The Mongolian Train'). Fragment of a manuscript by Christian Dotremont illustrating his text 'Signification et Sinification' which appeared in *Cobra 7*, Brussels, Autumn 1950.

'To write is to create text and forms at once.' This evaluation of the 'visibility' of writing was very much in the Cobra spirit, and Dotremont did not hesitate to reinforce it in his 1978 essay 'I write, therefore I create'. In writing, in fact, are merged 'the variety of forms of all truly spontaneous creation, the universality beneath the differences, experimentation at all stages of the work, from the creation of the work to the work itself, experimentation of exhibiting and of regarding things.'

At the end of 1950, the anti-Parisian Cobra group settled in Paris – but 'it was a trap!', as Dotremont swore in the great indictment which opened *La Pierre et l'Oreiller*, the autobiographical novel which he had then started to edit. Yet everyone had his reasons. For the Dutch it was because of the rejection to which they had fallen victim in Holland; Appel did not find it hard to persuade Corneille and Constant to leave their 'grumpy country'. The unexpected opportunity to do so was that Appel and Constant (but, inexplicably, not Corneille) had received a scholarship for a stay in France, to which was added a small bursary given personally by W. Sandberg. Their departure marked a real sentimental break. Only Constant would return to live in Amsterdam. Fairly symbolically, Appel and Corneille's first Parisian address would be, for several weeks, the small Danish Artists' House in Suresnes, which gave them time to find the warehouse in the leather market in the Rue Santeuil.

In a postcard dated 27.11.1950 and addressed to Pierre Alechinsky at the Ateliers du Maris, Corneille described their move to this building, which has since been knocked down to make way for the Censier university complex: 'We made partitions, doors, beds, cupboards and tables from a job lot of wooden beds which I found in the flea market. Fifty beds made out of hardwood, very solid.' And Appel recalled: 'It cost us an arm and a leg. And what work! We didn't know where to sleep during that time.' Before this transformation, the attic had had notable tenants: Dali and Bunuel in the Thirties; then Sartre during the Occupation; after that, a young lad who wavered for some time between becoming a painter or an actor: Daniel Gélin. A predestined place; as for myself, I had the opportunity to go there several times and I described it in the short monograph I dedicated to Corneille (Paris, 1960). A strong, unpleasant odour wafted around the building: 'Skinning. There's blood there. In fact, on market day, the gutters of Rue Santeuil run with blood and the neighbourhood rats come and drink it and get drunk on it.' The place had obviously been declared unfit for human habitation: Corneille and Appel were squatters – *Krakers* as they were called in Amsterdam by the young people who set about methodically invading the centre of the Dutch capital in the Sixties. Despite these precarious conditions, life at Santeuil was far from sad: celebrations and work took regular turns. And, as Dotremont remarked, the works of the two painters, who unfortunately fell out with each other, were a 'dramatic

health'. Corneille refined his vocabulary, identifying the motifs which would become definitively dominant for him – the bird, the woman, the labyrinth, which could equally well signify a town as the whole world in its richness in minerals, its fertility. Appel gave himself up to 'drunken bouts of colour': 'I paint in daubs, ever bigger daubs. The colours superimpose *ad infinitum*, I remove them, scrape them off, I put down others until the surface is at once free and complex.' For a while, Constant lived in the attics of the Rue Pigalle. He stayed away from Santeuil, where the sordid nature of the living conditions seemed unbearable to him, haunted as he was by war, suffering and misfortune; these were, moreover, the recurrent themes in his work at that time, where his intimate sentiments and his perception of the historical moment coincided. Was not his *Fallen Cyclist* of 1950 (Groningen Museum) really a personal fantasy? In Paris, he stepped up the disasters, fires, aerial attacks, scenes of devastation – several versions of *The Burnt Earth* (1951, Stedelijk Museum, Amsterdam), and death *Dead Cows* (Groningen Museum) or *The Wounded Dove* (1951, Boymans-van Beuningen Museum, Rotterdam). He often showed a hand raised against the sky. This hand would progressively become a clenched fist (1951–2), blood red, red of revolution, then flame, then crude form: the culmination of this 'season of hell' would be 'the sending out of the dove', according to the words of the poet Jan Elsburg, whose work Constant illustrated.

The spirit of catastrophe which ran through Constant's painting in 1950 was also familiar to Dotremont, who chronicled it in *La Pierre et l'Oreiller*: 'There's fighting in Korea, but he [the narrator of the book] thinks that individual catastrophes also count . . . It is hard to be in Stalingrad in winter with millions of SS approaching and so many machine guns applauding death. But hard too to be Stalingrad itself, to be occupied and surrounded and driven against the wall, delivered from the fire into the cold. Well, man is less the approaching SS, the one soldier who defends himself, the other who flounders, the one who believes he is in an absolute hovel away from the action, than this town itself where hope hides despair, where the sky really is a cover. He is less a soldier than a battlefield. He is less the tenant than the place. A place where so many things pass by that it is a place no longer – blood, memories, clouds, words and exterior currents; but a place even so, because the levers which control all the things which pass through hardly obey his hands. It is us, the scorched earth, the scorching earth.'

These words were of consequence above all to Jorn, who had come in his turn to seek refuge in Paris. After calling at the Ateliers du Marais, he too had been living since the autumn at the Danish Artists' House in Suresnes, with Matie and four children, the two youngest and Matie and Constant's two daughters. Their destitution had reached the limits of tolerability. But if malnutrition was assuredly ruining his health (he would

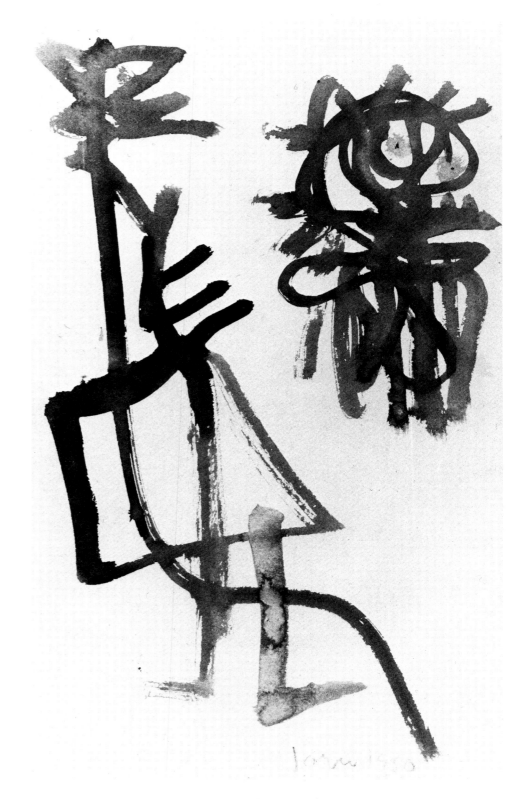

Asger Jorn, indian ink drawing (30 × 19 cm). Ateliers du Marais, Brussels, 1950.

176

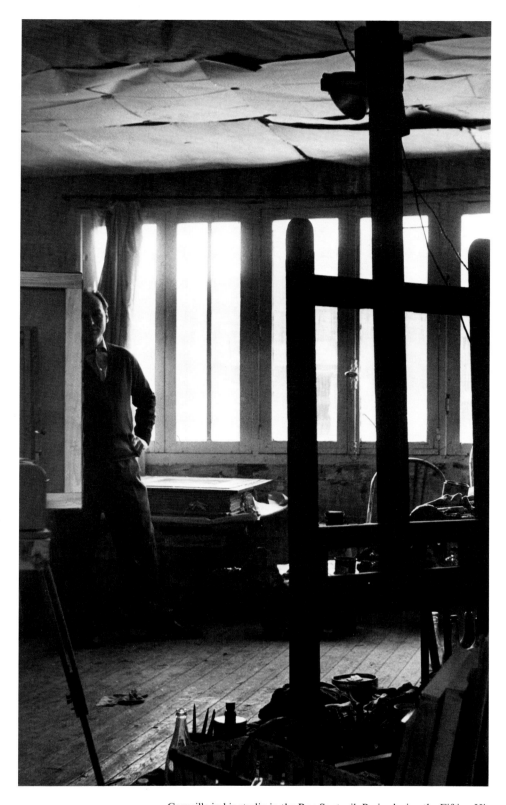

Corneille in his studio in the Rue Santeuil, Paris, during the Fifties. His studio adjoined Appel's. Photo Shunk-Kender.

only leave Suresnes in the Spring to go to the sanatorium in Silkeborg), it diminished his determination, his creative impulse, his mania for expression not at all. Like Constant, and contrary to the happy squatters of the Rue Santeuil, Jorn was painting projections of his anguish; the nightmarish creatures which are the *Aganaks*, other definitive monsters like *The Golden Swine* (Kunstmuseum, Silkeborg) and the second *The Eagle's Share* and some *Frightened Birds*.

Guy Atkins' catalogue lists some fifty medium and large format paintings for the six months at Suresnes. Humour was not absent in this infernal motion, as can be seen, for example, in *Morbid Fantasies*, a painting full of the frolics of dark forms and light colours. When tuberculosis triumphed, there were also some canvasses which were vehement incantations of misfortune: *Phoenix de luxe*, *The Spring Procession* and that hymn to the world and to love, as Carl-Henning Pedersen could have evoked it, *The Woman and the Tree of Life*. One last painting, begun at Suresnes and which Jorn would not finish until two years later, speaks for itself: *The Land of Suffering* (1953). And the sardonic *Return to the Hated Town*, painted in 1951–2 in the morgue at the Silkeborg sanatorium, would respond to it.

Jorn had become more and more pre-occupied with the symbolism of forms; from documents, he studied motifs decoarting two golden horns found in Gallehus in Denmark, which dated from the fifth century A.D. (These horns disappeared from the museum in Copenhagen in 1802.) Jorn was seeking to understand the causes and effects of the permanence of certain emblems. He was convinced that they would reappear in spontaneous painting as archetypal forms. Would art's future be its pre-history? Dotremont said nothing less than this in *La Pierre et L'Oreiller*: 'Modern man is seeking a prehistoric stone on which to lay his head.' Only 'Paris is totally hostile to prehistoric man who is already rising up out of the ruins of history.'

Paris hostile to Cobra? To be more precise, nothing would come easy there for the group, but they did have some sincere friends there, who were intent on supporting them with the limited means they had available. Starting with Michel Ragon, who had just completed *Expression et Non-Figuration*, a book containing ideas cherished by Jorn and Atlan, with reproductions of pictures by various Cobra artists. On the occasion of its publication at the beginning of 1951, Librairie 73 in Boulevard Saint-Michel hosted a small Cobra exhibition at his request, in which everyone played some small part – Corneille in Paris, Alechinsky in Brussels and Dotremont – but from afar, since he already had *Le Grand Hotel des Valises* in mind! In fact, the Cobra delta had much modified, in that Paris had to some extent replaced Amsterdam. And if Brussels remained the anchoring point for collective activity, thanks to Pierre Alechinsky, Copenhagen, where Dotremont was spending the most lucid time of his life (he had obtained a grant from the Danish government to study Viking art), had become the point of engulfment.

The exhibition at Librairie 73, which had gathered together, as was customary, original works and documents, had a famous 'aquatter' – Georges Mathieu. It was always the case with Cobra exhibitions that somehow, they inadvertently, in a way, attracted new artists to the spirit of the enterprise; in the indefinition of a living art, the twists and turns and hesitations of the path, how could it be otherwise? The presence of Mathieu at Librairie 73 was as much of a surprise as would be that of the Italian sculptor Lardera at the final exhibition at Liège. The exhibition at Librairie 73 gave the influential critic from the pro-Titoist weekly, *L'Observateur*, Charles Estienne, the opportunity to speak about Cobra with obvious sympathy, though not without a good many reservations, as can be understood from the title of his article 'Is Experimentation Creation?'. 'For Cobra, I think the hardest is yet to come – to give us facts which prove to us that a style is possible, not from a base of experimentation – which is common to every artist, but on the level of experimentation. What's more, one would need to be blind not to read straight away, beneath the voluntary or involuntarily grimacing mask affixed by the Danish or Dutch groups, the hagard anguish of a civilization – our own – which is attempting to reconstruct itself in destroying itself!' (March 1951). The exhibition presented works by Stephen Gilbert, Alechinsky, Pol Bury, Hugo Claus, Collignon, Egill Jacobsen, Asger Jorn, Atlan, Doucet, Appel, Corneille, Österlin, Tajiri and Van Lint.

During his period of arguing with Jorn, Dotremont brought out *Petit Cobra 4*, dedicated to Max Ernst, who went 'into adventure in reality as an imaginative person and into the imaginary as a realist.' The occasion for this tribute was an exhibition of 'several works by Max Ernst, presented in collaboration with Cobra', at the Galerie Apollo in Brussels in January 1951. Dotremont was planning a French issue of *Cobra*, but he soon had to abandon the idea as the helpers he needed let him down one by one. 'The rabbit breeders in Paris publish a richly illustrated brochure, the film buffs publish a copious review, all kinds of dissident groups publish bulletins, but experimental art cannot find the means to express itself,' he wrote to Alechinsky, not without bitterness. Since Dotremont's split with the Belgian Communists, Jorn had been less and less keen to pursue his collaboration with him – as Constant had been. On the other hand, Jorn was preparing a group exhibition at the Galerie Pierre in the Rue des Beaux-Arts, that same gallery where fate had deemed that he should meet Constant in 1946. Since the gallery had low ceilings, he decided, in agreement with Pierre Loeb, only to exhibit five painters, with a total of eighteen medium-size pictures. After much effort and many difficulties, which were interpreted by Dotremont in Copenhagen as plots to keep him and the Belgians away, the five painters chosen were Appel and Corneille (without Constant), Jorn himself, Egill Jacobsen (who was living in Savoy at the time) and Mogens Balle, called in by Jorn at the last

Le Petit Cobra No. 3, Brussels 1950. Cover by Pierre Alechinsky (linocut with engravings of wood taken from a botany book dating from the end of the nineteenth century).

Le Petit Cobra No. 4, Brussels, Winter 1950–1. Cover by Georges Collignon (monotype print). Format of both booklets: 13.6 × 21.5 cm.

A view of the 'Five Cobra Painters' exhibition at the Galerie Pierre, Paris, April 1951. Three paintings by Karel Appel, amongst which *A cat* (1951), on the left and, on the wall at the back, *Man, animals and birds* (1950). Behind Appel's sculpture, Jorn's picture *Luxurious Phoenix Painting* (1951).

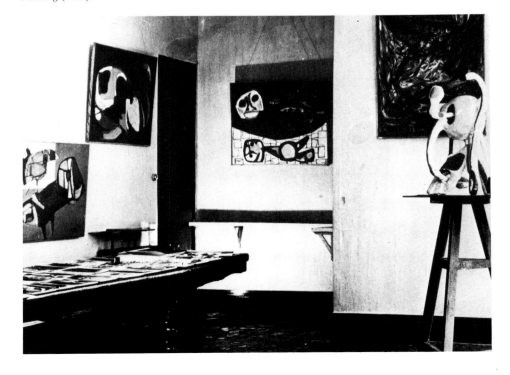

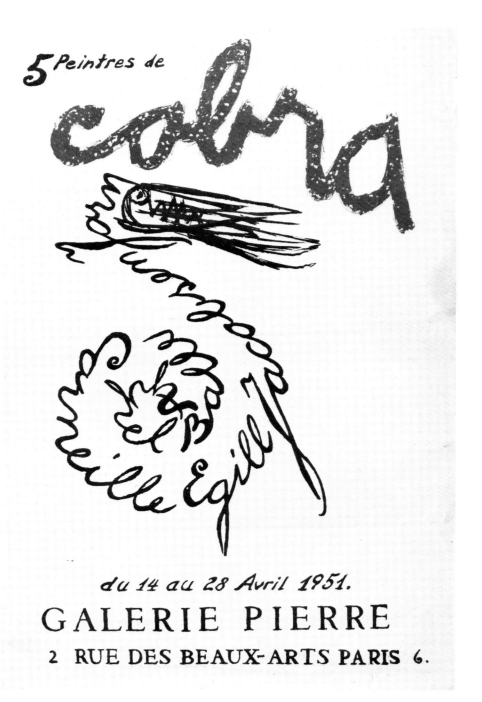

Lithographed poster by Asger Jorn (41 × 32 cm) for the 'Five Cobra Painters' exhibition at the Galerie Pierre, Paris, April 1951: Appel, Balle, Corneille, Egill Jacobsen, Jorn.

minute to replace Ejler Bille, with whom Jorn had broken off relations (Bille-Balle, the game of sounds had its influence on Jorn's choice). The exhibition, which took place from 14 to 28 April, was prefaced by Michel Ragon: 'Cobra is an occasion of happy encounters.' In reality, nothing was happening, discord had set in and illness had struck. Before the end of the exhibition, Jorn was forced to leave Paris: 'I learnt like everyone else', Dotremont wrote from Copenhagen to Alechinsky, 'that Jorn had a very severely infected lung and that he had set off for the sanatorium in his home town of Silkeborg. This is something which would seem to

resolve the Jorn–Cobra conflict, in a most unfortunate way,' (letter of 26.4.1951).

This new situation led Dotremont to believe that he could after all publish a new issue of the review, not in Paris but in Copenhagen, where he benefited from the efficient co-operation of the young poet Uffe Harder. This would be issue 8–9, bi-lingual in Danish and French; as we know, it would not go beyond proof stage. Although a number of articles and poems were supplied by the Belgians (Noiret, Havrenne and de Heusch), the bulk of the issue would consist of a kind of anthology of young Danish poetry, to which Dotremont himself contributed under the pseudonym of Bent Findel. With this name, he would put his signature to love poems (*Lukket og åben*?' – 'was it snowing?'): Dotremont had just met the 'Danoiselle' to whom he would henceforward dedicate all his work.

It is clear on reading the editorial and Dotremont's various notes throughout the review that he did not yet dare admit that Cobra was heading inescapably towards its end and that he, Dotremont, was tired of fighting: the 'bacillus of catastrophe' as he called it in *La Pierre et l'Oreiller*, was in full spate and was about to 'bleach' everything. Dotremont seized on Denmark first of all and admonished it: 'All the signs are of Denmark having consumed, from its interior to its borders, all its efforts at solidarity, its desire for exchanges, its desire to confront itself with realizations other than its own. Certain Frenchmen are like giraffes – they contemplate things from too great a height, from the moment when it is not a question of something of their own; whilst the Danes behave like ostriches and do not see them at all.' Dotremont reaffirmed the dialectic of the national and the international, of the individual and the collective which was the basis of Cobra: 'Certainly these artists do not wish to abandon their personal points of view; just as a national culture should not sacrifice itself by letting itself be absorbed by international cultural life, but should participate in it in a constant evolution, so the intellectual does not have to sacrifice his individuality in a collective enterprise . . . After a year and a half outside the Parisian myth, and without the cement of programmes, Cobra has become the most international

Karel Appel, pen sketch (7.5 × 11.5 cm), Paris, 1951.

179

Cover design drawn by Carl-Otto Hultén for a Swedish
edition of *Cobra*, which was never realized, (1951).

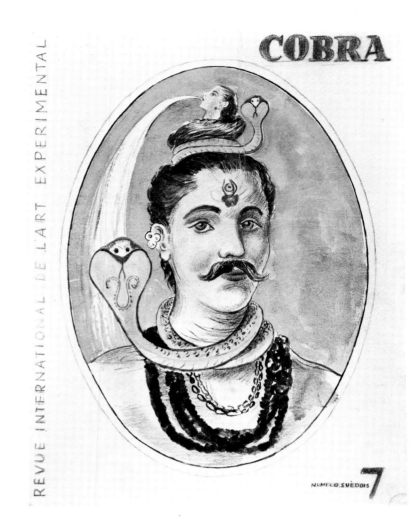

Pen sketch by Asger Jorn (6.5 × 10 cm) for issue 8–9 of
Cobra.

Rough layout for a subscription sheet for
Les Taches à Conviction ('The Marks of
Conviction'), a book planned by
Christian Dotremont and Pierre
Alechinsky, of which only a few notes
remain, written by Dotremont. In 1952,
this title would be taken up again by
Alechinsky for an etching in which the
poet's name is featured.

Christian Dotremont contrasted these two objects in *Cobra*: *Bull's Head* by Pablo Picasso (1942) and an ancient Scandinavian bronze.

I JULI KOMMER I KØBENHAVN COBRA's

særnummer 8—9 med bidrag af følgende medarbejdere:

Jens-August Schade: »En aften i café Laurits Betjent« (4. akt).
Bent Findel — Uffe Harder — Iljitsch Johannsen — Ivan Malinovski — Jørgen Sonne: Digte (på dansk og fransk).
Knud Hiortø (uudgivet fragment).
Luc Zangrie: Etude sur le carnaval de Malmédy.
Pol Bury — Christian Dotremont — Marcel Havrenne.
Francis Ponge: Fabriksskorsten.
Denne nye tekst af Francis Ponge, som er een af de mest frem-trædende forfattere i Frankrig idag, er den første, der offent-liggøres af ham i Danmark.

Michel Ragon: Les fonctionnaires de l'art abstrait vont-ils se mettre en grève?

MALERI — TEGNING — SKULPTUR
af: Mogens Balle, Asger Jorn, Wilmar (D.), Svavar Gudnason (Is.), Alechinsky, Louis Van Lint (Bel.), Appel, Constant, Corneille, Wolvekamp (Hol.), Atlan, Doucet, Dubuffet, Giro-nella (Fr.)
Billeder »hors texte«, bl. hvilke et originalt træsnit af Edgar **Tytgat, den store flamske naivist.**

Abonnement på alle Cobra's publikationer i 1951 (Cobra, le petit cobra, bøger) inklusive de 15 første hefter i Cobra-biblioteket (Udgiver: Munksgård) 50 kr
Abonnement på alle Cobra's publikationer 1951, uden hefterne i Cobra-biblioteket 30 kr.
Subskription på hefte 8-9 4 kr.
Girokonto: 28249.
Cobra: adresse i Danmark, Uffe Harder, Smakkegårdsvej 8.
 Gentofte.

Contents of *Cobra 8–9*, the double issue which was planned in Copenhagen and never went beyond proof stage. *Right:* drawing by Karel Appel (13 × 8 cm) for that issue.

and most precise expression for the art which wants to give sensibility every chance to deploy itself, instead of forcing it down specific channels.' And Dotremont formulated the hope that 'someone will do the necessary so that we will no longer be reduced to having to accept, but can impose ourselves.' This sentence, on which the editorial closed, indicated fairly clearly that Dotremont was close to giving up. In a contemporary letter to Pierre Alechinsky (23.3.1951), he justified himself: 'Writing articles, hundreds of notes, rewriting other people's texts etc., being a courier all the time, is like the writer being screwed twice, once in the public eye and again, above all in his own. It's masturbation, making it in small artificial ejaculations; in this game, the writer becomes impotent. It is not only a question of time. I've put all the effort in the world into getting this book off the ground: I've spent my talent in another direction, I no longer know how to construct a book. If I'd only occupied myself with organizing exhibitions, like you occupy yourself with organizing this review with me, I would not have lost this talent. It is precisely the fact that the review is on the same literary plane as the book which annoys me. You have had a lot to do with Cobra, review and exhibitions; but, if you want your dilemma to become the same as mine, and your Cobra activity to annoy you like it annoys me, you must do hundreds of caricatures every day, draw to order, retouch other people's drawings etc. Then your talent as a painter would be under attack like mine as a writer has been.' It happened that the organization of Cobra left Alechinsky little time to be a painter, which made him sad. 'But after all,' he would reason thirty years later, 'perhaps all my tasks in helping Dotremont with his Cobra work prevented me from producing a certain number of bad pictures, which is just as well!'

As his disappointment increased, his illness progressed – 'I am exhausted,' he wrote in a letter of 4.5.1951) – and his amorous passion heightened, Dotremont became detached from Cobra, perhaps from painting itself, even if only temporarily. This seemed to be the case from his article 'Holbaek's Experiment' which would open issue 10 of Cobra, the last. It was an ambiguous article, like an unexpected paraphrase of Pascal's mocking exclamation: 'Oh vanity that is painting . . . '. Dotremont wrote: 'I am hardly an enemy of painting, nor a friend of nature, as they say. But they say wrong.' Further on: 'We only touch the walls in order to open them. Windows always look on to something . . . paintings must also always look onto something.' Which could obviously not be, to take up Pascal again, 'these things of which one does not at all admire the original' but rather 'what reality itself does not allow to be seen.' Dotremont insisted: 'With the least possible painting.'

At this point in the collective race, Dotremont passed the baton to Pierre Alechinsky. In Belgium, Cobra had obtained the support of the Royal Society of Fine Art in Liège, and that of a patron, Baron Ernest van Zuylen. Thus could take place – 'so that Cobra can die beauti-

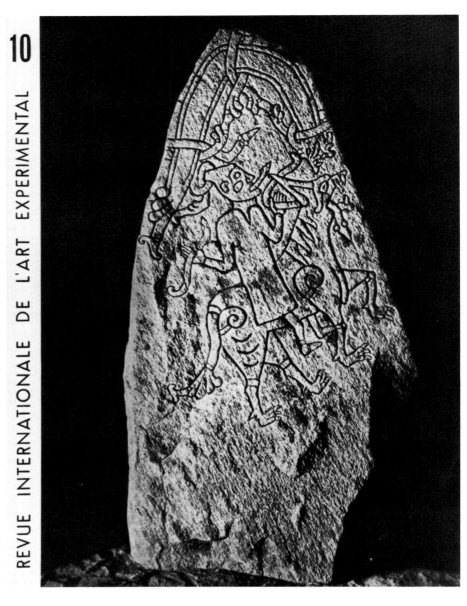

10

REVUE INTERNATIONALE DE L'ART EXPERIMENTAL

Cover of *Cobra 10*, Brussels, October 1951 (24.5 × 32 cm). Photograph of a runic stone from Jelling in Jutland. As the back cover announced, this would be the last issue of the *Cobra* review.

fully', according to Jorn's sarcastic wish – the second international exhibition of Cobra Experimental Art at the Palais des Beaux-Arts (today the Palais de la Boverie) in Liège, from 6 October to 6 November 1951. And it was on this occasion that the final issue of the review, *Cobra 10*, appeared.

Alechinsky's paintings during the Cobra years had titles which were apt to imply hesitation: *Attempt at Colonization* (1950, Museum of Fine Art, Ostend), *Night Exercise, Writing Exercise,* or again *Entrance to the Grotto* – an entrance seen from outside. It was thus a matter of crossing the threshold, of 'rejoining the cosmic', Alechinsky wrote in 'Abstraction faite', a text published in *Cobra 10*. And it was true that Alechinsky was still in Cobra only through that 'immanent dynamism' which he was learning to allow to appear on the canvas, but which remained secondary to a certain 'good painting' – quite inevitable no doubt, the Dutch Cobra

group had also drawn on it in their time. A journey to Denmark, in the course of the summer of 1950, in the company of Micky and Dotremont, helped him to get away from it: in Copenhagen, he was able to see the fine Carl-Henning Pedersen retrospective, *Eventygrets Malerier*, and to visit Elise Johansen's collection, prior to spending some time in Malmö with the Imaginists; it was a pilgrimage to the source. 'The less the Nordics see the sun, the more they paint the light. Night envelopes them, but their eyes have a piercing desire.' Invited with Pol Bury to the Spiralen salon, he then took part in the 4th salon of *Les Mains Éblouies* at the Galerie Maeght in Paris in October, together with Corneille, Doucet and Collignon. *Sun*, a small oil on canvas which he exhibited there, harked back to that Lyrical Abstraction which Bazaine, Ubac and certain others presented as a new vision of the world, a new *situation*: that of a less 'separate' consciousness? As if to preserve himself from this fine, and perhaps useless, intellectualism, Alechinsky evoked Groucho Marx: 'A child of four could understand that! Bring me a child of four!' Later, Alechinsky would say: 'It takes years to find the childlike inside oneself. At the outset, one is an old man. Cobra is a form of art which heads towards childhood, tries to recover folk art and child art for itself. With the means available to adults, non-naïve means. It is not naïvety which is required.'

Tall Grass (1951), one of the canvasses exhibited by Alechinsky at Liège, showed that he had crossed the

Pierre Alechinsky, *Snake*,
Brussels, 1950. Indian ink (43 × 41 cm).

Catalogue for the Spiralen exhibition, Copenhagen, 30 December 1950–4 January 1951. Cover designed by Knud Jans. Among the exhibitors: Pierre Alechinsky, Mogens Balle, Pol Bury, Asger Jorn.

threshold of the grotto. It showed him in a complete jumble (entirely natural), a veritable thicket of forms and symbols, of inextricable form-symbols; after *Tall Grass* came *Migration* then *Winter* (1951) and so on until *The Ant Hill*. Describing this evolution on the occasion of the Tajiri–Alechinsky exhibition (Amsterdam, February–March 1953), he spoke no longer of children but of 'the first men who search with humble passion for the grass, still and already living, the tree, the sea, fire, the sk and the movement of the seasons, removed from destruction and construction.' But most of all, Alechinsky would henceforth follow his Ariadne's thread, his personal archetype, the serpentine line. It appeared in *Sun*, in *Entrance to the blue Grotto*, then disappeared for a time, to reappear in *Sea Serpent* (1955) and *Salut!* (1955) – a toast to a welcome return. The artist had finally emerged from that interior forest where he had been painting, 'the branched hand on the lookout, and nothing is lost between what he discovers and what he sees' (Dotremont). His trade as an engraver had stood him in very good stead.

But to return to 1951 and the article 'Abstraction faite' which featured in issue 10 of the review. A certain convergence between Cobra and the École de Paris was becoming apparent, and was made manifest by the Exhibition at Liège, which did not prevent Cobra values from being vigorously formulated once again, and for the last time: the material brought forth from the imagination, the concrete immediacy of the work ('nothing more concrete than these paintings . . . where the acts of thinking and painting straddle and interpenetrate each other'), spontaneity ('for the moment, it is thus – failing anything else – that the painter can advance, walk on previous pictures without seeing them too much, without turning round on land already explored'). Experimentalism ('the picture is a land of experiment') led Alechinsky to praise action, which aligned Cobra

184

Anders Österlin, *Painting*, 1948. Oil on canvas (65 × 90 cm).
Collection of the artist.

Carl-Otto Hultén,
Tormented by the Heavens, 1950.
Various techniques on canvas (55 × 38 cm).
Collection of the artist.

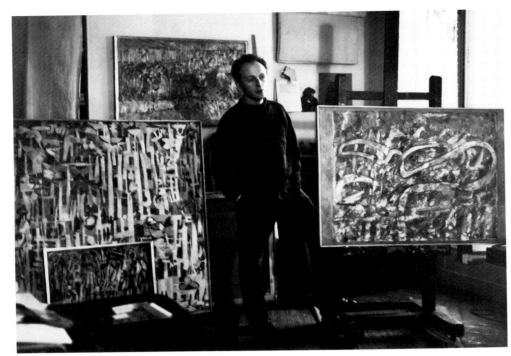

Pierre Alechinsky in his studio at rue Piat, Belleville in 1954. On the left, *The tall grass* (1951); foreground, *Forest on the look-out* (1954); on the wall *Cliff*; on the right *Sea serpent* (1954). Photo Henny Riemens, Paris.

with the American Abstract Expressionists, then little known or unknown in Europe. ('One cannot foresee that, at the very moment of action . . . it is through action alone that the thought can intercede in matter'). Alechinsky stood firm in taking exception to cultural models, such as were in circulation in industrial and bourgeois society. Childhood must be given precedence over adulthood, primitiveness over anaemic knowledge: 'The nearer man draws to chaos, . . . the more he will act with lyricism.' He invoked the 'great heretics' (Antonin Artaud; Van Gogh, 'the suicide of society'), not in order to follow them towards the abyss, but – and this is Cobra's vital optimism – to announce a new departure: 'It is not aesthetics which engender poetic creation, but creation itself which manages to clear a way for itself in spite of all the dogmas.' In a second part which was never published, Alechinsky developed his attack against the subject in painting, as it was conceived by those he named frankly as 'stalinians'. He finally set his sights – and this would remain a permanent feature of Cobra – on going beyond the paradoxical love-hate relationship with the subject: 'It is not *because* of the field of corn that we are bowled over by Van Gogh, but *despite* the field of corn: we should in fact say: despite the yellow field.'

One of Charles Estienne's texts, 'Prelude to the wedding' was inserted in *Cobra 10* in the form of a thin booklet. Estienne, who, as we have seen, had been one of the few critics to welcome the Cobra artists to Paris, expounded on this occasion on what the future of art should be according to him, in that mid-century period – a new wedding with Nature. Obviously Charles Estienne was not preaching any kind of return, be it realist or impressionist, to the natural spectacle: he remarked (with amused pleasure) that, in abstract painting, the purest geometrical form had great trouble avoiding being referential or having symbolic meaning. The form

'always preserves, if it is real – real in the plastic sense – . . . something of the humus and of the deepest silt of our origins.' In this, Estienne was in accord with André Breton (whom he quotes) as he was with Jorn, Constant and Dotremont; it was for this reason that he set his mind to another 'great natural encounter', which would materialize the following year: this would be the salon Octobre at the Craven Gallery, to which several of the Cobra group would be invited. 'From one side and the other, from a line where *mental representation* and *perception* meet . . . pure abstraction and primitiveness advance towards each other, and, having left the most opposing poles, they find that they are the same as each other in plastic and poetic terms . . . It all happens as if art were in the process of renewing its ancient pact with Nature, rediscovering it from within, whilst the immense stampede of the figurationists and stylizers slave pathetically to discover only its exterior, its picturesque quality.'

The path indicated by Charles Estienne turned out to be one of the most fertile in discoveries and works of art; it would lead to what would be called 'abstract landscape painting', 'new nature' and 'painters of *dépaysage*', visions of a kind of 'golden age' which stood, between Utopia and nostalgia, against the 'iron age' of the conquests and ravages of industrial civilization. *Cobra 10* finished, moreover, on a lyrical 'call to resistance' from Luc Zangrie, 'Towards a new Totemism'. It called upon poets and artists who had 'deserted' to go 'to the forests and rediscover the dignity of freedom. The discretion of wood, the elasticity of fibre . . . it seems to me that the art of my painter friends is becoming more and more alienated from the town, and is trying again in an obscure way to find the key to the fields. Like folk art, it is an agrarian art. The forms they invent are the adulterous daughters of the buds; they augment nature, innocent and awkward, or joyous and

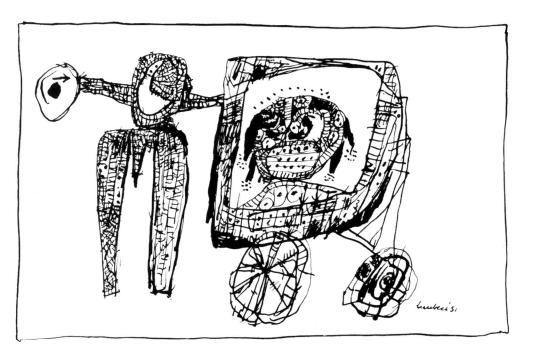

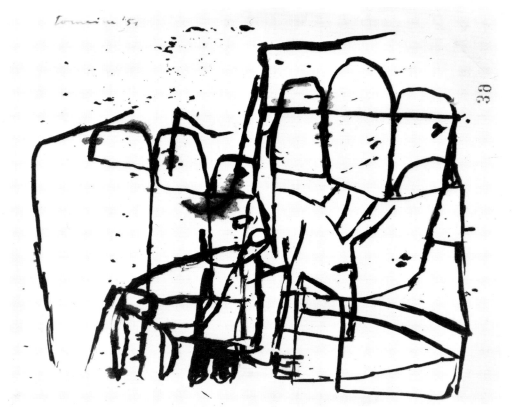

above
Lucebert, *Pram*, 1951. Indian ink (15.6 × 23.6 cm). Collection of C.A. Groenendijk, Amsterdam.

below
Corneille, drawing, Paris, 1951. Indian ink (21.5 × 26.5 cm).

wise, some hastily, distractedly, the better ones lovingly, with the desire to assume their obvious responsibility in the creation of the world. The vegetable kingdom will once again become a huge province in the painted realm. Already, painters are playing truant there.'

These words, the last of Cobra as an organized movement, could be read in the last lines of the last text of the last issue of the review, but they continued to animate the future developments of Cobra art. Twenty-five years later, Karel Appel would rediscover them 'naturally' in that 'monologue for two voices' which brought us together before his *Face-Landscapes*: 'We must resume relations with and rediscover the profound solidarity of the living: in the violence of the act of painting, in the colours rushing forth and becoming forms, it is the very movement of nature which appears and is transformed into human faces. Man and nature once again find themselves interdependent, as they should never have ceased to be' (exhibition at the Galerie Ariel, Paris, June 1977). Cobra art is like a modern totemism – animal, vegetable, imaginary – which the passion for living sets against the triumphant indifference of technology, the great taboo of our century.

In parallel with the publication of issue 10 of the review, the second (and last) international exhibition of Experimental Art, organized by Cobra, took place from 6 October to 6 November 1951, in the buildings of the former Palais des Beaux-Arts in Liège. This exhibition comprised twice as many works as that of the Stedelijk Museum in Amsterdam. Certainly the means which had been lacking to Cobra in 1949 were available this time in setting up the exhibition; for example, special transport-ation was laid on for the collection of paintings and sculptures. There were two centres of organization: Brussels, with Alechinsky; and Copenhagen, with Uffe Harder. Dotremont, who had commuted between the two, was forced to abandon the enterprise as late as August. 'I visited Jorn, who is confined to bed in a splendid sanatorium; I had to settle the Danish particip-ation with him,' he wrote to Alechinsky from Silkeborg on 23.8.51. 'I had felt ill for weeks and weeks. I talked about it to Jorn, who had me examined by one of the best specialists in the world. The X-ray was developed yesterday: I have two infected lungs . . . I have to be hospitalized as quickly as possible . . . the chief doctor has asked me to move into Jorn's ward immediately. I restricted myself to taking the odd meal with Jorn, which gave me the opportunity to say: I already have a lung at home. Jorn thought it would be better if I stayed in his sanatorium . . . we were thinking, he and I, of forming the Tubercular section of Cobra. I will have to stop my involvement in exhibitions etc. and restrict myself to putting a book together. All the time, I feel like I've got a dagger in my back, but I crack jokes the whole day long. I become more and more cheerful. We have to live after all!' When the Liège exhibition came to an end, and with it the organized period of Cobra, Dotremont said sadly: 'I profoundly regret that this exhibition was a defeat for me whilst being a success for Cobra.' In fact, he was already planning new publications, amongst which was a small 'personal' review, which in fact never saw the light of day, but whose title was almost perfectly programmatic for Dotremont himself: *La Volonté de se fixer dans la liberté* ('The will to settle oneself in freedom').

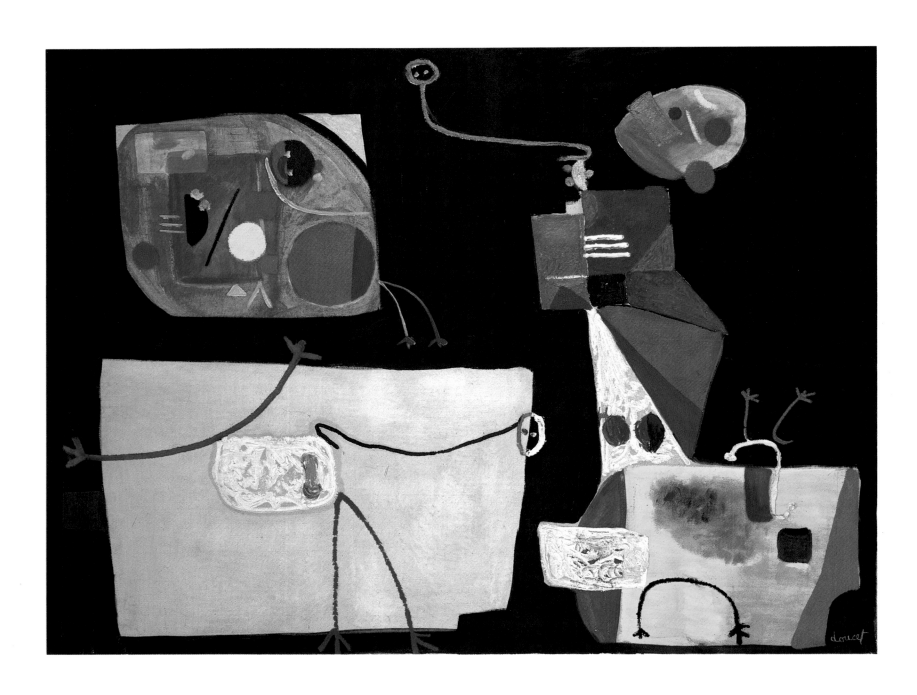

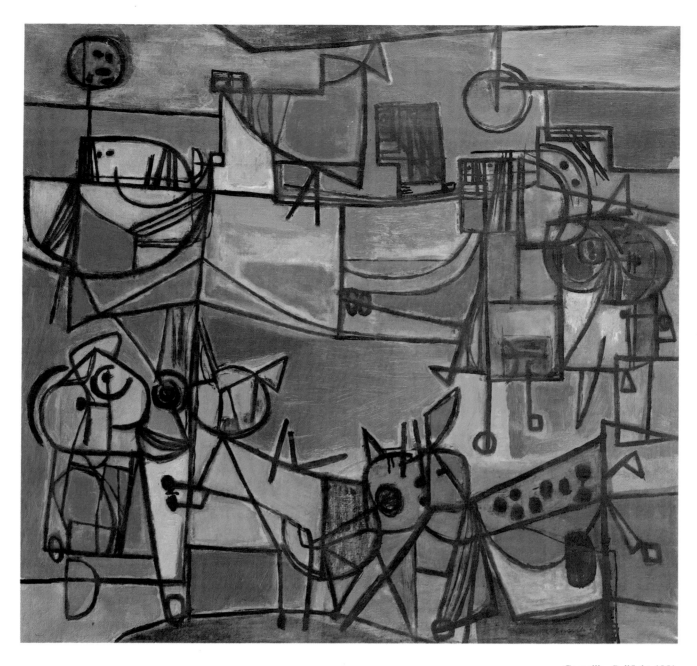

Corneille, *Bullfight*, 1951.
Oil on canvas (74 × 75.5 cm).
Private collection, Paris.
Photo Luc Joubert, Paris.

Jacques Doucet, *Homage to Armstrong*,
c.1950. Oil on canvas (85.5 × 115.5 cm).
Kunstmuseum Silkeborg. Photo Lars Bay.

Second International Exhibition of Cobra Experimental Art, Palais des Beaux-Arts, Liege, 6 October–6 November 1951:

right

The Shinkichi Tajiri room. Works in plaster and iron, 1951. Photo Violet Cornelius, Amsterdam. *Below:* Etienne-Martin's *Dragon*, 1947. Limewood (200 × 100 cm). On the left, the painter Edgard Tytgat. Photo Serge Vandercam, Brussels.

opposite

above: Works by Carl-Henning Pedersen and Henry Heerup, whose sculptures were exhibited on a bed of coal. Photo Serge Vandercam, Brussels. *Below:* works by Corneille (left) and Alechinsky (right), with two sculptures by Alberto Giacometti, *The Chariot* (1950) and *The Clearing, 9 Figures* (1950). Photo Violet Cornelius, Amsterdam.

Thanks to Corneille's insistence, the architect Aldo van Eyck once again accepted the task of arranging the works. In the staterooms of the Palais des Beaux-Arts with their Corinthian columns, van Eyck strove to achieve a spatial discontinuity which would give each painting and each sculpture a kind of protected space. The sculptures particularly benefited from his originality: Giacometti's painted bronze *The Chariot* was placed at the end of a black platform which sloped gently over several metres; beside this, on a flat white plinth of the same oblong dimensions, he had sited Giacometti's miniscule people of *The Square*. To display Heerup's sculptures – red and grey granites (*Sitting Animal, Profile of a Bird*), a shale (*Monkey's Head*), and a sandstone (*Bird Resting*) – van Eyck used a bed of coal, thus evoking the subsoil of the region around Liège; nothing could have pleased Heerup more, suffering as he did from seeing his works, which were conceived in and for the fresh air, as close as possible to nature, cooped up.

The exhibition in Liège was held in quite a different spirit from that of the one in Amsterdam. This was first and foremost because it marked the entry of Cobra into an artistic community, instead of its aiming to be a moment of provocation and rupture. Cobra art, which, despite its lack of material success, was henceforth in the full flood of creation, here fearlessly confronted its predecessors and its allies – hence the presence on this occasion of Miró and Giacometti (whom the Danish Abstract Surrealists had come to know through Wilfredo Lam, and whose work was an admirable synthesis of afro-american folk inspiration and the modern spirit), and of Bazaine and Ubac, two adherents of Lyrical Abstraction. Other welcome guests were Étienne-Martin with a *Dragon* carved from a tree stump, a splendid piece of 'grafted nature', and Louis van Lint, whose 'experimental vivacity', and 'refusal of rigidity' were much valued by Dotremont and Alechinsky. One of van Lint's paintings, which has particularly lively colours, was entitled *Fools' Paradise*. One critic did not miss the chance to pronounce – and this was the most widely held opinion – that this title 'suited the entire exhibition, which was otherwise indescribable.'

The Danish contingent was without Else Alfelt and Ejler Bille and once again minus Egill Jacobsen, Svavar Gudnason and Sonja Ferlov. There were only three painters: Jorn, with his Suresnes canvasses, Carl-

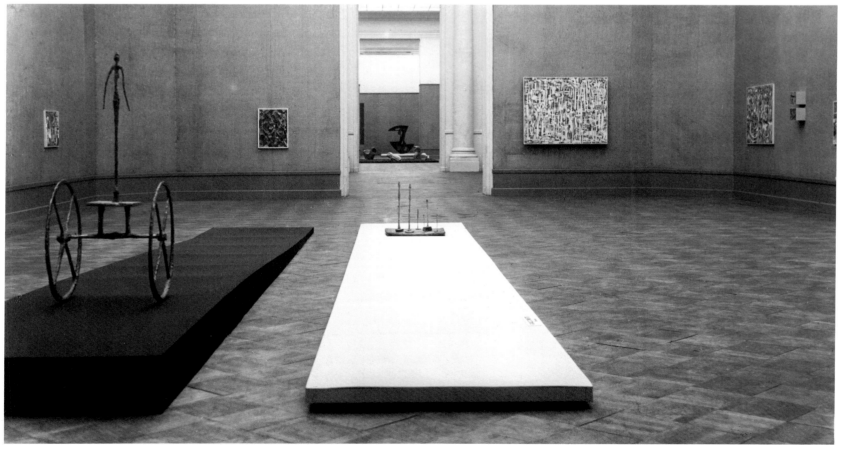

Karl Otto Götz, *Daphnis and Chloë*, 1950. Woodcut (195 × 203 cm).

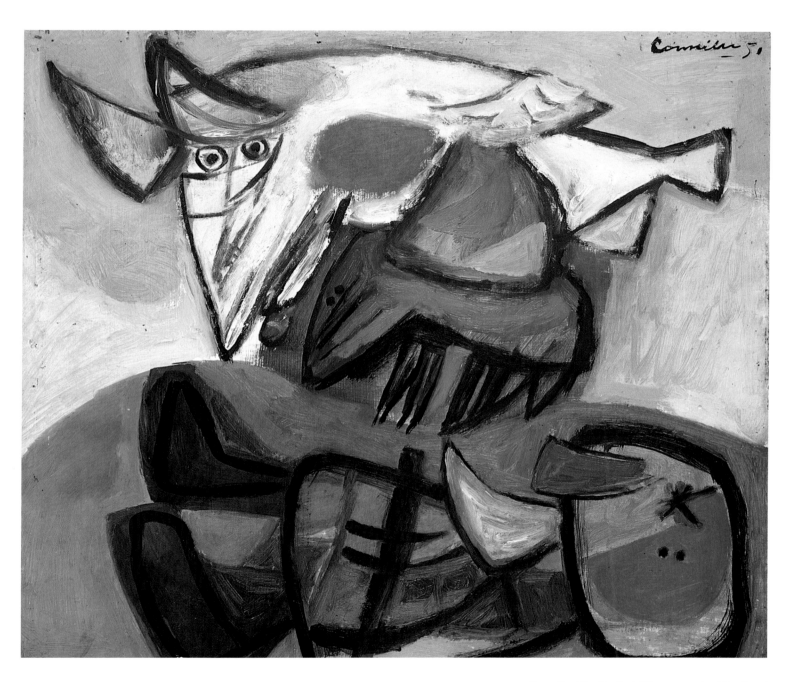

Corneille, *The Big Bird*. Oil on masonite (50 × 55 cm).
Private collection, Paris. Photo Luc Joubert, Paris.

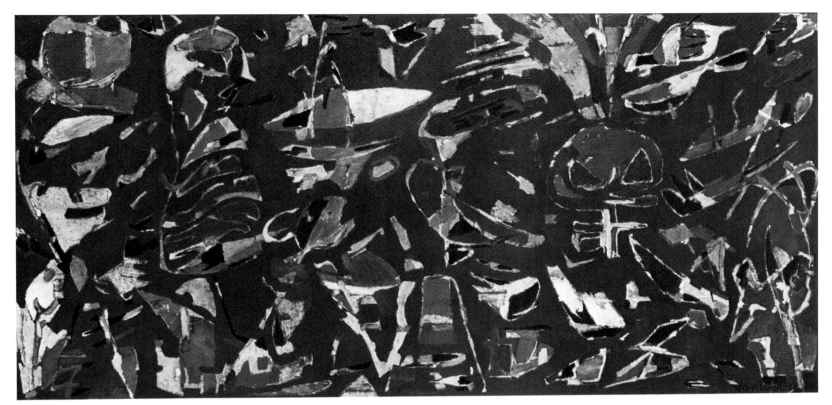

Henning Pedersen (*Heavenly Trumpets, Orange Form, The Sea Gods, Landscape of Light* and *Italian Picture*) and Erik Ortvad; and two sculptors – Heerup, working in stone and Thommesen in wood, with five pieces each.

Holland found itself without Brands or Rooskens. Constant, Appel and Corneille exhibited pictures painted in Paris. Each now in full command of his powers, the divergence of temperament between them was evident; Constant was the political painter, Corneille the traveller, sensitive to all the world's movements, whilst Appel was playing regally with excess and richness. Wolvecamp, who had returned to Amsterdam after a stay in Britanny, was also there.

Apart from Ubac and Bazaine, Paris was represented by Atlan and Doucet, as in Amsterdam. They both managed to get to Liège, by rather fortunate means; Atlan gave little talks in the exhibition rooms. Germany's contribution was *Five Variations on a Theme* by K. O. Götz and some small canvasses from Heinz Trökes and Siegfried Stolpe. The Malmö group was reduced to Anders Österlin who sent eight pictures. There were also some newcomers: the Canadian Albert Dumouchel, the Spaniard Francisco Nieva, who was working with Édouard Jaguer in Paris, and the Italian sculptor Berto Lardera. Tajiri alone represented the USA (the catalogue being listed by country), with a collection of eight sculptures in metal and plaster, which occupied a whole room at the Palais des Beaux-Arts. The most important participation in numerical terms was that of the Belgians. Pierre Alechinsky exhibited six paintings, amongst which were *Tall Grass, Night Exercise* and *Picnic*. With him were some of his companions from the Ateliers de Marais; Olivier Strebelle,

Second International Exhibition of Cobra Experimental Art, Palais des Beaux-Arts, Liège, 6 October–6 November 1951:

above
Louis van Lint, *The Fools' Paradise*, 1951 (since destroyed). Oil on canvas (150 × 300 cm). Work inspired by projections from a magic lantern known as the 'cine-magique de Belthèque'.

left
Reinhoud, *The Duck*, 1950. Copper (46 × 15 × 32 cm). Private collection.

opposite above
The Karel Appel room with a canvas by Joan Miró in the background. Photo Serge Vandercam, Brussels.

opposite below
At the entrance to the Palais de Beaux-Arts, 6 October 1951: Top row, left to right: Corneille, Robert Kaufmann, a museum attendant, Jean Raine, Theo Wolvecamp, Tony and Karel Appel, K.O. Greis. Middle row: Janine and Corneille Hannoset, Shinkichi Tajiri, Micky Alechinsky, Reinhoud, Pierre Alechinsky, Luc de Heusch. At the front: Michel Olyff.

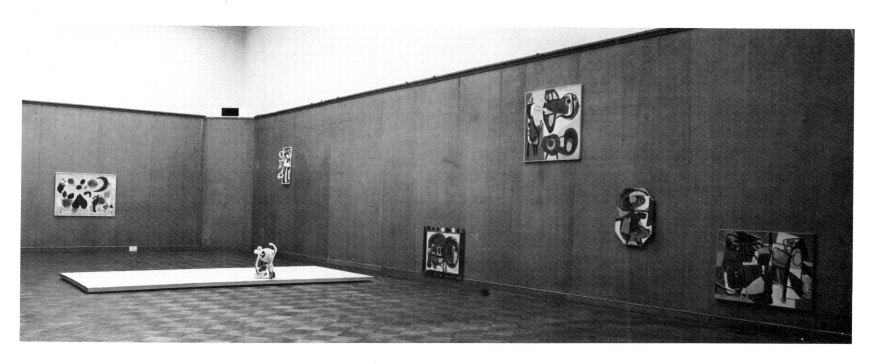

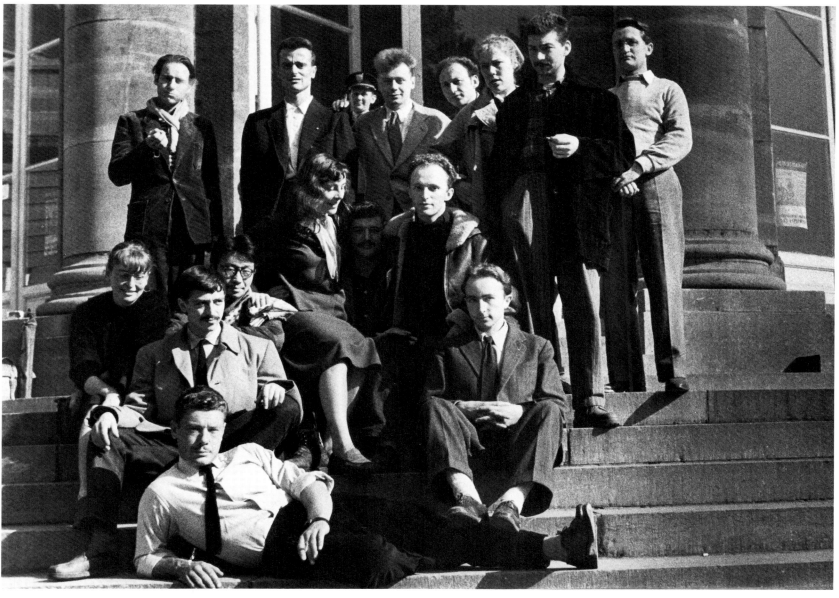

Stills from 16 mm footage shot by Karl Otto Götz in Liège during the Second International Exhibition of Cobra Experimental Art:

left
Karl Otto Götz miming a speech on the balcony of the Palais des Beaux-Arts.

below left
Constant in front of the steps of the Palais des Beaux-Arts.

opposite
Three 'tongue-pokers': Karel Appel, Tony Appel, Theo Wolvecamp.

Constant, lithograph (40 × 28.3 cm) in the series *8 times war*, 1951. Stedelijk Museum, Amsterdam. Museum photo.

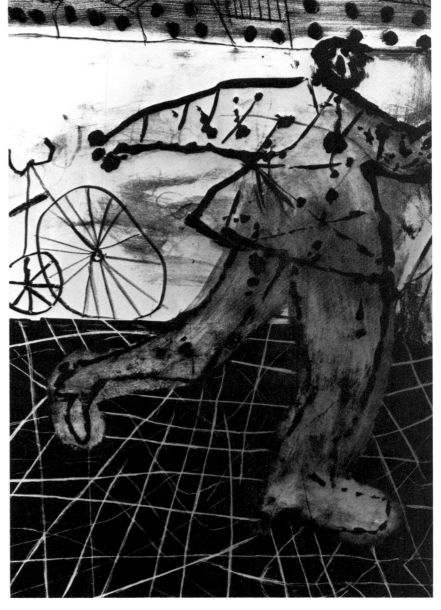

the ceramist and Reinhoud (d'Haese), the sculptor and coppersmith, who was still searching for his own freedom and would not really be 'Cobra' until ten years later. He exhibited a *Duck* and a *Cock* in beaten copper, heralding the 'anthropo-zoological' garden which would be his major work. There was a tapestry by Corneille Hannoset, ten lithographs by Jan Cox, some paintings by Georges Collignon and four paintings, the 'compositions', by Pol Bury, who had managed to overcome a crisis in change of style: 'With all my problems from 1950 to 1953 I painted pictures with the idea that something must come up . . . something of indefinable form.' These would be his *Mobile levels*, combinations of abstract forms cut into rigid material. From that point on, Pol Bury would be a constructor of movements, of slowness at first, a dialectician of the imperceptible and a strategist of instability. Far, very far away from Cobra.

In a location specially arranged at the very heart of the exhibition, Jean Raine presented a festival of experimental and abstract film, which he directed himself. As we know, the cinema was always one of Cobra's more or less thwarted pre-occupations. Jean Raine gathered together forty or so short, often very short, footages of film, whose intention and techniques were related to then current pictorial research. The festival and *Cobra 10*, which published Raine's article 'L'Écran et le Pinceau' ('The Screen and the Brush'), paid tribute in particular to the Canadian Norman McLaren, whose films used the technique of painting directly onto the celluloid itself. Other programmes were dedicated to abstraction in the cinema (Fernand Léger, Germaine Dulac, Len Lye), to Surrealism (Hans Richter) and to special techniques and sound research. The 'world première' of *Perséphone*, lasting, in its final version, for twenty-two minutes, was planned for 14 October; in the event, however, it no longer bore witness to the Cobra spitit. Noiret commented: 'Cobra missed so many things. Including its own death.'

For Cobra, Liège was a contradictory combination of success and failure: an exhibition officially prepared and recognized, inaugurated by the authorities, yet receiving a reception by the Press which was almost unanimously unfavourable. There was only one decent way out, which was that taken by most of the avant-garde movements – to split up. 'I felt,' Alechinsky said, 'Dotremont felt, we all were obliged to feel, that the time had come for us to immerse ourselves in a more secret or more personal activity until someone came along to dig us up one after the other, or until we had been forgotten completely.'

No farewells, no announcements; a simple coming to a halt, as if of its own accord. Each of them went back to his own sphere of action. There followed a period of filtering and maturing. Of propagation, too, in the course of which Cobra art would, in fact, reaffirm itself, develop, find new support and unexpected friends. But it would no longer be a coherent group. The only common bond that remained was Christian Dotremont.

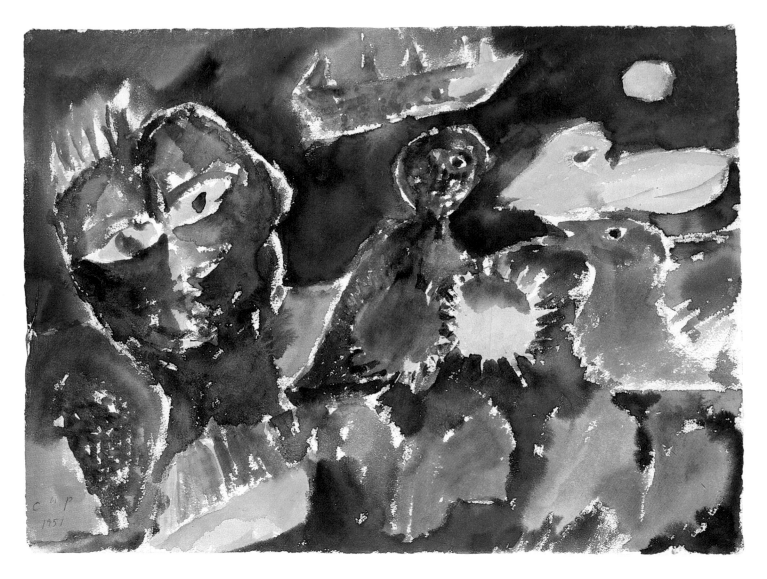

Carl-Henning Pedersen, untitled, 1951.
Gouache on paper (40 × 51 cm).
Collection of Jean Pollak, Paris.
Photo Luc Joubert, Paris.

Asger Jorn, The eagle's share, 1951.
Oil on masonite (74.5 × 60 cm),
Kunstmuseum, Silkeborg. Photo Lars Bay.

198

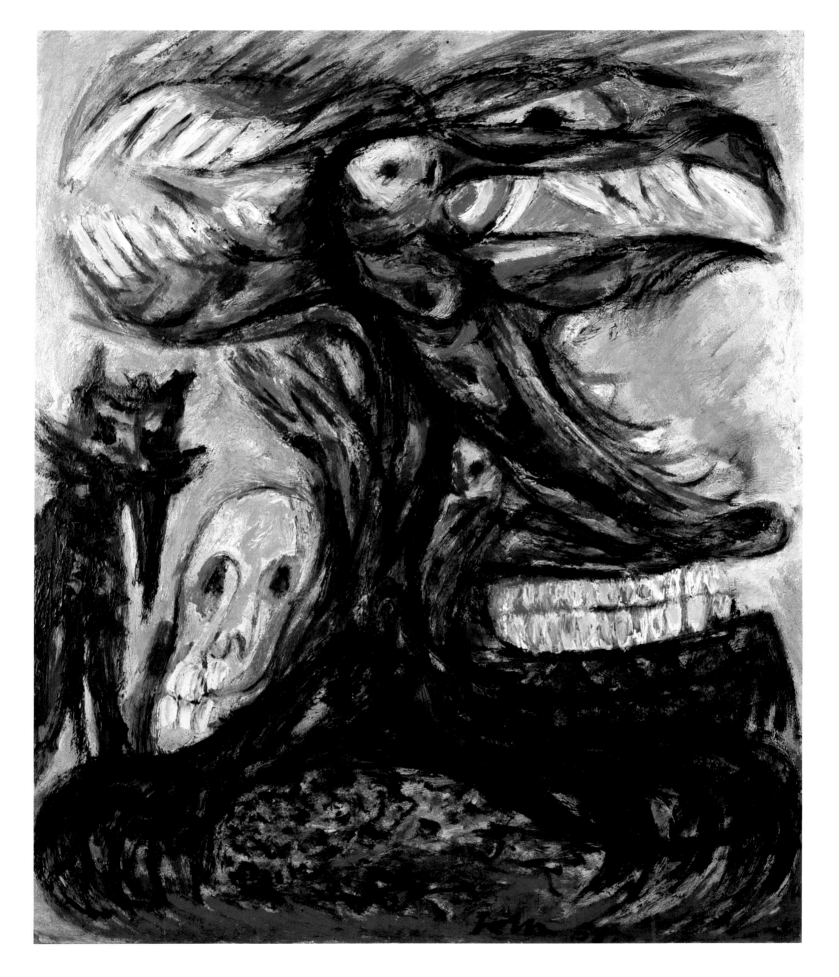

Asger Jorn, photographed by Pierre Alechinsky at the printers Clot, Bramsen et Georges, Paris, 1972.

3. Cobra after Cobra

It was Alechinsky who took the initiative of announcing on the back cover of *Cobra 10* that this would be 'the last issue of the review'. He himself had settled in Paris where Corneille and Appel were already living. Constant spent a few months in London before returning to Amsterdam; he had started to undergo a profound change which would progressively alienate him from the Cobra style, as a prelude to alienating him from painting itself. He had developed a completely different, more conceptual, awareness of space and was painting pictures which belonged to a geometric abstract style, dominated by colour and more social in content. What would later be the Utopia of 'New Babylon' was born in the confusion of the lessons learnt in the English metropolis. Jorn was undergoing treatment at the sanatorium in Silkeborg where he had at his disposal a vast workshop adjacent to the morgue, which at last permitted him to tackle large scale works (the *Seasons* cycle and *Silent Myth*); he took advantage of the hours of enforced leisure to write *Held Og Hasard*, a continuation of his reflections in the Cobra years and the first version of that experimental asthetic which would remain his unceasing preoccupation throughout his entire life. As for Dotremont, he left the sanatorium at Silkeborg, after several months of 'long, fairly systematic conversation' with Jorn, for another sanatorium at Eupen in Belgium, where he wrote *La Pierre et l'Oreiller*, which he finished in 1953.

In Paris, Alechinsky had gone to study etching at Stanley William Hayter's Studio 17 which had played, and would continue to play, host to the greatest artists of the middle of the century, from Miró to Pollock (when Studio 17 was in exile in New York during the war), from Tamayo to Nevelson. The experimental spirit prevailed at Studio 17; Hayter taught that it was essential to develop one's own technique. 'Technique . . . [is] like a call to the artist's creative imagination; it awakens forms and ideas in his imagination which without it would remain latent; it is thus inseparable in a work from the content itself,' Hayter would explain in an article which we wrote together (*Les Cahiers du Musée de Poche*, no. 1, March 1959). Here can be found one of the fundamental principles of Cobra applied to etching. Alechinsky etched eleven plates at Hayter's studio, one of which was *The Marks of Conviction*, one of Dotremont's Cobra projects; these etchings would only be published in their entirety in 1968 under the punning title of *Hayterophilies*. These marked the start of an immense output of prints, etchings and lithographs which would swell to more than 900 pieces over thirty years. Corneille, who also spent some time at Studio 17, Appel, Jorn and Pedersen each produced a quantity of prints and there is in this another common denominator for Cobra – their attraction to sensitive techniques, the fulfilment of which they would find in copper and stone, zinc, linoleum, wood – confidence in the material, in matter itself.

Christian Dotremont and Asger Jorn, *Sana Nothing to see*. Word-picture drawn in 1952 when both were in the Silkeborg Sanatorium. Kunstmuseum Silkeborg. Museum photo.

We have a valuable testimony on the Parisian situation in the early Fifties and on European artistic developments as they were perceived in Paris at that time in the form of the *Premier Bilan de l'art actuel*, under the direction of Robert Lebel in 1953. As far as Cobra, which was only mentioned as a group in a footnote to the chapter on Belgian painters, was concerned, only the Danes and the Malmö Imaginists are dealt with individually by Édouard Jaguer in his article 'Scandinavian Trajectories'. Jaguer, who would always remain an internationalist in tendency, produced the review *Phases* whose first issue, published in January 1954, can be considered as a last avatar of Cobra. Moreover, it was Alechinsky who made sure it appeared. Significantly, the cover showed not a work by a contemporary artist but an Ibo sketch from Nigeria, supplied by the Psychiatric Centre of Abeokuta. The review contained works by Dotrement, Havrenne and Scutenaire, and reproductions of drawings by Corneille Alechinsky, Carl-Henning Pedersen, Jorn, Tajiri and Karl Otto Götz.

Theoretical reflection was provided in *Phases 1* in a text by Michel Tapié, which proceeded to an artistic reconciliation between New York, Paris and Italy under the banner, vague in its intentions, of *art autre* ('other art'). According to Tapié 'Others' were those with 'a Dionysian sense of the adventurous quality of un-

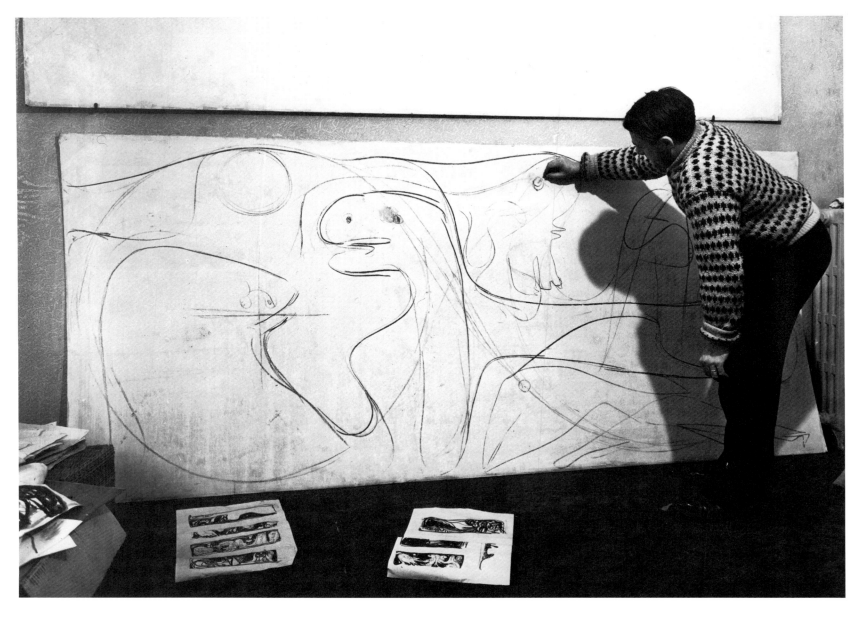

Asger Jorn in Silkeborg in 1952. First sketch for *Silent Myth – Opus 2*
(135 × 300 cm). Painting today in Silkeborg Library.

Asger Jorn, one of eighty coloured
linocuts illustrating his book *Held og
Hasard* ('Risk and Chance'), Silkeborg
1952.

Asger Jorn, *The wheel of life*, 1952–3. Oil
on briquette panel (184 × 161.5 cm).
Statens Museum for Kunst, Copenhagen.
This painting is the second in the
'Seasons' cycle. Museum photo.

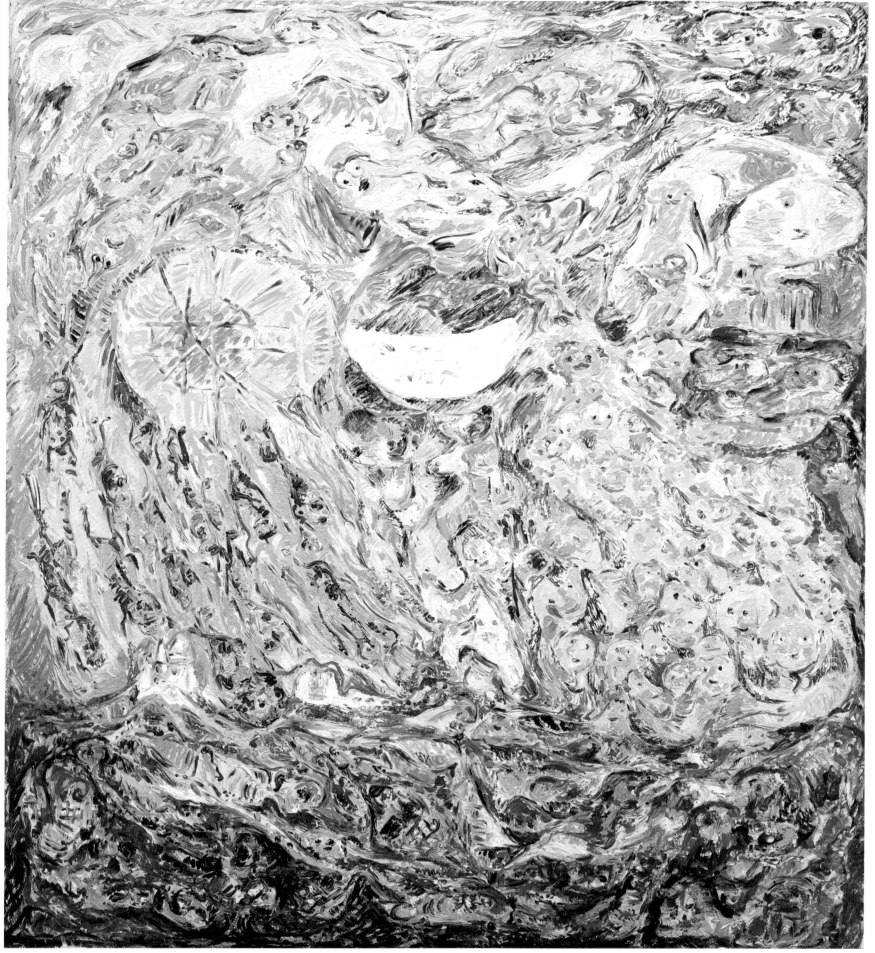

explored regions' and who 'conditioned new forms very lucidly (or unconsciously) as if space could be conceived as the fundamental matrix, engendering forms accidentally, seeking to use forms to express itself better in a perpetual dynamic of disposability.'

This somewhat complicated style, which was to impose itself on Paris as a dominant critical discourse (but not, however, on *Phases*), contrasted rather strongly with Dotrement's great humorous monologue *L'Arbre et l'Arme* which featured in *Phases 1*. Written as the preface to a joint Tajiri-Alechinsky exhibition which had taken place in February–March 1953 in Amsterdam (Kunsthandel Martinet), it was Dotremont's most significant piece of writing since *Le Grand Rendez-vous Naturel*. It gave a perspective of the road they had trodden – in every sense of the word, since Dotremont, his health temporarily restored, had also found his feet again. 'Furthermore, for us who are returning from afar, art is without doubt the last chance of our immediate existence – helpful love, helping love. Politics never cease to attack all our senses to the point where they still sometimes create an illusion of movement, but, in fact, they hatch miracles and they hatch catastrophes. Science does not cease to make discoveries, but it no longer allows us to watch and no longer sees itself what it does; it *liberates* the innermost forces of objects so that the armies from above or the armies from below can occupy us tomorrow – and no-one protests. Only art still discovers miracles and freedom from time to time; only art still protests against catastrophes and Occupation; only art still escapes sometimes from the sinister contemporary game of protesting against war at the same time as discovering it. Only art . . . but only certain people in art, notably, as well as myself, Alechinsky and Tajiri.' *L'Arbre et l'Arme* had been written in Scandinavia and posted page by page. Later, in lyrical vein, a mixture of joy at having overcome his illness and exultation in his love for Bente-Gloria, Dotremont wrote the text under the title *Nous irons dans les bois et nous y laisserons les lauriers*, which would be published in the small purple catalogue of the Salon Octobre, the second and last of that name, organized by Charles Estienne in October 1953. In it, Dotremont took to task the cold abstract artists of the Salon des Realités Nouvelles where, he said, not without a certain wicked excess, 'there is no beauty, luxury or voluptuousness; all is order and calm; but not the sort of order and calm Baudelaire dreamed of; damn it, no, more like the *order which rules in Warsaw*. Just as the police detest the troubles of life, the riots of love, so the 'New Realist' dreads stains. Like the police, he cleans until beauty is empty, luxury hygienic and voluptuousness sterilized.' It was true that the Salon Octobre had been formed with the aim of exalting lyrical and informal non-figuration against the second wave of constructivists. *Octobre* could therefore include Corneille, Tajiri, Alechinsky, Dotremont and Jaguer, who, in the catalogue, praised Picabia, to whom *Octobre 2* paid homage as it had

previously done to Duchamp, both being about equally ignored or despised in Paris.

Just like *Octobre*, *Phases* demonstrated how Alechinsky's and Corneille's integration into Paris took place in those fluctuating zones of the senses where Dadaïsm, Surrealism and lyrical non-figuration converged. Appel would attract Tapié more openly towards Expressionism *per se*. And Tapié not incorrectly analysed the relationship between Appel's brutality and *l'art brut*, whose active companion it was: 'After Van Gogh, Rouault (I am thinking particularly of the *Réincarnations du Pere Ubu*), Kirchner and the very topical Dubuffet,' he wrote, 'we see with Appel to what extent the work of a temperament which has the means to translate all the inner cosmology of the human drama into a force, can be generous, as directly as profoundly, making use of all the registers, despising all purism, all restrictive systems, giving all its opportunities to the most subtle violence, to the most complex evidence.' (*Appel's Total Adventure*, an exhibition at the Palais des Beaux-Arts, Brussels, 1953.) It should be noted that Tapié made no reference at all here to Cobra.

In Brussels, even though the Ateliers du Marais survived for a time after the departure of Pierre and Micky Alechinsky, the three literary companions of Christian Dotremont, committed like himself to marrying poetry with the plastic arts whilst outside the established cultural circuit, decided to start a review which was destined to have a lifespan ten times longer than that of Cobra; this was *Phantômas*. And the three companions were Joseph Noiret, Marcel Havrenne and Théodore Koenig. *Phantômas* would retain Cobra's internationalism, albeit directed towards the South, Italy and France, but maintained also a distance 'from certain movements which on the other hand it did not oppose' (P. Puttemans, *Discours sur le peu d'orthodoxie* in 'Wild Belgium', *Phantômas 100*). That is to say, Dada, in its second incarnation after 1950, and Surrealism, seen by the *Phantômas* poets as being 'entered in history' after having 'accomplished its mission of awakening and having exhausted the quasi-totality of its methods, not inasmuch as it was an emanation of eternal romanticism, but as a literary and artistic movement.' To summarize, it was explained for us in one of the review's rare programmatic texts, written some ten years after its foundation: '*Phantômas* is not pataphysic, nor dadaist, nor surrealist, nor post-surrealist, nor para-surrealist.' *Phantômas* would attract Serge Vandercam, Jean Raine, Paul Bourgoignie and many others who passed through Cobra or made their start during the Cobra period; it took an interest in *l'art brut*, naïve art and anti-art – all the components of the 'classicism of the marginal', as Jean Dypréau called it. There was also in *Phantômas* a method of considering intellectual and artistic creation from the standpoint of a game: *Homo Ludens* was the great point of reference, as it would be for Constant's 'New Babylon'. Stemming from this there was also a marked slide from black to green as far as the colour of

humour was concerned, a slide, perhaps, in tune with the fundamental project of the age, which was passing from transformation-revolution-destruction of the world to ecology in the course of those same years. In *Phantômas*, there was an ecology of the spirit.

In the short term, exchanges with Milan, and Italy in general, were most important for Cobra after Cobra. At the very time when Cobra was coming to an end in Liège, two young Italian painters, Enrico Baj and Sergio Dangelo, had joined forces in Milan to launch the *Movimento Nucleare*. Some of their artistic premises, such as the reference to Surrealism, which they sought to surpass, and their experimental spirit, call Cobra to mind. But their movement appeared rather to be a development of Dadaism, about which they were better informed than the Cobra members had been, coupled with an element of reflection on the contemporary world: 'We think we are artists belonging to an era when atomic and nuclear research are opening infinite horizons to man,' Baj declared. Finally, they were equally resolutely opposed to Abstraction and to the academism which, to some extent, resulted from it throughout Europe: 'We are against abstract artists, denying not only geometric abstraction, but abstraction in itself.'

Enrico Baj's meeting with Sergio Dangelo took place in the course of the summer of 1950; they were two young artists in search of themselves and of others. Born in 1924, Baj had only recently devoted himself to artistic research; and Dangelo was just eighteen years old. They were of that generation which was striving to erase the stigma of war, spending their nights, in Milan as in Paris, in cellars where jazz was all the rage. But artistic life in Milan was particularly impoverished; at the beginning of 1952, Dangelo left for Brussels, where he met the *Phantômas* poets and visited the already half-deserted Ateliers du Marais. He brought with him works, still hesitant in their experimentalism, which he had painted with Baj. Robert Delevoy took an interest in them and exhibited them at the Galerie Apollo; it was on that occasion that the *Manifeste de la peinture nucléaire* was published under the joint names of Baj and Dangelo. 'The nuclear artists,' it read, 'wish to fight back all *isms* of a style of painting which, whatever its genesis might be, falls invariably into academism. They want to, and they can, re-invent painting. Forms disintegrate – the new forms of man are those of the atomic universe. The forces are electrical charges. Ideal beauty no longer belongs to a race of stupid heroes, nor to the robot, but coincides with the representation of nuclear man and his space. Our consciousness, charged with unexpected explosives, is the prelude to a *fact*. Nuclear man lives in this situation, which only men with blind eyes can fail to grasp. Truth does not belong to us; it is in the *atom*. Nuclear painting documents the research into its truth. Brussels, 1 February 1952.'

As the genre would have it, the *Manifesto* was peremptory and could not fail to attract, or repel, spirits according to their nature. In Italy, the Nuclear artists would never number more than about ten people, exhibiting communally without really constituting a group, bound 'dogmatically and narrowly to determined principles', as their chronicler Tristan Sauvage (Arturo Schwarz) stressed in the book he dedicated to them (1962). What is relevant and helps us understand the coming together with Jorn, which would take place the following year, is Baj's and Dangelo's avowed desire to throw into question the very elements of artistic creation, the concrete notions of style, invention and matter. In their early works, they too were searching for a union of the imagination and the material, 'by playing with emulsions, colours, unpredictable forms.' They, too, invoked 'chance', which Jorn recognized as the Grand Master. Dynamic or static chance, Baj would say, in defining two phases in his own work: 'The trajectory of nuclear experimentation begins in a passive moment, receptive in the face of matter and its varied imagination, and ends in an eminently active and constructive moment . . . a clear priority of matter during the early years, a clear priority of the artist afterwards.'

Passing through Paris, where he visited Alechinsky, Dangelo returned from Brussels with a suitcase full of Cobra documents. He and Baj, in Milan, soon made contact by letter with Jorn, at the time when the latter was staying for six months in a chalet near Villars in Switzerland, having succeeded in getting away from Silkeborg, where he had regained his health. So it happened that Jorn presented the 'Nuclear' exhibition in Turin in December 1953. Faithful to his strategy, Jorn immediately made allies of these artists. 'I find an immense desire in these painters,' he wrote, 'to break through with daubs, scribbles and outpourings; to model forms, images and symbols, to wrench them from primitive chaos, to reduce progressively all possible chance, to condense a magma of phosphorescent glaze which goes from being *nuclear* to *natural*. In these symbols can be found the core of the artistic language necessary to express this new world which, as we can feel, is in the process of self-creation all around us.'

In June of the following year, Baj and Dangelo, who were indefatigable in finding opportunities to exhibit their works, cemented their new alliance at Arturo Schwarz's bookshop and gallery in Milan, in a joint exhibition with Jorn, Appel and Corneille, entitled *Il segno e la parola* ('The Sign and the Word'). It was once again thanks to Baj and Dangelo that Jorn, the wanderer, the 'survivor' as he liked to call himself, was able to settle with his family in Albisola, which would become, thanks to him, an international meeting place for artists. Jorn was, in fact, entertaining a plan of creating a follow-up to Cobra: this would be MIBI – 'Mouvement International pour un Bauhaus Imaginiste' ('International Movement for an Imaginist Bauhaus'). From the summer of 1954, the factory of Tullio Mazzotti, a man of great sensitivity and excep-

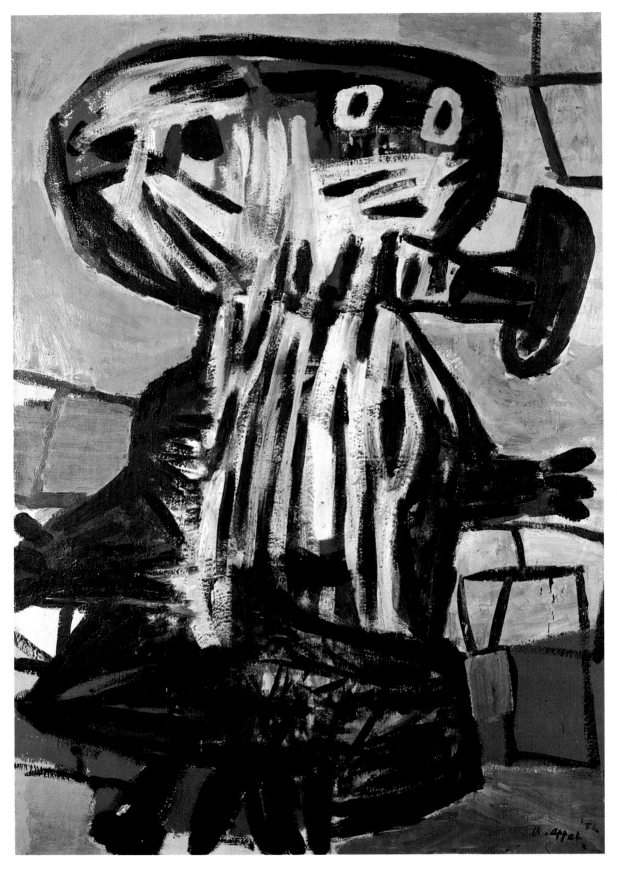

Karel Appel, *The Street Singer*, 1952.
Oil on canvas (130 × 89 cm). Private collection.

Asger Jorn, untitled, 1954.
Oil on cardboard (37 × 25 cm).
Private collection, Paris.

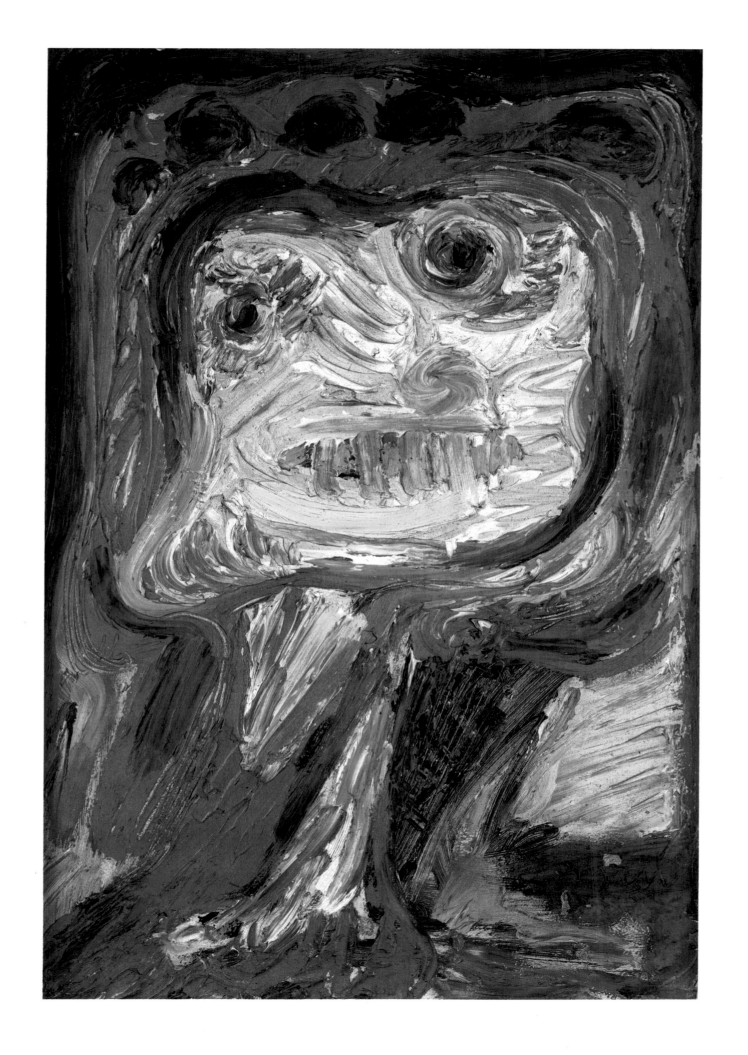

tional openness of mind, thus became the centre for a 'first experiment', dubbed MIBI, of 'international encounters' in the Bregneröd spirit. Emilio Scanavino and Lucio Fontana took part in it (the latter had rented Jorn his studio in the Piazzetta Pozzo Garitta, and it was here that Jorn situated the 'witches' he would later paint), also Appel and Corneille, then Matta, whom Jorn had got to know at Le Corbusier's during the war. Later, Edouard and Simone Jaguer would join them, who at that time were the best 'French Connection' of the former Cobra members. All the participants devoted themselves to 'experimental' ceramics, approaching it as an art rather than a craft or an industry. Later, Jorn would say that Albisola 'showed that the experimental artist can and should take hold of industry and submit it to non-utilitarian ends.' It is not so easy for a painter to pass from one technique to another without preparation. No matter: Jorn's example was contagious, irresistible. In fact, Jorn was the only one amongst the group who had really mastered ceramics, having devoted his last few months at Silkeborg to learning the craft. His last works, like the great mural *Relief* at the grammar school in Aarhus, bear witness to it being an integral part of his work. He had (and this is no surprise) a feel for earth, for clay – for *materia prima*: the earth and the daydreams of the will, the earth and the imagination of its forces.

Imaginist Bauhaus: the slogan, not unparadoxical, was born of an exchange of correspondence between Jorn and the Malmö Imaginist, C.-O. Hultén, whom Jorn tried in vain to lure out of Sweden, and from conversations with Jaguer and Alechinsky. It was a supplementary episode to the struggle of Jorn, Cobra and the Nuclears, against all attempts to rationalize art. 'A life which is totally rationalized and ordered sends the intellect to sleep and replaces it with reflexes which are automatic, routine and somnambulist,' Jorn would say time and time again. 'Intellect and creative thought light up when faced with the unknown, the accidental, disorder, the absurd and the impossible.' The enemy, this time, was Max Bill, who had opened a new Bauhaus in Ulm, where his intention was to take up once again, in part, Gropius' conceptions. Jorn had proposed that painting, which had never been taught at the original Bauhaus, should be taught there. As might be expected, Max Bill refused, which gave rise to an exchange of correspondence touching on polemics, or rather on two parallel monologues. At least, this emerges from *Image et Forme*, an article in which Jorn gave an account of it, and which would constitute the opening chapter of his collection *Pour la forme ébauche d'une méthodologie des arts*, published in 1958. One has to say that Jorn had nothing of the teacher in him. Even if he was recognized by many as a 'master' (in the zen sense, assured and disconcerting at the same time), he always preferred to share his convictions and researches with friends and fellow workers rather than to impose his knowledge (or non-knowledge) on disciples or pupils, convinced as he

Albisola, Summer 1954. Left to right: Roberto Matta and Malitte, Asger Jorn, Corneille. Photo Henny Riemens, Paris.

Asger Jorn in Mazotti's pottery, Albisola, Summer 1954. Photo Henny Riemens.

was that 'the direct transfer of artistic talent is impossible.'

'*Bauhaus* is the name of an artistic inspiration,' he wrote to Max Bill at the beginning. The latter replied: '*Bauhaus* is not the name of an artistic inspiration, but the signification of a movement which represents a well-defined doctrine.' Jorn retorted: 'If *Bauhaus* is not the name of an artistic inspiration, it is the name of a doctrine without inspiration, that is to say dead,' (exchange of letters, January–February 1954). In fact, Jorn reproached Max Bill for impoverishing the ideas of the original Bauhaus in refusing to consider that art is also an individual expression. For Jorn, 'humanity exists thanks to individuals and the interest of the individual goes beyond his own existence. Common interests in humanity represent a collective subjectivity. We have reached a new concept of subjectivity today; it revolutionizes the whole theoretical base of art and techniques to come.' The analysis Jorn made of the historical moment could not but alienate him irrevocably from Max Bill: 'We have linked the phenomena and they have entered into a living synthesis; we have created a dynamic conception of art and of technique.' It was the same spiritual movement as Cobra, but systematized

Asger Jorn, *Clown in danger*, 1953. Indian ink (29.6 × 20.8 cm). Kunstmuseum, Silkeborg. Museum photo.

this time. Jorn was attempting to state an aesthetic which was relevant not only to artistic activity but also to what could be called the 'framework of life': architecture, urban planning, the environment, decoration. 'The ultimate goal of all art and all technique is to create common values, to serve human interests.' And these were not pre-determined; they belonged to the future and would only manifest themselves by virtue of experi-

ment: 'What is the importance of experiment in art? It is both essential and intangible . . . like yeast is to dough. It doesn't add anything to the work itself, but it inspires it and lifts it to a dramatic level.' One degree more of generalization, and Jorn would be able to pass from a practice of 'experimentation' in art to an 'integrated cultural revolutionary attitude'. This would become Situationism.

During the MIBI period, and even beyond it, Jorn and Baj exchanged not only theoretical ideas, but also, stimulated by their work together, formal ideas marked by their shared taste for satire. From 1953 onwards, Baj perfected the anthropomorphization of his images: from the genetic magma which was his first-born imaginary space, via successive avatars, emerged the 'ambiguous personality' who would become his dominant fantasy, and whose unexpected metamorphoses his work would watch out for: an *ultrabody*, disembarked, it seemed, from 'interplanetary space': or a highly decorated military man. In 1955, this rather merry monster still called itself *Trillali-Trillala* and refused, as Arturo Schwarz remarked, to cross the threshold of adulthood into the so-called age of reason. He also refused to allow himself to paint on common canvas (whose principal merit, in the eyes of the painter, was that it disappeared under brushstrokes). On the contrary, Baj used furnishing fabric and wallpaper as a base; later, it would be bad, over-polished pictures bought at the flea market – picture-postcard landscapes, mediocre nudes. There is no doubt that Jorn appreciated Baj's lack of self-consciousness and, although he for his own part remained faithful to traditional media, not being attracted like Baj to cotton wool or pompoms, many of his pictures from 1954 to 1956 were none the less responses to those of his Italian friend, like two compères at the Commedia dell'arte. Thus, the little *Cosmic song of an interplanetary singer, Biabadu, I love grand gestures*, and several other of Jorn's works were exhibited under the rubric 'frivolous pictures', in case anyone should doubt it. This was in anticipation of the 1959 'modifications', contemporaneous with those of Baj. But it is clear that this project dated back a long way for Jorn and was linked with his concept of destruction (or vandalism) as a creative force, to which must be added his interest in the processes of 'diversion', an interest shared by his new friends of the *Internationale Lettriste*, Guy E. Debord and Gil J. Wolman ('Mode d'emploi du détournement' in *Les Lèvres Nues* No. 8, May 1956).

MIBI lasted for four years from 1953–7. As well as being an open group of artists whom Jorn hoped to carry along with himself, it represented a marked stage in his personal theoretical reflection and in his practise of art. MIBI progressively sought to cover the range of the cultural front-line, with the intent of modifying its methods and habits. Jorn came straight out with it in *Pour la Forme*: 'Compromise is impossible in every way with the established elements, amongst which we must place those who consider that a single novelty is

opposite
Asger Jorn, *My castle in Spain*, 1954.
Oil on briquette panel. (123.7 × 91.5 cm).
Statens Museum for Kunst, Copenhagen. Museum photo.

above
Enrico Baj, *Ultrabody in Switzerland*, 1959.
Modification. Oil on canvas (120 × 70 cm).
Private collection.

above left
Asger Jorn *The disturbing duck*, 1959.
Modification. Oil on canvas (53 × 64·5 cm).
Kunstmuseum Silkeborg. Museum photo.

left
Asger Jorn, *The avant-garde will not give in*, 1962.
Modification. Oil on canvas (73 × 60 cm).
Private collection.

sufficient in a man's life and that, from then on, he has played some role in its appearance and can grow old with it.' To get back into the game without respite; there is a moral in that which would be Jorn's throughout his life, highlighting its successive stages. Perhaps Kierkegaard should once more be called to mind.

If Italy remained the principal arena of Jorn's public activity, it was in Paris, where he lived for part of the time from 1955 onwards, that he found new allies and new concepts, which influenced his thinking. The *Internationale Lettriste*, founded in May 1952 by Guy E. Debord and Gil J. Wolman, could not help but attract him. It represented dissent at the heart of Lettrism with its creator Isidore Isou, whom it had reproached as being abusively doctrinaire and theoretical – or, put another way, not sufficiently experimental. Lettrism can be taken as the equivalent in the verbal world to what Jorn and Cobra had intended in the world of forms: after the destruction of the conceptual and phonetic organization of language, the invention of new constructions from elements thereby freed could begin – more physical, more organic, where spontaneity, rhythm, the cry, the 'cry-rhythm' as François Dufrêne called it. In the lettrism of the dissidents, all human senses had equal right to exist, from breath to rumblings in the bowels, from onomatopoeia to spitting: 'The promise of a new art, an infinite range of applications', with, as *Potlatch* (No. 26, July 1956), the bulletin they published at that time, would have it: 'an exclusive concern with novelty, which is not a taste for originality at any price, but the will to submit oneself to the mechanisms of invention.' Wolman and Debord also criticized Surrealism as being an historical system that had been overtaken because it had become enclosed in the aesthetic it had created. They called for a new 'lifestyle': 'We must experiment as far as possible with architectural forms as much as with the rules of conduct,' (*Potlatch*, No. 22, September 1955). They turned their attention to town planning with the ambition of expanding on a different way of running a town: 'method of approach to constructing a way of life.' Even more than those of Jorn, these ideas were very close to Constant's. They all met up in September 1954 in Alba in the province of Savona. Without doubt, they were moving away from painting. This did not worry Jorn too much; he did not stop painting and certain pictures of this period rank amongst his masterpieces, for example *Letter to my son*, on which he worked between Albisola and Paris. At the same time, he became passionate about Giuseppe Pinot Gallizio's 'industrial painting'. Gallizio had a warm personality and an inventive mind, which his training as a chemist had directed towards certain techniques. He settled in Alba and, at once, MIBI decamped there and opened an experimental laboratory, where Jorn, Gallizio and their entourage attempted to develop their sketches with Albisola ceramics – an attempt to divert industry from an exclusively utilitarian purpose. When Gallizio exhibited his creations (rolls of paintings) in Turin in the spring of 1958, this would be the slogan of his situationist colleagues: 'Against independent art, against applied art, for art which is applicable to the construction of an environment.' And Jorn underlined on this occasion what separated Gallizio from industrial design: 'It is not a matter of models to reproduce but of the realization of a unique creation, perfectly useless, apart from experimentation on a situationist environment.' Jorn was also struck by the fact that, during the exhibition, 'no-one came to buy a single picture, not even at a give-away price, but instead, entire rolls were sold to collectors.' The art market, which Jorn and the Situationists, like so many others after them, attempted to break, demonstrated in this that it was capable of taking in everything, of directing everything.

Gallizio and Jorn called the First World Congress of Free Artists at Alba from 2 to 8 September 1956: Constant went, but not Dotremont, nor Alechinsky, who had felt a sense of foreboding about it. The Congress marked a certain distancing from the Cobra past, as well as a break with Baj and the *Movimento Nucleare*, and it marked also the agreement between MIBI and the *Internationale Lettriste*, from which would be born, a year later, the *Internationale Situationniste*, also in Italy, at Cosio d'Arroscia. The common platform elaborated at Alba was that of *unitarian urbanism*, 'which must use the whole range of modern arts and techniques.' 'The character, out-dated beyond all renovation, brought to an art within its traditional limits' was stressed in the closing resolution of the Congress. An ex-painter, and announcing himself as such, Constant was completely at ease with this; Jorn doubtlessly rather less so, but he was capable of following a theoretical reflection through for its own sake, without worrying too much whether it agreed or disagreed with his artistic work. Later he would say frankly, in an interview given to Jacques Michel (*Le Monde*, 27.1.1971): 'Basically, I know nothing. At least, nothing I can explain. In front of the canvas, I only know what I must do. How I must do it. The why remains beyond the realm of understanding.' – 'Even when you have got an idea?' – 'It is always a vague one and I am forced to acknowledge that the end result has very little to do with the idea. It is good to have ideas, even if you don't follow them. I don't know what purpose that serves. I only know that it does serve a purpose.'

It is possible to date the beginning of Cobra's integration – of Cobra art's integration – into the European panorama from these particularly intense years. Even if Jorn and his friends were going in the opposite direction, for reasons of global revolutionary strategy. And the Italian stage was decisive, thanks to dealers like Carlo Cardazzo and Arturo Schwarz, and thanks also to the enlightened patronage of Paolo Marinotti. From 1959 onwards, this 'industrial poet', as he liked to call himself, organized a series of great exhibitions at the 'International Centre of Art and Costume' in a Venetian palace, all of which were epoch-

Asger Jorn, *Portrait of Gaston Bachelard*, 1960. Oil on canvas (65 × 81 cm). Kunstmuseum Silkeborg. Photo Lars Bay.

making. Since the first one, *Vitalita nell' arte*, largely inspired by William Sandberg, certain Cobra members had been involved (Alechinsky, Appel, Hugo Claus, K. L. Götz, Jorn, Lucebert, C.-H. Pedersen, Wolvecamp) and had been confronted for the first time in a meaningful way with those who had been inspired by what Michaux calls, in his preface to the catalogue, 'the passion for the profligacy of liberty'. These included Michaux himself, Dubuffet, Bram van Velde, and also Jackson Pollock, De Kooning, Alan Davie, Moreni, Vedova, Sonderborg, and Saura.

The importance of Cobra in general and Jorn in particular increased steadily in Marinotti's eyes and was noticeable in the exhibitions he organized: *Della natura all' arte* (1960), *Arte e Contemplazione* (1961), *Visione Colore* (1963), this last one being prefaced by Dotremont, with whom Marinotti was then in contact, with the following: 'Long live the little! (or should it be the maybe); Long live excess (or is it a matter of time); Down with the average! (or perhaps it's the best).' On this occasion, the following gathered at *Visione Colore*, each with a selection of their important works: Alechinsky,

Appel, Corneille, Ejler Bille, Egill Jacobsen, Jorn, Svavar Gudnason, Lucebert, Carl-Henning Pedersen; also friends and adherents, such as Dubuffet, Baj, Horst Antes, Alan Davie, Sam Francis, Maurice Wyckaert, as well as four newcomers, *protégés* of Jorn who had formed the Spur group in Munich: Lothar Fisher, Heimrad Prem, Helmut Sturm and Hans Peter Zimmer.

Marinotti took up his pen himself to explain this choice; it constituted one of the first attempts to put Cobra in its historical perspective: 'Only the art which reflects or inspires custom, that is the essence of a character which encapsulates the germs of a personalized community, can be alive, universal and create points of departure. That is why Cobra represented the spirit of a change which illuminated a substance, whose forms and purposes needed restating. Cobra was a movement of habit in the most intimate and general sense, in an ethical just as much as an aesthetic relationship with man's new conscience in the face of the ancient and modern worlds . . . If Cobra has *sprung forth* decisively from these exhibitions,' Matinotti concluded, 'it is not because they drove in decisive stakes, but because their conceptual criteria of research and of realization were clear in all their boldness, right up to the supreme proof, namely the confrontation of works and ideas' (*XXe Siècle*, No. 25, June 1965).

Now that we are able to take a retrospective look at the whole period, we can only be astounded by the volume of Jorn's activities and the multiplicity of his production. From 1956 onwards, Jorn showed just what his prolific genius was capable of. And he did so amidst a struggle for coherence – difficult also to perceive, but should we not, bearing in mind Valery's famous essay, speak of an 'Asger Jorn method'? In terms of the paintings alone, the second volume of Guy Atkins' catalogue opens in 1956 with number 954; at the time of Jorn's death in 1973, there were a thousand numbers more. His writings, of which there is as yet no complete bibliography, compose a sizeable library in themselves, mainly in Danish and French. They cover a vast area, ranging from pure philosophy to economic theory, from aesthetics to archaeology. Several major books illustrated by Jorn, such as *Signes gravés dans les Églises de l'Eure et du Calvados* (1964) or *La Langue verte et la Cuite* (1968, a parody written in collaboration with Noel Arnaud of Levi Strauss' *Le Cru et le Cuit*) or indeed the issues of *Situationist Times* (with Jacqueline de Jong), created new bonds between the language of pictures and that of words. Finally, Jorn had initiated enterprises of a collective nature from one country to another; after MIBI, the Internationale Situationniste, which he left in 1961; then the Scandinavian Institute of Comparative Vandalism (1962–4), a name most significant of the manner Jorn affected of short-circuiting the serious and parody, knowledge and derision. The term 'vandalism' refers to the *Histoire du Vandalisme* by Louis Réau, an art historian and member of the institute. But where this scholar saw only dangers and works of art in danger, Jorn was striving to isolate a category of expression in its

Passing for press *La Langue Verte et la Cuite* (a
work by Noël Arnaud and Asger Jorn) at the
printers Fratelli Pozzo in Turin, 1968: from left
to right; two workers, Noël Arnaud, Pierre
Alechinsky, Asger Jorn, two workers, Ezio
Gribaudo. Photo Aschieri, Turin.

Christian Dotremont's shoe and the cover of
Cobra 4, photographed by Karl Otto Götz,
Amsterdam, November 1949.

opposite above
Noël Arnaud and Asger Jorn, *La
Langue Verte et la Cuite*, J-J.
Pauvert Éditeur, Paris, 1968:
illustration on the back of the
jacket.

opposite below
Henry Heerup, *Head*, 1950.
Granite (tongue painted red),
(68 × 73 × 62 cm).

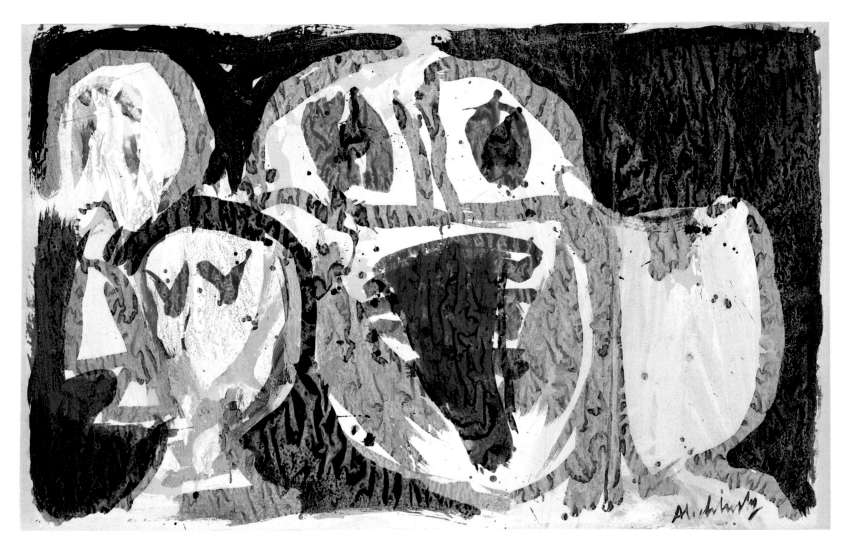

Pierre Alechinsky, *Loosened tongue*, 1970. Acrylic on paper, mounted on canvas (100 × 153 cm).
Private collection. Photo André Morain, Paris.

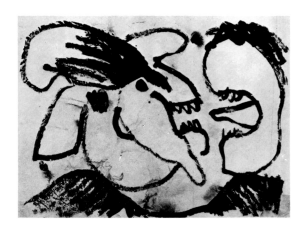 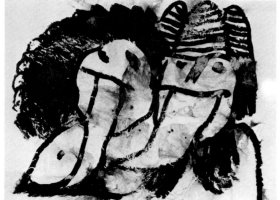

Pierre Alechinsky, indian ink sketches for *The tongue pokers*, texts by the Israeli writer Amos
Kenan, translated into French by Christiane Rochefort, Fratelli Pozzo, Turin 1961.

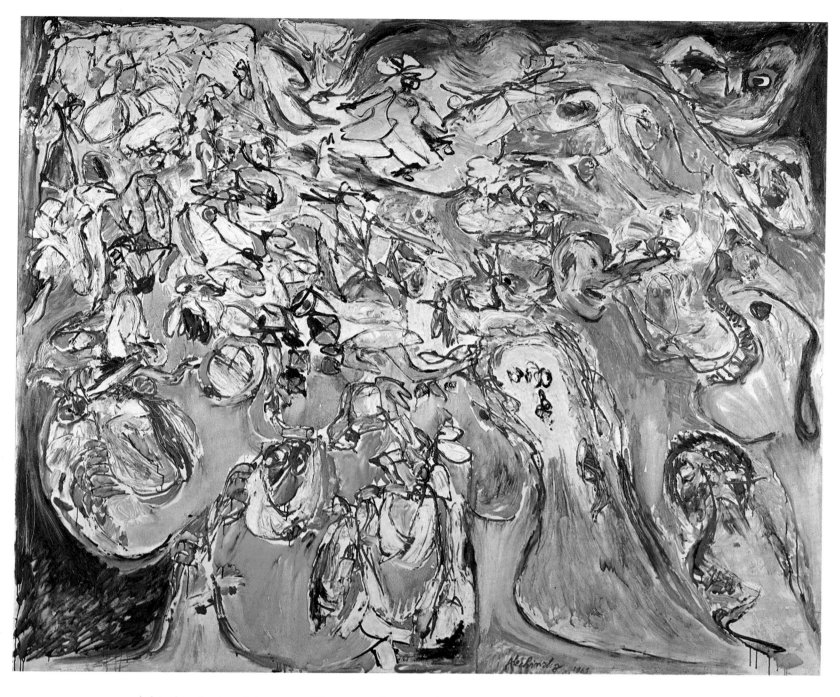

Pierre Alechinsky, *Alice grows up*, 1961. Oil on canvas (205 × 245 cm).
Private collection. Photo Aschieri, Turin.

own right, thereby touching a sensitive spot of our age: is not a good part of contemporary artistic activity inspired by destruction? 'Solitaire – Solidaire', according to Camus' formula, Jorn was aware he was living a personal myth, which played itself out for him between the two poles of risk and chance, to recall the title of the book he wrote in the Silkeborg sanatorium. Confidence in risk, desire for chance. This helps us understand how he could have obtained support or aroused admiration at the two extremes of the social scene, as much of a Marinotti as of a Debord: the great capitalist hedonist or the determined revolutionary. And perhaps for the same reasons: 'The exquisite, enchanting game of an incalculable calculation transposed and desired . . . A being who does not even conform to himself, so mobile and mysterious is his path, so much is the gift of himself

linked to an expression which will never be definitive, but which is nevertheless indelible,' wrote Marinotti in 1965 (*Jorn in Venice*). And Debord wrote in 1972: 'We have become famous, we are told. But an age which is still unaware of all its methods is also far from having recognized all of ours. Asger Jorn has done so much in all directions that many people do not know that he has been a situationist more than whatever else he has been; he, the permanent heretic of a movement which cannot admit orthodoxy . . . Jorn is one of those people who is not changed by success but who continually transforms success into other stakes. Contrary to all those who have based their careers recently on a single exhausted artistic gag, and contrary to those who, more recently, have

presumed to base their imaginary general quality on one single affirmation of total revolution which is totally redundant, Asger Jorn never prevented himself from intervening, even on the most modest scale, in all the areas accessible to him.' (In *Le Jardin d'Albisola*, Turin, 1974.)

Jorn expanded the polarity of the instinct and the intellect and attempted to maintain (this was his wager) a kind of alternation without harmonization, an attitude of whose dangers he was not unaware. In the interview with J. Michel quoted earlier, he explained: 'I reject systems of rationalization and am fascinated by them at the same time . . . to find a weakness in them. It reassures me to know if I am capable of reason. If I am not heading for a kind of madness.' – 'You are on a path of painting where you could go astray?' – 'Easily . . . The separation of the spiritual and the sensorial leads to schizophrenia, split personality.' Even if Jorn was not referring specifically to psychoanalysis, one cannot help thinking of the famous 'malaise in civilization' as analysed by Freud: nature and/or culture, civilization and/ or primitiveness, spiritual and/or sensorial. Jorn, like Klee and like Kandinsky, was exemplary in living life to the full. If his works mark the more or less peaceful co-existence of these contrary factors, they still never stop at that indefinable point, which, in the normative era, was called equilibrium. There is something else in them, which Dotremont understood perfectly when he said: 'With Jorn, harmony and discord are in unison . . . Jorn refutes the art in art. He takes it on and he refutes it. He refutes it and takes it on. He takes on himself and refutes himself.' From then on, there was no point in emphasising the unequal quality of Jorn's work; luck wasn't always on his side. This did not matter much to him: 'Art without the risk doesn't interest me.' Each work was original, an experiment impossible to repeat (which distinguished it from scientific experiment), something which only existed in the pure present of its actual creation, as unconscious of the past as it was indifferent to the future. In the same years as he painted some of his major works, such as his anti-Guernica picture *Stalingrad, or no grounds for prosecution, or the mad laughter of courage* (Kunstmuseum, Silkeborg), Jorn proposed the following definition: 'Art is an invitation to expend energy without a precise end in sight other than what the spectator himself can impart. It is prodigality . . . Artistic value, as opposed to utilitarian value (normally called material) is progressive value, because it is the stabilization of man himself by a process of provocation.' And anyone who ever heard it will never forget Jorn's laugh, which would be called homeric if 'viking' did not suit it better.

After Cobra was disbanded, Constant tended progressively away from art in as much as it represented individual creation and separate activity. His theoretical texts in *Reflex* and *Cobra* gave a foretaste of this development – an end to bourgeois, individualist culture, a movement towards an experimental phase, that is to say, towards unlimited freedom which must 'allow the discovery of the laws of a new creativity', paving the way for a revolution which alone 'will be able to make us recognize our desires.' Inserted in the framework of dialectical materialism, Constant's thinking was swept along by an increasingly politicized analysis. Yet Constant remained an artist, a man with an eye for space, a craftsman's hand. He may well have proclaimed the end of specialization, persuaded himself he should try another type of activity where the whole of life itself became the work, but he never stopped painting, drawing, sketching. After his brief flirtation with colourist geometry, he could not contain his irrepressible impulse to spontaneity, as his great canvas *Farewell p.* ('p' for painting, or for 'putain' – whore?) makes clear. His formal archetypes persisted: the ladder and the wheel, and also flying forms like birds or threatening aircraft. In other paintings which are no less 'Cobra', such as *Artificial landscape* (1963), *Homo Ludens* (1963), *Gypsy Festival* (1964), there is a hint of the emergence of a new space which will be that of 'New Babylon', the theory of which he would more precisely demonstrate in his sculptures. This was a labyrinthine space, a structured space, the projection of changing social space; the Utopia of *Homo Ludens*. The MIBI congress at Alba had been a crucial time for Constant, one which would decide the orientation of his activities for fifteen years to come. He was thinking much more than Jorn about architecture and, quite as much as him and Debord, he was seeking a new organization of social space, which would permit a 'new way of living'; whence 'unitary urbanism', which he would define in the 'Amsterdam Declaration' (1958) with Debord, when the International Situationist was formed.

Gallizio owned a piece of land in Alba where gypsies came to make camp. At his suggestion, Constant worked on a project for a permanent encampment: a vast single roofing system with moveable partitions with which the gypsies could arrange the interior space, adapting it to the number of inhabitants. In order to visualize it better, Constant started on a series of small constructions in wire and plexiglass which would lead him to the vast 'New Babylon' project, of which the two fundamental assumptions were that the world's population would become nomads and that play would become generalized.

Constant's influence on the youth movements and counter-culture of the Sixties (particularly on the 'Provos' in Amsterdam) was considerable. So was it still possible for him to maintain his ties with Cobra? The answer is necessarily ambivalent; social creativity, as Constant conceived it, can be considered as the amplification (if not the systematization) of collective creation which Cobra sought to practise. *Homo ludens*, whose arrival was marked by 'New Babylon', was a familiar demon of the years 1948–51. It can also be said that Dotremont understood, as did Constant, that tension between direct action and long-term vision which is the

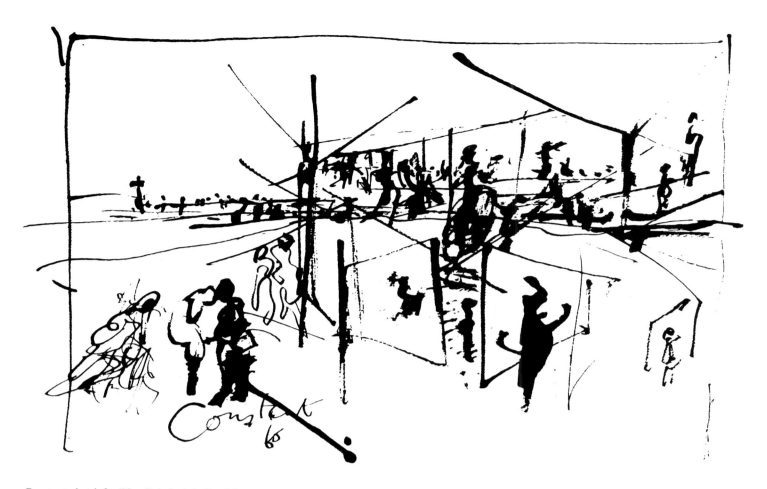

Constant, sketch for 'New Babylon'. Indian ink on paper.
Amsterdam, 1965.

mark of all Utopian thought. A certain amount of optimism is essential . . . That apart, divergences were beginning to appear which were divergences of temperament, of behaviour. Constant's particular talent inclined him to grand conceptual generalizations; rather indifferent to the past, to 'roots' – folklore and archaeology – he projected himself into the future, even if the future came to appear more and more unattainable in the course of his work. And the progress of technology would never cease to be entirely positive for him.

'I find it difficult to reply to your question about the connection between "New Babylon" and Cobra,' he wrote on 27.2.1972 to his Parisian dealer, Daniel Gervis. 'The Cobra movement is historically linked to the social situation after the War, to the economic breakdown and the isolation of artists. Contrary to what many people think now, Cobra never expressed aesthetic points of view and always supported the greatest freedom in the use of methods. It was after the economy got back on its feet that the classification and integration of artists into the system was accomplished, little by little. Cobra, too, was classified and consumed. The repressive tolerance which marks our era forces the artist to change position all the time, to counter each cultural thesis immediately, as soon as it is recognized, with its antithesis, a process which is speeding up more and more. As early as 1948, I emphasized the dialectic character of artistic activity.

Since then, my attitude has always remained open to experiment, which means I have continued to avoid aesthetic standpoints. This explains the diversity which characterizes my artistic output during the course of the twenty years which separate us from Cobra. There will be no more formalism or styles, there will only be experimental research.' 'Research', not 'art'; for Constant, experimental art did not exist, had never existed. 'When one establishes that critics and art historians insist on speaking of experimental art as if it was a particular style of painting, when one sees a disparate mass exhibited in museum under the name of *experimental art*, works which are dominated by *action painting*, one sees just how confused their minds are.' (Catalogue for the retrospective in The Hague, 1965.)

During the 'New Babylon' years, Constant's work tended to divert the traditional methods of the visual arts away from their context of forms and meanings. 'The real choice,' he said, 'is between abandoning all creative activity and preparing a future culture, which is desirable, albeit not yet realizable . . . It is true that one must believe the Revolution will succeed in order to take this latter position.' ('Autodialogue', *Opus International*, No. 27, 1971). But 'revolution' is such an all-purpose word. It was in invoking it, more or less abusively, in those same years that so many artists who wanted to embody it gave themselves over to anti-art,

219

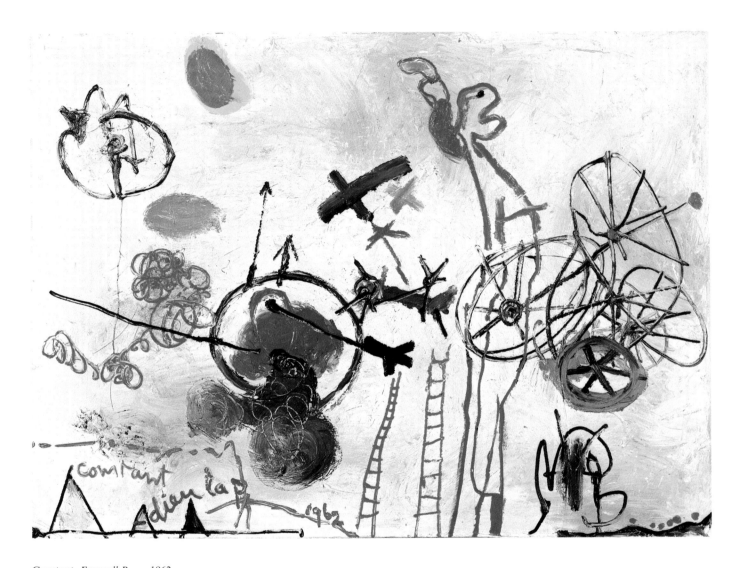

Constant, *Farewell P . . .*, 1962.
Oil on canvas (113 × 146 cm).
Private collection. Photo Victor E. Nieuwenhuys-
A. van den Born, Amsterdam.

Asger Jorn, *The only possession*, 1960.
Oil on canvas (100 × 81 cm).
Collection of Jean Pollak, Paris.
Photo Luc Joubert, Paris.

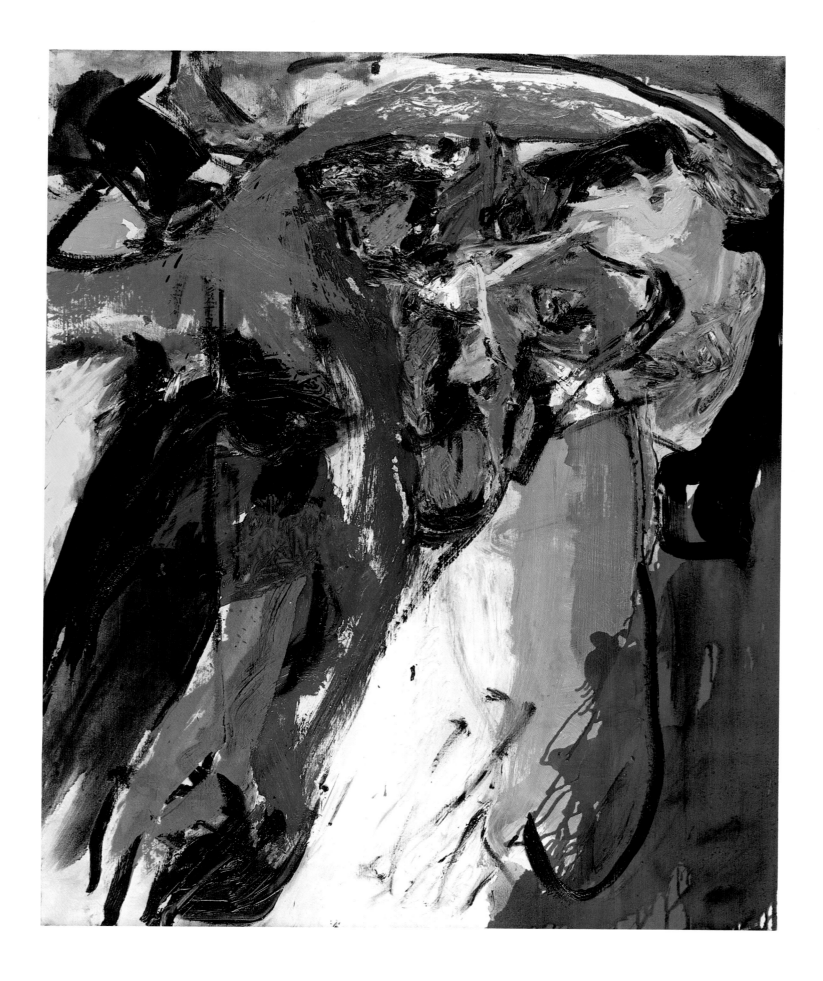

non-art, poor art. Quite logically, Constant kept his distance from them: 'The fact that no-one is shocked by it rather shows their lack of effect.' And he added this comment, which explained his attitude for the future: 'It is not giving up the creative impulse, but this impulse itself which threatens bourgeois society.'

As far from this as he could possibly be, Dotremont drew the logogram *Let's go beyond anti-art!* in 1974. And little by little, Constant himself returned to being the artist he had never really ceased to be: from 1960 onwards, it would be as a painter that he would traverse the Utopian space of 'New Babylon'; a desert at first, the labyrinth would be animated by unexpected scenes, not at all futuristic, such as the *Meeting of Justine and Ubu* (1975). Constant progressively changed his spontaneous techniques for a more and more traditional style (semi-perspective, transparency of colours etc.), in order to separate himself, as he said, from 'today's official art', that is anti-art. The demon of negation, of the dialectic, made him a painter who was once again happy to paint and who treated 'grand subjects', almost allegories: *Liberty insulting the people* (1975), *Joy and sadness of love* (1976), *The Last Supper* (1979). He even re-invented the sensitive portrait: *Fanny Kelk* (1980). Here, we are far, very far away from the New Babylonian Utopia, where art was life itself and vice versa. The Revolution didn't happen; what will become of the 'post-modern' age?

The first exhibition of Cobra after Cobra took place in 1956 at the Galerie Taptoe in Brussels, organized by Dotremont. It was no longer a 'collective manifestation': the Cobra members had developed so much along their own individual lines that it could no longer be termed a group. Everyone realized it; the director of the Galerie Taptoe, Walter Korun (who was a participant in International Situationist), spoke about it with Jorn in an interview published in the bi-lingual Flemish review *Kunst-meridiaan* (29.3.1956): 'Cobra? We unwittingly added a climate of continuous research and experimentation to the unity of form and expression,' Jorn said. 'As in nature, it is necessary to destroy in order to construct something these days. In Cobra, there was an astonishing possibility for a living, organic relativism in art, instead of a determined relativism.' – 'So the best guarantee against any kind of formalism is the artist's lively interest in experiment in the broadest sense of the word?' – 'I am convinced of it. It is the only way, and now we can consciously exploit this knowledge in the interests of perpetual freedom in the act of painting.'

Such became Cobra after Cobra: an artistic practice henceforth conscious of itself, conscious of the freedom it had and of its strength. But consciousness here did not mean discarding spontaneity; one of the most significant traits of Cobra art remained its desire to be uninhibited, its uninterrupted relationship with the 'unknown world of the psyche'. This is why forms which unfolded in Cobra pictures often harked back to the archetypes which were not fixed images, according to Jung, but 'the

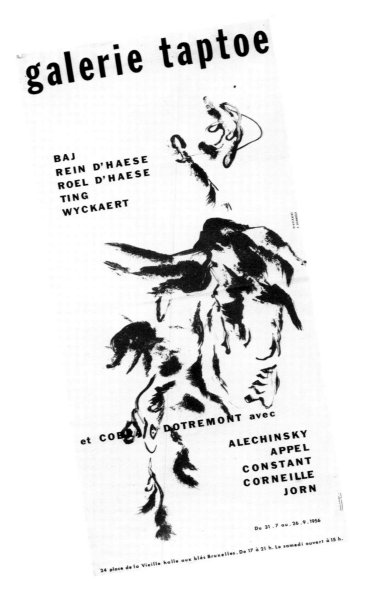

Maurice Wyckaert and Corneille Hannoset, poster for the first post-Cobra exhibition, organized by Christian Dotremont at the Taptoe Gallery, Brussels, 31 July–26 September, 1956.

way in which the mind feels psychical reality.' (*Contribution to the psychology of the archetype of the child*). A Cobra work can be recognized from the tension it manifests (tension or conflict, although the work is precisely about the conquest of that conflict); tension between what forms owe to individuality, to the conscious will of art, and what they extract from the subconscious, where they plunge with a kind of ease which is more and more sure of its methods. In every Cobra work, no differentiation was made between the seen and the imagined, the sign and the symbol, forms and forces.

A substantial proportion of the works exhibited at the Galerie Taptoe came from Paris, where the Cobra group was now widening its base and where Jorn had also settled; along with Albisola, it would be his main dwelling place. In the Parisian panorama, each of the Cobra artists followed his own course, meeting only occasionally and then not all of them together; they got together, for example, for the important exhibition

'Phases of Contemporary Art', organized by Édouard Jaguer in March 1955 in Paris (at the Galerie Creuze), then again in May 1957 at the Stedelijk Museum in Amsterdam; or in the volume *La Jeune École de Paris*, which I edited in 1956. In fact, the Cobra group remained magnificently rebellious against the classifications and definitions which so delighted the leading lights of Parisian artistic life. For example, it took almost ten years for Jorn to be acknowledged in Paris, the only Dane in Cobra to be so, and even so, his recognition was a spin-off effect of his growing fame in Italy, Germany and the United Kingdom. Jorn's barbarian style of painting could never fail to shock 'French taste' – if that exists – but it was also this aspect which attracted certain people, such as Jacques Prévert, who praised him (in his preface to Jorn's 1957 exhibition at the Galerie Rive Gauche) as 'a hereditary vandal, a peninsular person, innocent, simple and hilarious, an innocent witness of life without trial . . . a tube of colour can burst into laughter right in the middle of his studio. It only does this to frighten him. But with this same colour, which changes dimension and intensity in bursting into laughter, he can sadly paint his children, whom he thinks he has heard crying in the next room.'

Asger Jorn, catalogue cover for the first one-man exhibition in the USA at the Lefebre Gallery, New York, in November 1962.

Jorn's non-situation and that of Cobra, followed by their progressive integration, is inscribed in the general evolution of art in Paris, where for some time it has been felt proper to despise expressionism, aggravated by a great deal of ignorance of it. Certainly it took the discovery of the New York School, action painting and abstract expressionism to open a few eyes, along with the

Asger Jorn, Signature-drawing.

confused and complex impulsions of Michel Tapié's *art autre*, *tachism* (Charles Estienne, supported for some time by André Breton) and *informal art*. The disturbing appearance of works by Fautrier, Dubuffet, Wols, Hartung and Mathieu was also a factor. But this is the history of European painting itself at the middle of the century; willing or not, Jorn found himself integrated into it, with museum exhibitions, international awards (although he did refuse the Guggenheim Award) and the speculation of dealers.

Karel Appel's integration had been even more rapid, or, to put it another way, fame had come earlier to him. He was guided by his Taurean nature and a very sound sense of the moment, 'despising all purism, all restrictive systems, giving every opportunity to the most subtle violence, the most complex evidence,' as Michel Tapié put it. Around 1952, Appel was still dominated by anguish, a tragic feeling about life which appeared to him, in its mix of colours, like a sort of tragic carnival. Is that not typically Dutch? 'Man is in despair through his own madness,' he noted at that time. 'In despair because of society's madness, because of faith and love. In despair because of the madness of anti-society. In despair because of the madness of possession, of being incapable of possession. Of not having wanted to possess.' Appel differed from Jorn and Constant in that he was not searching for salvation outside of painting: 'To paint is to struggle constantly with oneself.' He concentrated the forces he recognized inside and outside himself on a single canvas, which was a fragment of his life before becoming a picture. 'I never try to make a picture, but to cry out.' Or again, as his wax effigy at Tussauds in Amsterdam affirms: 'I do not paint, I strike.' Appel struck and struggled against an invasion of fairly wild forms. 'A throng, a surge,' Dotremont wrote in a message sent from the Lofoten Islands in March 1965. The task was to transform them positively into a *Cat*, a

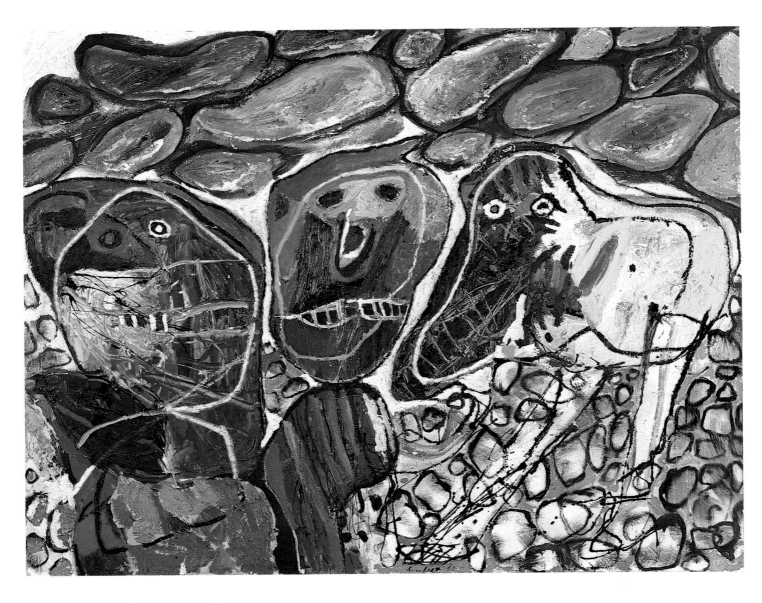

Lucebert, *In Egypt*, 1962. Oil on canvas (115 × 145 cm).
Stedelijk Museum, Amsterdam. Museum photo.

Karel Appel, *Bespectacled animal*, 1957.
Collage, ink on paper. Private collection.

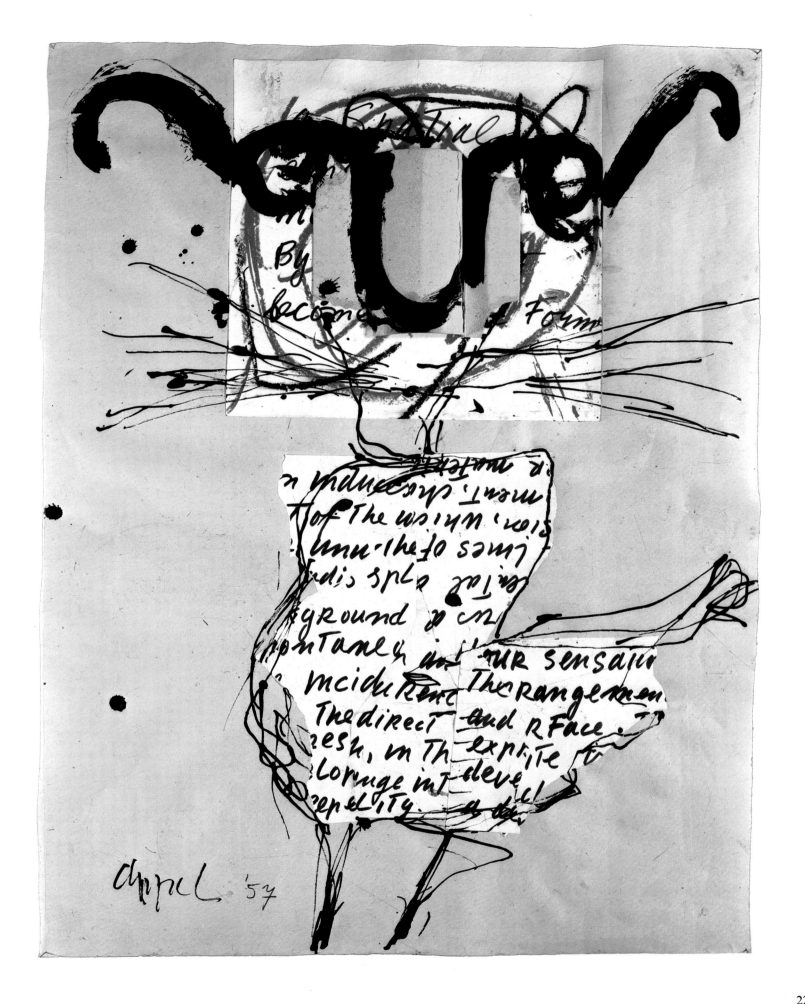

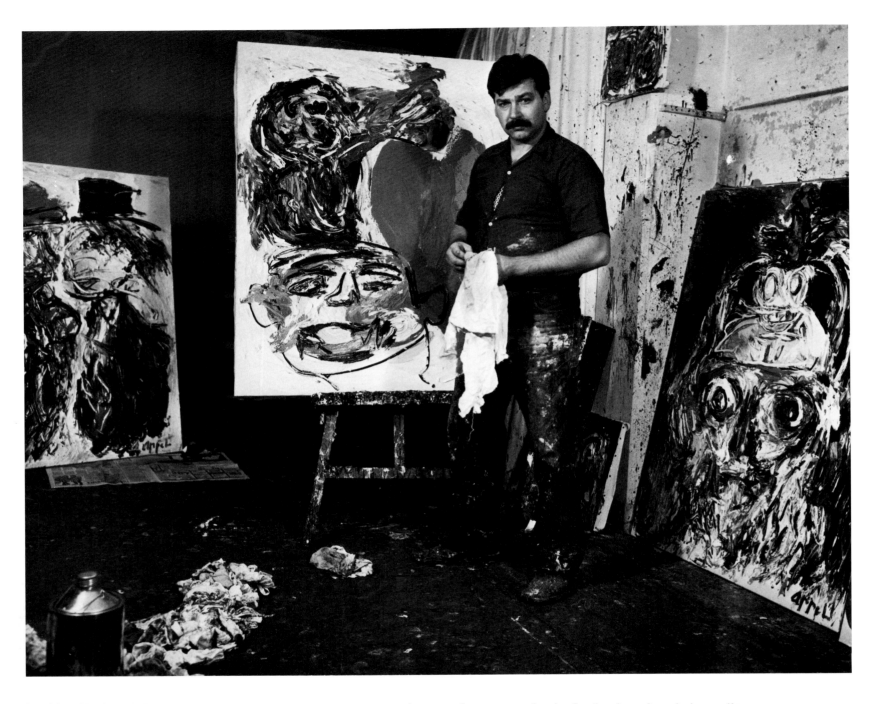

Karel Appel in his studio in the rue Brezin, Paris, 1961.
Photo Daniel Frasnay, Paris.

Bird, a *Weeping Crab*, a *Tragic Nude*, a *Young Girl*, a *Red Landscape*. Giving the freest rein to the vehemence of his impulses, to his mania for painting, Appel was the colourist of current life: 'One is not striving to create art, to have a style, to follow the rules. Something is born, something "happens".' But each time, Appel gained more complete control of the storm he had called up. The tale of the sorcerer's apprentice had nothing on him. He was a virtuoso of chaos, because he knew how to be swept along by it, from work to work. And he ran the richest gamut of feelings 'between melancholy and fury', as Hugo Claus said of him.

Thus indescribable beings appeared by the hundred on his canvasses: men, beasts, objects all prey to the demon of metamorphosis, freely changing their quality 'from one end of the earth to the other, like molten lava.' The colours of *angst* mixed with those of derision; but, from 1960 onwards, a kind of dizziness entered the game; for example, that of colouring the trunks of olive trees to turn them into garden monsters. Or later, the construction of monumental toys, such as the *Anti-Robot*, which salutes the Science Faculty in Dijon, from its height of six metres, with a dying flower, right in the middle of the university campus. Appel reassured himself with art and trusted it: 'a leap of the imagination without limit, beyond even madness, violent and explosive love of life.' The painter, as he saw it, was a magician who had the power to 'make the impossible possible'. He had something of the *shaman*, something of the clown about him. He was not fooled; primitive-

ness and sophistication were the extreme limits of modernism, between which his own activities were not without risk: 'I am a decadent barbarian,' he said. And he disguised himself as a butcher, or as a cosmonaut. Whatever it was, a festival or a defeat, Appel was always motivated by an insatiable, irrepressible pleasure in painting which he, like few others, had the power to share with us. Cobra pleasure.

Corneille was certainly the most direct illustration of totemism in Cobra art; as the name the artist chose for himself (it was only his second christian name) indicates, it is the crow and the bird in all its forms which appears most naturally and most often in his paintings. He would have been the last to be surprised by it: 'My strokes on the canvas always turn into birds. The bird is the most perfect image of movement. It is not only movement towards a goal, but also joy in movement for its own sake. Do you ever look at birds? They fly, suddenly change direction and swoop down. They seek only pure movement, the pure pleasure of movement. It is that movement which I am seeking,' (preface to his album of six lithographs, *Vogelvluchten* ['Flight of birds'], 1960).

There is here a whole catalogue of characters which allows us to deduce the artistic destiny which shaped his life and work. Movement, the joy of movement? That was translated first and foremost into ceaseless travel. Having become a Parisian from 1950 onwards, Corneille, who like all the members of Cobra was profoundly sensitive to the rhythm of a great metropolis, missed no opportunity to escape from it and to set off to explore the world. The tropics had an enduring attrac-

tion for him and would never be zones of sadness as far as he was concerned. The Mediterranean, Africa, South America, his trips were numerous – sometimes veritable expeditions, like his trek from Senegal to Ethiopia in 1957–8. And always happy. The small garden where Corneille lay stretched out and dreaming in the grass as a child had taken on such dimensions that it had exchanged all possible localization for the cosmic colours of happiness. Like the migratory birds of the North, Corneille returned ceaselessly to that season for which they shared a common nostalgia; Summer. He was the painter of Summer, the eye of Summer.

As far as his painting was concerned, the Cobra era had been one of labyrinthine wandering in the town, almost of imprisonment. Christian Dotremont described his canvasses of that time as 'inspirational topography, not because of a fixity, but because of simple and complex movement, as if repeated but always different, curved lines and straight lines, spirals and radiations, perfection and cracks . . . Paintings [like] a single unfolded surface from which to fly away. To return. To return, but each time to become anew.' (*Le Géologue ailé*, catalogue of the 1974 Corneille exhibition at the Palais des Beaux-Arts, Charleroi).

This 'becoming', after Cobra, was determined by the 'fatality of the sun' to which Corneille delivered himself. It came to him like a revelation during a stay at Hoggar in 1952 and he recounted it in a fine narrative *Le Tademaït ou l'Opulente monotonie* ('The Tademaite or opulent monotony'): 'This landscape, at once the most dead and the most invigorating that I know, has taught me many, many things.' For several years, his painting

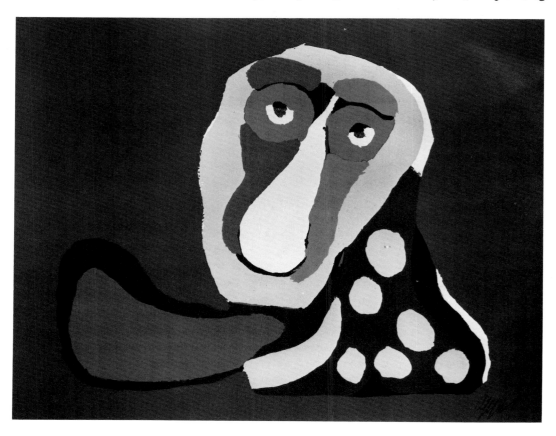

Karel Appel, lithograph in six colours (50 × 65 cm) for *Le Petit ludeum de Karel Appel – Poems by Jean-Clarence lambert*, La Hune Éditeur, Paris, 1976.

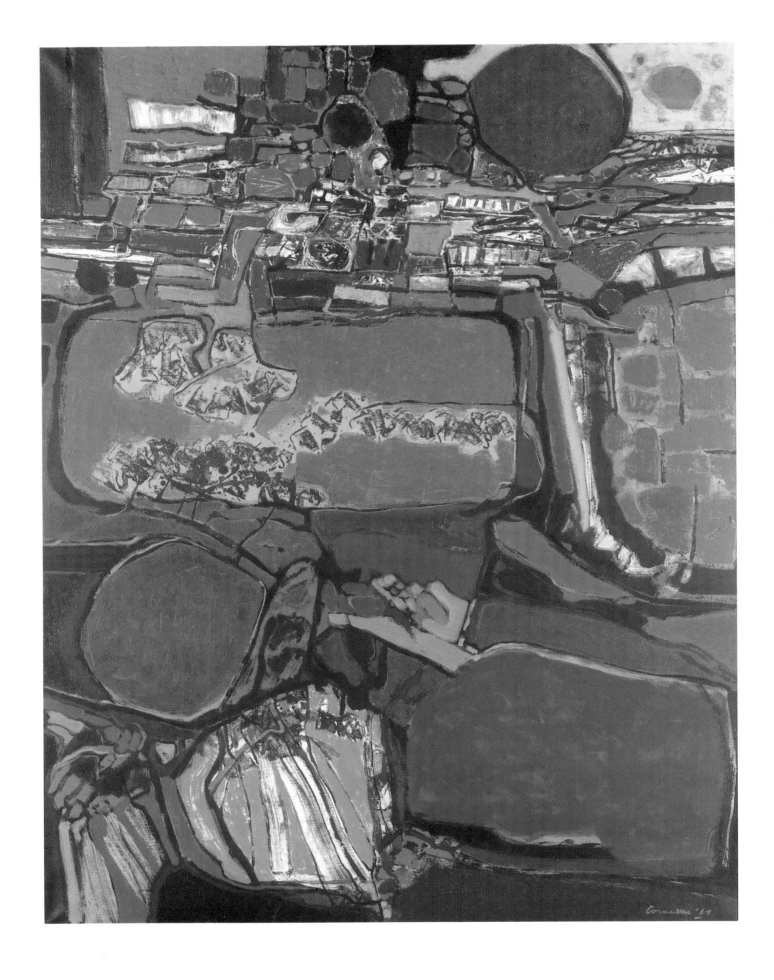

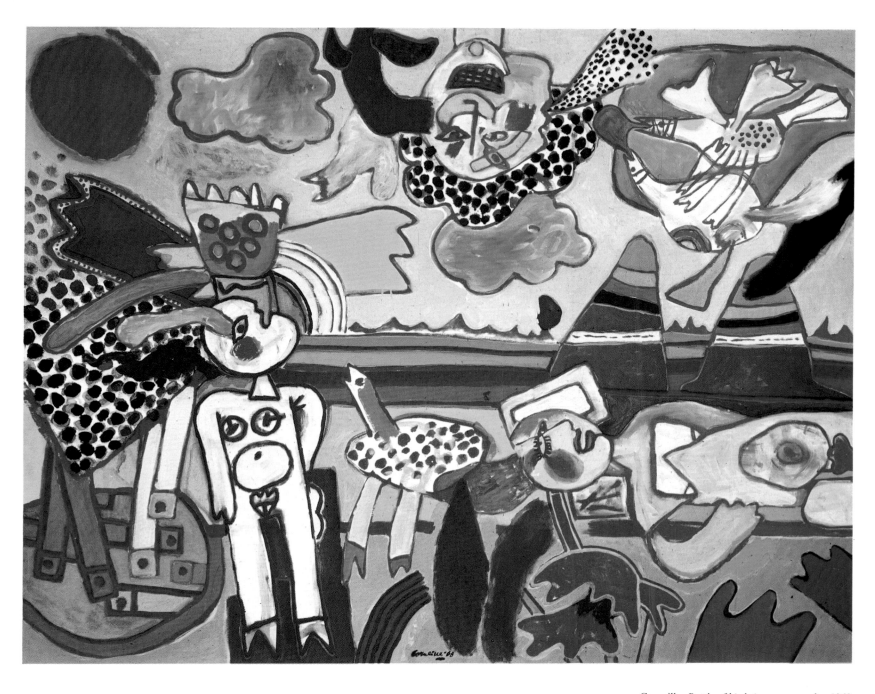

Corneille, *Battle of birds in a summer sky*, 1968.
Acrylic on canvas (130 × 162 cm). Private collection.

Corneille, *Among the stones*, 1961.
Oil on canvas (116 × 89 cm).
Museum Boymans-van Beuningen, Rotterdam.
Museum photo.

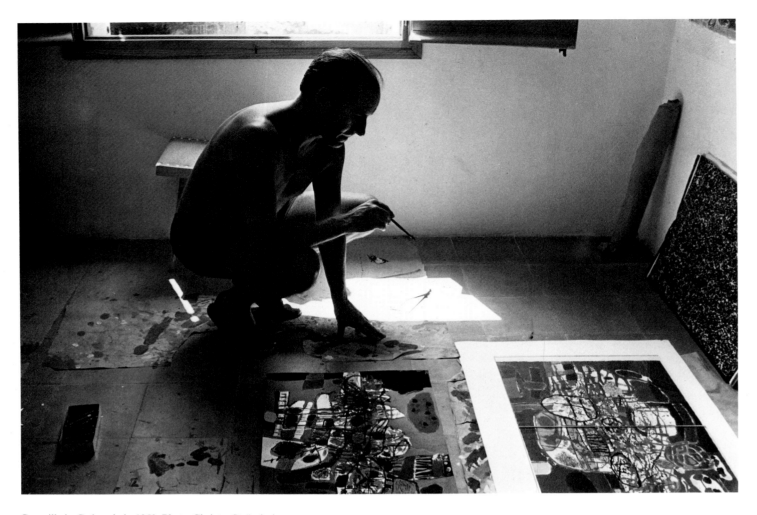

Corneille in Cadaquès in 1953. Photo Christer Strömholm.

became mineral, organic; it evoked rocks, the earth, the deep life of metamorphoses from the inside. The canvasses have names like *Burnt Earth*, *The Great Earth* (1958, Stedelijk Museum, Amsterdam), *Amongst the stones* (1961, Boymans-van Beuningen Museum, Rotterdam). Corneille had abandoned all thought of figuration, even allusive figuration, although he would sometimes specify in his title that the incandescent red blob recurring obsessively in the upper part of his compositions was the sun. The African sun. In fact, Corneille had drawn towards the group known within the École de Paris as the 'abstract landscape artists'. It was a renewed and dazzling affirmation of Bachelard's ideas; in several of my writings of that time, including a monograph dedicated to Corneille, I tried to apply the principles reserved by the philosopher of the imagination for poetry itself to the plastic arts. And Bachelard was the first to rejoice in it.

Figurations – birds, of course, then women (indicating fertility, the fertile earth), and natural elements, such as flowers and volcanoes – reappeared in Corneille's canvasses at the end of the Sixties. For the most part, this was due to his direct contact with the folk art of Brazil, Mexico and the Caribbean – new exoticism, it might be called, in all that implies of the paradisiac feeling; but it was an exoticism lived from within, like that of Gauguin, in the innocence of forms, the joyous sentiment of colour. For a European who was neither a colonial nor a tourist, it represented a crossing over, almost a transgression. Henceforth, Corneille had direct access to that Eden on earth which was art before art. Cobra too had searched for that.

If Cobra had been his school, which he freely acknowledged, Alechinsky, the movement's youngest protagonist, was still far from real self-discovery when the movement disintegrated. He painted extraordinarily dense canvasses – forests and anthills, forests swarming with ants – it was his vegetal, earthy period; a picnic, but an uneasy one: 'We shall never be as innocent as the caterpillar.' In Stanley William Hayter's engraving workshop something manifested itself to him which would have far-reaching consequences – the hidden personality in his hand, in his two hands. 'Whilst most people are surprised to see their drawing reversed by printing, Alechinsky sees his as being restored by it, giving free rein to his hand; in this way he makes himself aware of art's main terms of reference, in its creation and in its reading, left to right,' Dotremont said. At the same time, Alechinsky met Walasse Ting, who had just arrived from China, and who was exhibiting his ink paintings at the Fachetti Gallery. Fate was kind. In his little room near the Gare du Lyon, Ting taught him the 'Chinese style'; paper on the floor, inkwell in one hand,

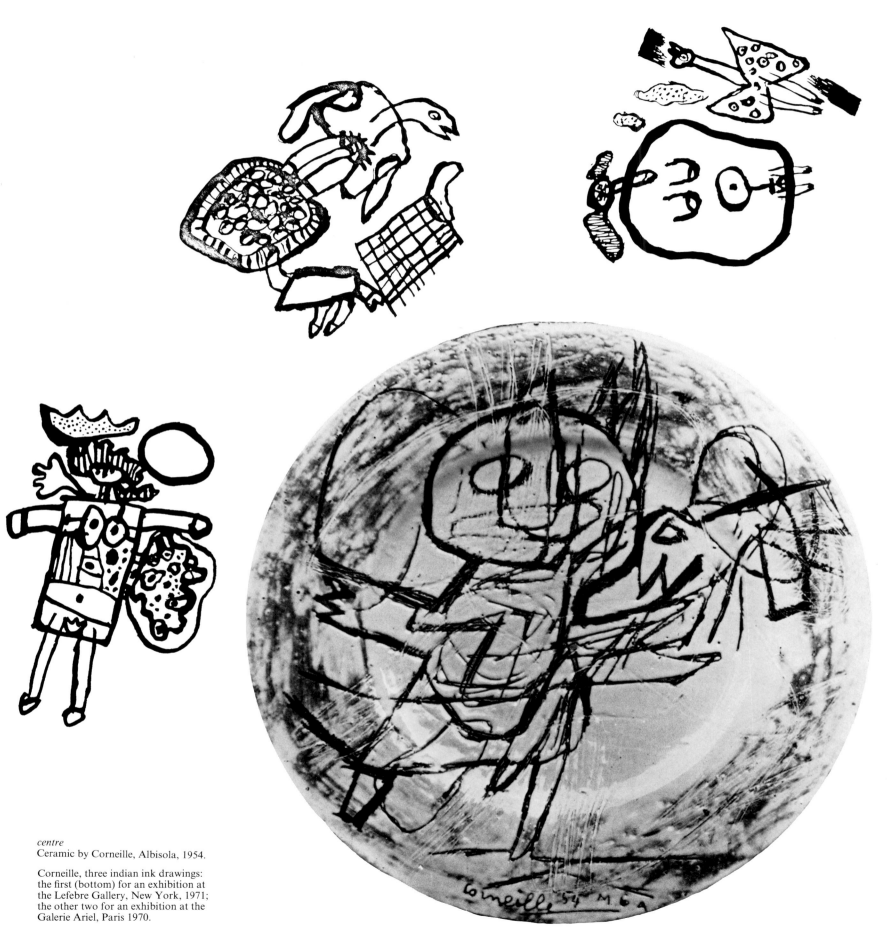

centre
Ceramic by Corneille, Albisola, 1954.

Corneille, three indian ink drawings:
the first (bottom) for an exhibition at
the Lefebre Gallery, New York, 1971;
the other two for an exhibition at the
Galerie Ariel, Paris 1970.

Christian Dotremont and Karel Appel, *Sleep in your language*, 1962.
Gouache and pencil on paper. (49.5 × 64.5 cm).
Kunstmuseum, Silkeborg. Photo Lars Bay.

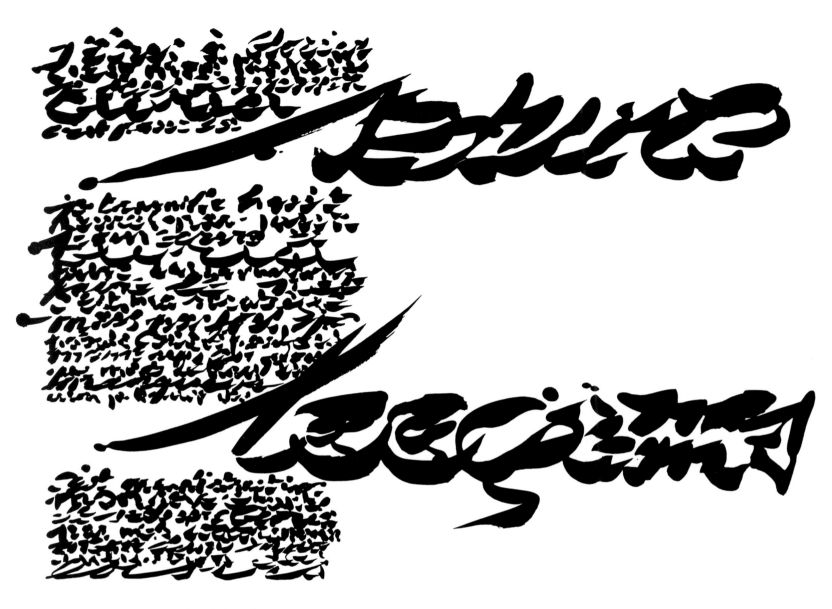

Christian Dotremont, *Logogramme* ('word-picture'),
Tervuren 1969. Indian ink on paper (40 × 56 cm).

Text: 'I write to Gloria – it is my work – I am a writer to
Gloria – to seduce her – I work eight hours a day – to write
to Gloria – to make rough copies – to make fair ones – that
is my strategy – sometimes I take a break – sometimes even
a year – so that she'll miss my letters – and then I trace
logograms – it distracts me – my dream-being – to seduce
Gloria through my logograms themselves – in a civilisation
of leisure.'

Christian Dotremont and Mogens Balle,
L'imaginerfs contre les imaginouilles and *La Culture
regarde l'art voit* ('Culture looks, art sees').
Woodcuts in colour from a series of eight
'spontaneous posters' collected under the title
L'Imaginatrice (Copenhagen-Brussels 1968).

233

brush in the other, the whole body mobile; like this a greater liveliness of line could be achieved amongst the symbols and empty spaces. Alechinsky wanted to know more; he left for Japan, which, in 1955, was still not involved in international modernism. Welcomed to Kyoto by the calligraphers of *Bokubi* ('Joy of ink'), he made a documentary film entitled *Calligraphie Japonaise*, which allowed him to demonstrate how the people of the Far East 'adjust their hand to their whole body', how their actions were capable of being 'changeable, personal, serious'. Dotremont wrote the commentary for the film: 'Where there was a struggle between a flat, anecdotal reality and an impersonal, immobile hand a complicity developed between *abstract* reality, which is in the depths, and the moving, trembling, personal hand of the heart.'

Alechinsky's quest was the same as Dotremont's, but each pursued his own parallel course, always directing themselves towards works which emanated from the basis of their respective individualism. 'The painter realizes that he is the trustee and the master of all the spontaneous force which Western writing has gathered; he realizes that there is a place between the quasi-mathematical writing he has learnt at school and the

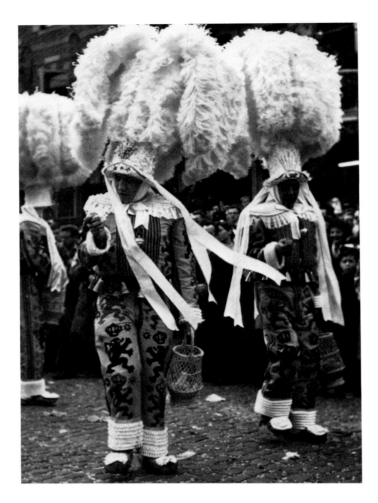

Pierre Alechinsky and Karel Appel at Bougival, 1976.
Works with four hands. Photographs by Micky Alechinsky.

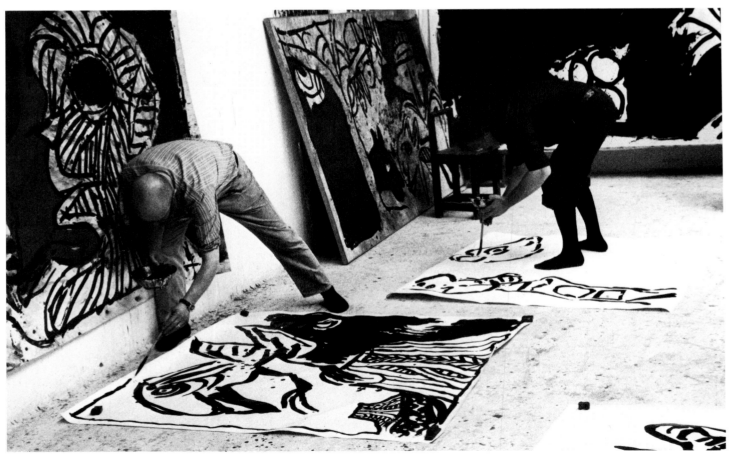

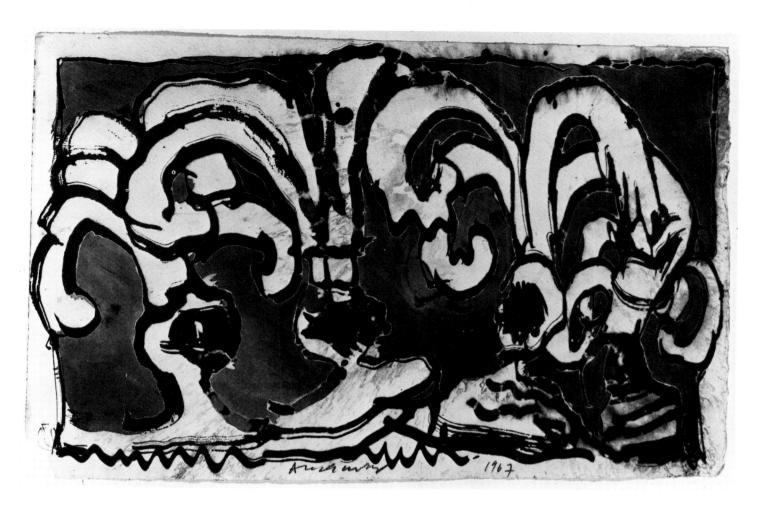

Pierre Alechinsky, *The Gilles of Binche*, La Bosse (Oise), 1967. Indian ink and tint (21.8 × 34.3 cm) Musée national d'Art moderne, Centre national d'Art et de Culture Georges-Pompidou, Paris.

formalist game of conjecture for a writing-painting which has a much more frank and natural relationship with the Universe than congealed painting.' Dotremont was on the track which would lead him to the 'logograms'.

The pictures Alechinsky painted on his return from Japan resisted a surface orientalism. They were ironical – at the Salon de Mai in 1956, he exhibited a *Disoriented Orientalist*. It was not until the following year that he would execute his first 'great ink drawing' *Grass writing*, painted/written on two pieces of paper joined together on the floor of his studio. It was that yellow paper used in couture, which would remain his principal medium when he came to mounted acrylic painting.

A long apprenticeship to freedom, a long haul in finding himself. 'Nothing prepares the painter for being alone. He serves his apprenticeship surrounded by colleagues. Then, one day, he has to enter a cell in order to paint.' Alechinsky had so many monsters to exorcise, to tame on the 'unsilvered mirrors' of his pictures! 'Seeing ourselves there, we will pass into their night, because the smacking of their mouths, orifices, scrapings and manifestations.' A visceral night, a *Sleepless night* in a *Lost world* (1959 paintings), where the risk is to *Disappear* (1959 painting), devoured by *Jaws* (1959 painting). Henceforth there was evidence of this haunting shape, of meanderings and intertwining, of corridors, circumvolutions, folds upon folds, knots and

dénouements, flowing and beginning again in a living labyrinth: the snake. From Cobra to *Central Park* (1965), his first picture with 'margin notes', painted in acrylic, Alechinsky's profound plan was always an inextinguishable metamorphic continuum of all action, all lines, evoking that archetypal form which was obviously the most 'cobric'. It was she, the Breugelesque witch with her band of red tears in *For Dulle Griet* (1965), just as she was the infernal brazier in the *Theatre of the armies* (1967); she was seen again perfectly explicitly in *Living Cobra* (1966), or in *Luxury, Calm and Voluptuousness* (1969), whose dominant purple, warm colours and reference to Baudelaire constituted a kind of tropical nocturne: 'the snaking of the storm', Dotremont wrote in one of the integrated logograms of *Abrupte Fable* (1976). Alechinsky often had recourse to puns in his art, which was so much favoured by Cobra; thus the exaggerated headdresses of the Gilles at the carnival in Binche became volcanoes expelling coiling spirals and cobra-esque peelings, following a visit to Mexico. In another more rustically familiar space, the same collection of disordered forms became *Scraps of a meal* (1969–70), before reappearing in a newly invigorated form in *Decorative bestiary* (1973). Ridicule or night-

235

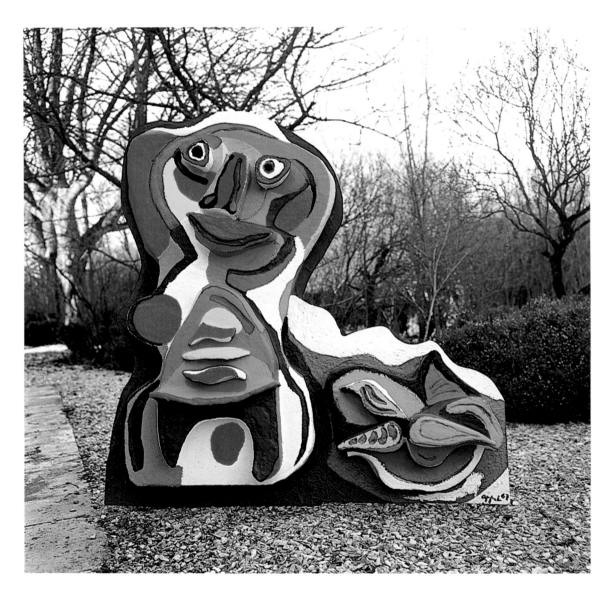

Karel Appel, *Person with a flower*, 1967. Multicolour laminated and expanded polystyrene (185 × 180 cm).

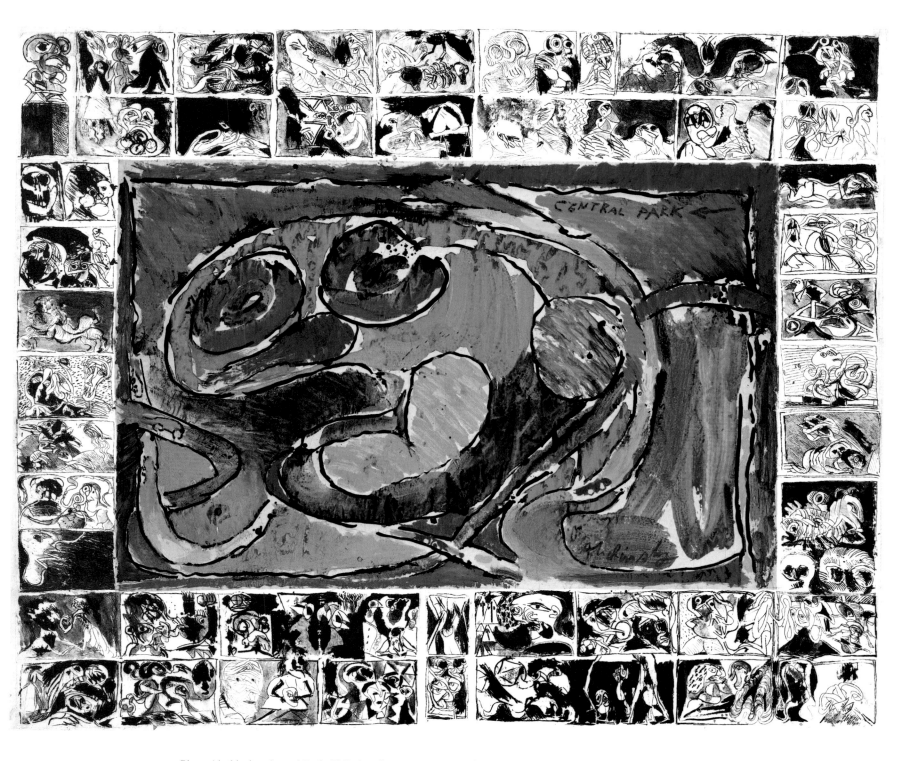

Pierre Alechinsky, *Central Park*, 1965. Acrylic on paper mounted on canvas (with 'margin notes' in indian ink on Japanese vellum) (162 × 193 cm). Private collection. Photo Francois Walch, Paris.

mare? Terror or farce? As we know, fantasy (particularly in Alechinsky's work) is often hard to distinguish from the satirical. A picture painted in 1970, a self-portrait, indicates to us that we should not try to make the distinction; this is the artist as *Trained trainer*. Trainer of monsters, trained by his monsters.

Alechinsky was faithful to Cobra in maintaining friendly ties with most of the companions of his youth (his correspondence with Dotremont, for example, consists of several hundred letters). Over the years, too, he multiplied the 'work of four hands', not only with Jorn, Dotremont and Appel, but with other artists who, although they were never directly involved in Cobra, nevertheless shared its values, its techniques, and its sensitivity – artists such as Walasse Ting, the Spaniard Antonio Saura (who was also a close friend of Jorn) and the Mexican Alberto Gironella. Pierre Alechinsky was a painter-writer and his books (*Titres et Pains perdus*, 1965, *Roue Libre*, 1971, *L'avenir de la propriété*, 1973) illustrate this interspecialism (or anti-specialism) in their highly elaborate text and imagery. Inter-specialism was one of Cobra's strongest motivations.

Although he never felt the need to work in three dimensions (and in that he differed from Jorn, the ceramist, Constant the modeller and Appel the sculptor of tree trunks), Alechinsky loved nevertheless to maintain a connection with sculpture; this was principally through Reinhoud who, more clearly even than he, was a Cobra born of Cobra. An expatriate Fleming, separated from his large, nationalist, family (amongst his brothers and sisters, his eldest brother Roel d'Haese had already emerged as a sculptor), Reinhoud had rented a corner of the Ateliers du Marais where he would beat his anvil like a coppersmith, having a marked preference for the hammering technique they practised. 'He bashed away, starting off with all his might,' Dotremont recalled. 'He was very young and thus had very little time, having very little "brass", as they say and very little copper either. All this row would wake us all up. Alechinsky made brushstrokes on a canvas and I tapped away on a typewriter: not much competition. In this orchestra, Reinhoud was the tom-tom, without a jungle. Later, he would play in the Rue de la Poste, in an even more popular part of Brussels, where he was more alone amongst even more people. But he has always had a sense of folklore and he had long conversations with the characters of Bosch and Breugel.'

It would take almost six more years before Reinhoud was ready for his first exhibition (at the Galerie Taptoe in Brussels in 1956). Like Alechinsky's, his was a long coming of age: in the Cobra spirit of friendship, the painter and the sculptor shared an old school in the Oise, which served them as a workshop where they could exchange ideas and monsters. There were many common designs, but each one worked for himself; they were particularly inspired by the serpentine spirals of orange peel and these spirals would recur at a certain period in Reinhoud's copperwork (*Situation of interlacing, Head*

to tail and several sculptures from the years 1964–6), as well as in Alechinsky's canvasses (*For Dulle Griet*, 1965, *Living Cobra*, 1966, etc.). Luc de Heusch said: 'They conspire like thieves at a fair.' A fair which, taking everything into consideration, had the appeal of a Flemish village fair (*kermis*). Reinhoud and Alechinsky re-invented something of the profound imagery of Flanders and Walloons; one is tempted to say of Reinhoud that for him the Breugelesque 'combat of the money-boxes and safes' never ceased, that comic-heroic dance of anthropo-zoomorphic metal. The spectacle afforded to us by Reinhoud, hammered, forged or soldered, invokes a new kind of *Temptation of Saint Anthony* with neither sainthood nor saint. Of course, it was temptation which had triumphed, and the Devil and his followers had become a collection of comic *Migraines* (fourteen figures in silver-plated lead, 1967–8). 'Reinhoud's monsters,' wrote Alechinsky, in

Reinhoud, *Balzac a little crumpled*, 1962. Copper (157 × 120 cm). Kunstmuseum Silkeborg. Museum photo.

Reinhoud, Sculptures, La Bosse (Oise), 1969. Left: *Is the water good?*
brass (81 × 29 cm); *Public Bath*, half-red copper (76 × 41 cm).
Centre: *Blower*, copper (65 × 52 cm).
Right: *Deep in each pig is a sleeping man*, copper
(64 × 22 cm). *Accompanist*, brass (66 × 23 cm).
Photo Pierre Alechinsky.

presenting their *Solo de sculpture avec divertissement
pour peintures à quatre mains* ('Solo for sculpture with
divertimento for four-handed paintings'), 'no longer
know if they have been made, how, why. Or if they have
been shunned . . . In fact, why so many monsters? We
are monsters too.' (Reinhoud, Alechinsky, Ting, Galerie
de France, Paris, October–November 1963). The human
form appeared and disappeared, as in all Cobra art, in
dreams and nightmares. *It concerns you*, in copper, gave
a foretaste of one of the cripples of 1970.

For Jean Raine, as a painter, Cobra happened
entirely, and belatedly, after Cobra. He had had spas-
modic contacts with Alechinsky who presented his first
Paris exhibition at the Galerie Ranelagh in March 1964:
'Things do not go so quickly. There is only a slow mist,
out of which emerge certain forms destined to be seen
first of all by themselves then, slowly, by others. The
important thing is that they do emerge, these forms, and
their ability to do so is not a privilege but a joyful
infirmity.' The slow progression of Jean Raine towards
painting had the appearance rather of a regression:

going forward warily towards 'man germinating in
original animality' as he would call it. Had he not,
though, formulated the hyper-Rimbaldian hope, in a
poem written as early as 1948: 'Ten years, ten years of
my life to sleep one night as an ape'? Cobra was nostalgic
in this way for the instinctive, for psychological man.
Jean Raine, who had pursued his study of psycho-
analysis very deeply – too deeply, perhaps, for an artist –
recognized above all obscure and negative impulses in
this. The definitive Golden Age was only a myth, which
he set out to explode, Eden a hell in all of us, as he cried
out in his poems; and he demonstrated that 'passing
from the cry to the word is a deadly adventure' in his
great *Encres* ('Inks') of 1962–4 and again when he finally
moved on to colour (after 1966) in paintings which are
also psychological studies. He was besieged by himself
within himself, attacked and attacking, in a drunken
disorder: 'I drink myself to the threshold of uncon-
sciousness when I work.' Death was prowling in this
magma; panic fear.

Climbing up and tumbling back down (he liked this
ironic undervaluation), gave Jean Raine occasional
access, in a brutal way, to the most disturbing, most
threatened and most threatening areas. Or perhaps it
was a case of *Simulations* of a 'complacent teratology of
horror'. As one would say of cancer, the illness was
widespread, to the point of being insupportable. But

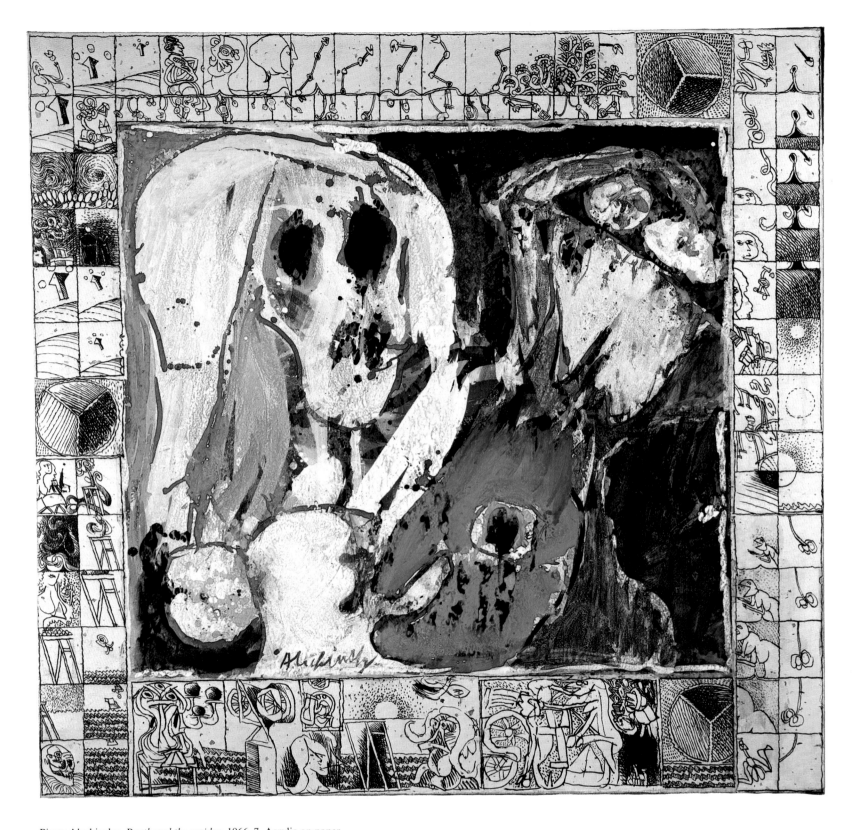

Pierre Alechinsky, *Death and the maiden*, 1966–7. Acrylic on paper
mounted on canvas, with 'margin notes' in indian ink on Japanese vellum
(137 × 137 cm). Collection of Marion Burge-Lefebre, New York. Photo
Otto Nelson, New York.

Christian Dotremont, logogram, Tervuren, 1978. Indian ink on rice paper (150 × 91.5 cm). Collection of Meyer and Golda Marx, Museum of Art, Fort Lauderdale, Florida. Museum Photo.

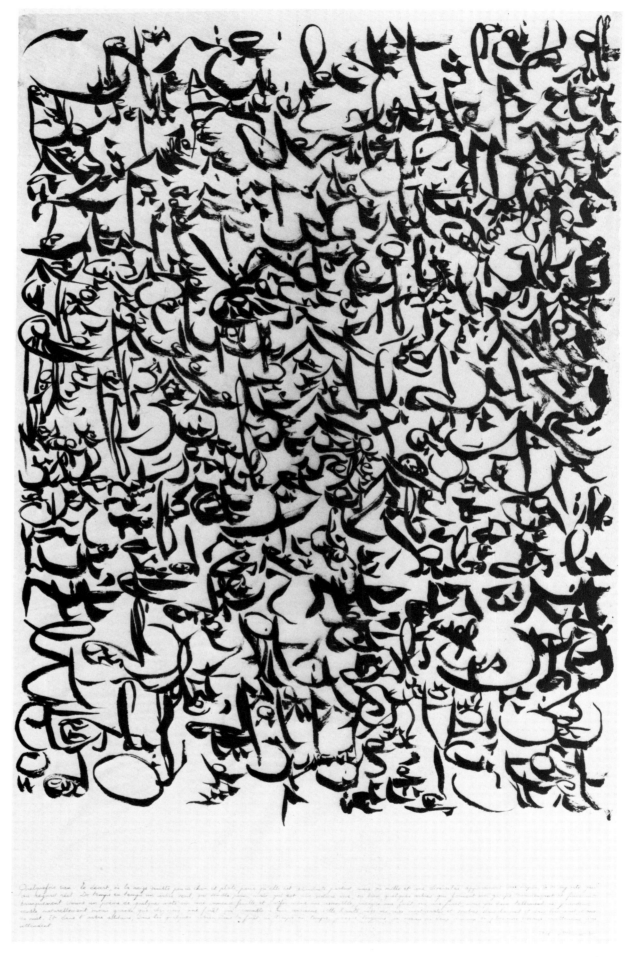

'Sometimes nothing. The desert where the snow is flat doesn't look like much, because there is so much of it everywhere; but a thousand and one things appear there to the Lapp. From time to time, a single tree, which seems lost, but which is a living victory, or perhaps several trees forming a group, starting and finishing abruptly like a poem of a few words on an immense sheet of paper, and sometimes even a wood, almost a forest, yes a forest, but which, amongst so much grandeur, appears naturally less grand than at home. A forest which resembles an old town with dark roads inextricable from the night, in their night, in its night. And in the solitary tree, in the few trees, in the forest, from time to time, almost always, a bird, two birds or several birds, unexpected, waiting.'

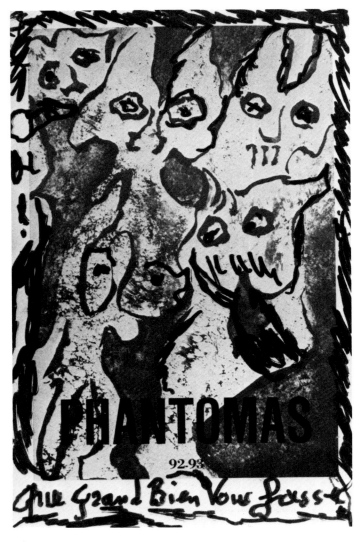

Jean Raine, collection of poems illustrated by the author and published by the review *Phantômas* (No. 92–3, Brussels, 1970). Cover with handwritten additions by the artist.

does not every form of instinctive painting take risks? Jorn knew it, feared it, enjoyed it. Jean Raine was closer to Wols: he 'de-painted autodestruction'. And he did not proclaim himself any the less as a blind painter because he painted so many eyes rising up from the eddies of his paintings and devouring the face that bore them. When I visited him in the ancient castle of Rochetaillée near Lyon, where he has chosen to live since 1968, he told me: 'I would not like to pass for an artist.' But before that he wrote: 'In painting as in everything else, a wasted action opens the field for a fertile imagination.' The work as a wasted action. Life itself? At the extreme limit of Cobra.

Mogens Balle too was another Cobra painter after Cobra. The youngest Dane in the group, he had participated in the gatherings at Bregneröd and in the exhibition at the Galerie Pierre in Paris. 'Cobra got me going and still motivates me now.' In Denmark, the post-Cobra period was only perceptible on the level of a few individuals, or exhibitions, when Dotremont endeavoured to mark its continuation in writing. His great friendship with Mogens Balle was important in that

respect; Dotremont visited him often in the former country school in Asmindrup where he lived. He followed the development of his work as a painter attentively and composed word-pictures in collaboration with him on many occasions. In the preface to the 'Salute to Denmark' exhibition at the Lefebre Gallery in New York in 1964 (which was first and foremost a salute to the Danish members of Cobra), Dotremont said of Balle that he 'fought with sidereal space' – a 'cosmonaut', he went on to say in *Art, Temps et Terre*, another preface, this time for Balle's one-man exhibition the following year at the Jensen Gallery in Copenhagen. A 'Bachelardian cosmonaut', even: 'Balle accumulates the lands of all his colours, kneads them, mixes them. And far from closing the picture in this way, he opens it; he opens what geologists call techtonic windows.' Dotremont stressed that if Balle created images according to the material – according to Cobra – it was in the particular climate of Denmark, where 'spontaneity is neither exuberant nor subdued . . . rhythms interplay, howling respects the murmur and the force of colour harmonizes with the light mist.' Balle knew none of the tensions which afflicted Jorn; he was closer to Carl-Henning Pedersen's legendary edenism, even though the forms appearing on his canvasses remained non-referential – *Daydreaming*, as he called a painting of 1976. 'I just need to press the colour from the tube to feel inspired, just need the colours to claim certain areas and to give expression to something poetic which I had not sensed at the outset.' If a precise symmetry was needed in the post-Cobra period then Jean Raine, the shipwrecked shipwrecker, would be the land of disasters and Mogens Balle the serene walker in the realms of nature, sky and earth. Through his friendships, Balle also prolonged Cobra; he illustrated Joseph Noiret and Uffe Harder, and pursued the experiment of the fundamental affinity between writing and drawing with Dotremont. The collection of word-pictures published on Dotremont's fortieth birthday in 1962 is just as precious in this respect

Christian Dotremont and Serge Vandercam in Brussels preparing their exhibition 'Muds' at the Société Royale des Beaux-Arts de Verviers, 27 June–5 July 1959).

Christian Dotrement, *Nowhere than here is the living elsewhere.* Ivalossa (Lapland), 1976. Snow word photographed by Caroline Ghyselen.

as *La Chevelure des Choses*, created with Jorn in the Silkeborg days, or as the series worked on with Appel, Alechinsky, C.-O. Hultén or Corneille. 'The first trace is sometimes this, sometimes that, an alternation which allows us to grasp all possible unity and which prevents impulse from getting lost in habit. One can see that Balle has taken up words traced by Dotremont as forms and vice versa . . . The spontaneous nature of these drawings must be stressed, spontaneity being definable as the art of evading chance as well as premeditation,' (afterword to *Dessins-mots*). These joint exercises, of which Dotremont was so fond, were only possible because he, the poet, wrote as easily as one breathes and because he only made a distinction between the visible and the legible in order to make them inter-relate better.

Dotremont's experiments in writing with Serge Vandercam in 1959 in Brussels came up with the most 'material' support they could hope for – mud. Serge Vandercam, who had been a photographer during the Cobra period, soon turned away from it to painting: 'violent, strong colours, furious, using thick paint, dishevelled.' He was a painter of abstract landscapes and was pleased to associate his poet friends, Cobra or otherwise, in his work, in the 'sharing of words and

symbols.' On one occasion when they were planning to engrave a panel together, he and Dotremont recognized something of the quality of terra-cotta about it; and Vandercam, who was prepared to use every material and style, suggested that they should make shapes from the peat of the Hautres Fagnes, whose very special flora he had just been photographing. Three weeks later, the 'Mud' exhibition opened in Verviers (June–July 1959): 'Twenty or so modelled and inscribed articles, as well as ten *bouologismes* ('mudologisms') – where every detail of the earth is a treasure trove of memory,' to quote one of Dotremont's inscriptions. 'If the texts were written with a boaster or with a mirette, more often than not it was on unfired clay; if with a brush, with white, ochre or green tempera, it was usually on terra cotta . . . None of the texts had been written or conceived prior to writing on the clay.' These details given in the catalogue hold true for all the Cobra co-productions in which Dotremont was involved throughout his life – more than three hundred of them scattered along the path of his wanderings: 'Art needs personal experiments as well as collective experiments.'

For Dotremont, Cobra without a visible end was alive, a forest constantly renewing itself by eternally inventing new seasons. He would never stop going more and more deeply into Cobra's very principles; in 1979 when illness suddenly got the better of him, he had just given praise once again, prompted by a stay in Ireland,

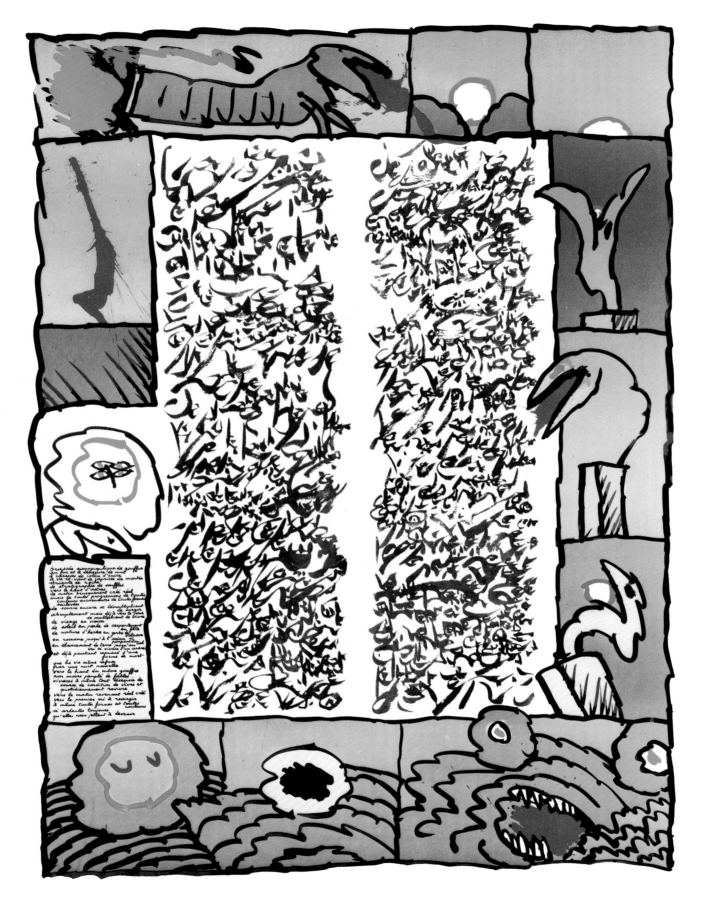

Christian Dotremont (logogram) and Pierre Alechinsky (margin notes), *Seismographic armful*, 1972.
Lithographed poster (72 × 52 cm). Maeght Publishers, Paris. 'Seismographic armful of the abyss – in
disproportion to the night – with the caresses of the anger of ink – with the comings and goings of the whims of
the mounted – striation of rock – stratigraphy of breath – towards the height of the stars . . .'

je donne tous vos étés
pour un seul nuage noir
qui est drapeau

Christian Dotremont and Serge Vandercam. Word picture, 1958. Oil and greasepaint on canvas (28.5 × 29 cm).

to the 'fabulous immediacy of the real' (*Logbokletter*). He had complied with it, for his own part, with the logograms, a long, premeditated ephiphany of writing restored to its full dimensions. 'I stress that the logograms are original manuscripts. None of them are copies . . . I suggest that you will see a sketch in their exaggeratedly natural, excessively free form of writing, not a naturalist sketch, to be sure, but material in any case, depicting my cry or my song, or both together. After which, you can read the text, which is always clearly written in the logogram.'

It was towards 1962, when he was launching 'word-pictures' with various friends that Dotremont made his first logograms, very small ones at first. But their origin stemmed, as we know, from much greater heights: Magritte, Éluard, Picasso, his first exchanges with Jorn. Jorn particularly, whose article published in the last issue of *Helhesten* (November 1944), entitled 'The Prophetic Harps' was familiar to Dotremont: 'Painting and writing are one and the same. The picture is written and writing makes pictures. There is writing, graphics, in

Christian Dotremont and Mogens Balle, *In a hovel in Shanghai*, 1962. Word picture on top of a Japanese folk etching. Indian ink (18.4 × 26 cm).

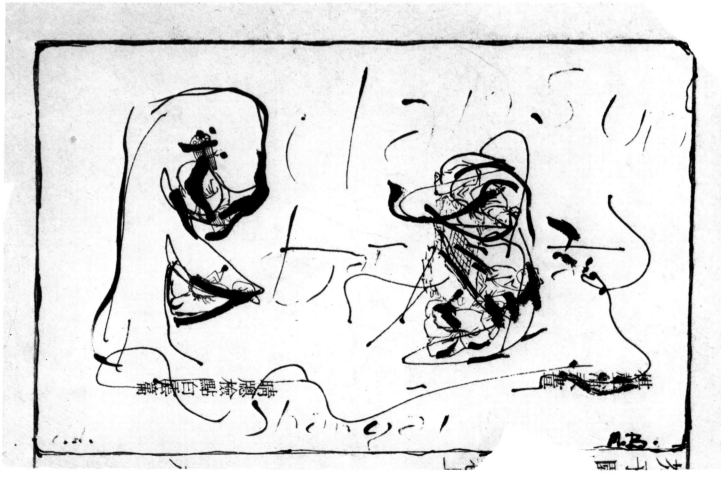

Christian Dotremont and Asger Jorn, *It becomes speckled*, 1963. Word picture. Indian ink on paper.

below left
Christian Dotremont and Karel Appel. Word picture, Tervuren, 1977. Gouache and indian ink (77 × 56.5 cm). Photo Speltdoorn, Brussels.

below right
Christian Dotremont and Carl-Otto Hultén, *Du Fria* ('Ye who are free' – words of the Swedish national anthem), 1962. Word picture. Indian ink and tint (36 × 24 cm).

Christian Dotremont, *Let's go beyond anti-art* 1974.
Logogram at the top of a blank page (27 × 20 cm).
Indian ink.

each picture, just as in every piece of writing a picture is to be found . . . the frontier between painting and writing has always been very flexible.' For Dotremont, another significant factor had been the concrete experiment which he had described and commented on in *Signification et Sinification* (*Cobra 7*). This was the viewing of one of his manuscripts in a mirror, in the vertical direction, which led him to affirm that his writing, seen from that angle, 'had something Chinese about it'. A singular experience for someone who had never ceased to 'dream Chinese'! 'The French phrase appeared to me then like the ciphers on the cover of an indecipherable poem.' He also made the discovery that hand-writing, the tracing of letters, possessed something irreplaceable in the dialect of the manifest and the latent, and that printing and typewriting 'half-kill the writer in killing his writing.' Cobra's efforts to get back to the basics of art, to the immediacy and spontaneity of the being, comprised more than handwriting, which had a life of its own in being recognized as an independent system of language; graphics were images meriting consideration in their own right, to which the same regard should be shown as to plastic forms. Handwriting is in the hand – which does not only depend on the conscious movements of the writer; the relevant conditional reflexes of his organic memory, of his subconscious, also come into play. Thus, in the Cobra sense, writing rejoined painting in a common destiny and

Dotremont became, through his logograms, more than simply a writer, if he could ever have been legitimately called that. He was more a 'painter of writing': 'Don't tell me that the logograms are abstract. And don't say that they are calligraphics. I do not seek out beauty, I sometimes find it and then I accept it. My goal is neither beauty nor ugliness, my goal is a verbal-graphic unity of inspiration. My goal is this source.'

The logograms, which have been the subject of important exhibitions around the world (Paris, New York, Scandinavia, etc.), and of which a certain number have been gathered together in a superb *Logbook* (1975), illustrate in the most immediate way – in black and white – that most important aspect of Cobra, that obsession, that moral passion, that renewed challenge, that dizziness – spontaneity. The key to the present moment, containing the past and the future, memory and imagination. It is nostalgia and vision – a fabulous time. That of art. That of Cobra.

So there is no conclusion.

Jorn died in 1973, Dotremont in 1979. That is fact. But art like Cobra's which is so close to the vital impulse could not finish just like that: the works exist, past and future, in a metamorphic continuum. 'Sure, Pop is highly-rated. But we don't think that art should consist in running after innovation,' Dotremont wrote in a minor tract of 1965. And he added: 'The late Cobra is doing very nicely, thank you, and you?'

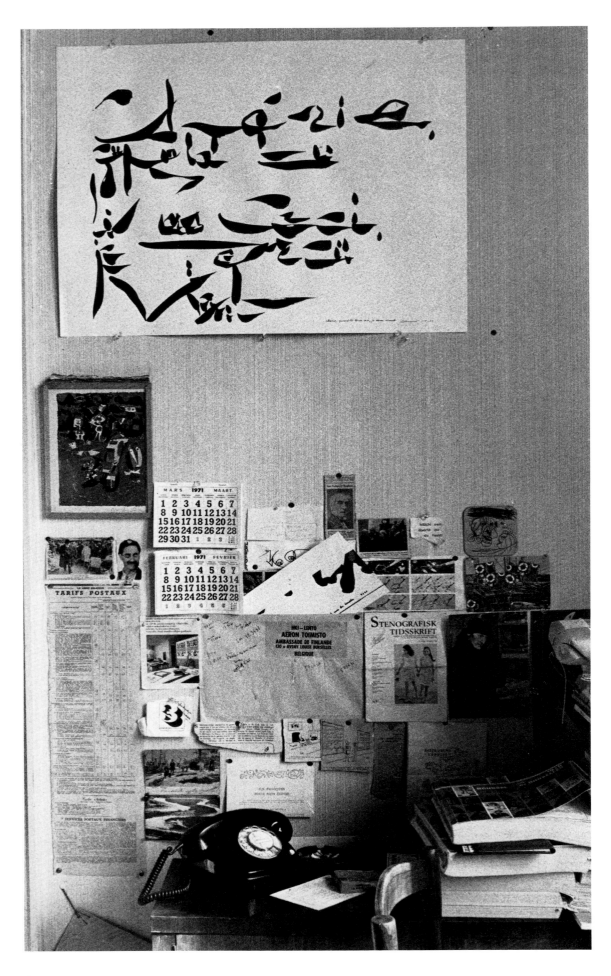

Christian Dotremont's rooms at 'Pluie de Roses', Tervuren, photographed by Pierre Alechinsky in 1971. On the wall, the logogram: *Cherie, quand tu liras ça, je serai vivant*, ('Darling, when you read this, I shall be alive'). Indian ink (54 × 72 cm). Sundry items affixed to the wall with drawing pins: a lithograph by Asger Jorn taken from *Helhesten*, Gaston Bachelard doing his shopping, Groucho Marx, Jean Paulhan as an academician, a postcard from Lapland, a drawing by Pierre Alechinsky (*Ah! les beaux jours!*) on a beermat, a postcard with cut-outs by Michel Butor, 'two sisters' on the cover of a magazine for typists, postal tariffs, etc.

Bibliography
Compiled by Robert Maillard

General Works

Artaud, Antonin. *Van Gogh, le suicidé de la société*. K. éditeur, Paris 1947.
Bachelard, Gaston. *La Psychanalyse du Feu*. Gallimard, Paris 1937.
Bachelard, Gaston. *Le Nouvel Esprit Scientifique*. Félix Alcan, Paris 1937.
Bachelard, Gaston. *L'Eau et les Rêves*. José Corti, Paris 1941.
Bachelard, Gaston. *L'Air et les Songes (Essai sur l'imagination du mouvement)*. José Corti, Paris 1943.
Bachelard, Gaston. *La Terre et les Rêveries de la Volonté*. José Corti, Paris 1948.
Bachelard, Gaston. *La Terre et les Rêveries du Repos*. José Corti, Paris 1948.
Bachelard, Gaston. *Le Matérialisme rationnel*. P.U.F., Paris 1953.
Bachelard, Gaston. *Le Droit de rêver*. P.U.F., Paris 1970.
Bord, Janet, and Lambert, Jean-Clarence. *Labyrinthes et Dédales du monde*. Les Presses de la Connaissance, Paris 1977.
Boutonnier, J. *Les Dessins des enfants*. Preface by Gaston Bachelard. Éditions du Scarabée, Paris 1953.
Breton, André. *Anthologie de l'humour noir*. Éditions du Sagittaire, Paris 1940.
Breton, André. *Manifestes du surréalisme*. Gallimard, Paris 1965.
Brøndsted, Johannes. *The Vikings* (Eng. trans.). Penguin Books, London 1960.
Cassou, Jean. *Situation de l'art moderne*. Éditions de Minuit, Paris 1950.
50 ans d'art moderne. Exhibition catalogue. Universal Exposition, Brussels 1958 (Apr.–July), Palais international des Beaux-Arts.
Emblèmes, totems, blasons. Exhibition catalogue. Texts by G. Dieterlen, Pierre Francastel, Jean Guiart, Claude Lévi-Strauss, Rémi Mathieu, Jean Nougeyrol, etc. Musée Guimet, Paris, March–June 1964.
Le Masque. Exhibition catalogue. Texts by Claude Lévi-Strauss et. al. Musée Guimet, Paris, Dec. 1959–Sept. 1960.
Dictionnaire général du surréalisme et de ses environs (Edited by Adam Biro and René Passeron). P.U.F., Paris 1982.
Dubuffet, Jean. *Prospectus et tous écrits suivants* (2 vol.). Gallimard, Paris 1967.
Dumézil, Georges. *Les Dieux des Germains. Essai sur la formation de la religion scandinave*. P.U.F., Paris 1959.
Durand, Gilbert. *Les Structures anthropologiques de l'imaginaire*. Bordas, Paris 1969.
Éluard, Paul. *A Pablo Picasso*. Éditions des Trois Collines, Geneva–Paris 1944.
Estienne, Charles. *L'art abstrait est-il un académisme?* Éditions de Beaune, Paris 1950.
Fierens, Paul. *Le Fantastique dans l'art flamand*. Éditions du Cercle d'Art, Bruxelles 1947.
Focillon, Henri. *La Vie des formes*. P.U.F., Paris 1943.
Freud, Sigmund. *Moïse et le Monothéisme*. Gallimard, Paris 1948.
Huizinga, Johan. *Homo ludens. Essai sur la fonction sociale du jeu*. Gallimard, Paris 1951.
Jaffé, H. L. C. *De schilderkunst van de 20e – eeuw*. Meulenhoff, Amsterdam 1963.
Jean, Marcel. *Histoire de la peinture surréaliste*. Le Seuil, Paris 1959.
Jung, C. C. and Ch. Kerenyi. *Introduction à l'essence de la mythologie*. Petite Bibliothèque Payot, Paris 1980.
Klee, Paul. *De l'art moderne*. Éditions de la Connaissance, Brussels 1948.
Klee, Paul. *Journal*. Berbard Grasset, Paris 1959.
Lefebvre, Henri. *Critique de la vie quotidienne*. Bernard Grasset, Paris 1947.
Lefebvre, Henri. *La Somme et le Reste*. Paris 1959 (reprinted by Bélibaste, Lausanne 1973).
Lourau, René. *Autodissolution des avant-gardes*. Éditions Galilée, Paris 1980.
Masson, André. *Le Plaisir de peindre*. La Diane Française, Paris 1950.
Mathieu, Georges. *Au-delà du Tachisme*. Julliard, Paris 1963.
Mauduit, J. A. *Quarante mille ans d'art moderne*. Plon, Paris 1954.
Myers, Bernard S. *Expressionism. A Generation in Revolt*. Thames and Hudson, London 1963.
Passeron, René. *Encyclopédie du surréalisme*. Somogy, Paris 1975.
Passeron, René. *L'OEuvre picturale et les Fonctions de l'apparence*. Librairie J. Vrin, Paris 1980.
Poésie naturelle (La). Documents collected and introduced by Camille Bryen and Alain Gheerbrant. J. éditeur, Paris 1949.
Ragon, Michel. *Vingt-Cinq ans d'art vivant. Chronique vécue de l'art contemporain: De l'abstraction au Pop'Art*. Casterman, Paris 1969.
Tapié, Michel. *Un Art autre*. Paris 1954.

Denmark

General works, texts and documents

Vilhelm Bjerke-Petersen. *Symboler i abstrakt kunst*. Copenhagen 1933.
Vilhelm Bjerke-Petersen. *Surrealismen*. Copenhagen 1934.
Linien. Copenhagen 1934–35, 1937 and 1939.
Helhesten. 12 issues, Copenhagen. 1st series: No. 1 (13 March 1941), no. 2 (10 May 1941), no. 3 (17 Sept. 1941), no. 4 (18 Nov. 1941), no. 5–6 (18 June 1942); 2nd series: no. 1 (30 Oct. 1942), no. 2–3 (10 March 1943), no. 4 (24 Dec. 1943), no. 5–6 (11 Nov. 1944).
Peter V. Glob. *Helleristninger og Magi*. Helhesten, I 2, Copenhagen, May 1941.
Høst. Exhibition catalogue (1942–50).
Ole Sarvig. *Et Foretrag om Abstrakt Kunst*. Helios, Copenhagen 1945.
Elna Fonnesbech-Sandberg. *Dem jeg mødte*. Carit Andersens, Copenhagen 1945.
Den Ny Realisme. Manifesto signed by Else Alfelt, Ejler Bille, Kujan Blask, Henry Heerup, Egill Jacobsen, Robert Jacobsen, Johannes Jensen, Asger Jorn, Tage Mellerup, Richard Mortensen, Erik Ortvad, Carl-Henning Pedersen, Niggo Rohde and Erik Thommesen. Høst Exhibition, Copenhagen, Nov.–Dec. 1945.
Déclaration du Groupe expérimental danois. Bulletin international du Surréalisme Révolutionnaire, Brussels, Jan. 1948.
Jens-August Schade. *Le Voleur de commodes*. Le Surréalisme Révolutionnaire, no. 1, Paris, March–April 1948.
Høst. Exhibition catalogue, Copenhagen, 19 Nov.–5 Dec. 1948.
Jørgen Roos. *Sur le cinéma expérimental au Danemark*. Le Petit Cobra, no. 1, Brussels, Feb. 1949.
Press cuttings on the Høst exhibition, Nov.–Dec. 1948.
Cobra 1, Copenhagen, March 1949.
Jørgen Nash. *Le Blé*. Cobra 1, Copenhagen, March 1949.
P. V. Glob. *Les 'Guldgubber' scandinaves*. Cobra 1, Copenhagen, March 1949.
Christian Dotremont. *Les Rencontres de Bregneröd*. Le Petit Cobra, no. 2, Brussels, Aug.–Sept. 1949.
H. Rasmussen. *Danske Manglebraedder*. Cobra 6, Brussels, April 1950.
Christian Dotremont. *Note sur le Congrès Cobra de Bregneröd*. Cobra 7, Brussels, autumn 1950.
Uffe Harder. *Three Poems*. Cobra 8–9, Copenhagen, Aug. 1951.
Jens-August Schade. *Un soir au café Laurits Betjent*, Cobra 8–9, (proofs), Copenhagen, Aug. 1951.
Jan Zibrandtsen. 'Moderne Deense Schilderkunst' exhibition. Stedelijk Museum, Amsterdam, Oct. 1953.
Édouard Jaguer. *Trajectoires scandinaves*, Le Soleil Noir, Paris 1953.
Collection of Mrs. Elise Johansen (catalogue). Text by Édouard Jaguer. Statens Museum for Kunst, Copenhagen 1954.
Jan Zibrandtsen. *Moderne Dansk Maleri*. Gyldendal, Copenhagen 1957.
Christian Dotremont. *Helhesten og Cobra – Ett dansk aventyr*, Paletten, no. 3, Stockholm 1960.
Édouard Jaguer. *Danska karakteristiker*, Paletten, no. 3, Stockholm 1960.
Troels Andersen. *De pre-Cobrabeweging in Denemarken*. Museumjournaal, series 7, no. 7–8, Oslo 1962.
Uffe Harder. *Danmark og Europa i Kunsten*. Aktuelt, Copenhagen, 27 Dec. 1962.
Lawrence Alloway. *Danish Art and Primitivism*. Living Arts, Magazine, Lente 1963.

Collection d'Anna et Kresten Krestensen. Lars Rostrup Bøyesen. Copenhagen 1963.
Uffe Harder. *Au Danemark, les individualités s'affirment.* La Galerie des Arts, no. 13, Paris, Feb. 1964.
Christian Dotremont. *Salute to Denmark.* Lefebvre Gallery, New York, 18 Feb.–21 March 1964.
Robert Dahlmann-Olsen. *A Danish Contribution to International Development in Art since 1933.* Smithsonian Institute, Aug. 1964.
W. Haas Stokvis, Robert Dahlmann-Olsen, Pierre Alechinsky, Michel Ragon, Carl-Henning Pedersen, Erik Nyholm, Uffe Harder, Svavar Gudnason, Ejler Bille, Constant (texts by). Louisiana Revy, 7th year, no. 1, Humlebaek, Aug. 1966.
Gunnar Jespersen. *De Abstrakte (Linien, Helhesten, Høstudstillingen, Cobra).* Berlingske, Copenhagen 1967.
Virtus Schade. *Cobra fra hoved til hale.* Uffe Petersen Schmidt, Copenhagen 1971.
Art danois, 1945–1973. Lars Rostrup Bøyesen and Knud Voss. Grand Palais, Paris, 23 May–16 July 1973.
Gunnar Jespersen. *Cobra.* Gyldendal, Copenhagen 1974.
Anthologie de la poésie danoise contemporaine, Jørgen Gustava Brandt, Uffe Harder and Klaus Rifbjerg. Gallimard-Gyldendal, Paris–Copenhagen 1975.

Alfelt, Else
(Copenhagen 1910–Copenhagen 1974)

Egill Jacobsen. *Else Alfelt.* Helhesten, II 1, Copenhagen, Oct. 1942.
Édouard Jaguer. *Else Alfelt. 'Les Artistes Libre',* Cobra Library, Munksgaard, Copenhagen 1950.
Else Alfelt, retrospective: *Et digt om Fuldmanen,* Copenhagen, 19 Nov.–4 Dec. 1960.
Poul Gammelbo. *Else Alfelt.* Gyldendal, Copenhagen 1968.
Catalogue of the Carl-Henning Pedersen og Else Alfelts Museum, Herning, Danmark 1976.

Balle, Mogens
(Copenhagen 1921)

Illustrated books
Christian Dotremont. *Dessins-mots.* Grizanta Fonds, Söborg, Denmark 1962.
Uffe Harder. Tilstande. Copenhagen 1965.
Joseph Noiret. *Histoires naturelles de la crevêche.* Phantomas, Brussels 1965.
Christian Dotremont. *L'Imagitatrice.* Copenhagen and Brussels 1969.
Christian Dotremont. *Abrupt, etc.* Kalundborg, Denmark 1972.

Studies
Gunnar Hellman. *Mogens Balle.* Galerie Hybler, Copenhagen 1960.
Tegneord van Mogens Balle en Christian Dotremont – Tusch, Gouaches, Akvareller. Galerie Prisma, Copenhagen, March 1963.
Christian Dotremont. *Mogens Balle.* Galerie Jensen, Copenhagen, Jan. 1965.

Bille, Ejler
(Odder, Jutland 1910)

Writings
Fra naturalism til symbolik. Linien, 1st year, no. 5, Copenhagen, 15 Sept. 1934.
Svavar Gudnason. Helhesten, I 5–6, Copenhagen, June 1942.
Om Nutidens grundlag for en skabende Kunst. Helhesten, II 1, Copenhagen, Oct. 1942.
Erik Thommesen. Helhesten, II 5–6, Copenhagen, Nov. 1944.
*Det nyskabenda.*Høst exhibition catalogue, Copenhagen, Nov.–Dec. 1945.
Picasso – Surréalisme – Abstrakt Kunst. Copenhagen 1945.
L'Expérience est dans la vie. Cobra 1, Copenhagen, March 1949.
Kunstens Sprog. Høst exhibition catalogue, Copenhagen, Nov.–Dec. 1949.
Geschmackskunst. Cobra 5, Hannover 1950.

Levende Kunst og Formalisme. Prisma, No. 2, Stockholm 1950.
Kommentar til mine skulpturer. Signum, 1st year, no. 3, Copenhagen 1961.
Vilhelm Bjerke Petersen 1909–1957. Galerie Hybler, Copenhagen 1962.
Brev om Cobra. Louisiana Revy, 7th year, no. 1, Humlebaek, Aug. 1966.

Studies, monographs
Carl-Henning Pedersen. *Ejler Bille.* Helhesten, II 2–3, Copenhagen, March 1943.
Michel Ragon. *Ejler Bille.* 'Les Artistes Libres', Cobra Library, Munksgaard, Copenhagen 1950.
Poul Vad. *Ejler Bille.* Munksgaard, Copenhagen 1961.
Poul Vasd. *Ejler Bille. Peintures – Sculptures.* Maison du Danemark, Paris, 12–16 March 1965.

Ferlov, Sonja
(Copenhagen 1911)

Richard S. Mortensen. *Sonja Ferlov. Om den spontane methode til irrationel erkendelse.* Linien, Copenhagen 1935.
Christian Dotremont. *Sonja Ferlov.* 'Les Artistes Libres', Cobra Library, Munksgaard, Copenhagen 1950.
Troels Andersen. *Sonja Ferlov-Mancoba.* Sigmun, 2nd year, no. 3, Copenhagen 1962.
Robert Dahlmann-Olsen. *Sonja Ferlov-Mancoba.* Arkitekten, no. 25, Copenhagen 1963.
Troels Andersen. *Sonja Ferlov-Mancoba.* Borgen, Copenhagen 1979.

Heerup, Henry
(Copenhagen 1907)

Writings
Text in Linien, 1st year, no. 1, Copenhagen, 15 Jan. 1934.
Udtalelser af Henry Heerup. Helhesten, II 4, Copenhagen, Dec. 1943.
Al kunst bør vaere folkelig. Helhesten, II 5–6, Copenhagen, Nov. 1944.
Fløjte huggas billedbog. Hvedekorns Bogserie, Copenhagen 1953.
Om Skralde modeller. Signum, 3rd year, no. 2, Copenhagen 1963.
Min Arbejdsbog. Jørgen Brynjolf, Copenhagen 1966.

Illustrated books
Jens August Schade. *Sjov i Danmark.* Forlaget Helios, Copenhagen 1945.
Kaj Tølbøll Lauristen. *En verden i fabler.* Henrik Sandberg et Sønner, Copenhagen 1968.

Studies, monographs
Ejler Bille. *Ung dansk Billedhuggerkunst.* Samleren, 13th year, Copenhagen 1936.
D. S. Hansen. *Om Henry Heerup.* Helhesten, II, 4, Copenhagen, Dec. 1943.
Christian Dotremont. *Henry Heerup.* 'Les Artistes Libres', Cobra Library, Munksgaard, Copenhagen 1950.
Poul Christensen and Palle Nielsen. *Henry Heerup Linoleumssnit og Litografier.* 'Grafisk Orientering', Hans Reitzel, Copenhagen 1962.
Preben Wilmann. *Henry Heerup.* Munksgaard, Copenhagen 1962.
Preben Wilmann. *Heerup.* Maison du Danemark, Paris, 8 Nov.–5 Dec. 1963.
Robert Dahlmann-Olsen. *Henry Heerup.* Galerie Gamnel Strand, Copenhagen, Dec. 1967.

Jacobsen, Egill
(Copenhagen 1910)

Writings
Kunstens frihed. Exposition Kunstnernes Efteraars, Copenhagen, Nov.–Dec. 1938.
Kunsten contra Reaktionen. In collaboration with Jorn (Jorgensen). Arbejderbladet, Copenhagen, 15 Dec. 1940.
Saglighed og Mystik. Helhesten, I 1, Copenhagen, March 1941.
Introduktion til Carl-Henning Pedersens Billeder. Helhesten, I 3, Copenhagen, Sept. 1941.

Asger Jørgensen (Jorn). Helhesten, I 4, Copenhagen, Nov. 1941.
Text in the Høst exhibition catalogue, Copenhagen, Oct. 1942.

Studies, monographs
Robert Dahlmann-Olsen. *Egill Jacobsen.* Helhesten, I 2, Copenhagen, May 1941.
Christian Dotremont. *Egill Jacobsen.* 'Les Artistes Libres', Cobra Library, Munksgaard, Copenhagen 1950.
Harald Leth. *Egill Jacobsen.* 'Vor Tids Kunst', no. 54, Rasmus Navers Forlag, Copenhagen 1956.
Michel Ragon. *Egill Jacobsen.* Maison du Danemark, Paris, 14 June–5 July 1962.
Christian Dotremont. *Egill Jacobsen malerier fra 1962.* Galerie Blanche, Stockholm, Nov. 1962.
Christian Dotremont. *Egill Jacobsen,* Munksgaard, Copenhagen 1963.
Per Hovdenakk. *Egill Jacobsen,* vol. I: *Malerier 1928–65, Paintings 1928–65.* Borgen, Copenhagen, 1980.

Jorn, Asger
(Vejrum 1914–Aarhus 1973)

Writings
For a complete catalogue of the artist's writings to 1963, refer to *Bibliography of Asger Jorn's writings to 1963,* compiled by Guy Atkins and Erik Schmidt. Permild and Rosengreen, Copenhagen 1964.
Skabelsesprocessen. Linien exhibition catalogue, Student's Circle, Copenhagen, Dec. 1939.
Kunsten contra Reaktionen, published with Egill Jacobsen. Arbejderbladet, Copenhagen, 15 Dec. 1940.
Intime banaliteter. Helhesten, I 2, Copenhagen, May 1941.
De profetiske harper. Helhesten, II 5–6, Copenhagen, Nov. 1944.
Conversation avec Schade. Le Livre, no. 3, Paris, July–Aug. 1948.
Om forholder mellem automatismen og den spontane vision paa baggrund af den billedmaessige betydning. Vilhelm Serber, Copenhagen 1948; reprinted in Arkitektur, IV 4, Copenhagen, Aug. 1950.
Discours aux pingouins and *Le Réalisme dans l'art populaire suédois.* Cobra 1, Copenhagen, March 1949.
Les Formes conçues comme langage. Cobra 2, Brussels, March 1949.
Sociale sild og realistike oliefarver. Exhibition catalogue of the Spiralen Group, Copenhagen, Dec. 1949–Jan. 1950.
Eksperimentet. A 5, Meningsblad for unge arkitekter, IV 4, Copenhagen, Feb. 1950.
Danemark: I.A.E. (Internationale des Artistes Expérimentaux). Le Petit Cobra, no. 3, Brussels 1950.
L'Art sans frontières. Cobra 6, Brussels, April 1950.
Le Frey (Frö). De la fête populaire au mythe universel. Cobra 7, Brussels, autumn 1950.
Preface to and editorship of the first series of 'Artistes Libres' (15 vol.), Cobra Library, Munksgaard, Copenhagen 1950.
Held og hasard. Dolk og guitar. Silkeborg 1952.
Asger Jorn om sig selv. Kunst, I 1, Copenhagen, Sept. 1953.
Fin de Copenhague (with G. E. Debord). Bauhaus Imaginiste. Permild and Rosengreen, Copenhagen 1957.
Guldhorn og Lykkehjul. A/S Selandia, Copenhagen 1957.
Entretien avec Walter Korun (29.3.1956). Kunst Meridiaan, V 4–5–6, entitled 'Taptoe 58', Brussels 1958.
Pour la forme. Ébauche d'une méthodologie des arts. Internationale Situationniste, Paris 1958.
Peinture détournée. Modifications exhibition catalogue. Galerie Rive Gauche, Paris, May 1959.
La Fin de l'économie et la Réalisation de l'art. Internationale Situationniste, no. 4, Paris, June 1960.
La Création ouverte et ses ennemis. Internationale Situationniste, no. 5, Paris, Dec. 1960.
Critique de la politique économique, suivie de la Lutte finale. Internationale Situationniste II, Paris, 1959–60.
La Pataphysique, une religion en formation. Internationale Situationniste, no. 6, Permild and Rosengreen, Copenhagen 1961.
Naturens orden. De divisione naturae. Borgen, Copenhagen 1962.
Vaerdi og økonomi. Borgen, Copenhagen 1962.

Mind and sense. The Situationnist Times, no. 5, Copenhagen, Dec. 1964.
Ting og Polis. Borgen, Copenhagen 1964.
De la méthode triolectique. Dans ses applications en situlogie générale. Borgen, Copenhagen 1964.
Signes gravés sur les églises de l'Eure et du Calvados. Borgen, Copenhagen 1964.
Johannes Holbek og nutidens Kunstopfattelse in *Johannes Holbek*, Kunstmuseum, Silkeborg 1965.
Gedanken eines Kunstlers. Éditions Galerie van de Loo, Munich 1967.
La Langue verte et la cuite (with Noël Arnaud). J. J. Pauvert, Paris 1968.
Au pied du mur (with Noël Arnaud and François Dufrêne). Galerie Jeanne Bucher, Paris, March 1969.
Tegn og underlige gerninger. Copenhagen 1969–70.
Le Peintre par lui-même. Jorn à l'état sauvage. Interview with Jacques Michel, 'Le Monde', Paris, 27 Jan. 1971.
Magi og skønne kunster. Borgen, Copenhagen 1971.
Indfald og udfald. Borgen, Copenhagen 1972.
Gotlands Didrek (with Armin Tuulse, Jørgen Sonne, Niels Lukman). Permild and Rosengreen, Copenhagen 1978 (posthumous).
Folkekunstens Didrek. Permild and Rosengreen, Copenhagen 1978 (posthumous).

Illustrated books
Jadefløjten. Nogle kinesiske digte. Royal Academy of Art, Copenhagen 1943.
Jørgen Nash. *Salvi Dylvo*. Helhestens Forlag, Copenhagen 1945.
Jørgen Nash. *Leve livet*. Thanning and Appel, Copenhagen 1948.
Guy-Ernest Debord. *Mémoires. Structures portantes d'Asger Jorn*. Internationale Situationniste. Permild and Rosengreen, Copenhagen 1959.
Friedhof der Maulwürfe. Ein Roman von C. Caspari. Éditions galerie van de Loo, Munich 1959.
Occupations 1939–1945. Préface de René Bertelé. Galerie Rive Gauche, Paris 1960.
Jørgen Nash. *Stavrim, sonetter*. Permild and Rosengreen, Copenhagen 1960.
La Chevelure des choses, 1948–1953 (with Dotremont). Preface by Alechinsky. Éditions galerie Rive Gauche, Paris 1961.
Schweizer Suite, 1953–1954. Preface by Werner Haftmann. Éditions galeries van de Loo, Munich 1961.
La Flûte de jade – Jadefløjten – The Jade Flute (with Walasse Ting). Enker-Verlag, St. Gallen 1970.

Studies, monographs
Egill Jacobsen. *Asger Jørgensen*. Helhesten, I 4, Copenhagen, Nov. 1941.
René Renne and Claude Serbanne. *Asger Jorn*. Galerie Breteau, Paris 1948.
Christian Dotremont. *Asger Jorn*. 'Les Artistes Libres', Cobra Library, Munksgaard, Copenhagen 1950.
Christian Dotremont. *Asger Jorn (Toiles. Lithographies. Dessins)*. Galerie Taptoe, Brussels, March–April 1956.
G. E. Debord. *10 jaar experimentele kunst: Jorn en zijn rol in de theoretische inventie*. Museumjournaal, 4th series, no. 4, Otterlo 1958.
Christian Dotremont. *Asger Jorn renaissance tegen de Renaissance*. Museumjournaal, 6th series, no. 1, Otterlo 1961.
Michel Ragon. *Asger Jorn*. Cimaise, 8th year, no. 51, Paris, Jan.–Feb. 1961.
Robert Dahlmann-Olsen. *Beskedne Luxus Billeder*. Galerie Birch, Copenhagen, Feb. 1962'.
Jacques Prévert. *Nouvelles Défigurations*. Galerie Rive Gauche, Paris, June 1962.
Guy Atkins. *Asger Jorn*. 'Art in progress', Methuen, London 1964.
Guy Atkins and Erik Nyholm. *Asger Jorn's Aarhus Mural*. Westerham Press, Kent 1964.
Virtus Schade. *Asger Jorn*. Stig Vendelkaer, Copenhagen 1965.
Pierre Alechinsky. Notes on Jorn in *Titres et Pains perdus*, Denoël, Paris 1965.
Paolo Marinotti. *Jorn à Venise*. Centro Internazionale delle Arti e del Costume, Venice 1965.
Max Loreau. *Vers une peinture péremptoire*. Galerie Jeanne Bucher, Paris, April–May 1967.
Guy Atkins. I – *Jorn in Scandinavia, 1930–1953*. Lund Humphries, London 1968; II – *Asger Jorn. The crucial years 1954–1964*. Lund Humphries and Yves Rivière – Arts et Métiers Graphiques, London–Paris 1977; III

– *Asger Jorn. The final years 1965–1973*, Lund Humphries and Borgens Forlag, London–Copenhagen 1980.
Ezio Gribaudo. *Jorn – Cuba*. Texts by Georges Limbour, Antonio Saura, Wifredo Lam, Carlos Franqui. Fratelli Pozzo, Turin 1970.
Jean-Clarence Lambert. *Jorn Celui-Qui*. Galerie Jeanne Bucher, Paris, May 1972.
Wieland Schmied, Werner Haftmann, Ursula Schmitt, Guy Atkins, Troels Andersen and Christian Dotremont. *Asger Jorn*. Kestner-Gesellschaft, Hannover, 16 Feb.–18 March 1973.
René Bertelé, Christian Dotremont, Jacques Prévert, Guy Marester. *Jorn. OEuvre gravé*. 'Archives de l'art contemporain', CNAC, Paris 1973.
Mario De Micheli. *Jorn scultore*. Photographs by Mario Recrosio. Giampolo Prearo Editore, Milan 1973.
Ezio Gribaudo. *Jorn: le Jardin d'Albisola*. Texts by Alberico Sala and Guy E. Debord. Fratelli Pozzo, Turin 1974.
Asger Jorn, 1914–1973. Johannes Jensen and Troels Andersen. Kunstmuseum publication, Silkeborg 1974.
Asger Jorn. Werkverzeichnis Druckgrafik. Wieland Schmied, Troels Andersen and Guy Atkins. Galerie van de Loo, Munich 1976 (Engravings).
Asger Jorn à Silkeborg. Le Musée d'un peintre. Texts by Troels Andersen, Erik Nyholm and the artist. Musée d'Art moderne de la Ville de Paris, 14 Oct.–12 Nov. 1978.
Dessins d'Asger Jorn. Poems by Jens August Schade and Édouard Jaguer; texts by René Renne, Claude Serbanne and Édouard Jaguer. Silkeborg Museum – Phases, Silkeborg – Paris 1979.
Erindringer om Asger Jorn. Texts collected by Troels Andersen and Aksel Evin Olesen. Galerie Moderne, Silkeborg 1982.
Asger Jorn's samlinger. 1953–73. Text by Troels Andersen. Kunstmuseum, Silkeborg 1982.

Pedersen, Carl-Henning
(Copenhagen 1913)

Writings
Abstrakt Kunst eller Fantasikunst. Helhesten, II 4, Copenhagen, Dec. 1943.
Middelalderens kalkmalerier. Helhesten, II 5–6, Copenhagen, Nov. 1944.
Kunsten og den opvoksende ungdom. Høst Exhibition, Copenhagen 1944.
Billedkunsten i dag. Kunstnernes Efteraars exhibition, Copenhagen, Oct. 1945.
At vaere Spontan. Kunsternernes Efteraars exhibition, Copenhagen, Nov. 1948.
L'Étrange Nuit. Cobra 1, Copenhagen, March 1949.
Fantasiens undervaerk. Kunstnernes Efteraars exhibition, Copenhagen, Oct.–Nov. 1949.
Jeg vil fange solens gyldne lys. Art Centre at Raadhusstraede 3, Copenhagen, 17 April–1 May 1957.

Illustrated books
Drømmedigte. Helhestens Forlag, Copenhagen 1945.

Studies, monographs
Egill Jacobsen. *Introduktion til Carl-Henning Pedersens Billeder*. Helhesten, I 3, Copenhagen, Sept. 1941.
Catalogue *Carl-Henning Pedersen Eventyrets malerier*. Høst Exhibition, Den Frie Udstillings Bygning, Copenhagen, Nov.–Dec. 1950.
Jørgen Nash. *Carl-Henning Pedersen*. Konstrevy, 30th year, no. 5–6, Stockholm 1955.
Anna and Kresten Krestensen, Erik Andreasen. *Carl-Henning Pedersen – En indføring i hans billedverden – Universum Fabularum*. Munksgaard, Copenhagen 1957.
Christian Dotremont. *Carl-Henning Pedersen. Peintures, aquarelles et dessins*. Galerie de France, Paris, 15 Feb.–16 March 1963.
Erik Andreasen. *Carl-Henning Pedersen*. Rasmus Naver, Copenhagen 1965.
Virtus Schade. *Carl-Henning Pedersen*. Stig Vendelkaer, Copenhagen 1966.
Erik Andreasen. *Carl-Henning Pedersen. Paintings. Watercolors. Drawings*. Museum of Art Carnegie Institute, Pittsburgh, 25 Oct.–8 Dec. 1968.
Catalogue of the Carl-Henning Pedersen og Else Alfelts Museum, Herning, Denmark 1976.

Thommesen, Erik
(Copenhagen 1916)

Writings
Kulturel frihed – Folkelig kultur. Lang og Folk, 30 March 1948.
Levende Kunst-formalisme. Høst Exhibition, Copenhagen 1948.
Dualisme. Høst Exhibition, Copenhagen 1949.
Le Fond et la Forme. Cobra 10, Liège, Oct. 1951.
Kommentar til mine tegninger. Signum, 2nd year, no. 2, Copenhagen 1962.

Studies, monographs
Ejler Bille. *Erik Thommesen*. Konstrevy, 28th year, no. 4–5, Stockholm 1952.
Poul Vad. *Erik Thommesen*. Munksgaard, Copenhagen 1964.

Belgium

Texts, documents, reviews
René Magritte. *Les Mots et les Images*. La Révolution Surréaliste, no. 12, Paris, Dec. 1929.
L'Invention collective (2 issues), Brussels, Feb. and April 1940.
Christian Dotremont and Marcel Mariën. 'Le surréalisme encore et toujours', Cahiers de poésie, Paris, Aug. 1943.
La Terre n'est pas une vallée de larmes. Éditions 'La Boétie', Brussels, Feb. 1945.
Le Ciel bleu (9 issues), Brussels, 22 Feb.–19 April 1945.
Le Salut Public (special issue on Surrealism), Brussels, June 1945.
Le Savoir Vivre. 'Le Miroir infidèle', Brussels 1946.
Les Deux Soeurs (3 issues), Brussels 1946–47.
Pas de quartiers dans la révolution. Manifesto of the Belgian Revolutionary Surrealist group. Brussels, 7 June 1947. Signed by Marcel Arents, Paul Bourgoignie, Marcel Broodthaers, Achille Chavée, Andre de Rache, Christian Dotremont, Irène Hamoir, Marcel Havrenne, André Lorant, Albert Lude, René Magritte, Marcel Mariën, Paul Nougé, Léonce Rigot, Louis Scutenaire, Jean Seeger and Armand Simon.
La cause est entendue. Signed notably by Paul Bourgoignie, Achille Chavée, Christian Dotremont, Marcel Havrenne, Louis Scutenaire, Jean Seeger.
Bulletin international du Surréalisme Révolutionnaire. First and only issue, Brussels, Jan. 1948.
Le Surréalisme Révolutionnaire. Bi-monthly review. First and only issue, Paris–Brussels, March–April 1948. Texts by Noël Arnaud, Paul Bourgoignie, Christian Dotremont, Édouard Jaguer, René Passeron, Jens-August Schade, etc. Illustrations by Jacques Doucet, Josef Istler, Asger Jorn, Richard Mortensen et al.
Bulletin intérieur du Surréalisme Révolutionnaire. Published by Christian Dotremont, Brussels, no. 1, May 1948.
Phantomas. Founded by Joseph Noiret, Marcel Havrenne and Theodor Koenig. 163 issues, Brussels, 15 Dec. 1953–15 Dec. 1980.

Studies and monographs
Édouard Jaguer. *Au pays des images défendues*. Aujourd'hui-Art et Architecture, 5th year, no. 27, Paris 1960.
L'Humour vert. Phantomas, Brussels 1962.
Francine C. Legrand. *Peinture et Écriture*. Quadrum, XIII, Brussels 1962.
Christian Bussy. *Le Mouvement surréaliste en Belgique*. Opus International, special issue 19–20,

Paris, Oct. 1970.
A. Choisez. *Het tijdschrift Cobra*. Brussels University 1970–71.
La Belgique sauvage. Phantomas, 18th year, special issue, Brussels 1971.
Phil Mertens. *Belgische tijdschriften voor plastische kunsten, na 1945*. Museumjournaal, series 16, no. 5, Otterlo 1971.
José Vovelle. *Le Surréalisme en Belgique*. André De Rache, Brussels 1972.
Christian Bussy. *Anthologie du surréalisme en Belgique*. Gallimard, Paris 1972.
Phil Mertens. *La Jeune Peinture belge*. Laconti, Brussels 1975.
Phantomas. Exhibition catalogue, Musée d'Ixelles, 10 Oct.–9 Nov. 1975.
Harry Torczyner. *Magritte, signes et images*. Draeger–Le Soleil Noir, Paris 1977.
Marcel Mariën. *L'Activité surréaliste en Belgique (1924–1950)*. Le Fil Rouge, Lebeer Hossmann, Brussels 1979.

Alechinsky, Pierre
(Brussels 1927)

Writings

Les Poupées de Dixmude. Notes by Luc de Heusch (Zangrie) and photographs by Roland d'Ursel. Éditions Cobra, Brussels 1950.
Recette, L'Antimoine . . ., Avis. Cobra 5, Hannover 1950.
Giacometti. Cobra 6, Brussels, April 1950.
Aux pieds du mur de l'Atlantique, Ève-la-Terrible and *Le Rêve d'un jeune curé*. Cobra 7, Brussels, Autumn 1950.
C'est en forçant . . . Le Tout Petit Cobra, no. 4, Brussels 1950.
La Ville Mourante. Le Petit Cobra, no. 4, Brussels, Winter 1950–51.
Abstraction faite. Cobra 10, Liège, Oct. 1951.

Engagement i Kunsten. Louisiana Revy, 7th year, no. 1, Humlebaek, Aug. 1966.
Au-delà de l'écriture. Phases, no. 2, Paris 1955.
Calligraphie Japonaise. Quadrum I, Bruxelles 1956.
Nuit et jour. Walasee Ting exhibition. Galerie Taptoe, Brussels, April 1956.
Toko Shinoda et la Calligraphie Japonaise. Les Beaux-Arts, Brussels, 3 Oct. 1959.
Les Caves. Preface to 'La Chevelure des choses' by Asger Jorn and Christian Dotremont. Galerie Rive Gauche, Paris 1961.
Déplacement. Nouvelle Revue Française, 10th year, no. 119, Paris, Nov. 1962.
Étranger de métier. 'Visione Colore' exhibition. Centro Internazionale dell' Arti e del Costume, Venice 1963. *Note sur une morsure*. Alechinsky Exhibition, La Hune, Paris 1963.
Text to 'Solo de sculpture et divertissement arrangé pour peinture à quatre mains' (Reinhoud, Ting, Alechinsky), Galerie de France, Paris, Oct.–Nov. 1963.
Taking Bury apart. Pol Bury exhibition, Lefebvre Gallery, New York 1964.
Jean Raine. Jean Raine exhibition. Galerie du Ranelagh, Paris, March– April 1964.
Titres et Pains perdus. Notes sur les disparitions, les pertes de sens, les difficultés de transmission, les oublis, les manques et les persistances inutiles. Denoël, Paris 1965.
Idéotraces. Denoël, Paris 1966.
Le Tout-Venant. Galerie de France, Paris 1966.
Ting's studio. Daily Bûl, La Louvière 1967.
Contre l'embonpoint. Illustrations by Reinhoud. Dedalus éditeur, Paris 1967.
Le Test du titre. Georges Visat and Eric Losfeld, Paris 1967.
La Louvière. Daily Bûl, La Louvière 1969.
Roue libre. 'Les Sentiers de la création', Albert Skira, Geneva 1971.
L'Avenir de la propriété. Yves Rivière, Paris 1973.
Ad Miró. Derrière le Miroir, no. 193–94, Maeght, Paris 1971.
Les Moyens du bord. Alechinsky exhibition, Musée d'Art moderne de la Ville de Paris, Feb.–April 1975.
Far Rockaway. Fata Morgana éditeur, Montpellier 1977.
Peintures et Écrits. Yves Rivière – A.M.G., Paris 1977.
Dernier jour de Christian Dotremont. Argile, XXIII–XXIV, Maeght, Paris 1981.

Ensortilèges. Revue de l'Université de Bruxelles, special issue, 'La Belgique malgré tout. Littérature 1980'.
Robert L. Delevoy on *James Ensor* (Fonds Mercator, Brussels 1981).
Encrier de voyage. La Nouvelle Revue Française, no. 345, Paris, Oct. 1981.
Pluie de roses. Édition Art Investment, The Hague 1982.
Pollock, sorcier, sourcier. Jackson Pollock Exhibition, Musée national d'Art moderne, Centre Georges-Pompidou, Paris, April 1982.

Illustrated books

Marcel Lecomte. *Le Sens des tarots*. E.N.S.A.A.D., Brussels 1948.
Luc de Heusch. *Les Métiers*. E.N.S.A.A.D., Brussels 1948.
Hugo Claus. *Zonder vorm van Proces*. Draak, Brussels 1950.
Christian Dotremont. *Vues, Laponie*. Brussels 1957 (also Appel, Corneille and Jorn).
Christian Dotremont. *La Reine des Murs*. Galerie de France, Paris 1960.
Les Tireurs de langue. Texts by Amos Kenan, adapted by Christiane Rochefort. Fratelli Pozzo, Turin 1961.
Christian Dotremont. *Moi qui j'avais*. Girard, Paris 1961.
Amos Kenan. *A la gare*. Arte Graphica Uno, Milan 1962.
André Balthazar. *La Personne du singulier*. Daily Bûl, La Louvière 1963.
Walasse Ting. *One Cent Life* (with Appel, Jorn Reinhoud, etc.). Kornfeld, Zurich 1964.
Joyce Mansour. *Carré blanc*. Le Soleil Noir, Paris 1965.
Christian Dotremont. *Rectangles et Noeuds* in 'Paroles peintes II'. Éditions Lazar-Vernet, Paris 1965.
Communication, Seize manifestations d'hypertrophie calligraphique. Daily Bûl, La Louvière 1967.
François Nourissier. *De la Mort*. La Balance, Brussels 1967.
Joyce Mansour. *Le Bleu des fonds*. Le Soleil Noir, Paris 1968.
Julio Cortázar. *Histoires des Cronopiens et des Fameux*. 'Les Poquettes volantes' Collection, Daily Bûl, La Louvière 1968.
Achille Chavée. *Au demeurant*. Daily Bûl, La Louvière 1969.
Joyce Mansour. *Astres et Désastres*. The London Art Gallery, London 1970.
Michel Butor. *Hoierie – Voierie*. Giorgio Soavi Editore for Olivetti, Genoa 1970.
Louis Scutenaire. *Pointes*. Georges Visat, Paris 1972.
Jean-Clarence Lambert. *Laborinthe*. Georges Fall, Paris 1973.
Roger Caillois. *Un mannequin sur le trottoir*. Yves Rivière, Paris 1974.
Michel Butor. *Rêve de l'ammonite*. Fata Morgana, Montpellier 1975.
P. A. Benoît. *Entre le pouce et l'index*. P.A.B., Alès 1975.
Yves Bonnefoy. *Par expérience*. F. B. éditeur, Paris 1976.
André Frénaud. *La vie comme elle tourne*. Maeght, Paris 1979.
E.-M. Cioran. *Vacillations*. Fata Morgana, Montpellier, 1979.
Pol Bury. *Le Dérisoire absolu*. Daily Bûl, La Louvière 1980.
Joyce Mansour. *Le Grand Jamais* (with Roberto Matta). Maeght, Paris 1981.
Yves Bonnefoy. *L'Excédante*. F.B. éditeur, Paris 1982.

Studies, monographs

Luc de Heusch. *Fêtes, trouble-fête, peintures, etc.* Alechinsky Exhibition. Galerie Apollo, Brussels, Nov. 1948.
Luc Zangrie (de Heusch). *Alechinsky*. 'Les Artistes Libres', Cobra Library, Munksgaard, Copenhagen 1950.
Christian Dotremont. *L'Arbre et l'Arme. A propos d'une exposition Tajiri – Alechinsky*. Phases, Paris 1953.
Christian Dotremont. *Que se passe-t-il*. Alechinsky Exhibition. Galeries Nina Dausset, Paris, Nov.–Dec. 1954.
Francine-Claire Legrand. *Pierre Alechinsky*. Quadrum, XI, Brussels 1961.
Jacques Putman. *Pierre Alechinsky, conversation dans l'atelier*. L'Œil, no. 82, Paris, Oct. 1961.

Christian Dotremont. *Aquarelle und Tuschzeichnungen*. Galerie van de Loo, Munich, Oct.–Nov. 1961.
Gérald Gassiot-Talabot. *Alechinsky et ses monstres*. Cimaise, 9th year, no. 60, Paris, July–Aug. 1962.
Édouard Jaguer. *Alechinsky ou la Revanche des dragons*. Art International, Lugano, Jan. 1963.
Christian Dotremont. *Peintures à quatre mains* (Alechinsky and Ting). Art International, Lugano, Dec. 1963.
Yvon Taillandier. *Alechinsky oder 20 Jahre Impressionen*. Galerie van de Loo, Munich 1967.
Jacques Putman. *Pierre Alechinsky*. Fratelli Fabbri, Milan – Odege, Paris 1967.
Luc de Heusch and Chris Yperman. *Pierre Alechinsky*. Palais des Beaux-Arts, Brussels, Jan.–Feb. 1969.
Gunnar Jespersen. *Le Plaisir de peindre*. Galerie Birch, Copenhagen 1970.
Luc de Heusch (film by). *Alechinsky d'après nature*. 1970.
Alain Bosquet. *Alechinsky*. Le Musée de Poche, Paris 1971.
Les Estampes. Catalogue raisonné de 1946 à 1972. Yves Rivière, Paris 1973.
Amos Kenan, Roger Caillois. *Alechinsky*. Musée d'Art moderne de la Ville de Paris, Feb.–April 1975.
Freddy de Vree. *Alechinsky*. Kunstpocket, no. 3, Schelderode, 1976.
Jean-Clarence Lambert. *Central Park*. Yves Rivière, Paris 1976.
Appel et Alechinsky. Encres à deux pinceaux et leurs poèmes by Hugo Claus. Preface by Christian Dotremont. Yves Rivière – A.G.M., Paris 1978.
Pierre Georgel (with Marcel Lecomte). *Dessins d'Alechinsky. Donation de l'artiste au Cabinet d'Art graphique*. Centre Georges-Pompidou, Paris, July–Sept. 1978.
Hugo Claus. *Treize manières de regarder un fragment d'Alechinsky*. Bilingual edition, Ziggurat, Anvers 1979.
Georges Duby. *Travaux d'impression, principalement*. Galerie Maeght, Paris 1980.
Antonio Saura and Jean Frémon. *Encres sur cartes de navigation et peintures de l'année*. Derrière le Miroir, no. 247, Paris, Oct. 1981.

Bury, Pol
(Haine-Sainte-Pierre 1922)

Writings

De la pièce montée à la pierre. Cobra 2, Brussels, March 1949.
Bonuzzi. Cobra 6, Brussels, April 1950.
La Première Planche de l'atlas psychologique universel. Cobra 7, Brussels, Autumn 1950.
Le Temps dilaté. Strates, no. 3, Brussels 1964.
L'Art à bicyclette et la Révolution à cheval. Gallimard, Paris 1972.

Illustrated books

Marcel Havrenne. *La Main heureuse*. Éditions Cobra, Brussels 1950.
Joseph Noiret. *L'Aventure Dévorante*. Éditions Cobra, Brussels 1950.

Studies, monographs

Dore Ashton. *Pol Bury*. Maeght, Paris 1970 (with a major bibliography).
André Balthazar. *Pol Bury*. Preface by Eugène Ionesco. Cosmos, Brussels 1976.

Claus, Hugo
(Bruges 1929)

Delfstof. Poem illustrated by the author. Cobra 6, Brussels, April 1950.
Zonder vorm van Proces (with lithographs by Pierre Alechinsky, Draak, Brussels, June 1950.
Dialoog over een jonggestorven kunstenaar. Cobra 7, Brussels, Autumn 1950.
De Blijde en onvoorziene week. Illustrations by Karel Appel. Éditions Cobra, Paris, Dec. 1950.
Het wandelende vuur. Illustrations by Corneille. Éditions Cobra, Paris 1950–51.
April in Paris. With gouaches by Corneille. Single copy. Paris 1951.
Paal en Perk. Private edition. Paris 1951. De Sikkel, Anvers 1955.
Love Song. Illustrations by Karel Appel. Andreas Landshoff and Harry Abrams, Amsterdam–New

York 1963.
Karel Appel Painter. A. J. G. Strengholt, Amsterdam 1963 (Dutch edition, 1964).
Gedichten (1948–1963). De Bezige Bij, Amsterdam 1965.
Poèmes. Translated by Maddy Buysse. Mercure de France, Paris 1965.
Poèmes for 'Encres à deux pinceaux' by Karel Appel and Pierre Alechinsky (trans. by Freddy de Vree). Yves Rivière–A.G.M., Paris 1978.

Collignon, Georges
(Flémalle-Haute, Liège 1923)

Brian Martinoir. *Le Crayon et l'Objet*. Illustrated by Collignon. Éditions Cobra, Brussels 1950. (Also appeared in Cobra 10, Liège, Oct. 1951).

Cox, Jan
(The Hague 1919 – Anvers 1981)

A. Corbet. *Jan Cox*. De Sikkel, Anvers 1952.

Dotremont, Christian
(Tervuren 1922 – Buizingen 1979)

Because of Dotremont's special position in relation to Cobra, we felt it justified to extend his bibliography beyond that movement alone.

1. Poems, books, pamphlets and broadsheets
Ancienne Éternité. 'La poésie est là', Louvain 1940.
Ce petit pays si beau . . . La Revue Belge, Brussels, Feb. 1940.
Souvenir d'un jeune bagnard. La Nouvelle Revue Belgique, Brussels 1941.
Le Corps grand ouvert. 'L'Aiguille aimantée', Anvers 1941.
Noués comme une cravate (with a drawing by Oscar Dominguez). La Main à Plume, Paris 1941.
Oleossoonne ou le moment Spéculatif. 'Les Grands Moyens', Louvain 1942.
Les Dangers de la rue Serpente. Quatre-Vingt et Un, 2nd series, *c.* 1942.
Lettres d'amour (with a drawing by René Magritte). La Main à Plume, Paris 1943.
L'Avant-Matin. Le Serpent de mer, Spa, 1944.
Le Matin. Le Serpent de mer 1944.
Quand un homme parle des hommes ou les Ceintures de la connaissance. Éditions 'La Boétie', Brussels 1944.
Note sur les coïncidences, précédée de *Variations précises sur quelques moyens d'échapper à l'existence* . . . Éditions 'La Boétie', Brussels 1944.
La Mathématique du ténu. Éditions 'La Boétie', Brussels 1943.
Les Grottes du Tendre. Les Quatre Vents, no. 8, Paris 1947.
Les Poèmes. Reflex, no. 2, Amsterdam, Feb. 1949.
Jambages au cou (drawings by Corneille). Éditions Cobra, Amsterdam 1949. Reprinted by Michel Cassé, Paris 1970.
Le 'Réalisme-Socialiste' contre la révolution. Éditions Cobra, Brussels 1950.
Les Grandes Choses. 'Le Premier Pas', Paris 1953.
Avant dans la nuit. Phases, no. 1, Paris, Jan. 1954.
La Pierre et l'Oreiller. Gallimard, Paris 1955 (reprinted 1981).
Dépoésie (2 décembre 1955). Review 'Plus', no. 1, Brussels 1957.
Vues, Laponie (drawings by Alechinsky, Appel, Corneille and Jorn). Paris 1957.
Hors blanc (lithographs by Karel Appel). Paris 1958.
Fagnes (drawings by Serge Vandercam). Brussels 1958.
Petite Géométrie fidèle (lithographs by Corneille). Patris, Paris 1959.
Digue (photographs by Oscar Schellekens). Brussels 1959.
La Reine des Murs (lithographs by Alechinsky). Galerie de France, Paris 1960.
La Chevelure des choses (word-pictures by Jorn–Dotremont, 1948–53). Galerie Rive Gauche, Paris 1961.
Moi qui j'avais (drawings by Alechinsky). Girard, Paris 1961.
Ancienne Éternité (engravings by Raoul Ubac). Adrien Maeght, Paris 1962.
Dessins-mots (with Mogens Balle). Grizanta Fonds, Söborg, Denmark 1962.
Abstrate (with Alechinsky). Copenhagen 1963.

Jorn leve. Tervuren 1964.
Logogrammes I et Logogrammes II. Éditions de la revue Strates, Tervuren 1964 and 1965.
Rectangles et noeuds in 'Paroles peintes II', Éditions O. Lazar-Vernet, Paris 1965.
10, rue de la Paille, Bruxelles. Brussels 1968.
L'Imagitatrice (with Mogens Balle). Copenhagen and Brussels 1969.
Pour Sevettijärvi; Vues, Laponie; Logogrammes. L'Éphémère, no. 9, Fondation Maeght, Paris (spring, 1969).
Ltation exa tumulte et différents poèmes. Éditions, Brussels 1970.
Typographismes I. Éditions, Brussels 1971.
J'écris à Gloria. Olivetti éditeur, Milan 1971.
Progrès lapons. Proses – poèmes – tracés. L'Éphémère, no. 17, Fondation Maeght, Paris, 1971.
Abrupt, etc. (with Mogens Balle). Kalundborg 1972.
Les Transformes (with Jean-Michel Atlan, Brussels 1950). Yves Rivière, Paris 1972.
Linolog I et Linolog II (with Alechinsky). Jacques Putman éditeur, Paris 1972.
Feuille orée. Atelier Clot éditeur, Paris 1972.
Avancements d'un phoque. Le Journal des poètes, 42nd year, no. 4, Brussels 1972.
Brassée sismographique. Maeght éditeur, Paris 1972.
De loin aussi d'ici. Éditions, Brussels 1973.
Logbook. Yves Rivière éditeur, Paris 1975.
La Linguistique réelle. Éditions, Brussels 1977.
J'écris donc je crée (introduction by Freddy de Vree). Ziggurat, Anvers 1978.
Logbookletter. Éditions, Tervuren 1979.

Posthumous publications
Traces. Including 'J'écris donc je crée', 'Diptyques', 'L'Antilinguistique', extracts from 'Logbook', 'Les Grandes Choses', 'Note sur les coïncidences'. Preface by Joseph Noiret. Éditions Jacques Antoine, Brussels 1980.
Grand Hôtel des Valises. Locataire: Dotremont. Compiled by Jean-Clarence Lambert, including 'La Cobraïde', 'Jorn leve', 'Ancienne Éternité', 'Vues, Laponie', 'De loin aussi d'ici', plus texts by Alechinsky, Appel, Pol Bury, Corneille, Constant, Doucet, Édouard Jaguer, Jorn, Joseph Noiret, Ubac; 'dotremontage' by Pierre Faucheux. Éditions Galilée, Paris 1981.
La liberté, c'est d'être inégal. Bougival 1981.

2. Minor monographs, prefaces, articles and tracts
Notes techniques sur l'image dite surréaliste dans 'La Conquête du monde par l'image', La Main à Plume, Paris, April 1942.
L'avenir est membre du surréalisme. 'Le Surréalisme encore et toujours', Cahiers de poésie, Paris, August 1943.
Langage du langage in 'La Terre n'est pas une vallée de larmes', single issue. Éditions 'La Boétie', Brussels, Feb. 1945.
Raymond Roussel, le poète extrême. Le Ciel bleu, no. 1, Brussels, 22 Feb. 1945.
Comment traverser le miroir. Le Ciel bleu, no. 5, Brussels, 22 March 1945.
La Littérature. Le Ciel bleu, no. 7, Brussels, 5 April 1945.
Prisme infini de la lenteur. Le Ciel bleu, no. 9, Brussels, 19 April 1945.
Le Surréalisme – Le Mysticisme, Les Noms contre les Mots. Le Salut Public. Brussels, June 1945.
Labisse. Trente reproductions de tableaux et un portrait du peintre. Éditions 'La Boétie', Brussels 1946.
Le Savoir Vivre. 'Le Miroir infidèle', Brussels 1946.
Le Suractuel (single issue published by Dotremont). Brussels 1946.
C'est entre eux que les mots font l'amour. Le Salut Public, no. 9, Brussels, 15 June 1946.
Mon quartier. La Révolution la Nuit, 2nd cahier, Paris 1946.
La grasse matinée (with Seeger and Scutenaire). Anonymous publication, Brussels, Sept. 1946.
Des codes, L'Explicite et l'Implicite, Le Surréalisme Révolutionnaire, in the review 'Les Deux Soeurs', Brussels (3 issues, Oct. 1946–May 1947).
Les Bonnets de nuit!, Les Grands Transparents, Ode à Marx. Tracts, Brussels 1947.
Le Surréalisme en 947 (with Noël Arnaud). 'Pata-logue' officiel de l'Exposition internationale du Surréalisme, Paris 1947.
Dans l'ordre de la nécessité révolutionnaire. Bulletin international du Surréalisme Révolutionnaire, single

issue, Brussels, Jan. 1948.
La Revue la plus vivante du monde. Le Surréalisme Révolutionnaire, Paris 1948.
Le Coup du faux dilemme, Les Jeux et les Ris, Le Petit Panorama. Le Surréalisme Révolutionnaire, single issue, Paris, March–April 1948.
La cause était entendue, founding principles of Cobra, signed by Noiret for Belgium, Jorn for Denmark, Appel, Constant and Corneille for Holland. Duplicated sheets, Paris (8 Nov. 1948), published in le Petit Cobra, no. 1, Brussels, Feb. 1949.
Qu'est-ce que c'est? et *Un sonnet expérimental* (with Colinet), Le Petit Cobra, no. 1, Brussels, Feb. 1949.
Cordialement. Exposition 'Apport 49'. Galerie Apollo, Brussels, 17 Feb.–2 March 1949.
Impressions et Expressions du Danemark. Cobra 1, Copenhagen, March 1949.
Les Pouvoirs de l'automatisme et Colombus, roman feuilleton. Cobra 2, Brussels, March 1949.
Il vous reste trois jours pour visiter l'Exposition expérimentale 'Le Fin et les Moyens'. Tract, Brussels, 25 March 1949.
Par la grande porte. Exhibition of Appel, Constant, Corneille, Galerie Colette Allendy, Paris. Éditions Cobra, Amsterdam, May 1949.
Dans le plus grand secret l'Institut national de Cinématographie scientifique réalise un film sans précédent, Les Difficulteurs, Cinémasurréalifeste, Rune Hagberg, Roger Livet. Cobra 3, Brussels, June 1949.
L'Objet à travers les âges. Tract/Preface to the exhibition of the same title, Palais des Beaux-Arts, Brussels, 6–13 May 1949.
Rapide explication de deux mots, Les Grandes Choses, Dictionnaire dispersé des rencontres and (with Anders Österlin) *Vive l'amitié des peuples surréalistes*, Le Petit Cobra, no. 2, dedicated to the meetings at Bregneröd. Brussels, Sept. 1949.
Cobra, lien souple des Groupes expérimentaux danois, belge et hollandais, Brussels, 20 Oct. 1949.
Les papiers jaunis, les archives, les photos qui ont perdu leur éclat . . ., Le Grand Rendez-Vous naturel (1st part). Cobra 4, Amsterdam, Nov. 1949.
Et je ne vais dans les musées que pour enlever les muselières. Cobra tract, Brussels, Dec. 1949.
Oscar Dominguez, Peintures. Galerie Apollo, Brussels 1950.
Les Garanties mythologiques de la nature. Cobra 5. Hannover, early 1950.
Le Grande-Rendez-Vous natural (2nd part); *Hubinont, Heerup; Jacques Calonne; Colombus, roman*. Cobra 6, Brussels, April 1950.
Pol Bury. Peintures récentes. Galerie Apollo. Brussels, April 1950.
The activities of the Internationale of Experimental Artists in Germany, Belgium, Denmark and Holland, concerned principally with the second International Cobra congress and the 'Appel Affair'. Petit Cobra no. 3, Brussels, Spring 1950.
Cobra. Publicity poster in *Reality*. Association for intellectual and artistic progress in Wallonie, Brussels, May 1950.
Manifestations décentralisantes et unificatives Cobra pour le contact. 8-page pamphlet, Brussels, May 1950.
Quant à moi. Rixes, no. 1, Paris, May–June 1950.
Karel Appel, Constant, Corneille, Sonja Ferlov, Henry Heerup, Egill Jacobsen, Asger Jorn, Carl-Henning Pedersen: 8 monographs, 'Artistes libres' series, Cobra Library. Ejnar Munksgaard, Copenhagen 1950.
Les Développements de l'oeil. Exhibition of photographs by Raoul Ubac, Roland d'Ursel and Serge Vamdercam. Galerie Saint-Laurent, Brussels, 30 Sept.–15 Oct. 1950.
Week-end à Zandvoort, Les Rencontres internationales de Bregneröd, Marc Mendelson, Signification et Sinification, Le Rôle de la spirale dans la cosmogonie du capitaine Christesco. Cobra 7, Brussels, Autumn 1950.
L'Art contre la guerre, La Première Exposition collective des Ateliers du Marais . . ., *Raoul Ubac, Le venin de Cobra est en voie de devenir un produit important pour la médecine moderne, Max Ernst*. Le Petit Cobra, no. 4, Brussels, early 1951.
Les Moyens et la Fin. Text on P. Alechinsky. La Revue graphique, 2nd year, no. 11, Brussels, Feb. 1951.
Cobra blev grundlagi d. 4 november 1948 . . ., *Le Danemark et l'étranger, Lukket og aben, Est-ce qu'il neigeait?* (under pseudonym of Bent Findel), *L'École de la mémoire*. Cobra 8/9 in proof stage, Copenhagen (July 1951), published in the reprint of the review,, J.-M. Place éditeur, Paris.
L'Expérience de Holbaek. Cobra 10, Société royale des Beaux-Arts, Liège, Sept. 1951.

L'Arbre et l'Arme (Concerning an Tajiri-Alechinsky exhibition, Galerie Martinet, Amsterdam). Éditions Phases, Paris 1953.
Journal bien-portant du journaliste malade. Sillages, 2nd year, nos. 11 and 14, Eupen, Aug. and Nov. 1953.
Ne perdons pas le nord. Sillages, 2nd year, no. 13, Eupen, Oct. 1953.
Nous irons dans les bois et nous y laisserons les lauriers. Salon 'Octobre'. Galerie Craven, Paris, Oct. 1953.
Que se passe-t-il. Alechinsky Exhibition. Galerie Nina Dausset, Paris, Nov.–Dec. 1954.
André Lhote: Les Chefs-d'oeuvre de la peinture égyptienne; Paysages et Personnages de Maurice Vlaminck and Roberto Matta. Three articles in La Nouvelle Revue Française, Paris (no. 25, Jan 1955; No. 26, Feb. 1955; no. 35, Nov. 1955).
Il est rare d'être sûr . . . Asger Jorn exhibition. Galerie Taptoe, Brussels, March–April 1956.
Robert Le Bidois: L'Inversion du sujet dans la prose contemporaine; Julien Green: Le Malfaiture. Two articles in La Nouvelle Revue Française, Paris (no. 39, March 1956; no. 46, Oct. 1956).
Des jambages et des accents. Museumjournaal. Published by the Dutch Museums of Modern Arts, series 3, no. 1, Otterlo, May 1957.
Parfois c'est l'inverse. 'Phases' exhibition. Stedelijk Museum, Amsterdam, May–June 1957.
Paul Nougé: Histoire de ne pas rire. La Nouvelle Revue Française, no. 56, Paris, Aug. 1957.
Calligraphie japonaise. Prospectus on the film by Pierre Alechinsky and commentary, Paris 1957.
La Fidélité à l'audace . . . Phantomas, 4th year, no. 9, Brussels, Autumn 1957 (special issue dedicated to Marcel Havrenne).
Lettre à Paul Colinet sur le Danemark. Daily Bûl, no. 5, La Louvière, April 1958.
Pour une création homogène. Daily Bûl, no. 6, La Louvière, Sept. 1958.
Helhesten og Cobra – Ett dansk aventyr. Paletten, no. 3, Stockholm 1960.
Au Sameoedam, Laponie. La Nouvelle Revue Française, no. 105, Paris, Sept. 1961.
Pierre Alechinsky. Galerie van de Loo, Munich, Oct.–Nov. 1961.
Cobra en Belgique. Museumjournaal, series 7, no. 7–8, Otterlo, Jan.–Feb. 1962.
A propos de l'exposition 'Cobra et après' à la galerie Aujourd'hui – Conversation avec Svavar Gudnason, le peintre le plus nordique de Cobra. Les Beaux-Arts, no. 971, Brussels, 30 Mar. 1962.
Reinhoud. Preface in English for an exhibition at the Lefebre Gallery, New York, Oct.–Nov. 1962.
Egill Jacobsen malerier fra 1962. Galerie Blanche, Stockholm, Nov. 1962.
Cobra. L'Œil, no. 96, Paris, Dec. 1962.
J.-H. Soerensen. Galerie Ariel, Paris, March 1963.
Ailes et Sabots. 'Visione Colore' exhibition. Centre Internazionale delle Arti e del Costume, Palazzo Grassi, Venice, July–Oct. 1963.
Egill Jacobsen. 'Danish Contemporary Artists', Munksgaard, Copenhagen 1963.
C.-O. Hultén. Galerie Pierre, Stockholm 1963.
Strates, review entirely compiled by Dotremont: no. 1 (Oct. 1963), no. 2 (April 1964), no. 3 (Oct. 1964), No. 4 (April 1965), no. 5 (Oct. 1965), no. 6 (April 1966), no. 7 (Oct. 1966).
Duo pour une voix. Alechinsky Exhibition. Galerie Birch, Copenhagen, Jan. 1964.
Salute to Denmark. Works by M. Balle, E. Bille, H. Heerup, E. Jacobsen, A. Jorn, C.-H. Pedersen and P. Woelck. Lefebre Gallery, New York, Feb.–Mar. 1964.
Les Changements. Daily Bûl, no. 10, La Louvière, 1964.
Mogens Balle. Exhibition at the Galerie Jensen, Copenhagen, Jan. 1965.
Quelques observations au sujet d'une exposition Cobra (1966 exhibition at the Museum Boymans-van Beuningen, Rotterdam, 1966; appeared in Phases, 15th year, 2nd series, no. 1, Paris, May 1969.
Cobra, la peinture et l'objet. Les Beaux-Arts, no. 1281, Brussels, 26 March 1970.
Tiré à part de la revue 'Présence de l'Actualité' (no. 3568), Brussels, May 1971.
Récital Jacques Calonne. Program. Bistrot-Antiquaire 'Le Huchier', Brussels, 25 May 1971.
Preface to a Jacques Calonne exhibition. Galerie Dierieckx, Brussels 1971.
Une rencontre lithographique de vagabonds. Introduction to an album of lithographs by Pierre Alechinsky, Karel Appel, Corneille, Egill Jacobsen, Asger Jorn,

Carl-Henning Pedersen. Dan Graphic, Copenhagen–Silkeborg 1973.
Le Géologue ailé. Corneille retrospective. Palais des Beaux-Arts, Charleroi 1974.
Interview 'Le Musée au regard des artistes'. L'Arc, no. 63 (Beaubourg and the museum of tomorrow), Aix-en-Provence 1975.
The Young Vic, La Navette, Pop et Design. Sionna, Brussels (respectively in no. 1, May 1975, no.2, Sept. 1975; no. 3, Dec. 1975).
Ni deuil ni dieu pour Groucho-the-Look, Titres presque vieux. Sionna, Brussels (nos. 10 and 12, Jan. and Sept. 1978).
Préface to a book by Appel and Alechinsky: 'Encres à deux pinceaux et leurs poèmes par Hugo Claus'. Yves Rivière–A.M.G., Paris 1978.
Félix Rozen ou le Transéquilibre. Preface to an exhibition of F. Rozen. Champfleury, Paris 1979.
Cobra, qu'est-ce que c'est? First published in English as 'What is Cobra?', in the catalogue to the Exhibition at the Lefebre Gallery, New York, (Jan. 1979). This text was the last Dotremont wrote on Cobra. It appeared in the reprint of the review published by Éditions Jean-Michel Place, Paris 1980.

Posthumous publications
Erik Ortvad (1949 text). Kunstmuseum, Silkeborg, 1979.
Cobra Écriture Peinture (1962–1978). Writings by Dotremont in works by Alechinsky, Appel, Atlan, Balle, Bury, Claus, Corneille, Hultén, Jorn, Reinhoud, Vandercam. Galerie Détour, Namur, Oct.–Nov. 1980.
Pierre Alechinsky, text in German, 10 Oct. 1956. Alechinsky retrospective, Kestner–Gesellschaft, Hannover, Nov.–Dec. 1980.
Mémoires d'un imaginiste. Argile, XXIII–XXIV, Maeght, Paris 1981.

3. Studies, monographs
Achille Chavée. Pour un jeune poète – A Christian Dotremont, in the collection of poems 'D'ombre et de sang'. Éditions du Boomerang, La Louvière, 1946.
Pierre Alechinsky. Notes on Dotremont in 'Titres et pains perdus', Denoël, Paris 1965.
Pierre Alechinsky. Log notes, in 'Roue libre', Skira, Geneva 1971.
Yves Bonnefoy. Dotremont. Exhibition catalogue. Galerie de France, Paris 1971.
Joseph Noiret. Logogrammes. Palais des Beaux-Arts, Brussels 1972.
Dotremont-lès-logogrammes. Film by Luc de Heusch, Brussels 1972.
Jean-Clarence Lambert. Les Chemins de la désécriture. Opus International, no. 33, Paris, Mar. 1972.
Jean-Clarence Lambert. Dotremont og venner fra Cobra. Sophienholm Art Centre, Lyngby, Jan.–Feb. 1973.
Luc de Heusch. Logogrammes. Jacques Damase Gallery, Brussels 1975.
Max Loreau. Dotremont – Logogrammes (monographs). Éditions Georges Fall, Paris 1975.
Annemarie Balle. Dotremont og Logogrammerne. Éditions Anagram, Copenhagen 1976.
Michel Butor and Michel Sicard. Dotremont et ses écrivures. Éditions Jean-Michel Place, Paris 1978.
Entretiens de Tervuren (with Jean-Clarence Lambert), Éditions Galilée, Paris 1981.
Entretiens (with Eddy de Volder). Belgian Radio-Television, Brussels 1978.
Joseph Noiret and Claude Margat. Dotremont. Édition Ubacs, Rennes 1978.
Annemarie Balle. Christian Dotremont. 28.02.79. Asmindrup, Denmark 1979.
Pierre Alechinsky. Dernier jour de Christian Dotremont, 'Argile', XXIII–XXIV, Maeght éditeur, Paris 1981.
Joseph Noiret. Logogrammes, in 'Argile', XXIII–XXIV, Maeght éditeur, Paris 1981.
Jean-Clarence Lambert. Dotremont alias logogus. Preface to 'Grand Hôtel des Valises. Locataire: Dotremont'. Éditions Galilée, Paris 1981.
Michel Butor. Ballade de la boussole en deuil, in 'Treize à la douzaine'. Michel Beaulieu, Montreal 1981.
Uffe Harder and Georgina Oliver. Dotremont. Photographs by Peter A. Johansen and Felix Rozen. Borgen, Copenhagen 1982.
Freddy de Vree. Christian Dotremont schilder van woorten. Verbeeldt, no. 1, Groningen, April 1982.

Havrenne, Marcel
(Jumet 1912, Brussels 1957)

On vous montre des tableaux. Cobra 2, Brussels, March 1949.
Pour une physique de l'écriture. Cobra 4, Amsterdam, Nov. 1949; repub. by Temps mêlés, Verviers 1953.
La Main heureuse (drawings by Pol Bury). Éditions Cobra, Brussels 1950.
Pol Bury. 'Points de repère', no. 2. Galerie Le Parc, Charleroi 1950.
Ce que parler veut dire. Cobra 5, Hanover 1950.
J'écris pour vivre . . . Cobra 6, Brussels, April 1950.
Blankenberge ??? L'Écriture rêvée. Cobra 7, Brussels, Autumn 1950.
Entre la rose-fleur et la rose-mot. Cobra 8–9 (proofs), Copenhagen, Aug. 1951.
Pour une physique de l'écriture. Verviers 1953.
Du pain noir et des roses. Foreword by Jean Paulhan. George Houyoux ed., Brussels 1957.
Various articles in the review Phantomas, Brussels (April 1954, Sept. 1954, Aug. 1956, Winter 1956, Winter 1957, Jan. 1959, Jan. 1960, Dec. 1961, Dec. 1968). Daily Bûl, La Louvière (March 1957, June 1957).

Studies
Phantomas, 4th year, no. 9, Brussels, Autumn 1957. Special number dedicated to Marcel Havrenne. Texts by Christian Dotremont, J. L. Borges, M. Lecomte, J. Noiret, É. Jaguer, P. Alechinsky, P. Bury, N. Arnaud, etc.

Heusch, Luc de
Pseudonym: Luc Zangrie
(Brussels 1927)

Sur le terrain des Basumba. Cobra 6, Brussels, April 1950.
Perséphone. Cobra 7, Brussels, Autumn 1950.
Étude sur le carnaval de Malmédy. Cobra 8/9 (proof stage only), Copenhagen 1951.
Pour un nouveau totémisme. Cobra 10, Liège, Oct. 1951.

Lint, Louis van
(Brussels 1909)

Léon Louis Sosset. Louis van Lint. De Sikkel, Anvers 1951.

Noiret, Joseph
(Brussels 1927)

Un tableau vous crache ses couleurs à la figure. Cobra 2, Brussels, March 1949.
L'Homme sans phrases. Cobra 3, Brussels, June 1949.
Métamorphose apaisante. Cobra 4, Amsterdam, Nov. 1949.
L'Aventure dévorante (with Pol Bury). Éditions Cobra, Brussels 1950.
Le Menuisier du Ciel. Cobra 5, Hanover 1950.
La Grande Muraille de Chine. Cobra 6, Brussels, April 1950.
Le Délire figuratif. Cobra 7, Brussels, Autumn 1950.
Le Tout Petit Cobra. No. 1, 2, 3 and 5, Brussels 1950.
Description de Cobra. 'Cobra and after – and even before' exhibition. Palais des Beaux-Arts, Brussels, 31 March–14 April 1962.
Histoirse naturelles de la crevêche (with lithographs by Mogens Balle). Phantomas, Brussels 1965.
Cobra. Bibliothèque Phantomas, Brussels 1972.
Cobra. Phantomas, 18th year, Brussels 1973.
Logogrammes de Dotremont, in Argile, XXIII–XXIX, Maeght, Paris 1981.

Raine, Jean
(Brussels 1927)

Writings
Acousticons et Sonotones and L'Oiseau au candélabre. Cobra 3, Brussels, June 1949.
Péniblement. Cobra 6, Brussels, April 1950.
La Mère terrible and Le Rôle de la spirale dans le test du gribouillage. Cobra 7, Brussels, Autumn 1950.
Un propos ayant pour objet le dessin. Cobra 10,

Brussels, Autumn 1951.
Petit Festival du Film expérimental et abstrait. Programme. Palaise des Beaux-Arts, Liège, Oct. 1951.
Douze Poèmes d'amour. Éditions du Frêne, Brussels 1957.
Quelques pâleurs d'amour, 1947–1960 (with illustrations by the artist himself). Phantomas, Brussels, Sept. 1970.
Poèmes figuratifs. Éditions Saint-Germain-des-Prés, Paris 1979.

Studies
Marcel Lecomte. *J.R.* Galerie Saint-Laurent, Brussels, 6–15 Oct. 1962.
Pierre Alechinsky. *Jean Raine*. Galerie Le Ranelagh, Paris, 17 March–30 April 1964.

Reinhoud
Reinhoud D'Haese, *known as*
(Grammont 1928)

Joyce, Mansour. *Phallus et Momies*. 'Poquettes volantes', Daily Bûl, La Louvière 1968.
La Bande (sculptée) à Reinhoud vue par Julio Cortázar. Galerie de France, Paris, Oct. 1968.
Luc de Heusch. *Reinhoud*. Poème de Joyce Mansour. Fratelli Pozzo, Turin 1970.
La Fosse de Babel. Text by André Balthazar, Italo Calvino, Julio Cortázar and Joyce Mansour. Published by the author. Paris, Jan. 1972.
Jo Verbrugghen. *Reinhoud*. Kunstpocket, Schelderode, 1978.

Ubac, Raoul
(Malmédy 1910)

Writings
Les Pièges à lumière. L'Invention collective no. 2, Brussels, April 1940.

Studies
Georges Limbour. *Raoul Ubac*. L'Œil, no. 29, Paris, May 1957.
Michel Ragon. *Ubac*. Cimaise, 8th year, no. 53, Paris 1961.
Ubac. Texts by Jean Bazaine, Yves Bonnefoy, Paul Éluard, Paul Nougé and Michel Ragon. Maeght, Paris 1970.
Jean-Clarence Lambert. *Ubac, une archétypologie*. Opus international, no. 56, Paris, July 1975.

Netherlands

General works, texts and documents
Dessins d'enfants. Exhibition catalogue. Stedelijk Museum, Amsterdam, Dec.–Jan. 1949.
Aldo van Eyck. *Een appèl aan de verbeelding*. Pamphlet. Dutch Experimental Group. Cobra, Amsterdam, Jan. 1950.
A.-M. Hammacher *Stromingen en persoonlijkheden* (Courants et Personnalités). Meulenhoff, Amsterdam 1955.
Vijf 5 tigers. Poems (Remco Campert, Jan Elburg, Gerrit Kouwenaar, Lucebert, Bert Schierbeek). De Bezige Bij, Amsterdam 1955.
H. L. C. Jaffé. *De Stijl*. Meulenhoff, Amsterdam 1956.
W. Jos de Gruyter. *L'Art hollandais d'après-guerre*. Palais des Beaux-Arts, Charleroi, Dec. 1960–Jan. 1961.
W. Sandberg and H. L. C. Jaffé. *Kunst van heden in het*

Stedelijk. Stedelijk Museum–Meulenhoff, Amsterdam 1961.
J. Martinet. *Chronologie van Cobra en Reflex vooral van de Nederlandse activiteiten* (Chronology of Cobra and Reflex in the context of the Dutch). Museumjournaal, series 7, no. 7–8, Otterlo 1962.
Louis Gans. *Na 1945*. Exhibition of Dutch art since 1945, '150 jaar Nederlandse Kunst'. Stedelijk Museum, Amsterdam, July–Sept. 1963.
Willem Sandberg. *Sandberg over zijn werk in het Stedelijk*. Museumjournaal, series 8, no. 8–9, Otterlo 1963.
W.-L. de Haas-Stokvis. Préface to the exhibition 'Cobra 1948–1951', Museum Boymans-van Beuningen, Rotterdam, May–June 1966 (with biographical notes on Cobra artists).
Exhibition Catalogue. *Oog in oog met Hans en Alice de Jong*. Gemeentemuseum, Arnhem, June–Sept. 1970.
Dolf Welling. *Stedelijk '60–'70. Les collections d'art néerlandais 1960–1970*. Palais des Beaux-Arts, Brussels, Sept.–Oct. 1071.
Willemijn Stokvis. *Cobra*. De Bezige Bij, Amsterdam 1974. Source work for the study of Cobra. Contains excellent bibliography.
Écrivains néerlandais (Pays-Bas, Belgique flamande). Les Lettres Nouvelles, special issue, Paris, April–May 1975.

Appel, Karel
(Amsterdam 1921)

Writings and conversations
Karel Appel over Karel Appel. Triton Pers, Amsterdam 1971.
Océan blessé. Poèmes et Dessins. Éditions Galilée, Paris 1982.

Illustrated books
Hugo Claus. *De blijde en onvoorziene week*. Éditions Cobra, Paris, Dec. 1950.
Simon Vinkenoog. *Atonaal* (with Corneille). Stols, The Hague 1951.
Hans Andreus. *De ronde kant van de aarde*. Paris, May 1952.
Bert Schierbeek. *Het bloed strommt door*. De Bezige Bij, Amsterdam 1954.
Emmanuel Looten. *Haine*. Paris 1954.
Emmanuel Looten. *Cogne Ciel*. Paris 1954.
Emmanuel Looten. *Rhapsodie de ma nuit*. Georges Fall, Paris 1958.
André Frénaud. *Unteilbares Teil*. 1960.
Bert Schierbeek. *Het dier heeft een mens getekend*, 1962.
Hugo Claus. *Love Song*. Andreas Landshoff and Harry Abrams, Amsterdam–New York 1963.
Jean-Clarence Lambert. *Le Petit Ludeum de Karel Appel*. La Hune Editeur, Paris 1976.
Jean-Clarence Lambert. *Éloge de la folie*. Yves Rivière, Paris 1977.
Jacquot et Pépi. Children's book. Meulenhoff Landshoff, Amsterdam 1980.
Jean-Clarence Lambert. *Le Noir de l'Azur*. Éditions Galilée, Paris 1980.
Duo pour pinceau et crayon (with Dotremont). Text by Pierre Alechinsky. Édition Art Investment, The Hague 1982.

Studies, monographs
Christian Dotremont. *Karel Appel*. 'Les Artistes Libres', Cobra Library, Munksgaard, Copenhagen 1950.
Michel Tapié. *L'aventure totale d'Appel*. Palais des Beaux-Arts, Brussels, Oct.–Nov. 1953.
Michel Tapié. *Karel Appel*. Galerie Rive Droite, Paris 1955.
Hans Neuburg. *Karel Appel*. Galerie Lienhardt, Zurich, Dec. 1959–Jan. 1960.
Lucebert and Bert Schierbeek. *Karel Appel*. Gemeentemuseum, The Hague, June–July 1961.
Jan Vrijman. *De werkelijkheid van Karel Appel* (photos Van Der Elsken). De Bezige Bij, Amsterdam 1962.
Willem Sandberg and Ezio Gribaudo. *Sculptures de Karel Appel*. Text by Michele L. Straniero: 'Journal d'Ulysse à Roseland'. Fratelli Pozzo, Turin 1962.
Hugo Claus. *Karel Appel Painter*. A. J. G. Strengholt, Amsterdam – Harry Abrams, New York 1962; translated into Dutch by Strengholt, 1964.
Simon Vinkenoog. *Het verhaal van Karel Appel*.

Bruna, Utrecht 1963.
L. Gans. *De mythe van Karel Appel's anrotzooien*. Museumjournaal, series 8, no. 10, Otterlo 1963.
Christian Dotremont, Bert Schierbeek, Simon Vinkenoog, Lucebert. *Karel Appel*. Stedelijk Museum, Amsterdam, June–August 1965.
Peter Bellew. *Karel Appel*. Fratelli Fabbri, Milan and Odege–Hachette, Paris 1967.
Julien Alvard, Michel Tapié, Emmanuel Looten, Christian Dotremont, Herbert Read, Stéphane Lupasco, Willem Sandberg and Hugo Claus. *Karel Appel. Reliefs 1966–1968*. 'Archives de l'art contemporain', CNAC, Paris 1968.
Jos A. L. de Meyere. *Appel's Oogappels*. Central Museum, Utrecht, Sept.–Nov. 1970.
Rombout. *Appel's Appels*. Travelling exhibition in Canada, Company Rothmans de Pall Mall Canada Ltd, April–July 1973.
Jean-Clarence Lambert. *Dialogue avec Appel*. Galerie Ariel, Paris, June 1977.
Peter Berger. *Karel Appel*. Van Spijk BV, Venlo 1977.
Ed Wingen and Nico Koster. *Het gezicht van Karel Appel*. Van Spijk BV, Venlo 1977.
Ed Wingen. *Thirty Years of Paintings by Karel Appel*. Van Spijk BV, Venlo 1977.
Zwart (Appel–Alechinsky, Hugo Claus). Andreas Landshoff, Amsterdam 1978.
Jean-Clarence Lambert. *Works on Paper*. Preface by Marshall McLuhan. Abbeville Press, New York 1980.
Alfred Frankenstein. *Karel Appel*. Meulenhoff Landshoff and Harry Abrams, Amsterdam–New York 1980.
W. A. L. Beeren and Vim Beeren. *Het nieuwe werk van Karel Appel 1979–1981*. Museum Boymans-van Beuningen, Rotterdam, Jan.–March 1982.
Th. van Velzen and Mariette J. Jitta. *Karel Appel. Werk op papier*. Gemeentemuseum, The Hague 1982.

Brands, Eugène
(Amsterdam 1913)

Writings
To the point. Reflex, no. 1, Amsterdam, Sept.–Oct. 1948.
De beet van Cobra. 'Eugène Brands–Cobra 1948–1951' exhibition. Galerie Delta, Rotterdam, Oct.–Nov. 1964.

Studies
Virtus Schade. *Eugène Brands fra Cobra*. Kunst, 15th year, no. 1, Copenhagen 1968.
Eugène Brands-Schilderijen, Assemblages en Gouaches. Stedelijk Museum, Amsterdam, Oct.–Nov. 1969.

Constant
Constant A. Nieuwenhuys, *known as*
(Amsterdam 1920)

Writings
Manifest. Reflex, no. 1, Amsterdam, Sept.–Oct. 1948.
L'Avant-Garde artistique en Hollande. Paris, 6 Nov. 1948.
Cultuur en contra-cultuur. Reflex, no. 2, Amsterdam, Feb. 1949.
Les Neuf points du Groupe expérimental hollandais. Le Petit Cobra, no. 1, Brussels, Feb. 1949.
Høsterport. Cobra 1, Copenhagen, March 1949.
C'est notre désir qui fait la révolution. Cobra 4, Amsterdam, 1949.
De Experimentele Groep. Kunst en Kultuur, 10th year, no. 11, Amsterdam, Nov. 1949.
La Déclaration d'Amsterdam (with Guy E. Debord). Internationale Situationniste, Bulletin no. 2, Dec. 1958.
Première Proclamation de la Section hollandaise de l'Internationale Situationniste and *Une autre ville pour une autre vie*. Internationale Situationniste, bulletin no. 3, Paris, Dec. 1959.
Fragment d'une lettre. Internationale Situationniste, Sept. 1958. Éditions La Bibliothèque d'Alexandrie 1959.
Description de la zone jaune. Internationale Situationniste, bulletin no. 4, June 1960.
Nya Babylon (in Swedish), Paleten, no. 2, Göteborg 1964.
Opkomst en ondergang van de avant-garde. Randstad 8, De Bezige Bij, Amsterdam 1964.

New Babylong. Provo, no. 4, Amsterdam, Oct. 1965.
De dialektiek van het experiment. Constant retrospective. Gemeentemuseum, the Hague, Oct.–Nov. 1965.
De New Babylon. Informatief no. 4. Published for the 23rd Venice Biennale 1966.
Niew Urbanisme. Provo, no. 9, Amsterdam, 12 May 1966.
En ny tid. Louisiana Revy, 7th year, no. 1, Humlebaek, Aug. 1966.
Opstand van de Homo ludens. Paul Brand, Bussum 1969.
Auto-dialogue à propos de New Babylon. Opus International, no. 27, Paris, Sept. 1971.
Het zien van beeldende kunst. Mededeling Centraal Museum, no. 12, Utrecht, Dec. 1975.

Illustrated books
Gerrit Kouwenaar. *Goede morgen Haan*. Experimentele Groep in Holland, Amsterdam 1949. 30 copies printed.
8 fois la guerre. Lithographs. Amsterdam 1951.
Jan G. Elburg. *Het uitzicht van de duif*. Galerie Le Canard, Amsterdam, Nov. 1952.
Aldo van Eyck. *Voor een spatiaal colorisme*. Amsterdam 1953.

Studies, monographs
Christian Dotremont. *Constant*. 'Les Artistes Libres', Cobra Library, Munksgaard, Copenhagen 1950.
Michel Ragon. *Constant*. Galerie Breteau, Paris, Nov. 1950.
Guy E. Debord. *Constant*. Galerie van de Loo, Essen 1960.
Hein van Haaren. *Signalement van Constant*. Museumjournaal, 10th year, no. 5, Otterlo 1965.
Nic Tummers. *Aantekeningen over de ontwikkeling van het werk van Constant als experimenteel*. New Babylon, Informatief no. 1, Amsterdam 1965.
C. Caspari. *Ueber die Leichtigkeit ein Labyr herzustellen*. New Babylon, Informatief no. 3, Amsterdam 1966.
Hein van Haaren. *Constant*. Meulenhoff, Amsterdam 1967.
Victor E. Nieuwenhuys. *Constant – Aquarelles, gravures, sculptures*. Galerie Daniel Gervis, Paris, March–May 1972.
J. L. Locher. *New Babylon*. Gemeentemuseum, The Hague 1974.
Fanny Kelk. *Over het nieuwe werk van Constant*. Editie Collection d'art, 7, no. 8, Amsterdam 1976.
E. de Wilde and Fanny Kelk. *Constant – Schilderijen 1969–1977*. Stedelijk Museum, Amsterdam, March–May 1978.
Fanny Kelk. *Het aquarellen van Constant*. Editie Collection d'Art, 9, no. 5, Amsterdam 1978.
J. L. Locher. *Constant. Schilderijen 1940–1980*. Gemeentemuseum, The Hague, Sept.–Nov. 1980.
Freddy de Vree. *Constant*. Kunstpocket, series 2, no. 10, Schelderode 1981.

Corneille
Cornelis van Beverloo, *known as*
(Liège 1922)

Writings
Le Port. Reflex, no. 1, Amsterdam, Oct. 1948.
Fin de journée. Reflex, no. 2, Amsterdam, Feb. 1949.
Copenhague. Cobra 1, Copenhagen, March 1949.
Rentre chez toi . . ., Promenade au pays des pommes. Cobra 4, Amsterdam, Nov. 1949.
Je ne connais pas Amsterdam. Petit Cobra, no. 3, Brussels, early 1950.
Le Salon bourgeois. Cobra 5, Hannover 1950.
De Tademaït of de weelderige eentonigheid. Tijd en Mens, Amsterdam, April 1952.
Journal de la Tour. Diario de la Torre. La Nuova Foglio, Pollenza-Macerata 1975; reprint by Éditions Galilée, Paris 1981.

Illustrated books
Christian Dotremont. *Les Jambages au cou*. Éditions Cobra, Amsterdam 1949.
Christian Dotremont. *14 Improvisations*. Amsterdam 1949 (single copy).
Corneille. *Promenade au pays des pommes*. Éditions Cobra, Amsterdam 1949. Reprinted by Michel Cassé éditeur, Paris 1970.
Simon Vinkenoog. *Driehoogballade*. Private edition, Paris 1950.

Hugo Claus. *Het wandelende vuur*. Paris 1950–51.
Hugo Claus. *April in Paris*. Paris 1951. Single copy.
Simon Vinkenoog. *Atonaal* (with Appel). Stols, The Hague 1951.
Jean-Clarence Lambert. *Elle c'est-à-dire l'aube*. Falaize éditeur, Paris 1957.
Vol d'oiseaux. Album of six lithographs. Paris 1960.
Jean-Clarence Lambert. *Jardin errant*. Arturo Schwarz, Milan 1963.
Max-Pol Fouchet. *Femmes de nuit et d'aube*. Georges Fall, Paris 1966.
Jean-Clarence Lambert. *Ollintonatiuh*. Éditions Printshop, Amsterdam 1973.
Les Aventures de Pinocchio. La Nuova Foglio, Pollenza-Macerata 1973.

Studies, monographs
Christian Dotremont. *Corneille*. 'Les Artistes Libres', Cobra Library, Munksgaard, Copenhagen 1950.
Hugo Claus. *Over het werk van Corneille*. Kunsthandel Martinet and Michels, Amsterdam 1951.
Simon Vinkenoog, Rudy Kousbroek, Jan G. Elburg, Hugo Claus, Lucebert, Gerrit Kouwenaar. *Sextet voor Corneille*. Kunsthandel Martinet, Amsterdam 1954.
Charles Estienne. *Corneille*. Galerie Colette Allendy, Paris 1954.
W. Sandberg. *Corneille*. Galerie Craven, Paris 1956.
Michel Ragon. *Corneille*. Cimaise, 3rd series, no. 4, Paris, March 1956.
Jean-Clarence Lambert. *Corneille*. Le Musée de Poche, Paris 1960.
A. W. Hammacher. *Corneille*. *Le Labyrinthe et l'Ordre*. Quadrum, IX, Brussels 1960. Also published in the Corneille exhibition catalogue, Gemeentemuseum, The Hague 1961.
Max Loreau. *Corneille*. Stedelijk Museum, Amsterdam, Oct.–Dec. 1966.
W. de Haas – Stokvis. *Corneille. L'Oiseau et la Terre fleurie*. Openbaar Kunstbezit, 14th year, no. 6, Amsterdam, June 1970.
F. T. Gribling. *Corneille*. Meulenhoff, Amsterdam 1972.
André Laude. *Corneille, le Roi-Image*. Éditions S.M.I., Paris 1973.
Christian Dotremont. *Le Géologue ailé*. Palais des Beaux-Arts, Charleroi 1974.
Elverio Maurizi. *L'Opera grafica di Corneille 1948–1976*. La Nuova Foglio, Pollenza-Macerata 1976 (catalogue of graphic works).
Erik Slagter. *Corneille*. Kunstpocket, 2nd series, no. 2, Schelderode 1977.
André Laude. *Corneille aujourd'hui*. Galeri Kända Mälare, Jönköping, Sweden 1978.

Elburg, Jan G.
(Wemeldinge 1919)

Het uitzicht van de duif. Woodcuts by Constant. Galerie Le Canard, Amsterdam, Nov. 1952.
De gedachte mijn echo. Poetry. De Bezige Big, Amsterdam 1964.

Kouwenaar, Gerrit
(Amsterdam 1923)

Poëzie is Realiteit et Zeg het woord. Reflex, no. 2, Amsterdam, Feb. 1949.
Goede morgen Haan. Drawings by Constant. Experimentele Groep in Holland, Amsterdam 1949. 30 copies printed.
De 'A' van Cobra. Museumjournaal, 7th series, no. 7–8, Otterlo, 1962.
Sint Helena komt later. Poèmes 1948–58. Em. Querido, Amsterdam 1964.

Lucebert
Lubertus J. Swaanswijk, *known as*
(Amsterdam 1924)

Minnebrief aan onze gemartelde bruid Indonesia. Reflex, no. 2, Amsterdam, Feb. 1949.
Verdediging van de 50 gers. Cobra 4, Amsterdam, Nov. 1949.
Lucebert 1948–1963 gedichten. Edition compiled by Simon Vinkenoog with drawings by Lucebert. De Bezige Big, Amsterdam 1965.

. . . een morgen de hele wereld. Van Gennep, Amsterdam 1972.

Studies
Lucebert exhibition catalogue. Van Abbe Museum, Eindhoven, 1961. Text by the artist: *Kalm aan kinderen, er valt iets zwaars*.
H. L. C. Jaffé. Catalogue of the Venice Biennale: *Lucebert*. 1964.
J. E. Eijkelboom. *Lucebert*. Meulenhoff, Amsterdam 1964.
Exhibition catalogue for *Lucebert. Schilderijen, gouaches, tekeningen en grafiek*. Stedelijk Museum, Amsterdam, April 1969.

Rooskens, Anton
(Griendsveen 1906, Amsterdam 1976)

Rooskens exhibition catalogue. Kunsthalle, Recklinghausen, Oct.–Nov. 1961.
Hans Sonnenberg. *Anton Rooskens – Cobra 1949–1951*. Galerie Delta, Rotterdam, Dec. 1963–Jan. 1964 (with a text by Rooskens: 'De a van Cobra').
Anton Rooskens. A. van Wiemeersch, Ghent 1970.
Anton Rooskens exhibition catalogue. Galerie Ariel, Paris (in collab. with the Galerie Krikhaar, Amsterdam), Jan. 1972.

Schierbeek, Bert
(Enschede 1918)

Ochtendgrauen. Cobra 4, Amsterdam, Nov. 1949.
Het bloed strommt door. Illustrations by Karel Appel. De Bezige Bij, Amsterdam 1954.
Het dier heeft een mens getekend. Illustrations by Karel Appel. De Bezige Bij, Amsterdam 1962.
De Experimentelen. Meulenhoff, Amsterdam 1963.
Een broek voor een kotopus. De Bezige Big, Amsterdam 1965.

Tajiri, Shinkichi
(Los Angeles 1923)

Christian Dotremont. *L'Arbre et l'Arme* (about a Tajiri–Alechinsky exhibition, Kunsthandel Martinet, Feb.–March 1953). Phases, Paris 1953.
Aldo van Eyck. *Hello Shinkichi*. Stedelijk Museum, Amsterdam, March–April 1960.
H. L. C. Jaffé. Catalogue of the Venice Biennale: *Tajiri*. June–Aug. 1962.
Th. van Velzen. *Signalement van Tajiri*. Museumjournaal, series 11, no. 6, Otterlo 1966.
Tajiri-beelden 1960–1967. Stedelijk Museum, Amsterdam, April–June 1967.
Leonard Freed. *Seltsame Spiele*. Verlag Bärmeier and Nikel, Frankfurt 1970.
Tajiri. Sculptures. Drawings. Graphics. Books. Video tapes. Films. Museum Boymans-van Beuningen, Rotterdam, April–May 1974.

Wolvecamp, Theo
(Hengelo 1925)

Theo Wolvecamp. Stedelijk Van Abbe Museum, Eindhoven 1961.
Theo Wolvecamp. Court Gallery, Copenhagen 1969.

France

Texts, documents, reviews

La Conquête du monde par l'image. Texts by Noël Arnaud (L'Image dans la poésie collective), Christian Dotremont (Notes techniques sur l'image dite surréaliste), Raoul Ubac (Note sur le mouvement et l'oeil), Paul Éluard (Poésie involontaire et poésie intentionnelle), etc. La Main à Plume, Paris 1942.
André Breton. *Rupture inaugurale.* Éditions Surréalistes, Paris, June 1947.
Catalogue of the International Exhibition *Le Surréalisme en 47.* Galerie Maeght, Paris, July 1947.
Noël Arnaud and Christian Dotremont. *Le Surréalisme en 1947.* Paris 1947.
La cause est entendue. Paris, 1 July 1947. Signed, for France by Suzan Allen, Noël Arnaud, Yves Battistini, Lucien Biton, Max Bucaille, Paulette Daussy, Raymond Daussy, Pierre Desgraupes, Pierre Dumayet, Pierre Dumouchel, Jacques Halpern, Édouard Jaguer, Hubert Juin, Lucien Justet, Jacques Kober, Jean Laude, René Passeron, Tibor Tardos.
Invitation to the first International Conference of Revolutionary Surrealism, Brussels, 10 Oct. 1947.
Noël Arnaud: *Le Surréalisme Révolutionnaire dans la lutte idéologique (vers un surréalisme scientifique);* René Passeron: *Introduction à une érotique révolutionnaire.* Bulletin international du Surréalisme Révolutionnaire, first and only issue, Brussels, Jan. 1948.
Le Surréalisme Révolutionnaire. First and only issue, Paris–Brussels, March–April 1948. Texts by Noël Arnaud, Édouard Jaguer, René Passeron. Illustrations by Jacques Doucet, Josef Istler, Asger Jorn, etc.
Bulletin intérieur du Surréalisme Révolutionnaire. 5 bulletins: 24 May, 14 June, 21 June, 25 June, 5 July 1948, Paris.
Programme for the study session organised by the International Centre for the Documentation of Avantgarde Art, Paris, 5, 6, and 7 Nov. 1948.
Christian Dotremont. *Par la grande porte.* 'Appel, Constant, Corneille' exhibition. Galerie Colette Allendy, Paris, 3 May–2 June 1949.
Jean Bazaine. *Note sur la peinture.* Cobra 6, Brussels, April 1950.
Michel Ragon. *Les Mains éblouies* exhibition. Galerie Maeght, Paris 1950.
Rixes. Avant-garde review (Max Clarac-Sérou, É. Jaguer, J. Serpan). First and only issue. Paris, May–June 1950.
Michel Ragon. *Les Fonctionnaires de l'Art abstrait vont-ils se mettre en grève?* Cobra 8–9 (proofs), Copenhagen 1951.
Michel Ragon. *Cinq Peintres de Cobra.* Galerie Pierre, Paris, 14–28 April 1951.
Phases. Avant-garde review directed by Édouard Jaguer. Paraît depuis Jan. 1954, Paris. Infrequent publication.
Internationale Situationniste. 12 issues (June 1958–Sept. 1969). Reprint, Van Gennep, Amsterdam 1970.
The Situationist Times. Issue 4 (texts by Gaston Bachelard, Aldo van Eyck, H. L. C. Jaffé, etc.), issue 5 (texts by Pierre Alechinsky, Reinhoud, etc.). Éditeur Jacqueline de Jong, Paris 1963 and 1964.

Monographs, studies

Michel Ragon. *Expression et Non-figuration.* Éditions de la Revue Neuf, Robert Delpire, Paris 1951 (preface by Jean Cassou).
Guy E. Debord and Gil J. Wolman. *Mode d'emploi du détournement.* Les Lèvres nues, no. 8, Paris, May 1956.
Hubert Juin. *Seize Peintures de la Jeune École de Paris.* Le Musée de Poche, Paris 1956.
Édouard Jaguer. *Traveling van A naar Z.* Museum-

journaal, series 3, no. 1, Otterlo, May 1957.
Ce que sont les amis de Cobra et ce qu'ils représentent. Internationale Situationniste, no. 2, Paris 1958.
Jean-Clarence Lambert. *La Jeune École de Paris **.* Le Musée de Poche, Paris 1958.
G. E. Debord. *10 jaar experimentele kunst.* Museum-journaal, series 4, no. 4, Otterlo 1958.
Michel Ragon. *Le Groupe Cobra et l'Expressionnisme lyrique.* Cimaise, 9th year, no. 59, Paris, May–June 1962.
Michel Ragon. *Une nouvelle figuration.* Jardin des Arts, no. 95, Paris 1962.
Michel Ragon. *Cobra.* Jardin des Arts, no. 101, Paris 1963.
Michel Ragon. *Naissance d'un art nouveau.* Albin Michel, Paris 1963.
Jean-Jacques Lévêque. *Actualité de Cobra.* 20th century, 26th year, no. 23, Paris 1964.
Gilles Béraud. *La Création collective – Cobra libertaire.* University of Paris, 1972–73.
Gil J. Wolman. *Résumé des chapitres précédents.* Éditions Spiess, Paris 1981.
Édouard Jaguer. *Le Moment Cobra et le Surréalisme.* Champs des activités surréalistes, Bulletin de liaison no. 15, C.N.R.S., Paris, Feb. 1982.

Atlan, Jean-Michel
(Constantine 1913 – Paris 1960)

Texts
Conversation with Aimé Parti. Paru, no. 42, Paris, May 1948.
Abstraction et Aventure dans l'art contemporain. Cobra 6, Brussels, April 1950.

Illustrated books
Franz Kafka. *Description d'un combat.* Trans. Clara Malraux and Reiner Dorland. Maeght, Paris 1946.
Michel Ragon. *L'Architecte et le Magicien.* La Porte Ouverte, Rougerie, Limoges 1951.
Jacques Damase. *Les miroirs du roi Salomon.* Tisné, Paris 1962.
Christian Dotremont. *Les Transformes* (Brussels 1950). Yves Rivière, Paris 1972.

Monographs, studies
Michel Ragon. *Atlan et Pignon, membres permanents du Salon 'Corner'.* Cobra 1, Copenhagen, March 1949.
Michel Ragon. *Atlan.* 'Les Artistes Libres', Cobra Library, Munksgaard, Copenhagen 1950.
Michel Ragon. *Cri rouge. Poème sur les peintures d'Atlan.* Cobra 7, Brussels, Autumn 1950.
Michel Ragon. *Atlan.* Cimaise, 4th year, no. 3, Paris 1957.
Atlan. Retrospective, organised by 'Corner'. Charlottenborg, Copenhagen 1960.
Michel Ragon and André Verdet. *Jean Atlan.* René Kister, Geneva 1960.
Michel Ragon. *Atlan.* Georges Fall, Paris 1962.
Berbard Dorival. *Atlan. Essai de biographie artistique.* Tisné, Paris 1962.
Jean Cassou. *Jean Atlan* Exhibition. With texts by the artist. Musée national d'Art moderne, Paris, Jan.–March 1963.

Doucet, Jacques
(Boulogne-sur-Seine 1924)

Jean Laude. *Jacques Doucet.* 'Les Artistes Libres', Cobra Library, Munksgaard, Copenhagen 1950.
Michel Ragon. *Doucet.* Cimaise. 1st year, no. 4, Paris, Feb.–March 1954.
Imre Pan. *Jacques Doucet.* Signe (Cahier d'Art Contemporain), no. 64, Lescaret, Paris 1963.
René Passeron, Charles Estienne, Michel Ragon. *Jacques Doucet. Encres mêlées.* Éditions Saint-Germain-des-Prés, Paris 1975.

Germany

Götz, Karl Otto
(Aix-la-Chapelle 1914)

Meta. Art review published by K. O. Götz under the pseudonym of André Tamm. 10 numéros, 1948–53.
L'Art populaire allemand. Cobra 6, Brussels, April 1950.

Studies
Will Grohmann. *K. O. Götz.* Quadrum, III, Brussels 1957.
Pierre Restany. *K. O. Götz.* Cimaise, 5th year, no. 1, Paris 1957.
Will Grohmann, Édouard Jaguer, Enrico Crispolti, Kenneth B. Sawyer. *Karl Otto Götz.* Edizioni dell' Attico, Rome 1962.
Édouard Jaguer, Will Grohmann, Manfred de la Motte, etc. *Karl Otto Götz.* Galerie Hennemann, Bonn 1978.

England

Gilbert, Stephen
(Fife, Scotland 1910)

Stephen Gilbert. Cobra Paintings 1940–1950. Court Galery, Copenhagen, Oct. 1971.

Iceland

Gudnason, Svavar
(Höfn Hornafjadur 1919)

De Gamle Paroler. Text by Gudnason. Louisiana Revy, 7th Year, no. 1, Humelbaek, Aug. 1966.
Ejler Bille. *Om Svavar Gudnason.* Helhesten, I 5–6, Copenhagen, June 1942.
Robert Dahlmann-Olsen. *Svavar Gudnason.* Kunstvereniging, Copenhagen, Oct.–Nov. 1960.
Christian Dotremont. *A propos de l'exposition 'Cobra et après' à la galerie Aujourd'hui – Conversation avec Svavar Gudnason, le peintre le plus nordique de Cobra.* Les Beaux-Arts, no. 971, Brussels, 30 March 1962.

Italy

Augusto Moretti. *Vers un art populaire italien.* Cobra 6, Brussels, April 1950.
Baj and Dangelo exhibition catalogue. Galerie Apollo, Brussels 1952.
Il Segno e la Parola (Enrico Baj, Dangelo, Asger Jorn, Karel Appel, Corneille). Galerie Arturo Schwarz, Milan 1953.
Édouard Jaguer. *Enrico Baj.* Schettini Editore, Milan 1956.
Vitalità nell' arte. Preface by Henri Michaux. Centro Internazionale dell' Arti e del Costume, Palazzo Grassi, Venice, Aug.–Oct. 1959.
Gillo Dorfles. *Baj.* Quadrum, XII, Brussels 1961.
Tristan Sauvage (Arturo Schwarz). *Art nucléaire.* Éditions Vilo, Galerie Schwarz, Paris–Milan 1962.
Visione Colore. Texts by Paolo Marinotti and Christian Dotremont. Centro Internazionale dell' Arte e del Costume, Palazzo Grassi, Venice, Jul.–Oct. 1963.
Paolo Marinotti. *Parthénogenèse et Fécondation.* XXe Siècle, new series, no. 25, Paris, June 1965.
Catalogue raisonné de l'oeuvre complet d'Enrico Baj, by E. Crispolti. Introduction – Herbert Lust: 'Enrico Baj dada impressionist'. Giulio Bolaffi, Turin 1973.
Arte nucleare. 1951–1957. Opere, testimonianze, documenti. Galleria San Fedele, Milan 1980.

Sweden

Erwin Leiser and Elsa Grave. *Skånsk Avantgarde Konst*. Image Forlag, Malmö, Feb. 1949.
Édouard Jaguer. *Tour à terre. Le groupe de Malmö*. Le Petit Cobra, no. 2, Brussels, Aug.–Sept. 1949.
Imaginisterna. Museum, Malmö 1952.
Édouard Jaguer. *Les Imaginistes suédois: Carl Otto Hulstén, Gösta Kriland, Max Walter Svanberg, Anders Österlin*. Galerie de Babylone, Paris, Apr.–May 1953.
Édouard Jaguer. *Trajectoires scandinaves*. In 'Premier Bilan de l'art actuel'. Le Soleil Noir, Paris 1953.
Ingemar Gustafson. *Imaginisterna*. Skånska Konstmuseum, Lund University, March 1954.
Imaginisterna. Skånska Konstmuseum, Lund University, Jan.–Feb. 1967.
Situationister 1957–1971 (text in Swedish and English). Skånska Konstmuseum, University of Lund, May–June 1971.

Hultén, Carl Otto
(Malmö 1916)

Édouard Jaguer. *La Face inconnue de la terre*. Phases, Paris 1960.
Christian Dotremont. *C. O. Hultén*. Galerie Léger, Malmö, Nov. 1962.
Christian Dotremont. *C. O. Hultén*. Galerie Pierre, Stockholm, Feb. 1963.
Christian Dotremont, Gunnar Ekelöf, Göran Printz-Påhlson. *C. O. Hultén. Arbeten 1938–1968*. Konsthall, Lund, Sept.–Oct. 1968.
Louise Robert, Ingvar Holm, Artur Lundkvist and Sven Sandström. *C. O. Hultén: Vandra och Förvandla*. Liljevalchs Konsthall, Stockholm, Nov. 1978–Jan. 1979.

Österlin, Anders
(Malmö 1926)

Lasse Söderberg. *Anders Österlins Labyrint*. Salamander, no. 2, Malmö 1955.
Marianne Nanne-Braahammer. *Anders Österlin*. Paletten, no. 2, Göteborg 1961.
I når Bild. Skånes Konstförenings Publication, Malmö 1965.

Czechoslovakia

Zdenek Lorenc et Ludvik Kundera. *Skupina Ra*, Collections 5 and 6. Edice Ra, 1947.
Zdenek Lorenc. *Déclaration du groupe Ra*. Bulletin International du Surréalisme Révolutionnaire, Brussels, Jan. 1948.
Vladimir Boucek. *L'Art populaire et lÉpoque actuelle*. Cobra 1, Copenhagen, March 1949. (Resumé of article in 'Blok'.)
Ludvik Kundera. *Un peu plus de poésie populaire*. Cobra 1, Copenhagen, March 1949. (Resumé of article in 'Blok'.)
Frantisek Smejkal. *Surréalisme et Peinture imaginative en Tchécoslovaquie*. Phases, no. 10, Paris, Sept. 1965.
Václav Zykmund. *Du groupe Ra*. Výtvarné umeni, no. 4, Prague 1966.

Index

259